Max Beckmann – Retrospective

Haus der Kunst, Munich
February 25–April 23, 1984

Nationalgalerie, Berlin
May 18–July 29, 1984

The Saint Louis Art Museum
September 7–November 4, 1984

Los Angeles County Museum of Art
December 9, 1984–February 3, 1985

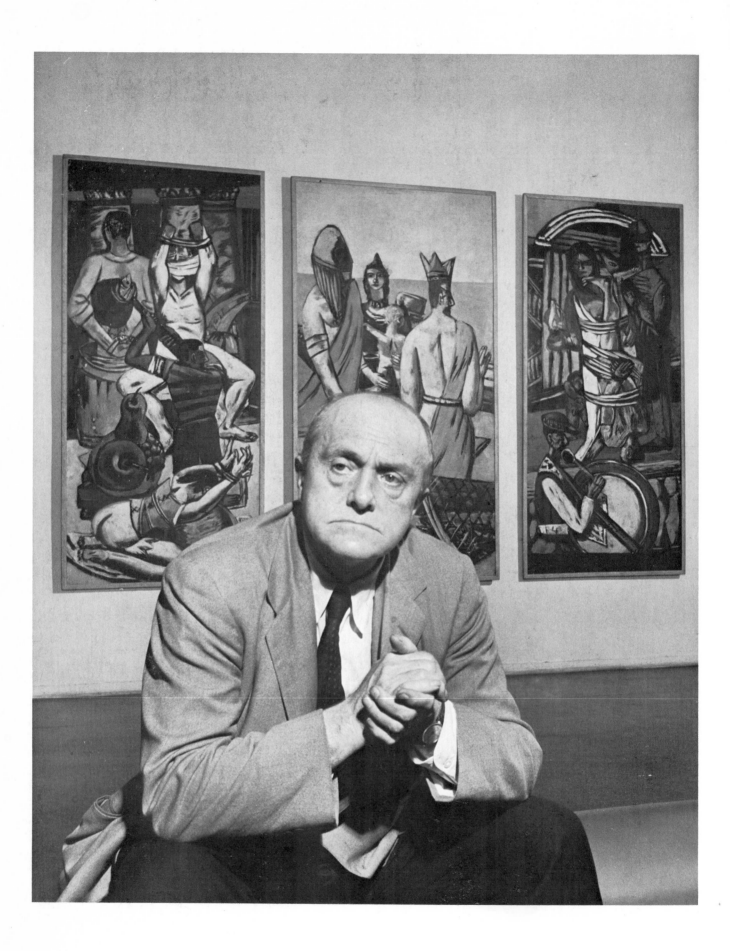

Max Beckmann

Retrospective

Edited by

Carla Schulz-Hoffmann
Judith C. Weiss

Contributors

Walter Barker, Peter Beckmann, James D. Burke
Wolf-Dieter Dube, Peter Eikemeier
Charles Werner Haxthausen, Bruno Heimberg
Stephan Lackner, Christian Lenz
Sarah O'Brien-Twohig, Doris Schmidt
Carla Schulz-Hoffmann, Peter Selz, Cornelia Stabenow

The Saint Louis Art Museum
in association with Prestel-Verlag, Munich
and W·W·Norton & Company, New York·London

MAX BECKMANN : RETROSPECTIVE is presented in cooperation with the following institutions

Bayerische Staatsgemäldesammlungen, Munich and
Ausstellungsleitung, Haus der Kunst, Munich

Nationalgalerie, Berlin

The Saint Louis Art Museum

Los Angeles County Museum of Art

This exhibition is supported through a generous grant from the
May Department Stores Company, in memory of Morton D. May.

Additional support has been received from the National
Endowment for the Arts, and the Missouri Arts Council.

Cover

Double-Portrait, Max Beckmann and Quappi, 1941 (detail, cat. 95)

Frontispiece

Max Beckmann in front of the triptych, *Departure,* 1947,
The Museum of Modern Art, New York

Printed in Germany
Color separations: Brend'Amour, Simhardt GmbH & Co., Munich
Typesetting: Fertigsatz GmbH, Munich
Printing: Karl Wenschow – Franzis-Druck GmbH, Munich
Binding: R. Oldenbourg, Heimstetten
ISBN 0-393-01937-3

Contents

Catalogue

Appendix

The following museums, galleries, and individuals have graciously
lent works of art to this exhibition:

Museums and Galleries

Amsterdam, Stedelijk Museum
Ann Arbor, The University of Michigan Museum of Art
Basel, Kunstmuseum
Basel, Kunstmuseum, Kupferstichkabinett
Berkeley, University Art Museum, University of California
Berlin, Staatliche Museen Preussischer Kulturbesitz, Kupferstichkabinett
Berlin, Staatliche Museen Preussischer Kulturbesitz, Nationalgalerie
Bielefeld, Kunsthalle
Boston, Museum of Fine Arts
Cambridge, Mass., Fogg Art Museum, Harvard University
Cambridge, Mass., Busch-Reisinger Museum, Harvard University
Chicago, The Art Institute of Chicago
Dortmund, Museum am Ostwall
Duisburg, Wilhelm-Lehmbruck-Museum
Düsseldorf, Kunstmuseum
Düsseldorf, Kunstsammlung Nordrhein-Westfalen
Essen, Museum Folkwang
Frankfurt, Städtische Galerie im Städelschen Kunstinstitut
Hamburg, Hamburger Kunsthalle
Hannover, Kunstmuseum Hannover mit Sammlung Sprengel
Kaiserslautern, Pfalzgalerie
Karlsruhe, Staatliche Kunsthalle
Kassel, Staatliche Kunstsammlungen, Graphische Sammlung
London, Marlborough Fine Art Ltd.
Lugano, Switzerland, Sammlung Thyssen-Bornemisza
Middletown, Davison Art Center, Wesleyan University
Minneapolis, The Minneapolis Institute of Arts
Minneapolis, University of Minnesota Art Museum
Munich, Bayerische Staatsgemäldesammlungen, Staatsgalerie moderner Kunst
Munich, Staatliche Graphische Sammlung
New York, Richard L. Feigen & Co.
New York, The Metropolitan Museum of Art
New York, The Museum of Modern Art
New York, Catherine Viviano Gallery
Paris, Musée National d'Art Moderne, Centre Georges Pompidou
Philadelphia, Philadelphia Museum of Art
Portland, Oregon, Portland Art Museum
Saarbrücken, Moderne Galerie des Saarland-Museums in der Stiftung Saarländischer Kulturbesitz
St. Louis, The Saint Louis Art Museum
St. Louis, Washington University Gallery of Art
Stuttgart, Staatsgalerie, Graphische Sammlung
Toledo, Ohio, The Toledo Museum of Art
Wuppertal, Von der Heydt-Museum
Zürich, Kunstmuseum

Private Collectors

Joan Conway Crancer
Fred Ebb
Richard L. Feigen, New York
Elise V. H. Ferber
Heinz Friederichs, Frankfurt a. M.
Mrs. William J. Green
Hauswedell & Nolte, Hamburg
Klaus Hegewisch
Bernhard and Cola Heiden
Fielding Lewis Holmes, St. Louis
Dr. and Mrs. Henry R. Hope
Dr. Lore Leuschner-Beckmann
R. E. Lewis, Inc.

Mr. and Mrs. Paul L. McCormick
Perry T. Rathbone
The Regis Collection
The Robert Gore Rifkind Collection, Beverly Hills
Georg Shäfer, Schweinfurt
William Kelly Simpson, New York
Otto Stangl, Munich
Mr. and Mrs. Jerome Stern
Dr. and Mrs. W. V. Swarzenski
Karin and Rüdiger Volhard, Frankfurt a. M.

and numerous private collectors
who wish to remain anonymous

Foreword

The idea of a comprehensive retrospective exhibition on the centenary anniversary of the artist has been a goal of all the participating museums for several years. It is fitting that the Bayerische Staatsgemäldesammlungen in Munich and The Saint Louis Art Museum, with the Günther Franke Bequest and the Morton D. May Bequest respectively, should take responsibility for a major exhibition in which all the important aspects of the artist's work would be represented. Accordingly, the intention from the beginning has been not to produce a temporary catalogue of the exhibition, but to achieve a lasting study of the artist's work.

The initiative for the exhibition essentially was taken by Professor Dr. Wolf-Dieter Dube, now the Generaldirektor of the Staatlichen Museen Preussischer Kulturbesitz, Berlin, during his previous appointment in Munich. His early meetings with The Saint Louis Art Museum, as well as discussions with the late Morton D. May, Stephan Lackner, and Robert Gore Rifkind, defined the breadth of the enterprise and determined the first selection of paintings. In 1983 Dr. Carla Schulz-Hoffmann accepted responsibility for the exhibition on the German side and directed the final selection of paintings. The conception of the catalogue was hers and, apart from a large section containing articles both by internationally acknowledged Beckmann experts and younger authors, it expressly aims to explain the artist's often hermetic imagery. All the works included in the catalogue are discussed in such a way that the public at large is given an opportunity for continued interpretation. The principal American coordinator was Judith C. Weiss of The Saint Louis Art Museum, who wrote the catalogues and commentaries for the drawings, watercolors, and prints; she also had responsibility for selecting all works of art on paper for the exhibition and securing their loans. The corresponding commentaries for the paintings were prepared by Dr. Carla Schulz-Hoffmann, Dr. Cornelia Stabenow, Dr. Christian Lenz, Dr. Angela Schneider, Lucy Embick, Martina Bochow, and Dr. James D. Burke. We are most grateful to all of these individuals for their planning of the exhibition and their participation in the catalogue.

The organization and financial responsibilities for this large international retrospective were handled by the Haus der Kunst in Munich, in cooperation with The Saint Louis Art Museum. We especially thank Magdalena Huber-Ruppel for her remarkable efforts in scheduling the tour, transportation, insurance arrangements, and catalogue production. This was ably managed on the American side by Helene A. Rundell, Assistant Registrar of The Saint Louis Art Museum. The organizers of the exhibition are grateful to Bruno Heimberg, who has been responsible for the care and condition of all works in the exhibition. We thank Prestel-Verlag, particularly Jürgen Tesch and Franz Mees, for their efforts in producing a very attractive and comprehensive catalogue.

The editing of the English edition of the catalogue was overseen by Mary Ann Steiner, Coordinator of Publications at The Saint Louis Art Museum. The entire project has benefitted greatly from her high degree of professionalism, her expertise, and good humor. Barton Byg and Jamie Daniel, who translated the essays, and Peter Fuss, who translated the commentaries of the paintings, merit special mention. Additional translations were prepared by John Bass, Larry and Bettes Silver, and Veronika Jenke. Ann Abid, Librarian at The Saint Louis Art Museum, assisted with the Bibliography for the English edition.

Our profound thanks is given to the May Department Stores Company for its generous financial support of the exhibition. Their sponsorship of the international

tour of the exhibition is in memory of Morton D. May, a friend and collector of the artist, who died in 1983.

A most important component of such a large exhibition which will travel for several years is the cooperation and generous spirit of the lenders. The thread that binds the organizing museums to the individuals, galleries, and museums which have so graciously parted with their works of art is a unique and precious one. Our gratitude extends to all lenders to the exhibition, though we mention only a representative few here. We thank Mrs. Mathilde Beckmann (New York), Dr. Peter and Maja Beckmann (Murnau), and Catherine Viviano (New York), without whose great helpfulness we could not have secured the variety and quality of works in the exhibition. In addition, we are grateful to Ingo Begall (Frankfurt), Dr. Klaus Gallwitz (Frankfurt), Richard L. Feigen (New York), Allan Frumkin (New York), Barbara Göpel (Munich), James Hofmaier (Cologne), the late Harold Joachim (Chicago), Dr. Stephan Lackner (Santa Barbara), Marlborough Fine Art Ltd. (London), Christa Maul (Munich), Perry Rathbone (New York), Robert Gore Rifkind (Los Angeles), Prof. Dr. Werner Schmalenbach (Düsseldorf), Wynfried Schulz (Munich), Dr. Margret Stuffmann (Frankfurt), and Liselotte von Szilvinyi (Frankfurt).

Max Beckmann's art stands as an enigmatic and singular presence in 20th-century German art. That museum visitors in Munich, Berlin, St. Louis, and Los Angeles will appreciate the special beauty of these works and be moved by the deep concerns of the artist would be the best compensation for the many efforts put toward the exhibition.

Erich Steingräber
Bayerische Staatsgemälde-
sammlungen, Munich

Hermann Kern
Ausstellungsleitung
Haus der Kunst, Munich

Dieter Honisch
Nationalgalerie,
Berlin

James D. Burke
The Saint Louis
Art Museum

Earl A. Powell, III
Los Angeles County
Museum of Art

The May Department Stores Company is pleased to join with the Haus der Kunst and the Bayerische Staatsgemäldesammlungen in Munich and The Saint Louis Art Museum in sponsoring the international tour of works by the German artist Max Beckmann, organized on the centennial celebration of his birth.

Max Beckmann was a special friend of Morton D. May, who died in April 1983 after serving The May Department Stores Company for 45 years, 21 of those years as either president or chairman of the board of directors.

Mr. May's admiration for and interest in Beckmann began in the mid-1940s and coincided with the artist's move from Amsterdam to St. Louis in 1947. Mr. May was the largest private collector of Beckmann's works.

The foresight of Mr. May formed the basis of a collection of range and quality that is an important part of this exhibition. During his lifetime Mr. May was notably generous in supporting the art activities of the community and in lending works of art to museums throughout the United States and abroad. It is only fitting that The May Department Stores Company carry on that tradition. We are therefore proud to join in this exhibition and hope that the visions that dominated the art of Max Beckmann and captivated the interest of Mr. May will excite and inform the visitors to the exhibition, both in Germany and in the United States.

David C. Farrell
President
The May Department Stores Company
St. Louis, Missouri

Citations of reference materials in the text and footnotes are as follows:

Göpel = Erhard and Barbara Göpel: *Max Beckmann. Katalog der Gemälde*,
 2 volumes, Bern, 1976.

von Wiese = Stephan von Wiese: *Max Beckmann's zeichnerisches Werk 1903-1925*,
 Düsseldorf, 1978.

Bielefeld = *Max Beckmann – Aquarelle und Zeichnungen 1903-1950*, exhibition
 catalogue, Kunsthalle Bielefeld, 1977.

VG = Catalogue of prints by Max Beckmann, in preparation by James Hofmaier,
 commissioned by the Max Beckmann Gesellschaft under the direction of
 Klaus Gallwitz.

Gallwitz = Klaus Gallwitz: *Max Beckmann – Die Druckgraphik – Radierungen, Lithographien,
 Holzschnitte*, Karlsruhe, 1962.

Peter Beckmann

Beckmann's Path to His Freedom

"Learn the forms of nature by heart, so you can use them like the musical notes of a composition. That's what these forms are for." Max Beckmann offered this advice to his students in the third of his "Letters to a Woman Painter." He continues: "Nature is a wonderful chaos, and it is our task and our duty to order this chaos... and to complete it." For him grief, endlessness, wildness, melancholy, and lethargy are part of the chaos of nature. "This alone is enough to make us forget the grief of the world, or to give it form. In any case, the will for Form carries in itself part of the salvation for which you are seeking."

What Beckmann expresses here is an essential part of his truth. What is the nature of this truth? It mocks any objectivity, and it sees its own nature, with personal feelings and values, as being connected to nature in general. It is therefore a truth that Beckmann personally possesses, but one which he also wants his imaginary adressee to reach in her own way.

After many years of coming to know his "self" by heart, i.e., his own nature, through his numerous self-portraits, and after many years of learning by heart the "other" nature, Max Beckmann now stands before us as a model in this century. Despite all barriers, temptations, and detours to seeking his "self" outside nature, he found it by persisting *with* nature. For him to depict this persistence in paintings, to give it form and pursue it to the point of transcendence, was a liberation from the constraints of the ego. The freedom won in this way is thus not the shedding of the super-ego, but communication with it. Ultimately he found that communication in the space surrounding everything. The all-encompassing space was for him the seat of the gods. His freedom always remained in connection to forms. He transformed the "wonderful chaos of nature" into the nature of his own vision, composed of "notes" which he drew from this chaos.

It is anachronistic to refer to nature as a wonderful chaos. Aren't we in the process of depriving nature of its wonders and deciphering its laws, so that it can no longer be seen as chaos? Doesn't everything follow laws that can be discovered? But this was not paramount for Max Beckmann. Repeatedly my father would contradict me indignantly whenever I would attempt to answer his questions about man by way of scientific conclusions. For him such an answer was an assault on the mysteries. It was a misguided temptation to lose individuality and to create false security somewhere in those categories of thought which are devoid of secrets.

Max Beckmann may often seem intransigent and even brutal in his works, but he was an extremely concerned man, as the biography by his wife Mathilde attests. He was very cautious and often extraordinarily attentive to others and their opinions. He never lectured on his paintings in his studio, in fact, he accepted any way one might see or speak of them. He seemed to want most of all to preserve the spontaneity of the subjective impression of the viewer.

If I were to objectify an image of Beckmann, I would not be able to see it. If I were to objectify a landscape outside my window, I would not be able to see that either. I am only able to see when I visually project my feelings and my

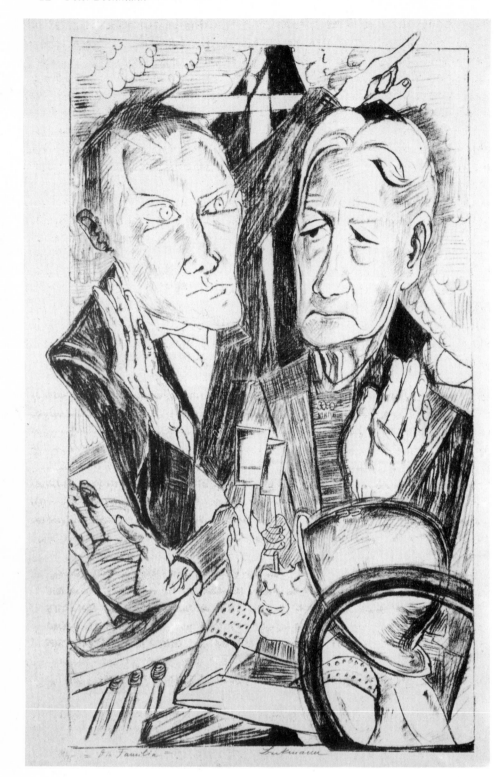

Fig. 1 Max Beckmann: *The Family,* plate 10 of the series *Hell*, 1919, lithograph, Private collection

mood onto the painting on the wall. I change the landscape outside my window according to my own relation to eternity and transcendence. Only when I project my feelings, joys, and sorrows, my own chaos onto this landscape, can I truly see. But today, how can one feel pain, melancholy, lethargy—one's personal spiritual dilemmas—through the mirror of nature and examine them self-critically? We have psychotherapists and other experts to relieve us of this self-criticism and to categorize us within their spheres of knowledge. When Beckmann paints a flower or an ocean, it is *his* flower and *his* ocean, yet still the flower and the ocean. If he portrays himself in the picture then, as subject, he has objectified himself. Thus, giving shape to something redeems it, be it a flower, an ocean, or one's own face.

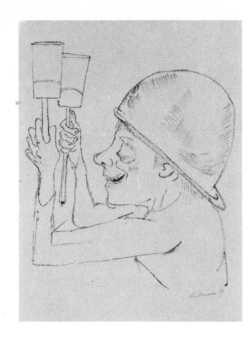

Fig. 2 Max Beckmann: *Peter with Hand Grenades,* 1919, drawing, Private collection

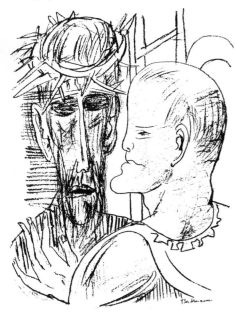

Fig. 3 Max Beckmann: *Christ and Pilate,* plate 15 of the series *Day and Dream,* 1946, lithograph, Bremen, Kunsthalle

Although some art of our times reveals a freedom that exists separately from nature and natural form, Max Beckmann accepted a bond with the forms of nature even as he gave them shape. He did not reject rules that even the subject must conform to; indeed, he himself had great respect for these rules. Perhaps the fascination of his life's work arises from the tension between unconditional freedom and an equally unconditional will to create his own order.

For Beckmann, nature includes himself, the Other and the Others, as he is able to see and study them. Both background and process are involved. The more closely he studied, the more successfully he could transcend and project the process into shape.

I repeatedly see before me a work from the cycle, *Hell,* done in 1919, entitled *The Family* (cat. 257, fig. 1). The family members depicted there are my grandmother Minna Tube, my father, and I. Grandmother and my father are presented with extremely different gestures. The old woman is resisting something with both hands. Father is distancing himself from something with his right hand; with the left he points energetically out of the picture. The angle of both their gazes passes over me, the child, as I hold up two objects that look like pots on sticks in visibly joyful anticipation. This event is explained by the work *Peter with Hand Grenades,* also from 1919 (fig. 2). It depicts the joyful child alone, with the pots on sticks.

The scene took place in Grandmother's apartment in Berlin, Pariserstrasse 2, at a time when returning soldiers were camped in a park nearby, next to Meier-Otto-Strasse. From time to time they would give the hungry children something from their stew pot: barley soup with raisins, a paradisiacal memory for me. I remember also that I once found two tins without sticks under the bushes in the park. I probably took them to be cans of food, and proudly brought the treasure home. Father immediately saw they were hand grenades. Away with them!

In the drawing, there is not the slightest suggestion of fright over the hand grenades or even a scolding for me. The joy of a found treasure is not taken from the child; he and his find are literally overlooked. The scene is transformed into a demonstration of resistance against the principle of war, battle, and weapons.

Beckmann struggled for a lifetime to give shape and order to the chaos of nature, both his own and ours. He gained from the reality of war "new images of the tortures of Christ." Even while he was surrounded by this reality, he could say, "My art is well fed here." It must be granted to anyone who can do this that he depict brutality and its methods while at the same time take up an attitude of resistance against it.

Beckmann goes even further. However attentive, careful, and loving he was with other people, objects, and plants in the activities of daily life, he was able to depict himself as a model of brutality. *Christ and Pilate* (cat. 297, fig. 3) is an example of this. It shows Beckmann as a brutal Pilate, looking past Christ, almost as if uninvolved, and pushing him toward the court of his enemies. This work was done about 1946 as the last in the series, *Day and Dream.*

Nature cannot become conscious of its own brutality. Beckmann saw nature as chaos, but recognized that he too belonged to this chaos. He found the way to his freedom by means of the very brutality he found in himself, and with it he dug himself out of his own chaos. There is no doubt about the meaning of Julius Meier-Graefe's statement—"I see such people as Beckmann as the opposite of gravediggers. Let us call them Life-Diggers."

Translated from the German by Barton Byg

Carla Schulz-Hoffmann

Bars, Fetters, and Masks:
The Problem of Constraint in the Work of Max Beckmann

> How could he ever have resisted fantasy,
> When he resisted only by means of fantasy.
> JEAN PAUL (Friedrich Richter)[1]

> It is our greatest hope that we *know nothing*...
> I am content that I *do not know,*
> for that gives me the certainty of an unknown
> solution, which is both path and goal.
> MAX BECKMANN[2]

An oeuvre as gigantic in scope and variety as Max Beckmann's should be approached with modesty since individual attempts at interpretation lead only to polishing the small stones of a whole mosaic. This is doubtless true of all great art, and unquestionably Beckmann must be counted among the few towering artistic personalities of the 20th century. Indeed, any work of art that could be exhaustively interpreted would hardly be judged as great. But Beckmann's oeuvre seems to present very special problems. It is difficult to grasp in a literal sense: it both provokes and excludes the viewer at the same time.

Whether we judge this positively or negatively, Beckmann's work always exists on two levels. He painted no picture which is merely beautiful, although he involved himself to an extraordinary extent with the medium. There is not one "decorative" painting in Matisse's sense. Even when a work appears as a breathtaking *peinture,* it lures the viewer into a deceptive security which is merely a facade for the abyss looming behind. This is perhaps the basis for the relation to medieval art which has been attributed to his early work,[3] for there too the wretchedness of the world was disguised in lofty beauty. Beckmann is supposed to have said that the painting *Women's Bath* (cat. 20) was intended to have the effect of a medieval stained glass window.[4] This suggests an essential aspect of his painting which extends beyond his early period, namely that the crystalline clarity and translucence seem to come from a source of light behind the canvas, as if through a window, allowing the colors to radiate. Behind this arresting beauty, unique in Beckmann's paintings, he can hide the anguish and despair, revulsion and hate that were never far from him—an effect that can arise even from technique, for instance from an unusually strongly colored ground (cf. Bruno Heimberg's essay on this point).

An introduction to an artist's work, particularly Beckmann's, must confine itself to only a few aspects and then attempt an interpretation on this basis. Since such an approach will always be subjective, no matter how objective the critical method strives to be, an explanation of the approach before us is in order. An introduction which has readability and accessibility as its goals must have general relevance and address the particular significance of Beckmann. Although model interpretations of paintings in chronological order was a possible avenue of approach, a grouping around repeated images and patterns of composition seemed more productive. For in these repetitions are revealed the variables and constants of the artist's view of the world.

Anything more than a cursory study of Beckmann's work will reveal that images of constraint and the denial of freedom appear in a broad range of

1. Norbert Miller, ed., *Jean Paul—Werke,* Vol. 3, *Titan,* Munich, 1966, p. 262.

2. Max Beckmann, unpublished letter, August 27, 1948. Emphasis from original, Dr. Peter Beckmann, Murnau.

3. It is known that Beckmann occupied himself intensely with works from this period. Cf. the chronology in this catalogue.

4. "The painting should have the effect of a Gothic stained-glass window," cited in *Max Beckmann, Katalog der Gemälde,* Erhard Göpel and Barbara Göpel, eds., Bern. 1976, Vol. I, p. 144, no. 202. Henceforward cited as *Gemälde-Katalog,* Vol. I.

variations throughout his oeuvre. This can be seen in the way the viewer frequently sees a painting through bars; in the figures which are shackled, enslaved, or crippled; in the distortion of pictorial space that binds and limits the movements of the objects and persons within it; and in the incorrect proportioning of interiors and their inhabitants who hit the ceilings and fall out of the pictorial frames. Such constraint can be related to the viewer, to the figures in the picture, to the artist, or to all at once. As an effect it can mean coerced bondage as well as a conscious, freely chosen exclusion of the external. The latter leads us to the leitmotif of disguise and masking found throughout Beckmann's work, another aspect of freedom denied in the refusal to be recognized as who one is.

To what extent the lack of freedom in his paintings is identical to that of the artist himself, or whether it instead represents a totem for casting protective spells in order to give the artist a degree of freedom will be investigated. This will be discussed in connection with the psychological state of the artist; conclusions may therefore vary from painting to painting.

Although this approach to interpreting Beckmann's oeuvre makes use of criteria familiar in the literature,[5] it no doubt leaves out some essential aspects or relegates them to the periphery. But those disadvantages seem more acceptable than the alternative of an enumerative and narrative ordering.

Foundations in the Early Work

"All I know is this, that I will consecrate all my energies to following the idea I was born with—the idea found perhaps embryonically even in "Drama" and "Sterbeszene"—until I can go no further."[6]

While this statement might be interpreted as an after-the-fact projection of an artist concerned with inner continuity, it also makes clear that, even as a mature artist, Beckmann did not wish to see himself as standing in contradiction to his early achievements. This insight has only recently led researchers to adopt a systematic approach to his early work.[7] While a detailed discussion of this phase of his development is not appropriate here, it is important to revise an approach which has seemed almost sacrosanct: the division between pre-War and post-War works. That division, seemingly justified by the visual evidence, is now being questioned.[8] This is not to minimize the shattering effect the First World War had on Beckmann and the ensuing mark it left on his repertoire of images. But it is important to establish that this caesura did not totally overturn Beckmann's world view and replace it with a completely different one. Rather, what had always been present was integrated into a total pattern that became more and more complex. The accumulation of various sources of philosophical development within the artist's pictorial repertoire resulted in an expansion, but not a fundamental change.[9] It is too simple to assume that it was only the painful experience of the War, independent of any personal predilection, that transformed Beckmann from a rather superficial bourgeois painter of catastrophes into a complicated artist of nearly hermetic content. It seems instead that what had been latent all along was released, and was enriched with a panoply of literary and philosophical sources gathered along the way.

Recognition of this fact, however, seems to be the origin of a misunderstanding in recent research. It is all too easy, given the artist's affinity for the most varied philosophical and literary models, to be tempted to trace exactly his pictorial motifs to these sources, thus degrading Beckmann to the level of an illustrator of philosophical and literary models. But Beckmann was too much a painter to be interested in packaging a little Schopenhauer or Nietzsche here, a little Jean Paul or some religious maxim there, to produce congenial pictures.

5. Cf. especially: Friedhelm W. Fischer, *Max Beckmann—Symbol und Weltbild,* Munich, 1972, henceforward cited as *Fischer I.* For reasons of accessibility and readability, this essay will rarely refer to the current secondary literature.

6. Max Beckmann, cited in Reinhard Piper, *Nachmittag: Erinnerungen eines Verlegers,* Munich, 1950, p. 30.

7. Cf. especially *Max Beckmann—Die frühen Bilder,* exhibition catalogue Kunsthalle Bielefeld and Städtische Galerie im Städelschen Kunstinstitut, Frankfurt am Main 1982/83. Henceforward cited as *Bielefeld/Frankfurt Catalogue 1982/83.*

8. Important new approaches in this context are found in E.-G. Güse, *Das Frühwerk Max Beckmanns: Zur Thematik seiner Bilder aus den Jahren 1904-1914,* Frankfurt/Bern, 1977.

9. Here there is a need to reexamine F. W. Fischer's thesis that after the War Beckmann came to a new orientation of his world view; cf. *Fischer I.* p. 15.

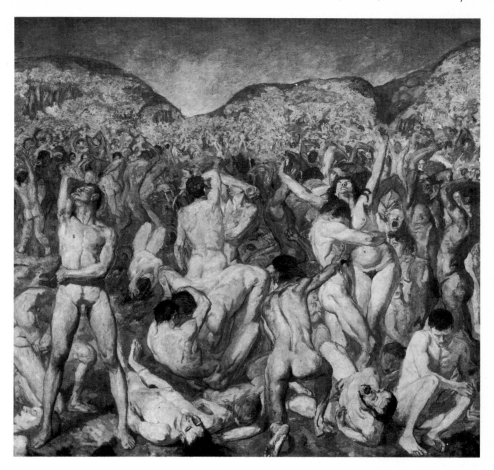

It is more likely that Beckmann stored up a plenitude of images in his optical memory and recalled them as needed, which explains the congruence of such varied, even heterogeneous, motifs within a single work. Only thus can it be understood (if one doesn't wish to label Beckmann a charlatan), why, when asked, he himself was never able to account for the origins of these motifs. This is simply because he stored them without scholarly intentions, without a mental filing system which spit out the appropriate image on demand. Instead it was more arbitrary, wholly according to his subjective needs and partly guided by the subconscious. He was not interested in developing logical systems or images to correspond to logical, rhetorically constructed philosophical thought complexes. He wished rather to bring together in individual works images that were newly experienced every day, lived through, and thus never static. These individual works can be ultimately collected into a general system, whose single true constant, however, is ambiguity.

This, of course, is not to exclude investigation of individual motifs. It is often appropriate to retrace Beckmann's inspirations, but this still rejects any too literal linking of his paintings to corresponding models. However much Beckmann may have been inspired by one or the other philosophical or literary source, he was never its pictorial exegete. Nor was he a repressed theoretician who merely had the habit of expressing himself in images rather than in philosophical treatises. What is so obvious is seldom taken into full account: Beckmann was first and foremost a painter, who made use of all these models as his materials.

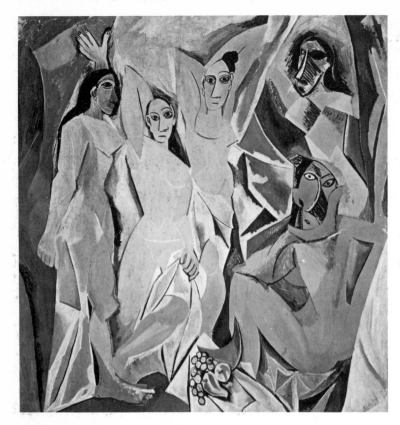

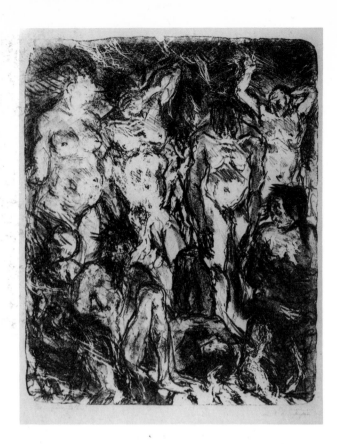

Central Themes in the Early Work

Besides landscapes and portraits, Beckmann concentrated his images on the maximum vitality of tightly-packed groups of people. "My heart is attuned rather to a rougher, more ordinary, more vulgar art. Not the kind that lives dreamy fairy-tale moods in a poetic trance, but which gives direct access to the frightful, vulgar, spectacular, ordinary, grotesquely banal in life: an art that can always be immediately present to us where life is most real."[10]

Beckmann believed he could approach this by way of exaggeration. Even when his pictorial subjects indicate a contemporary catastrophe, they are anything but realistically factual reports. Instead, the event serves as the basis for an internally stylized depiction of life's great intensity, which is necessarily brought out most penetratingly in borderline situations, in the struggle with the powers of nature, or in struggles between individual people[11] (cf. cat. 10, 12). Here, the lack of freedom is seen as the constraint of the individual in the group; the mass of humanity becomes the individual's adversary, forcing him to conquer his own territory. It has justifiably been concluded that such paintings as *The Battle* (fig. 1) or *Scene from the Destruction of Messina* (cat. 10) represent "on a mass scale the pure struggle for mere existence... All against all, one could even suppose, since clearly separate parties cannot be distinguished."[12] Here we find the modernity of these paintings, which are often formally unsatisfactory. Far from the precocious virtuosity of a Picasso, they often get stuck in academic stiffness, an occasional unpleasant tendency to extremes and grand gesture. But behind this conscious rejection of moralistic classification stands an attitude not unlike Picasso's *Les Demoiselles d'Avignon* (fig. 2). There, too, any elevating or neutralizing moral is repressed in favor of a purely artistic approach. While this approach was primarily formal for Picasso, in Beckmann there is an interest in content. This points to the difference between the two artists. Beckmann is concerned with representing vitality as a principle of life and as a moral category; such an approach binds him to symbolic traditions as well as to the philosophy of Schopenhauer and Nietzsche.

Fig. 2 Pablo Picasso: *Les Demoiselles d'Avignon,* 1907, oil on canvas, New York, The Museum of Modern Art

Fig. 3 Max Beckmann: *Hell,* 1911, lithograph, Private collection

10. Diary entry of January 9, 1909, cited in Hans Kinkel, ed., *Max Beckmann, Leben in Berlin: Tagebuch 1908/09,* Munich, 1966, p. 21.

11. Cf. E.-G. Güse "Das Kampfmotif in Frühwerk Max Beckmanns," in *Bielefeld/Frankfurt Catalogue 1982/83,* pp. 189-201.

12. Christoph Schulz-Mons, "Zur Frage der Modernität des Frühwerks von Max Beckmann," in *Bielefeld/Frankfurt Catalogue 1982/83,* pp. 137-145; this citation p. 143.

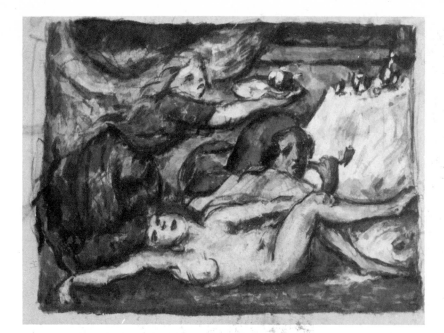

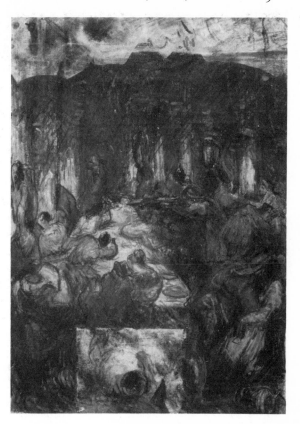

Fig. 4 Paul Cézanne: *The Orgy,* 1866-68, opaque ground, colored and black chalk, pencil on thin cardboard, Private collection

Fig. 5 Paul Cézanne: *Rum Punch,* 1966/67, opaque ground and watercolor over graphite and India ink on thin cardboard, Private collection

13. Joachim Poeschke also establishes this parallel in his essay, "Der fruhe Max Beckmann," *Bielefeld/ Frankfurt Catalogue 1982/83,* p. 134.

14. It is not only the taste of the times which explains this fact.

15. For a more extensive discussion, see Carla Schulz-Hoffmann, "Paul Cézanne—Aquarelle," in *Kunstchronik,* 35, No. 4 (April 1982), pp. 122-27.

16. The confrontation with the text by Flaubert had an effect on the triptych, *Temptation,* among other works.

These criteria of form and content bring Beckmann into strikingly close proximity with the early work of Cézanne,[13] whom Beckmann consistently admired. The parallels are especially striking in the unspectacular, small-format graphic works. Here the artist's burgeoning imagination expresses itself more freely and with less restraint. The sultry eroticism and brutality in works such as *Hell,* 1911 (fig. 3) and *The Night,* 1914 (cat. 225) convey an atmosphere similar to that in Cézanne's *The Orgy* (fig. 4) or *The Rum Punch* (fig. 5). In order to understand the issue here, it is useful to recall the ensuing development of Cézanne whose process of unusual self-discipline sought to eliminate the drastic sensuality of the early works. The somewhat brittle works of the mature Cézanne concentrate literally on "pure perception." On the surface there is no connection between these and Beckmann's coarse-featured, chaotic beginnings, where sexual obsessions are bluntly articulated.[14] In many of the later works a self-imposed rigidity appears, an almost manic clinging to the same few, modest motifs. But this too is a tool, a defense against latent passions which were perceived as a threat and restrained only by determined struggle. It is no accident that "The Temptation of St. Anthony," which explores the affinity between passion and asceticism, was of great significance to Cézanne. The final version of Flaubert's *Temptation of St. Anthony* had been published in 1874. Although Cézanne's visual translation of the theme cannot be seen as an illustration, it seems certain at least that he knew Flaubert's tale. Temptation, and the possibility of encountering it in all its forms, is the theme of Flaubert's story which is a complex interweaving of religious, mystical, and Gnostic ideas. For a time this theme was also decisive for Cézanne. His response seems to have been to resist; earlier he had been more given to contempt. This position has a parallel in Schopenhauer's image of life, although one cannot assert a conscious influence open to de facto substantiation.[15] For Beckmann, too, Flaubert's *Temptation of St. Anthony* was later to play a significant role.[16] But what a different reaction from that of Cézanne! In contrast to Cézanne's conscious denial of self stands Beckmann's attempt to make the world accessible in *all* its sensual manifesta-

tions, to anticipate not one but all sides. He articulated these thoughts concerning his participation in the War on May 2, 1915: "It is not that I am participating in this business as a historian, but rather that I involve my life with this cause, which in itself is a manifestation of life, like illness, love or lust. And just as I follow, unwillingly or willingly, the extremes of fear of illness and lust, love and hate—well, now I am attempting that with war. All is life, wonderfully varied and overflowing with inspirations. Everywhere I find deep lines of beauty in the suffering of this horrible fate."[17] The recognition of dependence on a fate that is superior, foreign, and incomprehensible, but also the awareness of an existential bond with *all* manifestations of life were facts of reality for Beckmann. One had to confront them and come to terms with them in order to perhaps become a "self" one day.[18]

This insight appears in Beckmann's early works as strident, sometimes ostentatious, gesture. At first it may seem unusual that everything coalesced into a subject for a painting, even an experience of being deeply moved. This is illustrated by a little episode which Beckmann terms an "unpleasant scene." His impressions of a brutal battle end with the following, typically painterly sketch: "The small black mass was strange on the large, snow-covered square. The sad, angry voice echoed up along the buildings of the square to the huge, dark night sky, in which bright, long, narrow shreds of cloud passed with tremendous speed."[19] The concern is less with dismay over the brutality among humans than with a fascination with sounds or contrasts of color and form. These were the direct expressions of the vitality of life that he sought again and again as inspirations for large-format paintings of catastrophes or historical paintings such as *Scene from the Destruction of Messina* (cat. 10).

The individual's sense of loss and isolation represented there also becomes a theme in some family and self-portraits, but by other means. In *Conversation* (cat. 7), Beckmann shows himself sitting to one side, outside the circle of those close to him. They in turn do not relate with or make eye contact with each other. The lost gaze, which signals isolation within the environment, becomes a characteristic trait of the artist's self-portraits. In modified form it keeps recurring until the last portrait of his second wife, *Quappi in Gray* (cat. 119). Even the *Self-Portrait in Florence* (cat. 8), which presents a self-confident attitude and a grand, bourgeois manner, permits no direct eye contact with the viewer, despite the dignified frontal pose. Beckmann seems to be looking at an undefinable goal which is inaccessible to us. There is no doubt that he sees a distance between himself and the others, a barrier of which he was always, often painfully, aware. The *Double-Portrait* (fig. 6), showing him with his wife Minna, is also permeated by a melancholy separateness, even in a context of intimacy and trust. This painting, like the previous examples, is clearly related to the work of Manet (cf. fig. p. 35). It does not even attempt to give the illusion of an unrestricted mutuality, but rather leaves the individual in an existentially determined isolation. In a positive sense, this attitude supports a determined respect for the unique nature of the other. This respect is symptomatic of the artist's great portraits, enveloping them in an aura of untouchability.

Pictorial Construction as a Metaphor of Constraint

Beckmann's expression for the chaos of a world in which the individual is subject to existential conditions without understanding their meaning can first be found in compositional and structural aspects of his work. A tightly compressed pictorial construction where tiny box-like spaces leave the individual no room for movement, points of view that are shifted against each other to distort the

17. Max Beckmann, *Briefe im Kriege,* Munich, 1955, p. 64. Henceforward cited as *Briefe im Kriege.*

18. Thus he notes on May 4, 1940: "I have tried my whole life to become a kind of 'self.' And I will not desist from this and there will be no whining for pity and mercy, even if I were to roast in flames for all eternity. I, too, have my rights—" in Max Beckmann, *Tagebücher 1940-1950,* Munich 1979, henceforward cited as *Tagebücher 1940-1950.* A remark made to a student in St. Louis is also revealing in this context (cf. essay by Walter Barker). There he states that an artist who wants to represent an object must achieve two things: "...first the identification with the object must be perfect, and secondly, it should contain in addition something quite different... in fact it is this element of our own self that we are all in search of." That is, reality is ultimately only important in relation to the artist where its representation is concerned. Objects are only relevant insofar as I can perceive myself in them. Here the Romantic notion of knowledge as pure self-knowledge comes to bear, as found in the lovely passage from Novalis: "One of them succeeded—raised the veil of the Goddess of Saïs—But what did he see? He saw—wonder of wonders—himself" in Novalis, *Monolog: Die Lehrlinge zu Saïs,* Hamburg, 1963, new edition, p. 241.

19. Max Beckmann, *Sichtbares und Unsichtbares,* ed. Peter Beckmann, Stuttgart, 1965, p. 68; henceforward cited as *Sichtbares und Unsichtbares.*

Fig. 6 Max Beckmann: *Double-Portrait of Max Beckmann and Minna Beckmann-Tube*, 1909, oil on canvas, Halle, Staatliche Galerie Moritzburg

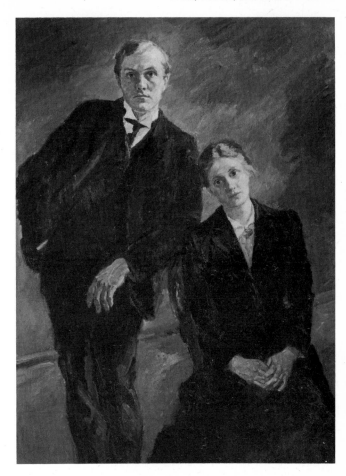

objects, and markedly "disorderly" arrangements are appropriate visual devices for this.

Women's Bath (cat. 20) is a perversion of the usual renderings of that theme and approaches the limits of absurdity. It shows a suffocating dungeon, not unlike a bunker, literally stuffed full of figures. The women and children are shut off from the outside as well as isolated among themselves, making them captives in a double sense. Separation from the outside world, expressed by the lack of daylight, is amplified by the compositional barrier: the figures are arranged in a circle, thus presenting a closed pictorial form to the viewer. This formal link, however, is not joined by a psychological one. Except for the girl playing with a child in the foreground, all eye contact between the figures is absent. Thus the group is not only isolated from the outside but cannot give any support to the individual. In the crowded space, isolation within the group becomes an oppressive reality.

Similarly, the figures in *The Dream* (cat. 23) are penned in both by a steep vertical format and a constricting interior space. This double confinement—a technique used again and again by Beckmann—irrevocably imprisons the characters within their assigned roles. Their gestures and partly inexplicable twists seem to have become innate attributes, as if they must appear only in this way. Welded together into an unchanging pictorial figure, they become emblematic. To use a contemporary comparison, they have the effect of frozen "happenings," fixed forever in their foolish and arbitrary costumes. In this, and in the related melancholy and quiet obedience throughout the painting, is an expression of a deeply modern, almost existentialist feeling for life. It colors the mood of much of Beckmann's repertoire of images, and can well be compared to the works of George Segal (fig. 8). The homelessness of modern urban man, his sense of being lost, becomes evident here in the confusion of the surround-

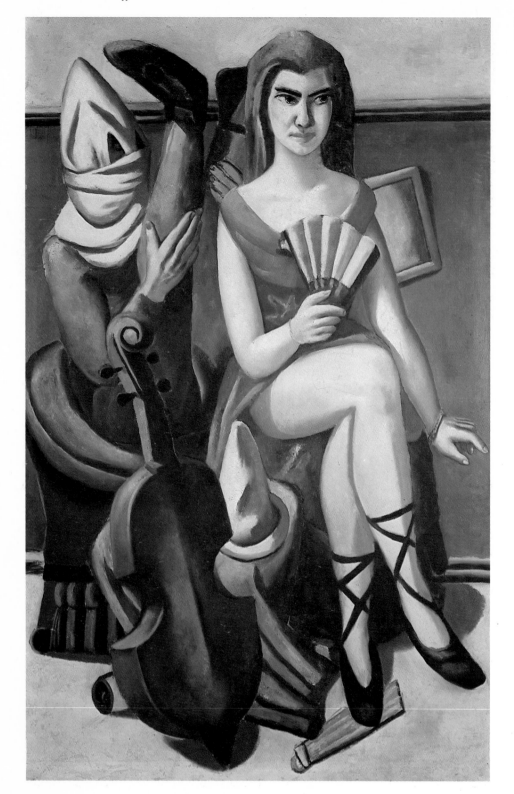

Fig. 7 Max Beckmann: *Carnival,* 1925, oil on canvas, Mannheim, Städtische Kunsthalle

ings. Alfred Döblin depicted it penetratingly in expressionist literature,[20] and in Kafka it became a central theme somewhat parallel to that of Beckmann. The costuming of the figures and their prescribed role-playing seem already to touch an idea of the World Theatre, which Beckmann had come to know via Schopenhauer.[21] Later he constantly reformulated it in his own remarks,[22] but it may suffice to recall the oft-cited diary entry from 1946: "You lick salt, you megalomaniacal slave; sweetly and endlessly comical, you dance in the arena of endlessness to the thunderous applause of the divine spectators. The better you do it, the more comical you are."[23]

20. Alfred Döblin, *Berlin Alexanderplatz,* 1929.

21. Cf. *Sichtbares und Unsichtbares,* p. 96 ff.

22. For a more detailed discussion of this subject, cf. *Fischer I,* p. 30 ff.

23. *Tagebücher 1940-1950,* July 4, 1946.

Fig. 8 George Segal: *Richard Bellamy Seated*, 1964, plaster of Paris and metal, St. Louis, Mr. and Mrs. Adam Aronson

In *Family Portrait* (cat. 25) and the much-altered second version, *Before the Masquerade Ball* (cat. 26), the characters are not really masked, except for the mask worn by Beckmann in the latter painting. But the interior, viewed with a wide angle, suggests a peep-show stage where the actors stand motionless as living pictures. The compulsiveness with which the figures remain fixed in their prescribed roles, the lack of breathing space, and the skewed perspectives all add to an atmosphere of inevitability which sweeps over the viewer as well. For if Beckmann portrays himself and those close to him as prisoners of the roles forced on them, one may deduce that he sees this as a fundamental condition of human life.

The Trapeze, (cat. 33) and *Dance in Baden-Baden* (cat. 34) express further aspects of Beckmann's suffocating insight about relationships among human beings. Here, again, the figures are given no breathing space; they are crowded together on flat strips of stage. In contrast to the earlier paintings, however, the sense of oppressive closeness is now primarily derived from the physical proximity of the individuals to each other, rather than from the space. In *Trapeze,* the actors are entwined in a closed pictorial pattern that cannot be unravelled; it seems to bind each inextricably to the others. *Dance in Baden-Baden* freezes the dancers into two-dimensional foils, welding them together into a diagonal pattern of surfaces dictated by the dancing position. It is disturbing in both cases that the extreme physical nearness has no emotional counterpart; the figures are linked together but are not interrelated. The suggestion that *The Trapeze* could contain a reference to the Gnostic idea of the Wheel of Life (with which Beckmann was familiar[24]) reveals the implications of this deeply negative view. The individual's lack of freedom thus takes on an absolute dimension. It refers both to the impossibility of free self-determination, i.e., the exclusion of free choice of action and individual decision and of open relationships among people. The latter either take the form of a compulsory sexual union in the course of life *(The Trapeze)* or an empty convention determined by social norms and patterns of behavior *(Dance in Baden-Baden).*

Restriction of space and claustrophobic constrictions of images are not only seen in the compositions with multiple figures. They are also evident in several portraits, especially from the first years after the War when they served as compelling symbols for physical or psychological restrictions. Along with a

24. *Fischer I,* p. 46, n. 133.

vitality on the part of the portrait's subject which threatens to explode the painting, the impression arises of a forceful curtailment of individual breathing room. Thus, the posthumous portrait of the composer Max Reger (fig. 9) presses the figure into much too small a format. Not only is he mercilessly bumping against the edges, but he is even drastically cut off by them. In *Self-Portrait with Cigarette on a Yellow Background* (cat. 36), the compact, almost brutal physicality, especially of the face and hands, contrasts with the extreme flatness conveyed by the pictorial space. Beckmann achieves this impression by avoiding perspectival aids which would indicate spatial relationships.

The opposite procedure is similarly significant: the physicality of the figures seems to be absorbed by the surface of the image. They have the effect of foils which no longer possess a physical presence. That negation of individual freedom of motion could hardly be given more distressing expression than in *Self-Portrait in Tails*, 1937 (cat. 75). The flat presentation is a painful correlate to the existential consumption which Beckmann saw in the form of National Socialism and which would soon lead to his emigration.

Painted five years earlier, *Self-Portrait in Hotel*, 1932 (fig. p. 64) is a precursor of this. Here Beckmann unmistakably encloses himself in the picture plane. The restrictive interior architecture locks him solidly in the center of the image, while both figure and ground are evenly colored with gray-pink tones. His "self-withdrawal" is underlined by the mummy-like clothing into which he burrows. It also clearly has a protective function at the same time. He is not only confined within the pictorial framework, but also in this depressing isolation, even though he is protected from the outside.

Fig. 9 Max Beckmann: *Portrait of Max Reger*, 1917, oil on canvas, Zurich, Kunsthaus

Fettering, Torture, Maiming

The signs of constraint discussed so far have been the results of formal or structural pictorial processes, and therefore could only be indirectly deduced. But many of Beckmann's works show violence as an active process, such as fettering, maiming, and torture. In these pictures the individual is usually a passive victim, and the cause of the violence is hidden from both victim and viewer. Beckmann created one of the most penetrating images of incomprehensible, senseless brutality in *The Night* (cat. 19). A detailed interpretation of this work can be found in the catalogue section, but there are two aspects which are particularly relevant to our theme. First is the atmosphere of violence which permeates the painting. It literally transforms the microcosm of the painting and explodes its "natural" orderliness. Violence is not merely practiced on and among human beings; violence and aggression are expressed by even the smallest detail of the decor. Humanity and the interior environment are equally victimized by these forces, whether or not they are directly exposed to them. Beckmann would never again use such extreme exaggeration, that ultimate stylization of horror transforming the painting into a negative icon: an image not of sanctity, but of perdition. By virtue of the horror *The Night* engenders in the viewer, it still preserves a possibility of distancing.

The second important point in this regard is related to the first. The painting is a parable about evil as such, so there is no one with whom the viewer honestly could sympathize. Perpetrator and victim are not differentiated; the distribution of roles seems to rely more on chance than on character traits. Consider, for example, the main male figure, the horribly abused and strangled victim with twisted body and the hand emphatically turned outward. Formally the image is reminiscent of traditional depictions of Christ being taken down from the cross (cat. 17). This applies more or less to the other figures also: for

25. *Fischer I*, p. 40. In my opinion the new interpretation of *The Night* recently suggested by Dückers cannot be conclusively related to the optical evidence. Dückers suggests that the strangled man is Beckmann, the gangster in the cap is Lenin, and the woman he holds like a parcel is Peter Beckmann (!); the dead father achieves reincarnation and salvation through the proletariat. In Alexander Dückers, *Die Hölle*, 1919, Berlin exhibition catalogue 1983, p. 94 f.

26. Cited in R. Piper, op. cit. (note 6), p. 33.

27. Max Beckmann, "Schöpferische Konfession," in *Tribüne der Kunst und Zeit XIII,* ed. Kasimir Edschmid, Berlin, 1920. p. 63 f.

example, the female victim in the foreground which, as a formal motif, is not far removed from scenes of mourning (cf. Beckmann's own *Large Death Scene*, cat. 5, among others). But certainly Beckmann did not really intend Christ here. It is more likely that this is a negative inversion of a central theme of salvation. This is not a parable about a possible redemption, but about human contingency and the lack of freedom in which the night is a symbol of the hell of humanity. There is no escape from this closed system, and neither perpetrators nor victims are really guilty. "...Iniquity does not lie in this or that circumstance; it lies in creation itself. It was introduced by demiurges and propagates itself according to the laws of concupiscence, constraint and death." [25]

For the artist, this hopeless situation, immanent to human existence, could only be borne out of spite. "In my paintings I confront God with all he has done wrong. ... My religion is arrogance before God, defiance of God. Defiance, because he created us so that we cannot love ourselves." [26]

The latter passage is especially indicative of Beckmann's attitude, particularly in the period immediately following the War, which was marked by internal and external depression and despair. The paintings and graphic work of these years reveal again and again his realization that all creation cannot be truly loved, it can only be depicted in all its negative manifestations. He does stress in 1920, however, "Actually it is senseless to love humanity, this pile of egotism to which one belongs. But I do it all the same. I love humanity with all its pettiness and banality. With its obtuseness and common stinginess and its oh so rare heroism. And in spite of this, each human being repeatedly, daily, becomes an astonishing event to me, as if he had just fallen from Orion." [27] In this context "love" refers more to a pictorial interest in human peculiarities than to active empathy. Along with his cynicism there are indeed repeated expressions of melancholia and grief over the stupidity and ignorance of humanity as in *The Dream,* 1921 (cat. 23). With all its absurdity and incongruity, it is a deeply melancholy parable about the vain endeavor of human action. The very motif of maiming here becomes a sign of inescapable constraint even though the individual remains unconscious of it. The blind man, the war cripple, and the man with the stumps of arms in the painting stumble around in a room without exits, oblivious to the truth that their actions are of no use to themselves or anyone else.

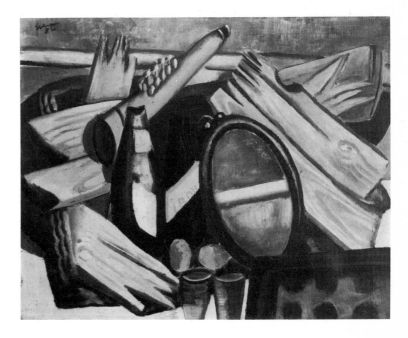

Fig. 10 Max Beckmann: *Still-Life with Billets,* 1926, oil on canvas, Private collection

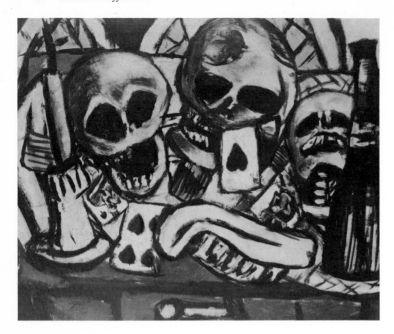

Fig. 11 Max Beckmann: *Still-Life with Skulls* (detail), 1945, oil on canvas, Boston, Museum of Fine Arts

It is surprising that in the ensuing years Beckmann generally discontinued multi-figure compositions presenting the theme just outlined. (The beach scenes from the mid-1920s fall into an emblematically coded category of their own and are not helpful in our context; see below). Until the first triptychs and the accompanying interest in complex figural compositions, the emphasis shifts to the self-portrait, very decidedly to the still-life, and less forcefully to the landscape. This shift raises the question of how the issues we are discussing are relevant to those themes.

Barriers as a Principle of Composition in the Still-Life

The individual subjects of *Still-Life with Fish and Paper Flowers* (cat. 28) take on a succulent, botanical existence in which they are bound together to form a closed compositional figure. Both organic and inorganic matter, removed from the outside, seem to lead a life of their own. This is accentuated by the ostensibly banal motif of the tilted, upside-down signature which alludes to the fiction of what was apparently alive. The objects are closely related to one another but separated from the border by the dark strip in front and the easel on the right. This clearly encloses the interior of the picture within itself, but does not exclude the viewer.

A totally different effect is presented by the unusual and disquieting *Still-Life with Billets*, 1926 (fig. 10). It excludes the viewer in an almost aggressive way, yet internally it conveys the impression of a disturbing disarray: the back of the chair, the lidded glasses, and even the oval mirror which reflects a segment of wall and floor separated by molding all act as barricades to the outside. This seems an unnecessary measure, since the interior is hardly inviting. Logs protrude at sharp angles in an apparently arbitrary and unmotivated arrangement. Between them, champagne bottles[28] with broken necks suggest the useless remainders of a social gathering, carelessly left behind. The meaning of the picture becomes clearer in light of the fact that Beckmann painted this still-life upon the death of his brother, Richard.[29] The lifeless relics of a celebration coalesce unmistakably into a traditional *vanitas* allegory. But here the symbols of a fleeting pleasure, the ripe fruits and the game, have been replaced with an unsavory, hollow heap of junk. They are the refuse of a by-gone situa-

28. The letters "IROY" on the label of the bottle indicate a favorite brand of the artist.

29. Cf. *Gemälde-Katalog*, Vol. 1., p. 185, no. 254.

Fig. 12 A.B. van der Schoor: *Vanitas,* ca. 1660/70, Amsterdam, Rijksmuseum

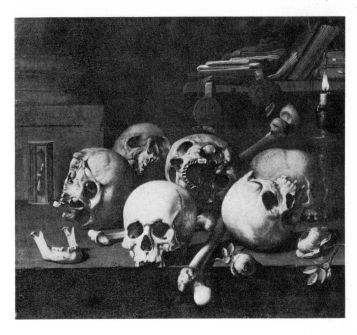

tion of vitality. Only the *Still-Life with Skulls,* 1945 (fig. 11) presents a similarly drastic transformation of classic still-life subjects. Horror at the insanity of war, which in turn is only an expression of the absurdity of human existence, is vented with grotesque irony and macabre wit. Indeed there are precedents even for this painting, such as a *vanitas* still-life from the last half of the 17th century by the Dutch painter, A.B. van der Schoor. The combination of skulls, a burned-down candle, an hourglass, and broken, wilted flowers expresses the theme of transience in uncommonly explicit pictorial language, at least for that time (fig. 12). If Beckmann knew this painting from one of his visits to the Rijksmuseum, he reinterpreted it quite drastically. With his characteristic mixture of irony and sarcasm, perhaps intended to hide the fact that he was inwardly moved, he notes in his diary, April 10, 1945, "Skulls is truly finished. Quite a funny picture—just as everything is getting pretty funny and ever more ghostly."[30] The prominent placement of playing cards gives the *vanitas* allegory an almost cynical accent:[31] in the center a black heart stands upside-down. The Game of Life is condensed to sarcastic persiflage.

Aside from this, Beckmann generally followed classical precedent in the choice of still-life subjects, though he would often expand their meanings either by unusual density or formal and compositional restructuring. An example of this is *Large Still-Life with Musical Instruments,* 1926 (fig. 13). The traditional repertoire of the genre includes musical instruments, sheet music, flowers, mirror or picture frame, and candle or flower holders. But there are a number of factors that give this still-life a decidedly subjective stamp which can only be understood in the context of the painter's personal language of images. The objects are arranged close together in a narrow horizontal format. The presentation is a combination of extreme viewpoints, making the objects appear not only overly large but also accentuated in their significance. The doubling is blatant: two saxophones, two flutes, two flower holders. The labels on the instruments—"Bar African," "On New York"—and the program with a black man on the title page suggest associations with the city, jazz, and night-life. In the pictorial subjects, these associations in turn are clearly connected to sexual threats and seduction. The phallus-womb symbolism of the saxophone, used by Beckmann since the mid-1920s, is carried into the flower holders, clarinets, and the Mardi-Gras horn which appears to be swallowing a doll. The suggestive animate impression given by lifeless objects is set against the threatening dark-

30. *Tagebücher 1940-1950,* April 10, 1945.

31. The motif of playing cards does occur in the traditional still-life, but not in this combination.

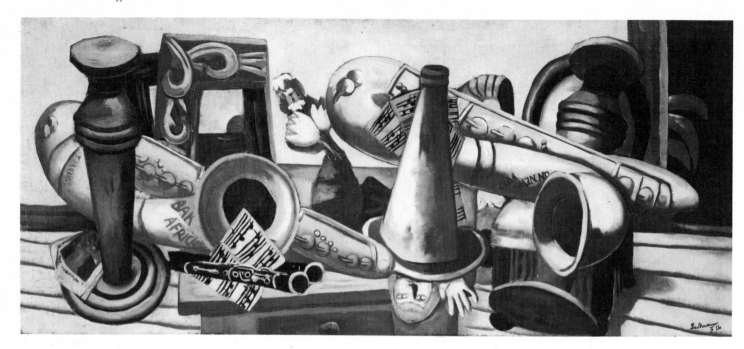

ness of the instruments' openings and strongly corresponds to the black door-way at the right. An almost animalistic sensuality is present, but it is cold and hostile in both color and form. The reference to "black jazz" introduces a sensuality which is the determining factor in the composition and, as such, it is presented free of value. The entire composition is subservient to it and follows in its wake. It is not accident that sun, moon, and sky are only illusionary presences, while the dark unknown beyond the doorway is the real threat. To a degree, Beckmann is depicting a state of affairs to which he sees himself hope-lessly subjected and which can only yield negative prejudices in him. As early as 1918 he wrote these sarcastic remarks which betray a profound despair: "... The more strongly, deeply and burningly moved I am by our existence, the more resolutely my mouth is closed; my will is all the colder to grasp this horrible quivering monster Vitality and lock it up in sharp lines and planes, clear as glass—to repress it, to strangle it."[32]

The partially comparable *Still-Life with Musical Instruments, (Supraporte)* of 1930 (fig. 14) amplifies this dark, threatening aspect. The extremely elon-gated format—the painting was designed to hang over a door[33]—deprives the still-life subjects of all breathing space and thus produces an almost tangible contrast to the serpentine vitality of the saxophones. A mirror which has replaced the light picture of the sea reflects a mysterious darkness behind the burning candle. The black doorway accentuates a similarly dark strip of door in the right foreground, opening the painting to the viewer. With the massive

Fig. 13 Max Beckmann: *Large Still-Life with Musical Instruments,* 1936, oil on canvas, Frankfurt am Main, Städtische Galerie im Städelschen Kunstinstitut

Fig. 14 Max Beckmann: *Still-Life with Musical Instruments (Supraporte),* 1930, oil on canvas, location unknown

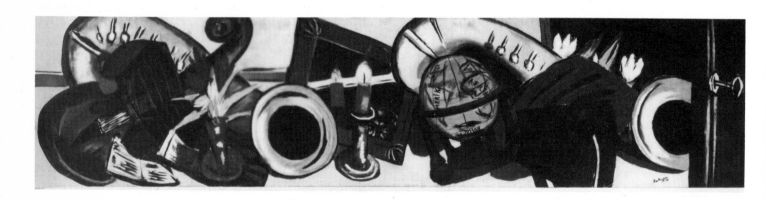

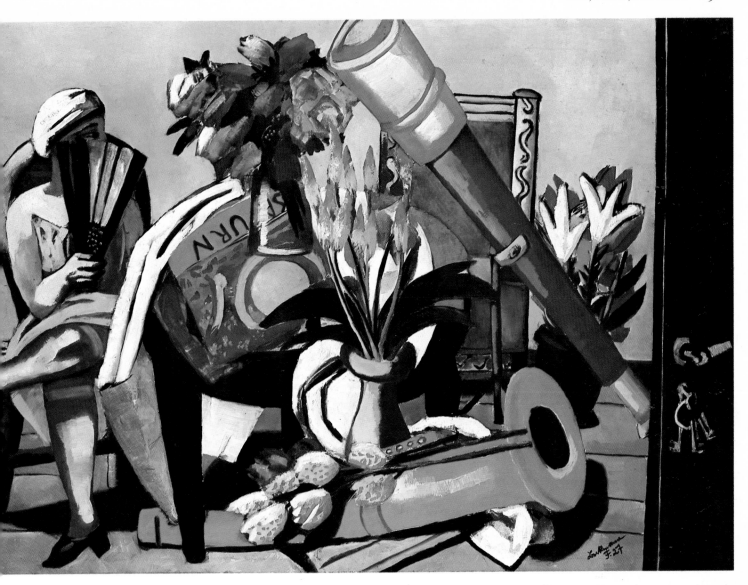

Fig. 15 Max Beckmann: *Large Still-Life with Telescope*, 1927, oil on canvas, Munich, Bayerische Staatsgemäldesammlungen, Staatsgalerie moderner Kunst

32. Max Beckmann, "Schöpferische Konfession," *op. cit.* (note 27), p. 63 f.

33. *Gemälde-Katalog* Vol. 1., p. 239, no. 338.

34. *Fischer I*, p. 58 ff.

35. As early as January 7, 1909, after visiting an exhibition he wrote: "The Matisse paintings displeased me greatly. One shameless impudence after another. Why don't people just make cigarette posters!" *Sichtbares und Unsichtbares*, p. 64.

broadening, the dark values, and the addition of unmistakable *vanitas* images, the sexual symbolism clearly shifts to the mystical realm of fate and death, and the painting becomes a metaphor of prefigured decay.

Large Still-Life with Telescope (fig. 15) is hermetic in a completely different way in that it seems to contain a secret that the artist knows, but not the viewer. An enchantingly beautiful still-life arrangement is made up of four bouquets, astrological instruments, a newspaper with the title SATURN, and a seated woman with a fan, turned away. Despite the bright colors and lovely subjects, the arrangement is presented as an impenetrably closed compositional figure. A radiant blue chair resembling a throne shimmers promisingly but inaccessibly in the background. A dark door with keys still in the lock seems to have opened up this mysteriously beautiful ambience. But at the same time, we have not been given the keys of understanding. The artist as magician, as a sage under the sign of Saturn who is able to draw near to the secrets of the world, is a justifiable interpretation of the still-life.[34] The luminous color of a mysterious, yet not disturbing pictorial repertoire transports the viewer into a fantastic fairy-tale world where the improbable is easily accepted as true. This may be seen in comparison to Matisse (fig. 16), toward whom Beckmann is known to have had the gravest reservations,[35] although in the still-lifes of the 1920s Beckmann's decorative coloration approached Matisse's. Even the formal treatment has a

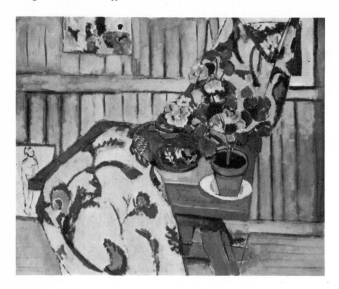

Fig. 16 Henri Matisse : *Still-Life with Geraniums,* 1910, oil on canvas, Munich, Bayerische Staatsgemäldesammlungen, Staatsgalerie moderner Kunst

similarity. For example, the way Beckmann's table seems tilted upward into the painting's surface and the way the objects on it are arranged parallel to it must be seen in light of the precedent set by Matisse. For Matisse, however, the meaning of the image is identical to its optical content; beauty and truth coincide. In Beckmann's still-lifes, on the other hand, beauty of form and color can also be perceived as a deceptive veil covering a deeper secret, even if we do not know whether or how this secret applies to us.

In contrast, a mixture of coldness and aggression emanates from the *Large Still-Life with Fish* (cat. 48) which combines motifs essential to the artist in a highly individual manner. Against the back side of a stretched canvas[36] draped with a cloth, two wind instruments, a newspaper, and three fish are arranged into a tightly closed composition. The black wall and brown floor provide a background for this "extinct life" which presents itself in sensual symbols of fish and the openings of the instruments. The symbols are actually lifeless, thus contradicting the aggressive manner put on only for show. If one considers the reference to the artist in the image of the stretched canvas, one can hardly avoid seeing this still-life as another metaphor for the entanglement of human beings in sexuality. Thus, this painting becomes a cynical polar opposite to *Large Still-Life with Telescope.* Witness the threatening aspect of the dark background, the metallic cold bodies of the fish, and the prominent black opening of the instrument. The generally hermetic arrangement of the still-life, which locks viewers out while still holding them in its spell, furthers this mood. In the earlier, basically optimistic painting, the artist was invoked as a magician who could bestow sensible and accessible beauty upon a pictorial ambience radiant in itself. But in *Large Still-Life with Fish* this flight of fancy is brought crashing down to reality.

Studio with Table and Glasses, 1931 (fig. 17)[37] reveals the extent to which Beckmann saw still-life subjects as emblems of basic human contingency and hence unable to be free. Here the objects form a tightly compressed pattern of surfaces which is closed on all sides and offers no route of escape. In the background a dark wall, a curtain, and a latticed window close off the free outside world, while a cloth with angular folds and one side of a French door serve as a barrier to the viewer in front. The composition is neither free in itself—the individual elements are so tightly interconnected that they reduce each other's spatial freedom—nor is it open to the viewer. Instead, the objects appear to lead a mysterious life of their own: the brutally exuberant cactus, the

36. This motif is so frequently found in the artist's work that an investigation of its interpretive possibilities would be worthwhile. Presumably this does not merely refer to the role of the artist in general, but to a secret beyond, that is closed to humanity. It reveals itself to the painter in the creative process and then is withdrawn from his grasp once more.

37. Lackner's interpretation of the scene as "a peaceful view of familiar objects" seems unlikely. Stephan Lackner, *Max Beckmann,* Cologne, 1978, p. 96.

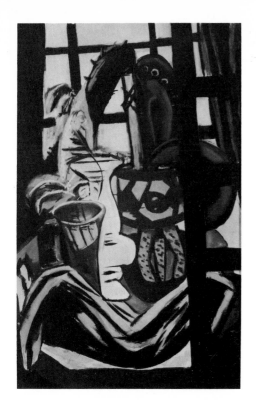

Fig. 17 Max Beckmann: *Studio with Table and Glasses,* 1931, oil on canvas, Munich, Bayerische Staatsgemäldesammlungen, Staatsgalerie moderner Kunst

dark saxophone with bars across its bell, the vase with the profile, and the Mexican pot all suggest a sultry sensuality which is both captive and repelling.

As a late example, the *Large Still-Life/Interior (Blue)* (cat. 125) shows a reversal of both the principle of barriers enclosing a composition and the specific meaning attached to objective signs. Emotional identification is prevented by uncomfortably cold colors, which have a generally repellent effect. In addition, the still-life arrangement, tilted upward into the surface plane, closes off access to the space behind it. While a table leg in the shape of a lion's paw seems flexible and life-like, the truly "living" objects, i.e., the threatening vitality of the flowers and leaves, have a cold artificiality. The ominous but still vital sensuality of the earlier still-lifes has given way to a severe, repulsive atmosphere which excludes any form of real sensuality and therefore is another aspect of freedom denied.

Landscape as an Emblem of Freedom

If freedom (as independence from human contingencies) can be articulated somewhere, it would seem most likely to occur in the realm of landscape. Beckmann was of course very much a "city painter" since only in the urban context did human existence in all its absurdities become concrete to him. But he longed for nature, specifically the sea, as the possibility of an unbroken unity. For him, the sea becomes nature's highest form, a metaphor for eternity itself (cf. the essay by Christian Lenz in this catalogue). Here the greatest possibility of open space is contrasted with the closed and crowded interior compositions, where the limitations of human existence become so evident. Beckmann saw his task as artist in the coexistence of the two: "Space—Space—and space again—the unending divinity that surrounds us and in which we ourselves are. I seek to give form to this in painting."[38]

It is noteworthy that Beckmann painted landscapes rather often and that depictions of the sea predominate. The frequency increased during the second half of the 1920s and the early 1930s. Landscapes in the sense of free, uncultivated nature, however, appear extremely rarely. Instead there are "park landscapes" where nature has been altered by humans and subjected to their laws. Therefore, as we discuss Beckmann's concept of freedom in relation to his landscapes, only depictions of the sea will be considered, for in them only is freedom revealed to be something absolute.

"And then to the sea, my old romance, it's been too long since I was with you. You swirling eternity in your embroidered dress. Oh, how my heart would swell. And this loneliness... If I were the king of the world, I would choose as my highest privelege to spend one month a year alone on the beach."[39] This letter of 1915 to his wife Minna already expresses the positive feeling Beckmann associated with the endless expanse of the sea. Significantly, the sea predominates among his first paintings (cf. cat. 1, 3, 4, among others). Despite a formal indebtedness to *Jugendstil* and then Impressionism, these works already contain essential elements of Beckmann's own interpretation of the theme. He selects segments of the sea and breaks a clear, horizontal expanse with as few vertical foreground forms as possible. Either the horizon line is clearly emphasized or the surface of the water extends to the very borders of the pictorial ground, except for barely visible areas at the top of the canvas. There are astonishing parallels to the early ocean paintings of Piet Mondrian (fig. 18), which are often based on a comparable foundation, although with more Calvinist strictness. For Beckmann, the expanse of sea became a parable of metaphysical and religious ideas.[40] Sky and sea are presented as autonomous forces; the events which take

38. *Sichtbares und Unsichtbares,* p. 22.

39. *Briefe im Kriege,* March 16, 1915, p. 25.

40. Cf. also Ulrich Weisner, "Konstanten im Werk Max Beckmann, in *Bielefeld/Frankfurt Catalogue 1982/83,* p. 157-173.

place in them cannot be pre-determined for the viewer, but may at some time be revealed. Beckmann's diary entry of August 23, 1903, which could stand as a theme of his entire life, reveals the degree to which he saw a secret of apocalyptic dimensions behind these forces: "Now the storm begins again more strongly. The whole sky was just shot through with lightning. Oh, and it thunders so magnificently. Now that is a sound. There they all are, unleashed, the fine grand forces of nature. Well go on, sky, thunder away, lightning away. Let me see more of your wondrous beauties. Or can't you even produce a respectable storm anymore. ...Play your primeval world symphony just one more time so that all that is comic and petty may be dispelled for me. There, all right, I thank you for the faint light, but more, stronger—you see that I am waiting. I am waiting for the tear from above in the gray covering of the sky, through which I will be able to see into eternity."[41]

Fig. 18 Piet Mondrain: *The Dune*, 1909/10, oil on canvas, The Hague, Gemeentemuseum

Depending on his subjective mood, Beckmann characterizes the unending space of sky and sea as a locus either of unreachable promise or still-justified hope. The sea itself is given the role of a catalyst. Depending on the degree to which it reveals itself and gives up its secret, the kaleidoscope of forms composing reality either disintegrates or comes together: "...And always the sea plays in my thoughts, from near and far, through sun and storm. Then the forms condense into things that seem understandable to me within the great emptiness and uncertainty of space which I call God."[42]

After the large number of ocean paintings from before the War, which in themselves express an unusual degree of unbounded freedom, the first paintings with this theme after the War only reappear in the late 1920s. There is an enormous difference with regard to the openness of the paintings and thereby accessibility for the viewer!

The difference in content can be seen in the example of the mysterious *Viareggio* (fig. 19). It betrays Beckmann's preoccupation with southern landscapes as well as with the "pittura metafisica" of a de Chirico or a Carrà. In place of the open sea, offering itself freely and expansively, is a narrow segment of water whose endlessness can only be supposed. Indeed, the gaze of the viewer is directed toward the sea and the three sailboats by the buildings and the lane between them. The boats are a jewel-like, gleaming climax between the gloomy, repellent foreground and the impenetrable leaden gray of the sky. This painting is the conscious encoding of an everyday scene. An obvious hierarchy of significance gives the sea and the boats a dominant position, magically attracting the eye to a promising yet unreachable goal.

A similarly unreal mood, reminiscent of the fantastic realism of Franz Radziwill, is conveyed by *The Harbor of Genoa* (cat. 49). The cold green sea and the black sky act as barriers, more suggestive of an impenetrable wall than an endless expanse.

In several works of the late 1920s (cat. 50 and 51, among others), the sea is presented as unbounded, but not accessible. The viewer is confined to the role of a spectator who must look at nature through a window or from a balcony. The motif takes on a completely different function in two large figural compositions of the 1930s, *Journey on the Fish* (cat. 70) and the triptych, *Departure* (fig. p. 40). As for the symbolism of death in the first example, the inevitable fall into a black abyss is counterbalanced by a poignant sign of hope in the background. Granted, there too the dark values of the foreground plane are continued, and the silver-blue sea stretches out like a bordered plane behind the leaden gray area of sky. This impression is emphasized by the clearly accentuated bend in the horizon line. But even here an escape seems to be suggested, although we don't know how it is meant, or whether it leads us to a positive or a negative goal.[43] In a passage from his "Letters to a Woman Painter," written in 1948, Beckmann again refers to the idea behind this painting. He speaks about the

41. *Sichtbares und Unsichtbares*, p. 45 f.

42. *ibid.*, p. 23-24.

43. Fischer's entirely negative interpretation of this motif is unconvincing because the unknown destination of the sailboat is not clearly classified in one direction or the other. Cf. *Fischer I*, p. 122.

emotional entanglements that inevitably lead to a fall, beyond which is hidden an obscure destination which in distant time promises us unknown salvation: "... Or have not the wide seas on hot nights let you dream that we were glowing sparks on flying fish far above the sea and the stars? Splendid was your mask of black fire in which your long hair was burning—and you believed, at last, at last, that you held the young god in your arms who would deliver you from poverty and ardent desire?—Then came the other thing—the cold fire, the glory. ...Under the cold ice the passion still gnaws, that longing to be loved by another, even if it should be on a different plane than the hell of animal desire. The cold ice burns exactly like the hot fire. And uneasy, you walk alone through your palace of ice. Because you still do not want to give up the world of delusion, still burning within you is that little point—the other! And for that reason you are an artist, my poor child! And on you go, walking in dreams like myself. But through all this we must also persevere, my friend. You dream of my own self in you, you mirror of my soul. Perhaps we shall awake one day, alone or together. This we are forbidden to know. A cool wind beyond the other world will awake us in the dreamless universe, and then we shall see ourselves freed from the danger of the dark world, the glowing fields of sorrow at midnight. Then we are awake in the realm of atmospheres, and self-will and passion, art and delusion are sinking down like a curtain of gray fog...and light is shining behind an unknown gigantic gleam. There, yes there, we shall perceive all, my friend, alone or together...who can know?"[44]

What was articulated as a dim intuition in *Journey on the Fish* becomes a radiant promise in *Departure.* In their abstraction, the sea and sky take on an absolute dimension as they stretch out to indeterminate depths behind those who are "departing." In them one can perceive associations of endless expanse, depth, and boundlessness, further amplified by the confining interior situations in the side panels. The very harshness of this contrast increases the impression of perfect calm in the middle panel, where sea and sky are offered as objects of meditation. Of course here, too, Beckmann limits the realm of freedom to a sphere accessible only to the eye. It is kept out of immediate reach by the diagonal barricade of the boat. The blond naked infant, surely more than coincidentally reminiscent of the Christ Child, is placed significantly in the center. The child is the only occupant of the boat who looks at the wide expanse of sea, thus becoming its true partner. What for us seems to be a distant promise and a yearned-for utopia appears to become a concrete reality in the silent dialogue between the two.[45]

After the mid-1930s, Beckmann produced a number of ocean paintings related to his first treatments of the subject, but with different methods of depiction. With the threat of National Socialism, the refuge of boundless freedom is again expressed, this time in unusually open painting which is often almost a spontaneous gesture (fig. 20 and cat. 76). Freedom, however, can certainly be seen as an unrestrained, almost brutal self-realization. The sea in *North Sea Landscape I (Storm)*, for instance, is anything but an accommodating refuge. Rather it is a wild, dark, primal force. Freedom is much more likely meant as independence from material constraints, an acceptance of indivisible union of spirit and matter, which Beckmann saw symbolically suggested by sea and sky.

The subject of *Swimming Pool at Cap Martin,* 1944 (cat. 104), banal in itself, becomes a metaphor for this central idea in the work of the artist. In the juxtaposition of the open sea and the constricted rectangle of the pool, a concrete, pictorial form is given to the contradiction between freedom and its opposite. On the one hand are the large surfaces of the sky and the sea scattered with sailboats. On the other is the artificially constructed pool, set apart by an exaggerated sea wall. With its formally aggressive ambience of pointed, sharp-

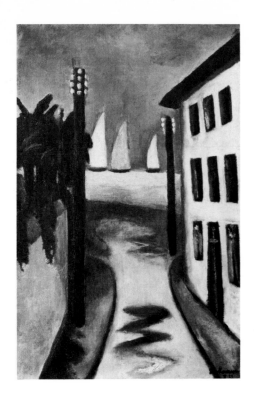

Fig. 19 Max Beckmann: *Small Landscape, Viareggio,* 1925, oil on canvas, St. Louis, The Saint Louis Art Museum

44. Max Beckmann, "Letters to a Woman Painter," trans. by Mathilde Q. Beckmann and Perry T. Rathbone in: Peter Selz, *Max Beckmann,* New York, The Museum of Modern Art, 1964, p. 133.

45. Fischer does not consider the boat as a barrier or the direction of the figures' gazes. From this standpoint his interpretation of the center panel is too one-sidedly positive. Cf. *Fischer I,* p. 93 ff.

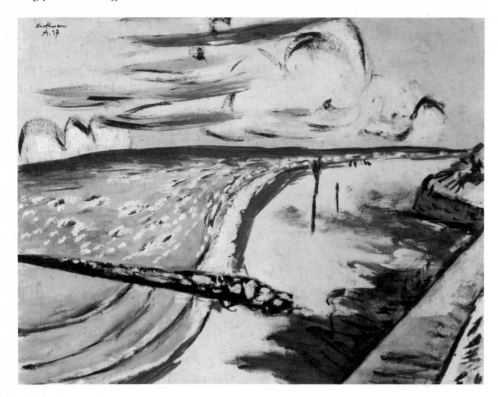

Fig. 20 Max Beckmann:
North Sea Landscape II, 1937, oil on canvas,
Private collection

edged elements, the pool is not at all inviting. Significantly, there are no people
in the pool, while there is lively action on the open sea. Only there is reflected
some of the expanse of endless space that for Beckmann was always a challenge
and a goal.

Sea and Horizon

It is striking that the motif of the sea, either in a framed picture or a mirrored
reflection, recurs repeatedly in the still-lifes. This has special significance in
light of the interpretive possibilities for landscapes and still-lifes in which Beck-
mann's world view is made manifest in both its positive and negative extremes.
Friedhelm W. Fischer's investigation of Beckmann's affinity for Gnostic and
cabbalistic mysticism often brings these issues into convincing prominence in
Beckmann's work in general.[46] In the artist's use of the sea motif, Fischer sees
the cabbalistic symbol *"en-soph,"* or the "Horizon of Eternity." According to
Papus,[47] one of the foremost exponents of this theosophy, the *en-soph* indicates
"pure Being, the Absolute, the Highest, the Divine, the Endless." "It is rep-
resented as a circular ring, which is divided internally by a horizon line. The
lower half is horizontally shaded and dark, the upper half light. In the hierarchy
of cabbalistic signs, *en-soph* takes the highest position. As an emblem it is the
pinnacle of all cabbalistic structures of knowledge."[48] Although Fischer explains
the origin of this symbol quite clearly, in some cases he places too positive a
value on it in Beckmann's oeuvre. For example, in its most valid formulations,
the still-life (beyond its *vanitas* symbolism) can be seen as an allegory of basic
and irreconcilable human contradictions, thus coalescing into his general view
of life. In this sense the sea/horizon motif goes beyond Fischer's interpretation
to become an image of an unreachable and futile promise. In the impenetrable
compositional structure of *Large Still-Life with Musical Instruments,* 1926 (fig.
p. 28), the framed sea with the rising or setting sun represents an unreachable

46. Despite one-sidedness or interpretations that are
too rigid or depart from the optical evidence, this
remains the most stimulating, virtually indispensable
general treatment of Beckmann's work.

47. Papus (Gerard Encaussé), *Die Kabbala,* Leipzig,
1910, p. 100.

48. *Fischer I,* p. 67.

Fig. 21 Max Beckmann: *Sunrise,* 1929, oil on canvas, Private collection

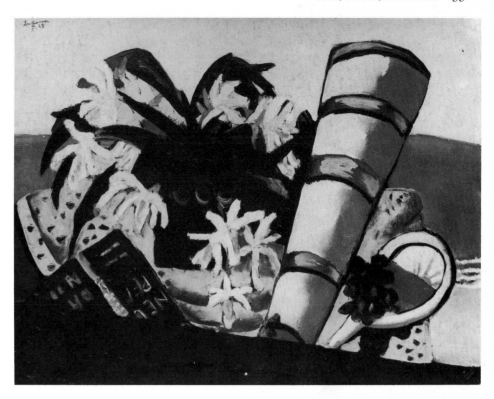

position in the background; it becomes the object of a longing that cannot be fulfilled. The *Sunrise,* 1929 (fig. 21) portrays this strikingly beautiful event not seen over the sea but in a small hand mirror.[49] Although the image is already a reflection of reality, the motif of the mirror heightens the sense of what is unreal and unattainable. The compositional arrangement itself implies that sunrise over the endless sea is an unattainable promise: the dark wooden barrier closes off the painting to the viewer but also keeps the objects glowing in the light beyond the viewer's grasp. This is especially significant for the telescope pointed skyward whose opening, and whatever could be revealed to the viewer there, are hidden by the wooden boards. Such a combination of objective signs recalls a poignant passage from Jean Paul's *Titan,* which Beckmann may have had in mind as an expressive image for these motifs. The young hero Alban visits an observatory, where he finds "the thin old, solitary, wifeless and childless astronomer, eternally calculating, always friendly and spontaneous as a child..." "But the old eye sparkled under the scant eyebrows as it looked into the sky, and his heart and tongue were poetically uplifted when he spoke of the highest place on earth, the bright sky over the dark, deep earth. ... He spoke of the indomitable World-Sea without limit, wherein the spirit which vainly seeks to fly over it will faint and sink down. The World-Sea's ebb and flood are seen only by the never-ending One below on his throne. ... He spoke of the hope after death in the starry heavens, which would then not be bisected by a slice of earth as now, but which would encompass itself without beginning or end."[50]

These thoughts correspond to Beckmann's pictorial formulations, and it seems likely that he also adopted and at times modified the cabbalistic symbol of the *en-soph.* Thus it is more enlightening to interpret the mirror motif in *Sunrise* as the limited, earthly cosmos, i.e., as that tiny and transitory segment of eternity which is bisected for us here by the "slice of earth" visible in the mirror. The striking emphasis on the horizon line reveals the spherical form of the earth as a planet enclosed within itself. And the telescope, to which we have no access, is directed toward the eternity of the cosmos invisible to us. The very

49. Cf. especially *Fischer I,* p. 66.

50. *Titan, op. cit.* (note 1), pp. 442-443.

Fig. 22 Antoine Watteau: *Gilles,* 1717-19, oil on canvas, Paris, Louvre

Fig. 23 Max Beckmann: *Argonauts,* triptych, ▷ 1949/50, oil on canvas, New York, Private collection

beauty of this shimmering still-life arrangement, with its air of deception, adds probability to this interpretation.[51]

From this point of view, a new interpretation by Joan Wolk appears to be problematic,[52] despite the intriguing association between the printing on the open book and Jean Paul's "Neues Kampaner Tal oder die Unsterblichkeit der Seele."[53] It is Wolk's thesis that *Sunrise* could be seen as a meditation painting, since it conveys to the viewer the image of a new world or even instills a wish to enter this world.[54] The latter may indeed have been intended by Beckmann, but this imagined "world" is not physically present in the painting. It can only be conceived as the cosmos which is visible through the telescope, but which is closed to us here.[55] To define this as that realm of existence after death, which can be opened up by love for another human, seems hardly comprehensible in regard to Beckmann's view of the world. Even the happy marriage to Quappi and the more peaceful external conditions of his life are not strong enough to change his viewpoint, following the ideas of Jean Paul, about immortality throught love.[56]

The *Double-Portrait Carnival* (cat. 43) reveals just how much Beckmann remained loyal to his basic views, despite the close relationship to a wife who supported and sustained him in his daily life. Masking, role playing, and individual isolation, in spite of the greatest physical and spiritual intimacy, are all themes of this peculiarly joyless painting. Another theme repeatedly formulated by Beckmann is the idea of confrontation with the darkness of an unknown fate. It is surely significant that the opening behind the couple (thus invisible to them) shows the viewer a black, undefinable space. The connection between Beckmann's rendition of himself here and Antoine Watteau's *Gilles* (fig. 22), already noted by Reifenberg,[57] illustrates the mixture of grief and melancholy of an individual who is conscious of his prescribed role.

The motif of the sea becomes an almost metaphysical, ritually sacred hieroglyph of meaning in the last completed triptych, *Argonauts* (fig. 23).[58] Indeed a reversal seems to have occurred here such that the figures in the foreground, with their suggestion of classical antiquity, are no longer placed before the endless sea. Instead they stand above it in the super-terrestrial sphere of unreal violet-red stars. And the ladder, which for Beckmann has repeatedly been a metaphor of vain undertakings, appears here as a connective element, a figurative allusion to both Jacob's ladder and the ladder to the heavens.

51. Surveying the long series of Beckmann's still-lifes one finds this trait again and again. The beauty of flowers in full bloom, or rather shortly before wilting, was often adopted by Beckmann in this way from the classical *vanitas* conventions.

52. Joan Wolk, "Das Vanitas-Motiv bei Max Beckmann and Jean Paul—Symbole der Unsterblichkeit und der Liebe," in *Max Beckmann—Frankfurt 1915-1933,* exhibition catalogue Städtische Galerie in Städelschen Kunstinstitut, Frankfurt am Main, 1983/84, pp. 51-

53. The letters Beckmann includes "NEU-PER/ ORN," can be completed as follows: "NEU(es)(Kam)P(an)ER(Tal)O(de)R (die) (U)N(sterblichkeit der Seele)," *ibid,* p. 55. This does not consider the last numerals, which resemble a Roman numeral two.

54. *ibid.*

55. It is not clear where Wolk derives the conviction that one is located on an island in the painting (*ibid.* p. 54). This interpretation probably results from too narrow and naturalistic an understanding of the mirror motif, which reflects nothing recognizable in the painting. If an island is really intended, the mirror still could not reflect the sea and sun in this way, since it is tipped over backwards. From a photographic point of view, then, it would have to reflect something located somewhat diagonally above it.

56. *ibid.*

57. Benno Reifenberg and Wilhelm Hausenstein, *Max Beckmann,* Munich, 1949, p. 70.

58. Cf. *Fischer I,* p. 221 ff.

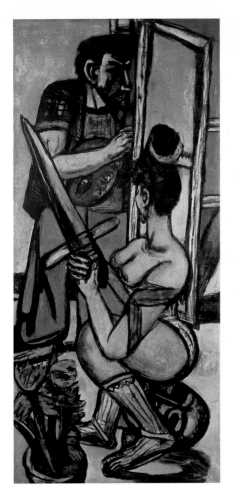

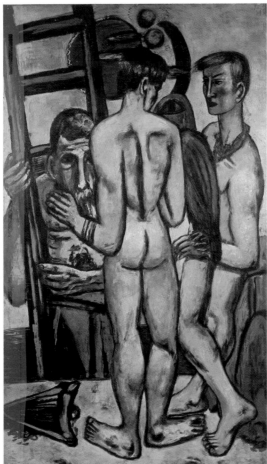

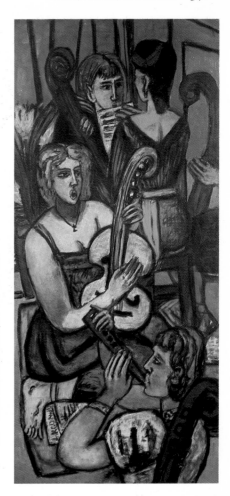

59. I refer especially to the horse's head that is visible in the window.

60. Beckmann initially referred to the figures in the center panel as "the gods." Noted by Gert Schiff, "Die neun vollendeten Triptychen von Max Beckmann; Marginalien zu ihrer Deutung," in *Max Beckmann—Die Triptychen im Städel*, exhibition catalogue Städtische Galerie im Städelschen Kunstinstitut, Frankfurt am Main 1981, p. 75. Cited henceforward as *Frankfurt Exhibition Catalogue, 1981*. Cf. in this regard Gert Schiff, *ibid.* p. 78.

The Modification of Pictorial Space

In the early 1920s, Beckmann represented crowded spaces which gave the people confined to them no freedom of movement. By the early 1940s they had become more often flat platform strips or compartments which are layered behind and above one another. Although these can be conceived as leading beyond the borders, they have no real extension of depth. This applies especially to the triptych, *Blindman's Bluff*, 1944/45 (fig. 24). As with *Perseus* (fig. p. 42), *Carnival* (fig. 26) or *Ballet Rehearsal* (cat. 132), the figures are arrayed on a narrow strip in the foreground, following traditional frieze-like formulas of representation. But here the arrangement covers the entire surface of the painting more like a relief and is composed only of closely-placed, interwoven figures. Optically, space can hardly be considered a pictorial interior that could be entered or inhabited; rather it is a coexistence of individual spatial compartments produced by the physicality of the figures against a flat ground. The disjointed confusion in a formal sense is amplified by the singularly controversial concert in the center panel: harpist, flutist, and drummer form a dissonant ensemble that leans partly toward classical antiquity and partly toward pagan barbarism. It is completed by the figure with a steer's head which serves as a paraphrase of Picasso's *Guernica* (fig. 25).[59] This recreation of the "gods" is framed by the figures in the side panels, two of whom seem mysteriously interrelated: the supplicant girl on the left and the blindfolded young man on the right.[60]

For our purposes, the contrast between the middle and side panels is most illuminating. In the center, the self-absorbed, free sport of the "gods" corresponds to the discordant, uncontrolled pictorial structure. The figures on either

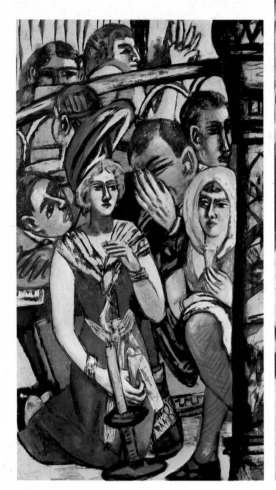

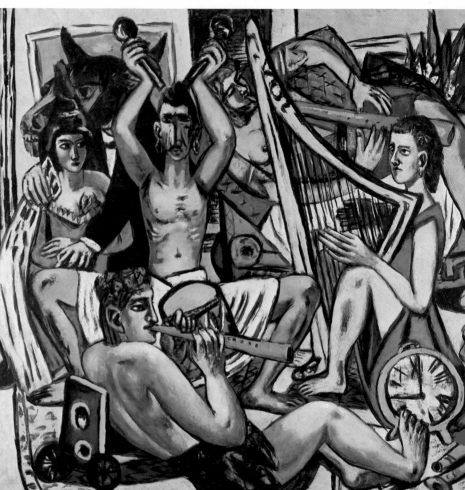

side, statically bound together, witness this carefree gathering as outsiders. That Beckmann saw himself as only temporarily belonging to it is revealed in a remark of September 19, 1945: "Now I am truly finished with *Blindman's Bluff* and unfortunately I must leave these dark and yet so festive rooms."[61]

Fig. 24 Max Beckmann: *Blindman's Bluff,* triptych, 1944/45, oil on canvas, Minneapolis, The Minneapolis Institute of Art

Fig. 25 Pablo Picasso: *Guernica,* 1937, oil on canvas, Madrid, Prado

Fig. 26 Max Beckmann: *Carnival,* triptych, 1942/43, oil on canvas, Iowa City, The University of Iowa Museum of Art

Motifs of Physical Violence since the 1930s

Physical violence and human enslavement become central motifs in three triptychs: *Departure,* 1932/33, *Temptation,* 1936/37, and *Perseus,* 1940/41. In the early 1920s there were mostly unsuspecting, pitiable figures who hardly encouraged a true identification on the viewer's part and thus were limited in subjective affect. Now more heroic and proud figures appear who seem to suffer humiliation without surrender. Earlier cynicism extended almost to the point of satire, such as in *Women's Bath* (cat. 20), where it was accompanied by anatomical distortions and tiny, over-filled, claustrophobic interiors. In the 1930s these have been replaced by figurations that seem *more probable* in every way, no matter how enigmatic the events that take place there may be. The mystery arises from the individual object symbols and the connections among them. While earlier the figures themselves seemed ignorant of the secret, now it often seems that those involved in Beckmann's pictorial dramas understand their fate thoroughly, but that the meaning remains concealed from *us.*

This problem came to one of its most valid solutions in *Departure* (fig. 27), Beckmann's first triptych.[62] Blunt physical violence, slavery, and psychological blindness are counterposed with contemplative peace and openness, which are conveyed directly by the contrast of interior and exterior space. In the center

61. *ibid.* p. 49.

62. Cf. especially *Fischer I,* p. 93 ff. and *Frankfurt Exhibition Catalogue, 1981.*

63. Fischer perhaps sees the immediate effects as being rather too concrete when he notes: "We may wonder if all this did not have an even wider meaning for Beckmann than the allegory of hope at a time of political despair." F. W. Fischer, *Max Beckmann,* New York, 1973, p. 52, henceforward cited as *Fischer II.*

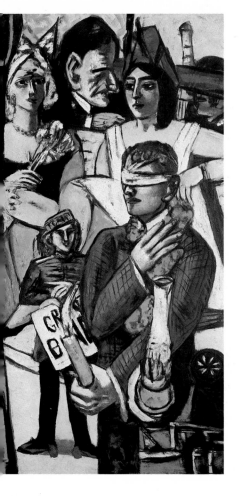

Fig. 25

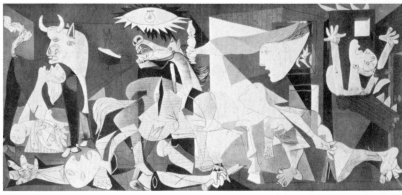

panel, the open sea and limitless horizon suggest an absolute degree of freedom, at least to the eye. In the side panels, both the pictorial figures and the viewer are inextricably confined within the scene by walls and peculiar pieces of architectural scenery. The interior becomes a prison, a locale for both physical and psychological constraint. Despite all the brutality and severity, no active or vital moment is perceptible. Rather, the figures seem frozen in their actions. An expression of unmitigated pain is found in the posture and strained musculature of the bound woman in the left panel. The other figures confine themselves rigidly to the part given them, while the faces of the victims are turned away. We identify them not as individuals but as types. Furthermore, Beckmann repeatedly thematized man's blindness in the face of a pre-determined, constrained existence. We need hardly substantiate further that this refers to a fundamental existential condition rather than to a concrete historical situation,[63] despite the threatening proximity of National Socialism.

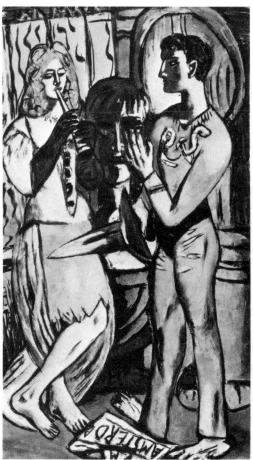

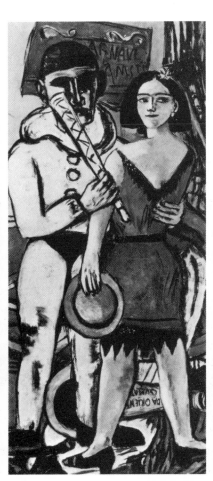

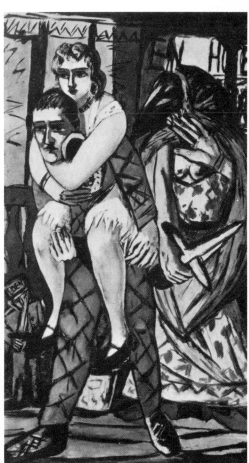

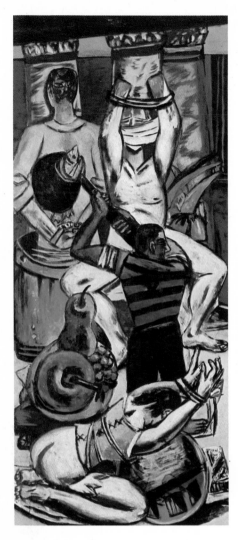
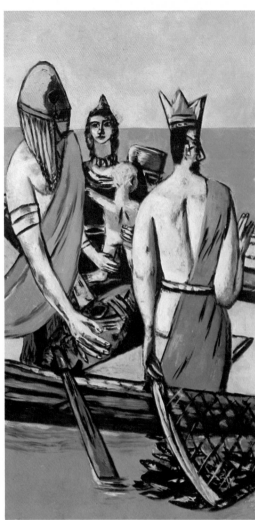
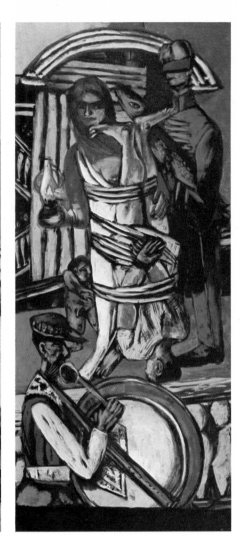

Perhaps the general problem behind this can be outlined more clearly by considering the two side panels in terms of a difference which has received too little attention. Unlike the left panel, the right does not contain the themes of torture *and* fettering, but *only* fettering. The eyes of the man in uniform are blindfolded and a second man hangs upside down, helplessly tied to a woman by means of bandages. Behind them is a gnome-like, naked creature, comparable to the malicious dwarf in the center panel of *Acrobats* (cat. 89). In both cases the freak is somehow related to the couple. In the earlier triptych, the couple appears to be intertwined with a coldly calculating passion, unavoidable and foreign to the world. Here they appear forcibly bound together, emotionless, and the woman obviously is given a dominant role. She is not bound to the man, but rather he is bound to her. One repeatedly finds similar emphasis and value placed by Beckmann on the inevitable entanglement of man and woman. Consider for example *Aerial Acrobats* (fig. 28) or *Journey on the Fish* (cat. 70). It is significant in this context that the woman gains greater and greater freedom and self-assuredness compared to the man, although the circumstances remain equally restrictive.

The figures in *Temptation* (cat. 73) are even further removed from direct expression of feelings. Here the lack of freedom is conveyed directly in the motif of fettering. The boy in the center panel and the two standing women in the side panels are enslaved with fetters, while the repulsive head-and-feet on the left and the crawling body on the right can be said to stand on a lower level and are mistreated in a baser manner. Regarding the three figures that are

◁ Fig. 27 Max Beckmann: *Departure*, triptych, 1932-35, oil on canvas, New York, The Museum of Modern Art

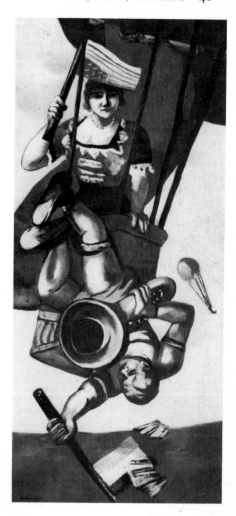

Fig. 28 Max Beckmann: *Aerial Acrobats,* 1928, oil on canvas, Wuppertal, Von der Heydt Museum

bound or caged, it is especially pertinent that all of them express melancholy and quiet resignation, thus turning the theme of temptation into one of passive acceptance of one's own role of victim. The women whom critics have repeatedly discussed as succumbing to temptation[64] hardly seem to be victims of their passion. They give the impression of yielding out of apathy, without thereby appearing mentally broken. This becomes even more obvious in the boy's case: he is not tormented by temptations, but rather envelops the woman in a gaze of sadness and resignation. Not a trace is to be found here of the passion and directness one would expect from such a theme. Instead, the impressions of quiet suffering and inevitability prevail, along with a certain satiety on the part of the women. The human fate of never being free, repeatedly being bound to material reality, is here found to be inescapable. And although the protagonists seem at least to sense this, their pride and dignity are not broken. The pitiable, wretched creatures of *The Dream* (cat. 23) have given way to human beings who think freely and freely accept their fate. The positive aspect of *Temptation* does not lie in the indication of a possible escape from this existential condition, but in the aura of psychological invulnerability which envelops the figures despite their de facto enslavement. Beckmann's faint hope, in a time when the very negation of a free existence became tangible in the barbarism of National Socialism, seems to have resided in this attitude of proud suffering instead of defiance or wild revolt.

In *Birds' Hell* (cat. 84) Beckmann concentrates on this other side, the source of violence. Significantly it is not human beings but huge, radiantly colored birds that serve as torturers. While there are certain references to National Socialism, the painting becomes an allegory of terrorism in general, an allegory

64. Cf. among others *Fischer I.* p. 136ff, *Frankfurt Exhibition Catalogue, 1981,* and Stephan Lackner, *Max Beckmann—Die neun Triptychen,* Berlin, 1965, p. 9.

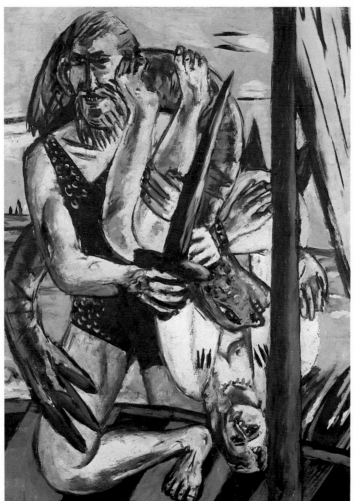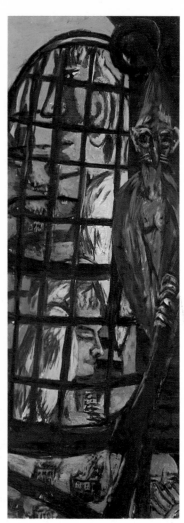

of that hell on earth to which individuals are inevitably subjected. But if individuals give in totally to their desires, this hell which defines them will swallow them up entirely. This interpretational approach may seem bold at first glance, but it becomes more plausible through comparison with *Temptation*. The young man tortured here is similar to the boy there. The birds are monstrously transformed counterparts to the bird of paradise in the right panel, and the fertility idol in the center panel, Diana of Ephesus, has become a Fury. In this nearly orgiastic painting, the perversion of human desire becomes an oppressive nightmare, at once real and unreal.

Fig. 29 Max Beckmann: *Perseus,* triptych, 1940/41, oil on canvas, Essen, Museum Folkwang

The triptych *Perseus* (fig. 29) also concentrates on the exercise of force in its central panel. Here it is not merely portrayed as a fact of reality but is also subjected to a value judgment. The mythological theme—the liberation of the oceans from the serpent monster and the rescue of Andromeda by Perseus—has been reinterpreted by Beckmann in an extremely idiosyncratic way.[65] There is no doubt that the hero now becomes a negative figure. His brutal exterior, unpleasant face, unkempt beard, and red mane of hair (Fischer is no doubt right in inferring here a perversion of Nordic heroes[66]) define him as more of an aggressor than a rescuer. The woman and the snake seem to be a single figure; they are *one* victim. Perseus is dominating not just anyone, but a woman. Beckmann leaves no doubt that this cannot be the solution to a basic human problem. The individual's lack of freedom, to Beckmann always partly a result of the division of the sexes, cannot be overcome through submission. That this freedom was always the freedom of the other as well was only made manifest in his works after the 1930s.

65. Cf. *Fischer II*, p. 65 ff.

66. *ibid.,* p. 68; however, it seems too speculative to suppose that Beckmann meant this figure to convey the fear of a German invasion of England or even Holland.

67. Cf. the study by Claude Gandelmann, "Max Beckmanns Triptychon und die Simultanbühne der zwanziger Jahre," in *Frankfurt Exhibition Catalogue, 1981,* pp. 102-113.

Isolation, constraint, and violence also play a significant role in the triptych *Actors* (fig. 30). As earlier in *Acrobats* (cat. 89), the figures presented belong to a well-defined, identifiable group. In contrast to *Temptation* (cat. 73), for example, this fact makes a superficial description of the events pictured easier to accomplish. In any case, the scene here is much more complicated than in *Acrobats*; more people in different places and on different levels take part in the preparation of a play. This fact is reminiscent of the expressionistic device of "simultaneous stage," where several scenes were played at once on a complicated stage with interlocking, multi-level parts.[67] The parallel applies merely to the formal problem of presenting several scenes that take place simultaneously, which here conveys the general situation of theater rehearsals and not the complex content of a play.

In the center panel, the actor costumed as king, who resembles Beckmann, commits suicide. It remains unclear whether this is an act or reality, but a tragic, unexpected turn of events is suggested by the prompter's open mouth and raised arms, and by the singer's interrupted song. While the director checks the script with stoic calm, an ugly court jester observes the scene with open cynicism and uneasiness: he, too, raises a hand as if astonished. An unpleasant old woman is paired with the jester, reminiscent of the evil dwarf and witch of fairy tales. A girl dreamily sitting on the steps provides the transition to the open orchestra pit, where a greenish male head and stagehands are visible, furiously engaged in fighting.

The relevance of the five bare feet, visible in the lower portion of the left panel, is unclear. The metal rings on the ankles are reminiscent of shackles

Fig. 30 Max Beckmann: *Actors*, triptych, 1941/42, oil on canvas, Cambridge, Mass., Harvard University, Fogg Art Museum

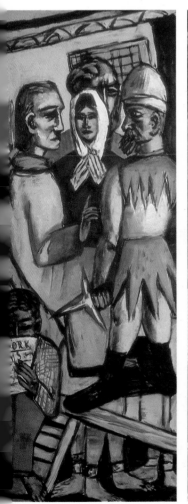
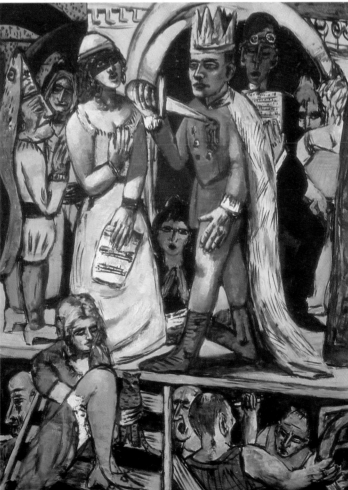

Beckmann repeatedly used in his paintings. But the bodies belonging to the feet are nowhere to be seen, and no space has been set aside for them. They seem actually to be severed feet which signify something else. Noise is articulated only in the lower levels, while in the upper areas everything seems to take place in an oppressive silence. The contrast becomes especially burdensome in the center panel, where the open aggression below is juxtaposed with resignation above. This resignation transforms aggression into an elegiac and melancholy despair, turning it against itself. The king's suicide—whether real or fake—takes place with such silent apathy that only the dagger and the wound verify the act. The body itself remains unmoved.

Gert Schiff[68] notes an enlightening connection between the king and the figure of Roquairol in Jean Paul's novel, *Titan.* Numerous remarks by Beckmann reveal that he was fascinated by the torn personality of Roquairol, the negative hero, desperately searching for his own identity, who finally kills himself on an open stage in a play he wrote himself. Roquairol's demand for the Absolute, his contempt for a merely normal existence, his frenzied search for authentic feelings, be they negative or positive, must have struck a responsive chord in Beckmann. As he portrayed himself as the king-figure, Beckmann may have been attempting to express a similar attitude toward the reality around him.

In this connection there is a surprising parallel between the king and the dwarf in the center panel. The colors of their clothing reflect each other: in both cases they are green, red, and yellow. On the one hand, this has the compositional function of a complementary contrast, since the middle panel is held together not by forms but by color. On the other hand, however, the content is meaningful as well. The repulsive dwarf and the melancholy king actually become counterparts, an impression amplified by the gray facial color. The dwarf is conceived as a negative, malevolently cynical persona, possibly intended as an alternative, an alter-ego, to the resigned life of the idealistic artist-king, who extinguishes himself in an act of hopelessness.

The two side panels complement and support the center panel, optically pushing it forward through the formal device of diagonal lines. In the left panel is the figure of Christ,[69] sure of Himself, calmly carrying out His instruction. In the other is the Janus face. Mirroring each other as young and old, Christendom and Antiquity, they are perhaps presented as equally valid possibilities. They also suggest social behavior in a group and isolated contemplation.

The Motif of Veiling

The motif of veiling suggests another plane of meaning. Beckmann integrated variations of it in compositions very different in content. Masks or disguises in general allow individuals to appear other than they really are. The disguise becomes an alter-ego or even pretends to be the true self that it represents. Thus, in *Masquerade* (cat. 117) the mask turns the woman into a cat. The viewer is deprived of any indication of the true identity and is inclined to identify the person with the characteristics expressed by the mask. A veil, however, hides the face without feigning another identity; in concealing, it arouses curiosity about what it is covering. The figure becomes an enticing or menacing mystery, whose meaning can only be disclosed through an unveiling. But in the painting, it remains manifest as an insoluble riddle.

One of the earliest examples of this figural type, found in the *Resurrection* of 1916 (fig. p. 83), can be clearly explained thematically. The form striding out of the picture at the upper left, on the side of the damned, has tightly wrapped

68. *Frankfurt Exhibition Catalogue, 1981,* p. 24.

69. According to Erhard Göpel, *Max Beckmann—Die Argonauten,* Reclams Werkmonographien zur bildenden Kunst 13, Stuttgart, 1957, p. 4.

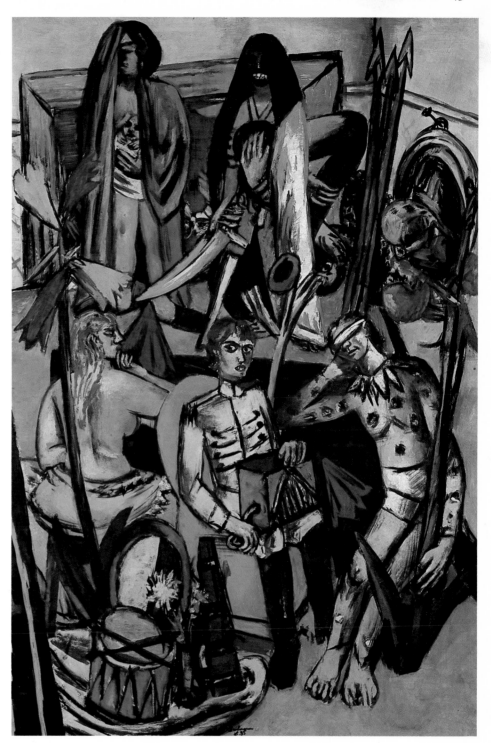

itself in a shroud which covers the arms, head, and part of the face. Whether this gesture of self-concealment is to be seen as a futile attempt at protection against a hostile environment or whether it is despair over the fate of damnation which is now irrevocably sealed is uncertain. Thus even here the motif takes on some of the unfathomable, ambiguous meaning essential to later versions. The veiled figure in *Lido* (cat. 40) appears as an absurd yet mysterious barrier between the grotesque activity in the sea and the viewer. In the *Carnival* of 1925 (fig. 7), the veiled figure introduces an element of caricature as well as profound horror. A figure with a covered head sits unnoticed behind the Pierette, and becomes a mocking caricature of her oblivious, elegant posture. The figure's dark eye sockets are directed nowhere. The absurdity of the acrobatic exercise heightens the already ghostly effect of the head in an almost surrealistic way.

In *The Organ-Grinder* (fig. 31), which is a distressing, rebus-like "song of life,"[70] two half-veiled figures approach us, complementing each other like Yin and Yang. They are again repeated by the symbol of the *en-soph*[71] in the mirror below, the cabbalistic symbol variously used by Beckmann. The left figure holds an aged-looking infant, similar to the child in *Birth* (cat. 81). The dark-skinned figure at the right, with a bloody sword and a wooden leg, is holding a dark shape resembling a head. The two seem to represent the cycle of life, birth, and death, but also silent passivity and brutal aggression.[72] The motif of partial veiling here could be a sign for what Beckmann saw as the fundamental deficiency of human beings: seeing and understanding all existence, even birth and death, only from the narrow perspective of one's own individuality, i.e., as the inability ever to know anything completely. Indeed, whenever we do believe we know something, a veil hides any comprehensive vision from us.

This implies that constraint is not a property of the figure itself, but rather is an attitude which arises in the viewer. The viewer's own ignorance and therefore the existential negation of freedom are demonstrated to him. This is equally visible in the dreamy, distant figure of the youth in harlequin costume. He wears a superfluous blindfold, naively ignorant of the ominous scene behind him. Related to the oversized flower—half blue flower of Romanticism and half symbol of death—this doubly blind youth becomes the incarnation of a humanity which in its ignorance believes it is safe, which in its blindness believes it is free.[73]

In *Studio*, 1938 (cat. 85) the veiled figure denies any revelation. Its banal existence (the clay model is covered with a cloth at night to keep it from drying out) is transformed by the dark of night, raising its own darkness to the level of mystery. Indeed, it becomes a frightening being. We are not certain whether this figure has understanding or is just as ignorant as we. Perhaps it personifies a fate unknown to us, or perhaps the protective cloth just hides a stagnant void. The figure in *Sculptor's Studio*, 1946 (fig. p. 141) is less ambiguous but no less threatening. It has been transformed into a darkly shrouded woman, vertical, hidden by an oversized sword. This contrasts singularly with the pale, half-naked woman whose back appears in the mirror. The gaze of the man, who is also visible only as a reflection, seems directed toward the dark goddess. The true pictorial reality thus becomes that which is beyond, concealed, casting its spell over everything and yet rejecting attempts to grasp it. The sword ensures its inaccessibility.

The motif surfaces again in *Farewell*, 1942 (fig. 32) in less complicated form. The pain of the imminent parting is evident in the veiled figure. Some dark premonition suggests to her that the separation will be final, for the figure has an aura of that same irrevocable, endless grief that is powerfully embodied in different variants of the famous "Mourners" by Claus Sluter (fig. 33). Beckmann's creation of the veiled figure would be unthinkable without this precedent, which one can assume he knew.[74] This parallel was already visible in *Resurrection* (fig. p. 83) and can be more or less clearly substantiated in most of the examples within this pictorial motif. One gets the impression that Beckmann did more than adapt Sluter's petrified symbol of mental pain that is so concentrated on the theme of death.

He also expanded it with another theme inherent in the veil, that of a mysterious fate. This is suggested for example in *The Journey* (cat. 103), and becomes decisive for *Dream of Monte Carlo*, 1939-43 (fig. 34), a complex allegory of basic human behavior and concrete historical threats. A woman reclines on the table, offering herself seductively; her bared breasts are exhibited like a trophy, as is the case for the woman seated. The woman on the table seems to hold the trump card, which she presents to the viewer with her face partially averted. The entire composition concentrates on this fact. The dealers or gam-

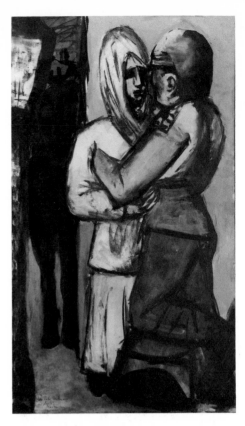

Fig. 32 Max Beckmann: *Farewell*, 1942, oil on canvas, Private collection

70. *Fischer II*, p. 57 ff.

71. *Fischer I*, p. 66 ff.

72. Fischer identifies the two dark figures above with the Indian deities Kali and Devi, who personify the destruction and preservation of life, but this is not corroborated by the optical evidence. Although the figure on the left seems less negative than the one on the right, it is difficult to see it as an embodiment of positive values. And the figure on the right with the wooden leg is not classified as female; it could present simply a generally martial element (see *Fischer, I.*, p. 134).

73. The black carpet divides foreground and background, suggesting a split between this world and the world beyond. The veiled figures are thus supposedly assigned to alien spheres. The male-female relationship in *Lifesong* comes out in the significant placement of the flowers. The liftboy and the sexless warrior of *Temptation* (cat. 73) are combined in the emotionally uninvolved organ-grinder. The related motifs of fire and the divided mirror also appear in the triptych.

74. Similarities can be found in medieval scenes of the deposition of Christ from the cross and the mourning of Christ, for example Dürer's *Lamentation of Christ* or the *Crucifixion of Christ* by the Master of the Ternsee Tabula Magna, both in the Alte Pinakothek, Munich.

Fig. 33 Claus Sluter: *Mourning Monk from the Tomb of Philip the Bold*, 1404-1405, Dijon

blers in the background, even their table, seem ineluctably drawn toward it. Their greedy looks and martially-drawn swords leave no doubt that they will ruthlessly fight to win at any price. (Even the small boy in the older woman's arms holds a threatening sword.)[75] So engrossed in their lust and greed, they do not notice that they have delivered themselves wholly into the clutches of a horrible fate: it already waits beside them, hideously shrouded and bandaged, holding a time bomb with a lighted fuse. The hideous creature on the left, whose eyes are stacked bizarrely on top of one another, is frighteningly reminiscent of the horrible *Children of Twilight-Orcus* (cat. 87). Fischer's term, "captors of the soul," for these figures is no doubt apt; it is they who plunge human beings back into the cycle of Becoming.[76] In *Dream of Monte Carlo* they attach themselves to the men without their knowledge, as their dark shadows. In color, too, this figure contrasts with the almost shimmering brightness of the men's faces.

Dream of Monte Carlo is a vision of an existentially inevitable, deadly passion for gambling with all its possible implications: first as a gamble for money, which in turn implies the obsessive contest for the woman who plays the role of the turn-of-the-century "femme fatale."[77] It remains an open question whether this, as Fischer believes, also anticipates the increasing political tension in Europe, thus expressing a concrete, tangible threat to human freedom. It is more probable that Beckmann took even this real situation as a stimulus to consider the overriding and ever-present constraint that turns the individual into a puppet of unknown forces. A similar function may be ascribed to the veiled and masked goddess of destiny in the triptych, *Carnival* (fig. 26). Indeed the horror seems to touch the figure itself there. The sword held away from her body and the gesture of her hand distance her from the young man who, with embittered spite, is trying to carry off the woman on his back while she clings to him with naive trust.

The Relationship Between Man and Woman

The relationship of man and woman formulates precisely one of the most important themes, perhaps even the central theme, of Beckmann's pictorial thinking. The opposition between man and woman cannot be overcome; it is both destructive and essential to life. It is a metaphor of existential negation of freedom, a vivid symbol of our pre-determined bond with material reality. In the vain but ever-present desire to eliminate this separation and fulfill oneself in the other, the individual is inevitably chained to the transience and banality of existence. It suffices to repeat the oft-quoted diary entry of July 4, 1946: "Cold wrath reigns in my soul. Is one never to be set loose from this eternal, hideous, vegetative physicality? Are all our acts ever to remain laughable inconsequentialities in relation to the boundless universe? ...Nothing is left to us but protest—Boundless contempt for the lascivious bait with which we are repeatedly lured back to take life's bit in our mouths. When we are then half dead of thirst and want to quench it, the mocking laughter of the gods appears. —You lick salt, you poor megalomaniacal slave; sweetly and endlessly comical, you dance in the arena of endlessness to the thunderous applause of the divine spectators. The better you do it, the more comical you are. The most comical are the ascetics, who invent for themselves yet another sensuality in renunciation or self-torment.—Saddest of all is the absolute profligate, because he drinks pitch instead of water.—Let us hold on to contempt."[78]

Asceticism and voluptuousness—Beckmann dealt with both extremes, but a primary relationship to all directly sensual manifestations of life was doubtless taken for granted. "If you yield to asceticism, the withdrawal from all things

75. Cf. *Fischer II*, p. 59.

76. To Stephen Lackner's question as to the concrete meaning of the word "Sortie" here, Beckmann replied, "Well, like in the Metro." Lackner immediately linked this to the River Styx of the Underworld. Cf. Stephan Lackner, *Ich erinnere mich gut an Max Beckmann*, Mainz, 1967, p. 79.

77. The extent of the influence of symbolic concepts on Beckmann's view of women would require separate analysis.

78. *Tagebücher 1940-1950*, July 4, 1946; cf. also Christian Lenz on this theme.

Fig. 34 Max Beckmann: *Dream of Monte Carlo*, 1939-43, oil on canvas, Stuttgart, Staatsgalerie

human, you will perhaps achieve a certain concentration, but you could also dry up in the process. If you plunge headlong into the arms of passion, you could easily be burned. Art, love, and passion are very closely related. For everything revolves more or less around awareness or enjoyment of beauty in whatever form. And intoxication is beautiful—is it not, my friend?"[79] It is obvious which way the scale is tipping here! For precisely here is the origin of the difference between himself and Cézanne—whom Beckmann consistently admired—and Picasso. Cézanne's asceticism was ultimately incompatible with Beckmann's feeling for life, whereas the foundations Picasso took for granted, without constantly reflecting on them, became an existential dilemma for Beckmann. This more or less clear conflict was the result of Beckmann's conscious recognition of the material limitations that were pre-programmed by external forces. It struck him again and again that the impossibility of freedom within every individual, could only be countered with defiance and contempt. This same conflict contributes to the singularity and greatness of Beckmann's artistic oeuvre. The contradictions of existence are reflected in an "impure" approach to painting, often aggressively founded on the opposition between beautiful *"peinture"* and "roughness."

Images of the inseparable intertwining of the sexes confront us repeatedly in Beckmann's work, either in encoded or open form. There is scarcely an example of a relaxed, balanced relationship. In these depictions lies the true explanation of the generally problematic nature of human contact, which Beckmann constantly reformulated in variations of group portraits and figural compositions.

The coloration, the strangely statuary pose, and individual attributes give the interaction of a costumed couple in *Parisian Carnival* (cat. 61) a demonic, inscrutable aspect. Here the carryings-on of Carnival are revealed to be in bitter earnest. The toy sword is unintentionally transformed into a dangerous weapon: the puncture in the woman's back bears blood-red traces of color. The dark barrier at the picture's front edge—a recurring motif in the artist's work—spatially encloses the couple, who stand fixated on each other. A gloomy, bald harlequin blows the Carnival horn, playing a dissonant accompaniment to the ongoing game of seduction, desire, and violence. The harlequin appears with shifting meaning in various paintings as the archetype of a mysteriously dark being from the world beyond. Here the woman is already given a dominant position. She has an unusual vitality compared to the man's flat stature, and stands in a challenging pose and heroic battle dress which significantly return much later in the middle panel of *Ballet Rehearsal*. Compared to the rather laughable "cardboard comrade," she appears strong and ultimately impervious. The trace of blood indicates only a superficial, harmless injury. This appraisal of Beckmann's image of women as indomitable survivors—despite ever-recurring criticism, resistance, and even negative implications—will be considered further. At the moment it seems important only to remember the strength of this woman. In the year it was created it seems most comparable to Beckmann's view of himself which he translated into *Self-Portrait with Saxophone* (fig. p. 66). The almost brutal, aggressively self-assured pose he claims for himself here was never again repeated in a self-portrait. Instead, these elements play an increasing role in portraits of women.

The female figure also takes the dominant position in the dense, hieroglyphic structure of *Brother and Sister* (cat. 69), which conveys a hopeless erotic entanglement. The man whose body is bizarrely twisted, flattened and bent upward in an unstable position, expresses helpless vulnerability. On the other hand, the woman seems less endangered not only because of her compact physicality and blonde mane of hair, but especially because of her stable position which determines the composition. Although she is just as entangled in a hopeless situation as the man, she does not break down and functions more as a seductive threat.

The theme is generally changed in *City of Brass* (cat. 102), which becomes a cold and aggressive prison for the naked couple there. The brutal pointed spears and towers grouped around the bed enclose the man and woman. There is no escape; this is their "living space." That this is identical with cold, emotionless sexuality is clearly expressed by the formal elements. The fantastic, dreamy scenery as a whole, as well as the self-absorbed concentration of the couple, refers to the blindness of the individual so often reiterated by Beckmann. This lack of vision prevents one from seeing through the predestination of human existence. Instead the individual repeatedly falls prey to the lascivious bait[80] offered by external forces.

One of the most striking constellations in this context is found in *Studio*, (cat. 109), perhaps an unspectacular painting at first glance. The work also bore the title "Olympia,"[81] suggestive of Manet's painting by the same name (fig. 35). Beckmann's version is a conscious or unconscious paraphrase. In both paintings a dark figure is paired with the female nude. In the Manet, it is a black servant who serves as a background foil for the courtesan, setting off her beauty. In

79. *Sichtbares und Unsichtbares*, p. 38.

80. Cf. note 78.

81. The former owner, Morton D. May, gave the painting this title, and Beckmann reportedly agreed. Cf. *Gemälde-Katalog* Vol. 1, p. 431, No. 719.

Beckmann's painting, it is a male nude sculpture which has eye contact with the woman, almost conveying the impression of life. While Manet intends primarily a formal and color contrast, Beckmann suggests an opposition in content. The composition is determined by male and female, black and white contrasts. But here the possibility of a resolution is suggested, as in the Yin and Yang symbol. Light and dark do not merely stand separate and opposed to each other, they each receive traces of the other. But the conditions under which such a harmony between the two could be thinkable are made clear in the confrontation of a living, vital nude on the one hand and a petrified male half-figure on the other.

Let us recall a few more outstanding portraits of women in which Beckmann treated, with varying detachment and objectivity, a theme deeply moving to him. This includes not only the "femme fatale," the Lulu, and the demonic force of destiny who enthralls and devours men, of which a more impressive image than *Columbine* (cat. 130) can hardly be imagined. But there are also women wholly at rest in themselves, completely sure of themselves, women who need not strike a pose. Consider, for example, the *Dancer with Tambourine* (cat. 107), who stands careless and boyish before the viewer without coquettishness. This is one of the few examples in the artist's work where the woman's physical and mental presence and strength are not perceived as a direct or indirect threat. Here the obviously well-balanced attitude easily accepts the difference of the other and tolerates it. This has a direct expression in the unaggressive coloration and generally restrained mood. Such self-assuredness also characterizes the matter-of-fact, unpretentious manner of prostitutes resting half-naked in the painting, *Girls' Room (Siesta)* (cat. 113) which has no provocative or even moralizing aspect, despite the sultry coloration. In contrast, the "bourgeois" companion piece, *Fisherwomen* (cat. 121), seems much more threatening in its purposeful, coldly calculating sexuality. It presents three half-naked women with a withered old woman as their counterpart and overseer. But how precisely and deliberately the enticements are placed: isolated parts of the body are exposed and ostentatiously presented like fetishes. Black bordering emphasizes the three-dimensionality or flatness of certain segments, giving the composition the character of a relief, similar to leaded glass. No impression of continuous space is given. The body is not a completely whole entity, but instead is composed of separate, three-dimensional sections that are arranged between flat areas. Restricting three-dimensionality to the unclothed parts of the women's bodies serves to increase and accentuate their emblematic character as fetishes. The faces of the women however betray nothing frivolous or obscene. Rather their acts seem to possess the zeal of a ritual, in which the fish that have been caught (obvious symbols of male sexuality) are both trophies and sacrificial animals.

As far as the unfinished *Ballet Rehearsal* (cat. 132) can be judged, it seems that Beckmann intended it to express an unusually high degree of internal and external freedom as a realistic possibility of existence. It is a pure "woman-painting." The Amazons (also considered as an alternative title) seem subjected to no compulsion whatever—hidden or manifest, direct or indirect. Even the girl in the right panel, comparable to the figure shackled to a spear in *Temptation* (cat. 73), is not visibly bound to the weapon, but seems to hold it by chance. The recurrent ladder motif has a clear, practical function here and is not at all an instrument of vain endeavors and unattainable desires. As it provides access to the stage loft, the ladder becomes a sign for the simplicity, clarity, and "skill for living" that mark the entire painting. Far from all the flights of escape that have been pre-programmed to fail, this attitude asserts that it belongs here. The figures are to be seen in this light as well. Overly large, they fill the entire height of the painting and even burst beyond it. Nor are they recognizably confined to a restrictive architectural space. On the contrary, they seem to dominate the

82. In my opinion one cannot find support in the triptych for the conclusion that it "criticizes the female as such" and that the snake charmer "is involved with a none-too-submissive sex object." Cf. Stephan Lackner in *Frankfurt Exhibition Catalogue, 1981*, p. 85.

Fig. 35 Edouard Manet: *Olympia,* 1863, oil
on canvas, Paris, Louvre

painting through their physicality and the immediacy of their fullness of life;
they reign over it as they see fit. The two women on the left in the center panel
are presented aggressively. They literally bare their teeth, and it is surely no
accident that they are eating fish in a barbarous, obscene manner. The women
in the side panels, however, present themselves as unselfconscious and self-
assured, which perhaps lends special significance to the crowned snake charmer
on the left.[82] The serpent is removed from the traditional Biblical context of
seduction and symbol of the Fall. Instead, the almost organic unity between the
woman and the snake tenderly coiled around her, in addition to the associations
of the crown, suggest a positive alternative to the negative, hopeless entangle-
ment of man and woman seen in the right panel of *Departure* (fig. 27). The
man's head visible in the mirror on the right (the dancer before it seems to be
looking at him in her hand-mirror) is a doubly-distanced reflection. It is no
longer a tangible, therefore vulnerable, meeting.

For Beckmann, freedom cannot be realized in the here and now. Instead it
must be postponed to a future which to the individual may seem to be an
unreachable utopia, a deluded fantasy, or yet be believed in as an inevitable
development. Despite all scepticism, self-doubt, and unconcealed sarcasm, a
concept of salvation does indeed seem to have taken shape for Beckmann. It is
not based on traditional Christian ideas, but rather on an understanding of the
philosophy of religion nourished from the most varied sources. Yet there is no
doubt that it remains fixed on a condition beyond death, however it may be
composed.

Freedom therefore is never an "earthly" reality; where Beckmann's work
points toward a positive goal, a way out, it is always a projection toward a
Beyond. Freedom in this world can at best consist of that small flexibility which
can be achieved through defiance: "One thing at least remains free for us.
Hate—Rage and inner obedience repudiate the repulsive, ever-unknown laws
held over us since all eternity in horrible, nameless constraint of the will.—
Nothing remains to us but protest—protest and arrogance of wretched
slaves—the only inner freedom—and with that one is to live."[83]

It is precisely in the reversal and negative formulation of Beckmann's associ-
ations with God and the gods that we discover a world view of deeply religious

83. Max Beckmann, *Tagebücher 1940-1950,* p. 168.

intent. Although it offers no consolation in a predestined existence, unfree from the start, there is still a belief in an ultimate state of freedom reached through and after death. Although its concrete form remains uncertain, and it may even be the freedom of nothingness, at least it overcomes all material restrictions. "Saw my paintings radiating in distant gods in dark night—but—was it still I?—no—far from me, my poor self, they circled as independent beings who scornfully looked down on me, 'that we are' and 'You n'existe plus'—oho—battle of the self-born gods against their inventor?—Well, I must bear that, too —whether you will or no—until beyond the great partition—then perhaps I will be myself and "dance the dance" of the gods—outside my will and outside my imagination—and *still I myself.*"[84]

84. *ibid*, p. 72.

Translated from the German by Barton Byg

James D. Burke

Max Beckmann:
An Introduction to the Self-Portraits

Like Dante, Max Beckmann has portrayed an epic journey of discovery in which our guide is the artist himself, viewed through his self-portraits. Concerned with man's fate, Beckmann struggled with grand and noble themes in a century racked with discord and disaster. His artistic works aspired to the heroic; as we shall see, he conceived of himself as a hero of Homeric proportions.

Beckmann's lofty aspirations concerned the role of art, the subjects which he chose to paint or draw, and himself as an artist. From the beginning of his career, he was clearly conscious of the great traditions and accomplishments in the history of art. He sought serious themes—themes of human action—and spurned those ideas which might be viewed as trivial or merely decorative.

Thus it is no surprise that we encounter here an artistic personality who would depict human disasters such as the sinking of the great ship *Titanic* (cat. 12), the earthquake at Messina (cat. 10), and the Passion of Christ. He painted allegories like *The Bark* (cat. 42), *Birds' Hell* (cat. 84), or the *Acrobats* triptych (cat. 89), which confronted contemporary issues. Few artists have so consistently been concerned with such heady subjects, but for Beckmann they were a necessity, a way to face the realities of modern life. In our century, no artist has been more a part of his own times.

In the mad and turbulent early years of our century, Beckmann reached for the most momentous subjects drawn from everyday life in Europe: war, destruction, and chaos. In his art he struck the human themes that accompanied those events: loss and despair, loneliness, confusion, contempt, and disorder. He grappled with the problem of the individual versus mass society, which came so dramatically to the fore in two wars and amid revolution and totalitarian states. He dealt with modern philosophy, theology, and literature. In all ways, he was a serious artist, seeking the profound.

Yet it would be wrong to review Beckmann's life and work only as a catalogue of disasters or to see his life as pessimistic. There remains another side to his work in which we find modest and rewarding images of enduring memory. Sensitive portraits, bright still-lifes, lively city views, landscapes, and scenes of café society continued throughout his lifetime. Changes of character are to be found in style as well, for there are paintings of harsh color and strident execution existing side by side with works of an opposite temperament. He joined van Gogh, Poussin, Velásquez, Corinth, Watteau, Munch, Reynolds, Liebermann, and many others in the depiction of self-portraits.

Throughout his career there are self-portraits. A brief count would list over 80 in all media. Not since Rembrandt, whom Beckmann admired all his life, had any artist faced himself so often. Self-portraiture is fraught with pitfalls, into which many artists have been lost. Self-pity, vanity, and foolishness are the primary dangers, for who among us can truly confront himself, who even wishes to? Only the greatest fool or the most ambitious personality would try, and in the latter context we come to Beckmann.

Always aware of himself and ever prepared to attempt the most challenging difficulties in art, Beckmann produced a series of self-portraits that span his 51 creative years. Through them, we can not only discern the changing fortunes of the artist, his self-esteem, and the changing style of his production, but we can also discover some measure of genuine perception of himself, which can give a profound and often intimate revelation of his character.

Like Rembrandt, Titian, Goya, and other old masters whom he admired, Beckmann changed and grew often. We often measure artists by the significance of their changes of style and subject, searching for that which may have meaning and profundity. In this century, other than Picasso, Matisse, and Cézanne, it is only Beckmann who has grown and changed so much, with so much effect.

Youth and vanity are the hallmarks of Beckmann's earliest self-portrait (cat. 2), executed in an academic turn-of-the-century style about 1900 when he was still a schoolboy. Blowing soap bubbles has a long artistic tradition with *vanitas* connotations of the transience of life. As in the tradition, the youthful sitter extends the sense of fleeting time, innocence, and naiveté that can be seen in examples by Frans van Mieris, Jean-Baptiste Chardin, and Edouard Manet. This dreamy youth who profiles himself above a distant landscape and looks symbolically skyward, is drawn in sober browns. It is a perfect union of juvenile meaning, style, and subject; competent yet more than a little foolish. But as such it is a key to Beckmann's beginnings in its ambition to confront a major theme from the great masters of the past and in its striking self-consciousness.

Only a year later, in a drypoint in 1901 (fig. 2), his youthful emotions assume a more direct course. Taking over the expressive shriek from Edvard Munch's lithograph of 1895, (fig. 1) Beckmann depicts himself as the screamer. Munch was well-known and widely exhibited in Germany, and therefore quite accessible to the young artist. As one of his first attempts at printmaking, it suits Beckmann's youthful purpose to show himself as a virulent, if over-emotional person. After all, it was thus that Rembrandt had shown himself in his youth, shouting with emotion in a self-portrait etching of 1630 (Bartsch 13).

Fig. 1 Edvard Munch: *The Scream,* 1895, lithograph

Fig. 2 Max Beckmann: *Self-Portrait,* 1901, drypoint, Private collection

Fig. 3 Max Beckmann: *Self-Portrait,* 1904,
etching and drypoint, Private collection

The years 1903 and 1904 find more confident self-portraits completed during his art school years in Weimar. A dark and haunting lithograph of 1903 (cat. 211) presents a mysterious and forbidding visage to the viewer.

In the same year, he drew himself in profile again, a young buck in a straw hat, coat, and tie (cat. 133). The drawing style here is looser and more spontaneous, the view now more casual. Having left the Weimar Art Academy, Beckmann had traveled to Paris and moved to Berlin in 1903. Now, under the influence of his direct experience with the French Impressionists and post-Impressionists as well as the Berlin moderns such as Max Liebermann, Lovis Corinth, and Max Slevogt, the young artist had arrived at a new style. The strokes in drawing, etching, or paint are more evident, and the subjects suffused with greater light. These effects are most apparent in the etched self-portrait of 1904 (fig. 3). Washed out with light falling from above, it is comprised of small marks of varying density, through which the face finds shape. Bright, intense, and direct, Beckmann confronts himself and the viewer fullface, defining the format and dramatic intensity which will persist throughout his life.

The greatest accomplishment of his youthful work in this period (1899-1907) was his painting, *Young Men by the Sea,* 1905 (fig. p. 113), which was purchased by the Weimar Museum in 1906. It was submitted to the annual juried exhibition of the German Artists League, and it won for Beckmann the Villa Romana Prize of a six-month sojourn in Florence. He married and set off for Italy, fresh with success.

Every aspect of this good fortune is to be seen in the grand self-portrait of 1907 (fig. 4), itself a summation of his post-Impressionist style. Loose in its brushwork, fresh in its color and execution, harmonious in its tonality and organization, the format for his greatest self-portrait is set here. Poised, showing one hand with a cigarette, dressed in suit and tie, Beckmann faces the canvas to record his own newly-found confidence and stature. Florence and Fiesole, venues of the great artists of the past he so revered, lay behind him; a new life is anticipated in this confident but expectant painting. Beckmann's penetrating gaze reveals his seriousness of purpose without cloying charm or

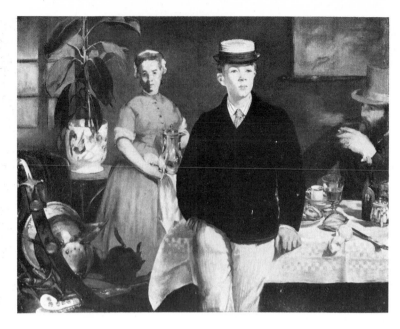

any trace of self-pity. The formal pose meets the viewer directly and, like Manet's *Luncheon in the Studio,* 1868, (fig. 5), it symbolizes a coming of age for its young subject. The casual but obvious gesture of smoking recalls earlier *vanitas* subjects. As with the soap bubbles of 1900, Beckmann alludes to the impermanence of life, in a gesture he will return to many times.

The striking *Self-Portrait in Florence* of 1907 marks the end of his youth and the beginning of his first maturity. The succeeding years, up until the outbreak of World War I, formed Beckmann's first and most heroic period of work (1907-14). It was an era of substantial recognition for Beckmann; the seriousness of purpose and youthful idealism evinced in the Florence self-portrait would be realized, only to be devastated by the great War. Thus begins a series of canvases to rival the great masters of the past in size, subject, and execution. Like Rubens, he would paint a huge *Resurrection,* 1909 (fig. p. 85), discussed by Professor Dube in the pages following. Like Rembrandt and the Italians, he would do a *Crucifixion,* 1909. Like Delacroix and Géricault, he would look to contemporary newspaper accounts of calamities to paint such works as the *Destruction of Messina* in the earthquake of 1919 (cat. 10), or *The Sinking of the Titanic* (cat. 12). Like Goya, he could confront man's inhumanity to his fellow man in a fearful and turbulent age in epic paintings like *The Night,* 1918-19 (cat. 19), and again in *Birds' Hell,* 1938 (cat. 84). These heroic themes are yet further demonstration of his ambition to rival the art of the past, to confront and renew subjects of extraordinary significance into the new century. For his concern with tradition, Beckmann was showered with praise and a monograph was published on his work in 1913, when he was only 29 years old. He was at once a prodigious success, but his more modest works also included touching sketches (cat. 141-142) and prints of city life, cafés, and bars.

In the rich, painterly, and very post-Impressionist style of this period we find only a few self-portraits. The most ambitious is the serious and sober double portrait with his wife Minna from 1909 (fig., p. 21). Melancholy and deeply moving, the double portrait is the first of several in his work that appear over many years. By 1910, he portrayed himself with palette and brush, dressed up in topcoat and bowler hat as the very picture of middle class accomplishment in *Self-Portrait with Hat* (fig. 6). The painting recalls Rembrandt's self-portraits during the 1630s when he, too, was a popular success at a young age. Rembrandt is again the source for the self-mockery found in Beckmann's laughing self-portrait of 1911 (fig. 7).

Fig. 4 Max Beckmann: *Self-Portrait in Florence,* 1907, oil on canvas, Private collection

Fig. 5 Edouard Manet: *Luncheon in the Studio,* 1868, oil on canvas, Bayerische Staatsgemäldesammlungen, Neue Pinakothek

Fig. 6 Max Beckmann: *Self-Portrait with Hat,* 1910, oil on canvas, destroyed in the war

Fig. 7 Max Beckmann: *Self-Portrait (Laughing),* 1911, oil on canvas, Private collection

In the same year, we find the modest lithographic self-portrait (cat. 213), lit by artificial light at night, which is questioning, moody, and intent. The dry-point self-portrait of 1913 (cat. 219) is equally impressionistic in execution and lighting, but it is small and sensitive and much less descriptive than ever before.

A sense of his pre-war integration into society is indicated by *The Street* (cat. 14), where Beckmann includes himself as a member of the crowd. Serious of purpose, and dressed like a burgher, Beckmann moves straight along.

War, Shock, and Recovery, 1914-18

It was a harsher-looking Beckmann who stared into the War with the drypoint of 1914 (cat. 222). The portrait is stronger, clearer, and even bolder than his previous self-images. He volunteered for the Army Medical Corps as an orderly, served on the Russian front, and then was transferred to Flanders in 1915. In prints and drawings, he confronts and interprets the War, for in this period we find subjects of an army morgue (cat. 227) and an exploding hand grenade (cat. 228).

The next self-portrait (cat. 15) hardly seems to contain the same person we have known thus far. Not only has the face been transformed in this self-portrait of the artist as medical corpsman, but something drastic has happened to the execution of the painting as well. Fear and terror register plainly in his face, which is a record of the mass slaughter of men that the War brought to every front. Beckmann has thus survived, but at what cost? His face is a mask of pain, and his style has become quick and almost crude, lacking the accomplished finish that the Old Masters had taught him. By the summer of 1915, mentally and physically broken with exhaustion, he was discharged from military service.

Racked with nightmares and recurring terror, Beckmann moved to Frankfurt to stay with the hospitable family of his friend, Ugi Battenburg. His sense of individuality was enormously shaken, as was his sense of the values of society and culture. Like so many veterans, and like the citizenry at large, Beckmann was shocked and disoriented by the political chicanery and unspeakable carnage of the War. Only a year earlier, he had been young and idealistic, even fervent in his patriotism, but the intervening experience had brought him face to face with death and gore, a hell come to earth. In the pages following, Professor Haxthausen refers to Beckmann's trials in the War and the changes it wrought.

Fig. 8 Max Beckmann: *Company III. Family Battenberg,* 1915, oil on canvas, location unknown

A few self-portraits of 1915-16 are less overtly distressed (cat. 233-235) than the painting above. Staring blankly at us, blowing ephemeral smoke rings, the etching of 1916 (cat. 235) gives evidence of the new, vigorous drawing style that emerges more clearly after 1916. More is suggested than is actually delineated here; Beckmann works the plate even more forcefully and recklessly. He is distant and removed in these images, staring blankly (cats. 233, 235) or even looking away, avoiding the viewer (cat. 234); even in the midst of his friends the Battenbergs, he represents himself as alone and distant (fig. 8).

A glimpse of his extremely frustrated and distressed state is provided in the masterful drawing *Self-Portrait* (fig. 10). Lonely and wounded, Beckmann clutches at his own throat while drawing. This is one of the few intimate moments we are allowed to share, for virtually all the other post-War self-portraits present a mask or disguise to us.

No better example is the painting of this same time, the *Self-Portrait with Red Scarf,* 1917 (fig. 9). Here is the horror-stricken witness to the apocalypse. He stares away, clad in a gawky and Gothic death mask painted in gruesome hues. Clearly a vision of himself as the maimed psychological survivor, it remains a deeply disturbing work, a lasting emblem of survivorship. Surely this is one of the greatest icons of the great War—self-effacing, ironic, bold, and strongly repellent.

The other works of this time are religious: another *Resurrection* is begun and never finished. *Adam and Eve, Deposition,* and *Christ with the Woman Taken in Adultery* (cats. 16, 17, 18) present the new subjects, as Beckmann now takes refuge in the Christian tradition. Rejecting the aspects of the post-Renaissance tradition to which he was so devoted before the War, he embraces late Gothic painting. It was clearly time for a new style, as well as for a new emotionality, in Beckmann's work.

Fig. 9 Max Beckmann: *Self-Portrait with Red Scarf*, 1917, oil on canvas, Stuttgart, Staatsgalerie

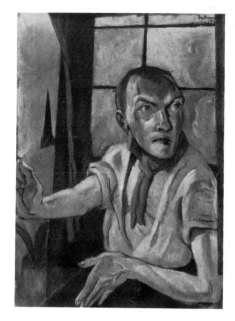

Fig. 10 Max Beckmann: *Self-Portrait*, 1917, pen and black ink, Chicago, The Art Institute of Chicago, Gift of Mr. and Mrs. Allan Frumkin

New Solutions, New Styles, 1918-33

The estrangement and alienation that Beckmann shows in his own face, directly or symbolically, appear throughout his work of this period. It was the curse of his generation that in Europe, as in America, the society that emerged in 1918 was deeply hurt and seeking new paths. The lost generation of the 1920s was one clear reaction to the War, and many veterans and citizens never found redemption or recovery. Beckmann grew and moved onward, still more idealistic and stern of purpose, as reflected in the etching of 1918 (cat. 238).

This angry man would appear again in the next two years. The staring face is bitter and serious, "determined to force the spectator into an act of painful recognition," as the late Friedhelm Fischer notes.[1] Beckmann's revenge for the War was to reply with a new series of moral lessons, painted on canvas, etched and drawn. The cadaverous persona of the *Self-Portrait in Red Scarf* would deliver us *The Night*, 1918-19 (cat. 19), his own Munch-like shriek against war, terrorism, revolution, and atrocity. The artist appears once more angry and irrational in a 1919 lithograph (cat. 247).

The irrational side of Beckmann is clear in the drypoint, *Large Self-Portrait* of 1919 (cat. 261), and in the self-portrait lithograph that forms the title page to the *Hell* portfolio (cat. 247). In the former, Beckmann portrays himself as a tough character, cigarette in mouth, still a bit mad. The latter is wild-eyed and crazy, as deranged as Peter Lorre in the Fritz Lang motion picture, *M*, from 1931. In sharp light that shines weirdly from below, this self-image portrays a demented and distraught quasi-maniac who will guide us through the pages of *Hell* that will follow, with scenes of revolution, entrapment and enclosure, brutality, and terror. For Beckmann, this is a capsule history of recent times, a reckoning of the facts of present-day life in the world he knew in 1919. Our guide, Beckmann, will be a crazed denizen of this underworld.

In these years there were visible indications of Beckmann's readjustment and reconciliation. The happy *Family Scene*, 1918 (cat. 239) is set outdoors, and however diminished, Beckmann is present with his wife, son and mother-in-law. The exceptionally beautiful *Main River Landscape* 1918 (cat. 242) and *Landscape with Balloon*, 1918 (cat. 243) are harmonious and free, however much the latter owes to Vincent van Gogh. His wife is seen at the *Theater Box*, 1918 (cat. 245), albeit distant; his friends partake in a virtual yawning contest (1918, cat. 244), a sign of boring social life.

1. Friedhelm W. Fischer, *Max Beckmann*, trans. by P. Falla, New York, 1973, p. 16.

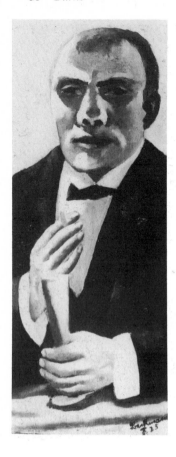 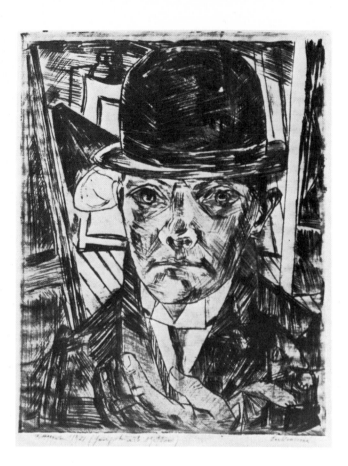

This same madman reappears in the extraordinary *Self-Portrait with Champagne Glass,* 1919 (cat. 22). His face is a smirking mask, grimacing yet looking away, trying for elegance in a tawdry setting. With cigar and glass in hand, the pose is artificial and mannered. As one of Beckmann's first mature scenes of café life, it is ironic, chilling and cynical in tone. Beckmann loved cafés and nightclubs, for there he could relax in the crowd, apart. In his writings, Beckmann was always aware of his individuality, knowing the distance between the self and the crowd. This image foretells the hollow-faced self-portrait in the *Königin-Bar* drypoint of the following year (cat. 269), with its greater fear of empty spaces, overfilled and overactivated. Simultaneously attracted and repelled by the café, Beckmann gives us another hollow stare.

Despite all this he was still capable of rendering a most sensitive and intimate subject, *Portrait of Fridel Battenberg* (cat. 21). Lightly colored and beautifully finished, it remains one of Beckmann's most approachable paintings. Fridel Battenberg was his friend and host for several years after the nervous breakdown of the War; by all accounts she was a sweet and kind person. We should recognize that Beckmann was a deliberate and intensely self-aware painter again, easily able to change modes of expression from mocking and vulgar self-portraits, as above, to warm and touching portraits like this one.

A new sense has begun to pervade Beckmann's self-portraits, however. In the *Self-Portrait with Champagne Glass on a Yellow Background* (fig. 11), and the *Self-Portrait as Clown,* 1921 (cat. 31) his mien is stern and less vulnerable. He has collected himself with the circus scenes and masquerades he so often depicted. Laden with symbols, this self-appointed fool bears a new dignity and a melancholic echo. Like the tragic clown of literature and music, he is alone and revealed. Beckmann will return to these clown and circus themes often, endlessly exploring one's loneliness in the crowd, contrasting the exhibited on-stage persona with the hidden inner self. The theme appears in *The Dream,* 1921 (cat. 23), *The Trapeze,* 1923 (cat. 33), *Varieté,* 1921 (cat. 32), or in the more

Fig. 11 Max Beckmann: *Self-Portrait with Champagne Glass on a Yellow Background,* 1925, oil on canvas, destroyed in the war

Fig. 12 Max Beckmann: *Self-Portrait in Bowler Hat,* 1921, drypoint, Private collection

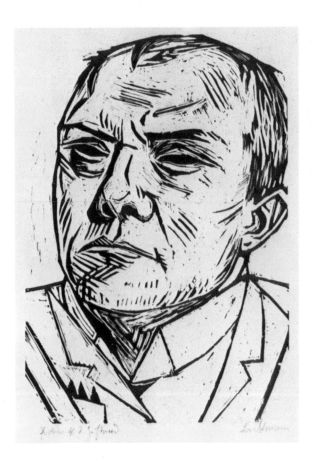

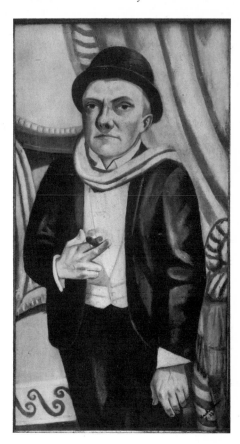

Fig. 13 Max Beckmann: *Self-Portrait*, 1922, woodcut, St. Louis, The Saint Louis Art Museum

Fig. 14 Max Beckmann: *Self-Portrait in Front of a Red Curtain,* 1923, oil on canvas, Private collection

personal and self-deprecating drypoint, *The Barker*, 1921 (cat. 271). Like Brecht and Weill, he played the vulgar announcer of a bourgeois circus, and like Mack the Knife, Beckmann taunted his audience.

Composed but sad, Beckmann's *Self-Portrait in Bowler Hat*, 1921 (fig. 12, cat. 266-268) returns to a well-dressed *vanitas* theme. With symbolic cat, lamp, and cigarette, Beckmann is our blunt and direct guide to himself and his universe. Successive states of the print clarify this position, as the image becomes more concrete and graphic. Dressed like a middle class dandy, Beckmann gives the visible appearance of an enthusiastic participant in the Roaring Twenties of the Weimar Republic. Yet the meaning is ambiguous, for he knows how thin the veneer of café society is, and how evanescent these appearances are, for the symbols here portray a new *vanitas*.

Nonetheless, there is no more forceful self-image in this century than the woodcut self-portrait of 1922 (fig. 13). The woodcut medium is exploited to the utmost. Bold, unyielding, and forceful in jagged lines and psychic power, it is an eyeless mask of confidence. Again, our stern and serious guide to man's higher callings appears, ever galvanized, ever prepared for the moral battlefield. He is a hero; with its reminiscences of a sightless, ancient sage, even the image is heroic.

When with others, he invariably stresses the separateness of individuals and particularly of himself. In *Family Portrait*, 1920 (cat. 25), he sits alone on a bench; in *Before the Masquerade Ball*, 1922 (cat. 26), he turns his masked face away from the others to stare at us. Here are self-portraits of the artist as loner, with a tragic feeling for the isolation of the self, however much the circumstances might recommend association with others.

Beckmann can return to the genteel life for a dowdy self-portrait in informal dress, *Self-Portrait in Front of a Red Curtain,* 1923 (fig. 14). Or he can transform himself again into a blunt mask in the unyielding *Self-Portrait with Cigarette on a Yellow Background*, 1923 (cat. 36). The mask is shocking, too strong; the gold

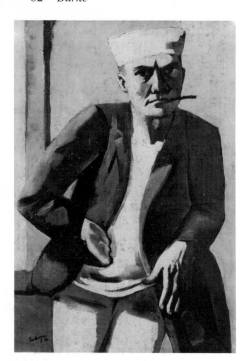

Fig. 15 Max Beckmann: *Self-Portrait in a White Cap,* 1926, oil on canvas, Private collection

ground recalls the background of Gothic religious painting. Cold and factual in intention, it is still unapproachable: the mask is up, the artist hides, the viewer is deflected.

The culmination of Beckmann's circus and carnival images is surely the *Double-Portrait Carnival,* 1925 (cat. 43), with his beautiful new wife, Quappi. The fun of costume parties is implicit, yet they are together and separate at the same moment. Beckmann presents himself as a clown, sensitive and thoughtful, but unremittingly tragic. Writers have compared it to Watteau's self-portrait as the clown, *Gilles* (fig., p. 36) with its overtones of tragedy. But as much as Beckmann loved costumes and masquerades, there is here an enduring sense of the singularity of self and the inevitable, solitary nature of each of these two individuals. In color and execution, the double portrait is bold, even more simplified than ever before, more abstract and flat. Beckmann is the lonely showman, appearing before the crowd with his tragic message, aware of his own frailty. Again, the clown is both guise and disguise at once; it is yet evident in the *Self-Portrait in a White Cap,* 1926 (fig. 15), where he presents himself as the lonely sailor.

The *Self-Portrait in Tuxedo,* 1927 (fig. 16), is commonly accepted as one of Beckmann's greatest works. Frontal, bold, and strident, the elegant and successful painter stares down the viewer. This worldly man relentlessly confronts us. He is relaxed but unyielding. Beckmann was increasingly successful in the 1920s, garnering much recognition in artistic circles as well as an appointment as a professor in the Art Academy at Frankfurt in 1925. A scholarly monograph had been published the previous year, written by four of the best-known art writers of the time. In the preceding five years, Beckmann's work had been shown in virtually every large city in his native country, as well as in Vienna, Zürich, Bern, and Paris. In other words, he was one of the most important living artists of the day in Germany.

Beckmann wrote more and spoke frequently on his role as an artist and the artist's role in society. The self-confidence of *Self-Portrait in Tuxedo* is directly linked to his words, in which he frequently extolled freedom and self-reliance. The artist was at the center of this new philosophical universe, even the supreme priest. For Beckmann, there is a renewed surety of purpose; the battered ego of the war years is now commanding the action, at whatever cost. Sins of

Fig. 16　Max Beckmann: *Self-Portrait in Tuxedo,* 1927, oil on canvas, Cambridge, Mass., Busch-Reisinger Museum, Harvard University

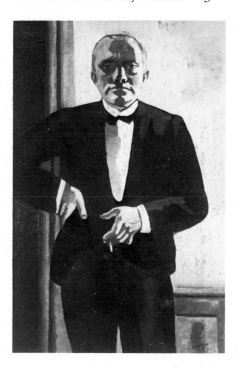

pride aside, this is a startling painting, for not only do we face the artist's personality but also a physical sense of painted surface bolder than ever before. It was the apex of his career to date, in which his heroic character is assertively put forth.

After 1929, Beckmann lived mostly in Paris, traveling routinely back and forth to Frankfurt to carry out his teaching duties. He enjoyed considerable fame, gained through increasingly frequent gallery and museum exhibitions, as well as the general approval of art writers and critics. In 1931 he had been strongly featured in an exhibition of contemporary German painting at The Museum of Modern Art in New York while the Nationalgalerie in Berlin devoted a whole room to his paintings, an exceptional honor. The Musée du Jeu de Paume in Paris had even acquired a painting in 1931. The influence of French painting is evident in simplified forms and compositions, and stronger paint textures are apparent in works such as *The Bath*, 1930 (cat. 62) and *Man and Woman,* 1932 (cat. 64). The fleshy and voluptuous figures and rich sensual moods are new elements in his art during this period.

Exile and Loss, 1933-47

In January, 1933, Beckmann moved to Berlin; three months later, after Hitler's election to power, Beckmann was fired from his teaching post at Frankfurt. Thus began the most difficult period of his life, for he had been so well-known and outspoken that he was a clear target for the Nazis. As early as 1931, the National Socialist press had attacked Beckmann, and he was one of a number of artists, writers, musicians, theologians, and liberal academics who were removed from official positions and whose works were proscribed by Hitler's government. A premonition of his future isolation and his need to protect himself from the hostile climate of the times can be seen in *Self-Portrait in Hotel,* 1932 (fig. 17).

In Berlin, he sought anonymity in the crowded city. With the *Departure* triptych of 1933 (fig. p. 40), he symbolized parting from his homeland, though he had not yet left it. It was the journey of the human spirit that concerned him in these darkening years; he focused on themes of freedom and liberation in allegorical form. This was the first of Beckmann's monumental triptychs, rep-

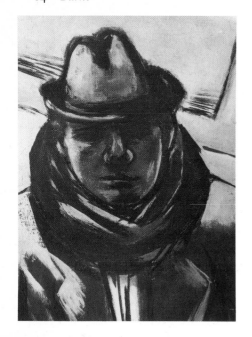
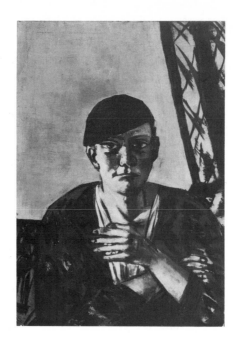

Fig. 17 Max Beckmann: *Self-Portrait in Hotel,* 1932, oil on canvas, Düsseldorf, Alfred Schmela (detail)

Fig. 18 Max Beckmann: *Self-Portrait in Black Beret,* 1934, oil on canvas, Cologne, Museum Ludwig

resented here by the *Temptation* triptych, 1936-37 (cat. 73), the *Acrobats* triptych, 1939 (cat. 89), and *The Beginning,* 1946-49 (cat. 122).

A sense of Beckmann's symbolic and real loss of place and person is to be seen in the *Self-Portrait in a Large Mirror with Candle,* 1933 (cat. 68). The candle, mirror, and shadow are allusions to the impermanence of human life, symbols of transience that have survived from the Middle Ages to the present. This is the closest Beckmann will come to a pure *vanitas* subject in the traditional sense. As in his other works, symbol and allegory are active parts of his artistic vocabulary, as the essays in this book make clear. His physical presence is now but a fleeting symbol; the painting is the absolute opposite of the *Self-Portrait in Tuxedo.*

In the *Self-Portrait in Black Beret,* 1934 (fig. 18), the artist is composed and enclosed. The lonely self has returned and will hauntingly reappear over the next years. In 1936 it surfaced in the mysterious seer of *Self-Portrait with Crystal Ball* (fig. 19). Beckmann was one of the main attractions in the "Degenerate Art" exhibition in Munich in July, 1937. Organized by the National Socialists to denigrate modern art, it portrayed Beckmann and others as "anti German" and contrary to the purposes of the state. Two million visitors were to see this infamous exhibition, which was the culmination of four years' official attack on these artists. The day after the exhibition opened, Beckmann left Berlin for Amsterdam, never to return to his native country. The Netherlands had long been neutral in Europe (as it was in the First World War), and served as a haven for refugees of all kinds.

His departure was well-timed, for in that same year the government ordered the museums to get rid of all works by Beckmann. Over 500 were removed from public collections and sold, including ten paintings in this exhibition (cat. 17, 18, 29, 42, 43, 50, 52, 53, 56 and 61).

The *Self-Portrait in Tails,* 1937 (cat. 75), was painted just before his departure for Amsterdam. No greater contrast could be found to compare with the *Self-Portrait in Tuxedo* of 1927. Now flat and incorporeal, Beckmann slips off the picture plane to escape us. Formally, this is the most brilliantly colored and aggressively painted of all the self-portraits. The action of brushstrokes is clearly visible, a suitable model for the "action painting" ethos of the late 1940s and the 1950s. His gaze escapes us, as this arch character tries to vanish. A disappearing self-portrait, it is the ultimate in opposites. Except for the face which has modelling and form, all the rest is shape and paint-as-paint. For the

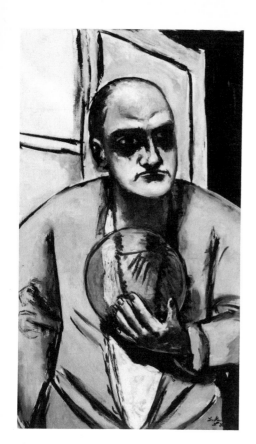

Fig. 19 Max Beckmann: *Self-Portrait with Crystal Ball*, 1936, oil on canvas, Private collection

painter's art, this is an exceptional and innovative work. It is Beckmann at his most prophetic moment and, despite the self-denial, it is a masterwork.

After his arrival in Amsterdam, Beckmann painted *The Liberated One*, 1937 (cat. 80), a self-portrait as a freed prisoner just released from chains, still wearing manacles. There is a sense of pain and loss, and a rare moment of self-pity. This is a time of troubled new allegories, some more obscure than ever before. Beckmann was again seeking new visions to reflect his new psychological state and the new state of disorder and unrest in Europe. *Birth*, 1937 (cat. 81) and *Death*, 1938 (cat. 82) were appropriate subjects. *Birds' Hell*, 1938 (cat. 84) is the critical painting of these pre-war years; it is his most extreme statement on inhumanity and suffering. Even today it is a troubling and frightful picture, a reminder of a wretched moment in modern times that most of us would sooner forget. It is one of the few contemporary works of art to confront the horrors of the 1930s and it stands, in its symbolic way, alongside Picasso's *Guernica* (fig., p. 39). While Picasso was more heroic in his vision, Beckmann was more willing to face evil. In this, we have traveled far from the sonorous Frankfurt views of the early 1920s, far from the jazzy color and manic café society of *Dance in Baden-Baden*, 1923 (cat. 34), full of social criticism. Beckmann shows us that he can be a painter of modern life, honoring Baudelaire's dictum that it is constantly necessary to face up to the subjects of the present day. As hateful as it is, Beckmann renders terror with a passion than can still turn stomachs today. This recalls Goya who, after facing the horrors of the Napoleonic War, also embraced the message of man's inhumanity. *Birds' Hell* is a major monument in the sordid spiritual history of our century.

Self-Portrait with Horn, 1938 (cat. 86) is the most mysterious and evocative of his images from this period. Dark, richly painted, and glowing with warm colors, the non-literal qualities are exceptional; it is still a work that tends to defy description and interpretation. Listening and alert, Beckmann seems to have put ego aside in his quest for understanding. As in the earlier brooding *Self-Portrait with Saxophone*, 1930 (fig. 20), Beckmann again appears with a horned instrument. In the later painting the horn is both a latent suggestion of his clarion call to the pure notes of truth and the waiting for a reply. His duty is still serious, his presence attentive.

By 1941, when he painted a *Self-Portrait in Gray Robe* (cat. 93), Beckmann was trapped in Amsterdam by the invading German army. He was isolated from friends and from the art world, alone, and in near-hiding. This solitary feeling is apparent in the painting. He appears in a bathrobe or dressing gown, no more the well-dressed gentleman of earlier times. This is one of the few instances where Beckmann portrays himself in the active role of the artist. It reminds us once more of his admiration for Rembrandt, as Peter Eikemeier observes in his essay here, recalling Rembrandt's etching of *The Goldsmith* (fig. p. 122). Alone and removed, Beckmann continues to make his art, as independent as always; his creative impulse is still strong.

The year 1941 saw another double portrait with Quappi (cat. 95), now dressed up and ready to go out for the evening. This recalls Rembrandt's famous portrait of *Jan Six*, 1654 (Bredius 276), where the sitter also takes an introspective moment before stepping outside. Now guiding and supportive, Quappi is closer to her husband than to the lonely Pierrot she stood beside in the 1925 double portrait. Beckmann is not so alone, but remains distant. He is the larger figure and the more isolated. Over all, this is more a self-portrait. Four years after it was painted, at the War's end, it was acquired by the Stedelijk Museum of Amsterdam.

During the War years Beckmann had no external contacts with friends and other artists. He had no one-man exhibitions in Europe between 1932 and the liberation in 1945. In 1944, 60 years old and having suffered a heart attack, the

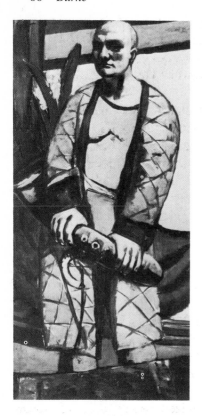

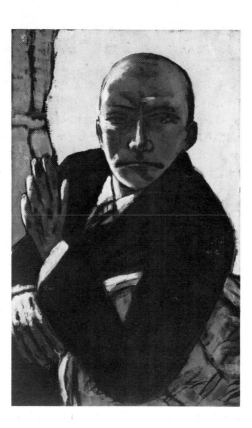

Fig. 20 Max Beckmann: *Self-Portrait with Saxophone,* 1930, oil on canvas, Bremen, Kunsthalle

Fig. 21 Max Beckmann: *Self-Portrait in Black,* 1944, oil on canvas, Munich, Bayerische Staatsgemäldesammlungen, Staatsgalerie moderner Kunst

German army once again attempted to draft him, increasing his anxiety. Life in Holland was difficult enough, since his work had often been attacked; he was painfully aware that he was an artistic and philosophical enemy of the Reich. The Beckmanns thus lived nearly in hiding, seeing few people.

A sense of this isolation can be found in two paintings of 1943-44. In *Les Artistes with Vegetables,* 1943 (cat. 99), a grave assembly of Beckmann and three friends sits at a table, each one distant from the other, without interaction. As emblems of the times, each holds something edible except Beckmann, who holds up a mirror, itself an emblem. This remains a gloomy reminder of their isolation and privation. More frightening and gloomy is the *Self-Portrait in Black,* 1944 (fig. 21), where we find the solitary artist hidden behind an awesome mask. The black suit is not the glamorous dress outfit of previous works, but a funereal garment. The smoking hand is a barrier gesture, warding us off. This is a self-protective image in the worst year of the War.

By 1945, with the liberation of The Netherlands, Beckmann's life began to improve. The Stedelijk Museum presented a small show of his work and in 1946 exhibitions were held in New York, Boston, San Francisco, and several other American cities, as well as in Munich and Stuttgart. Beckmann was in contact with his network of friends again, all over the world. Still, his status in Holland remained questionable, for he was now an "enemy alien," unable to obtain a passport or travel visa until 1947.

A feeling of the unsettled present is found in the *Self-Portrait,* 1946 (cat. 295) which is the lithographic title page in the portfolio *Day and Dream,* published in New York that year. Beckmann dons the artist's beret and emerges from behind the mask of the 1944 self-portrait, but it is an uncertain person we encounter at the end of this period of exile and loss.

Beckmann's paintings, drawings, and prints of the war years are remarkable. He never stopped his artistic work. Despite the invasion of Holland, he had adequate supplies, and painted many exceptional, large works including *The King,* 1937 (cat. 78), the *Acrobats* triptych, 1939 (cat. 89), and some fine small works. Beckmann was active, prolific and growing. Always incredibly

Fig. 22 Max Beckmann: *Self-Portrait with Fish,* 1949, brush and black ink over chalk, Hamburg, Hamburger Kunsthalle

self-reliant, he moved into symbol and allegory to express his ideas more than ever before. Yet he still found time for portraits of Quappi (cat. 105): for a reprise of the first important painting of his youth, *Young Men by the Sea,* 1943 (cat. 100); and for some mysterious and glamorous images of beautiful women (cats. 90 and 97).

Lackner observes correctly that Beckmann had not "grown tamer with age," but that his works of the 1930s and 40s were still more compelling in technique and meaning.[2] Despite the War and the desperation it wrought, Beckmann's spirit, however battered, endured with its strong sense of values and individuality.

The New Beginning, The New World: 1947-50

Beckmann took English lessons when he accepted a teaching position at the School of Fine Arts of Washington University in St. Louis in 1947. The Beckmanns' move to the United States was the start of "much collective adulation," as he noted in his diary. "I was celebrated as an old master."[3] For the following three and a half years, Beckmann was lionized in America. He traveled widely, lectured, made many new friends at several colleges and art schools and went to parties and nightclubs. In short, he rejoined society in a new and hospitable land. In 1948, The Saint Louis Art Museum organized his first major retrospective, recognizing him as one of the most important living European artists. The exhibition traveled to Detroit, Los Angeles, Baltimore, and Minneapolis. He also had shows in many other American cities. *The New York Times* called the exhibition long overdue, noting that Beckmann "is wholly a man of his time," and that the retrospective "will extend further his already notable influence on our art."[4] In St. Louis the press observed the show was "full of the physical reality of humanity," and "an event of first-rate importance in the world of contemporary art."[5]

It is clear from his diary entries that Beckmann assimilated quickly. In 1949, he taught a summer school course at the University of Colorado in Boulder and while he was there he portrayed himself in a cowboy hat and plaid shirt, holding a fish (fig. 22). There is no pain or distance in this self-portrait; indeed, it is a more straightforward image than any time since the 1920s. Even with the symbolic fish, the quickly executed drawing is an amusing token of a new world. The same is true for a drawing in a zany nightclub (cat. 197), or some views of fantastic western landscapes (cats. 127 and 202). Quappi reappears, beautiful and collected (cat. 119). Beckmann's sense of humor returned intact, and portraits are now calmer and less careworn. His style became bolder, colors and paint are more sensuous, and the arrangements are simplified.

Nevertheless, there are many prodigious and weighty paintings from the American years. Beckmann won the prestigious First Prize at the Carnegie International Exhibition at Pittsburgh in 1949 for his *Fisherwomen* (cat. 121). Other serious works continued his philosophical and symbolic ambitions, such as *Masquerade* (cat. 117) or *The Beginning* triptych (cat. 122). In these paintings the anxiety and tragedy of his work in the preceding 15 years diminished. As serious as these works are, the old pessimism had faded, much to the disappointment of some latter day writers. Beckmann had reorganized himself in the new land seeking new and even more cosmic meanings. As the violence of spirit and execution lessened toward the last years of his life, the paintings became denser and more monumental. A more assured and active manner of painting and drawing is evident, typified by the quick ballpoint self-portrait in profile of 1950 (cat. 206), drawn while the Beckmanns were in California.

2. Stephan Lackner, *Beckmann,* New York, 1978, p. 148.

3. Max Beckmann, *Tagebücher 1940-1950,* January 17, 1949.

4. *The New York Times,* June 12, 1948.

5. *The St. Louis Post-Dispatch,* May 11, 1948.

Fig. 23 Pablo Picasso: *Seated Woman,* 1953, oil on canvas, St. Louis, The Saint Louis Art Museum, Gift of Mr. and Mrs. Joseph Pulitzer, Jr.

Fig. 24 Max Beckmann: *Carnival Mask, Green, Violet and Pink. Columbine,* 1950, oil on canvas, St. Louis, The Saint Louis Art Museum, Bequest of Morton D. May

Unlike Rembrandt, whose last self-portraits show an aged and frail countenance, Beckmann's last self-portrait of 1950 (cat. 126), is contemplative and virile. Self-composed, Beckmann seems absorbed in the very act of looking. He is the artist in the studio with his canvas behind him, studying an unseen painting.

Within a few months, Beckmann would unexpectedly die of a heart attack in New York where he moved in the summer of 1949 to take a teaching position at the Brooklyn Museum School. His style and subjects had renewed vigor in the United States, and the public acclaim enjoyed in the 1920s returned. His commitment to art was revalidated, his artistic vision fresh, his production vigorous. This last image of Beckmann as an artist makes the unexpected circumstances of his death all the more ironic. His life ends at the height of his powers, when maturity is upon him, not old age. Neither sad nor weak, Beckmann portrays himself with a greater self-understanding than ever before.

In human terms, Beckmann's self-portraits are a sequential revelation of self; in artistic terms, of style and substance. Here, in brief outline, we track his visage from youth to first success. We have measured his disastrous experience in "the war to end all wars," to recovery and the vast reputation he enjoyed before 1932. Through the exile, loneliness, and personal loss after 1933 until his emigration to the United States, we have witnessed his trials and struggle. In St. Louis and New York, a new life suffused his artistic work, and a new place was gained in art.

Today, we understand his place in the art of our century better than ever. He ranks with Picasso in his protean abilities, as well as in his influence. In fact, the two may be equal in their impact on post-World War II art, each in a different way. For both developed a new mythology in response to modern life, in differing visions (cf. fig. 23, 24). In the end, Beckmann is the more philosophical and the less direct. He is the modern master who requires the most interpretation and study. While the great power of his work has never abated, he is yet the most difficult to grasp, for his great mission was our moral instruction, a lesson as hard to learn now as in the past.

Charles Werner Haxthausen

Beckmann and the First World War

In 1919 an exhibition held in the Frankfurt bookstore of Tiedemann and Uzielli offered the public a first overview of the art Max Beckmann had produced during the years of the First World War. The work presented there provoked astonishment among those who had followed the promising career of the young painter before the War. In a review in the art magazine, *Der Cicerone,* Paul Ferdinand Schmidt registered a reaction that was typical of the critical reception at that time:

> The bridges from his earlier work seem sundered. Whoever knew and admired the Beckmann of 1913 may experience a shock upon first encountering such a radical change in style. There is probably not another example in recent German art of anyone who has achieved so fundamental a transformation of pictorial vision in such a few years ... The war has, one cannot say, accelerated his development; it has become for him a form-generating experience.[1]

Since this "new" Beckmann emerged, after several years of isolation, into the public eye at the end of World War I, this view has become an article of faith in the literature on Beckmann: the painter's experiences in the medical corps and his consequent nervous breakdown have been regarded as the key factors in the transformation of his art. Yet, strangely, this critical episode in Beckmann's development has been little investigated. Only in recent years has this state of research begun gradually to improve,[2] and many questions still remain untouched.

The most important facts about Beckmann's service in the War can be quickly summarized. When the War broke out, the painter was living in Hermsdorf, then a northern suburb of Berlin. Since he had no military training, he was not inducted for combat. About the beginning of September 1914 he traveled to the East Prussian front to bring gifts to the troops; through the intercession of an acquaintance, Countess von Hagen, Beckmann received permission to remain there as a volunteer orderly.[3] At some time during the same autumn he returned to Berlin; a dated portrait of his son Peter places Beckmann in Berlin at least in early December.[4] By the middle of the month—dated drawings again provide the evidence—he was back at the front, this time in Belgium, serving as a volunteer medical corpsman.[5] There he worked in several locales, at first in a typhus hospital, then in an operating room. At the end of March 1915 he was transferred to Wervicq, which lay directly on the front. There, in addition to performing his normal duties, Beckmann had a commission to paint murals in a delousing bath. As late as mid-June he was still stationed there, but his whereabouts and his status between that date and early September remain obscure; no documentation on this period has come to light. A letter from September 5th establishes that by this date Beckmann was in Strasbourg, serving as an orderly at the Imperial Institute for Hygiene. Further letters document his presence there at least into early October.[6] Evidently a short time thereafter he was granted a leave from his duties for health reasons, and was sent to Frankfurt, where in 1917 he was released from military service.

recent to today

1. P.F. Schmidt, "Max Beckmann: Zur Ausstellung seiner neuesten Arbeiten in Frankfurt a.M.," *Der Cicerone,* XI (1919), p. 380.

2. See, for example: the detailed analysis of Beckmann's drawings from World War I by Stephan von Wiese, *Max Beckmanns zeichnerisches Werk, 1903-1925,* Düsseldorf, 1977, pp. 45-108; H.G. Wachtmann's commentary on Beckmann's *Self-Portrait as Medical Orderly,* in "Von der Heydt Museum Wuppertal, Kommentare zur Sammlung," No. 2; Wuppertal, 1979, pp. 10-15; and Wolf-Dieter Dube's essay in this catalogue.

3. Cf. the chronology in Erhard and Barbara Göpel, *Max Beckmann: Katalog der Gemälde,* ed. Hans Martin Freiherr von Erffa, Berne, 1976, I. p. 17.

4. Von Wiese, cat. no. 202.

5. *Ibid.,* cat. nos. 206-208.

6. *Ibid.,* p. 171, n. 125.

During his service in the medical corps Beckmann remained artistically active. Besides completing one mural at Wervicq, he produced over 150 drawings and sketches which document his war experiences.[7] He also received a commission, probably in June 1915, to illustrate a collection of war songs. The book appeared in 1916 with 14 drawings, all war landscapes, by Beckmann.[8]

Beckmann's war experiences did not remain a private matter that he shared with only a few intimates. The letters to his wife Minna, the chief source for this period, were published during the War. Indeed, two groups of letters were published while Beckmann was still serving in the medical corps: in December 1914 seven letters from East Prussia, illustrated with ten drawings by Beckmann (von Wiese 169-175), appeared in the Berlin art monthly, *Kunst und Künstler;*[9] the following July the magazine printed seven more letters, now from Belgium, along with seven war sketches.[10] These fourteen letters, supplemented by 35 later ones, were then collected into a single volume with the title, *Briefe im Kriege* (War Letters), and published in 1916.[11]

Although Beckmann's letters and drawings from the War provide a wealth of information about what he saw and experienced there, much about this critical period remains unknown. To cite but two examples: very little is known even today about Beckmann's "spiritual and physical collapse," not even where and when it occurred;[12] and there is little published documentaion from the years of the most radical change in Beckmann's art—1916-18, the period of his convalescence in Frankfurt. Such areas as these must be illuminated by the study of previously unexplored source material if we are to gain a proper understanding of Beckmann's remarkable transformation, a transformation which marked his emergence as a major artist.

The present essay, based on published sources, necessarily has a limited purpose. I shall not attempt here to offer a comprehensive account of Beckmann's War experience and its impact on his art, but shall restrict myself to examining two aspects of this topic: Beckmann's attitude toward the War within the context of his artistic development, and the reflection of his War experiences in the colossal canvas begun in 1916 but never completed, *Resurrection*. This second aspect overlaps in part with the subject of Wolf-Dieter Dube's essay in this catalogue, but our respective approaches to *Resurrection* differ, and we examine the work in different contexts. Certainly the complexity of this painting and its pivotal role within Beckmann's oeuvre justifies such a broad basis of discussion.

Universal Enthusiasm for the War

As a somber witness to the frenzied jubilation that greeted the mobilization in Berlin, Beckmann is alleged to have remarked: "This is the greatest national catastrophe."[13] If he did utter these words, such gloom about the War was uncharacteristic of him and proved to be of short duration. Five years earlier, stimulated by the tense international atmosphere of the Bosnian crisis, he had conjectured that a war "would not be at all bad for our rather demoralized culture, if our instincts and drives would all once more be captivated by some interest."[14] And within weeks after the mobilization Beckmann, as a medical volunteer at the East Prussian front, was an eager participant, positive, even enthusiastic in his attitude toward the conflict. In September, after seeing a destroyed town for the first time, he wrote expectantly to his wife: "I hope to experience still more and am happy."[15] By the following April he could report with satisfaction that he was gradually getting to know "all the moods and possibilities of the War."[16] The clamor of battle became for him a sublime musical experience; the devastated landscape, lit up intermittently by the

7. *Ibid.,* cat. nos. 169-328.

8. *Kriegslieder des* XV. *Korps (von den Vogesen bis Ypern, 1914/15),* Berlin, 1916. For the drawings, cf. von Wiese, cat. nos. 307-320. Beckmann mentioned the commission in a letter of June 7, 1915 to his wife Minna. Max Beckmann, *Briefe im Kriege,* ed. Minna Tube, Berlin, 1916, p. 71.

9. Max Beckmann, "Feldpostbriefe aus Ostpreußen," (with ten drawings) *Kunst und Künstler,* XIII, (December 1914), p. 126-133.

10. Max Beckmann, "Feldpostbriefe aus dem Westen," *Kunst und Künstler,* XIII, (July 1915) p. 461-467.

11. See above, n. 8.

12. Normally Beckmann's nervous collapse is placed in the summer of 1915. Cf., for example, the chronology in Göpel, I, p. 17. On this question, see below, pp. 14 f.

13. Peter Beckmann, *Max Beckmann,* Nuremberg, 1955, p. 16.

14. Max Beckmann, *Leben in Berlin—Tagebuch 1908/09,* ed. Hans Kinkel, Munich, 1966, p. 22 (January 9, 1909).

15. *Briefe im Kriege,* p. 5 (September 14, 1914).

16. *Ibid.,* p. 48 (April 27, 1915).

17. Cf., for example, *ibid.*, pp. 18, 33, 37, 67.

18. *Ibid.*, pp. 20ff. (March 2, 1915).

19. *Ibid.*, p. 42 (April 18, 1915).

20. *Ibid.*, p. 13 (October 3, 1914).

21. *Ibid.*, p. 60 (May 11, 1915).

22. On this topic cf. Peter Paret, *The Berlin Secession: Modernism and Its Enemies in Imperial Germany*, Cambridge/London, 1980, pp. 235ff., and Annette Lettau, "Taumel und Ernüchterung. Deutsche Künstler und Schriftsteller im 1. Weltkrieg," in: *Der 1. Weltkrieg: Vision und Wirklichkeit*. Exhibition catalogue of the Galerie Michael Pabst, Munich, 1982, pp. 5ff.

23. See, for example, Beckmann's remarks on Hindenburg, *ibid.*, p. 9 (September 16, 1914), and the letter on February 9, 1915, from Courtrai: "It is impressive to see what our country is accomplishing, how it expands with elemental power, like a river overflowing its banks." *Ibid.*, p. 19.

24. Cf. Marc's essays "Im Fegefeuer des Krieges" and "Das geheime Europa," in Franz Marc, *Schriften*, ed. Klaus Lankheit, Cologne, 1978, pp. 158ff. and 163ff. Both texts were initially published during the first months of the War. On November 16, 1914, Marc wrote to Wassily Kandinsky: "I am not angry about the War, but deeply grateful for it. There was no other transition to the age of the spirit. The stall of Augias, the old Europe, could only be cleaned in this way; or is there a single person who wishes that this war had never happened?" Quoted from: *Wassily Kandinsky-Franz Marc: Briefwechsel*, ed. Klaus Lankheit, Munich, 1983, p. 267.

25. *Briefe im Kriege*, p. 67 (May 24, 1915).

26. *Ibid.*, p. 43 (April 18, 1915).

27. Karl Scheffler, "Der Krieg," *Kunst und Künstler*, XIII (October 1914), 4. The issue went to press on August 18.

28. Karl Scheffler, "Chronik," *Kunst und Künstler*, XIII (October 1914), 44. On Scheffler see also von Wiese, p. 45.

29. In *Kunst und Künstler*, XIII (December 1914/January 1915), 115ff, 149ff.

30. Waldemar Roessler (sic!), "Feldpostbriefe aus dem Westen," *Kunst und Künstler*, XIII (December 1914/January 1915), 123ff., 175ff., 212ff., 320ff. For Beckmann's letters, see above, n. 9 and 10. The magazine had published Beckmann's first drawings related to the War, done during the mobilization in Berlin: "Die erste Kriegswoche in Berlin, nach Mitteilungen Berliner Tageszeitungen, mit sieben Zeichnungen von Max Beckmann," Vol. XIII (November 1914), 53ff.

31. Cf.: Ernst-Gerhard Güse, *Das Frühwerk Max Beckmanns: Zur Thematik seiner Bilder aus den Jahren 1904-1914*, Frankfurt/Berne, 1977, pp. 14ff., 29ff,—hereafter cited as Güse 1977; by the same author, "Das Kampfmotiv im Frühwerk Max Beckmanns," in the exhibition catalogue, *Max Beckmann: Die frühen Bilder*, Kunsthalle Bielefeld and Städelsches Kunstinstitut Frankfurt, 1982, pp. 189ff.,—hereafter cited as Güse 1982; Dietrich Schubert, "Die Beckmann-Marc Kontroverse von 1912: 'Sachlichkeit' versus 'innerer Klang,'" *ibid.*, pp. 175, 180ff.; Wachtmann, pp. 10, 47f., n. 24.

flashes of bombs and grenades, was an apocalyptic spectacle.[17] If Beckmann sometimes suffered depression "over the loss of my individuality," he still rejoiced in "everything new that I see," marvelled at the "boundless inventiveness" of the world.[18] For him the War was "a wonder, albeit a rather uncomfortable one."[19] Although he had "shared the experience of frightful things," and had himself "died with the dying several times,"[20] although he had seen casualties beyond number, he remained impervious to the grim, insistent argument of so much horror: "I am quite pleased that there is a war," he wrote to his wife in May 1915.[21]

In this attitude Beckmann was by no means atypical within the German art world. In the first months of the War many leading German artists were swept along with the tide of euphoria: Max Liebermann, Lovis Corinth, Max Slevogt, and Ernst Barlach greeted the War with unqualified patriotic fervor; Oskar Kokoschka, Franz Marc, even George Grosz and Otto Dix volunteered for combat.[22] Yet Beckmann was evidently inspired not primarily by patriotic feeling, although he was capable of such;[23] nor did he share the utopian hopes of those who, like Franz Marc, welcomed the War as a purgative, apocalyptic event that would sweep aside an ailing, enervated culture and thereby serve as the first step to a general spiritual renewal.[24] That may have been Beckmann's view in 1909; nothing in his war letters indicates that he still held that belief in 1914. If at that time he continued to view war as a desirable component of human existence, beyond moral judgment, for him its significance now lay less in any eventual psychosocial or political consequences than in its personal ones; above all else the War was to be valued as a formative experience:

> What is important... is not that I am to some extent participating in this affair as an historian, but that I enter into the spirit of this thing, which is in itself a manifestation of life, like disease, love or lust. And just as I pursue... fear, disease, and lust, love and hate to their extreme limits, I am now trying to do exactly that with the War. All is life, wonderfully varied and abundantly inventive. Everywhere I find deep lines of beauty in the suffering and endurance of this terrible destiny.[25]

Most important, this "terrible destiny" offered Beckmann incomparable raw material for his art. As he noted pithily: "My art can gorge itself here."[26]

This attitude was by no means unique to Beckmann. Karl Scheffler, editor of *Kunst und Künstler*, expressed the view of many when he wrote, in August 1914, that the War must become "a school for the talented."[27] He predicted that those artists serving in the field "will be overwhelmed by the abundance of visions, by the terrible beauty of the War and by the thrilling pictorial richness of a landscape ravaged by war ... We imagine with pleasure our talented artists who, while they are good soldiers, will not cease to be artists with all of their senses ... The profit for our art is sure to be substantial."[28] Presumably to inspire German artists with historical models, Scheffler published a two-part article by Emil Waldmann with the title "Krieg und Schlacht in der Kunst" (War and Battle in Art).[29] And as examples of the war experiences of "talented artists" who promised to fulfill his hopes, he published drawings and letters from the front by Beckmann and his friend, Waldemar Roesler.[30]

Although Beckmann's attitude was typical of the war euphoria that gripped large segments of the German artistic and intellectual community, the War must also have had a special significance for him, one which is also not adequately explained by the recently cited influence of Nietzschean ideas on his early art.[31] This significance was related to the special character of Beckmann's art and the position in which, in 1914, he found himself as an artist.

History Paintings – Masked Reality

"This painter feels and thinks in superlatives," wrote Karl Scheffler in 1913, contrasting the young Max Beckmann with the German Realists and Impressionists; "he is all tension. … He wants not only the art of painting in itself, but also wants, by means of painting, the 'great idea,' ethical pathos, the heroic sensation."[32] Beckmann's most ambitious paintings of the period 1906-13 belonged to the pictorial genre of history painting: compositions on religious, mythological, or allegorical themes or of momentous events. In this eight-year period he painted more than 20 such pictures, grandiose in conception and generally large in format, including such apocalyptic visions as *The Flood* (fig. 1) and a *Resurrection* (fig. p. 85).

In the first monograph on Beckmann, published in 1913, Hans Kaiser claimed that the artist's history paintings were symbols for a thoroughly modern content—"the nerves and pathos of the world city" Berlin.[33] *Battle of the Amazons,* (cat. 11) for example, he cited as a metaphor for the "frightful human drama" of prostitution in the capital, "the struggle for existence by means of sex."[34] Recently Ernst-Gerhard Güse has interpreted several of these compositions as embodiments of Nietzsche's philosophy.[35] In the present context, however, what is at issue is not the specific content of these pictures, but Beckmann's manner of giving form to that content and how he employed the conventions of history painting. It was not his way to represent modern realities by means of modern motifs; he chose to disguise them in traditional mythological and religious metaphors, and to express the drama and pathos of those realities by means of a pictorial rhetoric reminiscent of baroque painting. True to a conservative academic tradition, Beckmann seems to have equated profound statements with the genre of history painting. Probably his compositions in this mode were also in part a quixotic attempt to rescue a great pictorial tradition on the verge of extinction in the "demoralized culture" of urban Germany, a tradition degraded to parody by artists like Corinth and dismissed as literary and out of date by progressive elements in the art world. Hans Kaiser recognized that Beckmann's artistic vision was foreign to the spirit of the times and attempted to make a virtue of this anachronism:

> The bold gesture and full-bodied pathos of Beckmann's painting disturb the frailty of his contemporaries … That which our age resists, and what it lacks, precisely that is what Beckmann's painting possesses, passion and heroic romanticism.[36]

Two of Beckmann's paintings in this category are particularly significant in this regard: *Scene from the Destruction of Messina* (cat. 10), painted in 1909, and *The Sinking of the Titanic* (cat. 12), begun in 1912 and completed about the first of April, 1913.[37] These two compositions, inspired by major catastrophes of the time, were pivotal in Beckmann's early development; they were key works in a gradual shift in his choice of subject matter. *Messina* was based on newspaper accounts of events surrounding the earthquake of December 28, 1908; it was, apart from Beckmann's portraits, his first large figural composition with a clearly contemporary subject. This fact already suggests that a modern subject had to have the tragic or catastrophic dimensions of subjects from history in order to capture his interest. Like Delacroix's *Scenes from the Massacre at Scios* (to which it was compared) and Géricault's *Raft of the Medusa* of nearly a century earlier, Beckmann's picture was an attempt to endow a contemporary subject with the pathetic grandeur of history painting, to elevate a recent event to that level of emotional gravity and universal significance characteristic of the great religious and mythological compositions of past art.[38] Conversely, such a

32. Karl Scheffler, "Max Beckmann," *Kunst und Künstler*, xi (March 1913), 297 f. Hereafter cited as Scheffler 1913.

33. Hans Kaiser, *Max Beckmann* ("Künstler unserer Zeit," i, Berlin, 1913), p. 12.

34. *Ibid.*, pp. 42 f.

35. Güse 1977, pp. 29 ff.

36. Kaiser, p. 45.

37. On the completion date for the painting see Güse 1977, p. 69, n. 287.

38. Cf. Kaiser, p. 28, and Scheffler 1913, p. 298. The latter aptly characterized Beckmann as a painter "who wants to develop something Michelangelesque out of events like those in the daily newspapers, somewhat like Géricault did, as he painted *The Raft of the Medusa*, or like Delacroix, when he took the Greek wars of liberation as his motif."

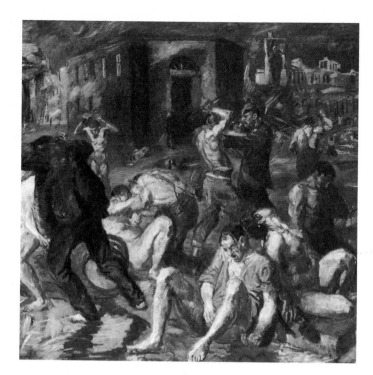

Fig. 2 Max Beckmann: *Scene from the Destruction of Messina,* 1909, oil on canvas, St. Louis, The Saint Louis Art Museum, Bequest of Morton D. May

Fig. 3 Max Beckmann: *The Kaiserdamm,* 1911, oil on canvas, Bremen, Kunsthalle

subject, with an immediate emotional appeal for Beckmann's audience, could aid him in his effort to breathe new life into this moribund genre.

Scene from the Destruction of Messina (fig. 2) was sharply attacked at the Berlin Secession: one critic, Robert Schmidt, declared that the painting "deserved to·be adapted as a cinema poster."[39] This hostile reception may help to explain why *Messina* remained isolated for a time as an experiment with contemporary subject matter. Indeed, quantitatively speaking, the following year—1910—marked the peak of his involvement with traditional history painting.[40] But in 1911 there appeared in Beckmann's production for the first time paintings with specifically urban motifs—not merely suburban landscapes, such as he had painted earlier, but street landscapes. In that year he painted three such works; two of them—*View of Nollendorf Platz* (fig. p. 94) and *The Kaiserdamm* (fig. 3)—represented readily identifiable sites in Berlin. In 1912 Beckmann painted no such themes, but on April 15th of that year there occurred a second catastrophe which inspired him to attempt another history painting on a contemporary subject: the sinking of the British passenger liner *Titanic,* in which 1600 persons perished. Again he developed his conception from newspaper accounts. Something of the ambition with which Beckmann approached this enterprise may be reflected in an essay which appeared in *Pan,* only a month before the *Titanic* disaster. There he intimated that he was striving for a painting that would "fashion types out of our time, with all of its discord and lack of definition, types that could be to us today what the gods and heroes of past peoples were to them."[41]

But when the *Titanic* was shown in spring 1913 at the Berlin Secession, the critics were of the opinion that Beckmann had fallen far short of such an achievement. Emil Waldmann, writing in *Kunst und Künstler,* saw the painting as proof that Beckmann was "still a long way from sovereign mastery," and was not afraid to risk an occasional failure.[42] For Curt Glaser *Titanic* lacked all persuasive power:

The shattering impact (of the disaster) is completely absent. One sees boats and people on a blue-green sea, sees a luminous ship in the background, but the relationship between the two is purely literary and established only by the

39. Cf. Kinkel in *Leben in Berlin,* pp. 42 f., n. 6 and p. 49, n. 21.

40. In 1910 Beckmann painted five works in this category: *The Coming of the Holy Spirit* (Göpel 124); *The Prisoners* (Göpel 127); *David and Bathsheba* (Göpel 128); *Christ Announces His Last Entry into Jerusalem* (Göpel 129); and *Cleopatra* (Göpel 136).

41. Max Beckmann, "Gedanken über zeitgemäße Kunst," *Pan,* II, no. 7 (March 14, 1912), p. 501.

42. Emil Waldmann, "Berliner Sezession," *Kunst und Künstler,* XI (July, 1913), p. 513.

knowledge of the viewer. The painterly qualities that Beckmann undeniably possesses will not help his *Titanic* picture achieve that fame which the *Raft of the Medusa*, as a portrayal of a similar disaster, will always enjoy beyond the hour of the event.[43]

Besides this negative reception of *The Sinking of the Titanic,* something else about the exhibition must have disturbed Beckmann: a large contingent of his more progressive contemporaries had finally penetrated the conservative Berlin Secession. Kirchner, Heckel, Schmidt-Rottluff, Pechstein, Mueller, and Kokoschka: all were represented there.[44] Their growing acceptance challenged Beckmann's favored position in the established art world. In a diary entry he wrote after he had had his first look at these works, he recorded his first worried reaction to this development: "Again tired and depressed because of new competition although I find Titanic very good."[45]

However Beckmann may ultimately have regarded his picture, after the Secession exhibition there was a sudden and decisive shift in his art. He ceased doing history paintings: his subject matter was now drawn exclusively from his immediate surroundings, and modern urban life became his dominant theme. For the first time in his career his painting became an art based exclusively on observed reality, on direct experience. His most ambitious work from 1914, *The Street,* which Beckmann cut by two-thirds in 1928, offered a crowded urban scene (fig. 4, cat. 14). Its large format (ca. 171 x 200 cm) and compositional complexity suggest that Beckmann intended it as a realist successor to his history paintings. The passion and pathos that had distinguished those earlier works were not apparent in this quotidian image of Berlin; those qualities were relegated to smaller pictures on subjects from the world of contemporary sport: *Wrestlers* and *Falling Bicycle Rider* (fig. 5, 6).[46] After the failure of his *Titanic,* Beckmann must have been discouraged from attempting the depiction of struggles and tragedies that he had not witnessed.

Against this background Beckmann's enthusiastic participation in the War becomes more readily understandable. Here was a chance to observe at first hand a calamity that in its dimensions and significance overwhelmed the Messina and Titanic disasters. Here, at last, was an opportunity to create a monumental composition based not on newspaper accounts or literary sources, but on a reality that he could see and experience. The first intimation of such a vision appears in a letter of October 11th from East Prussia:

> Outside, the wonderfully sublime clamor of battle. I walked outside through bands of wounded and weary soldiers who came from the battlefield and I heard this peculiar, terribly sublime music. It is as if the gates to eternity had been torn open when one of those great salvos resonates over here. ... I would like to be able to paint this noise.[47]

Two months later, probably in Berlin, Beckmann made a pair of rough sketches for a painting of the Resurrection (von Wiese 204, 205). It is difficult to conclude much from these extremely abbreviated drawings. As Stephan von Wiese has analyzed them, they would seem to depict Beckmann and his wife's family in the midst of a war landscape, surrounded by the resurrected bodies of dead soldiers.[48] (The recent death in combat of Martin Tube, Beckmann's brother-in-law, may have been the immediate stimulus for the sketches.) Despite the horizontal format of these rough designs, their conception, with conventionally symmetrical, vertical groupings of figures, is closer to Beckmann's first version of *Resurrection* (fig. p. 85), dating from 1908/09, than to the work that he would begin in 1916 (fig. p. 83).

When Beckmann made these sketches, he had experienced relatively little in the War. In East Prussia he had seen a couple of bombed villages, the devas-

Fig. 4 Max Beckmann: *The Street,* 1914, oil on canvas, New York, Private collection

43. Curt Glaser, "Die XXVI. Ausstellung der Berliner Sezession," *Die Kunst für Alle,* XX (July 15, 1913), p. 464.

44. Cf. Paret, *The Berlin Secession,* pp. 220 f.

45. Diary entry of April 11, 1913, first published in Güse 1977, p. 69, n. 287.

46. The image of *Falling Bicycle Rider,* also known as *Fatal Fall* (Todessturz), shows the falling racer at the moment when he is run over by the rival immediately behind him. Güse 1982, p. 199, has shown that the image was almost certainly a metaphor for Beckmann's uneasiness about growing competition from the avant-garde. In a note in the unpublished diaries, dated December 30, 1912 Beckmann had written: "Although I am only 28 years old, feelings of aging and fear of being overtaken. Feelings of a bicycle racer. Coryphaeus as new champions emerge. Rather ridiculously discontented about it."

47. *Briefe im Kriege,* p. 18 (October 11, 1914).

48. Von Wiese, pp. 100, 103; cf. also p. 48.

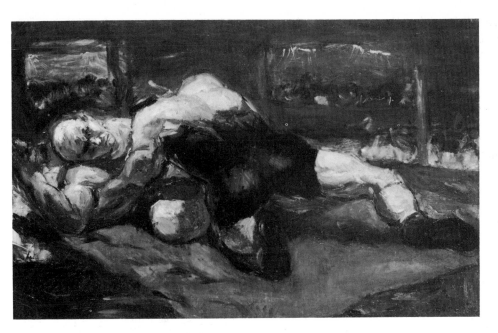

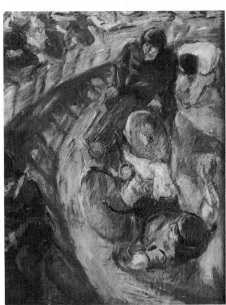

Fig. 5 Max Beckmann: *Wrestlers*, 1913, oil on canvas

Fig. 6 Max Beckmann: *Falling Bicycle Rider*, 1913, oil on canvas

tated landscape with "dead, grotesquely wounded oxen and horses;"[49] in the hospital he had sniffed the pungent odor of decay and experienced frightful things among the wounded and the dying.[50] But he had not yet encountered the full horror of the War; he still had not been at the front. This experience would come in Belgium. There his vision of resurrection would assume a more concrete form.

Although Beckmann was sent to Belgium in December 1914 his most significant experiences came after his transfer to Wervicq the following March. There he was stationed directly at the front.[51] Pleased to be so close to the action, he nevertheless had to wait a month before actually witnessing combat. On that day he recounted his first impressions to Minna:

> So today I was for the first time really at the front. Very strange and curious. In all the holes and trenches. These ghostly passages and artificial woods and houses. This disagreeable whizzing of bullets and the clap of guns. Strangely unreal cities like lunar mountains have risen there. A peculiar sound is caused by the rupturing of the air when the great guns are fired. It squeals like a pig being slaughtered. The dead were dragged past us. I did a drawing of a Frenchman who was half looking out of his grave. He had been disturbed in his rest by a grenade explosion.[52]

Beckmann had little fear, he reported, but "a strange feeling of security," as he made drawings while grenades exploded nearby. But, he added, the details were not so important; what mattered was to absorb "the atmosphere into one's blood;" that would give him:

> the confidence for the pictures that I have already seen before in spirit. I want to process all of this internally, so that later I can freely make things that are almost timeless: those black features peering out of the grave and the silent dead who approach me are dark greetings from eternity, and as such I want to paint them later.[53]

Two weeks later, writing about the pictorial images that obsessed him in his longing to paint, Beckmann alluded to motifs that anticipate aspects of his *Resurrection:* "I am always thinking to myself, how do you paint the head of the resurrected one against the red stars in the sky... or the glittering light that is reflected against the lead white sky from the blinding white of the aerial bombs,

49. *Briefe im Kriege*, p. 18 (October 11, 1914).
50. *Ibid.*, p. 13 (October 3, 1914).
51. *Ibid.*, pp. 30 f. (March 27, 1915).
52. *Ibid.*, p. 49 (April 28, 1915).
53. *Ibid.*, pp. 49 f.

and the wet, sharp, angular shadows of the houses?"[54] Then, on June 8th, there is a haunting image of the front, like a vision, in pregnant phrases that border on the ecstatic:

> This morning I was once more at the dusty, white-gray front and saw wonderful glowing, enchanted things. Burning black, like golden gray-violet against a ravaged loam yellow, and a pale, dusty sky, and partially and totally naked men with weapons and bandages. Everything was dissolved. Staggering shadows. Glorious pink and ashen limbs with the dirty white of bandages, and the dark, heavy expression of suffering.[55]

These naked, bandaged bodies already evoke specific qualities of the apocalyptic composition Beckmann would begin the following year. Then there follows in the same letter a description of a scene that is like a macabre parody of the resurrection of the dead:

> Yesterday we came across an old cemetery, which had been completely devastated by grenades. The graves were ripped open, and coffins lay around in extremely awkward positions. The grenades had indiscreetly exposed the ladies and gentlemen, and bones, hair and bits of clothing peered out of cracks in the damaged coffins.[56]

It was such realities as these, realities that must have made his earlier paintings seem academic and naive, which prompted Beckmann to write as late as May that he was "quite pleased that there is a war. Everything I have done up to now was just an apprenticeship, I am still learning and broadening myself."[57]

The War exacted a heavy payment for this education. Although Beckmann liked to play the role of the enthusiastic, aesthetically sensitive observer, hungry for experience yet detached and ironic in describing the horrors he encountered, he was gradually devastated by these experiences. As Hans Günter Wachtmann has observed: the enthusiasm for the War "was undoubtedly dominant in Beckmann's consciousness, while underneath the breakdown was preparing itself."[58] Beginning in April the letters to Minna betray a growing uneasiness. On the 20th Beckmann reported from Wervicq that he had been "somewhat nervous" while at work on his mural, "so that I always feel surrounded by enemies."[59] Then after repeated experiences at the front a growing tension becomes apparent, a fear for his life that his customary irony can no longer conceal. By the 4th of May he was prepared to concede: "Now for the first time I have had enough."[60] And on the 21st, after being the object of enemy fire, he wrote: "It is horrible and unpleasant. All the fibers of my body tensed up and looked and felt for what was coming next."[61] Three days later he had "another dream about the end of the world. Probably already my twentieth."[62]

Beckmann's published war letters break off on June 12th. When they appeared as a book the following year their author was on leave in Frankfurt, "for the recovery of my health."[63] Little is known about the nature and course of this illness. It is evident from sources recently brought to light by Stephan von Wiese that when Beckmann arrived in Strasbourg, probably around the beginning of September 1915, he was still capable of functioning as a nurse, therefore he had almost certainly not yet suffered a nervous collapse.[64] But a letter of September 5th to Minna reveals his disturbed mental state at that time and provides a clue to the symptoms of his developing malady:

> For me every day is a struggle. And indeed a struggle with myself and with the bad dreams that whir around my head like gnats. We are coming still, we are coming still! they sing. Oh, I would so like to complete the work I have begun. Work helps me get away from my various attacks of paranoia.[65]

54. *Ibid.*, pp. 58 ff. (May 11, 1915).

55. *Ibid.*, p. 72 (June 8, 1915).

56. *Ibid.*

57. *Ibid.*, p. 60 (May 11, 1915).

58. Wachtmann, p. 12.

59. *Briefe im Kriege*, p. 43 (April 20, 1915).

60. *Ibid.*, p. 53.

61. *Ibid.*, p. 63.

62. *Ibid.*, p. 67 (May 24, 1915).

63. The quotation comes from a letter Beckmann wrote on the verso of a drawing, sent from Halle to his Frankfurt friends, Ugi and Fridel Battenberg, and dated November 29, 1916. See von Wiese, cat. no. 350.

64. *Ibid.*, p. 171, n. 125. In a postcard from Strasbourg, Beckmann wrote to his Berlin acquaintances the Sievers that he had "landed here after many wanderings." The postmark bears the date October 10, 1915; on the return address Beckmann designated himself as a "volunteer orderly" ("freiwilliger Krankenpfleger") at the Imperial Institute for Hygiene. In a letter to Reinhard Piper, dated October, Beckmann reported that in his "free time" he had made a number of etchings; he was using "every free minute for work." In an unpublished manuscript (quoted in Göpel I, p. 130), Fridel Battenberg recalled that in 1915, after an extended stay with her husband in their Frankfurt apartment, Beckmann was ordered back to duty in Strasbourg. These sources show clearly that in Strasbourg he was still functioning as an orderly, and suggest that it was there that his mental condition deteriorated to a point that brought about his transfer to Frankfurt on health leave. This reading of the evidence is supported by Beckmann's letter to the Battenbergs, cited above in n. 59, and an exhibition review in the *Vossische Zeitung*, November 8, 1917, which mentions that Beckmann had been given leave from Strasbourg and sent to Frankfurt for health reasons; it moreover reports that he had resumed his medical duties in a Frankfurt hospital. The article, by "F.S-s." is cited by Barbara C. Buenger, "Max Beckmann's Artistic Sources" (Columbia University Dissertation, 1979), p. 88, n. 1.

65. Published in von Wiese, p. 171, n. 125.

Fig. 7 Max Beckmann: *Assault*, 1916, drypoint, Collection R. Piper

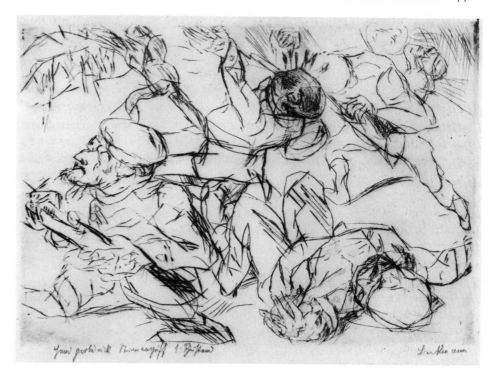

But whom did he mean? Whose coming filled him with such dread? Was it bad dreams in general, was that what "sang" so menacingly? Or was it something *in* the dreams? The probable answer is contained in a recollection of Lili von Braunbehrens. Some time later Beckmann related to her that while in Belgium he had to live over a cellar that was used as a morgue; "eventually," he told her, "the dead came to visit me."[66]

Resurrection as anti-Resurrection?

These encounters with the "resurrected" dead, the recurrent apocalyptic nightmares,[67] and a morbid sensitivity to what Beckmann called "the mystery of the corpse,"[68] all gave to *Resurrection* a power and conviction, an intensity of vision that left his previous history paintings far behind. This was no mere invented allegory; this was an image distilled from memories and dreams that left Beckmann no peace. Even if, as Wolf-Dieter Dube proposes, Beckmann's conception was partly influenced by late medieval depictions of the Last Judgment and textual passages from Jean Paul and the New Testament,[69] many of the motifs in the composition had a palpable reality for him. They were founded on impressions that had been seared into his memory: the ravaged, "dusty white-gray" war landscape and the devastated towns; the "glittering light" of exploding bombs against the "lead white sky;" the "pink and ashen limbs with the dirty white of bandages;" "the silent dead who approach me." Yet Beckmann's dead do not rise up out of graves that have been ripped open, but from a subterranean vault (more intelligible in the drypoint version than in the unfinished painting), visible through an open trap door. It is a motif that recalls that cellar in Belgium.

In view of the oppressive, particularly ghastly associations that these motifs must have had for Beckmann at this time, it seems appropriate to ask whether this "resurrection" is to be understood at all in the customary sense of the word—as victory over death, as awakening to new life.[70] In contrast to Beckmann's earlier version, there is apparently no Last Judgment represented here. Among the risen there is none who is clearly blessed; there is no radiant

66. Oral communication by Lili von Braunbehrens to Stephan von Wiese, cited by him, p. 171, n. 124.

67. As late as December 21, 1916, Beckmann described to his wife such an apocalyptic dream, one that in its details was clearly influenced by his experiences at the Belgian front. Quoted in von Wiese, pp. 76, 107.

68. See the letter of May 21, 1915, in *Briefe im Kriege*, p. 65.

69. Dube, in this catalogue.

70. To my knowledge Beckmann never discussed the meaning of the painting. The unfinished work, never exhibited in Beckmann's lifetime, remained a visible presence in his Frankfurt studio from 1916 until he left the city in 1933. It was positioned against a wall, its painted surface facing outward toward the room. (Cf. Göpel I, p. 131 f.) Nevertheless, as Benno Reifenberg later recalled, "there was then, after the War, never any talk about the picture." (In B. Reifenberg and Wilhelm Hausenstein, *Max Beckmann*, Munich, 1949, p. 7.) For discussion of *Resurrection*, see the following: Peter Beckmann, "Verlust des Himmels," in *Blick auf Beckmann: Dokumente und Vorträge*, ed. Hans Martin von Erffa and Erhard Göpel, Munich, 1962, pp. 23 f.; Klaus Gallwitz (intro.), in the exhibition catalogue *Max Beckmann: Das Porträt—Gemälde, Aquarelle, Zeichnungen*, Badischer Kunstverein Karlsruhe, 1963, pp. 17 f.; Peter Selz, *Max Beckmann*, The Museum of Modern Art, New York, 1964, pp. 25 f.; Friedhelm Fischer, *Max Beckmann*, trans P.S. Falla, New York, 1973, pp. 12 ff.; von Wiese, pp. 100 ff.; Dube, in this catalogue; Karin von Maur, "Auferstehung," in *Malerei und Plastik des 20. Jahrhunderts*, Staatsgalerie Stuttgart, 1983, pp. 85 ff.

heaven, no God enthroned, dispensing His divine justice. Instead there is a blackened sun in that central position. The dead crawl up out of their vaults; it is not clear to what end.

Was then Beckmann's title intended ironically? For him the idea of resurrection had assumed a concrete, intensely personal yet gruesome meaning. Did he conceive this painting as a kind of "anti-Resurrection," using the Christian associations evoked by the title as a foil for his own relentlessly grim and macabre vision, shaped by his experiences during the War and his all too believable dreams of risen corpses? Certainly the Biblical images of resurrection and apocalypse have their terrifying aspect, but Beckmann's image, with its grotesque, anguished figures and joyless, gray harmony, seems devoid of consolation, bereft of the idea of redemption. It is resurrection as apocalyptic nightmare. Such a hard-bitten, parodistic treatment of the theme would be consistent with the spirit of the remarks which Beckmann made about 1919 to Reinhard Piper: "My religion is arrogance toward God, spite for God. ... In my pictures I reproach God for everything He has done wrong."[71]

If this composition were to be interpreted as Beckmann's personal, bitterly ironic vision of the Resurrection, then the figure of the painter himself, standing in the trap door with wife and son and his friends Ugi and Fridel Battenberg,[72] would play not the role of witness or survivor, as has been suggested,[73] but that of a guide: like Vergil in the *Inferno* and *Purgatorio,* he interprets this awful vision to those who accompany him. Indeed, he seems to be just in the process of explaining something to Minna as he glances back toward the rising corpse in the middle foreground.

The portrait group in the lower left is perhaps intended in part to function as a *repoussoir:* it intensifies by contrast the credibility of the apocalyptic vision. The familiar world of appearances is here clearly a pictorial illusion, nothing more than a painting; it is the visionary that is palpably real.[74] The resurrection that unfolds before us is therefore not the mere invention of a history painter, a pictorial fiction concocted through the imaginative reading of texts; it is a reality whose space the artist inhabits, a reality which he has experienced in the depths of his being.

Resurrection was, apart from the mural painting in Wervicq (subsequently destroyed), Beckmann's only painting directly related to his experience in the War. In 1914-15 he made eight drypoints based on episodes in the hospital, the morgue (cf. cat. 227), and the field (cf. cat. 228).[75] But from 1916, the year in which he began work on *Resurrection,* there is only one print—*Assault*—about the War, although Beckmann made at least sixteen prints that year (fig. 7). Then, in 1918, he made a version of *Resurrection* in drypoint, perhaps as a substitute for the painting that he would, for whatever reason, not complete (cf. cat. 246). Ten drypoints, a mural, a colossal but unfinished painting: quantitatively speaking, this was a modest result indeed when measured against the eager anticipation with which Beckmann entered the War, and compared to the over 150 sketches and drawings he produced in his year or so of service. It is curious that as a painter he did not make use at least of the drypoint motifs. It is as if the creation of *Resurrection*—the largest canvas Beckmann would ever paint—became for him an act of catharsis, perhaps even a sort of exorcism. Once he had worked out the image of this stupendous composition, even without completing it, the subject of the War was finished for him.

71. Reinhard Piper, *Nachmittag*, Munich, 1950, p. 33. Friedhelm Fischer first pointed out this relationship between Beckmann's remarks and *Resurrection* in *Max Beckmann: Symbol und Weltbild*, Munich, 1972, p. 22. Hereafter cited as Fischer I.

72. Since he had been transferred to Frankfurt in autumn 1916 Beckmann had lived with the Battenbergs, thus during the time that he worked on *Resurrection.*

73. According to Gallwitz (p. 17), Beckmann appears in the composition as a witness; von Wiese (p. 106) characterizes him as a survivor.

74. Only Dube (p. 69) sees the portrait group as "real" persons standing in the landscape, the quadrangle around them as a "propped-open trap door," like that on the lower right. The relative scale of these figures argues against this interpretation: they are noticeably smaller than the figures immediately behind them as well as the portrait group opposite them on the right.

75. See VG nos. 71, 73, 77, 78, 79, 80, 81, 85. There are also drypoints which, though related to the War, do not comprise motifs from the hospital or the front: nos. 70, 74, 76, 82, 83.

76. P.F. Schmidt, "Max Beckmann," first published in *Der Cicerone,* XI (1919), 675-684; quoted from the reprinted text in *Jahrbuch der jungen Kunst,* I (1920), 117.

77. Meier-Graefe, preface to the portfolio *Faces,* Munich, 1919, quoted from the reprinted text in *Blick auf Beckmann,* p. 53.

78. Beckmann's remarks on the picture were recorded by Reinhard Piper in an unpublished manuscript, "Besuch bei Max Beckmann," quoted by von Wiese, p. 173, n. 175.

79. The quotation is from Beckmann's text, written in 1918, for the anthology *Schöpferische Konfession,* ed. Kasimir Edschmid, Berlin, 1920; here quoted from the reprinted text in *Die Zwanziger Jahre: Manifeste und Dokumente deutscher Künstler,* ed. Uwe M. Schneede, Cologne, 1977, p. 112. Hereafter cited as Schneede.

80. This development is also reflected in texts by Beckmann. In 1914 he professed his commitment as a painter to representing the illusion of spatial depth ("die raumtiefe Kunst"). He contrasted his position with the "flat and stylizing decorative" tendency within the avant-garde. "The one seeks its entire effect in the plane... the other seeks with spatial and plastic form to approach life directly." ("Das neue Programm," *Kunst und Künstler,* XII, 1914, 301.) At that time Beckmann apparently saw no possibility of a synthesis between the two tendencies; but in 1918, in his text for *Schöpferische Konfession,* he described his art in terms of just such a synthesis: "The most important thing for me is volume... volume in the plane, the depth in the sense of the plane, the architecture of the picture." (Quoted from Schneede, p. 112.) On February 8, 1918, some months before completing his essay, Beckmann had written to Reinhard Piper: "With my painting and prints I can now prove that one can be new without doing Expressionism or Impressionism. New on the basis of the old law of art: volume within the plane." (Quoted from von Wiese, p. 173, n. 190.)

81. Beckmann in Schneede, p. 114.

82. In 1917, between the commencement of work on *Resurrection* and the execution of *The Night,* begun in August 1918, Beckmann painted three subjects—*Deposition, Christ and the Woman Taken in Adultery,* and *Adam and Eve*—which can still be classified within the traditional categories of Christian iconography, which therefore look back at least in this respect to the subject matter of his art prior to the War. These works probably constituted, as Friedhelm Fischer has observed, a final "attempt with traditional themes" (Fischer I, p. 15).

Although the number of Beckmann's works with war motifs is small, the First World War had the most profound effect on him both personally and artistically—an effect which was surely different from what he had anticipated. If the precise causal relationship between the War experience and the transformation of Beckmann's art is difficult to establish, it is nevertheless clear, as Paul Ferdinand Schmidt remarked in 1919, that this change "falls in the War years, as an immediate consequence of his presence at the Flemish front."[76] Moreover, critical moments in this process of change, a change that was stylistic as well as iconographic, occur in works that, chronologically or thematically, are associated directly with the War.

During the War, Beckmann quickly abandoned the Impressionistic style in which he had worked throughout his career, up until the end of 1914. The change was drastic. "The eyes become slits, through which only essentials penetrate. ... The drama in which he was a supernumerary shrinks the inchoate visions of this lover of frenzy into realities that are hard and sharp like numerals"—thus did Julius Meier-Graefe describe Beckmann's transformation.[77] The tendency toward a firmer, more concentrated style is already clearly visible in *Self-Portrait as Medical Orderly* (cat. 15); painted in Strasbourg in the fall of 1915, it was the first oil Beckmann had done since *In the Automobile* (fig. p. 95) from late 1914. "Here there comes out for the first time what I had experienced in the War," Beckmann later remarked about this work. "One sees in the features around the nose and forehead... how the later hard, severe form is beginning to develop."[78] These qualities of form were more evident in the paintings of 1917, although there was still a residue of softness from Beckmann's earlier manner. The worked-up areas of *Resurrection,* which probably date from 1918, moved further in this direction; finally, in *The Night* (cat. 19), on which Beckmann worked from August 1918 until the following March, there was a consolidation of the new style. "Sharp lines and planes clear as glass"[79] have supplanted the shimmering painterly forms of the pre-War years; the earlier turbulent impasto has tightened into a thinner facture that never detracts from the incisive linearity of the design; and the deep but often amorphous spaces of the earlier paintings have been compacted into dense configurations suggestive of bas-relief, with the most extreme tension between surface and volume.[80] In the distorted forms and perspectives of this new style Beckmann's art assumed qualities which are commonly designated "expressionist;" yet in its formal rigor and hard-nosed sobriety, in its distaste for all "swollen mysticism,"[81] it anticipated the tougher, anti-expressionist sensibility of the next decade.

The Night also reveals a consolidation on the iconographic level. In his history paintings of the pre-War years, Beckmann had usually employed traditional subjects as metaphors for a reputedly modern content. With *Messina* and *Titanic* he was most probably attempting to invent new, contemporary metaphors for a content that transcended the specific event. In none of his large, ambitious compositions did Beckmann draw his metaphors from his own experience or his own environment. Not until *Resurrection* did he make such an attempt. As I have proposed, despite its title, the painting did not have a traditional subject; the *theme* was traditional, but Beckmann's specific conceit was personal and thoroughly original. This composition was therefore a decisive turning point for him. To be sure, its apocalyptic, visionary quality still looks back to the history paintings of 1906-13; yet, while at work on this painting in 1918, Beckmann must have come to realize that the traditional subjects of history painting—mythological, religious or whatever: subjects which he was still inclined to paint in 1917[82]—had become inadequate as metaphors for his

intensified experience of the world. Somehow he must have fully realized at last the potential efficacy of metaphors drawn from the life of the city, where he had found so little that was worthy of his vision before.[83] Among Beckmann's paintings, *The Night* is the first fruit of this discovery. With this work he took a decisive step toward that goal he had formulated in 1912: "to fashion types out of our time... that could be to us what the gods and heroes of past peoples were to them."[84] In short: to create a contemporary equivalent of history painting.

Toward the end of the War, when Beckmann wrote his contribution to the anthology, "Schöpferische Konfession," he had become a strikingly different person from the ambitious young artist of the pre-War years and the enraptured author of *Briefe im Kriege*. In earlier writings on his art, he had been concerned almost exclusively with formal questions; he seemed to have reflected little on the broader purpose of his art, on its function in society.[85] Dazzled by his precocious success, he had perhaps been too narrowly preoccupied with the dynamics of his career, with vain dreams of artistic glory. At times he had egocentrically viewed and judged reality primarily as fodder for his art; his enthusiasm for the War was symptomatic of that attitude. Beckmann probably had to become a victim of the War, had first to be slowly but profoundly shattered by the cumulative horror of such slaughter, suffering, and dying beyond measure, in order to grow beyond this narrow, narcissistic view of his art. He seemed to refer to his earlier self when he wrote in his text for the "Schöpferische Konfession:" "That was what was unhealthy and loathsome in the period before the War, that the frantic commercial pursuits, the craving for success and influence had in some form or other infected each of us."[86] Now, in 1918, as he anticipated the misery and humiliation of Germany's imminent defeat, he saw his role as an artist to be an altruistic one:

> We must share in all of the suffering that is coming. We must sacrifice our hearts and our nerves to poor, deceived humanity's horrible screams of pain. Especially now we must get as close to the people as possible. That is the only thing which can motivate our quite superficial and selfish existence. That we give to people an image of their fate, and that one can do only if one loves them.[87]

transformation

83. Beckmann began moving in this direction as he took up urban motifs in 1913-14. *Falling Bicycle Rider* (see above, n. 46) was an early sample of his invention of a modern urban metaphor, although there the application of the principle was more limited, in terms of both the formal and iconographic complexity of the work and its specific content.

84. See above, n. 38.

85. Franz Marc was critical of the narrowly sensuous conception of art presented by Beckmann in his polemical essay of 1912, "Gedanken über zeitgemäße und unzeitgemäße Kunst" (which was directed against Marc), above all of his definition of artistic quality. See Marc's article, "Anti-Beckmann," *Pan*, II, no. 19 (March 21, 1912), 555 f.

86. Beckmann in Schneede, p. 114.

87. *Ibid.*

Wolf-Dieter Dube

On the "Resurrection"

"There is nothing that I hate as much as sentimentality. The stronger and more intense my will to capture the unspeakable aspects of life, the more heavily and deeply the shock waves of our existence burn within me. My mouth is ever clamped shut, and my will is ever more coldly determined to get my hands on this horribly convulsing monster of vitality, and to cage it up in sharp lines and surfaces which are as clear as glass—to weight it down, to strangle it.

I do not cry, for I despise tears and consider them to be a sign of slavery. I constantly think only of the matter at hand—a leg, an arm, piercing the surface by means of the wonderful sense of foreshortening, the division of a space, the combination of straight arrangements of the small, multiply varied round areas with respect to the straight and flat areas of wall angles, and the depth of table tops, wooden crosses, or housefronts. The most important thing for me is the roundness which can be captured through height and width. The roundness inherent in the surface, the depth in the feel of the surface, the architecture of the painting...

Piety! God? What a beautiful, much misunderstood word that is. I will be both whenever I have created my work in such a way that I am finally able to die. A hand which I have painted or drawn, a face which is grinning or weeping—these are my confessions of faith. If I have felt anything of life, this feeling is contained therein..." [1]

When Max Beckmann wrote these words, he had already been working for about two years on his great canvas. He had noted his determination, penciled between the figures already on the canvas, with "to the matter at hand."

In 1916, after his release from military service because of a psychological breakdown, Beckmann set up a giant canvas in his new studio in Frankfurt. The dimensions of this canvas were 345×497 cm; the painter entitled the work *Resurrection,* (fig. 1). [2] Beckmann worked for nearly two years on the painting. In 1918, he made a drypoint based on the painting, which clarified some of the details without altering the total concept or resulting in any progress (cf. cat. 246). In the end he let the picture sit uncompleted, in the most literal sense, for it remained leaning against a wall in the studio, upright so that it was visible, until Beckmann left Frankfurt in 1933. That fact alone leads us to conclude that *Resurrection* must have been a work which was particularly important to him. This has been indicated in the available literature; Klaus Gallwitz has stated, "this was the image of all the future works which Beckmann was to paint." [3] Friedhelm W. Fischer, who contributed so much to our understanding of Beckmann, also considered the painting of 1916/18 to be the pivotal point in his work and the most powerful catastrophic image he created. "All of the earlier visions of destruction are contained within it, and all of those which came later proceed from it. The painter produced variations on the theme of world catastrophe until his death." [4] In light of observations such as these, it is all the more shocking to realize that there has not been a thorough analysis of this painting until now. [5]

1. Max Beckmann, "Schöpferische Konfession" in *Tribüne der Kunst und der Zeit,* XIII, Berlin 1920. Cited in Dieter Schmidt (ed.), *Manifeste – Manifeste 1905-1933,* Dresden, no date, p. 139 ff.

2. The associated drawings which confirm that Beckmann had been considering the idea of the painting since 1914 have been gathered together and discussed by Stephan von Wiese, *Max Beckmanns zeichnerisches Werk 1903-1925,* Düsseldorf, 1978, pp. 100-108. I have decided not to follow von Wiese's interpretation of *Resurrection.*

3. Klaus Gallwitz, catalogue for the exhibition, *Max Beckmann – Das Portrait,* Karlsruhe, 1963.

4. Friedhelm W. Fischer, *Max Beckmann: Symbol und Weltbild,* Munich, 1972, p. 22.

5. The present essay is the expanded version of my essay "Auferstehung im Werke Max Beckmanns" in *Kunst und Kirche,* 2 (1982), pp. 67-72.

In the present attempt to accomplish this analysis, we must take into consideration the background of Beckmann's personal experience of the War. Beckmann, who was capable of absorbing any form of reality with an unbelievable degree of intensity, had at first perceived the horrors of war taking place around him as a great adventure, indeed, almost as an expression of life. The letters which he wrote to his wife[6] in 1914 and 1915 clearly confirm this: "... outside... the wonderfully sublime sound of battle" (10.10.1914), or "... saw wonderfully enchanted and glowing things. Burning black to golden gray-violet, ruinous loam yellow, and a lurid, dusty sky; partially and completely naked men with weapons and bandages. Everything hysterical. Reeling shadows. Sumptuously rosy and ash-colored limbs with the dirty white of bandages and the sombre heavy expression of sorrow." (8.6.1915). And yet at the same time he sensed "the inexpressible absurdity of life" (24.9.1914), and that the "existence of life had really become a paradoxical joke to him" (21.5.1915). The unprecedented experience of the agony and torture going on around him resulted in a need for artistic expression which could describe the immense and unspeakable suffering. This certainly could not be accomplished realistically by means of the creation of a painting of a battle scene such as the one Beckmann had already done in 1907 (fig. p. 17). It could only be rendered in the form of a vision, relying on a pictorial tradition which had been passed down to him. Again his wartime letters provide a reference to the form which Beckmann's imagistic idea had assumed: "Whenever a volley flies overhead, it is as if the gates of eternity had been torn open" (11.10.1914); "The rows of streets gape open like on the final Day of Judgment" (3.4.1915); "In the partially dark trench, there are half-naked men, drenched in blood, to whom the bandages are applied. Their expressions are great and laden with pain. New representations of the scourging of Christ" (4.5.1915); "Everything is foundering, time and space, and I keep thinking only of how I will paint the head of the resurrected one against the red stars in the sky of the Final Judgment" (11.5.1915); and, finally, "Tonight I again had a wonderful dream about the destruction of the world. Almost the twentieth dream of this sort... Everything in it seemed as if it had been dissolved into the feeling of unending breadth and height and the frightening sense of the 'new'" (24.5.1915).

Vision from the Experience of Suffering and Pictorial Tradition

Over the grayish-white primer coat of the canvas, which determines to a great extent the chromatic character of the painting, Beckmann has drawn in outline a landscape consisting of two hills. Into the hollow between them sinks a house which has been torn apart. There is a purplish-black moon in the low sky, and the huge, extinguished disk of the sun is pressing down on the surface of the earth. World-wide catastrophe has devastated the ground and forced it to open up: "There was a violent earthquake, and the sun became black, like coarse black cloth, and the moon turned completely red, like blood. The stars fell out of the sky to earth, like unripe figs falling from the tree when a strong wind shakes it. The sky disappeared, like a scroll being rolled up, and every mountain and island was moved from its place. Then the kings of the earth, the rulers and the military chiefs, the rich and the mighty, and all other men, slave and free, hid themselves in caves and under rocks on the mountains. They called out to the mountains and to the rocks, 'Fall on us and hide us from the eyes of the one who sits on the throne, and from the wrath of the Lamb!' (Revelations 6:12-16). As if he would belong among those who had hidden themselves in caves, Beckmann painted himself, his wife Minna, his son Peter, and his friends the Battenbergs, half hidden within the entrance of a vault. With expressions which are both anxious and bewildered, the painter and his wife look down at a corpse

6. Max Beckmann, *Briefe im Kriege,* Berlin, 1916, 2nd ed. Munich, 1955.

Fig. 1 Max Beckmann: *Resurrection,*
unfinished. 1916-18, oil on canvas, Stuttgart,
Staatsgalerie

7. The cat Titti belonged to the Battenbergs and was
thus a part of Beckmann's everyday environment.
See: Lili von Braunbehrens, *Gestalten und Gedichte
um Max Beckmann,* Dortmund, 1969, p. 43.

lying at the lower edge of the painting, in front of which sits a black cat, howling
at the moon.[7] While the dead rise up and crawl out of the catacombs, the painter
observes the resurrection taking place in a diagonal progression towards the
upper right. The corpse, rigidly stretched out on the ground, rises up and begins
to hover. Still laboring under its pain with its burial garments coming undone,
the figure is able to right itself and stand with its head lowered, raising its hands
to its face, slowly awakening to consciousness.

This process forms the middle section of the composition. To the left and the
right are symmetrically arranged groups, like the wings of a triptych. These
"wings" illustrate the possibilities of either being admitted into or rejected from
heaven, corresponding to the pictorial tradition of the Last Judgment. This is
also evident in the choice of sides: Beckmann shows those who are being
accepted into heaven on the right side (the righteous side), while those who
have been cast out are on the left. He does, however, change the iconographic
tradition of portraying these sides in that he views them from his own perspec-
tive, rather than that of the Universal Judge, who "just as the shepherd sepa-
rates the sheep from the goats, ... will put the sheep at his right and the goats at
his left" (Matthew 25:33). The diagonal movement from the lower left to the
upper right is thus even more firmly established, both formally and in terms of
content. The pivotal point at which a judgment is made and which also forms
the logical mid-point of the total pictorial composition is the hovering figure,

whose very stance is symbolic of one whose eternal reward has not yet been decided. The figure is found in the middle of the picture, as is described in the apocryphal "Testament of Abraham:" "Because the judge found their sins and their good deeds to be of equal value, he was unable to send them to their doom, but also could not place them among those who would be saved—he therefore had them stay in the middle until such time in the future when the Universal Judge would arrive."[8] "We must indeed assume," wrote Beckmann to his wife on April 24, 1915, "that this life is not all that there is. How and why this is, is really none of our business. One must be ready for anything, and still keep one's head held high..." For the central figure in *Resurrection*, this being ready for anything could mean that he will take the next step on his way. Therefore he is depicted with his eyes turned heavenwards and his hands raised in prayer. The incarnate who previously was represented in a grayish-green color is brought to life by the use of red, as are the small figures with the lion in the background.

Beckmann has described the process of resurrection in individual phases, which can be read as a sequence of instantaneous events in somewhat the same way as Ezekiel's vision of the dead (Ezekiel 37:1-10) is constructed in separate consecutive sequences of action.[9] This figure takes a step along the path towards the right with a great, ecstatic, upward gesture, which is hindered nonetheless by his burial garments. Next to the figure, a woman in white stockings appears facing front, with her arms raised in the traditional stance of an *orant*, a deceased person awaiting the resurrection. A human couple, certain of salvation, can be understood not only to represent a resurrected humanity, but also Adam and Eve, who have taken their places as the first to be saved in pictorial representations of the Last Judgment by Michelangelo as well as Rubens.[10]

Accordingly, Eve is represented by the female figure at left who is shown from the front. Her blue stockings and green and red robe are expressed in more intense colors. Nevertheless, her resigned attitude and gaunt, small-breasted body indicate her hopelessness of ever becoming a new, natural human being through the reunification of her soul, spirit, and body. Despair, suffering, sorrow, and contempt are the attitudes presented in the left half of the picture. Inexpressible sorrow is symbolized by the form of the exhausted mother with her newborn child; both of them are lying on a shroud. Since we are unable to determine whether this signifies a place of birth or an actual burial shroud, perhaps Beckmann is referring here to Matthew 24:19: "And alas for those who are with child and for those who give suck in those days." Two of the figures embody sorrow and despair. One is wrapped in the shroud it is pulling up over its head, while the other covers its eyes with its left hand as it raises the right hand in a gesture of defense. Finally, there is the gesture of contempt which is expressed in every figure, reaching far back into the picture, which simultaneously cuts this group off from the middle section of the picture and connects it to it. It quite obviously represents the other alternative for the figure in the middle of the painting, namely, a stance of protest against a deficient creation, revealing one more aspect of Beckmann's attitude of "being ready for anything."

Corresponding to the symmetry of the groups are vaults with trap-doors within both halves of the lower section of the painting. In the drypoint they are clearly discernible. On the right the painter himself appears with his family and friends; the women fold their hands in prayer. On the left, in front of a raised trap-door, a group of people in evening clothes has gathered, who apparently still belong among the living. Apparently aware of their fates, they fearfully wring their hands, and two of the women are on their knees: "Pangs and agony will seize them, they will be in anguish like a woman in travail. They will look aghast at one another, their faces will be aflame. Behold, the day of the Lord

8. Leopold Kretzenbacher, *Die Seelenwaage*, Klagenfurt, 1958, p. 57:

9. See Ruth Feldhusen, *Ikonologische Studien zu Michelangelos Jüngstem Gericht*, Unterlengenhardt – Bad Liebenzell, 1978, p. 28.

10. Sigrid Esche, *Adam und Eva*, Düsseldorf, 1957, p. 52 ff.

Fig. 2 Max Beckmann: *Resurrection,* 1909, oil on canvas, Stuttgart, Staatsgalerie

Fig. 3 Peter Paul Rubens: *The Great Final Judgment,* oil on canvas, Munich, Bayerische Staatsgemäldesammlungen, Alte Pinakothek

comes, cruel, with wrath and fierce anger to make the earth a desolation and to destroy its sinners from it." (Isaiah 13 : 8-9). Thus, the event is reflected in the same behavior by both the living and the dead.

The Precursory Form of the Triptych

There have been many conclusions drawn about the extent to which Beckmann's work changed stylistically after his release in 1916 from serving in the War, and there are references as well to the similarities between his work and paintings of the late Middle Ages. This is particularly true of *Resurrection,* not only with regard to the individual figures, but in terms of the total composition of the work, which can be viewed specifically in comparison to his earlier *Resurrection* painting made in 1909 (fig. 2). In the earlier work, the large number of bodies, arranged in two columns, ascend into heaven in a sweeping, upright format. Their acceptance into heaven is indicated by means of a glimmering light, yet the figures seem nonetheless overcome with doubt and fear. In the tradition of painting of the Universal Judgment, which was developed in Italy and reached its culmination in the *Great Last Judgment* of Rubens (fig. 3), Beckmann has included himself. The great mass of those who are rising from their graves and striving upwards towards salvation is contrasted with the two dark bodies in the lower left corner of the painting. These figures appear to be devastated: one is hanging his head, the other is holding his ears.

Fig. 4 Hans Memling: *The Last Judgment*, 1466-73, Danzig, Museum Pomorskie

The proportional relationships are very different in the later *Resurrection*. Beckmann made allowances for this fact in his choice of format. Along with the stylistic reference to paintings of the late Middle Ages, this format also drew on the pictorial tradition of the diagonally structured representations of the Last Judgment common in northern Europe. *Last Judgment* by Stephan Lochner in the Wallraf-Richartz-Museum in Cologne, and Hans Memling's triptych of the *Last Judgment* (fig. 4) are examples of this. Common to all of these compositions is the fact that each is divided into three sections: in the middle section, the Universal Judge is seated above those who have been resurrected; on the left are those who have been saved; and on the right are the damned. It was therefore obvious that this division of the work into three parts should eventually be carried out literally by using the triptych form, as in Memling's painting. Beckmann also appears to have been thinking along these lines, for the *Resurrection* of 1916/18 contains the idea of the triptych in a precursory form. The constant presence of the painting confronted the artist with this problem every day in his Frankfurt studio. It would appear that, since the painting was not set up in Beckmann's Berlin studio when he moved there in 1933, he no longer felt he needed the picture (assuming the painting was not set up because of other external circumstances). He had already found a farther-reaching solution in his first completed triptych, *Departure* of 1932/33 (fig. p. 40).

We have already stated that the *Resurrection* of 1916/18 contained in essence all of the paintings that followed it and referred to all that had preceded it. This referential character can also be discerned in the details of the work. Beckmann cites another artist only at one point: the completely enshrouded figure in the upper left-hand corner of the painting, which seems almost to stand out from the painting, represents a paraphrase of one of the mourning figures from the tomb of Phillipe Pot, Grand Duke of Burgundy, of 1480, which Beckmann had seen in the Louvre.[11] The other references are limited to his own work. Thus, the foreshortened nude reclining at the lower edge of the painting was taken from the drypoint, *The Morgue* of 1915 (fig. 5; see also cat. 227). The figure in the upper left, already discussed as a representation of doubt, reappears again in 1935 as the sculpture, *The Man in Darkness,* (fig. p. 138), and plays a decisive role in its interpretation.[12] More significant, however, is the fact that Beckmann took the representations of himself, his family, and his friends in

11. Cat. Paris, Musée National du Louvre 1950, Marcel Aubert and Michéle Beaulieu, "Description raisonnée des sculptures du Moyen age, de la Renaissance et des temps modernes," I:*Moyen age,* p. 241-245, No. 355.

12. Stephan Lackner, *Max Beckmann,* New York, 1977, ill. 25.

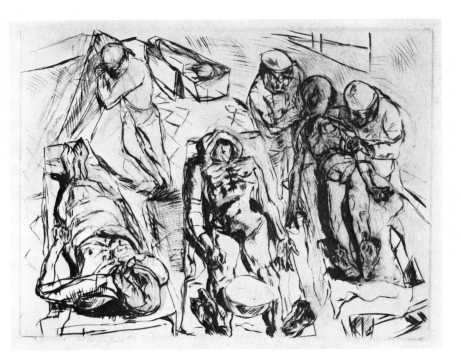

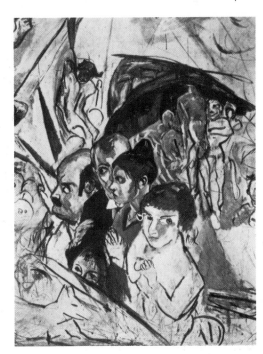

Fig. 5 Max Beckmann: *The Morgue*, 1915, drypoint, Frankfurt a. M., Städtische Galerie im Städelschen Kunstinstitut

Fig. 6 Max Beckmann: *Resurrection*, 1916-18, oil on canvas, Stuttgart, Staatsgalerie (detail with self-portrait)

the painting of 1916/18 from the painting of 1909. In this painting, as in the earlier one, the groups are placed in the lower part of the picture, and are distributed across the entire breadth of the canvas, so that they illustrate the tension between vision and reality in the same way. They make manifest the unavoidable truth, which can only be comprehended as a vision, that every individual is affected by the reality of death and resurrection. The loneliness of the human individual at the moment of judgment, his isolation in the infinity of space and eternity of time are further emphasized by the fact that the painter shows us human beings who are bound to each other by ties of blood and friendship. Yet they seem as incapable of communication as the dead. The isolation experienced on the final Day of Judgment has a retroactive existential effect on life itself, and for this reason the people themselves are interchangeable (fig. 6). In 1916/18, the Battenbergs have replaced the figures of Countess Hagen and Franz Kempner in the painting of 1909, whereby Fridel Battenberg has taken over the function of Franz Kempner as the device for establishing contact with the viewer. Minna Beckmann is praying in both paintings; in the later painting, she and her husband are observing the same figure. The connection with the painter (by means of their glancing in the same direction) is established in the earlier painting by the figure of Annemarie Tube, Beckmann's sister-in-law, whose praying stance is taken by the figure of Eve in the later one. Beckmann himself, however, is glancing in the direction of those who are without hope. The figure of the painter has been carried over completely from the earlier painting—his stance and clothing are the same—making clear just how little his view of the world had changed in the years between the paintings and as a result of his experience of the War. In his "Bekenntis" of 1918 he confirmed this: "The war is now coming to its sad end. It did nothing to change my ideas on life; indeed, it only served to confirm them."[13]

The Influence of Jean Paul's Dream Visions

The direction of Beckmann's glance, in particular his observation of the resurrection in the painting of 1916–18, indicates that he was reflecting on himself, i. e., that he was painting a vision of his own resurrection. He had become aware of the paradox of death, and of the fact "that we are not dead as living men, but not living as dead ones," through his study of the work of Jean Paul.[14]

13. Max Beckmann, "Schöpferische Konfession," see footnote no. I.

14. Käte Hamburger, "Das Todesproblem bei Jean Paul," in *Jean Paul. Wege der Forschung*, Vol. CCCXXXVI, edited by Uwe Schweikert, Darmstadt, 1974, p. 80.

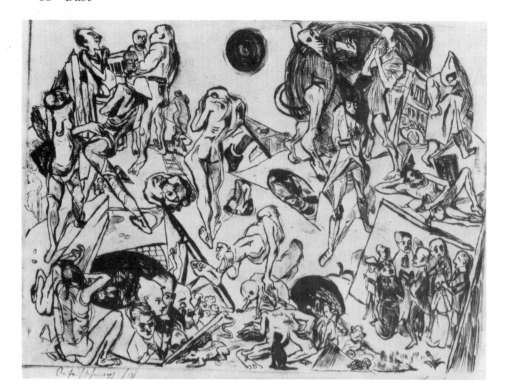

Fig. 7 Max Beckmann: *Resurrection*, 1918, plate 12 in the portfolio *Faces*, drypoint, Private collection

If we consider the relationship of reality to vision within this context, we come to a conclusion that was already reached by publisher Reinhard Piper in his memoirs: "Jean Paul was both a visionary and a realist at once, as is Beckmann. We both recalled his *Dream of a Battlefield,* his *Speech of the Dead Christ from Heaven to the Effect That There Is No God,* and the *Lenten Sermons in Germany's Week of Martyrdom.*"[15] Piper refers here to two important sources necessary to an understanding of Beckmann—the "Speech of the Dead Christ" from *Siebenkäs,* and "The Beauty of Dying while in the Prime of Life" from *Autumn Blossoms.* Both of these are dream visions. The "Speech of the Dead Christ..." which appeared in 1796, depicts the most extreme negation of anything that is meaningful through a cosmic vision of the disintegration of the universe. The goal of such a vision is, as Jean Paul emphasizes in his preface, the stimulation of genuine belief through a shock effect. In his preface, the poet makes the observation that atheism can be connected without any contradiction to a belief in immortality, "...since the same necessity which in this life threw my bright dew-drop of a self into a calyx or placed it under the sun can retrieve it in the next one—indeed, I can be embodied more easily a second time than I was the first." His text, "The Beauty of Dying..." written in June 1813 under the influence of the poet's experience of the partial annihilation of the Lützow volunteer corps, attempted to explain the deaths of German youths in the prime of life as something desirable, whereby "the young man or woman merely passes over from the inner land of the ideal into a higher land of the ideal..." and whereby "the angel of death, when many people are crawling around in their many days of suffering in cold, drafty, gloomy catacombs, suddenly destroys for them the cliffs which block the path to the Resurrection." Beckmann, who in World War I was subject to the same kind of experience as Jean Paul, was so interested in this essay that he directly adapted the metaphor of the catacombs for the drypoint *Resurrection* of 1918 (fig. 7).

In the second part of the text, Jean Paul describes a dream patterned after "The Speech of the Dead Christ...," which is a gruesome vision of death and annihilation. A monster leads the dreamer through many stations of the Passion to the gateway of the battlefield: "All at once, a heartrending sound of misery rose up from behind the gates, as if the universe were being rent asunder

15. Reinhard Piper, *Nachmittag,* Munich, 1950, p. 31.

16. I consider it to be a basic misunderstanding when Friedhelm W. Fischer, in *Max Beckmann,* New York, 1973, p. 11, notes: "what Beckmann has done is to merge together two separate types of painting: a drawing-room discussion and a vision of the general resurrection."

17. An example of this is "The Judgment of the World" by Hermann tom Ring in the Landesmuseum in Münster (for literature on this see Theodor Riewerts and Paul Pieper, *Der Maler tom Ring,* Munich-Berlin, 1955, No. 45 Table 46). Two kneeling patrons forced to pay attention to what is going on by an angel, observe the Final Judgment. One holds a book in his hands, in which the words from the 143rd Psalm can be read: "Enter not into judgment with thy servant, for no man living is righteous before thee."

18. Annemarie and Wolf-Dieter Dube, *Ernst Ludwig Kirchner – Das graphische Werk,* 2nd edition, Munich, 1980, No. 262-268.

19. Piper, *op. cit.,* p. 19.

because it had been created by the Devil rather than by God and had been abandoned to perpetual torture." The gates open up, and the horrors which the poet then witnesses cause him to sink in a faint to his knees: "What I saw was too hideous for any human being to look upon, and had no precursor in human memory." Then the dream image is transfigured to the islands of the blessed, where the young men who have died for the fatherland spend eternity in a state of constant bliss: "The cedar island came, as if it were flowing down, ever nearer to the green cloud. Young men, larger than in life, glanced down happily into the blue ocean and sang songs of joy: others looked with enchantment into the heavens and folded their hands in prayer. Several dozed in the bowers of the rainbows and shed tears of joy; behind them were lions, and eagles were circling above them." The reference already made to the group of young men in the background of the *Resurrection* of 1916–18, can now be explained in terms of Jean Paul's text. These are the young men whom time has sacrificed to eternity in order to save individuality.

Beckmann's thoughts and ideas revolve around this very irony of individuality, and it is because of this that he so often includes himself in his paintings, particularly in the representations of the resurrection. In so doing, he has associated himself with traditions. We are reminded of Michelangelo, who included his own portrait in the fresco of the *Last Judgment* as part of the flayed skin of St. Bartholomew. The example of Albrecht Dürer is also relevant: Dürer included the entire figures of both himself and his friend Konrad Celtis in the center of the painting, *The Martyrdom of the Ten Thousand*. The artist, whose friend is at his side, functions as a witness to the inferno of the martyrs or to the Day of Judgment and therefore also could be understood as part of the tradition of the *Divine Comedy*. This is especially true in the case of the *Resurrection* of 1909.[16] Finally, there is the tradition of the donor portrait, by means of which the living person is brought into the painting and thus associated with the blessed event being portrayed.[17] This presentation of the individual is meant not only as a way of continuing an image of the person after his death, but also to encourage him to pray during his lifetime and after his death, thus shortening the period of purification—an idea which is directly related to the resurrection.

The testing of the individual in this life and the overcoming of depression brought on by the loss of individuality—subjects which plagued Beckmann during the War— were certainly the inspiration for the *Resurrection* of 1916–18. However, the question of the hereafter, which was by necessity tied up with these problems, was one to which Beckmann did not have the answer at the time. Beckmann's contemporary, Ernst Ludwig Kirchner, had expressed his anxiety about the possibility of losing his individuality in a series of woodcuts, *The Wonderful Story of Peter Schlemihl*, 1915, entitled after Adelbert von Chamisso. Just as Kirchner was unable to complete the sequel because he could not satisfactorily represent the recovery of the soul, so Beckmann was unable to complete the *Resurrection*. He had had great plans for the painting, as he reported to Reinhard Piper in 1917: "I want to paint four more paintings of the same size, and build modern devotional halls for them."[19] Devotional halls? For what purpose, we must ask. Perhaps as a place in which to exhibit paintings like *Resurrection,* under the influence of the same sort of ideas which had inspired Jean Paul to write "The Speech of the Dead Christ...", in which he formulated in his preface: "If my heart ever feels as though it has died, and is so unhappy that all feelings within it which might affirm the existence of God have been extinguished, I would rejuvenate by reading my own essay, and it would heal me and return my feelings to me."

Translated from the German by Jamie Daniel

Sarah O'Brien-Twohig

Beckmann and the City

"Right now, even more than before the War, I need to remain among the people. In the city. Our place is right here. We must take part in all the misery that is to come. We must surrender our hearts and our nerves to the terrible cry of pain uttered by the poor, deluded people."[1]

With this unequivocal statement Max Beckmann defined his reaction to the First World War. It also constitutes a trenchant personal and artistic manifesto of his creative activity in the post-War period.

The War not only exposed Beckmann to terrible suffering, both physical and psychological; it also exposed him, like so many of his contemporaries, to the "condition humaine" which transcends the established social order and unites all men in their common fate. His war letters[2] chart the gradual erosion of his initial enthusiasm for the Nietzschean vitalism unleashed by war[3] and his eventual overwhelming disillusionment with the senseless suffering it caused.

But equally pervasive in Beckmann's letters is a spontaneous empathy with and love for his fellow men. Cast in with a cross-section of mankind for the first time, he is constantly filled with wonder and warmth by the sheer variety of human types he encounters: "There are marvelous people and faces among them. Many that I love and that I shall draw. Coarse bony faces with intelligent expressions and wonderful, primitive, direct opinions... masklike, senselessly witty, endlessly chattering faces, next to grotesquely humorous, truly funny faces. People with enormous heads and black, wild eyebrows next to good-naturedly smiling, gluttonous existences... Oh, at long last, life again!"[4]

In addition to depicting war-ravaged towns and scenes in field hospitals and morgues, Beckmann constantly sketched his fellow soldiers: eating, drinking, dancing, in the shower, even in the latrine. Every aspect of their lives fascinated him.[5] And when he wrote "Théâtre du Monde—Grand Spectakel de la Vie" across the poignant sketch of the *Man in a Wheelchair with a Crutch* (cat. 145), it is to some extent intended as an ironic allusion to pre-War vitalism. However, in another sense it refers to the War's crass juxtaposition of death and man's life-affirming ability to turn a blind eye to the proximity of death.

"Dear, petty bickering, commerce, and ambition go on as they did before, even though, a few kilometers from here, death is singing its savage song." He then adds, significantly: "How fortunate it is that people have no imagination."[6] It is this tolerance of the passivity of the masses that distinguishes Beckmann's post-War attitude from that of George Grosz. The latter emerged from the war seized with misanthropic contempt for his fellow Germans: "I feel no kinship with this human mishmash..."[7] and declared his intention to draw out of a sense of perversity, to convince mankind "that this world is ugly, sick, and a lie."[8]

Beckmann, on the other hand, directs his anger towards God because "he has made us in such a way that we are unable to love each other."[9] Unable to reconcile the existence of such evil with the concept of a benign and loving God, he felt that mankind had been cruelly deceived; hence all men, whether aggressed upon or aggressor, were deserving of his sympathy.

1. Max Beckmann, "Schöpferische Konfession" in *Tribüne der Kunst und Zeit* edited by K. Edschmid, Berlin 1918. Quoted here from "Confession 1918" in *Der Zeichner und Graphiker Max Beckmann*, exhibition catalogue of the Hamburg Kunstverein, 1979/80, p. 11.

2. Max Beckmann, *Briefe im Kriege*, Munich, 1955. Henceforward cited as *Briefe im Kriege*.

3. Ernst-Gerhard Güse, *Das Frühwerk Max Beckmanns*, Hamburg 1974, p. 77ff.

4. *Briefe im Kriege*, March 2, 1915.

5. Compare Stephan von Wiese, *Max Beckmanns zeichnerisches Werk* 1903-1925, Düsseldorf 1978, Nos. 236, 239, 248, 314.

6. *Briefe im Kriege*, March 4, 1915.

7. Georg Grosz, *Briefe 1913-1959*, edited by Herbert Knust, Reinbek 1979. Letter to Robert Bell, 1916-1917, p. 42.

8. Georg Grosz, "Abwicklung," *Das Kunstblatt*, Vol. 8, No. 2 (1924) p. 36.

9. Conversation with Reinhard Piper in: Reinhard Piper, *Nachmittag*, Munich, 1950, p. 33.

"It's really pointless to love mankind, this pile of egoism to which we also belong. But I do so all the same. I love them with all their pettiness and banality. With all their stupidity and their cheap complacency and their oh, so rare heroism. Yet nevertheless, every day, each human being, is a new event for me, just as if he had fallen down from Orion. Where can I satisfy this feeling more than in the city?"[10]

The city therefore becomes the peacetime equivalent of the human melting pot seen in the War. Only in the city can modern man fulfill his tragic destiny. Beckmann sees it as the artist's responsibility, indeed as his duty, that "Precisely now we must get as close to people as possible. This is the only thing that can give some motivation to our otherwise thoroughly superfluous and selfish existence. To give people a picture of their fate – and this can only be done by loving them."[11]

Fig. 1 Max Beckmann: *Wittenbergplatz (Berlin)*, 1911, lithograph, Private collection.

Detachment within the Milieu

The intensity of his identification with the life of the urban masses differs crucially from Beckmann's attitude toward the city before the War. Outwardly at least, mundane life in Berlin did not hold for him the magical throb of modernity lauded by Baudelaire and the Impressionists. Rather, he strove to give more universal expression to "the whole pulsating life of the flesh"[12] in monumental archaic melodramas such as *Battle of the Amazons* (cat. 11). However, as his first biographer, Hans Kaiser, noted in 1913: "It is hard to imagine Beckmann without Berlin," that he is "the painter who feels this sensation of life in Berlin, which he embodies, in artistic form, in the intellectual sensations and visions of his works."[13] Thus even the melodramatic tumult of the *Scene from the Destruction of Messina* (cat. 10) is, in a metaphorical sense, a realistic symbol of Berlin evoking the pathos experienced by the city dweller constantly exposed to every imaginable danger and sensation.[14] More recently, critics see in it the first instance of the city "as a place of unrestrained public crime."[15]

In either event, during these early Berlin years, Beckmann saw his immediate environment chiefly as a catalyst to his imagination, as the raw material to be transformed by a creative sensibility. Only in 1911 does he begin to show an interest in depicting events witnessed in the streets and cafés of the city. *The Kaiserdamm* (fig. p.74) demonstrates his concern for capturing the effects of sparkling light without sacrificing material substance. The result is a curiously detached milieu description. *Wittenbergplatz*, 1911 (fig. 1), his first lithograph of an urban scene, is a tentative attempt to evoke the bustle of a crowd of pedestrians. Although he uses the Impressionist device of a cropped figure to create a sense of immediacy, he is apparently unconcerned by the psychological tension of city crowds, which Munch had captured so hauntingly in *Evening on Karl-Johan Street, Oslo*, ca. 1892 (fig. 2).

A total change of mood is evident in *The Street*, 1911 (fig. p. 117). In this depiction of a desolate backstreet hemmed in by anonymous tenement blocks, Beckmann for the first time adopts a high viewpoint to convey the claustrophobic effect of the looming buildings on the ant-like people in the street. There is no horizon visible and no hint of vegetation in this sinister image of the city as a soulless gray monotony inimical to the dignity of human beings.

A comparison between this scene and Macke's *Our Street in Gray*, 1911 (fig. 3) illustrates succinctly the aesthetic controversy between Beckmann and Franz Marc, one of Macke's colleagues in the Blauer Reiter.[16] Macke's scene, with its delicately luminescent oranges and blues, is concerned solely with the "inner sound" and "the space-forming energy of color," i.e., with the autonomy

10. Max Beckmann "Schöpferische Konfession," *op. cit.* p. 12.

11. *ibid.*, p. 11.

12. Max Beckmann, *Leben in Berlin*, Tagebücher *1908-1909*, edited by Hans Kinkel, Munich 1966, p. 34.

13. Hans Kaiser, *Max Beckmann*, Berlin 1913, pp. 7-12.

14. *ibid.*, pp. 28-29.

15. Christian Lenz, "Max Beckmann-Das Martyrium," *Jahrbuch der Berliner Museen*, Vol. 16, Berlin (1974) pp. 185-210.

16. Max Beckmann, "Gedanken über zeitgemässe und unzeitgemässe Kunst," *Pan* II 1911-1912, No. 17, pp. 500-501. See also Dietrich Schubert: "Die Beckmann-Marc Kontroverse von 1912: Sachlichkeit versus innerer Klang," *Max Beckmann-Die frühen Bilder*, exhibition catalogue, Bielefeld, 1982.

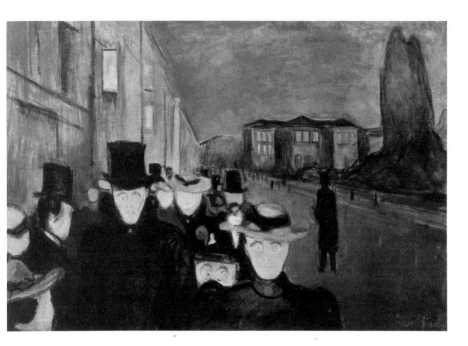

Fig. 2 Edvard Munch: *Evening on Karl-Johan Street, Oslo*, ca. 1892, oil on canvas, Bergen, Rasmus Meyer Collection.

Fig. 3 August Macke: *Our Street In Gray*, 1911, oil on canvas, Munich, Städtische Galerie im Lenbachhaus.

of form.[17] Beckmann, in keeping with his declaration that good art should combine "artistic sensuousness...with the artistic objectivity and detachment of the things represented,"[18] presents us with an expressively realistic evocation of the street.

Interestingly, some of the young Expressionist poets also fused intense feeling with concrete imagery, for example, Paul Zech's *Fabrikstrasse Tags* of 1911:

> *Nothing but walls. Without grass and glass,*
> *The street extends its motley belt*
> *of facades—no tram line whirrs.*
> *The pavement always glistens damply.*
>
> *If a man brushes past you, he touches you coldly*
> *Right to the marrow; the hard footsteps strike*
> *Fire from the tower-high steep fence,*
> *Even his short breath forms clenched clouds.*
>
> *No prison clamps all thought*
> *In ice, as does this walking*
> *Between walls that only look at one another.*[19]

That Beckmann was no Expressionist in the subjective manner developed by the Brücke artists is easily grasped by comparing the views he and Kirchner painted, in 1911 and 1912, respectively, of *Nollendorfplatz* (figs. 4, 5).[20] Both scenes are shown from a high viewpoint; Beckmann creates a broad panorama of the autumnal square, whereas Kirchner focuses intensely on the diagonal intersection of the busy, tram-laden square. Beckmann clearly responded in some degree to the aggressive vitality of the Expressionists' angular dynamism and use of bold splashes of pure color. However, at this stage Beckmann was more concerned with conveying "an unmistakable mood of the specific place" than with creating an "excitingly urgent street scene."[21] Hence his adherence to a detached viewpoint and broken colors, and his continued interest in specific architectural and seasonal qualities.

17. Gustav Vriesen, *August Macke,* Stuttgart, 1953, p. 132.

18. Max Beckmann, "Gedanken über zeitgemässe und unzeitgemässe Kunst" *op. cit.* p. 500.

19. In: *Twentieth Century German Verse,* ed. by Patrick Bridgewater, Harmondsworth, 1968, p. 72.

20. From 1910 to 1914 Beckmann and his family spent their winters in a studio apartment in a building at No. 6, Nollendorfplatz, since the house in Hermsdorf was difficult to heat. See Göpel, Vol. 1 p. 16.

21. Christoph Schulz-Mons, "Zur Frage der Modernität des Frühwerks von Max Beckmann," *Max Beckmann-Die frühen Bilder,* exhibition catalogue, Bielefeld, 1980, p. 144.

The Influence of Ludwig Meidner

By 1912 Beckmann was broadening his vision, seeking out more diverse experiences of city life. He made his first lithographs of people in cafés and bars. The impressionistic *Admiralscafé* (cat. 217) depicts the studied formality of an elegant café, while *Tavern* (VG 31) shows the more earthy milieu of a crowded workers' bar. The latter was possibly influenced by the tavern scenes of Jan Steen, whom Beckmann admired as a great humorist and dramatist.[22]

Among the factors that may have contributed to Beckmann's increased interest in city life was his visit to Ludwig Meidner's studio in 1912, which he later said had strongly excited him and given him new impulses.[23] Meidner was the first German artist to embrace the Futurists' call to evoke the frenetic activity of the big city, the completely new psychology of night life.[24] They aimed to create a synthesis of memory and optical perception by fragmenting and fusing all objects of perception so that their pictures would reflect the experience of simultaneity of the modern urban environment.

Fired by the idea that the cityscape consisted of mathematical battles, in which the human being feels physically besieged by the riot of lines and angles, Meidner exhorted German artists to paint "the tumultuous streets, the elegance of iron suspension bridges, the gasometers hanging in mountainous white clouds, the brilliant coloring of the buses and the locomotives of the express trains, the swaying telephone wires... the checkered kiosks, and the night... the night of the big city..." (fig. 14)[25] However, Meidner's own cityscapes have little of the dynamic optimism of the Futurists. Works such as *I and the City* were painted, mostly at night, with his back to the attic window; the reflection of his head in a mirror appears visually trapped in a quivering inferno of disembodied, endlessly shifting, linear fragments. Meidner's fundamentally pessimistic, demonic image of the city echoes that of Georg Trakl's poem *To the Silenced:* [26]

O the madness of the great city, when at nightfall
Crippled trees petrify beside the black wall,
The spirit of evil gazes from a silver mask.
The stony night displaces light with magnetic scourge.
O fading tones of evening bells.

Fig. 4 Max Beckmann: *View of Nollendorfplatz*, 1911, oil on canvas, Private collection.

Fig. 5 Ernst Ludwig Kirchner: *Nollendorfplatz*, 1912, oil on canvas, Private collection.

22. Max Beckmann, *Leben in Berlin, op. cit.*, p. 25.

23. Thomas Grochowiak, *Ludwig Meidner*, Recklinghausen, 1966, p. 38.

24. Umbro Apollonio, *Futurismus, Manifest einer künstlerischen Revolution 1909-1918*, Cologne, 1972, p. 38.

25. Meidner "Anleitung zum Malen von Grossstädten," 1914, in Grochowiak, *op. cit.*, p. 80.

26. *Georg Trakl Poems*, trans. by Lucia Getsi. Athens, Ohio, 1973, p. 125.

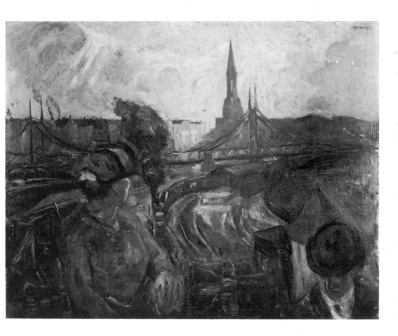

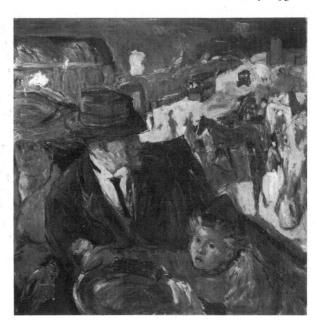

Fig. 6 Max Beckmann: *View of the Gesundbrunnen Station*, 1914, oil on canvas, Wuppertal, Von der Heydt Museum.

Fig. 7 Max Beckmann: *In the Automobile*, 1914, oil on canvas, Private collection.

Whore, who in icy tremors bears a dead child.
God's thunderous wrath lashes the foreheads of the possessed,
Purple pestilence, hunger shatter the green eyes.
O the horrible laughter of gold.

But mute humanity bleeds quietly in a dark cave,
Shapes the redeeming head out of hard metals.

Between 1912-14 the strong stimulus Beckmann speaks of is reflected chiefly in his more adventurous choice of urban themes, e.g., *Construction of the Hermsdorf Water Tower*, 1913 (fig. p. 114) and *Falling Bicycle Rider*, 1913 (fig. p. 75) and in his explicit depiction of contemporary disasters such as *The Sinking of the Titanic*, (cat. 12). Technically, however, he was reluctant to pursue Meidner's geometric and coloristic anarchy, preferring to maintain the more concrete reality of his paint surface. He only absorbed the full implication of Meidner's formal fragmentation in 1915 when he chose to depict the nightmarish chaos of a grenade exploding among a group of soldiers, an event he had witnessed at the battle front (cat. 228).

By comparison with either Meidner's pathetic visions or with Kirchner's aggressively distorted depictions of Berlin streets and prostitutes, Beckmann's *Street at Night* (cat. 13) still renders an impartial, objective reality. The trams, taxis, and cyclists in the bustle of the evening traffic are the only token gestures towards modernity. The Futurist synthesis of experience and memory still eluded him.

In *View of the Gesundbrunnen Station*, 1914 (fig. 6), he begins to adopt Meidner's device of silhouetting cropped foreground figures against the panorama of the railway to create a sense of immediacy. However, the dominant horizontality of the composition is more reminiscent of Munch's static configurations than of Meidner's dynamic angularity. The stormy sky which pervades the scene can either be taken as continuing evidence of Beckmann's concern with objective reality or, as has been suggested recently, as a "symbol of impending danger."[27]

In the Automobile, 1914 (fig. 7) is far bolder in conception. The spectator looks down on the Beckmann family seated somewhat tensely in an open taxi, which fills over half the canvas. Behind them, the diagonal, traffic-filled street shoots away in distorted perspective to convey the passengers' sensation of

27. See Hans Günther Wachtmann, *Kommentare zur Sammlung*, 2, pp. 4-9, for an extensive analysis of this work.

Fig. 8 Max Beckmann: *Brothel in Hamburg,*
1912, drypoint, Bremen, Kunsthalle.

being in the speeding vehicle. But as Beckmann uses neither Futurist fragmen-
tation nor brilliant Expressionist colors, the effect is paradoxically one of monu-
mental heaviness. Furthermore, the awkward spatial context established be-
tween the figures hints at psychological tension for the first time in Beckmann's
contemporary scenes. It foreshadows his subsequent interest in the psychologi-
cal interaction within a group. This tendency is further intensified in *The Street*
(cat. 14), where, for the first time, we encounter Beckmann's taut, anxious face
staring out of a bustling city crowd.[28]

Sexuality in the Big City

Another outcome of the new impulses he took from Meidner is his sudden
interest in depicting the theme of sexual attraction in a contemporary context.
The Nietzschean concept of love as a cruel and inevitable fatality had of course
played a major role in many of his early works, but it had been safely couched
behind the facade of mythological and Biblical scenes, e.g., *Samson and Delilah*
(cat. 215 and Göpel 155). Now Beckmann took up the challenge issued in the
1910 *Futurist Manifesto* to find artistic inspiration in the feverish atmosphere of
the city at night, with its bizarre array of characters, bon vivants and coquettes,
ruffians and drunkards.[29]

His first depiction of a brothel scene, the lithograph *Ulrikusstrasse in Ham-
burg* (cat. 216), is the first of a number of works based on his experiences in the
Hamburg 'Hafenkneipen' in March 1912.[30] It shows a group of girls soliciting
near the brothel doorway; one nude prostitute poses provocatively, implying
she could fulfill the male voyeur's every need. Although compositionally the
scene maintains the cool detachment of the casual observer, it is nevertheless
Beckmann's first attempt to give direct, contemporary expression to powerful
sensuality. As the following comment from 1909 reveals, it had long been in his
mind: "Sketched a scene from the Friedrichstrasse, which I noticed yesterday
on the way home... Men walking and turning around to look at a couple of
prostitutes. The women likewise turn around to look at the men... I would like
to include something of the thrill and magnetism which draws the sexes
together, especially when I am in the street, something that constantly fills me
with admiration for the magnificence of nature."[31]

28. To obtain this heightened effect, in 1928
Beckmann cut away almost two-thirds of the
picture's breadth, giving the remainder its high, steep
format. See Göpel, Vol. 1, p. 125.

29. Umbro Apollonio, *Der Futurismus*, op. cit., p. 38.

30. According to Göpel, Vol. 1, p. 16, this trip to
Hamburg and Helgoland took place in May 1912.
However, two sketches of this trip are precisely
dated: *Entwurf für die Nacht* 19.3.12 (von Wiese
102) and *Fahrt n. Helgoland* 24.5.12 (von Wiese
128).

31. Max Beckmann, *Leben in Berlin*, op. cit., p. 23.

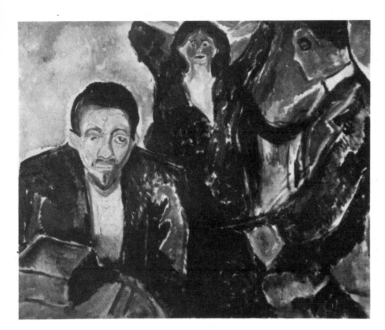

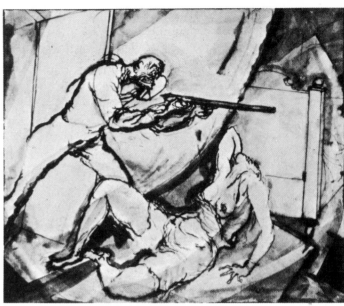

Fig. 9 Edvard Munch: *Passion,* 1913, oil on canvas, Oslo, Munch Museum.

Fig. 10 George Grosz: *Sex Murder,* 1912/13, pen and ink, private collection.

32. See the treatment of this theme in Beckmann's plays, *Das Hotel,* 1921, typescript in the archives of the Max Beckmann Society, Munich, and *Ebbi,* Vienna, 1924; reprinted, Berlin 1973.

33. See Rudolf Arnheim, *Art and Visual Perception,* Berkeley-Los Angeles, 2nd edition, 1974.

34. Max Beckmann, *Leben in Berlin, op. cit.,* p. 32.

35. von Wiese 102: "Two variations of a sketch for *The Night;* the upper version has notes concerning color, from which Beckmann's intention of executing the composition as an oil painting has been deduced.

With biting drama, *Brothel in Hamburg,* 1912 (fig. 8) depicts the problem of translating this fantasy into reality. Inside the claustrophobic confines of the brothel, our eye is drawn over the backs of two naked prostitutes to the male huddled before them. It is clearly a self-portrait. Detached objectivity has given way to the intense involvement of the voyeur as participant. Roles are dramatically reversed from the former scene: now the male cowers fearfully before the powerful reality of female sexuality in a manner reminiscent of Munch's *Passion,* 1913 (fig. 9). Compositional parallels are evident also, except that in Beckmann's scene the male is not rejected but initially paralyzed by the confrontation. His defensive stance is further characterized by the fact that he is still wearing his hat. However, the bowler hat of his contented alter-ego at the right, symbolically placed on the table between the girls, implies eventual satisfaction.[32]

Having left the rhetorical realm of voyeuristic fantasy, Beckmann sees sex not as a potential mystical union of souls, as Munch had, nor as a simple sensuous pleasure, as Pascin did, but as a necessary expedient in the individual's struggle for self-discovery. In order to give explicit expression to his increasing awareness of this tension, for the first time he feels intuitively drawn to the drypoint medium, exploiting its tendency to sharp angularity and harsh transitions between black and white areas to create a mood of dispassionate intensity. The acerbic quality of the drypoint line hinders any illusion of space or atmosphere, producing the desired effect of alienation and reducing the image to a "disembodied statement of properties."[33]

This change in graphic technique seems to be indubitably linked to Beckmann's concern with depicting the tensions of urban life. He does not use lithography again (apart from several instances) until the portfolio *Hell* in 1919 (cat. 247-257), by which time he was able to free the technique from any picturesque or atmospheric quality.[34] In short, the emergence of the drypoint technique in 1912 reflects his response to Meidner's exhortations to give honest expression to the unique problems of modern city life. It also marks an important development in Beckmann's search for objectivity.

Another composition dating from the same trip to Hamburg in 1912, *Sketch for "The Night,"*[35] executed later as a drypoint (cat. 225), shows the egotism of sexuality degenerating into the indifferent brutality of a sexual murder. Grosz also was intrigued by macabre murders, especially sex murders, and stimulated by Edgar Allan Poe, cheap detective novels ('penny dreadfuls'), and newspaper

reports of sensational murder cases.[36] The numerous urban murders at this time, many of them sexual in nature, were seen by contemporary criminologists as symptomatic of the inhuman living conditions and callous exploitation of the poor in the rapidly expanding German cities, especially in Berlin.[37] The sexual murder in particular was equated with the social sickness of the modern city. It can only be assumed that Beckmann was also, indirectly at least, influenced by similar sources.

However, Beckmann's approach to the theme differs significantly from Grosz's. The latter tends to focus on the violent act itself or on the dismembered female corpse flung across the bed, e.g., *Sex Murder,* 1912-13 (fig. 10) or *Double Murder on the Rue Morgue,* 1913. In *The Night* (cat. 225) Beckmann focuses instead on the three spectators, a man and two semi-clad women, staring with ghoulish morbidity at the corpse of a man whose final struggle has thrown him partly off the bed. Are they voyeurs, or perhaps also participants? The ambivalence of their attitude is clearly intentional, and the ambiguity of the whole scene is further heightened by the fact that the victim is no longer a woman but a well-built man.

This ambiguity is the key to the painting of *The Night* (cat. 19), Beckmann's major post-War statement about the nature of human aggression and brutality in general.[38] The anonymous mass murder of war is seen as a logical extension of sexual aggression and the horror of the sexual murder.[39] *The Night* gives expression to the entire misery that is to come which Beckmann writes about in the "Schöpferische Konfession". The atrocity takes place in a claustrophobic attic-like dwelling, reminiscent of the deadening, inhuman atmosphere of a vast urban tenement block. As in the earlier drypoint, the distinction between the victims and the aggressors, between the innocent and the criminal, between good and evil is deliberately blurred, implying that it is man's fate to be both.[40]

The Great Orchestra of Humanity

From the autumn of 1915, when he settled in Frankfurt, the city was no longer for Beckmann primarily an external phenomenon. He could not see it as an exciting symbol of mechanized beauty as Léger did, nor did he share the fascination of Brecht and Grosz for American cities, particularly New York. To Beckmann the city now meant people, the plethora of human types he had encountered in the War. It was for him the great orchestra of humanity,[41] in which individuals were locked in the struggle of their common fate. His tragically ironical *Resurrection,* 1916 (fig. p.83) significantly shows human society about to emerge, albeit unwillingly, out of dark, grave-like trenches into a horrific scene of urban devastation and human suffering. It is at once a fusion of Meidner's apocalyptic cityscapes and the "strangely unreal cities like mountains on the moon" he commented on seeing in the battlefields of Flanders.[42] The devastated city had become a material emanation of the evil of war, for which Beckmann, in a rage of negative piety,[43] held God responsible. Painting "out of spite against God"[44] he nevertheless refused to succumb to the annihilating pessimism that beset Grosz at this time.

What saved Beckmann was his unbounded love for his fellow man. He saw the individual as the only source of good[45] and set himself the task to "find the self in animals and men, the heaven and hell which together form the world in which we live... And for this reason I am immersed in the phenomenon of the individual, the so-called whole individual, and I try in every way to explain it and depict it."[46]

Beckmann was convinced that only in the freedom of the city and in the anonymity of the crowd was man able to find his true self. Yet he was also aware

36. Uwe Schneede, *George Grosz, op. cit.,* p. 16.

37. See also Dr. Erich Wulffen, *Psychologie des Verbrechens,* Berlin, 1910, p. 355.

38. See von Wiese, *op. cit.,* pp. 152-164.

39. Between 1919 and the beginning of 1922 at least 376 people were murdered for political reasons; the perpetrators were not apprehended.

40. See also Alfred Döblin, *Mein Buch "Berlin Alexanderplatz,"* 1932, in Alfred Döblin, *Berlin Alexanderplatz,* Munich, 1980, p. 412: "...just as it is impossible to draw a clear line between that which is criminal and that which is not, just as society—or rather, the part of society that I saw—was eroded at every possible turn by criminality. That in itself was a peculiar perspective."

41. Max Beckmann, "Schöpferische Konfession," *op. cit.,* p. 12.

42. *Briefe im Kriege,* p. 49.

43. Friedhelm W. Fischer, *Max Beckmann-Symbol und Weltbild,* Munich, 1972, p. 34.

44. *ibid.,* p. 19.

45. See Max Beckmann, *Sichtbares und Unsichtbares,* edited by Peter Beckmann, Stuttgart, 1973, in reference to Beckmann's marginal notations in Deussens "Allgemeine Geschichte der Philosophie," Vol. 1, p. 377: "Development towards the highest possible good is true only in the case of the individual, but still there is somewhere—despite everything—a connection to humanity as a whole, the problem being that one has to reckon with expanses of time lasting not hundreds, but thousands or even millions of years."

46. Max Beckmann "On My Painting" in M. Q. Beckmann: *Mein Leben mit Max Beckmann,* 1983, p. 190 and p. 196 (address delivered in London, 1938).

of the paradox that the existential loneliness of the individual is felt most strongly when in a crowd: "The more time I spend with people, the more unreal I seem to myself."[47] Beckmann shared Grosz's passionate hatred of collectivism as the greatest threat to mankind; hence, the individual struggle for self-realization was a matter of life and death. Thus, in the years after the War he explored, predominantly in his graphic works, the psychology of the individual and the dynamic of his relationship to the urban crowd.

Beckmann observed the phenomenon of loneliness in a crowd among his immediate circle of friends in Frankfurt. In the drypoint, *Party* (cat. 229), Fridel Battenberg stares hauntingly out of the crowd of her family and friends, symbolizing the grotesque paradox of their individual isolation. Focusing on the figures' heads, the composition fuses the spiritual intensity of Bosch's depiction of *Christ Crowned with Thorns* with the psychological intensity of Ensor's *Self-Portrait with Masks*.[48] In *Company III. Family Battenberg,* 1915 (fig. p. 58) Beckmann uses spatial distortion and awkward perspectives to convey his own feeling of isolation even among loving friends. The illusory nature of their apparent closeness is symbolically indicated by the skeleton hovering behind.[49]

Frankfurt – Stronghold of Expressionism

Beckmann remained based in Frankfurt from autumn 1915 until his dismissal from the Städel in 1933, making only brief visits to Berlin, Graz, and other cities. This was apparently a conscious decision[50] and is central to any evaluation of his attitude about city life. Curiously, the artist makes very few explicit statements about Frankfurt itself. For example, the autobiographical note he wrote for the Piper brochure in 1923 contains only the following obliquely ironical comment: "By accident I ended up in Frankfurt am Main. There I found a river I liked, a couple of friends, and also a studio."[51]

His complex relationship to Berlin was decisive in his attitude to city life and to the mysterious interaction between the individual and the crowd. In the years immediately following the War Berlin had negative associations for him, both on a personal and a suprapersonal level. He hated Berlin, its cold rudeness and snobbery.[52] He described it as corrupt and spiritless,[53] and insisted that the exhibition of his recent work being planned in 1920 by I.B. Neumann, his Berlin dealer, should first be shown in Cologne because that city was fresher and livelier. Presumably he was referring to the Cologne Dadaists Johannes Baader, Hans Arp, and Max Ernst and their notoriously provocative exhibitions in 1919 and 1920.[54] Although there is no record of him actually visiting Cologne at this time, he clearly associates that city with an open-minded, progressive society in which his stark objectivity might more easily be accepted.

In a perverse way Beckmann seemed to relish the fact that Frankfurt showed such reluctance to come to terms with the existentially necessary mixture of somnambulism and the terrible clarity of consciousness[55] of his post-War works.

"It's very interesting for me to be here right now, because Frankfurt and the *Frankfurter Zeitung* are a stronghold of Expressionism. Nevertheless, through my pictures I have already succeeded in convincing quite a number of people that the whole Expressionist affair is really nothing but a decorative literary one, which has nothing to do with a lively feeling for art."[56] In Beckmann's early Frankfurt years, Expressionist painters such as the Brücke artists and Kokoschka were regularly exhibited at Ludwig Schames' gallery. His dismissal of Expressionism in the "Schöpferische Konfession" as a false and sentimental mysticism, in contrast to his own naturalism against the self which produces an objectivity of inner vision,[57] is illustrated with exemplary forcefulness by comparing his *Self-Portrait with Red Scarf,* 1917 (fig. 11) to Kirchner's self-portrait

47. Max Beckmann, *Tagebücher 1940-50*, Munich 1979. October 27, 1945.

48. Beckmann visited Ostende, where Ensor lived, in 1915.

49. A motif of the *memento mori*, frequently occuring with Ensor.

50. For example in 1919 he turned down a position at the School of Art in Weimar. (Göpel, Vol. 1, p. 18.)

51. Letter to the editors of the Piper publishing firm, March 1923, in: *Almanach 1904-1924 des Verlages R. Piper & Co.*, Munich, 1923, pp. 79-86.

52. Julius Meier-Graefe, "Gesichter," 1919, *Blick auf Beckmann*, edited by Baron von Erffa and E. Göpel, Munich, 1962, p. 53.

53. Letter to I.B. Neumann, March 11, 1920.

54. In May 1920 for example, a performance took place in the Winter Brewery, at which a little girl in a white communion dress recited obscene poems at the entrance to the toilets.

55. Letter from Beckmann to Reinhard Piper, May 1917, in: Reinhard Piper, *Briefwechsel mit Autoren und Künstlern, 1903-1953*, Munich 1979, p. 161.

56. Beckmann's letter to Reinhard Piper, February 18, 1918; see footnote above.

57. Max Beckmann, in the catalogue for his graphics exhibition with I.B. Neumann, Berlin 1917.

as *The Drinker,* (fig. 12) painted during his 1915 nervous breakdown and exhibited at Schames' in 1916.[58] Half-dazed with world-weariness and pain, Kirchner gazes helplessly ahead as though united with the eternal in a trance,[59] the feeling of spiritual dislocation further heightened by discordant Expressionist juxtapositions of color. Beckmann, in contrast, "stares horror in the face"[60] and grits his teeth so as not to succumb to Kirchner's self-piteous despair. His outstretched hand has none of Kirchner's limp passivity; rather, it expresses his grim determination to make the most objective record of the horror he is witnessing. The corpse-like flesh tints, the thinly applied paint, and the anatomical and spatial distortions combine to create an expressive yet critically realistic statement. Both employ grotesque elements to achieve the desired shock effect. But by filtering it through his declared anti-naturalism, Beckmann avoids the rhetoric of Expressionism to reveal instead the ultimate truth concealed beneath the surface.[61]

Frankfurt in these years was also a stronghold of Expressionist drama. Kaiser's *Die Koralle* followed by *Gas* and Fritz von Unruh's *Ein Geschlecht* were presented there in late 1917 and 1918. These plays expressed despair and moral condemnation of reality, against which the playwrights posited their utopian hope in the renewal of society through "the new man." But their naive belief that this could be achieved by stirring men's hearts meant that instead of seeing post-War society with critical objectivity, they indulged in the anachronistic luxury of an expressive idealism—an idealism of intoxication.[62] Kaiser's oversimplified condemnation of industrialization as the cause of the War and as destructive to the integrity of the individual, and Toller's and Unruh's call for fraternity and philanthropy as the solution to humanity's malaise evaded the issue of how to confront the problems of a war-torn society. They ignored ways to construct a positive future out of the War experience, both in human and in material terms. Instead they strove blindly "in an almost frenzied attempt to overthrow reality, which proves itself the stronger. The intoxication of the Expressionist play simultaneously affirms its obsolescence."[63]

Beckmann dissociated himself completely from the rhetoric of Expressionist writers and artists, sharing instead Karl Kraus' more pragmatic and mature judgment of the situation: "...greater than the shame of war itself is the shame of those people who do not want to know about it, who accept that war happens, but not that it has happened."[64]

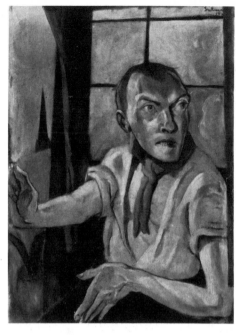

Fig. 11 Max Beckmann: *Self-Portrait with Red Scarf,* 1917, oil on canvas, Stuttgart, Staatsgalerie.

Existential Chaos in Berlin

For all his personal reservations, Beckmann acknowledged that Berlin was the arena where post-War chaos, hypocrisy, and misery were being acted out in great intensity. Berlin embodied for him the quintessence of 20th-century man's tragic destiny; it was an existential hell in which the individual must struggle to find his true salvation.

Several letters to Reinhard Piper reveal his ambivalence toward Berlin at this time. "I am happy to be back in Frankfurt. Just spent a couple of days in Berlin, making the usual spot-checks.[65] Starting Tuesday I will be in Berlin for a few days to complete some ideas I have about a certain theme."[66] Berlin was still an important catalyst to his imagination. However, he no longer saw it as an external phenomenon but as an abstract concept symbolizing the existential trauma of the 20th century.

Beckmann always insisted that the spiritual world was totally separate from the world of political reality. Hence he never felt drawn to make explicit political comments. He did not play with any idealistic notions of changing society; nor did he feel the cynical need to ridicule its shortcomings. As he stated in the

58. In 1916 Schames also exhibited Kirchner's *Friedrichstrasse, Berlin,* which probably influenced Beckmann's later ideas about painting cityscapes.

59. See Donald E. Gordon, *Ernst Ludwig Kirchner,* Munich, 1968, p. 108.

60. *Briefe im Kriege,* October 3, 1914: "I have been drawing, which protects one against death and danger."

61. See Thomas Mann, *Betrachtungen eines Unpolitischen,* Berlin, 1918, p. 584: "What is grotesque is more than true, excessively true, not what is arbitrary, false, unreal and absurd."

62. Günther Rühle, *Theater für die Republik 1917-1933. Im Spiegel der Kritik.* Frankfurt 1967, p. 13.

63. *ibid.,* p. 13.

64. Karl Kraus, *Die letzten Tage der Menschheit,* Vienna, 1919, Foreword.

65. Letter to Reinhard Piper, May 9, 1921, in: R. Piper, *Nachmittag, op. cit.*

66. Letter from Beckmann to Reinhard Piper, April 8, 1923, in: Reinhard Piper, *Briefwechsel mit Autoren und Künstlern, op. cit.,* p. 171.

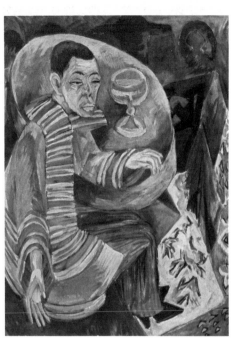

Fig. 12 Ernst Ludwig Kirchner: *The Drinker*, 1915, oil on canvas, Nuremberg, Germanisches Nationalmuseum.

"Schöpferische Konfession," he saw his role as that of the detached observer who dutifully penetrates the illusory surface of world events to reveal their impact on the ordinary man in the street. Probably he would not have been able to achieve the necessary distance from current events had he actually lived in Berlin. He could actively nurture his detachment and enjoy the relative peace and isolation of Frankfurt in order to make the most objective statement possible.

Beckmann chose to comment on the major political and economic events in Berlin between 1918-1923 and on the ensuing poverty and misery they brought to the city's population in a series of graphic works: *Faces,* 1918; *Hell,* 1919; and *The Berlin Trip,* 1922.[67] The last two are based on actual experiences in Berlin. Conceived as cyclical journeys through the awful reality of life in post-War Berlin, they are symbolic of the human tragedy of the time. The theatrical analogy is apt, for Beckmann originally thought of calling *Hell* "World Theatre" and considered *The Berlin Trip* as the moral sequel of the earlier cycle.[68]

Beckmann used the graphic cycle to create a visual stream of consciousness that would convey the tempo of city life. Juxtaposing the different scenes, he could create the sensation of moving through the various strata of urban society, observing their reactions to the historical events taking place in their midst. As in film, in which Beckmann was interested all his life, a series could allow the meaning to emerge not just from each individual scene, but also obliquely from the abrupt shifts of mood between one frame and the next. Indeed, the graphic cycle was in one crucial respect superior to film in that like time, it was simultaneously synchronic and diachronic.

Beckmann the observer cast his gaze back and forth among streets filled with starving cripples, brutal political murders, poverty-striken workers, fanatical political groups; rampant violence and murder; the compulsive ecstasy of wild dancing and nightclub life; the threatening stranglehold of patriotism; the last stand of the Spartacists; and conflict within the family.

Beckmann's interest in the expressive potential of the graphic series as a means of giving 20th-century society "a picture of their fate" links him with the 18th-century English artist, William Hogarth. Beckmann owned a Hogarth engraving of *The Night,* about which he commented to Piper in July 1919: "To me, this engraving seems beautiful. Things like this make me happy. Brueghel, Hogarth, and Goya, all three have that metaphysical objectivity which is also my goal."[69]

Hogarth was the first European artist to depict the corruption and loneliness of city life. He was also among the first artists of the modern era to adopt the graphic cycle, because it is inexpensive and flexible, in order to reach the widest possible audience with his moralizing sagas. Like Beckmann, he wished to turn a merciless spotlight on the moral vicissitudes of his age, especially the exploitation of the socially weak and man's cruelty to his fellow man. Like Beckmann, Hogarth believed that men reveal their true natures only through actions: "My picture is my stage and men and women are my players who by means of certain actions and gestures are to exhibit a dumb show."[70] Both artists were fascinated by the interaction of individuals in society, and both aimed to strike the passions of the spectator by means of negative statements. But underlying Hogarth's social criticism was an essentially optimistic belief, derived from Shaftesbury and Locke, in the innate goodness of human nature and the moral susceptibility of the human conscience. He was thus able to spice his didactic polemics with satire, burlesque, and parody in order to "laugh mankind out of its favorite follies and vices."[71] One of his last cycles, *The Four Stages of Cruelty,* 1751, with its insistent warning that vicious behaviour inevitably leads to murder, preempts with uncanny closeness the tenor of Beckmann's analysis of the inherent aggressiveness of Berlin society in the years after the First World War.

67. *Faces* was not conceived as a complete portfolio. Beckmann and Meier-Graefe compiled it from Beckmann's post-War work. See the letter from Beckmann to Meier-Graefe, mid-March 1919, in the Piper archive, Munich. *The Annual Fair,* a series of ten drypoints published by Piper in 1922, was not included, since it is a treatment of a symbolic theme, reflecting human existence as a whole by means of an allegorical code.

68. See the letter to Meier-Graefe, August 7, 1918, and letter to Piper, April 21, 1922 (Piper archives, Munich).

69. Conversation with Piper, July 1919, Piper archives, typescript.

70. Frederick Antal, *Hogarth,* London 1962, p. 143.

71. *ibid.,* p. 8.

Fig. 13 Max Beckmann: *Self-Portrait*, 1919, title page of the portfolio *Hell*, lithograph, Private collection.

However, Beckmann could not sustain Hogarth's belief that moral goodness could be taught. His cycles are motivated by the moral imperative to force his contemporaries to see the horror they have perpetrated, to shock them out of their apathy with his relentlessly negative statements. Optimistic satire gives way to tragic irony: he moralizes, but not didactically, for in this modern hell on earth there can be no exemption from the collective despair.

The Artist as Witness and Participant

The central theme running through all Beckmann's cycles[72] is the moral dilemma of the individual struggling against all odds to realize the saving potential of his true self. Thus each cycle opens with a self-portrait which not only serves as a prologue to the scenes of human disaster that follow, but also stands as an explicit declaration of Beckmann's dual role as witness and participant. He confronts us variously, clenching his stylus and with unflinching gaze (*Self-Portrait with Stylus*, cat. 233); peering out of a tomb-like hole with the flames of hell reflected in his anxious face (*Hell, Self-Portrait*, fig. 13, cat. 247); or as the responsible artist, who from the transient anonymity of a hotel window conscientiously records the events below (*Self-Portrait in the Hotel*, 1922 VG 212).

What does he see? First is the destructive effect of war and the ensuing social upheaval on the family, mirrored in his own immediate experience.[73] In *Family Scene (Beckmann Family)*, 1918 (cat. 239) his wife, son, and mother-in-law are seated on their balcony, forming a self-contained, stable triangular group ironically reminiscent of the Renaissance ideal of the Holy Family. Beckmann's pensive head projects awkwardly from a window behind them, conveying his acute feelings of isolation and despair; his pose is an ironical adaptation of medieval depictions of God the Almighty looking down from heaven.

In *The Family*, 1919 (cat. 257) his despair has turned to rage as he points up to what he believes is the divine source of evil in the world.[74] His pious mother-in-law counters with an emphatic gesture of denial, while young Peter innocently plays war with a helmet and hand grenades,[75] an ironic allusion to humanity's inability to learn from experience. Beckmann uses gestures as do Hogarth and Brecht: to reveal man's true self through his actions and reactions; this is the metaphysics of objectivity of which he speaks.

72. The cycles are not analyzed in detail, but considered thematically.

73. See Göpel, *op. cit.*, Vol. 1, p. 17.

74. See F. W. Fischer, *Max Beckmann, Symbol und Weltbild*, *op. cit.*, p. 19, footnote 21.

75. He thinks the hand grenades are tin cans. See Peter Beckmann's contribution to this catalogue.

Fig. 14 Ludwig Meidner: *Billowing Crowd*, 1913, etching.

The family is also seen as the most passively helpless social group in the face of food shortages (*Hunger*, 1919, cat. 251) and inhuman living conditions (*The Night*, 1922, cat. 275). Both contain ironic religious allusions, the former to the miracle of the loaves and fishes with the statue of Christ as the Good Shepherd in the background, while in the latter the destitute family huddles uncomfortably in the empty tenement room like the soldiers sleeping their way through the Resurrection.

In *The Way Home*, 1919 (cat. 248) Beckmann focuses intensely on the misery of the city streets. He depicts himself as the sympathetic, morally responsible citizen prepared to confront the continued human suffering caused by the War. It is with tragic irony that he finds himself met under the proverbial lamplight not by the promise of sexual pleasure—the prostitute hovers in the background—but by an appallingly disfigured war cripple whose physical deformity is accentuated by the dog's vitality. Beckmann's gesture indicates his solidarity with the cripple. The expressively angular forms of the figures project awkwardly out of the composition, heightening the zoom lens effect. The figures literally burst out of their cramped space, illustrating Beckmann's belief that through the evil of the war, mankind has forfeited all right to "space...the infinite divinity, which surrounds us and in which we ourselves exist."[76] Beckmann then widens the angle of his lens to take in the panorama of *The Street*, 1919 (cat. 249) "the frightening image of a mass of disturbed people unable to communicate."[77] It is one of the few instances in his post-War figurative scenes where he indicates a specific location—the spires of the Kaiser Wilhelm-Gedächtnis-Kirche are just visible on the horizon. The nervous diagonal lines of the cubo-futurist technique are exploited to create a sense of claustrophobic urgency. All forms, as well as the space containing them, are distorted and compressed into a series of staccato juxtapositions of straight and crooked lines and of black and white areas, creating "roundness in the surface, depth in feeling, the architecture of the picture,"[78] which he regarded as essential for the metaphysical objectivity of his interpretation of the tragedy of human existence. The city street is seen as a veritable inferno in which the suffering, deprived, and exploited masses mutually alienate and violate each other in a vicious dance of death. In the midst of the cripples, beggars, and prostitutes, several elegant bourgeois arrogantly refuse to acknowledge the reality before them. The print constitutes a bitter comment on the rhetorical exhortations to fraternity and humanitarianism being proclaimed by the Expressionists.

76. Max Beckmann, "On My Painting," *op. cit.*, p. 190.

77. F. W. Fischer, *Max Beckmann*, Zürich, 1976, p. 20.

78. Max Beckmann, "Schöpferische Konfession," *op. cit.*, p. 11.

Beckmann's expressive realism conveys unequivocally his conviction that "filth is the same everywhere," and that no one can be spared the psychological aftereffects of the War. Beckmann is almost more distressed by the unbridled aggression in post-War Berlin than he had been by the organized brutality of war itself. Only in the post-War series of city subjects does he fully explore the formal and psychological implications of Meidner's dynamic cubo-futurist fragmentation (fig. 14).[79]

Beckmann's social criticism differs fundamentally from that of his contemporaries in that it is always tempered by his compassion for and identification with the universal human condition. He reserves his anger for God. In contrast, Dix directs his anger towards humanity, and presents his war cripples as grotesque, repulsive caricatures. He uses physical distortion and the psychological potential of the collage to heighten the shock value. This is especially evident in the dog urinating on the blind *Match Seller*, 1920 and the appalling collage of advertisements for false limbs and sex aids in the background of the *Prague Street*, 1920 (fig. 15).

Grosz, on the other hand, sees the post-War trauma in material terms. He is concerned with the crass indifference of the rich and powerful towards the urban masses as in "I Did My Job... The Looting Is Your Business" in *The Robbers*, 1922. He focuses his polemic on the powerful elite, both the Prussian military and the capitalist carpetbaggers of inflation. Grosz wishes to make a political statement and therefore polarizes the argument more arbitrarily than Beckmann. He adopts a detached view of the city streets so as to present a dehumanized society segregated into workers, war cripples, military, and capitalist profiteers. Whereas Beckmann sees society as a sum of individual personalities and makes minute observations of the idiosyncrasies of individual behavior and reactions, Grosz echoes Brecht's "Fable of Individuation."[80] He reduces society to a limited number of types based on class distinctions which he depicts as anonymous caricatures dumbly acting out their preordained roles.

Beckmann is fascinated by the diversity of people in society and uses the diachronic quality of the graphic cycle to bring out the similarities and differences between the various social and political groups. Hence left-wing *Ideologists*, 1919 (cat. 252) and the frustrated left-wing intellectuals in *The Disillusioned II*, 1922 (VG 217) are crammed together as claustrophobically as the cripples and beggars in the street, the starving families in the tenement attics, or the Old Guard of *The Disillusioned I*, 1922 (VG 213). Each group is assiduously distinguished by dress, body language, environment, and social mores with the same attention to detail found in Hogarth. The dynamic diagonals used to evoke the chaos of the streets are now replaced by predominantly vertical forms that convey the narrow-mindedness of the various ideologies.

The ambiguous gesture previously noted in *The Night* is evident in all his explicit statements about the political fighting of 1919, e.g., *Martyrdom* (cat. 250)[81] and *The Last Ones* (cat. 256), reflecting his apolitical humanitarian stance.

A comparison with Dix's rendering of the same events (cf. *The Barricade*, 1920, destroyed in 1954) is revealing. Dix blends the rhetorical heroism of Romantic depictions of revolution with his usual grotesque caricature technique to present a thoroughly biased and negative criticism. In *The Last Ones* Beckmann depicts the desperate last-ditch battle of the left-wing forces cornered in a tenement attic, impartially conveying both the heroism and the tragedy of their situation.

"Single shots were dropping all the time... I looked for a moment into the boldly lit Café Vaterland. Despite the fact that at any moment bullets might whistle through the windows, the band was playing, the tables were full... and the lady in the cigarette booth smiled as winsomely at her customers as in the

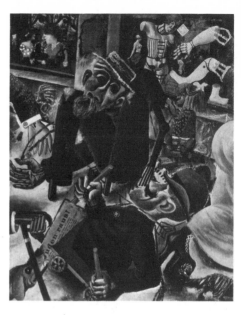

Fig. 15 Otto Dix: *Prague Street,* 1920, oil on canvas, collaged, Stuttgart, Staatsgalerie.

79. *The Grenade,* 1915, (cat. 228) is the only graphic of the war period exhibiting Meidner's influence in a formal sense.

80. Brecht, "Kleines Organon für das Theater" in *Gesammelte Werke,* Frankfurt a. M., 1967, Vol. 16.

81. See Christian Lenz, "Max Beckmann-Das Martyrium", *op. cit.,* pp. 185-210.

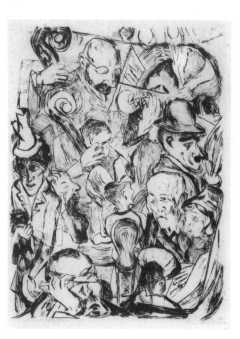

Fig. 16 Max Beckmann: *Café Music*, 1918, page 9 of the portfolio *Faces*, drypoint, Private collection.

sunniest days of peace."[82] Beckmann shared Count Kessler's amazement that the colossal historical event of the revolution made so little impression on the "unfathomably deep, primordial and titanic quality of Berlin" and that "it caused no more than local ripples on the even more colossally eddying movement of Berlin existence."[83]

The Underlying Despair of Café Society

Beckmann's depictions of cafés and bars in Berlin at this time portray the almost obsessional fervor with which Berlin society sought to escape the horror of contemporary life. He was fascinated by the fundamental sadness coursing beneath the apparent orgies of conviviality and dance.

Café, 1916 (VG 95) draws us, the spectators, in so close that we almost feel we are part of the group. An atmosphere charged with aloof despair rather than easy familiarity is conveyed by the nervous lines and elongated expressionist forms. In *Café Music,* 1918 (fig. 16), a steeply raked perspective is compressed into a narrow vertical format, enabling the spectator to look down on the heads and shoulders of the densely packed crowd that fills the picture space. The frenzied, noisy atmosphere is further intensified by the emphatic cross-hatching and the fragmented zig-zag forms, which create a staccato rhythm throughout the scene. Yet despite this bustling activity, in this veritable cross section of society all are locked in the purgatory of their private anguish, anxiety, or fantasies. The psychological intensity of the herd instinct evoked is reminiscent of Ensor's *Entry of Christ into Brussels,* 1888, or the crowd scenes in contemporary films. Beckmann's blindfolded face peers up from the lower edge of the print, turning away in despair and disgust.

In *Königinbar (Self-Portrait),* 1920 (cat. 269), his looming head completely dominates the design. He turns back to fix the spectator with the transparent, penetrating gaze of the seer, his face registering a detached horror at the stilted attempts of those behind him to dance their way into oblivion. His head is as entrenched in the composition as Meidner's had been in his cityscapes, reiterating his conviction that there can be no escape from this misery. Grosz also sees the café as an arbitrary meeting place of illusion and reality. For him there is no tragedy, only the cynical conviction that it merely reflects the hypocrisy, inherent lasciviousness, and latent aggression of a materialistic society. Using uncompromisingly harsh lines, much like graffiti, Grosz stresses the hideous deformities, both physical and moral, of his protagonists. Reality and illusion are fused to disclose weapons in the pockets of grimly determined gamblers (*Coffee House,* 1915/16) and voyeuristic sexual fantasies *(Nightclub [for Dr. Benn],* 1918). But cafés and bars are more importantly the haunt of vulgar and greedy speculators upon whose predatory misanthropy Grosz lavishes the full venom of his criticism. *(The Communists Are Dying and the Foreign Exchange Rate Goes Up,* 1919; *At Five O'Clock in the Morning,* 1920/21).[84]

In *Here Is Intellect,* 1921 (VG 207) Beckmann comes closer to Grosz's style of caricature to depict the latent aggression of café society. But the degree of generalization required for a successful caricature clashes with his underlying belief in the potential goodness of the individual. His strength lies in his sensitivity to the tragic numbness that lurks beneath the svelte masks of the elegant patrons of the bar. *Group Portrait, Eden Bar,* 1923 (cat. 290) is a trenchant distillation of the inherent contradictions of Weimar society.[85] Throughout his life Beckmann was fascinated by the involuntary moments of self-revelation within the relative anonymity of social bustle and noise (cf. *Femina Bar,* 1936, Göpel 445; *Parisian Society,* 1925/1931/1947, cat. 60; and *Prunier. In the Prunier Restaurant, Paris,* 1944, Göpel 667).

82. Harry Graf Kessler *Tagebücher 1918-37,* Frankfurt a. M., 1982, p. 55.

83. *ibid.,* p. 58.

84. See Georg Zivier, *Das Romanische Café-Randerscheinungen rund um die Gedächtniskirche,* Berlin, 1965. According to Zivier (p. 46), however, most of the currency speculators at that time were young men between 18 and 22 years old, who were eagerly sought out by the literati of the Romanisches Café, where Grosz was also a regular customer.

85. The Eden Bar at the Hotel Eden in Berlin was a meeting place for elegant artists and literati, such as Heinrich Mann, Gustaf Gründgens and Erich Maria Remarque. See Bernd Ruhland, *Das war Berlin, Erinnerungen an die Reichshauptstadt,* Bayreuth, 1972, p. 224.

The most potent image of the spiritual dichotomy of the age was dance. After the War, Europe was seized by a dance fever, with Berlin, by all accounts, as the most turbulent of all. The ecstatic rhythmic freedom of the tango, ragtime, Boston, shimmy, foxtrot, and later, the Charleston symbolized the most intense sensation of being alive. "With shouts of rapture, people plunged in, letting go at any price. This crazy dance fever, with its recklessly exaggerated orgies of contorted limbs, became the rage everywhere."[86]

Beckmann was enthusiastic about modern dance and jazz, which even before the War had been seen as a symbol of the modernity and liberalism of city life. In his 1923 autobiography for Piper Verlag he wrote that at the outset of the War he had been eager to learn the tango, adding with characteristic wryness that he loved jazz especially "because of the cowbells and the car horns."[87]

His depictions of the post-War dance fever are few, but they show his interest in its potential for revealing the individual through his actions and reactions. In *Malepartus*, 1919 (cat. 254), the fast beat and wild movements of modern dance are suggested by the dynamic diagonals of limbs shooting out in all directions. He is intrigued by the paradox of the awkward, stilted movements of the ill-matched couples who are performing exuberant rituals of the tango or ragtime. He sees through the narcotic quality of the dance to reveal the inner turmoil and unresolved tensions. In the metaphysical objectivity of Beckmann's vision, it is as much a dance of death as a dance of life. Once again, every figure is shown locked into the straitjacket of his individuality.

His only oil painting about dance, *Dance in Baden-Baden*, 1923 (cat. 34); a series of small woodcuts of dancing couples (VG 226, 227, 266); and the drypoint *Two Dancing Couples* (fig. 17) all focus on the deadly lack of spiritual communication of the couples despite their intimate physical proximity. The dynamic diagonals of earlier dancing scenes give way to far more static combinations of verticals, downward-pulling diagonals, and acidic colors to evoke the inherent sadness of elegant spa society rigidly shuffling through the motions of the foxtrot or tango. The physical crowding reinforces the absence of feeling as they either ignore each other's presence or eye each other suspiciously. It is far removed from the conventional image of the carefree Roaring Twenties, exemplified by the center panel of Dix's *Large City* triptych, 1929-32.

In *Striptease,* 1922 (cat. 276) and *Varieté,* 1924 (cat. 292), dance is elevated to the realm of an aesthetic performance, while the bourgeois onlookers are reduced to mere voyeurs. The numbed inertia and the relinquishment of personal responsibility by the individuals in the urban crowd are now contrasted within one scene to the uncomplicated eroticism of the strippers and the animal vitality of the revue dancers. The scene of the striptease depicts one of Berlin's nightclubs in which the audience could rent a mask to protect their anonymity during the show. Beckmann does not provide his figures with masks, for he wishes to show how totally individualized faces can both reveal and conceal the true self beneath.

Symbolism of the Mask

From the early 1920s Beckmann was fascinated by the paradoxical relationship between the inner and outer worlds and sought the richest means to give expression to it. Like Rilke, he concluded that although human beings cannot control their bodies, their consciousness can exert total control over their faces. Hence only through the stylized symbolism of the mask can the truth of men's unconscious fears and desires be disclosed.[88]

86. See Helmut Günther and Helmut Schäfer, *Von Schamanentanz zur Rumba,* Stuttgart, 1959, p. 205.

87. Max Beckmann, letter to the editors of Piper publishing house, *op. cit.*, March 1923.

88. Rainer Maria Rilke, *Duino Elegies,* Fourth Elegy, trans. by C.F. MacIntyre, Berkeley, 1961, p. 29.

Fig. 17 Max Beckmann: *Two Dancing Couples*, 1923, drypoint, Private collection.

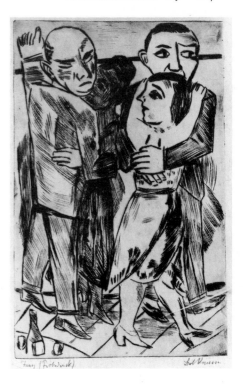

In the Tram, 1922 (cat. 283) marks the transition from the world of urban actuality to the symbolic world of the mask. In this searing portrayal of alienation and latent aggression in the big city, Beckmann depicts himself with a blindfold tied awkwardly round his face. However, it leaves his eyes uncovered so that his piercing gaze fixes the spectator with the full force of an accusatory challenge. Here his anger seems to be directed equally towards God and man.

In about 1923, when both the economy and Beckmann's personal situation began to stabilize, he turned to the symbolic world of the carnival, circus, and the stage in order to make more complex philosophical statements about the ineffable mystery of human existence. His investigations of the specific human problems of the city between 1915 and 1923, expressed primarily in his prints,[89] enabled him to pass through the first crucial stage of his search for the individual self.

Nevertheless, Beckmann remained fascinated by the dialectic between the individual and the anonymous city crowd. He loved the bustle of bars, hotels, and railroad stations where he could study people unobserved. Although he painted only one picture of the *Main Train Station in Frankfurt,* 1942 (Göpel 609), which was painted from memory during his Amsterdam exile, he frequently went there in the evening during his Frankfurt years "just to watch the people coming and going; in this way he saw the many "types" which he later used in his pictures. The stream of people, their moods and their whims, the excitement of travel, the busy to-and-fro of life, the joys and sorrows fascinated him and gave wings to his imagination."[90]

Curiously, he depicted very few scenes of Frankfurt itself. Most focus on the panorama of the Main River rather than the city streets and must therefore be classed as landscapes, such as the *Main River Landscape,* 1918 (cat. 242) and the *Drifting Ice,* 1923 (Göpel 224). The river, the only feature of the Frankfurt scenery he mentioned in his 1923 autobiography, doubtless evoked feelings of freedom and eternity that he associated with the sea.[91] *The 'Nizza' in Frankfurt,* 1921 (cat. 29) depicts the sunny, south-facing gardens along the right bank of the Main River. Beckmann himself described it as "a beautiful, placid landscape with a blue sky. Everything blossoms there..."[92]

89. More than two-thirds of Beckmann's graphic works were produced between 1915 and 1923.

90. Mathilde Q. Beckmann, *Mein Leben mit Max Beckmann, op. cit.,* p. 16.

91. *Briefe im Kriege,* March 16, 1915: "The highest privilege I would insist on, if I were king of the world, would be to spend a month out of each year alone on the beach." Another diary entry of July 4, 1950: "Freedom and infinity at the horizon of the sea."

92. Letter from Beckmann to Reinhard Piper, June 1, 1921, in: Reinhard Piper, *Briefwechsel mit Autoren und Künstlern, op. cit.,* p. 165.

Only in *The Synagogue*, 1919 (cat. 24); *The Iron Footbridge*, 1922 (cat. 30); and in the drypoint *Wooden Bridge*, 1922 (cat. 284) does he attempt to integrate human beings into scenes of architecture. Adopting in each case an imaginary bird's-eye view, the architecture is forced into a network of sharp, staccato diagonals and jarring juxtapositions of color to convey a threatening dynamism that completely overwhelms the scattered, dwarf-like humans.[93] Whereas in his graphic works of this period the city is dominated by the great orchestra of humanity which inhabits it, these two paintings of cityscapes seem to evoke the final words of "Schöpferische Konfession", in which he expresses his hope: "Someday to create buildings with my pictures. To build a tower where people can scream out all their rage and despair, all their wretched hopes and joys and wildest desires."

The one theme drawn from the city that Beckmann could also use in later years as a metaphor for the transience and arbitrariness of human existence is the hotel, the city within a city. Throughout his life Beckmann eagerly frequented the bars and restaurants of elegant cosmopolitan hotels, such as the Frankfurter Hof, the Hotel Eden in Berlin, the Hotel Polen in Amsterdam, and later the Plaza Hotel in New York. It is surely not meaningless that, except for the two scenes in the Claridge Hotel in Paris of 1930 (Göpel 335, 336), Beckmann only takes up the theme seen in *Self-Portrait in Hotel*, 1922 (plate 1 of *The Berlin Trip*), with its symbolic references to the uprootedness of the individual in the modern world, when he himself was homeless as an exile in Amsterdam. The revolving door of the hotel, like a wheel of fate, ejects random groups of people into the hotel lobby (e.g., *In the Hotel*, 1937, Göpel 487; *Two Women by the Stairs [Hotel Hallway]*, 1947, cat. 116; and *Plaza, [Hotel Lobby]*, 1950, Göpel 807). From the lobby they are conducted to their individual rooms by the bellhop whom Beckmann, referring to the right panel of *Departure*, 1932-35 (fig. p. 40), once described as the 20th-century messenger of fate.

Several works from the Amsterdam years depict figures moving through revolving doors, e.g., *Two Women in a Glass Door*, 1950 (Göpel 550); *Small Café Revolving Door*, 1944 (Göpel 685); and *Small Revolving Door on Yellow and Pink*, 1946, (Göpel 712). The protagonists are framed or bisected by the swinging glass panels of the door in such a way as to suggest that they are imprisoned, both literally and metaphorically.

His arrival in New York in September 1947 revived Beckmann's old excitement about city life: "Babylon is child's play by comparison, and here the Tower of Babylon becomes the mass erection of a gigantic and meaningless will. So I like it."[94] On returning to New York two years later he experienced "once again the freedom of the big city... I really don't care where it is, as long as it's not a small town."[95]

Beckmann was fascinated by the infinite variety and contrasts of New York, from the poverty of Harlem to the plush elegance of the Plaza, from the skyscrapers to his daily chats with the squirrels in Central Park. He never ceased to wonder at the city's unique beauty: "The early mornings here are indescribably beautiful across the endless park in whose most distant background a couple of orphaned skyscrapers emerge like far-off fantastic giants' castles from the brownish-red morning mist."[96]

The Town (City Night), 1950 (cat. 131), Beckmann's eulogy to New York, is a phantasmagorical fusion of the visual beauty of the city and the wild diversity of individual destinies it embraces. The composition is loosely based on Titian's *Venus and the Lute Player*, which depicts the neo-Platonic argument as to whether beauty is better apprehended through sight or sound.[97] Beckmann had admired the painting at The Metropolitan Museum a few days before beginning this work. Significantly, Beckmann translates Titian's sensuous Apollonian beauty into a voluptuous Dionysian nude sprawled erotically across a phallus-

93. A detailed analysis of the Frankfurt city pictures is given by Christian Lenz in: "Max Beckmann's Synagoge," *Städel Jahrbuch*, Vol. 4 (1973) pp. 299-320.

94. Max Beckmann, *Tagebücher, 1940-50, op. cit.*, September 9, 1947.

95. *ibid.*, August 31, 1949.

96. *ibid.*, September 27, 1947.

97. *ibid.*, March 1, 1950.

98. See Göpel, *op. cit.*, Vol. 1, p. 497.

99. Max Beckmann, *Tagebücher, 1940-50, op. cit.*, October 23, 1947.

ornamented couch, serenaded by the urgent rhythms of a young rock 'n roll guitarist. Yet her hands are bound behind her back, and she closes her eyes to avoid seeing the tragic array of human exploitation and despair spawned by the city. As in the works after World War I, the architecture is dwarfed by the human presence, represented here symbolically by a prostitute, a downtrodden man, a cynic, an aggressive figure of authority, and a crowd seeking escape in the bar. The monkey in the foreground reads a note addressed to Mr. Beckmann in New York by the light of a candle, symbolizing life. The second monkey, however, is totally absorbed in studying its image in a mirror, symbolizing the vanity of city life, while the naked figure wearing a gold crown squats in a traditional birth pose, symbolically counting gold coins.[98] Titian's lyrical adulation of beauty as an abstract concept is transformed by Beckmann into an allegory of the city as a vital, potentially positive life force, which man's insatiable egotism, sensuality, and materialism have turned into a veritable hell. The mutual alienation and aggression have made the salvation of the spirit and integrity of the individual into a remote dream. Beckmann's comment shortly after his arrival in New York seems to echo his relationship to cities: "Curious that in every city I hear the lions roaring!"[99]

Christian Lenz

Landscapes 1900-1916

Fig. 1 Max Beckmann: Illustration for *Eurydice's Return* by Johannes Guthmann, 1909, lithograph, Private collection

1. Max Beckmann, letter to Reinhard Piper, November 23, 1921.

2. Friedhelm W. Fischer, *Max Beckmann: Symbol und Weltbild*, Munich, 1972. Cf. Selz's criticism of Fischer in his review of recent Beckmann literature in: *The Art Bulletin*, 63 (1981), p. 170 ff. Gässler (1974) and Güse (1977) have also almost completely ignored the landscapes in their treatments of the early work.

3. Stephan Lackner, Cologne, 1978, p. 118, a perceptive connoisseur of Beckmann's work, comments on this with regret since he was strongly moved by the landscapes. The only literature that can be listed as dealing exclusively with Beckmann's landscapes is: F. Roh, "Beckmann als Landschafter," *Die Kunst und Das schöne Heim 50*, (1952), p. 9 ff. and Stephan Lackner, "Max Beckmann als Landschaftsmaler," *Frankfurter Neue Presse*, February 11, 1967. Further references to Beckmann's landscapes are found in Reifenberg (1949), Buchheim (1959), Busch (1960), Lenz (1976), Lackner (1978), Wiese (1978), Lenz (1982), and others.

4. Stephan von Wiese, *Max Beckmanns zeichnerisches Werk 1903-1925*, Düsseldorf, 1978, p. 21 f. Von Wiese transfers to a 1913 Beckmann drawing the concept of "the painterly" applied by Wölfflin to van Goyen and Hamann's concept of Impressionism. He also personally finds the formulation "a general philosophical and artistic 'superficiality'" appropriate to Beckmann. Could anyone truly prove a similar statement regarding Monet, Renoir or Liebermann rather than merely assert it? Von Wiese is compelled to note the uniquely clear ordering of this work, which cannot be reconciled with the usual idea of Impressionism. This would have been an opportunity to reject the term completely. Instead, von Wiese again digresses from the essence of this art by bringing Beckmann's formative way of drawing into close connection with "automatic drawing."

Max Beckmann's fame rests on figure paintings such as *The Night, Departure, The Dream,* and the *Argonauts* triptych. But he also painted landscapes and not just by way of exception: 190 out of 835 paintings are pure landscapes and an additional 30 are urban landscapes. Indeed, Beckmann began as a landscape painter. His landscapes are not confined to a few years or a single medium, but run throughout his entire career and appear in the form of drawings, etchings, and lithographs. In 1921, Beckmann said he wanted to "select pure landscape subjects" for a series of ten etchings.[1] As late as 1950, the year of his death, three important landscapes were completed.

Thus it is surprising that this aspect of Beckmann's art has so far been virtually ignored. No broad discussion, not a single book, has been dedicated to the landscapes. Even Friedhelm Fischer's outline of a general interpretation of Beckmann's œuvre was attempted with no consideration of the landscapes at all.[2] Those who seek only the significance of an image in works of art will turn quickly to figural paintings,[3] although even there they may not fully appreciate the richness of the presentation, nor understand its true meaning. The following remarks about selected landscapes reflect a different position, and should be taken as an initial approach to this important area of Beckmann's art.

In a 1909 lithograph Beckmann depicted Orpheus on the seashore (fig. 1). Beach, sea, and sky are clearly distinguished from one another, with the sea extending into a great distance. The densely layered clouds reveal this dimension as well as the height of the space. Everything in the picture generates a single space and reveals a single light. Land, sea, and sky are not only separate from one another, they each have their own character: the beach is partly bare sand and partly covered with a sparse growth; the water glistens in the soft rhythms of small waves; and in the layered clouds is a stronger rhythm which pushes the clouds out of the dense background on the horizon. Although all three realms are clearly distinct, they are united not merely by space and light but also by the atmospheric quality of the sea, evoking the sights and sounds of the North Sea. (Beckmann had not yet experienced the Mediterranean world.)

In this landscape there is a special place for the individual. Orpheus stretches out on his back in a patch of sand and lifts his head toward the heavens. The figure, with open arms and legs, is topped energetically by the terse triangular form of the head which is seen from below. The figure's position corresponds with his situation: Orpheus is crushed by the death of Eurydice and is trapped by his fate. He complains bitterly to the gods, but finds the heavens closed and indifferent to the cruelty of his suffering. In this way, the clouds and waves become an image of eternal immutability.

Is this lithograph "impressionistic," as has been claimed about Beckmann's work during the period before World War I?[4] Does the work capture the transient quality so essential to Impressionism? Can a summary label, casually invented for the art of Monet and his circle, be applied to Beckmann's works at all? A more careful look at the lithograph assures us that it cannot.

Fig. 2 Max Beckmann: *Old Botanical Garden,* 1905, oil on canvas, Private collection

Fig. 3 Paul Cézanne: *The Bridge in Mennecy,* ca. 1882-1885, oil on canvas, Paris, Louvre, Jeu de Paume

Perhaps the work is not a landscape at all. The man is not an incidental ornament. On the contrary, he is the most important element. Beckmann created this landscape for him, and everything in the work is related to him. His fate must take place in this particular nature. The landscape thus becomes the symbol for nature which bears fate within itself. But nature cannot consist of allegorical concepts alone; it must be nature in its fullness and with a being all its own. Only then does it come into contact with humanity.

In this work, nature and the individual confront each other with their whole beings in a tensive relationship. It is futile to search for historically related works among Beckmann's contemporaries or in the artistic generation before him. It is in Delacroix's *Jacob's Struggle with the Angel,* for example, that one first finds similar images. It then becomes clear that the tradition reaches back even farther, since the Old Masters could not conceive of any relationship between nature and man that did not emerge from a totality of being. Beckmann reveals himself as an artist of more modern times by bringing the individual into contact with the infinite. That subjectivism is a heritage of Romanticism and was once again given excessive expression by Beckmann's contemporaries such as Böcklin, Klinger, Munch, and the Jugendstil.

To be alone with the sea is a direct experience of infinity and an indication of the eternal as well. Beckmann loved the sea, depicted it repeatedly, and even spoke of his love for it in a well-known letter. As a volunteer orderly during the War, he described his return to the sea after a long interval: "And then to the sea, my old romance, it's been too long since I was with you. You swirling infinity with your embroidered dress. Oh, how my heart would swell. And this loneliness... It was silent and dreamlike, as if it were 3 a.m. in summer. A faint hint of twilight. Everything living was outside. Beyond. If I were the king of the world, I would choose as my highest privilege to spend one month a year alone on the beach."[5]

5. Max Beckmann, *Briefe im Kriege,* Berlin, 1916, p. 29.

Fig. 4 Max Beckmann: *Young Men by the Sea*, 1905, oil on canvas, Weimar, Kunstsammlungen Schlossmuseum

6. Joachim Poeschke, "Der frühe Max Beckmann," *Max Beckmann: Die frühen Bilder* (catalogue, Bielefeld/Frankfurt, 1982-1983), p. 131.

7. On this painting compare B. C. Buenger, "Beckmann's Beginnings: *Junge Männer am Meer*," *Pantheon*, 41 (1983), p. 134 ff., with the older literature up to Lenz, *Beckmann und Italien*, Frankfurt am Main, 1976, p. 10 f., where the difference from Liebermann is demonstrated. In regard to the short brush strokes, the author cites Impressionism, post-Impressionism, Realism, Trübner, Cézanne, and van Gogh as equally important models for Beckmann. This confusing historical context for the technique is matched by that for the motifs. The many naked men of Marées, Hofmann, Thoma, Liebermann, Klinger, and Munch should have been studied more carefully to determine what their essential similarities are to Beckmann's figures—or whether there is any similarity at all. Beckmann had referred negatively to "Trübner's schematic brushwork" in 1906, rendering the search for a similarity useless here (cf. letter to Piper, April 8, 1923, with reminiscences from the early years.).

8. On Cézanne and Signorelli cf. G. Berthold, *Cézanne und die alten Meister*, Stuttgart, 1958, no. 247 ff. At the end of the summer semester of 1903, Beckmann left the Weimar Kunsthalle and went to Paris. The fact that he saw drawings by Signorelli in the Louvre is reported by Reifenberg, *Max Beckmann*, Munich, 1949, p. 14. Beckmann's relation to Cézanne is worthy of study in itself. In addition to the areas discussed here, Beckmann also valued Cézanne's earlier paintings. This certainly means the earlier figure paintings, which impressed him with their plasticity ("Das neue Programm," *Kunst und Künstler*, 12, 1914, p. 301).

Beckmann did not paint momentous landscapes exclusively, however. He also chose unthreatening subjects as well. In the painting, *Old Botanical Garden*, 1905 (fig. 2), the painter selected the translucent green of the trees and bushes beside a shady path, with a glimpse of a building and the sky behind. It is an impression of nature in its simplicity and immediacy. Painted in short, firm brush strokes, the picture gains additional solidity from the stiff tree trunks and branches which are ochre in color. Nothing grand is portrayed; no earthshaking event is taking place. The person on the path is scarcely evident. As a figure, but not a human being, it has no fate.

The impression of nature, the light shifting from dim to bright, the short brush strokes, and the spare use of brown, ochre, and gray tones might suggest an Impressionist painting here. However, Beckmann allies himself with a style of art quite different from Monet's. In fact, Poeschke has indicated a connection with Cézanne.[6] In this case, Beckmann virtually imitated several paintings by Cézanne from the early 1880s, such as *The Bridge in Mennecy* (fig. 3) with the solid structure of stiff, short brush strokes, its stiff tree trunks and branches, and the contrast between green foliage and the bright wall. The curved path leading into the distance of Beckmann's painting can be found in numerous works by Cézanne. In spite of all his efforts, however, Beckmann never achieved Cézanne's energetic, 'logical' space and plasticity or his tense pictorial order. Instead, Beckmann constructed his paintings in spots and patches.

The central work of the early period, *Young Men by the Sea*, 1905 (fig. 4) reveals how important the qualities of plasticity and depth were to Beckmann at the time. The development of the painting can be traced to Beckmann's preparatory sketches and a pastel (Bielefeld 5; von Wiese 7), indicating a clear break with flat, ornamental presentation and a shift toward emphatic plasticity. The forcefully modelled, sinewy figures of the youths in this painting stand in sovereign physicality against the depth of the beach, sea, and sky. Beckmann was influenced here by Signorelli's *Pan*, which already at that point was demonstrably important to him. One must also refer back to Cézanne again since the short, stiff brush strokes[7] are found here as well. There is a further connection to Signorelli via Cézanne in that the French artist had copied the very same drawings by the Italian which Beckmann had seen in the graphic collection of the Louvre in 1903.[8] Beckmann's visit to the Louvre generated a strong distaste in him for the flood of Impressionistic imitations that predominated there. "This

Fig. 5 Max Beckmann: *Construction of the Hermsdorf Water Tower,* 1909, oil on canvas, Frankfurt a. M., Städtische Galerie im Städelschen Kunstinstitut

feeling probably also contributed to my *Young Men by the Sea* at that time," he recounted to Reinhard Piper. "My greatest love already in 1903 was Cézanne."[9]

For Cézanne, as for Beckmann, it was an interest in the almost sculptural construction of the figures that made Signorelli appealing and led to corresponding works of his own. Though no single example from Cézanne's numerous Bathers can be cited as a model for Beckmann's painting, the influence of Cézanne in the development of the painting is considerable. The approach to the figure, certain poses and gestures, as well as the brushwork, show a close relationship. Before 1905, no influence from Cézanne can be found in Beckmann's work: neither in 1904 nor even in 1903, the year he became acquainted with Cézanne's work.

Unlike the Orpheus lithograph of 1909, the relationship between figure and landscape in *Young Men by the Sea* is not determined by an event or by fate, but by simple, resolute existence. This existence is self-sufficient and unfolds naturally as a matter of course within nature. The resolution and permanence of this existence are the source of the painting's fundamental difference from the related paintings of Liebermann, which have a momentary and fleeting character. Like the paintings of Cézanne, Beckmann's work is marked by the classical relationship between humanity and nature: each strives against the other but is necessarily bound to it. Liebermann is more "modern" in this regard in that he lets his bathers dissolve into nature, which is possible only because neither humanity nor nature has any resolute existence.

It is striking that the short brush strokes not only fall into long rows of shading, but that they also create slight curvatures in the figures and in the landscape that tend toward a larger ornamentalizing pattern. This trait refers back to Beckmann's preceding works which are beautifully represented by the *Shore Landscape* of 1904 (cat. 1). There the waves and the formation of the beach are conveyed in pronounced curved lines. The view is presented from above so that it not only extends far out to sea but conveys the forms as flat. The paint is thinly applied and portions of the ochre cardboard are left bare so as to make use of its tone. The gray-blue sky, the blue-green sea, the gray-white waves that wash over the beach, the ochre beach, and the strong rust-red of the dunes combine to give a moody, melancholy coloration. It is no wonder that the

9. R. Piper, "Durch vier Jahrzehnte mit Max Beckmann, *"Mein Leben als Verleger,* Munich, 1964, p. 328.

Fig. 6 Max Beckmann: *Clearing Weather,*
1909, oil on canvas, location unknown

10. Christoph Schulz-Mons, "Zur Frage der
Modernität des Frühwerks von Max Beckmann,"
Max Beckmann—Die frühen Bilder, op. cit., p. 140.
Schulz-Mons cites the painting *Evening Forest
Landscape,* 1911, as evidence of Cézanne's influence,
but this painting is too late for the beginnings of this
influence and is not a convincing basis for
comparison with the French painter's works.

painting contains a stylized, Japanese-like monogram as was customary in Jugendstil. Similarities can be found in the work of contemporaries such as Leistikow and Munch who also use nature as an expression of the soul. Beckmann sets himself apart from them and other similarly disposed artists by letting nature retain more of its own individuality and variety.

In this early period, probably in 1904, Beckmann depicted himself in a landscape (cat. 2). He sits in front of the fields in late autumn and watches the soap bubbles as they float to the sky. The fields rise to a band of dark woods above which a cloud appears in the day's last light. A strikingly flat construction is one of the elements which link this painting closely to Jugendstil. The season and the lateness of the day as well as the soap bubbles are metaphors for ephemerality and dreamy thoughts that disappear in the distance. The painting generally relates humanity to nature in a strongly melancholy mood.

Even earlier in Beckmann's creative activity is a series of smaller landscapes —primarily seascapes—that are strong in mood but which have a somewhat more objective effect. That these small sketches were probably done directly from nature may account for some of their objectivity. They also have a pronounced expansiveness. Sand and sea appear beneath low-lying clouds in the weather's changing light. A human presence is suggested by a few houses, a boat, and a ship, but such presence is ultimately not important here. Rather it is the impression of a changing nature restrained in its moods that is of importance.

Beckmann did not automatically leave flat, ornamental presentations behind him after discovering the art of Cézanne. With their curvatures and high vantage points, *Sunny Green Sea* (cat. 3) and *Large Gray Waves* (cat. 4) give evidence of this, even though they betray his need for a systematic construction and a solidity of structure developed even in small units. The source of this is not in Cézanne's work but in Fauvism, as Schulz-Mons has correctly observed.[10] Developed out of neo-Impressionism, Beckmann integrated these forms into full-toned painting. It is not easy for a painter to adopt another method, with corresponding experiences of nature, and thus take a step beyond mere mannerism. However, Beckmann achieved this in *Hazy Sun,* 1905 (Göpel 40), where fog and hazy light have absorbed the bodies and turned depth into flatness.

Beckmann apparently noticed that this manner of painting could easily become rigid and lead to schematism.[11] Therefore his works of the ensuing years show a noticeable loosening of brushwork, irregular minor forms, and an increasingly spontaneous application of paint as in *Construction of the Hermsdorf Water Tower,* 1909, (fig. 5). It is possible that Beckmann's friend Waldemar Roesler encouraged this loosening of technique. Here, too, irregular brushwork and the translucent appearance of the subject may mislead one to apply the term "Impressionistic" in this case as well. This overlooks the fact that the spontaneous brushwork is integrated into the very clear ordering of the path, the rows of trees, the embankment, and the tower against the bright sky, an ordering which produces a spatial construction and opens up the landscape in terms of depth and height.

Such observations again reveal a reliance on Cézanne; not, however, in the works of the early 1880s, but rather in paintings from the preceding decade, such as *Village Street in Auvers, The Road to Auvers-sur-Oise* and—the most mature of the group—*House of the Hanged Man.* In these works Cézanne still uses a loose brushwork that only gradually becomes firm.

The significance of the tower in this painting was noted as early as 1913 by Kaiser, who was reminded of the Tower of Babel. This noteworthy symbol of solemnity has also led to recent suggestions of a connection between Beckmann and van Gogh.[12] Van Gogh was indeed important for Beckmann, but the apt comparisons of *Church Steeple in Nuenen,* 1885, or *Church in Auvers,* 1890 reveal little beyond the emotional emphasis on religious motifs which Beckmann took as mere suggestions. In detail there are no links close enough to eclipse the influence of Cézanne. *Construction of the Hermsdorf Water Tower* was painted in 1909, the same year as the lithograph discussed earlier. It is also the year of the large *Resurrection* and the same year that Beckmann began *The Descent of the Holy Spirit* (Göpel 124), which was finished the following year. It can thus be concluded that at this time Beckmann was concerned with the metaphysical realm and with God, as never before witnessed in his work. The landscapes are evidence of this—not only in the Orpheus lithograph and *Construction of the Hermsdorf Water Tower,* but also, for example, in the paintings *Sun Breaking through over the Sea* (Göpel 111) and *Clearing Weather* (fig. 6), both from 1909. In all of these Beckmann uses light as a phenomenon of weather for its metaphysical meaning.

Here we can find an early foreshadowing of the apocalyptic landscapes of the War years. Just as the Hermsdorf water tower rises monumentally against

Fig. 7 Max Beckmann: *Hilly Landscape Against the Sun,* 1914, pen and ink, Kunsthalle Mannheim

Fig. 8 Max Beckmann: *Resurrection,* 1914, pen and ink, Private collection

11. In another context he writes in his diary on January 7, 1909, that "one must return to diversity after the simplifications of the van Goghs and Gauguins." This indicates that he was aware of such necessities.

12. Christoph Schulz-Mons, *op. cit.* The author sees van Gogh's influence not only in Beckmann's way of developing the significance of the subject. He also traces Beckmann's technique to the Dutch painter. But which would then be the comparable works by van Gogh?

13. The drawing is labeled at the upper right "10.8.14/Beckmann," but "10.8." is written with a different pencil than the one used for "14/Beckmann." The landscape cannot have been done on August 10, 1914, since Beckmann was still in Berlin according to a letter of August 15, to Piper. He only went to East Prussia at the beginning of September. Von Wiese's suggestion, August 10, 1915, could be the correct date. The artist may have only added "14/Beckmann" as he sold the drawing later and mistaken the date. Still, it should be considered whether the error may be in the "10.8.," meaning that the landscape would have been done in 1914. This is supported by the close relationship to the first sketch of the second *Resurrection.*

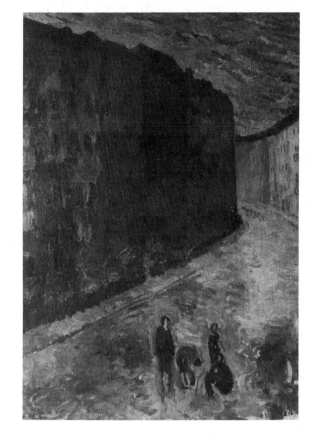

Fig. 9 Rembrandt: *Landscape with Three Trees*, 1643, etching, drypoint and etching stylus, Munich, Staatliche Graphische Sammlung

Fig. 10 Max Beckmann: *The Street*, 1911, oil on canvas, Private collection

14. Beckmann labeled another privately owned sketch, formerly Piper Collection (von Wiese 204), "First sketch for Resurrection, December 14." Therefore in von Wiese's 1978 book the sketches are reversed in the catalogue and in the illustrations, and von Wiese refers to this sketch as the first, as do almost all other authors. The drawing von Wiese 204 does reveal much more of the painting than von Wiese 205, so that it logically fits between von Wiese 205 and the painting. Beckmann probably erred in labeling the work. Von Wiese 205 is the initial sketch in every regard. Its technical data are the following: pen (not copying stylus) with violet ink on thin paper, uneven at the top with a piece torn out at the left; paper size 103 x 146mm, drawing ca. 87 x 103mm; labeled at lower right with pencil in German script: "Beckmann;" stamp on reverse: "Sammlung Reinhard Piper München."

15. Beckmann named van Gogh several times as one of the artists especially important to him. Over a period of decades he studied the life and works of the Dutch painter. Concerning *Hilly Landscape Against the Sun,* refer to van Gogh's drawing, *The Road to Loosduinen.* Here the brightness in the sky and on the road in this direction give the drawing a similar meaning.

16. On this topic cf. P. Eikemeier in the present catalogue.

17. Oil on canvas; 70 × 63 cm. The painting has an unusual signature at the lower right: the full name in German script without a date. Otherwise during this period Beckmann signed HBSL or MBSL and usually included the full date or an abbreviation. Is the signature so carefully inscribed here genuine? For my familiarity with this painting I am very much indebted to Dr. Peter Beckmann.

the sky like an omen with an aura of its own, so the chimneys and steeple of the ruined city of Neidenburg rise in a 1914 drawing, but now they are surrounded by thick clouds of smoke (von Wiese 188). Out of the clouds breaking before the light of *Clearing Weather* will come another war drawing of the Gate of Eternity (fig. 7).[13] A row of shell-damaged trees stand before it like the figures of people awaiting the Last Judgment. In the same year Beckmann actually did develop a *Resurrection* out of this drawing from nature. It was the first sketch (fig. 8)[14] for the large painting of 1916 (fig. p. 83). The War drawing confirms the suggestions drawn from the two 1909 paintings that there is no point in looking to contemporary painters or even to recent tradition for landscapes as eventful as those in the work of Beckmann. Though the painter was indeed related to van Gogh in terms of his perception of the world,[15] he here refers to the older tradition, specifically to Rembrandt.[16] The drawing *Hilly Landscape Against the Sun* is unthinkable without reference to Rembrandt's famous *Landscape with Three Trees* (fig. 9), and Rembrandt's drawings surely influenced the depiction of the ruins of Neidenburg and similar pen-and-ink wash drawings, as von Wiese has pointed out.

With *The Street,* 1911, Beckmann created his first pure urban landscape (fig. 10). He had been preparing the way since 1906 with several other paintings of suburbs and outskirts of cities, one of which has only recently surfaced (fig. 11).[17] It is very similar to *View from the Studio, Eisenacher Strasse 103,* 1906 in its light coloration, in the large proportion of flat forms, and in the brush strokes that are alternately short and straight or animated.

The 1911 painting differs from Beckmann's other urban landscapes of those years in that it presents the city as the ghostly cavern of a street, with a small group of people exposed to the mysterious appearance of light in the void. In the other urban landscapes one finds rather detailed representations of buildings, streets, squares, and people without so great a dependence on mood.

The locale of the *Resurrection,* 1916 is also an urban landscape. Out of the caverns, tunnels, holes, and crevices of a crumbled city creep the dead on the

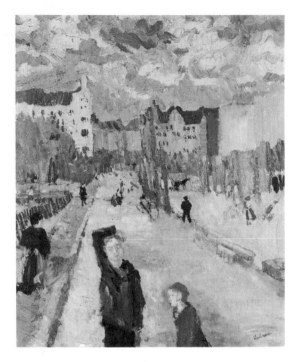

Fig. 11 Max Beckmann: *Suburb*, 1906,
oil on canvas, New York, art market

Fig. 12 Max Beckmann: *View of a Garden
from the Window*, 1916, graphite, Frankfurt
a. M., Städtische Galerie im Städelschen
Kunstinstitut

Last Day. In a reference to cubism, the artist had reformulated the drawings of
the war landscapes and the destroyed cities into this large apocalyptic landscape
in which he also refers to his own *Scene from the Destruction of Messina,* 1909
(cat. 10), and to Meidner's apocalyptic paintings from the years 1912 and 1913.

The city is the place where the ultimate existential decision takes place as
seen in the Messina painting, the most challenging work Beckmann ever under-
took. The landscape outside the city, the sea, or any aspect of nature is no
longer depicted for the time being. And if a glance is directed at such things
within the city, as in 1916 *View of the Garden from the Window* (cat. 155), then
the sky is no longer perceived at all. Instead the view is forced downward where
it is caught in the wiry lines of paths and branches.

Beckmann began his landscapes with a look directed upward and outward
toward the sky where his dreams ascended like soap bubbles. But the first
period of his life ended with a forcibly lowered, narrowed view that was fraught
with confused, fruitless, and hopeless ideas. It takes several more years before
the dead tree of his drawings again bears leaves and blossoms, and a few more
years before blue sky and sun are again visible in the paintings. Only with *The
Nizza in Frankfurt am Main,* 1921 (cat. 29) does the artist paint a picture in
which the sky is blue and nature presents itself in full bloom as well. A few years
later, Beckmann's happy personal circumstances would coincide with the dis-
covery of the Mediterranean, so that he again could devote himself to the
expanse of the landscape and the sea.[18] He succeeded in portraying the southern
sea and its cheerfulness, recapturing the landscape in all its beauty. He did not
relent in this when proscription in Germany, exile, and war brought renewed
threats and even suffering. Through lifelong observation and experience nature
became such an essential part of his own being that Beckmann was able to
create majestic North Sea landscapes (cf. cat. 76) during his proscription in
Germany, and he could lend classical splendor to the landscapes of *Faust II*
amid the distress of exile.

The large number of Beckmann's landscapes, spanning the entire first half
of the century, is enough to indicate the importance of this genre in art history
as well. Beckmann differs from most other artists of the 20th century, except
Klee, in that his works create an image of the beauty, order, and bounty of

18. On the significance of the Mediterranean world
for Beckmann cf. Lenz, *op. cit.,* 1976.

nature. This is to be appreciated all the more since after Monet there was a general striving toward homogeneous unification. Beckmann, however, distinguished the differing realms of nature and let their distinctive features interact powerfully. His landscapes show that there can be no high art without nature.

Translated from the German by Barton Byg

Peter Eikemeier

Beckmann and Rembrandt

*"The sociological denominator
sleeping behind the centuries is this:
a few great men who suffered deeply.
...
and then this: be silent and reign,
knowing that all is in decline,
yet still hold swords
before the Hour of the World."*

GOTTFRIED BENN

"During the hard and terrible period in Amsterdam, it was a source of comfort to Max to know that he was living in the same city in which Rembrandt had lived—Rembrandt, whom Max considered to have been the greatest artist of all."[1] This statement from his wife's memoirs will not be found so directly in Beckmann's own writings which often do more to camouflage his inner self than to reveal it. But the intensity of Beckmann's relationship with an artist whom he regarded as his spiritual ancestor and the great degree of inner correspondence and affinity with Rembrandt are reflected in Beckmann's work in numerous ways. A comparison of the two artists and their work reveals not only that Beckmann carried on a lifelong dialogue with the formulations and configurations of Rembrandt, but also that a broad spectrum of unconscious analogies and correspondences is pervasive. Obvious ties to their own time periods notwithstanding, a similar tone in the fundamental creative impulse which guided them both allows us to transcend the distance of three centuries.

Both artists were obsessed with their artistic output and reputation, and each left behind a substantial œuvre of paintings, drawings, and graphic work, each of a singular quality. Their work expresses the thematic concern which was central to them both: the representation of humanity in all of its enigmatic and contradictory manifestations, with all its limitations and sovereignty. In both we find traces of the spirit of Prometheus, the shaper of men, who defied the gods (Beckmann: "In my paintings, I reproach God for everything that he has done wrong ... my religion is one of arrogance and defiance in the face of God.")[2] and who never succumbed to suffering. In a small etching, hardly as big as the palm of a human hand, Rembrandt represented the artist as a shaper of men in the figure of a goldsmith who is putting the finishing touches on a Caritas group (fig. 1).[3] Whether Beckmann was familiar with this work and took from it the inspiration for his own *Self-Portrait in Gray Robe* (fig. 2, cat. 93) remains uncertain. The similarities in the articulation of the background, spatially constructed by means of horizontal and vertical components, are striking. More importantly, the close affinity between the artist and his work which is expressed in both the print and the painting would seem to bear witness to a common basic disposition. With deep seriousness, anxious concentration, and the same degree of meditative preoccupation, the artist carries out his task protectively, indeed almost tenderly. He holds the figure with his left hand in such a way that the exaggerated size of the hand elucidates and emphasizes this gesture. He looks with reserve and alienation upon a work which has surfaced from depths his intellect cannot penetrate.

The artists themselves were the primary point of departure for representing the enigma of human existence. To quote Beckmann: "Since we still do not

1. Mathilde Q. Beckmann, *Mein Leben mit Max Beckmann,* Munich, 1983, p. 150.

2. 1919, in a conversation with Reinhard Piper, cited in F. W. Fischer, *Max Beckmann: Symbol und Weltbild,* Munich, 1972, p. 17 f.

3. On the characterization see the notes by D. Schmidt in the catalogue to the exhibition, *Graphik in Holland,* Munich, 1982, p. 114.

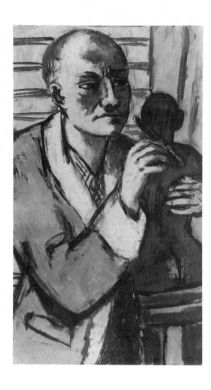

Fig. 1 Rembrandt: *The Goldsmith*, 1655, etching, Bartsch 123

Fig. 2 Max Beckmann: *Self-Portrait in Gray Robe,* 1914, oil on canvas, Munich, Bayerische Staatsgemäldesammlungen, Staatsgalerie moderner Kunst

know just what this 'I' really is, this ego, which forms you and me, each in his own fashion, we must pursue its discovery with greater intensity…What are you? What am I? These are the questions which incessantly hound and torment me, but which also perhaps contribute to my artistic efforts…"[4] The number of self-portraits which each painted, drew, or printed is not likely to have been exceeded by any other painter. From their earliest works until the last years of their lives, both studied their own faces and figures relentlessly, urgently, and insistently, including themselves in scenic representations and slipping, by way of experiment, into roles through the use of disguises. Even in the etched self-portrait of Beckmann as a 17-year old art student (fig. 4; cat. 210), the passionate drive toward self-contemplation is evident. This drive is presented in a coolly distant and analytical stance in the later paintings, but in reality it reveals a most refined sensitivity and vulnerability. The face, extremely distorted in a frontal close-up with its mouth open wide to scream and its teeth bared, confronts the viewer with aggressive directness. Rembrandt appears equally abrupt and with the same radical self-questioning attitude in his early self-portraits, such as the portrait of the 23-year old artist from the year 1629 (fig. 3). A probing drive towards recognition is expressed in this defenselessly exposed face, with its questioning and shaded eyes, its gaping, pouty lips, and its disheveled hair.

Subjectivity/Universality

A profound and incessant process of coming to terms with the self characterized the life's work of both Rembrandt and Beckmann. In contrast to the work of Rubens and Picasso, who are their great antipodes, a decisively introverted spiritual disposition is revealed.[5] This quality is frequently concealed behind a pose of superimposed worldliness, sophisticated clothing, swaggering behavior, or even an unkempt eccentric appearance. They looked at the world with their eyes wide open, and remained aware of the tradition from which their art had developed. However, both of them reacted to the outside world and the artistic tradition in an unusually subjective way which has resulted in numerous unsuccessful attempts to assign a precise meaning to any portion of their work.

4. Max Beckmann, *On My Painting,* published in an English translation by Buchholz Gallery, Curt Valentin, New York, 1941.

5. On Rembrandt, see in this context J.Q. van Regteren Altena, "Rembrandts Persönlichkeit," *Neue Beiträge zur Rembrandt-Forschung,* edited by O. v. Simson and J. Kelch, Berlin, 1973, p. 176ff.

Fig. 3 Rembrandt: *Self-Portrait*, 1629, oil on canvas, Bredius 2, Munich, Bayerische Staatsgemäldesammlungen, Alte Pinakothek

Fig. 4 Max Beckmann: *Self-Portrait*, 1901, etching, Private collection

Characteristically, Beckmann himself very rarely made any statements on the meaning of his paintings, and then only in the form of brief suggestions, so that interpretations which differ from these can be considered to be valid. Considering the numerous penetrating examinations which have been made into the work of both artists, the question arises as to whether a genuine understanding of their work is actually served by minute explanations of the artists' intentions or intellectual surroundings. A verse of the Bible which can be quoted to explain a work or the occasional reference to the writings of a particular author perform a worthwhile function, but they never really explain a work which represents the sum of all that which has been experienced until the point it was created. In addition, whenever the greatness and validity of a work of art extend beyond its historical time and place, it goes beyond the conscious intentions and goals of its creator, whose interpretative statements can at best provide us with one aspect of the truth. The general acceptibility of the artist's concrete motivation notwithstanding, the emotional accessibility of a represented situation determines the greatness and commitment of the work of art whose complexity and legitimacy are easily overlooked in the zealous obsession with facts. Whereas other artists showed a facet of reality, Rembrandt and Beckmann always kept an eye on the whole; they conceded space to the irrational and gave form to what was inexpressible. The fascination which emanates from their paintings can be attributed not least of all to the fact that they are "understood" even when the external content and motivation of their works cannot always or immediately be ascertained, and that they communicate as much through feelings as they do through the intellect.[6] The highest degree of subjectivity, transformed into determined artistic form, has here become universal and transcended time.

Parallels in the stylistic development of the two artists are most obvious in the early and late work. There is a tendency away from movement and diversity towards calm and simplicity. The turbulence which is apparent in the earlier paintings is followed by a period of composure and concentration. This ultimately leads to a reduction in the narrative element in favor of the increased monumentalization of the individual form.[7] The unwillingness to compromise and the rigorousness which characterized both oeuvres from the very beginning

6. For Rembrandt, we are reminded here of works such as the *Polish Rider* in the Frick Collection, New York, but also of many of his Biblical representations.

7. See here as well H. Gerson, *Rembrandt Paintings*, Amsterdam, 1968, p. 112.

 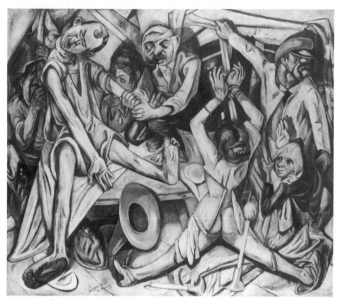

led in the later phase to a growing freedom with regard to the limitations of iconographic norms. Even in the very latest works of each artist, the creative force can be discerned as uninterrupted, to an extent found in the work of only a few artists.

Biblical Drama and Bourgeois Farces

If we survey all of Beckmann's work, we can recognize in all of his various creative periods numerous indications of direct, as well as indirect or unconscious, exchanges with individual works of Rembrandt. In light of the creative vehemence of Beckmann, these occurrences are rarely as obvious as they are in the drypoint *Adam and Eve* of 1917 (cat. 236). The affinity to Rembrandt's etching of 1638 on the same subject has been discussed by Christian Lenz.[8] Two examples can be referred to in order to explain the method and manner he used to adapt Rembrandt's impulse and thus confirm the individuality and greatness of his own creative work. *The Night,* 1918/19, (fig. 6, cat. 19), a gloomy scene of torture and death, is among the most important paintings of Beckmann's Frankfurt period. Thematically it is very close to a drypoint with the same title done in 1914 (cat. 225), which Fischer has recognized as being a loose adaptation of the Biblical theme of Samson and Delilah.[9] In the interim period between these works lay his incisive experience of the First World War, as well as his coming to terms with Rembrandt's representation of the same theme in the *Blinding of Samson,* 1636 (fig. 5), which had been acquired in 1905 for the Städel in Frankfurt. This drastic rendering of brutality, which both repulses and fascinates the viewer, must have been profoundly important to Beckmann, who, during the War, had been spiritually grieved by what human beings were capable of doing to one another. In his painting *The Night,* he adapted the density of the figural group which is crowded together into a small space,[10] as well as the number of figures which was seven (did he intend this to be a magic number?). Light and dark have exchanged places from inside to out, but light also plays an important role here. It is not the sparkling, ecstatic light of Rembrandt, but rather a lifeless, icy light which is without mercy. As in the *Blinding of Samson,* the hands and feet of the figures are the essential transmitters of meaning. The cramped foot of the victim, in which unbearable pain, powerless resistance, and the life-and-death struggle have been symbolically concentrated,[11] forms a prominent central point of crystallization in both paintings. The brutally power-

Fig. 5 Rembrandt: *Blinding of Samson,* 1636, oil on canvas, Bredius 501, Frankfurt a. M., Städelsches Kunstinstitut

Fig. 6 Max Beckmann: *The Night,* 1918/19, oil on canvas, Düsseldorf, Kunstsammlung Nordrhein-Westfalen

8. Ch. Lenz, "Mann und Frau im Werke von Max Beckmann," in *Städel-Jahrbuch* NF 3, (1971) p. 216.

9. F. W. Fischer, *op. cit.,* p. 23 f.

10. Later additions to the Rembrandt painting, which extended the surface of the picture above and to the side, were recently removed during restoration. Beckmann seems, whether he did this consciously or not, to have oriented himself towards the original section of the painting, as is shown in our illustration.

11. Similarly cramped feet appear, as a symbol of powerlessness, in the case of the fettered man in the central panel of *Temptation* (cat. 73).

12. See E. Göpel, *Max Beckmann: Die Argonauten,* Stuttgart, 1957, p. 4.

ful hands of the murderer which envelop the arm of the hanged man correspond to the fists of the hangman with the chain. Violence and helplessness are given a precise expression in these constellations of hands. In addition, the flat spherical heads, one bandaged, the other wearing a helmet, reveal in these two figures, who almost mirror one another, elements of inhumanity and barbaric brutality. Correspondences between the two paintings also can be found in the compositional use of diagonal lines and in the emphasis on the silhouette effect. Finally, the stylized curl of the victim in *The Night* may be interpreted as an ironic allusion to Samson's luxurious head of hair, the symbol of his power which was stolen by Delilah. An emotional drama whose subjects are masculine strength and feminine cunning, blind confidence and betrayal, the individual's will towards self-affirmation, and his failure in conflicts with power, this scene has been turned into a pitiful bourgeois-and-bad-guy scenario. The Biblical hero has been brought down by an outrageous quirk. His pain, courage, and despair, and the almost audible animal howl which shocks the viewer, have been replaced by a negligible, anonymous character who dies as wretchedly as he had lived. The viewer can hardly look upon the event as a tragic one, and feels neither empathy nor identification with the victims. The situation is so oppressive that it expresses a helplessness which transcends personal fate. It is the expression of the unbounded bitterness which Beckmann must have felt for the period in which such types were produced, in which the oppressors and the oppressed were equally worthy of contempt.

Isolation

From the dark years in Amsterdam, during which Beckmann sought and found comfort in the works of Rembrandt, we will concentrate on a related example of transformation, the triptych of 1941/42 entitled *Actors* (fig. 8). Beckmann himself indicated a connection with the Christ theme,[12] which Fischer makes specific

Fig. 7 Rembrandt: *Christ Before Pilate*, 1635, etching, Bartsch 77

Fig. 8 Max Beckmann: *Actors,* triptych, 1941/42, oil on canvas, Cambridge, Fogg Art Museum (middle panel)

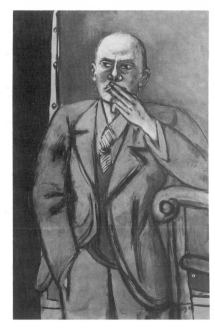

Fig. 9 Rembrandt: *Self-Portrait, 1669,* oil on canvas, Bredius 55, London, National Gallery

Fig. 10 Max Beckmann: *Self-Portrait in Blue Jacket,* 1950, oil on canvas, St. Louis, The Saint Louis Art Museum, Bequest of Morton D. May

in his discussion of the hidden allusion to Ecce Homo representations.[13] Actually, that inspiration seems to have come from Rembrandt's etching of 1635 (fig. 7) is evident not only in various details, but in the actual subject as well. The theatrical, multi-figured *mise en scène* can be found in the older work, as can the division of the piece into two levels. In both we find the exemplary, idealized action above, and the noisy, boisterous masses who understand nothing below. The dark arch of the gateway,[14] the palace facade, and the soldier with the lance also could have been taken from other representations of this theme. Two immediate references to the Rembrandt etching are the gnome-like figure with the wide mouth and the long strips of material hanging from its hat—whose precursor in the original bows his knees before Pilate—and the Janus-headed sculpture in the right wing of the painting which may have been inspired by the bust of Caesar on the high pedestal (fig., p. 43).

The Christ who was crowned with thorns and made a figure of ridicule with his naked, unprotected breast has been transformed into a mime with a paper crown whose features are those of the artist. He plays his role on the stage of time, a fool in the eyes of the world and yet a real king[15] who, alone and noticed by few, performs his own self-imposed act of salvation.[16]

Julius Held has characterized the recognition and representation of the existential loneliness of human beings as one of the fundamental themes of Rembrandt's art.[17] This is true to the same or even greater degree for Beckmann, whose figures, even within scenic frameworks, seem to be isolated and sunk in deep contemplation. For example, the brooding woman in the central painting of the triptych, *The Temptation* (cat. 73), is a sister to Rembrandt's *Bathsheba* in the Louvre. This characteristic is especially evident in the self-portraits as well as in the portraits of other people.

In their work, Rembrandt and Beckmann, each in his own fashion and yet parallel to each other, shed some light on the puzzling darkness which surrounds all of human existence, and opened up a small crack to the outside. While the one has used stories from the Bible as his point of departure about the basic human experience, the other has culled the depths of mythology to lend old wisdom a new form.

In the last years of their lives, both artists painted self-portraits. The 73-year old Rembrandt (fig. 9) and the 66-year old Beckmann (fig. 10, cat. 126) do not appear to us in these portraits as victors or as survivors, and certainly not as

13. F. W. Fischer, *op. cit.,* p. 162.

14. It also appears in the later version of the Ecce Homo theme of 1655 (Bartsch 76, 383 x 455 mm), which possibly also served as a source of inspiration: in the seventh and eighth states cellar-like spaces open up under the platform; the scene is divided like a triptych into three sections; there is also a female figure with her eyes covered: the sculpture of justice in front of the palace of Pilate.

15. Rembrandt too repeatedly portrayed himself in the robes and pose of a ruler, for instance, in the self-portrait of 1658 which is in the Frick Collection, New York (Br. 50).

16. The relationship with Rembrandt and the Christ-theme is one of several aspects of meaning contained in this multi-layered work. In general, we must be warned, in the sense of what has been stated above, against jumping to conclusions if one has succeeded in uncovering the artist's "tricks." This approach at best can be characterized as revealing one particle out of an entire mosaic.

17. J. S. Held, "Das gesprochene Wort bei Rembrandt," *Neue Beiträge zur Rembrandt-Forschung, op. cit.,* p. 122. By the same author: *Rembrandt's Aristotle and Other Rembrandt Studies,* Princeton, 1969, p. 30.

18. Thomas Mann and K. Kerenyi, *Gespräche in Briefen.* Zurich, 1960, p. 146 (letter of 1/1/47).

mellowed personalities. Rather, they are worn-out, exhausted, and skeptical men. Rembrandt's fur-trimmed robe and his patriarchal cap do not obscure the desolate condition of his body, his bloated face, the flabby lips, and the dull eyes which have become weary of seeing and prefer to direct themselves inward. To the same extent, Beckmann's dashing pose and garish clothes do little to disguise the forlorn quality of his gaze and the perplexity which is reflected in his hiding his mouth with a cigarette. And yet both of these works are anything but representations of resignation or of succumbing to external forces. The very fact that they were created presupposes a strength of mind and attitude, and is an indication of resistance to resignation: "A work of art, even if it is one of despair, can ultimately only be interpreted as an expression and a belief in life."[18] Beckmann standing in front of the stretched canvas, and Rembrandt, in an earlier state of the painting, holding maulstick and paintbrush in hand remind us that the defiance of Prometheus has not yet been extinguished.

Translated from the German by Jamie Daniel

Bruno Heimberg

Beckmann's Painting Technique

This attempt to describe Max Beckmann's painting technique is based on observation and study of a limited number of paintings. Although almost all periods of activity are represented, the following remarks are by no means complete and do not claim to be. Instead an attempt will be made to offer some insight into the process which produced these works of art by describing materials and technique.

As far as can be judged, Beckmann developed his typical methods and techniques as well as his preference for certain materials and implements relatively early in his career and in general remained true to them to the end of his life. Fundamental experimentation and revolutionary innovations are absent from his painting methods. Change and development are evident, however, in the confidence and virtuosity with which the artist used the means at his disposal to find new and subtler expressions for his pictorial ideas.

The habit of working on several subjects simultaneously is typical of the artist. In one day paintings already begun might be continued, other compositions concluded, and new ones sketched. Short pauses after exhausting work, followed by explosions of creativity, led to a number of new sketches for paintings. Here are examples from several diary entries: "Thur. Dec. 25, 1940. First holiday: sketched 6 paintings, ha ha,—. Sat. Apr. 12, 1941. ... worked very intensely on 5 paintings... Sat. Sept. 5, 1942, made 5 sketches, two *Departures*, *Yellow Lilies, Negerbar* and *Two Women. Frankfurt Train Station* is finished. Wed. Oct. 25, 1944, furiously finished *Pink Woman with Playing Cat.*— Sketched six or seven Caliente paintings... Wed. Nov. 23, 1949. Rested one day and already all kinds of nonsense boils up in me demanding a form—perhaps The Story of David—or something, we'll see."[1]

All the paintings discussed are painted on stretched canvas and fastened with nails. The sometimes unusual formats suggest that many of the stretchers were made to specific measurements; we know from the diaries that at least in some cases the canvas was placed on the stretcher by the artist or his helpers. "Fri. Nov. 2, 1945. New canvases are stretched despite trouble and the devil... Mon. Aug. 5, 1946... In the evening Johannes came and stretched canvases for the two new triptychs..."[2]

With the exception of a few paintings the artist always used a fine to medium coarse single-weave canvas with very little texture nap. It is striking that the strength and texture of the canvas remained constant regardless of the size or date of the painting. One result of this is that the surface of the small paintings seems more strongly influenced by the canvas texture than the surface of the large ones.

The mechanically-applied ground is always white. Thus, whether it is covered by a transparent underpainting or by a thick layer of paint, it serves as a kind of reflector, which decidedly enhances the radiance of the color.

As we try to trace the process behind the paintings, the fact emerges that Max Beckmann made use of preparatory studies only within a very limited context. These were either drawings in pencil, charcoal, or pen and ink, or

1. The Caliente paintings mentioned here refer to the Caliente Bar in Amsterdam where Beckmann was a regular customer. Max Beckmann, *Tagebücher 1940–1950* (1979), pp. 27, 31, 52, 102, 362.

2. *ibid.*, pp. 141, 173.

Fig. 1 Max Beckmann: *Resurrection,*
1916—18, oil on canvas, Stuttgart,
Staatsgalerie

compositional studies in oil. Most of the pictorial ideas awaiting realization
were sketched directly on the canvas (fig. 1), then fleshed out to final form in an
often long and tedious process. This process can be distinguished in the paint-
ings themselves, but is also reflected in numerous diary entries.

The following notes on the creation of the painting *Festival of Flowers at
Nice,* 1947 (fig. 2) illustrate how an original compositional idea is repeatedly
revised or abandoned during the actual painting process before it takes its final
form: "Sat. April 26, 1947. Sketched *Blumencorso* on an old self-portrait. Wed.
April 30, 1947. Did much work on *Nice,* begins to interest me. May 30, 1947.
Worked intensively for 6 hours on *Baccarat* and *Blumencorso.* Sun. June 8,
1947. Intensive work on *Blumencorso*—morning and afternoon. Fri. June 20,
1947. *Blumencorso Nice* finished. Sun. June 22, 1947... Painted over *Blumen-
corso* once more, good. Sat. July 5, 1947. Worked the whole day more or less
successfully on *Blumencorso.* Sun., July 6, 1947. ... I fooled around with *Corso*
all morning again.—Another basic revision has come up—well, we'll see.—Sun.
July 20, 1947. *Blumencorso.* Fri. July 25, 1947. Very hot—painted at night until
12:00, *Blumencorso* again. Sat. July 26, 1947. Again *Blumencorso* until 7:00.
Wed. July 30, 1947. Actually wasted the whole day on *Blumencorso.*—8 hours I
think. Wed. August 6, 1947. Still—(I'm ashamed of myself): *Blumencorso*
again—very good I think.—Sat. August 9, 1947. 4 more hours on *Blumencor-
so*—(a disgrace)—Sun. August 10, 1947. Whew—back from *Blumencorso* at 6 in
the morning—one last night.—Mon. August 11, 1947. The pink blooming twigs
in *Corso.*—Wed. August 13, 1947. Still at *Blumencorso* until the last minute
before the paintings were picked up.—truly pathologically long. Sent it off still
wet—well then—the devil take it.—Sun. February 13, 1949. In the evening (cold
studio, *Totensonntag*) made still more sketches of *Blumencorso in Nizza.*"[3]

There are a number of unfinished paintings in which Beckmann's working
method can be observed at various stages. A particularly instructive example is
the unfinished *Resurrection* of 1916—18 (fig. 1). There one can perceive a
network of coordinates drawn with a very fine pencil, evidently used as an aid in
transferring a small compositional sketch to the large format. The outlines of

3. *ibid.,* pp. 200, 204-208, 210, 212, 315.

Fig. 2 Max Beckmann: *Festival of Flowers at Nice,* 1947, oil on canvas, Fort Dodge, Iowa, Blanden Art Gallery

figures and fragments of landscape are applied very freely over this, using pencil and perhaps charcoal with no emphasis given to detail. One can assume that Beckmann's major concern at this stage is the composition itself rather than working out individual forms in detail. As the first step of consolidating the composition, the pencil or charcoal underdrawing is gone over with a transparent fluid paint, varying from gray to black, similar to India ink. This contours the drawing and creates a type of wash.

This process is not followed evenly across the entire surface, but is begun and intensified at points which interest the artist at the moment. They then spread across the whole canvas in a kind of crystallization process. Impressive evidence of the vehemence with which this work proceeds is found in such signs as splashes of paint and traces of scratches (cf. fig. 3, 4). Throughout his life Beckmann had the habit of sketching the composition first with charcoal or pencil and then with the brush, regardless of whether the project was a large triptych, a portrait, a landscape, or a still-life. In later years, as the brushwork became broader, the underdrawings were also done in a more regular way, resembling oversized brush drawings (cf. cat. 132).

With the brush underdrawing, the painting begins its course toward the surface. Intertwining and overlapping on many layers, it continues to develop and correct itself. At the same time as the underdrawing, or directly afterwards, the colored underpainting is done. It serves primarily to establish the three-dimensional aspect and to create a certain basic coloration (cf. fig. 3). However, both processes collapse into one since the desired plasticity and spatial depth are not primarily achieved so much by the perspectival methods of drawing but by color and surface structures and contrasts of light and dark.

In the process of painting, new forms arise from the color, which covers and thus alters the previous forms. Fields of color mutually limit each other. The black underdrawing or the white ground beneath it produces contours, thereby establishing additional form.

In a final effort, Beckmann often changed or clarified his formal concept (cat. 73). He may have outlined the forms already present with black paint, or amplified and sharpened the internal drawing where necessary. Sometimes he would generate an additional plane in the layering of the composition's depth by adding a system of black lines and surfaces. This last-minute correcting and tautening in order to achieve the final form is especially evident in the portraits, but also occurs in the landscapes and still-lifes. Thus, the final form of a sitter's outline was arrived at with the execution of the background, that of an horizon line with the execution of bright wallpaper (cf. fig. 5, cat. 55). In order to make certain ideas visible without either committing to them or having to destroy what was already present, he sometimes covered parts of the composition with paper shapes. "Sun. May 15, 1949. Was not so very satisfied with *Beginning,* too crowded—but—well... tried a paper covering late in the afternoon (attempt to eliminate the children in the left panel) —perhaps only exhaustion—will decide tomorrow."[4] At times, to check his paintings and test the balance of a composition, Beckmann would turn his paintings upside down or on their sides.[5]

In order to clear up unresolved problems of the color composition, Beckmann used pastels to set down the areas in question before they were completed in oils. *Ballet Rehearsal,* 1950 (cat. 132), is one of the few instances where one can still observe this procedure. Apparently he corrected sections that were already painted in the same way, either painting over them or scratching them off and painting afresh.[6]

In his famous London speech of 1938, Beckmann describes the importance of color in his work with the following words: "Color, as the strange and magnificent expression of the inscrutable spectrum of Eternity, is beautiful and important to me as a painter; I use it to enrich the canvas and to probe more

4. *ibid.,* p. 329. Here reference is made to the triptych, *The Beginning,* 1946-1949, (cat. 122).

5. "He would often turn the painting he was working on upside down or on its left or right side. Many times I heard him say, 'Standing a painting on its head is a test for the balance of the composition. When something doesn't fit it shows up right away. Every great painting of the past stands up to this test.'" M. Q. Beckmann, *Mein Leben mit Max Beckmann,* 1983, p. 147 f.

6. "Whenever Beckmann experimented with color in an unfinished painting or tried out colors for a new composition, he first used pastels in order to see the approximate results. Then he completely removed the pastel color, rubbed the section with a dry cloth, then with a rag soaked in turpentine, before finally painting over it." *Ibid.,* p. 146.

3

deeply into the object. Color also decided, to a certain extent, my spiritual outlook, but it is subordinated to light and, above all, to the treatment of form. Too much emphasis on color at the expense of form and space would make a double manifestation of itself on the canvas, and this would verge on craft work. Pure colors and broken tones must be used together, because they are the complements of each other."[7]

In order to arrive at dependable information concerning the colors Beckmann used in his paintings over the years, scientific studies were conducted and intense observations were made. In these studies, approximately 360 tests were performed on samples taken from the ground and from sections of paintings that are white, black, light and dark yellow, light and dark red, brown, light and dark blue, and green.[8] In a great variety of mixtures, the following were found: lead white, chalk, barium sulphate, titanium white, zinc white, ivory black, vine black, cadmium yellow, chrome yellow, yellow, red and brown ochres,

4

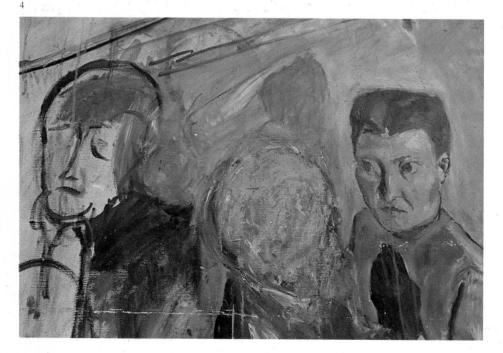

7. Max Beckmann, *On My Painting,* published in an English translation by Buchholz Gallery, Curt Valentin, New York, 1941.

8. Grateful thanks are due here to Karin Junghaus and Dr. A. Burmeister for their scientific contributions.

5
6

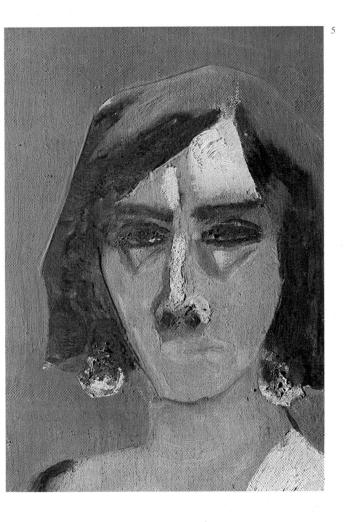

7
8

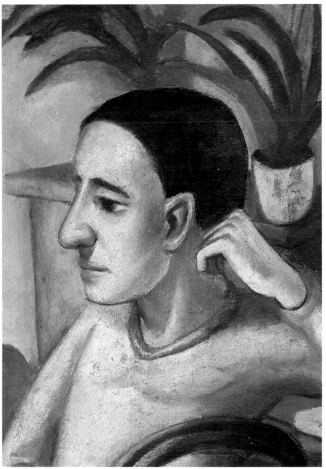
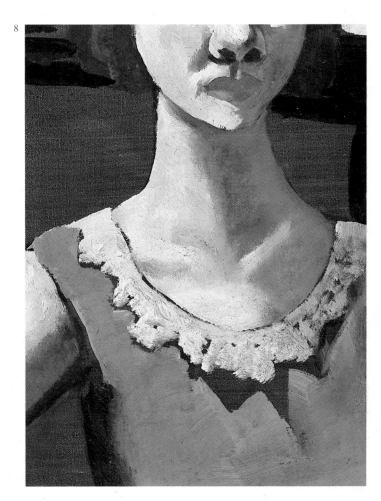

strontium chromate, zinc chromate, cadmium red, red-violet lacquer (madder lac), cinnabar, cobalt violet, Prussian blue, cobalt blue, synthetic ultramarine blue, chrome oxide green, and emerald green.

The *white ground* usually contains lead white, often mixed with zinc white or barium sulphate. In rare cases, chalk or titanium dioxide are present. Since these are commercially ground paints, Beckmann probably did not vary the compositions. In the white paint samples, lead white is by far most prevalent and is often unmixed. In later years, zinc white is frequently mixed into the paint. Beckmann used these two pigments, but mainly lead white, to mix with almost all the other colors he used.

The two *black pigments* are ivory black and vine black. In black areas ivory black is usually used, while other colors are mixed almost exclusively with vine black. Black areas of the paintings often contain—in addition to lead white—ultramarine, Prussian blue, brown ochre or red lacquer. Very often these pigments are not mixed with the black, but are layered over it, achieving a depth of coloration that would be otherwise impossible in such saturation and fullness. Without losing the finely nuanced tone produced by mixing with white and black, the radiance of the colors could be maximized.

In the *light yellow* areas of paint, cadmium yellow predominates and is found in all time periods. The use of strontium chromate, the next most frequently used pigment, is confined to a few years before 1930, and zinc chromate is found only in 1930/31. Yellow ochre and chrome yellow are present in very small quantities as mixing pigments. Most lightening is done with lead white and later with zinc white. Tone is adjusted with ultramarine blue and chrome oxide green.

In *dark yellow*, cadmium yellow dominates but is very often mixed with yellow ochre. Again, lead white, zinc white, and vine black are the most common mixing pigments, but the entire spectrum of red pigments used by Beckmann is also present.

For *light red*, Beckmann preferred cinnabar, but at times utilized cadmium red. As always, these are mixed with lead white and vine black.

The standard pigment in the *dark red* areas is a red-violet lacquer (alizarine madder lacquer), although in isolated cases cadmium red and red ochre are found. Mixing is done mostly with lead white and vine black, but also with ivory black, synthetic ultramarine blue, chrome oxide green, and Prussian blue. In both light and dark red, cinnabar, lead white, and vine black are constantly present, while cadmium red and zinc white appear more frequently in later years.

For *brown*, Beckmann used a brown ochre exclusively, mixed with vine black, lead white and, to a much lesser degree with synthetic ultramarine, chrome oxide green and red ochre. All the pigments are found continuously with very little variation over the years. In both light blue and dark blue, synthetic ultramarine blue is dominant. Starting in the mid-1930s Prussian blue appears in much smaller quantities, as does cobalt blue in the light areas. Lead white and vine black dominate in mixing; ivory black and later zinc white are less common. The only multi-colored pigment found was a red-violet lacquer in various places.

Regarding Beckmann's *green,* chrome oxide green dominates as practically the sole pigment with the exception of two 1926 paintings where emerald green is found. As always, lead white and vine black are most often used to mix with them; spare amounts of chrome yellow, synthetic ultramarine blue, and in later years zinc white and ivory black were also used. The relatively small number of paintings studied and the statistical imbalance of the material for comparison within the various periods of activity could produce certain imprecisions in the results. Still, some interesting conclusions are possible regarding the colors used and the mixing of colors.

One notes that, despite his extensive palette, Beckmann absolutely preferred to use a relatively small number of pigments. With the exceptions mentioned, these pigments appear repeatedly throughout his career. They are also preferred in combination with each other. All other pigments serve only as mixing colors and are significant for coloration within this limited function.

It is interesting that, even in the most radiant colors, white, black or both are almost always used to lighten, darken, or restrain.

The medium in the paints used by Beckmann was not analyzed, but they were probably normal commercial oil paints or resin oil paints. Beckmann worked these into extremely varied degrees of consistency, from very thick paste to the thinness of a glaze, almost like India ink[9] (cf. cat. 61, 91). Thick paint is applied with a spatula only in early paintings such as the floor portion of *Large Death Scene,* 1906 (cat. 5). Otherwise Beckmann used brushes of varying degrees of coarseness and various widths.[10] "Fri. June 3, 1949, Bought brushes for 40 dollars..."[11]

In most of the early paintings the paint mixed on the palette was applied with short, strong strokes layered next to and over one another, at times in relief. The surface texture this produced not only reflects the vigor of the painting process but also produces a three-dimensional modeling of the forms and details depicted (fig. 6). The color modelling of the bodies and objects occurs in several layers on top of one another moving from dark to light. In spite of the opacity of the thick paint, the underpainting plays an essential role because the deeper layers are visible between brush strokes, resulting in an effect of depth that is of special significance for the artist.

The striking pastel-like texture of the surface began to give way in the early 1920s, at the latest. It is replaced by an application of paint that is still generally opaque but is much more finely structured at its surface. As before, the paintings possess an extremely lively surface which is by no means inferior to the earlier paintings in textural variety. In many ways the surface becomes more subtly involved with the materiality of the subject portrayed, though it is no longer evident from a normal viewing distance. Modelling and the effect of depth are developed exclusively from light/dark effects and color contrast. To achieve this effect, Beckmann apparently used relatively small, rather soft brushes with which he applied the thick paint in thin strokes and, primarily in the light areas, with gentle thrusts (fig. 7).

The fineness of the brushwork is not related to the small size of the figure depicted, since Beckmann proceeded in a similar fashion on large surfaces like the life-size portraits (cf. cat. 73). Even when this style gave way to much freer and more spontaneous brushwork, the extremely thick paint of the earlier works never returned. It was replaced by a play of surface effects that became continuously freer and more refined. These effects are never decoratively self-sufficient, but always fulfill important formal functions. In the paintings of the early 1920s, Beckmann made use of a technique that he continued to develop in a multitude of variations until his death. He would completely or partially cover his white painting surface with a strongly colored glaze so thin and transparent that the white ground of the canvas beneath is brightly set off. It shines through like a kind of light reflector, giving radiance to the color on top of it (cf. fig. 8, cat. 50, 55, 61).

Not only did Beckmann pre-program an unvarying basic mood of color in this way, but one has the feeling that he also forced himself to an extreme of concentration. Unlike the procedures of revision described earlier, this method no longer allowed him to make corrections without destroying the layered structure and hence the entire composition.

Building on this pre-established basic system of coloration, Beckmann worked out the composition, producing very diverse contrasts and unusual

9. "At least since our marriage in 1925, Max Beckmann only used palette and brush, oil paints and turpentine for the paintings on canvas. In earlier years he sometimes added linseed oil...

If one looks at his paintings close up—and this applied to all Beckmann's oil paintings—one notes that the paint is thinly applied in some places and thickly in others. He compared that to using the pedal in playing the piano. 'It isn't good always to play fortissimo, and it is also not good always to play pianissimo; exhaustive use of one technique makes a piece monotonous and boring.'" M.Q. Beckmann, *op. cit.,* p. 331.

10. "The brushes he used were boar bristle and sable from the finest up to 8 cm wide." Max Doerner, *Malmaterial und seine Verwendung im Bilde,* Stuttgart, 1954, p. 356.

11. Max Beckmann, *Tagebücher 1940–1950, op. cit.,* p. 331.

effects. Color lies next to color, color over color, dark before light, opaque on transparent, paste-like on smooth, dull on shiny, and vice-versa. Earlier, he had mixed color on the palette or directly on the canvas as a means for modelling forms. It had been mixed in diverse shadings and nuances—even including gray, especially in the early paintings. Later, paints were placed more flatly and colorfully next to and on top of one another (cf. cat. 61).

Some paintings have only a partially colored underpainting or none at all. In these cases the white ground or the blended black underdrawing have been integrated into the composition as white or gray surfaces or as black or white contours (cf. cat. 90, 91, 93). The three-dimensional shapes of the objects depicted, as well as spatial depth, were no longer exclusively constructed with light/shadow effects or perspectival shortening. Instead they arose quite strongly from this layering, which allows one to see the basis of the things presented.

Although it would surely be going too far to call Beckmann's an "old master" technique, he does use those methods in modified form. For example, he places several layers of different colored glazes over one another in order to achieve a certain color effect or to enhance the colors' radiance. Or, like Rubens, he integrates the white ground into his color scheme.

The subtlety of Beckmann's color is partly due to the variety of levels of surface gloss. These can vary markedly within a single color surface, between different colors, or between the individual layers on top of one another.[12] While glossy areas have a transparent radiance, dull sections have a dim, tempera-like character. This contrast produces further surface effects which have a lasting effect on the coloration as well as on the sense of depth—due to the optical emphasis on multiple layering. We can be sure that Beckmann intended these effects and consciously considered them in his artistic deliberations, since he strictly refused to varnish his paintings.[13] Unfortunately, some of Beckmann's paintings have been varnished over the years, causing some of his intended effects to be lost.

Translated from the German by Barton Byg

12. "When he wanted glistening areas of color in the top layers he would take pure paint directly out of the tube with almost no turpentine; if the color was to be dull, he would use more," M. Q. Beckmann, *op. cit.*, p. 145.

13. According to M. Q. Beckmann, "He emphatically rejected varnish or any other final lacquer, and any kind of sheen on the surface." Cited in Max Doerner, *op. cit.*, p. 356.

Cornelia Stabenow

Metaphors of Helplessness:
The Sculpture of Max Beckmann

Max Beckmann's work and statements are indicative of the fact that he considered himself to be exclusively a painter. Thus it would seem that the eight small bronzes which were created in the mid-1930s and in 1950 played only a peripheral role in his total work. Sculpture seems merely to represent a medium with which he dealt for only a short period, and which served as a supplement to his actual work. In any case, these sculptures are less representative of the discipline of "sculpture" than they are of the mythological element in Beckmann's thought, not only in terms of the motifs they contain, but also in terms of their structure.

Deformation

Due to its iconographic fabrication of images and its strict formal system, the sculpturing process in itself functions as a transmitter of meaning. The concept of "sculpture," like painting, has been communicated in the most fundamental way. Beckmann wrote in a letter to his wife dated March 16, 1915: "I hope to gradually become simpler, more concentrated in my means of expression, but I know that I will never give up the full, round, vivaciously pulsing aspect of life... on the contrary, I hope to intensify it. You know what I mean by intensified roundness. I don't mean arabesques or calligraphy, but abundance and sculpture."[1] Sculpture as analagous to vitality is achieved by Beckmann the painter who expresses "roundness within the flat surface" in his paintings with securely, transcribed subject matter and dense compositional structure. For his bronzes, however, he chose a clarity which was unusual for him. The methodically modelled surface, as formulated by Rodin, Degas, and Matisse, allows the sculptures to become an outlet for movement rather than strictly defined bodies. It opens up the space around them and creates an interaction between light and shadow which seems to capture the "vivaciously pulsing element" more readily than the concrete structure of painting.

In contrast to this modelling, however, there is also an expression of constraint. The work of the artist, namely, the molding of clay for the prototype, takes priority and is not transformed. The rhythm of the figure develops by means of parts which are added on; it remains coincidental, as if it were imposed from without, since no means exists to organize the volume out of the physical essence. The dimensions of the limbs, hands, and feet are shaped, disproportionately to the head and body, into monumental, crude forms; at the same time, the figure is crowded together and compressed. Deformations grow or shrink without regard to any sort of continuity. In place of a volumetric and stabile body, a purely material process takes place, like some pliable matter which is caked together under pressure. The energetic quality of the individual forms is repressed and transformed into an encumbered heaviness, into materially constrained physicality. These are grotesque likenesses of human beings who bear their heroism as forms of helplessness and impotence. The body as the prison of the soul, i.e., the Gnostic concept of the bondage of humanity, has

1. Max Beckmann, *Briefe im Kriege,* Berlin, 1916.

been visualized by Beckmann in his paintings by a comprehensive iconography of the impossibility of freedom. But in his sculpture he expressed this only through the immanent contradiction between surface movement and the weight of the mass. A similar function is effected in his painting by means of pronounced distortion, whereby powerful, formally obviated movement is used, at least from the late 1920s onward, to express indirect confinement (cat. 56, 57, 66).

Motifs

In the sculptures, it is as if Beckmann stopped the action; the gesticulation remains disparate and incoherent, and can be characterized as demonstrative. Thus in *The Man in Darkness*, 1934 (fig. *2*), which is positioned sideways as if towards an imaginary wall, Beckmann arranges the hands in a protective gesture, raised in defense. The head is turned back in an emphatic attitude of perseverence. The movement, which is interrupted three times, is directionless, and the addition of the discrepant actions of going, groping, and seeing locks the figure in place. This impression is intensified by means of the surrounding deeply-shadowed zone formed by the cloth. Blindness is graphically illustrated: the eyes are forced to protrude unnaturally and sightlessly. Motifs of "not seeing" and "not knowing," which Beckmann used in many paintings from *The Dream* of 1920 onwards, illustrate the futile action and the marionette-like existence of mankind. (cat. 23, fig. p. 39, 45).

The Dancer, 1935 (fig. 1) reveals itself in the artistic position of the splits. This position, elegant and erotic in itself, is handled in a cumbersome and forced manner. The figure is deeply bowed, and its limbs rest heavily on the ground with no indication of a moment of release. The palms of the hands, which are opened upwards, accentuate this impression and can be read as a variation of the suffering gesture in evidence since *Deposition* of 1917 (cat. 17). In a similar way, the figure of *The Acrobat*, 1950 (fig. 5) is held in an exhausting balancing act, clinging to the ground with massive feet and hands. Appropriately, clowns, dancers, and acrobats occur throughout his other works as symbols of human existence, seeking a restful balance, but always being cast as the ridiculous plaything of an imposing and senseless mechanism (cf. cat. 33, 66, 89).

If we can also assume that Beckmann's personal situation in the 1930s, namely the beginning of his ostracism under National Socialism, was a motivation for his pessimistic attitude, then the world view of the artist is responsible for this iconography of surrendering, incapacitated human beings. *Self-Portrait in a Large Mirror with Candle*, (cat. 68), like the sculpture *Blind*, enveloped the individual in darkness and contumacy. Therefore it is not surprising that Beck-

Fig. 1 Max Beckmann: *The Dancer*, 1935, bronze, Munich, Bayerische Staatsgemälde-sammlungen, Staatsgalerie moderner Kunst

Fig. 2 Max Beckmann: *The Man in Darkness*, 1934, bronze, Munich, Bayerische Staats-gemäldesammlungen, Staatsgalerie moderner Kunst

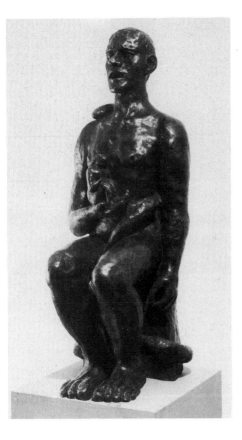

Fig. 3 Max Beckmann: *Adam and Eve,* 1936, bronze, Frankfurt a.M., Städtische Galerie im Städelschen Kunstinstitut

Fig. 4 Max Beckmann: *The Woman Snake-Charmer,* 1950, bronze, New York, Catherine Viviano Gallery

Fig. 5 Max Beckmann: *The Acrobat,* 1950, bronze, New York, Catherine Viviano Gallery

mann dramatizes the central theme of the Fall of Man in sculpture as well. The sculpture *Adam and Eve* of 1936 (fig. 3) concentrates on the heroic man who is shackled to his seat by the body of the snake. The pained expression on his face and the contrast of a monumentality reminiscent of Rodin compared to the constrained, bulky structure of the piece give this Adam a tragic quality. This is the trait taken on by the men in Beckmann's pictures when confronted with their counterpart, the dangerous woman (cf. cat. 70). Eve is only alluded to here in the context of the problem of sexual obsession. The sculpture of *The Woman Snake-Charmer,* 1950 (fig. 4) takes up this theme from the other viewpoint.

Sculpture as Motif in Painting

The fact that sculpture was an important metaphor in Beckmann's thought is evident in his paintings. The scene *Studio (Night),* begun in 1931 and continued

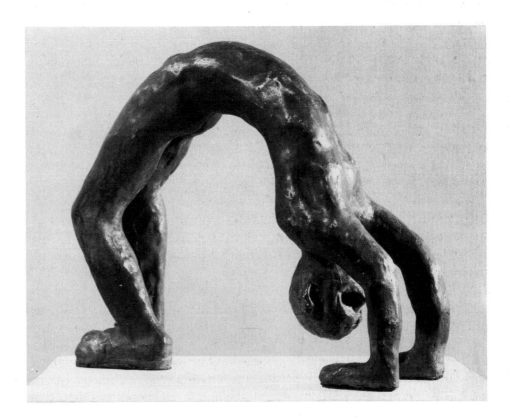

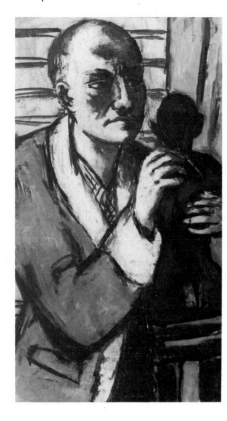

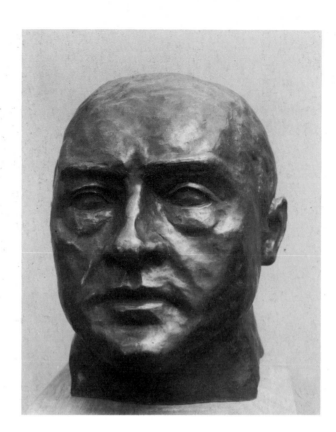

in 1938 (cat. 85), illustrates in a compact and upright format a trapped and hopeless inner space that surrounds a sculpture on a modelling table, a vase decorated with a serpent, a round mirror or picture frame, and the phosphorescent flower of paradise. The meaning of the sculpture, which had been covered with a large cloth as is necessary for clay models, extends beyond the reality of the studio, since the dark covering and the immense leg that appears from beneath it define the sculpture as a living, yet confined being. The figure exists within the context of its own blindness, comparable to *The Man in Darkness*. A threatening atmosphere persists. Even the telescope, an instrument of perception which recurs repeatedly in Beckmann's work from the 1920s on, remains locked without function into this world of calamity. It is strange that the figure, which is formed in the same way as the tangible sculptures, has taken on the demonic characteristics of its surroundings.

The human figure harnessed into a structural context of disquieting symbols in *Large Still-Life with Black Sculpture*, 1949 (cat. 124) is a variation on this theme. The serpent motif of the Fall of Man is missing. Yet *vanitas* symbols of flowers, fruits, mirrors, and burning candles, as well as a fish, the Gnostic symbol of the imprisoned soul, have been incorporated along with the dark bust of a woman. Night and a crescent moon wait outside the window as elements of the unknown, as they did in the horror scene of 1918/19 (cat. 19). The sculpture is characterized by the human face and sheltered in the transitory flame of the candle. The ladder, which also appears later in the *Argonauts* triptych (fig. p. 37), attempts to show a way out of this confined existence and at the same time creates a barrier between the image and the viewer.

Since sculpture also functions as an allegory for humanity, it is obvious that the analogy used since the early Renaissance between the story of creation and the mythos of the artist appears within the greater context of Beckmann's work. Beckmann represented himself as a sculptor only in one painting, *Self-Portrait in Gray Robe*, 1941 (fig. 6, cat. 93). The tradition of self-portrait as sculptor is not conveyed here, but rather the self-awareness of the artist who tenderly and protectively clasps his work. The action of placing his hand on the brown

Fig. 6 Max Beckmann: *Self-Portrait in Gray Robe,* 1941, oil on canvas, Munich, Bayerische Staatsgemäldesammlungen, Staatsgalerie moderner Kunst

Fig. 7 Max Beckmann: *Self-Portrait,* 1936, bronze, Private collection

Fig. 8 Max Beckmann: *Labyrinth,* 1944, oil on canvas, Private collection

Fig. 9 Max Beckmann: *Sculptor's Studio,* 1946, oil on canvas, St. Louis, The Saint Louis Art Museum, Bequest of Morton D. May

2. Armin Kesser, "Das Mythologische Element im Werk Max Beckmanns" in *Blick auf Beckmann,* Munich, 1962, p. 31.

3. In this matter and with regard to the problematic of the self-portrait, see Karl Arndt, "Max Beckmann: Selbstbildnis mit Plastik. Stichworte zur Interpretation" in *Ars Auro Prior, Studio Ioanni Bialostocki,* Warsaw, 1981, p. 719 ff.

4. Arndt's assumption (*op. cit.* Note 55) that the figure is a hermaphroditically characterized sculpture and thus could be a Gnostic symbol of redemption is not acceptable.

sculpture is merely a subordinate one. As early as 1958, Kesser wrote: "In a self-portrait, Beckmann has represented himself as Prometheus as he is forming man."[2] This is a convincing association, and yet Beckmann understood and represented himself throughout his life as a Promethean bearer of ideas—bringing fire to man against the will of the gods, after first creating him out of clay. It is striking, however, that in contrast to his many lofty statements and arrogant self-portraits, he portrays himself here without the titanic pathos marked by *Sturm und Drang.* Here he is not the knowing and defiant artist-priest who still identified himself with the cult of 19th-century genius, nor is he the violent creator of form who confronted us with protest and monumental style. Rather he is a man who is hesitant and controlled by inspiration, as in *Self-Portrait with Horn* (cat. 86). The theme of the work from 1941 is the creative act itself. Nonetheless, the self-portrait suits the role of the melancholy genius. We should not overlook the pronounced degree to which Beckmann used brooding and pain as characteristic forms of melancholy. Here the image of the suffering Prometheus, theosophically set forth in the esoteric doctrine of Madame Blavatsky, forms the background.[3] Prometheus, provided with consciousness, wanted to perfect mankind and failed because of his own impulsiveness. The skepticism of the self-portrait, reflected in the sculpted *Self-Portrait* of 1936 (fig. 7), corresponds to the pessimistic statements Beckmann made in his journals: "Playing the powerless role of the creator is our tragic occupation." (28.10.1944). Here it makes almost no difference whether this creation is a matter of the "ego which is dark, strange, estranged and closed-off from itself" or of the utopian belief that "creation...[is] salvation." (2.5.1941).

The Dream of the Sculptor

Even if the sculptures mentioned are not the rear view of the "Adam" which was developed in 1936, it is conceivable that there is a connection between their motifs.[4] In the painting, *Labyrinth,* 1944 (fig. 8), the serpentine decor of the window casings designates the sculpted busts of man and woman as the charac-

ters in the Fall of Man. *Sculptor's Studio,* 1946 (fig. 9) confronts a female nude, trapped in the mirror and viewed from behind, with the presence of a brooding figure similar to the shackled woman on the left side of the *Temptation* triptych (cat. 73). Beckmann's view of the world, marked by the Gnosticism and theosophy with which he mystified the forces of fate, was intensified during the 1940s, in a fantasy of brutality. Parallel to this, there were statements of doubt: "All of my efforts towards uniting humanity are lost, as usual" or, he felt that "there was still some sort of force which wants to be eternal but which is still deeply convinced of the pointlessness of it all." (*Tagebücher* 10. 3. 1946; 5. 7. 1949). *The Sculptor's Dream,* 1947 (fig. 10) brutalizes the comparison to the creation in two ways. The two giant hands of a being which is only partially visible grasp the naked human form which, like the sculptures, is deformed, bloated, and abbreviated in a monstrous way. Beckmann also understood his sculpture as being included in the conceptual context of the creator as a destructive, unidentified demiurge, who possesses human beings and keeps them in anguish. On the other hand, such a painting also helps decode the psychic situation of the artist himself. Beckmann repeatedly develops crude deformations which are coupled with trivial motifs. As in many paintings and graphics from the 1940s, including *The Sculptor's Dream,* this immediately arresting fantasy, which violates objects almost ritually, is released against the background of growing depression (cf. cat. 108, 110, 180, 196).

Fig. 10 Max Beckmann: *The Sculptor's Dream,* 1947, oil on canvas, Frenchtown, N.J. Stanley J. Seeger, Jr.

"Wild" Sculpture: Baselitz, Lüpertz, and Immendorff

The recent confident return to expressiveness and to a rich perspicacious iconography of images has necessitated a look back to the earlier Expressionist movement. The mythological motifs and the rigidly defined formal language which marked Beckmann's work have also reappeared in the work of contemporary artists. It is pertinent, therefore, to attempt a comparison in the area of sculpture as well with painters such as Baselitz, Penck, Lüpertz, and Immendorff because the principle of sculpture has also been included as a complement to their painting. Yet the resemblance is misleading. The new artists use their materials in a primarily primitivistic way, and they insert and accentuate colors which lead sculpture in the direction of painting. Sculptures by Ernst Ludwig Kirchner, or the "art brut" of Jean Dubuffet, or of the COBRA members or even de Kooning should be considered the precursors of these artists. Above all, the trivial element in their sculpture, developed out of folk art, does not strike us in Beckmann, and therefore points to another, more modern attitude.

The Intentionally Primitive

Like Beckmann, it is common for the "Neo-Expressionists" not to construct their sculptures organically from a central core. Georg Baselitz, who has worked since the 1970s in an expressive, figurative style and can be considered a protagonist of the "Young Wave," roughly knocks his figures out of wood with a hatchet (fig. 11). The spontaneous, rigorous process is certainly communicated, since the sculpture is left in a raw state. Gash marks are as unpolished as the splintered edges. The intended motif is indicated only in the most simplistic way, hardly revealed through the material. This unfinished form and the larger-than-life dimensions (the sculpture conceived for "documenta 7" but never exhibited was almost double life-size) bear witness to an obvious monumental quality. This element of barbaric seizure and deformity is found also in Beckmann, whose sculptures retain the appearance of a practice model. The expres-

sive interest, however, has been displaced. Beckmann molds the material differently and attributes a symbolic value to the deformity as well as to the violent gestures. In contrast, the deformation in Baselitz's sculpture does not serve the theme of the work: the aggressive process of striking the wood itself is primary. The material is not transformed, but cloven. Denial is the expression: denial of the traditional concept of skill, which Beckmann indeed accommodated in his treatment of surfaces; and even, denial of the enigmatic. The idol-like sculptures present themselves as being intentionally dilettantish and barbaric artifacts whose simplicity prevents any inferences of a world view. Baselitz's device, since 1968/69, of having the figures in his paintings stand on their heads can be interpreted as a metaphor for an "inverted world;" yet it remains striking that the unending variation of this idea as intended by Baselitz has devalued the concrete subject. Insofar as the images produce disoriented and free painting rather than precise expression, these sculptures incorporate the drastic expression of a primitive, non-descriptive vision.

The Ironic Principle

For Penck as well, the theme is not man but rather the direct approach to the material, whereby the aggressive and urgent treatment permits us to make inferences on the contemporary situation of a disillusioned world. Beckmann's mythos of the creator is lacking. It has been replaced by a provocative and liberating method of irony. Thus most of the painted bronzes of Markus Lüpertz achieve their hard-angled surfaces through a process similar to that used by Baselitz. In his model, Lüpertz handles the plaster not as a malleable substance, but as a block from which he forcefully cuts out his forms. This process is strikingly evident in the sculpture *Stand-leg/Play-leg* (fig. 12), whose monumental dimensions and aclassical torso make a mockery of the heroic

Fig. 11 Georg Baselitz: *Untitled,* 1982, carved wood, Hamburg, Galerie Neuendorf

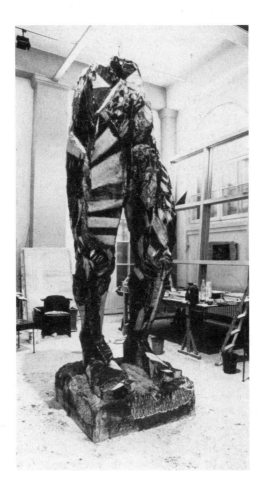

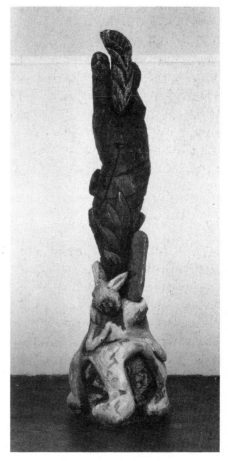

Fig. 12 Markus Lüpertz: *Stand-Leg/Play-Leg,* plaster of Paris

Fig. 13 Jörg Immendorff: *Time Sweat,* 1982, carved limewood

man. Beckmann had represented a similar idea in his metaphors of suffering and protest. The possibilities inherent in styrofoam sculpture are particularly interesting for this modern cynicism. The heavy, dense form is carried into the ridiculous by the lightness of the material, and the information is unmasked as a lie. In this same way, Antonius Höckelmann builds his sculptures out of dense concentrations of organic and vegetable forms. Their obscene sensuality and massive condensation dissolve at the instant the observer notices the porous industrial surface, the plaster which has been mixed in, and the lack of weight. Sensuality becomes a mockery, and the observer for whom Beckmann erected his deadly-serious symbols is misled.

The move from powerlessness to denial is the primary contrast between the idealistic Beckmann, who used symbolism and mythology for the benefit of mankind, and the new expressionists. The sculptures serve to a substantial degree to mirror this difference, although a comparison of the paintings would certainly be even more revealing. Today's expressionists, who can be compared to an artist like Dubuffet, are more concerned with the subversive power of anti-cultural and cynical viewpoints than they are with individual self-expression. This is evident above all in the sculptural work of Jörg Immendorff, who has taken the problematic of Germany as an intellectual theme and rendered it into a bizarre, extroverted symbolism (fig. 13).

Translated from the German by Jamie Daniel

Stephan Lackner

Beckmann's Exile in Amsterdam and Paris 1937-1947

Paradoxically, Max Beckmann's decade in Amsterdam, with all its danger, deprivations, and confinements, counts among his most productive periods. The more constrained the exiled artist felt, the wider became the spatial feeling, the more varied the subject matter of his art. While being forced to lead a day-to-day existence of petty cares, his spirit roamed through the vastness of history and mythology. Was this escapism or overcompensation? Or rather a sign of courage? Opposition against the dark powers comes to the fore in his diaries as well as in many paintings.

His productivity during his exile in Amsterdam is documented by the fact that he created five of his nine enormous triptychs there. Between July 19, 1937—his arrival in Holland—and August 29, 1947—his departure for New York—Beckmann finished 280 oil paintings, exactly one third of his total oeuvre. "What does not kill me, makes me stronger:" Nietzsche's motto was Beckmann's as well.

His sojourn in Holland was not of his own choice. He and Quappi left Germany the day after Hitler's programmatic speech about so-called "degenerate art." Hitler menaced all modern artists whom he did not like with sterilization or penal prosecution. Fortunately, Quappi's sister was married to a Dutch organist, and Max and Quappi were happy to take refuge in peaceful Amsterdam, the city of Rembrandt and Spinoza. Their first address was Pension Bank, Beethovenstraat 89. From there Beckmann wrote me on August 4, 1937: "...Tomorrow I can finally move into a new studio where I hope to find the necessary concentration for my work. The last days were far from amusing, searching for an apartment and studio, registering, un-registering, bureaucratic things which I find awful but which are necessary nevertheless. Yet the situation begins to clear up, I want to stay here for the time being, perhaps moving to Paris later on. But as an interim solution Amsterdam is not bad."

"Paris, the patented art metropolis" remained his aim, which he half-heartedly pursued for three years. He had visited the city as a youth, and he had spent several winters there with Quappi. It seemed clear to him that an international breakthrough for any modern artist could originate only from Paris. But in September 1937, when he returned there again, the chances for recognition of a German painter had deteriorated. France had granted asylum to many émigrés, myself among others. Yet slowly French popular and official opinion grew apprehensive about too many aliens in the job market and their effect on French culture. It became ever more difficult to obtain residence and work permits; besides there were pernicious rumors that Nazi spies used the refugee status as a cover. So, the great painter was not received with open arms in France.

Beckmann talked about this unsettled situation to me and other friends who knew the possibilities of the French art market. I bought several of his paintings, and he signed 140 lithographs for a play of mine, *Der Mensch ist kein Haustier, (Man Is Not a Domestic Animal),* which he had drawn in Amsterdam and which was now published in Paris (fig. 1). But then he was glad to return to Amsterdam.

The House on the "Stille Kant"

For the next ten years his address remained Rokin 85. The narrow, unobtrusively pretty house with its steep gable stood at the "stille Kant" (the quiet edge), which, however, was not so quiet: rattling, clanging streetcars and other city traffic were constant. The Beckmanns had rented the second and third stories. The second floor included a living room whose windows faced the street and a very small bedroom toward the courtyard. On the landing was a tiny kitchen, separated from the staircase by a curtain. The narrow, steep stairs led to a former tobacco storeroom which was roomy enough to accommodate Beckmann's huge canvases and equally large visions. This large room represented the greatest good fortune during those meager years. The tobacco merchant still lived on the ground floor, but he stored his wares elsewhere. The Beckmanns always maintained friendly relations with their neighbors. Quappi's sister, Hedda Schoonderbeek, provided new contacts with Dutch people; by and by a circle of friends became attached to the interesting couple. Meanwhile, in Paris, I endeavored to further the cause of Beckmann's art by inviting literati and connoisseurs like Wilhelm Uhde, Edmond Jaloux and other artists to view Beckmann's paintings. Max Ernst declined: "Mr. Beckmann's art interests me very little." However, I succeeded in winning over several new admirers. In Switzerland also I organized exhibitions. Irmgard Burchard, Käthe von Porada, Paul Westheim and I made plans for a large exhibition in London.

I kept the painter informed. On January 19, 1938 he wrote me a letter which is an example of his detached and yet temperamentally engaged philosophy.

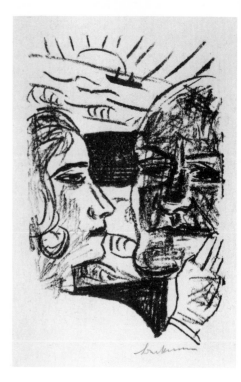

Fig. 1 Max Beckmann: sheet from the portfolio, *Man Is Not a Domestic Animal*, 1937, lithograph, Bremen, Kunsthalle

... Your report about the evening with Piscator (the famous theater director) amused me. It was predictable. Genuine art just cannot be made effective through hurly-burly and propaganda in a journalistic sense. Everything essential happens apart from everyday noise, only to attain a more far-reaching effect. The weak and unoriginal try to obtain a shabby fame for one day, and should get it. But this is not for us. One has to wait patiently for things to happen.—If you wish I shall participate (in the projected London exhibition) with a calling card. In this sense I accepted Westheim's invitation. But that must suffice. Most important will be the silent show in your own rooms. By this, as time goes by, you will obtain a central force with which to direct everything, if you submerge yourself completely and consider the game of life as a contest for spiritual power—the only game which is really amusing. But this must happen almost in secret. Everything too public diminishes your strength—at least during the birth of the will and during its youth... Politics is a subaltern matter whose manifestation changes continually with the whims of the masses, just as coquettes manage to react according to the needs of the male and to transform and mask themselves. Which means—nothing essential. What it's all about is: the permanent, the unique, the true existence all through the flight of illusions, the retreat from the whirl of shadows. Perhaps we will succeed in this.

Yours, Beckmann

Beckmann's art was not altogether unknown in Paris. In 1931 the Galerie de la Renaissance in the Rue Royale had shown his pictures with some success: the Musée du Luxembourg bought his *Landscape with Woodcutters*. Vollard and Picasso visited the strange show, and it was related that Picasso said: "Il est très fort." ("He is very strong.") In 1933 the Musée du Jeu de Paume acquired Beckmann's *Catfish*, an amusing beach scene which received a mythical eroticism from a man who holds a fish in an erect position before his body. In 1938, however, it was impossible to get Beckmann's work exhibited. One of his

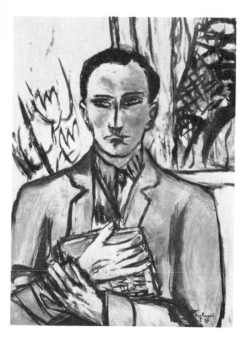

Fig. 2 Max Beckmann: *Portrait of Stephan Lackner,* 1939, oil on canvas, Private collection

friends from the Frankfurt days, Käthe von Porada, was the Paris fashion correspondent for German magazines, and she had excellent relationships with literary figures, artists, and critics. She hung Beckmann's paintings in her tastefully furnished flat and had a catalogue mimeographed. Edmond Jaloux had this to contribute: "This world remains in jeopardy. You can see here lovely landscapes, large and serene, sometimes even dreamlike which receive a particular kind of light as from another planet... Monsieur Max Beckmann paints with sober, frank, hard colors which jostle each other and form gripping contrasts... He will remain one of the greatest figures of a movement to which the future will render justice."

In Switzerland, the Bern Kunsthalle showed new works by Beckmann in March, 1938; these were also presented in Winterthur. I arranged exhibitions with art dealers in Zürich and Basel. Beckmann travelled to Zürich in June, and there Baron Simolin bought the *Self-Portrait with Crystal Ball*, which he courageously took back with him to Nazi Germany. Otherwise there were depressingly few sales. I augmented my own collection with some of the master's most significant canvases, and I commissioned him to paint my portrait (fig. 2).

The Exhibition in London

Meanwhile preparations for the big London show went ahead. It was conceived as a pictorial protest against the barbaric defamation of all modern art by the Nazi regime. An unsuspecting British public would be shown expressionist, abstract, and surrealist art.

In Germany, the exhibition of "Degenerate Art" travelled from Munich, Berlin, and other cities to Vienna, attracting perhaps two million visitors. The paintings, sculptures, and graphics were cruelly mocked both in the catalogue and in inscriptions on the walls; eight or nine works by Beckmann were among them. Exactly those artists of the period who presently are recognized as the most important were pilloried in the exhibition: Klee, Kokoschka, Kirchner, Heckel, Nolde, Marc, Kandinsky among them. The exhibition's director wrote: "One should shackle the artists beside their pictures so that every German could spit in their faces." It became imperative to try to rehabilitate the honor of these innovative creators outside Germany. The New Burlington Galleries in London had agreed to undertake this difficult experiment. Beckmann wrote to me about this on April 15, 1938, from Amsterdam:

> I agree to lend the *Self-Portrait with Horn*... Kati told me much about the efforts in Switzerland and England. I stated right away that it would be nonsense if you'd have to pay for the freight of the paintings from Switzerland. No, this the exhibitors have to do themselves. I cannot judge yet whether there is much to this London thing. But it's possible... I think back with pleasure to the few days we spent together in Paris. One could experience sometimes a harmony of feelings which otherwise is not frequent—that is at least something.
>
> *Always yours, Beckmann*

Several perspicacious and cosmopolitan English art connoisseurs like Herbert Read, Augustus John, and Kenneth Clark supported the enterprise. The important art critic, Paul Westheim, was a driving force initially, but had a falling-out with the organizing committee because the committee refused to exhibit a canvas by Kokoschka which had been slashed by the Nazis. Under the pen-name of

Peter Thoene, Oto Bihalji-Merin published a Penguin paperback with reproductions of the most important objects in the exhibition. The show was simply titled "Twentieth Century German Art" which entailed the inclusion of statues by Georg Kolbe who had remained in Germany; this, in turn, gave rise to reproaches that the organizing committee was anxious not to offend Hitler's sensibilities. That, of course, was nonsense.

The difficulties were enormous. Often it was impossible to establish contact with the artists who were scattered throughout the world, so that some of their available works had to be assembled without their consent. It is still astonishing what discernment and good fortune the exhibitors had. The alphabetical catalogue of 269 pieces reads like a Who's Who of that art which proved its "survivability:" Barlach, Baumeister, Beckmann, Campendonk, Corinth, Dix, Ernst, Feininger, Grosz, Hartung, Heckel, Hofer, Kandinsky, Kirchner, Klee, Kokoschka, Kollwitz, Lehmbruck, Liebermann, Macke, Marc, Meidner, Modersohn-Becker, Mueller, Nolde, Pechstein, Rohlfs, Schlemmer, Schmidt-Rottluff, Schwitters, Slevogt.

In the field of music, too, the accuracy of judgment proved amazing. On July 20, 1938, for the first time in England, chamber music pieces by Schönberg, Webern, Eisler, Hindemith, Křenek, and Berg were performed. The very first English performance of *Three-Penny-Opera* by Bertold Brecht and Kurt Weill was sung on July 28.

The British public was bewildered by these outlandish productions, but people were against Hitler and therefore inclined to well-meaning consideration. The press reaction was partly positive, partly perturbed by what was considered Teutonic exaggeration. Still, a permanent influence on British art can be felt to this day.

The London *Times* (July 14, 1938) complained: "The banning of such art from any country seems so ill-advised that one is reluctant to speak of its esthetic defects, but the characteristic defect of German Expressionism would appear to be... to dump the substance of pigment on canvas so that it calls so much attention to itself at the expense of unity in the work."

The opinion of the *Manchester Guardian* (July 7) was slightly more perspicacious: "...to us who have been spoonfed for so long from Paris this exhibition of a national spirit so different from that of France comes as a shock. German expressionism is more realistic than Rouault, more savage than van Gogh, and less sentimental than Munch. It is brutal, violent, hectic, but not undisciplined. Most of it is a frank statement of post-war conditions. The centerpiece of the main gallery is a huge triptych, *Temptation*, by Max Beckmann, big in conception, arbitrary in drawing, full of wild overstatements, but nonetheless powerful and gripping... It is a disturbing show."

Max Beckmann received an invitation to lecture about his art in the New Burlington Galleries. He wrote "Meine Theorie der Malerei" for this occasion which, under the title of "On My Painting," was later reprinted many times (cf. *Modern Artists on Art*, ed. Robert L. Herbert, Prentice-Hall, 1964). Beckmann and I travelled from Amsterdam to London on July 20, 1938. I remember him being in an elated mood, especially aboard ship. London pleased him immediately. He was flattered by receptions and intelligent interviews at which I functioned as an interpreter. On July 21, he gave the first public lecture of his life. A variety of dignified and easy-going aristocrats, anti-fascist literati, and enthusiastic young people had assembled for the occasion. Beckmann gave the impression of a bear who had ambled out of his wilderness to the dais. His German text received warm applause, which became still stronger after an English translation was read.

My mimeographed essay, "Max Beckmann's Mystical Pageant of the World," was laid out on a table near the triptych *Temptation* and was eagerly

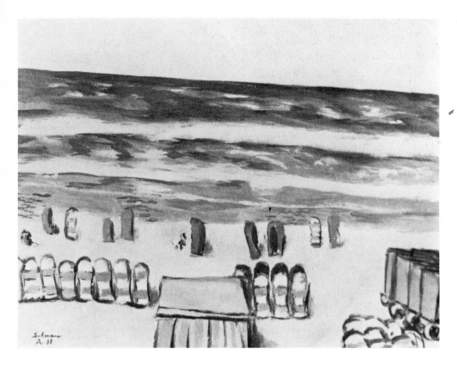

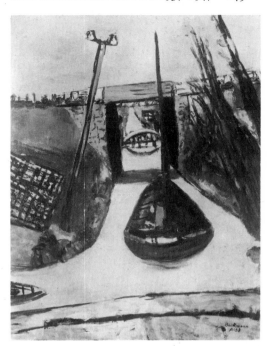

Fig. 3 Max Beckmann: *Blue Sea with Beach Chairs,* 1938, oil on canvas, Zürich, Private collection

Fig. 4 Max Beckmann: *Canal in Holland,* 1938, oil on canvas, Private collection

read. Besides the stunning triptych, five Beckmann oils were hung: *The Harbor of Genoa* (1927), *The Skaters* (1932), *Landscape with Woodcutters* (1932), *The King* (1937), and *Quappi* (1937).

The attendance figures were very high, but not the sales. Some dealers showed an interest in Beckmann's art, yet due to the ever-growing menace of war, purchases were not made. Still, Beckmann always remembered his London visit as an enriching experience, mainly because of his encounter with William Blake's watercolors in the Tate Gallery.

Fig. 5 Max Beckmann: *Dutch Girl with a White Cap,* 1937, oil on canvas, Private collection

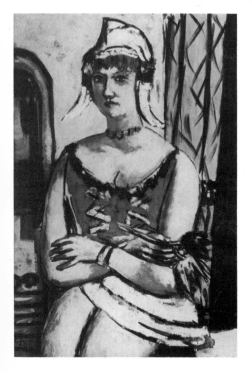

The Amsterdam Period

He returned to Amsterdam to continue painting with undiminished passion. His isolation in the old tobacco storage room was conducive to overpowering visions and pictorial experiments.

In what respect are the Amsterdam works different from those produced earlier in Frankfurt and Berlin?

The series of beach landscapes continued without a break (fig. 3); so did his flower still-lifes. However, his figural compositions show the change into a politically freer, but spatially more restricted culture. The first important oil after his emigration, *The Liberated One,* 1937 (cat. 80), presents Beckmann's head with squinting eyes, gazing into unknown distances. His hand grasps a broken chair, a window grill remains behind him, an optimistic blue light flickers across the scornful face. *Self-Portrait with Horn* (cat. 86), which followed one year later, has lost this optimism. The man holds a romantic horn in front of his mouth; he seems to have sent a signal out into the empty world, but he waits in vain for an echo.

Loneliness is a frequent characteristic in Beckmann's art done in exile. No onlooker is contemplated in his self-portraits. The face is brooding, seeking larger connections than those between artist and public. Thinking back to the *Self-Portrait in Tuxedo* of 1927 (cat. 53), there was a self-assured painter looking straight at his own image. Now a more secretive, sometimes conspiratorial mood produces the quality of underground testimony.

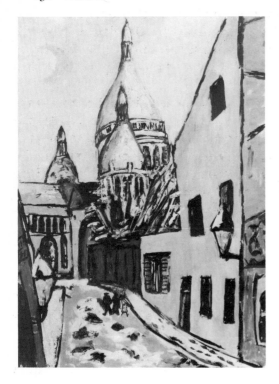

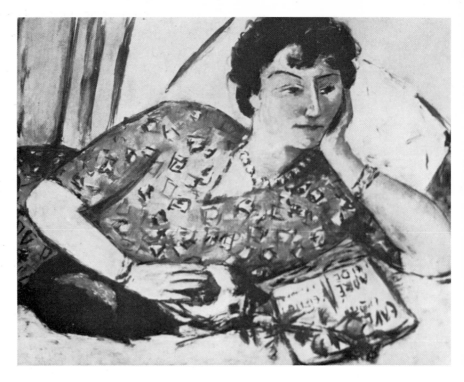

Fig. 6 Max Beckmann: *Sacré-Cœur in Snow,* 1939, oil on canvas, Private collection

Fig. 7 Max Beckmann: *Portrait of Madame Pomaret,* 1939, oil on canvas, location unknown

The images of circus and cabaret, his old favorite themes, remain just as thrilling, even amusing, in Beckmann's production during exile, but they let you guess at deeper, more symbolic backgrounds.

Allusions to the Nazi terror can be traced in several of these paintings. Undisguised references to the actual oppression are clearly found in the large, gripping *Birds' Hell* (cat. 84) of 1938. In the foreground a shackled, naked, slim intellectual is being carved up by a strange, pheasant-like bird with a knife. "Goldfasan" was a derisive term used by the German man-in-the-street to designate Hitler's strutting S.S. officers in their shiny uniforms. The pattern being graved into the victim reminds us of the bloody, hieroglyphic tattoo in Franz Kafka's story, "Penal Colony." The center of the canvas is shared by the Prussian eagle hoarding gold coins and a revolting goddess of fertility lifting her arm in a Nazi salute. Loudspeakers for propaganda and saluting columns make this a very directly engaged picture.

Occasionally a Dutch canal landscape (fig. 4) or a girl with typically Dutch headgear (fig. 5) indicate the new surroundings; but, of course, Beckmann did not turn into a Dutch painter. His provisional new country showed little interest in his art. It is true that the gallery Kunstzaal van Lier exhibited several of his paintings in 1938. But the first acquisition by a Dutch museum occurred only after the liberation, in April 1945, when the Stedelijk Museum in Amsterdam finally purchased his *Double-Portrait* (cat. 95).

Sojourn in Paris

It is understandable that Beckmann did not give up hope of having a breakthrough in Paris. He considered this an artistic and practical necessity. Therefore Max and Quappi Beckmann rented a small apartment in the 16. Arrondissement in October 1938. The fragile Louis XVI furniture and silk curtains did not seem to fit the powerfully built artist. He had to work in a delicately furnished room, always taking care not to splash paint around (fig. 6). The former director of the Galerie de la Renaissance, Madame Marie-Paule Pomaret, still admired

his art, and since her husband had become Minister of Labor Beckmann hoped for her sponsorship. He portrayed her in her living room, first drawing six pencil sketches. At these sessions I was allotted the task of holding her bulldog in position on the sofa; both French creatures appeared very lively in the finished oil painting (fig. 7).

Occasionally Beckmann sauntered through the galleries, especially on the Left Bank. Among living painters he was most appreciative of Georges Rouault. His opinion of Picasso was ambivalent: The Spaniard's uncompromising attitude impressed him, but some experiments he found too playful. He wished to be confronted one day in an exhibition hall with Picasso: "Then people could at last see who's who." Many years later this wish was fulfilled when his triptych *Departure* was hung opposite Picasso's *Guernica* in New York's Museum of Modern Art.

I sometimes accompanied him to the Louvre and Luxembourg museums. In the anthropological Musée de l'Homme he amazed me by his wealth of references and knowledge. Once we stood before a stone idol from the Easter Islands, and Beckmann remarked casually: "This too I once used to be." Indeed I saw a resemblance between the two profiles. His reading of Schopenhauer and Vedic scriptures gave rise to fascinating conversations.

In April 1939 my family and I decided that the time had come to emigrate to America. Our luggage and art collections were sent ahead to Le Havre. Early in the morning when we were scheduled to take the train from Paris to Le Havre we heard on the radio that our boat had burned completely. Were my beloved Beckmann paintings destroyed? I was desperate. But soon we learned that through sloppy handling our crates were still standing on the pier. A few days later we took another boat to New York.

Beckmann wrote several letters to me in New York, which are important human and biographical documents.

17 rue Massenet, Paris, April 26, 1939

My dear Ernst, thanks cordially for your friendly letter. I too was sorry not to have seen you any more, and I must confess that I miss you a little – decidedly. But some personal collaboration will surely occur again, and I'm looking forward to it. You must have gotten some humorous thrills from the burning of the "Paris." Perhaps you can use some of this in your writing. I believe anyway that the big trip will give you a new outlook. I am eager to see the results. I accept gladly your proposition concerning your portrait. I'm certain that it will be a good piece of work. I am writing you on a day of good omen, firstly the conscription in England and secondly, almost at the same hour, my "Carte d'Identité." At last! So I'll move to Paris, and I'll be able to unfold new, intense powers here since *la France* has taken me into her motherly arms. The stay at Cap Martin has benefited me greatly and colored all my ideas anew. Absolutely new things have come into my ken, and I'll have to work twenty years to realize all this. When you see our mutual friends, give them my best greetings and tell them that we have not resigned and that the *spiritual* Germany will again take its rightful place among the peoples. We are *at work*.

Always yours, Beckmann

Amsterdam, Rokin 85, May 22, 1939

Dear Ernst, many thanks for your letter and check which just reached me before I left Paris. Now I'll stay for two and a half months in Amsterdam, then the move to Paris shall take place. Before my departure I finished your portrait. I believe it turned out very well. But I don't want it to be shipped or photographed just yet since I wish to inspect it once more before releasing it. I

would have a disagreeable feeling if it should be immobilized too early. Where might this letter reach you, in New York or already in Detroit?

Here, I am intensively working on the new triptych number three; this will be a crazy story and gives me a heightened feeling of life, an enhanced life... I will see Valentin here still. Did you see the Barr exhibition at the [Museum of] Modern Art where my first triptych is shown? I would be interested to know how you liked it, as well as further impressions from your journey. Write me soon about that. Please send me the next monthly check here, I'll have it exchanged at the Amsterdam Bank. Very cordially, greetings to the Detroiters and to all acquaintances.

Always yours, Beckmann

(Postcard) Amsterdam, July 3, 1939

Dear Ernst, greetings and thanks for the communication. I'm utterly submerged in work. Le nouveau Trois (i.e. the new triptych) rises from dark waters, up over champagne, cadavers and the little madness of the world to final clarity. O my God, life is worthwhile. *B.*

Amsterdam, November 20, 1939

Dear Ernst, thank you very much for the letter and check. It is always a joy to hear from you, not because of the money, but because it reinforces the feeling of a metaphysical predestination between us. A somehow amplified symbol for fateful necessity: it's exactly these things which I pursue with a certain sportive interest, because they are extremely rare, like gold veins or diamond finds. Nonetheless they exist, and the net of enormous, unknown calculation in which we are caught up becomes almost visible, sometimes.

The war makes them evident in other ways, too. I'm writing this, during a blackout in Amsterdam, to the harmonious concert of wailing sirens. One must admit that unknown stage-directors try everything to make the situation more interesting, in the sense of a penny-dreadful. Critically we must state that, unfortunately, they don't have many new ideas any more, and that we have now the right to stage something new. And that, after all, will occur sooner or later. I, for my part, am busily preparing new stage sets among which the play may go on.

I'm sorry that you don't write more about yourself and your work. I'd like to know more about it. Is New York amusing, in the long run? Or would you think that one could produce more essential things in a cleansed Germany? At any rate, I derive great pleasure from my work and, to my own astonishment, I have not only new inspirations, but the feeling of being essentially at a beginning becomes stronger daily. Maybe this stems from my very much improved health, I feel much better than at that time in Paris. The war seems to agree with me, for I see a new world emerging, "ice cold out of fiery fevers." One has to reckon in very long-term complexities which by far transcend our short lives. A chain of developments extends over many millions of years. In these we have to personify one actor, certainly individualized, but boundlessly versatile, whose task it is to represent the actual state of existence..."

Since France was officially in a state of war from September 1939 on, Beckmann gave up his plans to move to Paris. Instead, he contemplated emigrating to America. He wrote to my father in New York on November 30, 1939: "...Yes, you were right in making the transition from the Old to the New World energetically and at the right time. Though I believe firmly in the ultimate victory of the democracies, it will take much time and misery. It was very kind of you, your dear wife and Ernst to think about my fate and to consider transplanting me again..."

He then wrote about the difficulties obtaining a visa, the dangers of a sea voyage in wartime, and the uncertainty concerning his livelihood in a foreign country. "...To sum up: if fate wants it so, I would be ready to accept all dangers and restrictions in order to bring my work—which I consider still unfinished—to a good conclusion. I would regard this as my duty toward the mission to which I am called."

In the United States, old and new friends of Beckmann's art wanted to help. Curt Valentin arranged exhibitions in New York, Kansas City, San Francisco, and other places. Alfred H. Barr, the director of The Museum of Modern Art in New York, promoted his reputation. The triptych, *Temptation,* received a prize at the Golden Gate Exposition in San Francisco. Chicago offered a teaching position. But Beckmann hestitated. A teacher's visa would have been limited to two years, and he feared that he might then be deported back to the Third Reich. The American consul in The Hague demanded stronger guarantees that the painter would not have to be supported by the American taxpayer, and refused to grant the visa. Time and opportunity passed. On May 10, 1940, the Germans invaded neutral Holland, and Beckmann was cut off from the outside world. For five years I did not even know whether he was still alive.

Fig. 8 Max Beckmann: *Portrait of Erhard Göpel,* 1944, oil on canvas, Barbara Göpel, long-term loan, Bremen, Kunsthalle

The German Occupation of Holland

As the German army advanced, Beckmann burned all the diaries he had kept from 1925 to May 1940. Perhaps he feared that he had criticized Hitler, whom he used to call "Aunt Emma," too outspokenly; perhaps he did not want to endanger former friends. The loss of this documentation is deplorable. However, in September 1940 he began new diaries, which he continued regularly until his death.

It is strange that Beckmann, who earlier had been attacked so viciously by the Nazis, remained relatively unscathed, even ignored, by the German occupiers of Amsterdam. There were hardships enough, however. Travel to other countries, including Germany, was forbidden. The deprivations, especially during the last war years, impaired his health. And, of course, he could not exhibit his works in public. He lived in a strange twilight zone, half underground, half tolerated by a German administration ignorant of artistic matters. Twice he had to appear for physical examinations for the draft, on June 15, 1942 and again on May 31, 1944; both times the almost sixty-year-old artist was found unfit for military service. In February 1943 he was tipped off that his paintings were to be seized by German officials; he had the canvases moved from his studio to the house of the art dealer, Helmuth Lütjens, who had Dutch citizenship. Bombings, hunger, and cold menaced him and his wife. Yet, compared to the terrible tragedy of the Dutch Jews and patriots, Beckmann's fate remained endurable. Quappi's skill, love, and devotion helped overcome many difficulties.

There is a famous German verse, the last lines of Goethe's play *Tasso:* "Thus the seafarer finally clings to the rock which was to be his doom." Beckmann may have quoted this to himself when several helpful Germans appeared in Amsterdam and made the continuation of his life and work possible. In April 1941 he received the commission to illustrate the *Apocalypse* with hand-colored lithographs. The work was printed in Frankfurt in 1943 by the Bauersche Giesserei, albeit in 24 copies only: every publication of more than 25 copies had to be submitted to the censor. The Munich art dealer, Günther Franke, bought Beckmann's paintings and smuggled them in tightly rolled bundles to his gallery where he secretly showed and sold them to trusted friends. Lilly von Schnitzler,

a faithful and wealthy patron, augmented her Beckmann collection while visiting the banished artist at various times. Erhard Göpel, the art historian, used his connections with German officials to help Beckmann when he was called up for military service. Göpel also acquired paintings and had his portrait done in Amsterdam (fig. 8).

Beckmann's only son, Peter, who was a staff physician with the Luftwaffe, visited his father several times and transported paintings back to Germany. Once his Luftwaffe truck was stopped at the Dutch-German border and the triptych *Perseus* was revealed to the puzzled eyes of the border guards who asked whether this wasn't degenerate art? Peter declared: "I've painted these myself as a joke. See, it says Beckmann here." In these precarious ways the contacts to German friends of Beckmann's art were renewed and maintained.

Probably the most important result of these clandestine contacts are the visionary pen drawings illustrating Goethe's *Faust*, Part Two (fig. 9, 10, 11). They were ordered by the Frankfurt printer and art patron, Georg Hartmann, and they kept Beckmann busy from April 15, 1943 to February 15, 1944.

Beckmann met regularly with people who were culturally stimulating: the poet Wolfgang Frommel, the painters Friedrich Vordemberge-Gildewart and Otto Herbert Fiedler. He portrayed these three together with himself in a mysterious underground atmosphere, contemplating foods which were hard to obtain at the time. (*Les Artistes with Vegetables*, 1943, cat. 99). Nevertheless he suffered from isolation, curfew and blackout regulations, and insufficient nutrition. The beach of Zandvoort where he and his wife had often bicycled, was cut off with barbed wire after June 1942. It is quite impressive now that the painter's fantasy and memory compensated for the lack of impressions. Again and again between 1940 and 1944 he painted landscapes from Cap Martin, Monte Carlo, and Bandol. Even the prosaic main railway station of Frankfurt reappeared in 1942, glorified with colors of turquoise blue and lemon yellow (fig. 12)—a singular emanation of an otherwise denied homesickness.

The liberation of Amsterdam at the beginning of May 1945 brought a release from spiritual pressure, but the difficulties of daily living remained. Food and coal still were rationed and rare. Bedsheets were stretched on frames and used as canvas for several important paintings. Beckmann's art had suddenly become very saleable again, even in Amsterdam. In the fall of 1945 the Stedelijk Museum exhibited 14 paintings by Beckmann. By 1946 many old acquaintances

Fig. 9 Max Beckmann: illustration for J. W. v. Goethe's *Faust II*, 1943/44–Boy charioteer (Act I)

Fig. 10 Max Beckmann: illustration for J. W. v. Goethe's *Faust II*, 1943/44– Mephistopheles: "Then to the deep! I could as well say height: all's one" (Act I)

Fig. 11 Max Beckmann: illustration for J. W. v. Goethe's *Faust II*, 1943/44 – Faust sleeping: "Unhallowed spectres, plague of mortal flesh" (Act V)

Fig. 12 Max Beckmann: *Main Train Station in Frankfurt,* 1942, oil on canvas, Frankfurt, Stadtgeschichtliches Museum

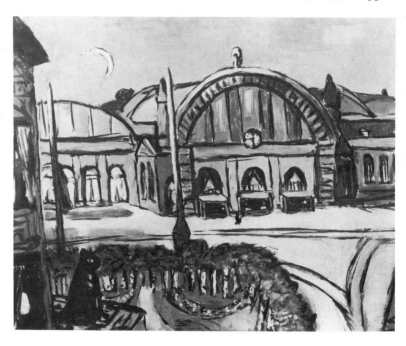

made their appearances from the United States, among them Curt Valentin and Hanns Swarzenski. At first drawings, then oil paintings, were shipped to New York and eagerly purchased by collectors and museums.

Travels and Emigration to America

In 1944 and 1945 I was an American soldier in France and Germany, but I was unable to contact Beckmann. As soon as mail service was reestablished in August 1945, I wrote him from Santa Barbara. His answer shows deep astonishment at finding himself and old friends still in this world. Poetic and sarcastic at the same time, his prose compresses complicated facts into pictorial symbols.

Amsterdam, Rokin 85—27 August 1945

Dear Stephan Lackner (Quinientosstreet) Ah—well. There you are living. Amazing to hear from you and California. The world is rather kaput, but the spectres climb out of their caves and pretend to again become normal and customary humans who ask each other's pardon instead of eating one another or sucking each other's blood. The entertaining folly of war evaporates, distinguished boredom sits down again on the dignified old overstuffed chairs. Incipit "novo canto" Nr. 2 –

Well, my dear friend, you must have experienced quite a lot and I am curious how you will use it in your work. It is regrettable that you couldn't materialize here at the Rokin as an American archangel Gabriel. The effect would have been first-class, and I had more or less counted on it. Well, now the angel has turned into an airmail letter, which isn't without charm, and leaves ample play for fantasy. I gather from some hints in your letter that you are still married and that your dear parents are well. I'm glad to hear both. I find it amusing that in Paris you rediscovered your girlfriend as a grandmother, and some old Beckmann paintings. By the way, three or four pictures are still standing around here which belong to you, according to our old agreements at the beginning of the war.

May I report about myself that I have had a truly grotesque time, full to the brim with work, Nazi persecutions, bombs, hunger and always again—work —in spite of everything. I've painted about eighty pictures, among them four large triptychs. The titles are: *Acrobats; Actors; Carnival;* and, finished only

eight days ago, *Blindman's Bluff*. I think some of it would give you pleasure, for you know a lot about me.

My situation at the moment is this: through the intervention of Professor Ruell, the director of the Rijksmuseum, I can stay here at least until November, in spite of my still being German—unless a wave of superpatriotic Dutch feeling should succeed in shipping all Germans without exception back to Germany. This possibility, concerning me, amounts to no more than ten percent. Nonetheless it would be very good if something could be done for me from America through some kind of an affidavit as a request to fill a teaching position or anything. It would be regrettable if now I would have to go back to Germany, because then any communication with other countries would become extremely difficult. Please think these matters over, perhaps together with Valentin or Swarzenski who, I believe, is in London right now. I am on tenterhooks to know how everything will turn out, and I hope to hear from you soon again. My nerves and capacity for work are stronger than ever, and I hope to go on producing essential things. Very cordial greetings, also from Quappi (who is all right).

Yours, Beckmann

The artist still had his German passport which, by the way, he kept for the rest of his life. The difficulties arising from this were overcome by a lucky occurrence. Towards the end of the German occupation, a Dutch underground fighter had fled into the Rokin 85 house, and the Beckmanns had helped the patriot escape across their roof. This good deed now found a recompense: the painter and his wife were declared to be "non-enemies" of the Dutch State.

From April to June 1946 Beckmann drew the 15 lithographs for the series, *Day and Dream,* which Curt Valentin published in New York. One of these, entitled *Circus,* shows a clown on a bicycle with a hugh milk bottle, and this bottle bears the only Dutch word in Beckmann's oeuvre: "Melk."

The influence of Beckmann's Dutch surroundings can be felt most distinctly in his landscapes. He created beautiful and dramatic views of Schiphol, Noordwijk, and Laren (fig. 13). Beckmann's landscape paintings, with their overwhelming intensity, express this philosophy of life as strongly as the more esoteric figural compositions; yet art criticism has neglected them. (Even the two excellent monographs on Beckmann by Friedhelm W. Fischer contain, among 92 illustrations, only a single landscape.) For an inner and topical biography of Beckmann, his renderings of the sea and mountains, plains, and cities are very revealing.

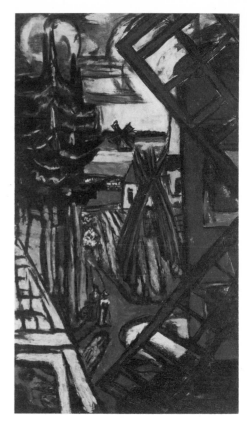

Fig. 14 Max Beckmann: *Riviera Landscape with Rocks,* 1942, oil on canvas, New York, Private collection

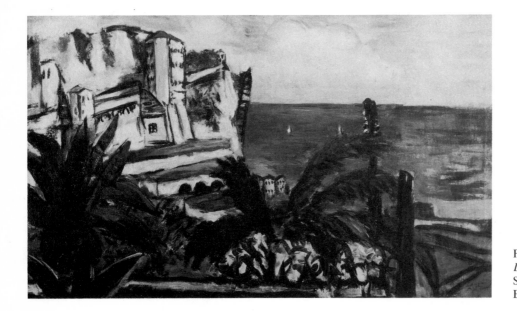

Fig. 13 Max Beckmann: *Large Laren Landscape with Windmill,* 1946, oil on canvas, St. Louis, The Saint Louis Art Museum, Bequest of Morton D. May

On March 25, 1947, Mr. and Mrs. Beckmann again could travel outside Holland. "Eight years without leaving this ironing-board country," notes the diary. Nice, Monte Carlo, Cap Martin suddenly were not memories filtered through art, but fresh and stimulating impressions (fig. 14).

My wife and I met the Beckmanns in Paris on April 19. He had lost weight. Deep shadows were under his sunken eyes, the eyes of someone who had gazed too intently into an abyss. His wide mouth no longer expressed the hard irony that had characterized him in his Berlin days; he had a resigned, almost contented smile. He did not seem angry at the world.

The next evening we visited the Bal Tabarin on Montmartre and looked at the colorful show through champagne glasses. Beckmann, who preferred hefty, well-rounded female figures in his art, was somewhat disappointed by the slender dancing girls. Viewing the cancan he opined: "It doesn't steam yet as it should." But now and then the joy of being free and alive lit up his eyes. On April 21 we inspected many older Beckmann canvases which my former French girlfriend had hidden in the upper story of a brewery, where they had been saved from Nazi confiscation.

Already on April 23 the diary registers: "Holland is very nice after all." He continued painting in his tobacco storage room until he embarked for America on August 29, 1947.

Was Beckmann's exile, all in all, a negative experience? I don't think so. He himself felt that exile represented not only injustice, persecution, and danger, but also a necessary part of his Karma. On September 17, 1948, during the second and final crossing from Le Havre to New York, he wrote in his diary: "I'm now reading Richard Wagner's autobiography, and I discover in his fate much of my own. Even though I have not exactly busied myself with barricades, it seems that an emigration of ten to fifteen years simply belongs as an organic part of every essential personality. This in spite of Goethe, Jean Paul and others. But even my old friend Goya had to skip his country in the late evening of his life—so, let's console ourselves with that."

Peter Selz

The Years in America*

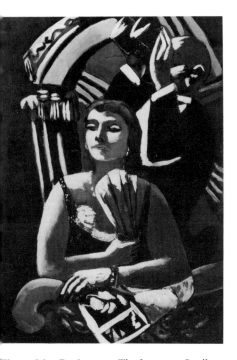

Fig. 1 Max Beckmann: *The Loge,* 1928, oil on canvas, Stuttgart, Staatsgalerie

*This essay is dedicated to the memory of I.B. Neumann, who introduced Beckmann's work in America, and who was also a good friend and mentor to me.
Some of the research for this essay was done in the comprehensive research library of the Robert Gore Rifkind Foundation in Los Angeles. I want to extend my thanks to Robert Rifkind and his staff for graciously permitting me to use this important resource.* P.S.

1. I.B. Neumann, "Sorrow and Champagne," in *Confessions of an Art Dealer,* p.43 (typescript of unpublished manuscript in possession of Dr. Peter Neumann, Palo Alto, California, who graciously permitted me use of the manuscript).

2. Henry McBride in *Creative Art,* V (1929), p.15.

3. Quoted in Alfred H. Barr, "Die Wirkung der deutschen Ausstellung in New York," *Museum der Gegenwart,* II (1931-32), pp.58-75.

4. Lloyd Goodrich, "Exhibitions: German Painting in the Museum of Modern Art in New York," *The Arts* XVII (1931) April 31, p.504.

5. James Johnson Sweeney, quoted in Alfred H. Barr, *op. cit.,* p.71.

When I.B. Neumann first came to New York in 1923 one of his chief aims was to promote the art of Max Beckmann. Neumann, a connoisseur who savored the best art of all periods and cultures, a wise and lovable man, a dealer passionately devoted to the work of his artists, had known Beckmann since 1912. He had published some of his graphics, had been his dealer, champion and friend, and in 1926 he mounted a Beckmann exhibition in his New Art Circle in New York, but there was little response. Additional shows, some with special issues of *Artlover* dedicated to Beckmann, were to follow.[1] Three years later Beckmann, who in Germany had now achieved a second period of national fame, received his first recognition in the United States when *The Loge* (fig. 1) was given honorable mention at the Carnegie International in Pittsburgh. From Pittsburgh the show went to Baltimore and St. Louis and prompted America's most prestigious art critic of the time, Henry McBride, to write of the "dynamics of his brushes that even Picasso might envy... a personage to be reckoned with."[2]

In 1931 the recently established Museum of Modern Art organized the exhibition "German Painting and Sculpture." With six paintings and two gouaches, Beckmann had the largest single representation. Alfred H. Barr, who had organized this first exhibition of modern German art in America, reported the critical response in *Museum der Gegenwart,* quoting many of the leading critics. Whereas a conservative reviewer like Royal Cortissoz found, not unexpectedly, the work "raw, gross and uninteresting,"[3] more positive attitudes were manifested by other writers. McBride felt that Beckmann dominated the show. In an article in *The Arts,* Lloyd Goodrich found Beckmann's vitality "as brutal as any of the other expressionists, if not more so. He has a strength that they lack."[4] The young James Johnson Sweeney, writing for the *Chicago Evening Post,* compares Beckmann's *Family Portrait* (cat.25) to works by Grünewald, Bosch, and Brueghel and speaks of his "obsession for line, contour and volume," counting Beckmann "without question in the first rank of contemporary painters."[5]

In 1938 Curt Valentin, an erstwhile assistant to Alfred Flechtheim in Berlin, organized the first of ten Beckmann exhibitions at his New York Gallery (originally called Buchholz Gallery). This show, accompanied by a modest brochure with quotations from Alfred Barr and Waldemar George, was sent on to Los Angeles, San Francisco, Portland, and Seattle. The triptych *Departure* (fig.2)—its centerpiece—was also shown at The Museum of Modern Art's Tenth Anniversary Exhibition "Art in Our Time" in 1939. The museum acquired the painting three years later. In 1939 Beckmann also received a $1,000 prize for his second triptych, *Temptation,* at the Golden Gate International Exposition in San Francisco. Although prices for his work remained rather low for quite a long time, Beckmann's work began to sell in the United States.

In the spring of 1946 Curt Valentin exhibited fifteen paintings and as many drawings which Beckmann had done in Amsterdam between 1939 and 1945. It was an important occasion. Georg Swarzenski, the former director of the

Städelsche Kunstinstitut in Frankfurt and a man thoroughly familiar with the master's work, wrote a brief introduction to the catalogue from Boston, saying "Perhaps never before has his imagination and his style of materialization gained such brightness and engaging persuasiveness."[6] And Beckmann's admirer, friend, and collector, Frederick Zimmermann, recalled later: "Here... we were seeing Max Beckmann in the fullness of his career, Beckmann in full control of the techniques and materials with which he was able to realize the rich moments of his powerful and penetrating vision."[7] *Time* magazine commented that "his fiery heavens, icy hells and bestial men showed why he is called Germany's greatest living artist. He has splashed on colors with the lavish hand of a man who wakes up to find a rainbow in his pocket."[8]

Invitation from St. Louis

It was at that time that he once more received calls from America. Henry Hope offered him a teaching position at Indiana University and Perry Rathbone, then the director of the City Art Museum of St. Louis, suggested an appointment at the art school of Washington University, which Beckmann accepted.

Like many artists of this century, Beckmann, however, was filled with heavy anxieties. As these offers for positions in America materialized Beckmann noted apprehensively in his diary:

> It is altogether quite hopeless—although it will probably work out. I still cannot find my way in this world. My heart is filled with the same dissatisfaction that it was forty years ago, only all the sensations diminish with age as the trivial end—death—approaches slowly. I wish I could be more prosaic and satisfied like the Philistines around me... Everything is falling apart. Hopeless... Oh, no, bad is life, is art—but what is better? The distant land—Oh save me you Great Unknown.[9]

The "Great Unknown" was not the distant land to which he was about to embark. It was death itself—both feared and welcomed. In the final years of his life he more frequently mentioned death as well as the severe depressions he experienced. He often referred to his heart ailment, and the word *"Weh"* (pain) appears in the diaries in numerous places. Later on, in the remarks he made when receiving his honorary doctorate at Washington University, he said:

> Indulge in your subconscious, or intoxicate yourself with wine, for all I care, love the dance, love joy and melancholy, and even death! Yes, also death—as the final transition to the Great Unknown...[10]

These were hardly words normally associated with a formal acceptance speech at an official academic function. But we are dealing with a person who fought conventions all his life, as well as with a man who was now preoccupied with death. Yet together with all this anxiety there was a great affirmation of life. In the very next sentence of the acceptance speech he states:

> But above all you should love, love, love! Do not forget that every man, every tree and every flower is an individual worth thorough study and portrayal![11]

These remarks were made in the spring of 1950 when Beckmann was actually at the height of his renown in America. Three years earlier, before sailing to America, he wrote about the impending departure from Europe as "the last sensation—except death—which life can offer me."[12] Quappi and he sailed on the S.S. Westerdam on August 29, 1947, and found Thomas Mann as one of

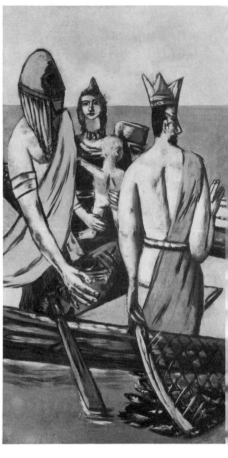

Fig. 2 Max Beckmann: *Departure,* triptych, 1932/35, (middle panel), oil on canvas, New York, The Museum of Modern Art

6. Georg Swarzenski, Introduction to *Beckmann,* Buchholz Gallery Curt Valentin, New York, 1946.

7. Frederick Zimmermann, *Beckmann in America* (address delivered before the Max Beckmann Gesellschaft in Murnau, July 1962), New York, 1967, p. 6.

8. "German Seeker," *Time,* XLVII, May 6, 1946, p. 64.

9. Beckmann, entry of September 17, 1946 in *Tagebücher,* p. 177.

10. Beckmann, "Ansprache für die Freunde und die philosophische Fakultät der Washington University, 1950," trans. Jane Sabersky, in *Max Beckmann,* Curt Valentin Gallery, New York, 1954.

11. *Ibid.*

12. Beckmann, entry for August 23, 1947 in *Tagebücher,* p. 214.

their co-passengers. But little interchange of ideas seems to have resulted from this fortuitous meeting of Germany's foremost painter and its leading writer.

After a brief stay in New York, the Beckmanns went to St. Louis, where his reputation had preceded him.[13] The artist enjoyed the gentle atmosphere of the old American Mississippi city. Provincial yet cosmopolitan, it reminded him of his old residence in Frankfurt. A man enormously attached to the physical aspects of life, Beckmann appreciated an atmosphere so much freer and opulent than his restricted life in Amsterdam had been. He liked meeting people, going to parties, dressing up for masquerades, visiting cabarets, drinking champagne. He often mentioned the food served at dinner parties as well as the people who attended. Perhaps he saw the physical aspects of life as a step to the metaphysical, perhaps he enjoyed them on their own account. After all, as he mentioned very early in his career, quality in art "is the feeling for the peach-colored glimmer of the skin, for the gleam of a nail, for the artistic-sensuous... for the appeal of the material."[14] While the style and meaning of his art had changed considerably since his early controversy with Franz Marc, the importance of the physicality of his work remained paramount. This certainly is one of the reasons why his paintings, with their chromatic splendor and dense interlace of warp and weft, have an immediate sensuous appeal which precedes any investigations of iconography.

Friends and Students

In St. Louis he enjoyed the company of H. W. Janson, who was the curator of Washington University's museum at the time. Above all, he became a close friend of Perry Rathbone who organized a major retrospective and published a catalogue in which he wrote an important interpretation of Beckmann's work. This exhibition, which traveled to Los Angeles, Detroit, Baltimore, and Minneapolis, helped cement the artist's reputation in America.

Assisted by Quappi, who acted as interpreter, Beckmann began to teach again after an interruption that began when the Nazis dismissed him from his teaching job in Frankfurt in 1933. "Art cannot be taught, but the way of art can be taught," he asserted in an interview.[15] His teaching position at Washington University was actually a temporary one, vacated by Philip Guston who had received a Guggenheim Fellowship succeeded by a Prix de Rome. Guston himself had admired Beckmann's work when he first saw it at Curt Valentin's 1938 exhibition and at that time he bought a monograph on the older artist.[16] He was always fascinated by what he referred to as Beckmann's "compressed" and "loaded" pictures.[17] And there is no doubt that the experience of Beckmann's work—not only his upturned figures with legs sticking in the air or ladders pointing into infinity—had a significant impact on the American painter. In Guston's late work, as in Beckmann's, there is also a particular combination of everyday reality which makes palpable an assumed strangeness and fantasy. There is furthermore a deep sense of the tragic in the work of both artists and a close affinity in their ultimate attitude toward art and its purpose. Beckmann might have stated what Guston stressed in 1965:

> Frustration is one of the great things in art; satisfaction is nothing... I do not think of modern art as Modern Art. The problem started long ago, and the question is: Can there be any art at all? Maybe this is the content of modern art.[18]

Stephen Greene, a former student of Guston's who joined him as instructor at Washington University a year before Beckmann's arrival, also admired the

13. In 1946 the St. Louis City Art Museum had purchased his *Young Men by the Sea* from Curt Valentin's 1946 exhibition. The Washington University Gallery of Art acquired *Les Artistes with Vegetables* from the same show.

14. Beckmann, "Gedanken über zeitgemässe und unzeitgemässe Kunst," in *Pan* (1912), pp. 499-502. Translated in Peter Selz, *German Expressionist Painting*, Berkeley and Los Angeles, 1947, p. 240.

15. Dorothy Seckler, "Can Painting be Taught?" *Art News*, L:1(1951), p. 30.

16. Dore Ashton, *Yes, but*, New York, 1976, p. 64.

17. *Ibid.*, p. 73.

18. Philip Guston, "Faith, Hope and Impossibility," (lecture given at the New York Studio School, New York, May 1965), in *Art News Annual*, 1966, pp. 101-103, 152-53. It is interesting that among the leading American painters it was only Philip Guston who, going beyond abstraction, formulated paintings which are great visual allegories of the anxiety of modern life by turning into his own inner self toward the end of his life. Like Beckmann before him, Guston said in 1978: "The visible world, I think, is abstract enough. I don't think one needs to depart from it in order to make art." (Guston, Lecture given at the University of Minnesota in 1978, printed in *Philip Guston*, Whitechapel Gallery, London, 1982.)

German painter for his "crowded, firmly molded compositions," as H. W. Janson observed in 1948.[19] And Greene affirms that "I still deeply admire the man. [His work] has a psychological power, a strong formal manner, it stays as the signpost of what I most admire in twentieth century painting."[20]

Both Guston and Greene had left by the time Beckmann arrived in St. Louis, but his impact continued to be felt by other artists who were his students, such as Nathan Oliveira who studied with him at Mills College in the summer of 1950 and who recalled that "most of all he was concerned with his own vision and dream and this was critical to me."[21]

Beckmann had painted many portraits of his wife and intimate companion over the years. *Quappi in Gray* (cat. 119), completed in 1948, was one of the last of these likenesses that covered a great range of moods and attitudes. In this portrait she appears with poised assurance, seated with arms crossed in a self-protective manner, holding the world at a distance. This is quite a different portrayal from the more open, pliant, and freer depictions of Quappi in earlier pictures. Much of the mood of this painting is established by the muted colors of related browns, greens, and grays as well as by the narrow, vertical format and the device of framing the sitter rather tightly between a curtain on the right and what appears to be a ladder—a frequent emblem of Beckmann's personal iconography—on the left.

The students at Washington University held regular masquerade parties which Beckmann greatly enjoyed. The mask, the world of make-believe, the mardi gras were very much part of his life and work. Over the years he portrayed himself in his paintings, prints, and drawings as clown, sailor, musician, sculptor, prisoner, man of the world, ringmaster, and frequently as actor. But he was also the observer, the *flaneur,* who looked at the world as a ship of fools. As with some of the scenes of the 1920s with similar themes, *Masquerade* of 1948 (cat. 117) is not a frolicking affair, but a vision of death. The strong man with his absurd satanic mask, tiny top hat, and large club confronts the stout cat lady who bears a large human skull in her right hand.

Images in the New Country

Beckmann generally accepted invitations to speak in different cities. In February 1948 he gave a lecture at Stephens College in Columbia, Missouri. This lecture, in the form of "Letters to a Woman Painter," encapsulates many of his thoughts about art, philosophy, religion, and life. One wonders what the young ladies of the college might have thought when Quappi read to them a passage such as:

> Have you not sometimes been with me in the deep hollow of the champagne glass where red lobsters crawl around and black waiters serve red rhumbas which make the blood course through your veins as if to a wild dance?![22]

But this query does furnish deeper understanding of the artist's own visual fantasy and provides greater insight into the meaning of a painting like *Cabins,* which was done in the summer of 1948.

The Beckmanns returned to Holland in the summer of 1948 to take care of their American visas as well as to see friends and make arrangements for a permanent move from Europe to America. *Cabins* (fig. 3), painted in Amsterdam directly after their arrival, was Beckmann's immediate response to the trans-Atlantic passage. It is a difficult, hermetic picture. Life on the ship is seen from its vortex. The narration does not follow linear order or time; different space cells do not mesh. A large fish with an enormous eye in the center of the painting forms a powerful diagonal thrust across the darkly painted surface. But

19. H. W. Janson, "Stephen Greene," *Magazine of Art,* XLI (April 1948), p. 131.

20. Stephen Greene, letter to the author, November 14, 1982.

21. Nathan Oliveira, letter to the author, November 2, 1982.

22. Beckmann, "Letters to a Woman Painter," translated by Mathilde Q. Beckmann and Perry T. Rathbone, quoted in Peter Selz, *Max Beckmann,* New York, Museum of Modern Art, 1964, p. 133.

the fish is white, like Moby Dick. A sailor, probably Beckmann himself, is trying to take hold of the monster which is tied to a board. Behind, below, above, and on the sides are episodes of the shifting facets of human life in its passage. Directly above the sailor a violent drama is being staged in this mystery play, while a mourning scene can be observed behind the window on the upper left. Below there is a voluptuous girl lying seductively on a couch. In the upper right a young blonde is combing her long hair. Below a young woman is seen drawing the picture of a ship while large white flowers bloom behind her. A ship sailing at sea inside a life raft on its side is seen on the right edge and the elevation of a blue house on the extreme left. A party seems to be taking place behind the porthole in the lower center. The two blue and orange columns cross the picture diagonally at right angles to the fish: there is no stability. In fact the make-believe world is in a state of collapse, and the sailor will never gain possession of the fish.

While working on this picture in his old Amsterdam studio, the artist began working on *Fisherwomen* (cat. 121), which he completed after his return to St. Louis. The fish in this picture appear to stand for phalli. Beckmann actually explained the meaning of the fish in his work to his old friend, W. R. Valentiner, who visited him in Amsterdam in July 1948 while he was working on this painting. In a "half serious, half satirical" manner he told Valentiner "that man originated in the sea and that we all derive from the fishes, that every male still has something of a particular fish about him, some are like carps, others like sharks, others like eels, which clearly reveal themselves in their love of life."[23] In this painting the phallic-looking fish are held by sensuous young women in seductive gestures. "These women," Beckmann told Quappi, "are fishing for husbands, not lovers."[24] The three nubile girls make use of all their female allurements: the black and green stockings and garters, negligees and tight corsets, uncovered breasts and thighs. The exposed buttocks of one of the creatures is seen through the neck of a suggestively placed vase. The provocative sexuality of the three young women is contrasted to the withered old hag, holding a thin green fish in the background, a juxtaposition which the artist also used in the slightly earlier Amsterdam painting, *Girls' Room (Siesta)* (cat. 113), where the interlocking bodies of young girls in suggestive poses are contrasted

Fig. 3 Max Beckmann: *Cabins*, 1948, oil on canvas, Düsseldorf, Kunstsammlung Nordrhein-Westfalen

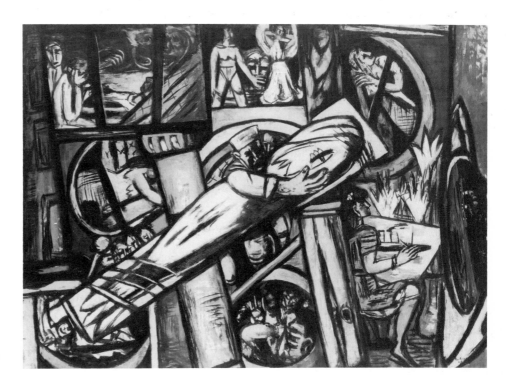

23. W. R. Valentiner, "Max Beckmann," in *Blick auf Beckmann: Dokumente und Vorträge*. Edited by Hans Martin von Erffa and Erhard Göpel, Munich, 1962, p. 85.

24. Mrs. Mathilde Q. Beckmann in an interview with the author, New York, April, 1964.

to an old crone who seems to be reading to them. The figures and objects in *Fisherwomen*, outlined by bold and heavy black lines, not only fill the available space, but they crowd it to the point of overload. After all, "It is not subject which matters, but the translation of the subject into the abstraction of the surface by means of painting."[25]

Beckmann always worked on several canvases simultaneously and all during this time he was involved in the completion of his triptych, *Beginning*, which he had started in Amsterdam in 1946. It was the most autobiographical of his triptychs and called forth many early memories. Not long after its completion in the spring of 1949 he set out to Colorado where he taught at the University during the summer. He liked the Rocky Mountains, managed to do a good deal of climbing despite the high altitude, and made fine drawings such as *Park in Boulder* (cat. 202). He then went on to New York where he had accepted a permanent teaching position at the Brooklyn Museum School, a job in which he took great interest. His arrival in New York coincided with the greatest moment for Abstract Expressionism, but Beckmann remained isolated from it, just as he had always stayed aloof from all the art movements of his time.[26] Indeed, pure abstraction held little interest for an artist who had stated in his London lecture: "I hardly need to abstract things, for each object is unreal enough already, so unreal that I can only make it real by painting it."[27]

Life in New York

Except for his own circle of friends, collectors, admirers, and students Beckmann remained relatively isolated in New York but certainly enjoyed being a celebrated European artist. In October he received First Prize at the Carnegie International for his *Fisherwomen*. Göpel lists no less than 23 exhibitions in 1950, 15 of which were held in the United States.[28] Living in New York, first in the Gramercy Park section and later on the Upper West Side, he delighted in going to the elegant bars at the St. Regis and Plaza hotels, not only to look at the passing scene but also to be seen. He explored Chinatown and the Bowery as well as the seedy dance halls of Times Square. In the winter he went for walks and fed the squirrels in the snow in Prospect Park.

The still-life, like the landscape, was always an important subject in Beckmann's oeuvre. His love for the material aspect of the world found its expression in these "feasts for the eyes." Often the colors create an ensemble of great richness, as in his *Large Still-Life with Black Sculpture* (cat. 124). Again the space is completely filled and the work seems almost noisy with clutter and agitation. There is clearly a *horror vacuii* in much of Beckmann's work, who would speak of his fear of being crushed by the "dark holes of space" and of painting "to protect myself from the infinity of space."[29] It is this impinging of objects on each other which negates any sense of stillness in most of Beckmann's still-lifes. In this canvas the flame of a candle gently outlines the classical sculpture. There is a bowl filled with fish, another candle, a nautilus shell, a group of pears, an epiphyllum plant which bends its blossom toward the sculpture. The lower part of the ornate mirror reflects additional objects which are not on the right table. "Many mirrors are necessary to see behind the mirror,"[30] the artist wrote in his diary just before embarking on this painting. The sickle of the new moon is seen outside the window and on the left is once more the grid of a ladder, set at a diagonal and occupying a frontal plane. Tucked away near the plant is a copy of *Time* magazine. This piece of current reality prevents any illusion of the still-life from gaining sway and, once discovered, has an alienating effect similar to Brecht's contemporaneous theatre. The painting is certainly indebted to similar and earlier compositions by Matisse and Picasso. Beckmann's painting, however, has greater density; it is filled with ambiguities and

25. Beckmann, "On My Painting," (lecture originally delivered as „Meine Theorie in der Malerei") given at the New Burlington Gallery, London, July 21, 1938. English translation in Herschel B. Chipp, Peter Selz and Joshua C. Taylor, *Theories of Modern Art,* University of California Press, Berkeley and Los Angeles, 1968, p. 188.

26. Beckmann, for example, always resented being called an Expressionist. In his Washington University lecture he said "I personally think it is high time to end all isms."

27. Beckmann, "On My Painting," in Chipp et al., *loc. cit.*

28. Erhard and Barbara Göpel, *Max Beckmann, Katalog der Gemälde,* Bern, 1976, vol II, pp. 107-108.

29. Beckmann, "On My Painting," in Chipp, et al., *loc. cit.*

30. Beckmann, entry for July 7, 1949, in *Tagebücher,* p. 339.

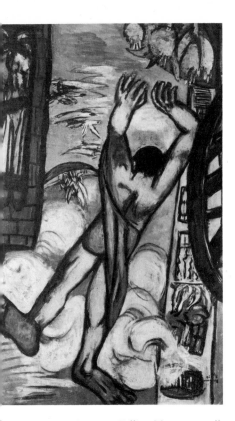

Fig. 4 Max Beckmann: *Falling Man*, 1950, oil on canvas, New York, Private collection

enigmas. The Parisian painters would never have introduced a rising moon with all its romantic implications in a still-life painting or held it in place with a segment of a ladder.

Goethe once wrote that "everything is symbol," meaning that everything stands for another thing, transcends itself, be it the ladder or the gigantic figure with outstretched legs in *Falling Man* (fig. 4). Beckmann said that it represents man falling through the sky on his way to earth.[31] But, undoubtedly filled with premonitions of dying, the picture stands for death and quite possibly Beckmann's belief in some sort of reincarnation into "another state of being."[32] The man travels past the burning dwellings of mankind toward magnificent burgeoning plants while supernatural beings—magical birds or angels—float in ethereal boats. The semi-circular object on the left has been interpreted as the railing of a balcony and as the wheel of time. Much of the painting is taken up by the intense azure sky. Never before had Beckmann opened up a picture in this manner in order to make room for space, which, although confined between the buildings, is infinite and without horizon. Ten years after expressing his fear of space in his London lecture, he stated: "For in the beginning there was space, that frightening invention of the Force of the Universe. Time is the invention of mankind, space or volume, the place of the gods."[33]

Soon after completing this transcendent picture, the artist painted a hellish vision, *The Town* (cat. 131). It is closely related to his earlier masterpiece, *The Night* (cat. 19), done more than thirty years earlier. Again the viewer witnesses a horrible act of torture. But now the grayish tints are replaced with rich and heavy colors, the brush stroke is looser, the forms less angular. The visual flow is smoother, but the space is again a claustrophobic room. Instead of the emaciated man being gagged to death on a wooden bench, the central figure has become the voluptuous body of a bound woman on a bier with phallic bedposts. This dominant figure is again surrounded by tormentors, but here they are more symbolic and sardonic than the more literal—but also cryptic—torturers in the earlier picture. In fact no mutilation takes place in *The Town*. The figures in the back, standing in a row, are all different in scale, creating a spatial discontinuum and dissonance, "so that some of the bewildering qualities of a large metropolis are conveyed directly by this means."[34] According to Beckmann's wife, the figures from left to right represent a prostitute, a disillusioned man, a guardsman, a cynic, and a street musician. There is a bar or bordello on the right. Below the bar lies a bottle of champagne, marked "REIMS". The monkey with the mirror might represent vanity, and the naked figure picking up coins in the center suggests avarice. The sphinx with the postman's cap holds a letter addressed to MB. Is he perhaps the messenger of death in medieval symbolism? The skyscrapers with human heads in the background "signifiy nothing in particular."[35] On the left bottom there is the familiar ladder stopping in mid-air.

The central figure of the nude in splayed pose, taken quite directly from the *Reclining Nude* of 1929 (cat. 59), is derived ultimately from the classical sleeping Venus or Odalisque, but she is no longer an idealized nude. Instead she represents Lulu, the Earth Spirit, who is about to be sacrificed in some sort of Black Mass by the demonic and disillusioned denizens of an infernal city at night. In the painting, as in other late works, events from daily life are intermingled with dream, fantasy, and myth into an allegory which conveys the ambiguities of existence. Beckmann, like Kafka who was born just a year before him, presents the absurdity of the human condition by the use of tangible but enigmatic objects and personae.

While working on *The Town* Beckmann painted a major picture to which he first referred in his diary as "Pierette," then as "Yellow Stockings" and also as "Mardi Gras Nude." Curt Valentin called the painting "Mlle D." and it is now usually known as *Columbine* or *Carnival Mask, Green, Violet and Pink* (fig. 5;

31. Beckmann's own interpretation as transmitted by his wife to the author.

32. Beckmann, entry for October 28, 1945, in *Tagebücher*, p. 140.

33. Beckmann, "Letters to a Woman Painter," in Selz, *Max Beckmann.* p. 132.

34. Margot Orthwein Clark, *Max Beckmann: Sources of Imagery in the Hermetic Tradition*, unpublished Ph.D. dissertation, Washington University, St. Louis, 1975, p. 333.

35. Göpel, *op. cit.*, vol. II, p. 497.

cat. 130). Like Picasso, Beckmann often painted circus performers, moun-
tebanks, clowns, saltimbanques, harlequins, and pierrots—people who like
artists exist on the fringes of society. Columbine wears a black face mask and
carries a pink pierrot's hat in her left hand. Her right hand, holding a cigarette,
is raised to her long grayish-blonde hair. Her red lips are sealed. The woman is
placed against a purple wall, interrupted by a green curtain, and is seated either
on a chair with round seat or a blue drum. Its surface is covered with playing
cards, "marked with rough crosses, suggesting death,"[36] that seem to be thrown
out carelessly in front of her lap.

As Friedhelm Fischer has pointed out in his analysis of this painting, both
the discordant color and the woman's body are foreboding. It is a threatening
painting with this dark Columbine as a monster, an archetypal image of woman,
both seductively inviting and ominously menacing. Beckmann was greatly
interested in Gnosticism as well as theosophy, and owned a copy of Helene
Blavatsky's *The Secret Doctrine*. He had read Carl G. Jung's essay on "The
Relation between the Ego and Unconscious"[37] and was probably intrigued by
Jung's theory of archetypal unities between the personal and the collective
unconscious, the tragic and the timeless, as revealed in this, one of his most
powerful and memorable paintings.

The picture was painted in 1950, a year in which two artists of the next
generation, Jean Dubuffet and Willem de Kooning, were also occupied with the
female image. Beckmann's woman is very flattened out. Except for the volume
indicated around her shoulders, she is almost two-dimensional, a feature which
is carried much further still in Dubuffet's grotesque *Corps de Dames*, where the
female body is totally lateral to the picture plane, indeed becoming a pictorial
flatbed. The body of Beckmann's Columbine looks as though it had been
wrenched apart and reassembled in an inhuman, hieroglyphic form.[38] Again de
Kooning, using a more Expressionist brush stroke, goes one step further in his
series of *Women*, called Black Goddesses at one time (fig. 6). The parts of the
body—arms and legs, buttocks and breasts—are almost interchangeable in his
wildly distorted paintings. Both Dubuffet's and de Kooning's women, however,
are endowed with cruel grins while this figure confronts us with a fearful, cold
stare.

Ever since his early youth—he painted his first self-portrait at 15 and it is the
earliest painting which the artist preserved—"Beckmann held the mirror to his
face, studied his personality and his reaction to the world and the world's to his
personality... Nobody since Rembrandt has examined his own physiognomy
with such penetration as Max Beckmann."[39] He completed his last *Self-Portrait*
(cat. 126) between January and May 1950 during a time of extraordinary activity
of painting, teaching, travelling, reading, exploring, even moving to a new
apartment in New York. In this final self-portrait Beckmann looks drawn, tired,
exhausted—but still defiant and perhaps more elusive than ever before. He
draws on his cigarette as though for nourishment and leans against the arm of a
high chair. The large flashing eyes of Beckmann, always the observer, are
watching. Behind him looms yet another new canvas. The most startling thing
about this picture, however, is the brilliant color: the unrelieved cobalt blue of
the jacket, the bright orange shirt, the green chair—all against the dark maroon
back wall. The very brightness of the colors contributes to the two-dimensional
appearance of the painting; their disparate, almost cruel quality give an insolent
air to this wistful figure.[40]

Travels in California

Soon after the *Self-Portrait* was completed, he left New York for another stint of
teaching summer school—this time at Mills College in Oakland, California. On

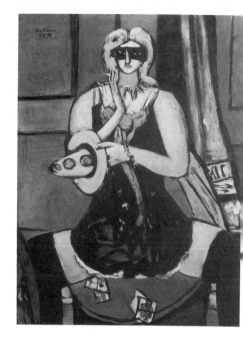

Fig. 5 Max Beckmann: *Carnival Mask,
Green, Violet and Pink. Columbine*, 1950, oil
on canvas, St. Louis, The Saint Louis Art
Museum, Bequest of Morton D. May

36. Friedhelm W. Fischer, *Max Beckmann*, London,
1972, p. 86.

37. Peter Beckmann (ed.), *Max Beckmann
Sichtbares und Unsichtbares*, Stuttgart, 1965, p. 110.

38. Fischer, *op. cit.*, p. 85.

39. Selz, "Einführung," in Peter Beckmann, *op. cit.*,
p. 5.

40. Selz in *Max Beckmann*, p. 97.

Fig. 6 Willem de Kooning: *Woman V,*
1952/53, oil on canvas, Canberra, Australian
National Gallery

the way he stopped in St. Louis to accept his Honorary Doctorate degree at Washington University, travelled to Los Angeles to renew his old acquaintance-ship with W. R. Valentiner, and then he stayed in Carmel for a month's vacation. He was greatly impressed by the Pacific coast. He wrote about the sea lions he saw at Pebble Beach and indeed painted a picture of them, piled up on a rock, after his return to New York. He was fascinated by the big eucalyptus trees and especially by the giant birds,[41] but he also expressed great concern about the outbreak of a new war in Korea. At Mills College he was received by Fred Neumeyer, who previously had invited Lyonel Feininger, László Moholy-Nagy and Fernand Léger to teach at the Mills summer session. Neumeyer remembered Beckmann looking like a bulldog wearing a white tuxedo; he commented on discussions with the artist about Hölderlin and Schopenhauer, Greek, Indian mythology, and the Cabbala.[42] While at Mills, Beckmann could see the whole range of his later work in an exhibition of paintings from the collection of his great patron, Stephan Lackner.

West Park (fig. 7) and *Mill in Eucalyptus Forest* (fig. 8) were painted in New York immediately after his return and represent his impression of the Mills College campus. *San Francisco* (fig. 9), based on a cursory drawing in his diary, is one of Beckmann's rare cityscapes. Like Kokoschka's portraits of the cities of Europe, it is a panoramic view seen from a high vantage point. *San Francisco* is a brilliantly colored, very dynamic painting with the curved arrow of Doyle Drive rushing past the Palace of Fine Arts towards the heart of a city which itself appears to be vibrating. A crescent moon and a sunset appear in the eastern sky in Beckmann's painting, which combines several aspects of the city seen from different viewpoints. In the immediate foreground he has placed three black crosses apparently stuck into the black earth of the curving ground. On the right above his signature is the fragment of a ladder.

Religious subjects occur frequently in Beckmann's early oeuvre, both in the more traditional paintings such as *The Flood, The Crucifixion,* or the huge Rubensian *Resurrection* canvas during his early romantic period, and also in more Gothic and expressive scenes such as the *Deposition* (cat. 17) of 1917. In his late work, however, he veiled his message in more cryptic imagery, adopting instead the sacramental form of late German medieval altarpieces. In 1932, at the age of 48, he began a series of triptychs, completing nine and leaving one unfinished at the time of his death. Without doubt the paintings which took the greatest concentration and show the deepest profundity are those in which he was able to synthesize reality and fantasy, the known and the unknown, most completely. In his diaries he refers to them as "Triptiks" (sic), which is the German word for the papers a motorist needs in order to cross the borders. Indeed, Beckmann used these major works to charter his trip through life. These paintings are often hermetic and esoteric, and in his London lecture he cites the Cabbala, saying:

> What I want to show in my work is the idea which hides itself behind so-called reality. I am seeking for the bridge which leads from the visible to the invisible, like the famous cabbalist who once said: "If you wish to get hold of the invisible, you must penetrate as deeply as possible into the visible."[43]

Their message, ambiguous and often concealed, is best comprehended by initiated individuals who have the proper set of mind and feeling. In a letter of 1938 in regard to *Departure* (fig. p. 40) he wrote to Curt Valentin:

> ...If people cannot understand it of their own accord, of their own inner 'creative empathy,' there is no sense in showing it... I can only speak to people who consciously or unconsciously, already carry within them a similar metaphysical code.[44]

41. On June 19, 1950, writing in Carmel, he says that he finally learned the name of these exotic birds: "Corcorane." He was probably referring to the Cormorant, a large black aquatic bird found on the Pacific coast.

42. Fred Neumeyer. "Erinnerungen an Max Beckmann," *Der Monat,* IV (1952), pp. 70-71 and "Prometheus im weissen Smoking," *Der Monat,* VII (1955), pp. 71-73.

43. Beckmann, "On My Painting," in Chipp et al., *op. cit.,* p. 187.

44. Beckmann, unpublished letter to Curt Valentin, February 11, 1958, cited in Selz, *Max Beckmann,* p. 61.

Fig. 7 Max Beckmann: *West Park,* 1950, oil on canvas, New York, Private collection

Fig. 8 Max Beckmann: *Mill in a Eucalyptus Forest,* 1950, oil on canvas, New York, Private collection

As we know, Beckmann always worked on several paintings at the same time. Before completing the *Argonauts* he had started *Ballet Rehearsal* (cat. 132) telling his wife that "this triptych would not give him much trouble and it would be completed in a much shorter time than all the others. This one would become a humorous and gay triptych."[45]

Left unfinished, this work permits us to observe how the artist committed his first ideas to a canvas which might, in fact, have taken a long time to finish. It reveals his methods in painting, showing all the steps from the original charcoal black outlines to the introduction of oil paint. In his first diary entry on December 3, 1950, referring to this triptych, Beckmann calls it "Artistinnen" (circus performers), and indeed the women on the left wing are ballet dancers which gave the triptych its later name. But on December 5, when, presumably, he was working on the center panel, he referred to it as "Amazons," which recalls his early *Battle of the Amazons* (cat. 11), in which life is asserted with a Nietzschean vitalism and "Will to Power," and where the women are slaughtered in a violent battle with men. Now in this last painting, the only indication of a male is the face (perhaps Beckmann's) which seems to peer through the porthole in the right wing. Except for the lone voyeur, this is a world in which only women are in attendance.[46]

45. Mathilde Q. Beckmann, in *Beckmann,* Catherine Viviano Gallery, New York, 1964.

46. This was pointed out to me by Robert Rifkind who has both Beckmann's *Battle of the Amazons* and *Ballet Rehearsal* in his collection.

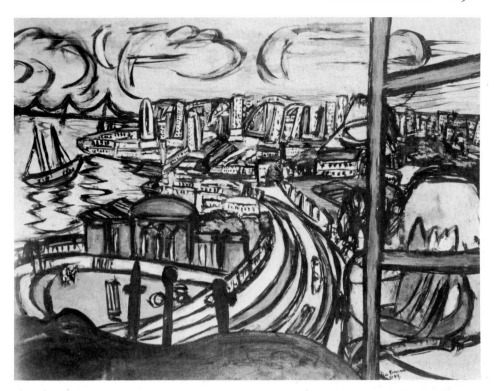

Fig. 9 Max Beckmann: *San Francisco,* 1950, oil on canvas, Darmstadt, Hessisches Landesmuseum

The Last Triptych

Beckmann's last completed triptych, *Argonauts* (fig. p. 37), can be seen as his testament. The left panel, originally called "The Artist and His Model," shows the painter practically attacking his canvas. The man resembles van Gogh in Gauguin's portrait of his painter friend at work (fig. 10); during the time in which Beckmann worked on the triptych—March 1949-December 1950—his diaries contain a number of very sympathetic references to "Vincent." In April 1949, for instance, Beckmann noted that he was re-reading van Gogh's letters and in November he went to see the van Gogh exhibition at The Metropolitan Museum. Beckmann must have identified with the energetic painter, yet it is the mask on which the woman is seated which has the greatest resemblance to his features. The woman, representing Medea[47] in the Argonaut saga, brandishes a sword which also looks like a symbol of virility. She can be seen as threatening, but she is probably meant to be a protectoress or an inspiring muse.

The right panel depicts the chorus of Greek tragedy—the intermediary between the action on the stage and the audience. Its purpose is to provide psychological distance and dramatic structure by means of measured comment. Beckmann's chorus is a chamber orchestra of beautiful, calm women playing and singing. While it is for the man to create and to engage in the adventure of life, it is the woman holding a sword who guards or inspires his genius, or the woman with guitar singing of his exploits. The right wing with the women rising in tiers, the stringed instruments on their necks reversed to fit into the oblong composition, and the deeply reverberating colors which resemble stained glass combine in one of the most beautifully resolved paintings in Beckmann's oeuvre.

The painter's canvas in the left wing forms an acute triangle with the ladder in the central panel. The two are related. In fact in south German dialect the word *Staffelei* signifies both an artist's easel as well as a ladder. The ladder had often served Beckmann as a symbol of anguish, longing, and fulfillment in the same manner as the canvas is the artist's proving ground. Here the ladder no longer stands empty. The wise old man emerging from the sea has withstood all

47. Göpel, *op. cit.,* I, p. 508.

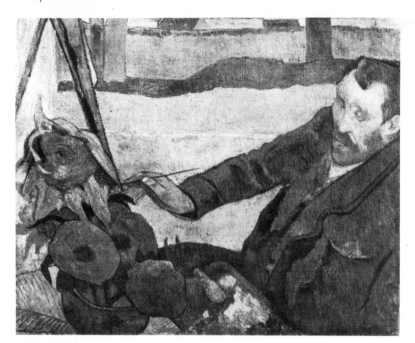

Fig. 10 Paul Gauguin: *Portrait of Vincent van Gogh,* 1888, oil on canvas, Laren, Collection of V.W. van Gogh

his trials and has completed the long journey. He now beckons with a prophetic gesture to the two young Argonauts setting out on their heroic adventure. On the right is Jason, a beautiful youth—the final state of an ideal figure which occupied Beckmann for a lifetime and made its first appearance in *Young Men by the Sea* in 1905 (fig. 11); we see the same basic composition again in 1943 (cat. 100). Both these paintings were important landmarks in his career. The composition is also related to paintings by Hans von Marées, a painter whom Beckmann always held in high esteem. The elbow of Jason rests on red rocks, their color inspired by the Garden of the Gods in the Rocky Mountains near Boulder. On his wrist is a fabulous bird whose blue head, and brown and green feathers may refer to the magical wryneck which Aphrodite gave Jason to help Argonauts pass through the Clashing Rocks of Symplegades. The gentle youth in the center, adorned with a wreath of flowers in his hair and golden bracelets on his arm, must be Orpheus, whose orange lyre lies on the yellow beach beside him. According to Apollonius of Rhodes, Orpheus was the first of the large crew of Greek heroes enrolled by Jason to sail the Argo. The old man may be Phineus, the king who had advised the Argonauts to send a dove out from their boat to explore the way, and who had been blinded by the gods for prophesying the future. But he may also be Glaucus, builder of the Argo, who later became a sea god endowed with the gift of prophesy.

The painting may at least in part be indebted to the interpretation of the Argonaut myth by the Swiss cultural historian, J. J. Bachofen, which was known to Beckmann.[48] Bachofen saw the myth, which describes the first encounter of the Greeks with the barbarians, as referring to the revolutionary change from a more ancient culture in which the "female principle" and greater harmony with nature prevailed over a culture of male dominance and Promethean striving.[49]

In the pink sky above the heroes Beckmann painted a purple eclipse of the sun, outlined by a fiery orange ring. On September 5, 1949, he expressed his astonishment when reading about sun spots in Humboldt and wrote: "I never knew that the sun is dark—very shaken."[50] Two orange new planets were included at this historic moment and they orbit between the sun and the crescent of the waxing moon.

The space in *Argonauts,* when compared with the earlier triptychs and other compositions, is less jammed. The painting is not as violent or disparate, but is

48. *Ibid.*

49. Charles S. Kessler, *Max Beckmann's Triptychs,* Cambridge, Massachusetts, 1970, pp. 94-95.

50. Beckmann, entry for September 5, 1949, in *Tagebücher,* p. 348.

Fig. 11 Max Beckmann: *Young Men by the Sea*, 1905, oil on canvas, Weimar, Kunstsammlungen, Schloßmuseum

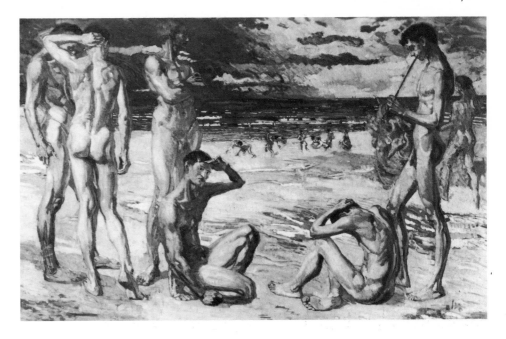

imbued with calm serenity and measure. The struggle between good and evil, the old dichotomy of black and white, no longer fully engaged the mature painter. He is now concerned with that spark of human activity which beckons to the great adventure, the quest for the Golden Fleece, and beyond that, to the achievement of peace and transfiguration. The old man-god points, as Beckmann might have said, to a plane of different consciousness.

On December 17, 1950, Beckmann sent his last letter to his son. He wrote: "I am just painting a triptych, *Argonauts,* and in 'Dodona' we shall see each other again."[51] This was ten days before he died. Dodona was the sanctuary of Zeus where an ancient sacred oak communicated the will of the god by the rustle of its leaves to those mortals who could understand the sound.

51. Beckmann, Letter to Peter Beckmann, December 17, 1950. Published in *In Memoriam Max Beckmann*, Frankfurt am Main, 1953.

Walter Barker

Beckmann as Teacher:
An Extension of His Art

At the age of sixty-three and near the end of his life, Max Beckmann became one of the most sought-after master teachers of painting in post-World War II America. From September 23, 1947 until his death in late December of 1950, he taught advanced painting classes at five art schools, visiting and lecturing at a number of museums and schools during the same period. By the most conservative estimate he taught over 150 students, criss-crossing the United States twice by train to do so. In all, including his teaching years in Germany, he taught a total of eleven years in six art schools.[1] This substantial teaching record, seen in the context of Max Beckmann's well-established and prominent position in the history of art, quite properly draws attention to Beckmann as a teacher.

Like all artists who teach, Max Beckmann assumed a noble and sometimes thankless task, and was subject to countless distractions and frustrations known only to the artist. In many cases the unspectacular business of teaching is poorly recorded and lost to history, a major part of an artist's life either disregarded or consigned to oblivion. However, in the case of Max Beckmann we are fortunate to have extremely reliable accounts from the artist's wife, close friends, museum directors, colleagues, and students. Through their eyes we are given an excellent glimpse of Max Beckmann as a teacher. In addition, Beckmann's essays on art provide us with concrete examples of lessons he gave his students, and the artist's notations in his diary from 1940 on document important times, places, and situations in which he taught. Thus we are able to see a colorful and dynamic teacher guiding and inspiring the young and hopeful in the way of art.

Max Beckmann's teaching career began in 1925 when he was appointed professor of a master class at the Städelsche Kunstinstitut, Frankfurt. He was then forty-one years old, and established as one of Germany's leading artists. According to Mrs. Beckmann, his classes were small, usually five to eight students – an ideal number for a master class. She remembers that he was fond of certain students and particularly enjoyed working with them.

However, in 1933 after the Nazis had labeled him a "degenerate artist" and ordered his dismissal from his teaching post, he is known to have said very little about either his students or his tenure at the Frankfurt Academy. Such a ruthless and typically uncivilized act by the Nazis had its effect on the artist, and his reticence on the matter was linked to the resulting wounds and frustrations. He had prepared himself for the dismissal, according to Mrs. Beckmann. Nevertheless, for Max Beckmann and his students normal class work must have been a trying experience for all concerned: a disturbing and distasteful environment in which to learn, and, for the teacher, fear for life itself mixed with horror and revulsion at what he saw happening to his country.

Given that Max Beckmann's art had arrived at a position of high resolution and that his beliefs and perspectives about painting were already fully formed, it is not difficult to believe that what and how he taught in Frankfurt was not greatly different from his teaching in the United States years later. Quite possibly it was in Frankfurt that he gained the experience and evolved the teaching philosophy that would serve him so well in the years to come.

Notes # 2, 5, 6, 8, 9, 11 and 12 are from conversations and letters collected for a book in progress, *Max Beckmann in America,* by Walter Barker.

1. Beckmann taught at the Städelsche Kunstinstitut, Frankfurt; Washington University, St. Louis; University of Colorado, Boulder; Brooklyn Museum School, New York; Mills College, Oakland, Ca.; and the American Art School, New York.

The memory of events in Frankfurt may well have been on his mind when fourteen years after his dismissal by the Nazis, he accepted an offer to teach at Washington University in St. Louis. "...may God grant that it turns out all right," he wrote in his diary on May 31, 1947 in Amsterdam. Understandably, the Frankfurt experience, his long absence from teaching, the difficulties of learning a new language and adapting to a new country, and the effects of the war did little to build confidence.

Westbound from Amsterdam to New York in September of 1947 he expressed his fears to his wife. "Well, I don't know if I can do it. The language... and I haven't taught for such a long time. Well—it's a tryout...But—I don't know. Well then, we'll just have to go back again."[2]

An Overwhelming Presence

However, in true Beckmann fashion he persevered, and in a very short time his fears were to disappear. After meeting his first class at Washington University he noted in his diary, "Pleasant surprise... a really lovely scene." In an interview with the *St. Louis Post-Dispatch* the same day, (September 23, 1947) he is quoted as saying, "It is thrilling to be able to teach the young again. I shall devote myself to developing their individual personalities. I promise not to raise a flock of little Beckmanns." The photograph of the artist which accompanies the article shows him relaxed and smiling, apparently in a positive mood. "... I want to find young people who will paint because it is their nature to paint. When as a child of eight my parents made me return a box of paints I had traded for my tin soldiers, I learned what it is to be deprived of artistic expression. I shall work hard here."[3]

That morning he had told his first class, through a brief paper read by Mrs. Beckmann, some of his concerns and a few maxims he would expect them to observe. The message was expressed simply enough, but on closer study revealed complexities and depths of meaning that would take his best students months to grasp and practice. For example: "If you want to reproduce an object, two elements are required: first, the identification with the object must be perfect, and secondly, it should contain, in addition, something quite different... In fact it is this element of our own self that we are all in search of."[4]

The painter Fred Conway, himself regarded as an outstanding teacher at Washington University and a colleague and friend of the artist, was one of the first to comprehend the depth and high seriousness of Max Beckmann's teaching.

> "Max was talking about painting in a big way, not today, not yesterday, but those truths that have seeped down from the efforts of countless men for five hundred years—those big truths you know, and I think that's one of those marvelous things he managed to do somehow or other—to take all these abstract things that have come down and bring them up to the contemporary scene in his own way. Still basic, fundamental—nothing panicky about it."[5]

And the artist, Muriel Wolle, director of the summer school at the University of Colorado when Max Beckmann was on the faculty, observed this same quality in Max Beckmann as a teacher.

> "I don't remember a summer when there was more unanimity of feeling among the faculty as to the magnitude of the man. We've had visiting artists... every summer... but, there has often been a big diversity of feeling about what they were doing... some thought they were more important than others... I think some of us feel that whether you wanted to paint like

2. Mathilde Q. Beckmann, conversation, 2 February 1972.

3. *St. Louis Post-Dispatch*, interview, 23 September 1947.

4. Address to first class, Washington University, St. Louis, 23 September 1947.

5. Fred Conway, conversation, 2 July 1970.

Fig. 1 Max Beckmann: *Students*, 1947, pen and ink, Private collection

Beckmann, or were interested in what he was doing, you had something there, and this was a great force, and you could make use of some of the things as you saw them. Even in later years, Beckmann was always spoken of as one of the high points of the visiting faculty."[6]

Thus we see that at the very outset Max Beckmann was placed in a category of his own and recognized as a unique teacher. Nonetheless, teaching conditions were sometimes difficult, and the artist had to work very hard to retain his integrity while getting across his message.

Classes in the United States were large, unlike those in Germany, averaging twenty students. At each new school and at the beginning of every academic year he was faced with an entirely new group of students with whom he had to establish rapport. Although only a handful were serious art students, he treated each as an individual, in every way expressing a real interest in them. There were times when teaching was exceptionally taxing for the artist. Summer sessions were unbearably hot, as were the early fall sessions. There was no air-conditioning, and the temperatures were sometimes well over one hundred degrees. In Boulder, the studio where Max Beckmann taught was located on the top floor of the university theatre building. In this improvised and poorly ventilated studio, forty sweating students soberly awaited the master's criticisms. Keeping in mind the heat, shortage of oxygen, altitude (five-thousand feet), and the artist's heart condition and age, we should not be surprised that on one occasion he noted in his diary that his "corrections" were "exhausting."[7]

Criticisms were usually conducted twice a week in the mornings, not the three or more per week as was customary. This was the artist's choice, as he expressed it, "not to rob the students of their responsibility."[8] Ordinarily Mrs. Beckmann accompanied him on his rounds to translate and generally assist, although on one occasion, Mrs. Beckmann remembers, he asked her to go another way through the class, probably because the artist wished to test his use of English. At Washington University on his way to and from his own studio, he would sometimes appear unannounced in the students' studio to criticize informally. His concern for their progress was particularly evident at those times.

6. Muriel Wolle, conversation, 12 July 1970.

7. Max Beckmann, *Tagebücher 1940-1950*, Langen-Muller, Munich, 1955 (excerpt dated 27 June 1949), p. 336.

8. Max Beckmann, letter to Cola Heiden, 29 April 1947.

As Max Beckmann's class monitor during the academic year, 1947-1948, at Washington University, I observed him closely. What I saw was confirmed by a number of other Beckmann students both at Mills College and at the University of Colorado. Although the artist greatly feared that teaching would become routine and consequently boring, he nevertheless worked out an approach that, for the most part, avoided this.

Beckmann usually made the rounds of his classes without a break, only occasionally stopping for a cigarette. Never one for small talk and deadly serious about the criticisms he was making, he wasted no time in beginning his study and critiques of a student's work. He was friendly in a manner which seemed to say, "I am happy to be here with you. Let us see what good paintings we can make here." At Mills College, in deference to the summer heat, he would hang his hat on the nearest easel as he came in the studio, while at the Brooklyn Museum School he occasionally wore his hat as he criticized; it was an impressive sight, for the hat with the brim usually slightly up-turned in the front became in his students' minds symbolic of something intrinsic about the artist. This hat came to be Max Beckmann's expression of his attitudes about the world: a jaunty defiance of the commonplace and a strong assertion of his presence. Every teacher has to be something of an actor with a capability of dramatizing the moment, and Max Beckmann, with his strong dramatic sense, knew this. It was impossible to work when he was in the classroom, so strong was his presence.

Teaching by Example

Kenneth E. Hudson, Dean of the Washington University School of Fine Arts where the artist first taught in the United States, described this feeling on his first sight of Max Beckmann as he met him at Union Station in St. Louis. "What I remember was the tremendously impressive impact of the man's personality and appearance, which of course, I am sure... all students experienced. The moment he walked through the door you got the kind of presence that you get when people of this aspect appear on the stage—you know immediately who the star is, that this was a person of importance—a VIP."[9]

The artist charged his class visits with an air of high drama. So electric was the atmosphere, the rapport between teacher and student so close, that usually only a word or gesture was necessary to convey meaning between master and pupil. Max Beckmann's remarkable ability to identify with others to an unusual degree served him well as a teacher, and his use of non-verbal, highly visual, and intuition-centered means of communication quickly overcame any language barrier that might have existed. Mrs. Beckmann's able translations of her husband's more complex criticisms contributed greatly to the effectiveness of the artist's teaching. Her quick grasp of the situation and sensitive responses to mood and meaning were an important aid to the students' understanding of the master. She was well liked by the students who saw in her an advocate and friend and who appreciated the complement her petite figure made to the monumentality of her husband. No description of Max Beckmann as a teacher is complete without mention of her contribution.

In the first months of his Washington University teaching assignment, Beckmann's English language repertoire consisted mainly of interjections such as his explosive, "Ho!" and "Ah ha!" (pleasant surprise and amusement mixed with praise); "Formidable!" (pronounced as in French and meaning very impressive—high praise); and, "Good, good!" (very high praise indeed). His English improved over the winter, and with English lessons in Holland the following summer his vocabulary increased considerably. However, it was the artist's

9. Kenneth Hudson, conversation, 22 November 1969.

Fig. 2 Stephens College, Columbia, Mo., *left:* Max Beckmann, in the *middle:* Mathilde (Quappi) Beckmann

well-known habit to speak cryptically and in monosyllables, so that his use of interjections was only partially due to linguistic difficulties. He also used bodily and facial gestures to great effect in conveying his reaction to a student's canvas. There was seldom any confusion about what the master thought or wanted, since his students watched him closely at all times.

With as few as six strokes of the brush he would reorganize a student's weak composition into a coherent and meaningful whole, changing a faltering and indecisive canvas into one imbued with a strong pictorial architecture. Beckmann's class was no place for the fainthearted. It was not unusual after the artist left to find broken sticks of charcoal on the studio floor as a result of his vigorous corrections of a student's work. The artist's practice of painting on a student canvas with a large brush dipped in a generous mix of black made the timid gasp, but the more serious student realized at once that the artist was teaching by example and, therefore, studied his technique and solutions attentively. Turning to the student after these demonstrations he would urge, "Color! More color!" or, "More paint! More paint!," said, however, in the spirit of suggestion rather than explicit direction. This use of suggestion was typical of the artist's verbal teaching methods, a classical artist's criticism rather than one of the professional academician.

Among the lessons learned on these occasions was that the act of painting or drawing itself is a highly physical activity which combines the mind and the body into one expression, as in the playing of a musical instrument or movements in a dance. The action began with the body in balance and lightly poised for movements toward the canvas. With the upper part of the body relaxed, the movement then flowed through the shoulder girdle and the ball and socket joint of the upper arm. With the elbow, wrist, and fingers in restricted but relaxed motion, the movement of the brush or charcoal was controlled by the action of the ball and socket joint rather than by finger or wrist activity. This tended to create continuous flowing lines and bold movements. In addition, Max Beckmann encouraged students to revise constantly, scraping and wiping out without hesitation. A rag and turpentine were as important as a paintbrush. This

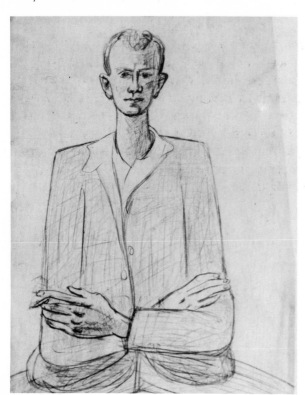

Fig. 3 Max Beckmann: *Study of Walter Barker*, 1948, graphite, Private collection

unceasing revision developed the students' self-criticism and responsibility for their own actions.

The Law of the Surface

Max Beckmann taught very fundamental, even classical ideas of painting, such as the importance of large movements in the composition. His concept of painting centered on the painting as an architectonic object as well as a conveyor of complex ideas expressed through imagery, symbolism, and visual metaphor. He insisted on what he called, "The Law of the Surface,"[10] in which the two-dimensional reality of the canvas is respected. Fred Conway described this in his analysis of Beckmann's work as "fitting the forms (of nature) to the surface, and not merely cutting up the forms to fit the surface." In this way the simultaneity of two and three-dimensional forms creates an energized field where forces can flow rhythmically into all parts of the painting.

The link between the simultaneity of two and three-dimensional forms, and simultaneity of events in life itself, did not escape the artist, who saw in his "Law of the Surface" no routine formalistic canon. What Max Beckmann was teaching was, in fact, one of the most important maxims from which he worked: that respect for this law was a strict condition or attitude which kept the artist on the path to art. "Art," he said, "resolves through Form the many paradoxes of Life." His suggestions for reading, which he earnestly recommended to promising students, were always books by writers who saw the absurdity as well as the meaning in life. Invariably his list included works by Stendhal, Flaubert, Dos Passos, Steinbeck, and others who saw duality as a factor in the lives of all men.

In one way or another Beckmann urged his students to respect the visible world as an anchor in the shifting sands of reality. Class models, in time, appeared less in poses reminiscent of Beaux-Arts classicism, and more like real-life characters in a Beckmann painting. The painter and teacher Nathan Oliveira, a Beckmann student at Mills College, remembers seeing the nude

10. Max Beckmann, *Letters to a Woman Painter, Part I.* 1948.

11. Fred Conway, conversation, 2 July 1970.

model in a Beckmann class wearing purple high-heeled shoes, lying on her back on a red velvet sofa, her legs propped up against the back and smoking a cigarette.[12] Max Beckmann taught from the same philosophical and aesthetic premises that he painted from, the combination of sound traditional and painterly ways combined with a lively appreciation and love of life around him, expressed in the forms of his time. Nothing he wrote or painted contradicted what he taught. When his classes ended, some students wept. They realized that their lives had been touched by a remarkable man. Max Beckmann as a teacher was the highly committed, inspired man that he was as an artist. Teaching for him could only be an extension of his art.

12. Nathan Oliveira, conversation, 27 July 1971.

Catalogue

Paintings

The authors of the painting commentaries are as follows:

M.B.	=	Martina Bochow
J.B.	=	James D. Burke
L.E.	=	Lucy Embick
C.L.	=	Christian Lenz
A.Sch.	=	Angela Schneider
C.Sch.-H.	=	Carla Schulz-Hoffmann
C.St.	=	Cornelia Stabenow

Reference

Göpel = Erhard and Barbara Göpel:
Max Beckmann. Katalogue der Gemälde,
2 Volumes, Bern, 1976.

1 Shore Landscape 1904
Oil on wood; 50 x 69.5 cm.
S.L.R.: MB 1904
Private collection
Göpel 16

Beckmann spent most summers between 1904
and 1910 by the sea, usually at the North Sea.
This period produced some twenty-eight paint-
ings of the sea, generally in the presence of
their subject; early on, these constituted al-
most half of his work. Apart from several oil
sketches from the year 1902, this work belongs
among the first great paintings on this subject.
From an elevated viewpoint in the dunes, one's
gaze extends over the breadth of the sea. The
water's weak swell breaks on contact with the
land and traces the contours of the shore in a
simplified form. An otherwise serene composi-
tion is given movement and depth by means of
expanding the beach diagonally from lower left
to upper right. Here Beckmann works de-
scriptively: brush and crayon are used to depict
the sea. As with almost all of his seascapes,
man plays either no role at all or a very subor-
dinate one. From the very first, his concern is
with the breadth, the expanse, and—as he
remarks in a journal entry much later
(27.9.45)—the freedom and infinity of the sea.

In this respect he distinguishes himself funda-
mentally not only from the French Impression-
ists, but also from the paintings of Liebermann
on this theme, whose beaches are peopled by
lively summer guests. A. Sch.

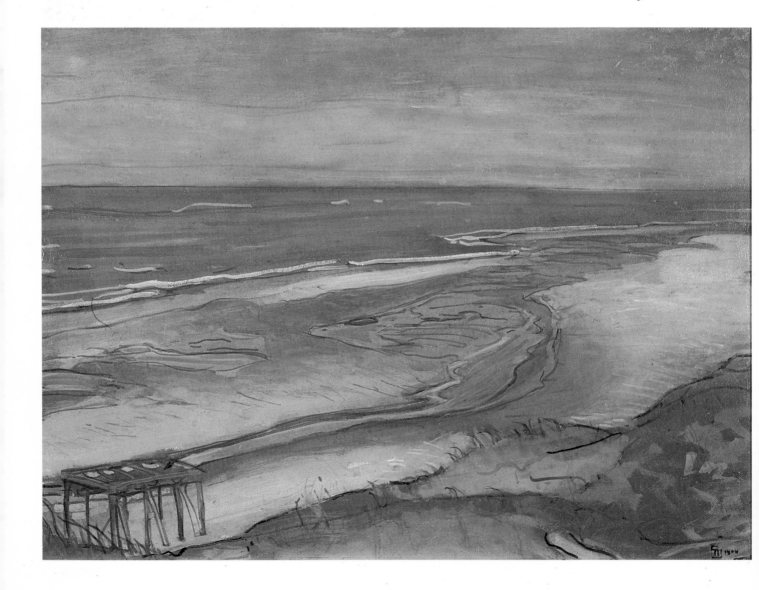

2 Self-Portrait with Soap Bubbles
ca. 1900

Mixed media on pasteboard; 32 x 25.5 cm.
unsigned
Private collection
Göpel 3

This is the second known self-portrait in a long series of self-images, in which Beckmann reveals something about himself and his current artistic habitat. Undated, it probably was produced between 1898 and 1900, when Beckmann was still a schoolboy in Braunschweig, prior to being accepted in the program in classical antiquity at the Academy of Art in Weimar. Here he sits in half-profile before a hilly, partially forested landscape, gazing at the soap bubbles that rise skyward. The motif of a youth blowing bubbles—symbol of the transience of life—is part of a long tradition extend-ing from Dutch artists and Murillo and, by way of Chardin, to Couture and Manet in the 19th century. It is uncertain whether the young Beckmann referred the allegorical content of the painting to himself. A. Sch.

3 Sunny Green Sea 1905

Oil on canvas; 81 x 110 cm.
S.L.L.: HBSL 1905
Private collection
Göpel 28

References: Selz, 1964, p. 11.; Schulz-Mons, 1982,
p. 140.

Large Gray Waves and *Sunny Green Sea,*
painted in the summer of 1905 in Jütland, dif-
fer from the *Shore Landscape* produced only a
year earlier in technique, theme, and style.
Both paintings are approximately the same size
and medium. The glazing technique is replaced
with a staccato-like brushwork by which the
movement of the individual waves, the under-
tow, and the eddy is reproduced. This brush-
work, which is characteristic of his painting
that year, seems especially well suited for
defining the nature of the sea not as a
homogeneous surface but rather as though it
were a breathing, agitated, fluctuating whole.
That impression is reinforced by the very high
horizon and the low viewpoint which seems to
place the viewer in the water. Selz sees in the
brushwork a dialogue with van Gogh, whereas
in the emphatically decorative and expansive

composition of the waves he recognizes ele-
ments of Jugendstil. A similar opinion is
offered by Schulz-Mons, who addresses the
problem of modernity and alludes to Beck-
mann's proximity to the Fauves, from whom
the artist nonetheless distinguishes himself by a
technique that employs tonal values. A. Sch.

4 Large Gray Waves 1905
Oil on canvas; 96 x 110 cm.
S.U.R.: HBSL 05
Private collection
Göpel 31

5 Large Death Scene 1906

Oil on canvas; 131 x 141 cm.
S.L.R.: HBSL August 06
Munich, Bayerische Staatsgemäldesammlungen,
Staatsgalerie moderner Kunst
Göpel 61

6 Small Death Scene 1906

Oil on canvas; 100 x 70 cm.
S.U.R.: HBSL 06
Berlin, Staatliche Museen Preußischer Kulturbesitz,
Nationalgalerie
Göpel 62

Reference: Gässler, p. 45.

These two paintings were no doubt produced in reaction to the death of Beckmann's mother, who died of cancer during the summer of 1906 and with whom Beckmann was very close. Gässler sees the two paintings, quite apart from the actual occasion of their genesis, as instances of a continuing evolution from impres- sionistic, idealistic depictions of landscape in the direction of symbolic thematic portrayals of the exceptional circumstances of human life. The *Large Death Scene* and the *Small Death Scene* differ in format, in style, and in repre- sentational statement. Whereas the former has to do with the last moments of the dying one, the latter is concerned with the grief of those left behind. Here the deathbed, removed to the furthest background of a far-off room, is identifiable only by means of the dark-clad people who are gathered around the bed. These figures, reminiscent of wailing women, kneel on the floor like supplicants. One has her arms raised high in what must be a gesture of grief and despair. In a closer room five larger figures are gathered; they, too, with the excep- tion of the child, are dressed in dark clothes in acknowledgment of death. Their relationship to the deceased and to one another is not further defined. The man's gaze is empty and, except for the seated woman whose very demeanor bespeaks despair, the characters here give an impression of helplessness. Their isolation is a motif that takes shape in another form in the painting, *Conversation* (cat. 7).

Stylistically, the *Small Death Scene* occupies an exceptional position among Beckmann's early work, both with regard to its brilliant col- ors—red and yellow wallpaper, black and white clothing, white bedding—and also to the mode of painting: the surfaces dissolve into single brush strokes, the contours are frayed. A comparison with Bonnard and Vuillard is obvious, but Beckmann intensifies the back- ground differently, bestowing at once greater distance and greater concentration on this small tragedy. The *Large Death Scene,* with its monumental composition accentuating the drama of the isolated figure, is closely related to Beckmann's early mythological paintings.

A. Sch.

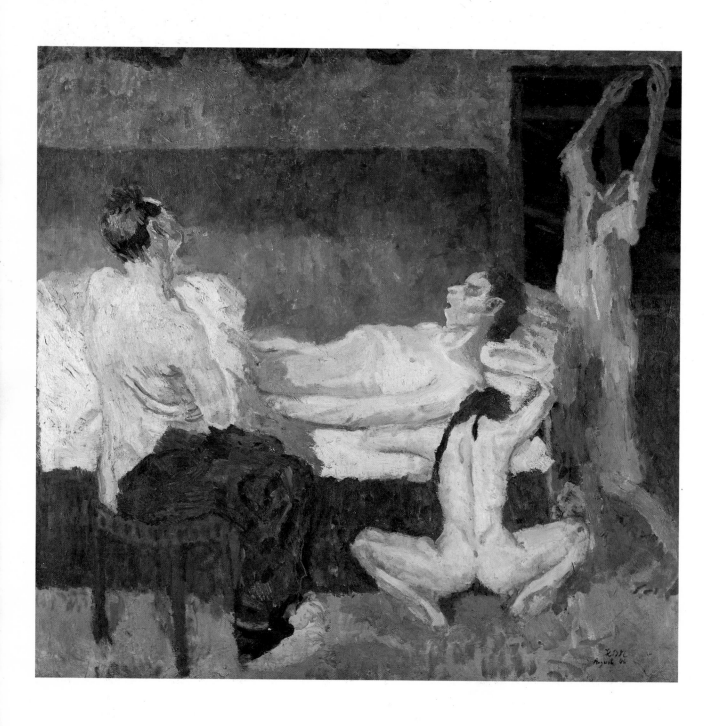

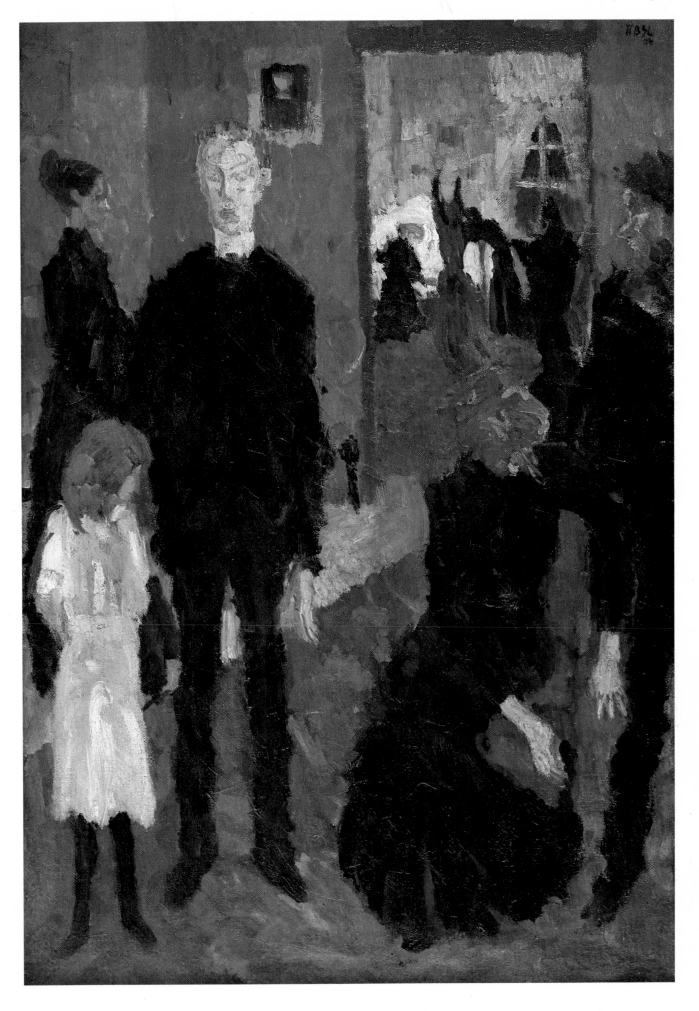

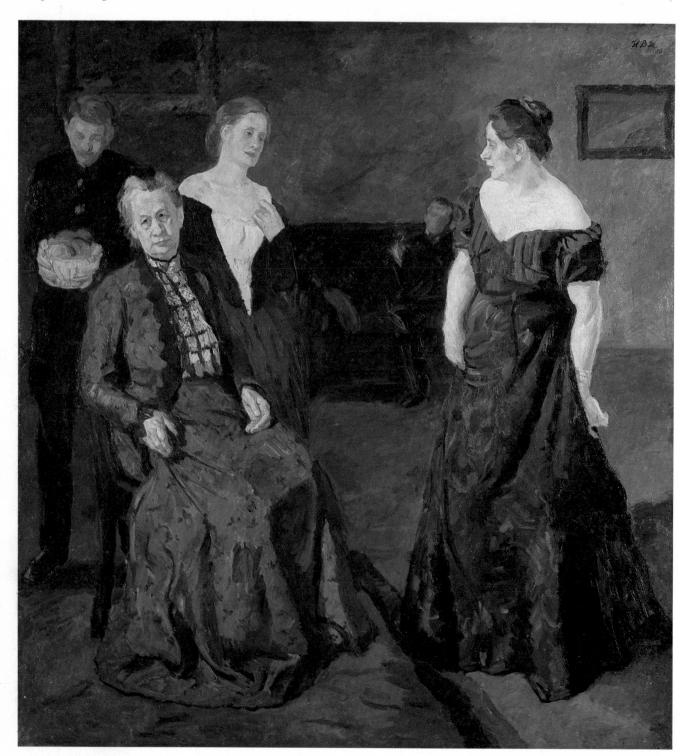

7 Conversation 1908

Oil on canvas; 179 x 169cm.
S.U.R.: HBSL 08
Berlin, Staatliche Museen Preußischer Kulturbesitz,
Nationalgalerie
Göpel 88

Reference: Reifenberg, 1921.

The painting *Conversation,* also called *Company I,* is followed in 1911 and 1914 by two additional large-scale pictures: *Company II* and *Company III.* In each instance the subject is a group depiction of the family and its circle of friends. In the left foreground we see Minna Tube, Beckmann's widowed mother-in-law, sitting in a chair; standing behind her to the right is the artist's wife, Minna Beckmann-Tube; and farther right stands Annemarie Tube, his sister-in-law. Max Beckmann himself sits on a sofa in the background. The picture on the wall is similar to *Summer Day at the Sea,* which Beckmann painted in 1907. The servant in the middle distance is pushed all the way to the left edge of the painting. Although the space is not defined, the pictures on the wall, the sofa, and the carpet suggest a living room. What is remarkable about the scene is the isolation of the figures.

The three women face different directions and have no eye contact. Each seems preoccupied with herself and her own "presentation," as if they are all rehearsing a play. Also noteworthy is that the center of the picture remains empty in its foreground, affording a view of the painter on the sofa. Perhaps he is contemplating the women as Paris did the goddesses. Whether Beckmann had such notions cannot, of course, be determined, but the concentration on the three women—there were several men among the Tube family as well—and the figure of the servant with the "golden" apples surely permits such an interpretation. If it is so, Beckmann would have expressed special homage to the family of his wife, at a time when Minna was expecting the birth of their child. A. Sch.

8 Self-Portrait in Florence 1907

Oil on canvas; 98 x 90 cm.
S.U.L.: Florenz HBSL 07
Private collection
Göpel 66
Reference: Lenz, 1976.

This painting was completed during a six-month sojourn at the Villa Romana—according to Minna Beckmann-Tube's recollection — in the winter of 1906. For his 1905 painting, *Young Men by the Sea,* Beckmann had been awarded the prize of the Artists' Alliance and a Florentine stipend in connection with it. This painting presents a front view of the artist in half-figure standing before his studio window, which affords a view of a portion of Florence and Fiesole. Dressed in a black suit with high shirt-collar he stands self-assured; his right hand beckons with a cigarette. That the young painter—Beckmann is 23—places himself against a background of one of history's most important art centers is more than a little intriguing. His urbane, sociable pose confronts the viewer. The portrait sustains its tension from the blackness of the suit on the one hand (a closed form) and the lightness of the landscape and the wall on the other (an open, perforated form). This contrast, which takes on a more decisive guise in later self-portraits (compare cat. 53), suggests that during his stay in Paris in 1906 Beckmann had come to terms with the art of Manet. Elements of Manet's style seem to be most evident in the dominating central role assigned to the color black —which, after all, unifies all the colors within itself—and in the motif of the window bars, although the window might also recall Corinth's *Self-Portrait with Skeleton* from the year 1896. A. Sch.

9 Self-Portrait (unfinished) 1908

Oil on canvas; 55.5 x 45.5 cm
unsigned
Beverly Hills, The Robert Gore Rifkind Collection
Göpel 99

Briefly indicated in breast, hand, and face, the 24-year-old Beckmann presents himself with that virtuosity of brush stroke familiar from Manet and Liebermann. The unfinished painting is in the nature of a study, with gestural brushwork and partially bare canvas. Yet in spite of its sketch-like texture, the picture already reveals what was to remain the artist's basic concern: the subordination of the means of painting – form and color – to the subject matter. The face, granted solidity by heightening with white and by shading, is the focal point of the picture and reflects the psychological state of the sitter. This self-portrait is close to that of 1907 (cat. 8). There, Beckmann had posed in the relaxed manner of the successful artist who, in 1906, had been awarded the *Deutscher Künstlerbund* prize and a study-grant for the Villa Romana in Florence. In contrast, the shaded face of this picture gives expression to that determination of Beckmann's which was to lend the *Self-Portait in Tuxedo* of 1927 (cat. 53) the character of an unequivocal claim to leadership.

A notable feature is the accentuated position of the hand which, instead of Beckmann's preferred attribute, a cigarette, he now appears to hold a brush. C. St.

10 Scene from the Destruction
of Messina 1909

Oil on canvas; 253.5 x 262 cm.
S.L.R.: HBSL 09
St. Louis, The Saint Louis Art Museum,
Bequest of Morton D. May
Göpel 106

References: Gässler, p. 139ff.; Lenz, 1976, p. 12ff.;
Güse, 1977, p. 33ff.

Beckmann began a sketch for the *Scene from
the Destruction of Messina* during the evening
of December 31, 1908, after he had read

accounts in the *Berliner Lokal-Anzeiger* and in
the *Berliner Illustrirten Zeitung* about a catas-
trophic earthquake in southern Italy in which
the city of Messina had been almost completely
destroyed. Of its 120,000 inhabitants some
80,000 perished. He wrote in his journal that
day: "I then read, still in the newspapers, more
about the terrible calamity in Messina; in the
course of a passage by a local physician, speci-
fically describing half-naked, released convicts
falling upon other people and their possessions
amid the frightful tumult, I conceived the idea
for a new painting." He wrote further on Janu-

ary 28, 1909: "It's strange—I would very much
like, for my own benefit, to write down a few
things about what interests me so much in this
work, but I can't talk about it at all. Well, yes.
I want space, space. Depth, naturalness. As far
as possible no violence. And austere colors.
The greatest possible liveliness, and yet not
overanimated. The pallor of an atmospheric
storm and yet all of our pulsating sensual life.
A new, still richer variation of violet red and
pallid yellow gold. Something rustling and rank
like a lot of silk that one peels apart, and wild
gruesome glorious life."

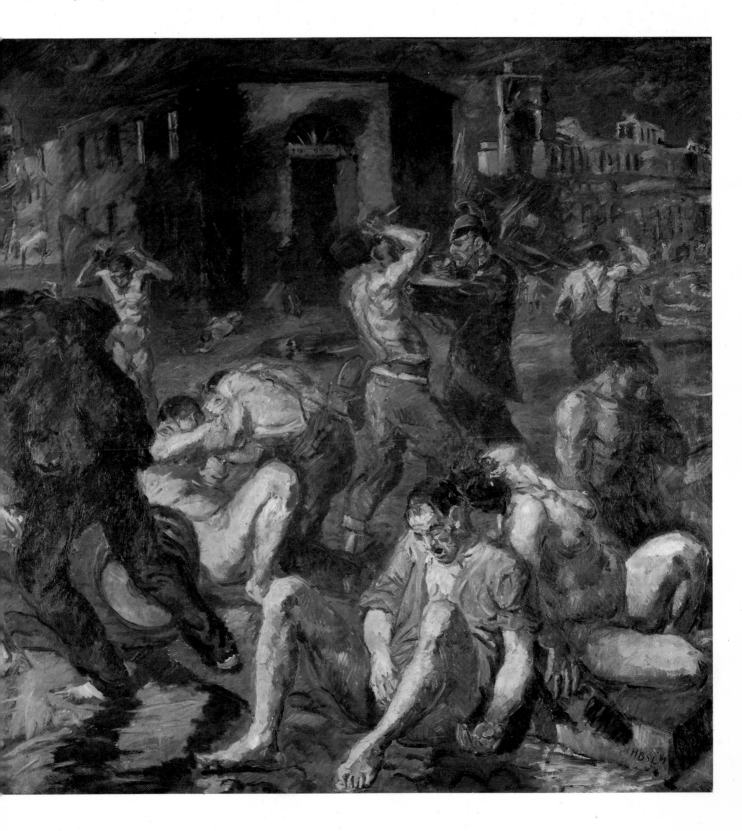

The painting presumably was finished in April of 1909, and was shown in the spring exhibition of the Berliner Sezession. The critics of the time found fault above all with the repulsiveness of the subject, exaggerations bordering on caricature, sensationalism, and the artist's regression into mere illustration. The first serious response was offered by Kaiser in 1913. He saw in the *Destruction of Messina*—whose pathos he associated with Delacroix's *Massacre of Chios*—a "realistic symbol of Berlin," a depiction of the dangers which life in the city threatened. Simultaneously he recognized in these figures a power to overcome these dangers. The individual, always in differentiated configurations of people in smaller groups, is especially pronounced in this painting. The half-naked man sitting on the ground on the right in front, his head badly wounded, uses his remaining strength to endure the pain. Likewise the naked woman sitting next to him strains upward, unwilling to surrender. Behind her is a man kneeling; he too strives to keep himself erect. Parallel to them, in the picture's ascending diagonal, are sporadic pairs confronting each other in warlike fashion. In the front left corner is a dark figure staggering onto or striking another barely recognizable figure. Next to them is a pair fighting, and behind them the convict wielding an axe and the uniformed man with a pistol. Both pairs were inspired by events which Beckmann witnessed in Berlin at night.

For some years Beckmann's early work, and particularly the Messina painting, had been the object of art-historical interpretation. While Gässler sees the menace, fear, and violence of metropolitan life, Güse turns to the influences of Nietzsche's philosophy, especially his vitalism. That Beckmann read Nietzsche is well known. Güse appeals above all to the fact that Beckmann does not take the suffering and distress of the earthquake victims as his main theme, but rather that he seems fascinated by the crimes, the pillaging, and the ruination of the city. For Beckmann the catastrophe allegedly is not so much the destruction of the city of Messina; rather, to him the city represents a realm inimical to "life," and its annihilation heralds a vital renewal.

That a vital renewal will issue from the city is not evident here. It seems rather that this Messina is a self-enclosed nightmare from which there is no escape. The relatively intact buildings depicted here (weighed against the reality that Messina was at the time ninety percent destroyed) suggest an impenetrable barricade circumscribing the area in which a battle of the survivors takes place. The same applies to Güse's explanations of the criminal figure whom Nietzsche conceives as both destroyer and conqueror of decadent society. The picture undeniably has to do with unchained drives, convict or criminal figures, and the intensity of life at its most extreme. But whether or not this conflict pertains to the social malaise preceding the first World War remains an open question. With the exception of the uniformed man, Beckmann makes no distinction among the raw, primitive characters, half-clothed or even unclothed, giving them no social identification.

A. Sch.

11 Battle of the Amazons 1911

Oil on canvas; 250 x 220 cm.
S.R. (on the quiver): HBSL 1911
Beverly Hills, The Robert Gore Rifkind Collection
Göpel 146

References: Lenz, 1971, p. 232; Güse, 1977, p. 43; Wiese, 1978, p. 37ff.

During the year 1909, when Beckmann did the first rough sketches for this composition, he wrote a letter to his wife from Wangerooge: "Hot bright air... Piles of people, the naked, the clothed. Wild battles. Grotesque carousings of fantastically dressed creatures. Love-scenes, rapes. Torrents of purple blood disappear along with writhing white bodies into the protective shadows..." This exotic and dramatic representational world of the young Beckmann, familiar to us from the Symbolists, forms the basis for the series of multi-figured monumental paintings, commencing in 1907, that stage the theme of combat and calamity (cat. 10, 12). Here it is the Amazons, figures from Greek mythology, who define the action. As warlike women, lasciviously spread-eagled victims, and recalcitrant booty, they bring the voyeuristic gaze of the viewer to themselves much like the artist's later nudes, prostitutes, and Columbines. The battle is the conflict between man and woman, expressive not only of the then current cliché about the "battle of the sexes," but also of an emotion peculiar to Beckmann, who to the very end of his life coupled the erotic again and again with the threatening and the catastrophic. It is significant here that his pessimistic view of the world is not yet strongly pronounced. Beckmann celebrates struggle as the ultimate possibility of existence, resulting in drastic and differentiated forms. Using a free, almost baroque manner of painting, he brings into being movement, vitality, and passion in the extremes of aggression and surrender. *Battle of the Amazons* reflects Beckmann's ethos during his Berlin years, with its affinity for Nietzsche's philosophy.

In its cool-toned coloration of greens and blues, this painting is similar to *The Sinking of the Titanic* (cat. 12). There is a faint reminder of the ecstatic sense one associates with van Gogh. Three rough sketches and six life studies attest to the long process involved in the completion of this picture (cat. 140). The painting contributed considerably to Beckmann's reputation after 1918 because it was done in the academic tradition.

C. St.

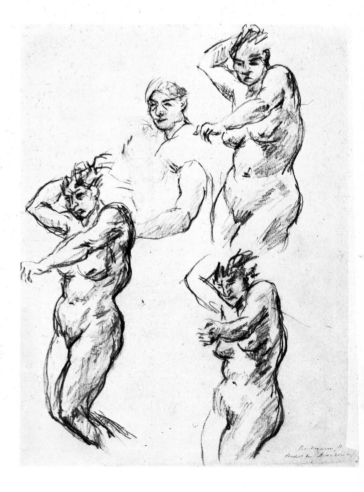

Max Beckmann:
Preliminary sketch for
"Battle of the Amazons,"
1909
Black chalk, Private collection

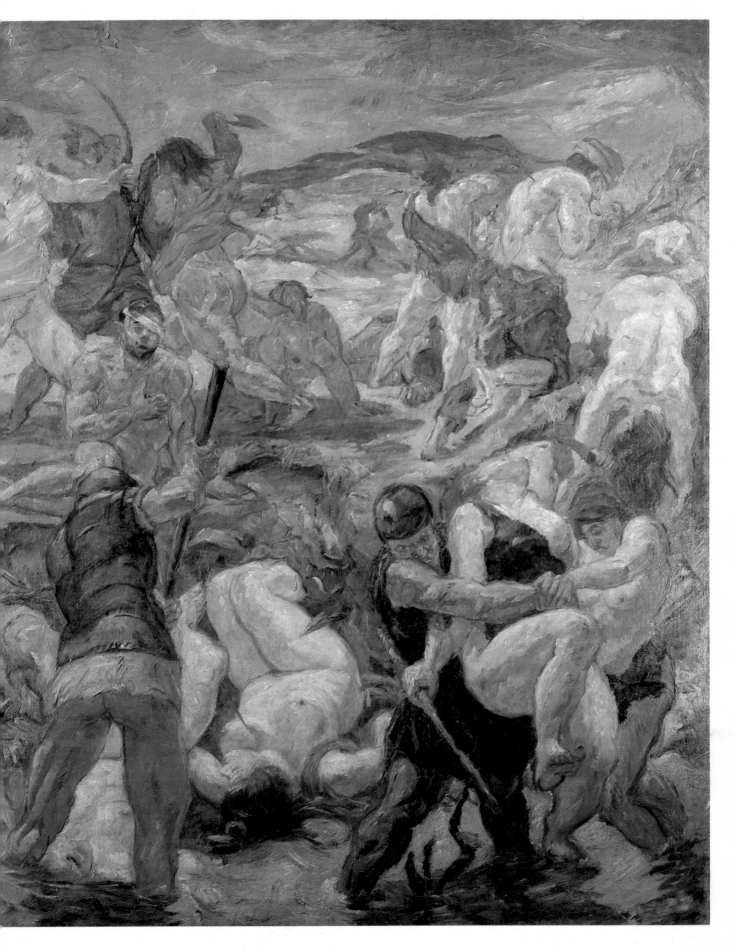

12 The Sinking of the Titanic 1912

Oil on canvas; 265 x 330 cm.
s.l.r.: Beckmann
St. Louis, The Saint Louis Art Museum, Bequest of
Morton D. May
Göpel 159

References: Gässler; Güse, 1977.

The second major painting in Beckmann's
early work that has a real-life catastrophe for
its theme is *The Sinking of the Titanic*, which
was exhibited in the Berliner Sezession of
1913. The critics of the day rejected it just as
they had the *Messina* picture, reproaching the
artist for his strained effect and sensationalism.
They alleged that the event was treated in an
entirely unsatisfactory way, since it is lacking in
pathos and thus fails to grasp the essence, that
which gives a comparable painting, such as
Géricault's *Raft of Medusa*, its lasting signifi-
cance. Even later criticism saw Beckmann's
efforts in the domain of historical depictions of
contemporary events as problematic, even
abortive efforts, taking for granted that it had
been the painter's aim to deliver a semblance
of an eyewitness account. Only the most recent
investigations have led to a revision of this
appraisal.

The *Titanic*, the largest and most representa-
tive ship of the White Star Line, sank in the
North Atlantic on its maiden voyage from
Southampton, England to New York during
the night of the 14th/15th of April, 1912, within
hours after colliding with an iceberg. Of its
2200 passengers, 1507 met their death. The di-
saster occurred on a calm sea under a starry sky.
Beckmann's impetus for the painting presum-
ably came from detailed reports of the calamity
in the Berlin daily papers. However, it is by no
means an illustration of the disaster in confor-
mity with what the survivors told of it. Seven
overloaded lifeboats drift in various directions
on an agitated sea. The *Titanic*—clearly identi-
fiable in a photo in the *Berliner Lokalan-
zeiger*—is brightly lit in the background. The
stern is hidden by the iceberg; a slight tilt sig-
nals the threat of sinking. Thematic here, as it
was in the *Messina* picture, is the struggle for
survival. The shipwrecked survivors cling to
the lifeboats, some of which are already
flooded with water. Their attempts to rescue
themselves are either tolerated with indiffer-
ence or actively repulsed; only one of the vic-
tims is being helped. The dramatic impact of
the event, heightened by the decidedly perni-
cious green tones of the sea and the people, is
discernible only through careful study of the
individual scenes. Gallwitz has rightly asserted
that what is at issue here is the depiction of a
collective catastrophe, not the capitulation of
technology to the forces of nature as the artist's
contemporaries proposed. Beckmann chose to
describe this mass phenomenon by means of a
decentralized composition which permits no
comprehensive view. Rather, the eye roams
from one boat to the other, losing itself in the
chaos which also threatens to engulf us, the
spectators, who seem to stand in the water.

A. Sch.

Jean Louis Théodore
Géricault:
The Raft of the Medusa,
1818/19
Oil on canvas, Paris, Louvre

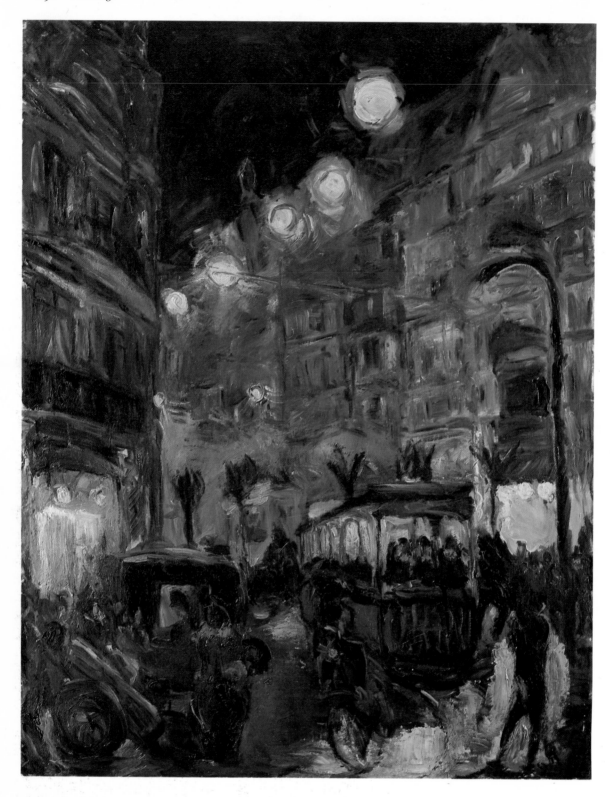

13 Street at Night 1913

Oil on canvas; 90 x 70 cm.
s.u.r.: Beckmann 13
Private collection
Göpel 179
Reference: Gässler.

From 1911 on, the theme of the city appears more frequently in the prints as well as in the paintings. But while the prints primarily treat scenes like *Tavern, Admiralscafé, Brothel in Hamburg,* i.e., typical expressionistic subjects, the paintings more often have to do with ordi-

nary street scenes. As Beckmann's only evening scene, *Street at Night* shows a narrow stretch of street, built up with houses dating from the early 1870s. We are able to discern an electric streetcar, an automobile, several motorcyclists, and small crowds of people. Only the figure at the front right, with its back to us, is emphasized; it stands in front of the streetcar and apparently lights up the tracks with a lamp. The diffuse mode of painting, confined to dark tones, gives rise to the impression of a convoluted and chaotic traffic jam. The work's thematic similarity to contempo-

rary street paintings by Meidner and Kirchner has been noted, as have the difference in styles. Whereas one associates their work with a clear and firm formal idiom that works with aggressive spatial boundaries, Beckmann adheres to a delicate and somewhat indeterminate arrangement of forms. His painting, based on light-dark contrasts and rich in tonal values, creates a mood which, in comparison with Meidner and Kirchner, has an almost pacifying effect. A. Sch.

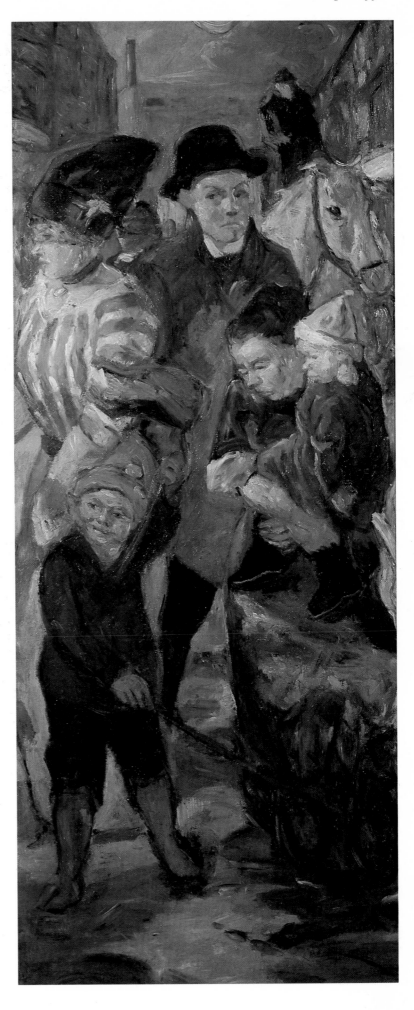

14 The Street 1914

Oil on canvas; 171 x 72 cm.
S.L.R.: Beckmann B.H. 1913 für Quappi
New York, Private collection
Göpel 180

The painting no doubt dates from early 1914, since it was reproduced in its original form in the catalogue of the first exhibition of the Freien Sezession, which opened on April 12. In 1928 Beckmann trimmed it on the right by almost two-thirds, which resulted in its tall and narrow format, and misdated it 1913. Max Beckmann later considered the painting to be one of his most successful early works—an understandable assessment when its tightly compacted, staggered arrangement of figures is compared with such later works as the side-panels of the triptychs *Departure* (fig. p. 40) and *Temptation* (cat. 73) or the *Family Portrait of Heinrich George* (cat. 74).

In front of a narrow street, which is bounded by three tall blocks of houses, we see Beckmann himself in the middle of the picture; next to him on the left, walking out of the picture, is his wife Minna. In front is their son, Peter, pulling a wagon and waving a black-white-red flag. The painter is partially hidden by an old woman holding a child on her arm. She does not belong to the family, but is one of the casual passers-by which had been numerous until Beckmann's revision. Beckmann later thought that he had painted this picture in the summer of 1914, under the impact of the declaration of war, and had reproduced the mood of the streets in the joyless faces of the adults. However, we know from his journals that in 1914 Beckmann was by no means an opponent of the war, but changed his attitude toward the struggle only after the murderous experiences on the western front. This transformation seems to have added to his confusion over the picture's date of completion. Actually painted prior to the declaration of war, it should in all likelihood be understood as a metaphor of human behavior, which struck Beckmann with unusual clarity in those teeming metropolitan streets. A. Sch.

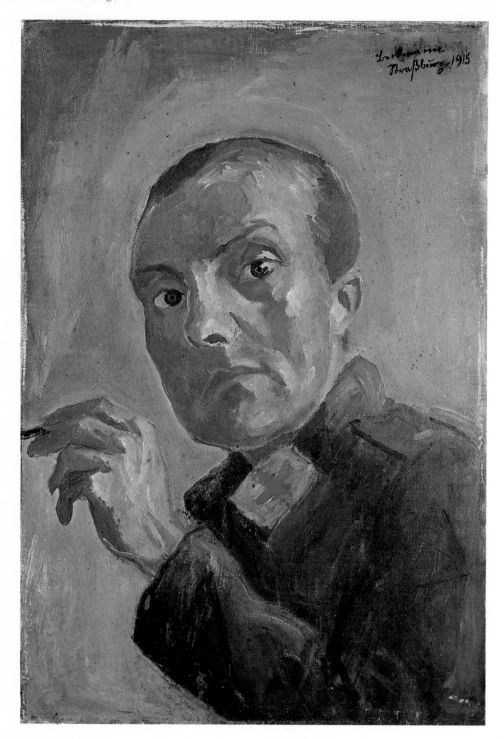

15 Self-Portrait as Medical Orderly 1915

Oil on canvas; 55.5 x 38.5 cm.
S.U.R.: Beckmann Straßburg 1915
Wuppertal, Von der Heydt-Museum
Göpel 187

References: Wichmann, p. 10; Jedlicka, 1959, p. 116;
Evans, p. 14; Güse 1977, p. 557; Wachtmann,
p. 10ff.; Zenser, p. 14f.

Beckmann no doubt painted this self-portrait
—his first oil painting since the late fall of
1914—in Frankfurt, but probably conceived it
in Strasbourg, where he was hospitalized after
his nervous breakdown in the summer of 1915.
At thirty-one he had a full year of military ser-
vice behind him; as a civilian volunteer he first
had gone to East Prussia as a medical attendant
and, since the beginning of 1915, had been a
medical orderly in Belgium. Beckmann's war
experiences left him with contradictory feel-
ings. Fascinated in a Nietzschean way by life's
dramatic outward form, by the "savage insan-
ity of this murdering on a gigantic scale," he
felt at the same time deeply perplexed by the
"unspeakable absurdity of life," as he wrote.
Drawings and etchings of the scenes of war,
made in sick bays, in operating rooms, and in
morgues, mirror the conflict that finally led to
the artist's breakdown.

All the more instructive is the manner in
which he confronts himself after this existential
tension. His shoulder thrust into the field of
vision with singular hesitancy, his painting
hand allowed only the smallest scope, Beck-
mann directs his gaze out of a painstakingly
self-controlled face searchingly and tenaciously
onto himself. He is a vulnerable and unsettled
man, too easily moved and lacking equilib-
rium. This man's face stays too powerfully at
the center, his chest is too contracted; he is
confined and at the same time supported by the
narrow boundaries of the picture. Beckmann
reclaims a resolute strength only from the alert
eyes, the firm mouth, the displaced nose, and
the arching brow. On October 3, 1914, he
wrote: "I have been drawing, this protects one
against death and danger."

This apprehension is evident here, where the
artist risks everything in order to begin again,
however minimally. Painting, much like his
responsibilities as a medical orderly, becomes a
necessary task, and he becomes a witness who
observes with watchful eye and writes with an
unsteady hand. The impressionistic and
sketchy mode of the painting, the gray-green of
the emptied surrounding area, and the spon-
taneity of the movement combine to produce a
kind of mirror-appearance. For this time only,
Beckmann examines himself not as bearer of a
role but as psychically bared individual. He
himself later evaluates the self-portrait:
"That's still mighty dreary in color. I really
slaved away at it. For the first time it becomes
evident what I had meanwhile gone through in
the war. In the drawing around the nose and
forehead I believe one can readily see the first
elaboration of the later strong, solid form."

G. Jedlicka's interpretation, namely that we
have here a "pleasing likeness" since the artist
presents himself "much more as a person
before the war than as one in the middle of
war," overlooks the honesty of this self-
encounter. Indeed the advance to a hard-won
stability is forcibly attested to here. It is sig-
nificant for this turning point in Beckmann,
who in 1915 no longer shares Nietzsche's vital-
ism and soon will adopt Schopenhauer's pes-
simistic attitude toward life, that his previously
impressionistic brushwork now holds the
psychically expressive quality of van Gogh's
early paintings: this portrait has an affinity
with the works revolving around the *Potato
Eater,* 1885. In contrast with other disinte-
grated, "terrified" self-portraits of these years,
this confrontation marks the beginning of a
self-discovery which around 1920 will result in
a defiantly self-confident personality. C. St.

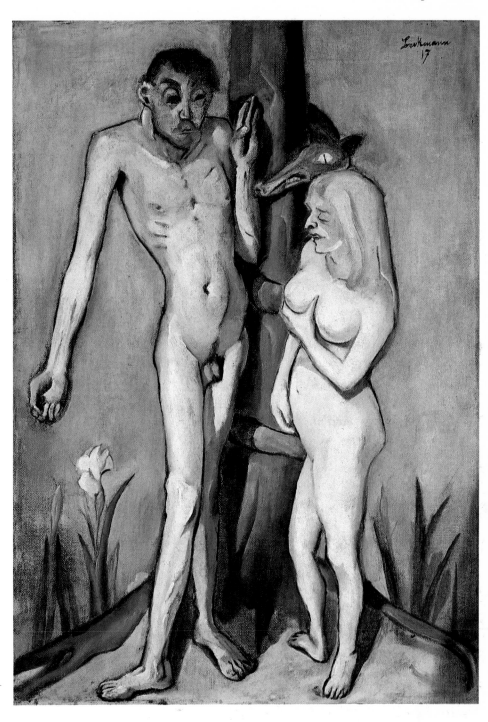

16 Adam and Eve 1917
Oil on canvas; 80 x 56.5 cm.
s.u.r. Beckmann 17
United States, Private collection
Göpel 196

References: Meier-Graefe, 1919, p. 55; Lackner, 1968, p. 4,8; Lenz, 1971, p. 216; Fischer, Munich, 1972, p. 24.

As with the other pictures about religious themes (cat. 17, 18) from the Frankfurt period, this portrayal of Adam and Eve is done in an expressive, angular, distorted style, reminiscent of a Gothic painting. The elongated aspect of the two figures, the severity of the contour lines, the extreme thrust of perspective from bottom to top, and the grisaille tone throughout create an ecstatic and unsettled graphic form that reflects Beckmann's shaken psyche during the years just after the war (cat. 15, and *Self-Portrait with Red Scarf,* 1917 fig. p. 59). The thematic statement takes its material from the Bible, *Genesis* 3:1-7. But it is neither the paradisiac primal state before the Fall (as Göpel claims) nor the ambivalently open-

ended situation of the 1932 version (cat. 64) that is represented here, but the moment of the Fall itself. Flanking the Tree of Knowledge according to the traditional iconographic model, Adam and Eve are already acting out the condition of lost innocence: "Then the eyes of both were opened, and they knew that they were naked." Beckmann forgoes the traditional motif of showing the couple with the forbidden fruits. Instead of proffering to Adam the fruit, Eve displays her breast. The "almost brutal" directness enables Beckmann to circumvent what is anecdotal in the old story and stage an event that dramatizes the archetypal interconnections of seduction, desire, and fear. Eve, facing in the same direction as the

crocodile-headed snake, is the handmaiden of evil, while the man is victim to "love in its brutish sense." Adam displays the palms of his hands like the Man of Sorrows (cat. 17, 18)—a gesture which Beckmann will use until 1921 to express the suffering and vulnerability of man (cat. 19, 21, 25, 31).

His predilection for the domain of guilt and sin—one might compare the work of Munch — is coupled here with the outlook of an artist who will increasingly assimilate pessimistic thought in the wake of Schopenhauer and trends in philosophy of religion. The 1917 etching *Adam and Eve* (cat. 236), in which the figures have reversed sides, takes up this theme even more forcefully. C. St.

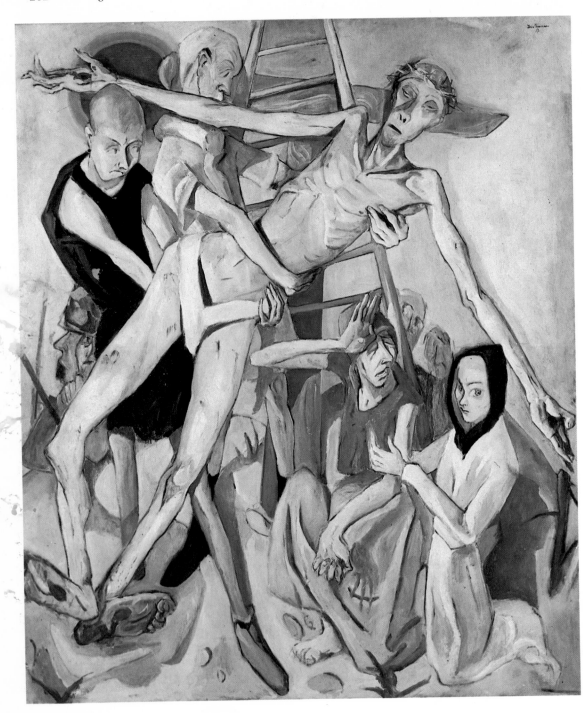

17 Deposition 1917

Oil on canvas; 151 × 129 cm.
S.U.R.: Beckmann 17
New York, The Museum of Modern Art, Curt
Valentin Bequest, 1955
Göpel 192

References: Hartlaub, 1919, p. 84; Meier-Graefe,
1919, p. 54 f.; Selz, 1964, p. 26 ff.; Göpel, 1976, I,
p. 134; Lackner, 1969, p. 116.

Already in 1919 Julius Meier-Graefe, a dedi-
cated advocate of modern art (particularly
French art) and a much-feared critic, made
some unusually emphatic sentences about the
ambiguity of Max Beckmann's first post-war
paintings: "These paintings are anything but
decorative. Their disposition is much more vio-
lent. An almost mystical embitterment impels

such forms: The voluptuousness of pain... A
fleshless Grünewald—fleshless, not soulless.
The details spell out the want of ardor of our
machine age, which would cauterize every last
remnant of the Baroque... Color, which could
soften the factual details, is despised... The
apparition stands with inexorable clarity. But
it is nonetheless animated. These terrifying
figures create an ornament in spite of them-
selves, even want to create it, just as precisely
opposed counterparts seek to coalesce... A
prodigious self-conceit has been driving this
loutish upstart all along... This self-conceit is
embraced by an entire nation, which sinned
extravagantly and atones extravagantly, which
by means of monstrous instruments of torture
has its rotten flesh burned away so that its spirit
might come to its senses."

With such forceful language Meier-Graefe
captures both the formal and the contentual
aspect of the *Deposition*. The death of Christ is
characterized by a disembodied numbness that
permeates every figure in the painting, simul-
taneously giving expression to a collective
indictment so uncompromising that it is almost
tyrannical. Even the living persons in this pic-
ture appear as bloodless and emaciated as the
superhumanly large and terrifying Christ who
diagonally dominates the entire surface of the
painting. In this respect the painting differs
immediately from *Christ and the Woman Taken
in Adultery* (cat. 18), which is identical in for-
mat and may have been intended as a companion
piece. In contrast to *Deposition*, the latter work
demonstrates such an utter sense of aggression
that its very loathsomeness has a definite,

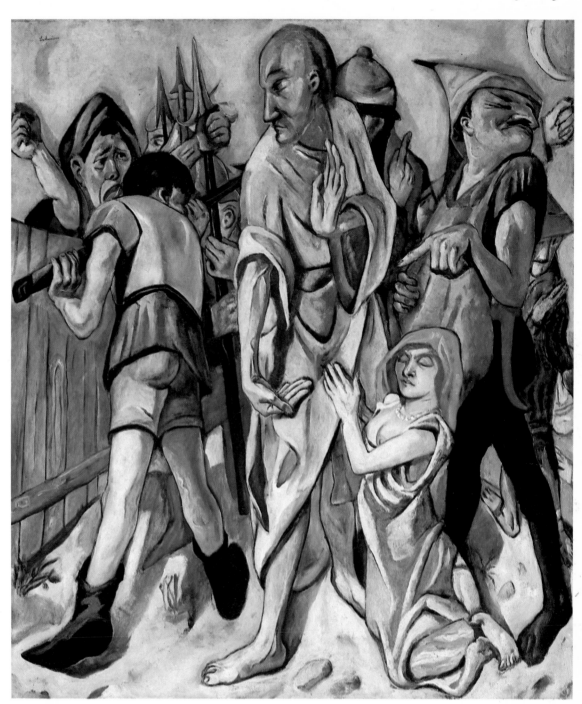

almost living, power of human hatred. Christ himself, however, is seen as forgiving and compassionate—an interpretation far removed from the passive figure of *Deposition*. What comes to pass here is an apocalypse of death as all-consuming, as the absolute end of every kind of vitality. What is represented here is not the Christ who triumphs over death or who redeems the world through His suffering, but a merciless indictment that drags down everything in its wake. Beyond that, the silent suffering of the attendant figures—their stilted movements, their over-thin, expressionistically mannered limbs as well as their benumbed and dubious despair—yields an impression of a Passion Play. The exaggeratedly triangular composition and unnatural perspectival distortions (which enable Christ to exhibit the stigmata

simultaneously) indicate a consciously "posed" picture, one having the accentuatedly emblematic character of a reproach. The kinship with medieval art, which Beckmann himself had constantly emphasized, undoubtedly comes to an end with this indigenously 20th-century interpretation of the figure of Christ. It allows no room for even the slightest hope. In a drawing made in 1946 Beckmann confronted the *Deposition* of 1917 once more. There the adjunct figures and the composition as a whole are freshly conceived, with a tendency toward caricature throughout, but the expression of futility and hopelessness remains decisive.

C. Sch.-H.

18 Christ and the Woman Taken in Adultery 1917

Oil on canvas; 150 x 128 cm.
S.U.L.: Beckmann 17
St. Louis, The Saint Louis Art Museum,
Bequest of Curt Valentin
Göpel 197
Reference: Lackner, 1978, p. 62.

The scene presented here presumably concerns a free interpretation of an occurrence depicted in the Gospel according to John (8:3-11): The Pharisees and scribes bring before Jesus in the Temple an adulteress who, according to the Law of Moses, should be stoned to death. Christ rejects this ("Let he among you who is without sin cast the first stone") and forgives the woman. Beckmann relocates the event out

of doors and combines it with figures who play only an indirect role in John's Gospel: the accusers, the mockers, and the guards. For him the Biblical prototype is merely the occasion for a general characterization of modes of human conduct. Additional pictorial stimulus may come from the conversion of Mary Magdalene, as set forth in the Gospel of Luke (Chapters 7-10) and especially in the apocryphal writings of the Legenda Aurea. The love of this woman (perhaps Mary Magdalene) for Christ is depicted here as a state of mystical rapture.

The group of four consisting of Christ, the adulteress, and the two men behind them is formally and in gesture closely connected. They stand crowded together so tightly in the same perspective plane that they would not have room separately. While Christ accepts the woman with his right hand, he wards the mob off with his left. In the security of this sheltering gesture, the adulteress feels so protected that she closes her eyes to her surroundings; as if absorbed in mystical contemplation, her hands turned prayerfully to Jesus, she places herself under his protection with complete confidence.

In this enraptured state, externals have become so insignificant that she does not even cover her naked breast. The luminous red-orange cloth on her head and the yellow reflection on her neck combine to form a kind of secularized halo; her radiant face is endowed with an aura of inviolable virginity. The man behind her, clothed like a butcher with cowl over his head and an apron on his front, plays the role of a derisive finger-pointer: "Look here, the whore!" His distorted face averted from the scene, the blood-spattered apron, the short, red saber at his side, and the tight black pants reminiscent of traditional representations of the devil all discredit him as accuser, and present him as an incarnation of the vulgar. Yet he can make neither the adulteress nor Christ look ridiculous. They are not touched by his mockery; on the contrary, their purity, expressed in their lighter coloration, actually makes him the ridiculous figure. The fourth figure has his head turned toward the crowd with his index finger raised admonishingly. Further back are three other only slightly discernible forms: an arm raised threateningly with a clenched fist; a figure whose legs are strangely twisted and suspended; and a grotesquely smirking face. The figure with his back to us on the left holds back the onrushing mob, pressing his spear against them with both arms. His tensed legs, muscles and veins prominent, and the energy with which he thrusts his entire weight onto his right leg attest to the effort he makes.

The pictorial idiom is confined to clarifying the event in universally familiar signs. Even without the Biblical background, most viewers understand the main features of the painting through its use of gestures. They know it is about a woman under the protection of someone defending her from mocking and threatening enemies. This secular, humanist interpretation is characteristic of Beckmann's last paintings on specifically Biblical themes. Stamped by the shattering experience of the First World War, they become metaphors for general shortcomings and base actions of humankind. That the single figure who acts positively and self-assured is a Christ who looks not unlike Beckmann underlines the secular character of the scene and throws a significant light on the artist's self-estimation. C. Sch.-H.

19 The Night 1918-19

Oil on canvas; 133 x 154 cm.
S.L.L.: August 18 – März 19 Beckmann
Düsseldorf, Kunstsammlung Nordrhein-Westfalen
Göpel 200
References: Linfert, 1935, p. 62; Busch, 1960, p. 53f.; Selz, 1964, p. 32, 35, 39; Fischer, 1972, p. 15ff.; Fischer, 1973, p. 14ff.; Lenz, 1974, p. 185ff.; Lenz, 1976, p. 18f.; Wiese, 1978, p. 152ff.; Erpel, No. 5.

This major work of the early Frankfurt period is one of Beckmann's first paintings to break with tradition. His intention, stated already in 1912, "to fashion from our very own time human types with all of their ambiguities and inner strife," is realized in a scenario of drastic circumstances. Three cutthroats have forced their way into a garret in which a family had been gathered for supper. Now the world has come absolutely unglued. The room sways, the window casements are breaking apart, the bodies of the victims sprawl disjointedly under the tight grips of the intruders. Two of them torture the husband: while one breaks his arm, the other strangles him with a noose pulled over the rafter. Half-stripped, in a bodice that has burst open and with legs spread wide apart, the wife is vulnerable to assault. Her fettered hands stretch imploringly toward the night sky and the crescent moon. The man with the cap clamps the girl under his arm; his stride, torsion, and grip suggest he will throw this human parcel out the window. Only the woman in the background remains an observer and allows us, with her tense and horrified gaze, to directly witness this senseless event.

All this takes place in an eerie silence. It is all the more relentless since "sharp, crystal-clear lines and planes" (Beckmann, 1918, p. 3), even more than the room, lock each thing tightly into itself. The straddled legs and ascending gestures of the victims are as benumbing as the violence of the murderers; both expressions are bound in a tightly meshed structure. The strangled pictorial structure, wrought of slants and knots—the noose, the hands of the pipe-smoker, and the hands of the woman, which are only seemingly tied to the window frame, —heightens the asphyxiating force of the whole; even the plaintive dog, the phonograph horn, and the burning candle remain voiceless. The other candle, fallen and snuffed out, suggests death. Hostility to life could not be pictured more concretely than it is in this cubically open pictorial battlefield. The deformation of figures as well as the poisonously cold, green-tinged coloration are reminiscent of Gothic art.

Max Beckmann:
The Night, 1914
Pen and ink, New York,
Private collection

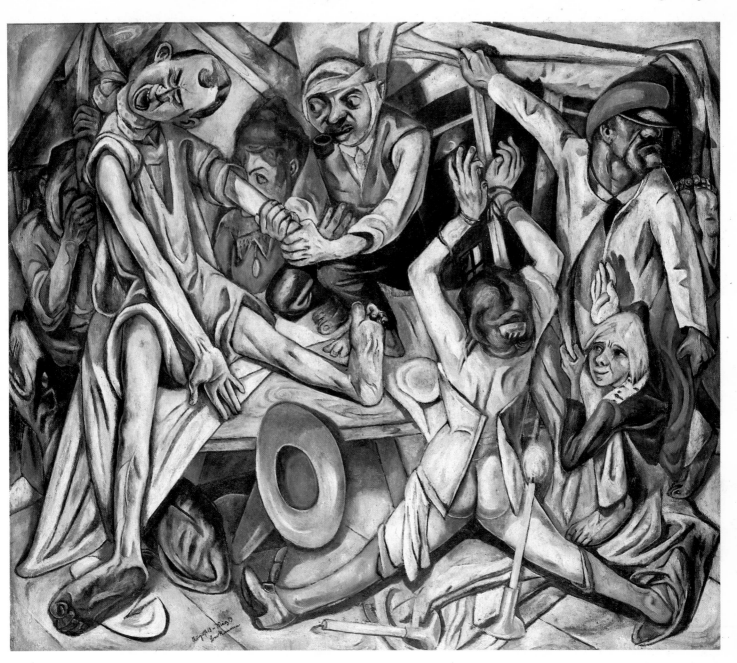

The meaning of the picture is complex and remains in the end undecipherable. Without doubt, *The Night* reflects the disquieting situation of the period after the War. The revolution in November of 1918, the collapse of Kaiser Wilhelm's government, the communist insurrection in January 1919, and daily life filled with memories of the war, poverty, luxury, and violence are all part of the emotional groundswell in Beckmann's aggressively realistic conception of these years. This scene of horror is similar thematically to the portfolio of lithographs from 1919 entitled *Hell* (cat.247-257), and in particular to the sheet entitled *Martyrdom* (cat.250), which refers to the assassination of Rosa Luxemburg. As on the title sheet of the series, *City Night* (1920), horror that had previously been confined to the theater of battle now breaks in upon the private realm. The hanging victim has his predecessors in the drawings and illustrations of

Beckmann that were produced in 1914/15 after seeing operating rooms and morgues. In spite of the historical factors and the image of the murderers as small-time proletarians overcome with blind rage, there is more here than mere political allegory. As was already the case in the early pictures of war and catastrophe (cat.10, 11, 12), Beckmann is concerned with the metaphysical meaning of life in general. "We must participate in the entire misery that is about to come. We must surrender our hearts and our nerves to the ghastly cries of grief of the poor deluded people... This will give the people an idea of their destiny..." (Beckmann, 1919, p.4).

It is those very claims, whose source is in his war experience of 1915, that determine the intention of the painting. Life is suffering: Beckmann gives the male victim the broken body and the protrusive limbs of the Man of Sorrows (cf. cat.17). The gesture of the arm as a

sign of dire need and a hint of overcoming are an essential attribute of the artist and his friends until 1921 (cat.21, 31, and also *Carnival*, 1920). Life is earthly hell; there is no way to comprehend the distribution of roles among perpetrators and victims. Here, as in the artist's later work, there is an intimation of an unhealthy connection between sexuality and death. From the point of view of both the work itself and that of depth psychology, the torturer no doubt embodies human desire taken to the point of extinction, and the victim is man in the fetters of corporeality. The observing woman may be the instigator, and thus portray a further negative aspect of life's impulses (cf. the sketches for *The Night* and the etching *The Night*, cat.225). At the same time this earthly hell is an insane spectacle which must weigh not on the conscience of the Gnostic gods, as happens in Beckmann's work, but on that of the Christian God. Beckmann's philosophy

from 1919 on is oriented no longer toward Nietzsche but toward Schopenhauer. It is expressed here in the dissective mode of representation, and is demonstration of suffering just as the allusion to the carnival themes will be the hallmark of the early 1920s. The witness is dressed as Pierrette; the noose of the hanging victim is the polka-dotted kerchief of a clown. According to Göpel, the pipe-smoker and the *voyeuse* refer to Beckmann's friends, Ugi and Fridel Battenberg. The composition of the painting is repeated in the sixth sheet of the 1919 portfolio, *Hell* (cat. 253). Lenz (1976) was able to show convincingly the influence of Italian art on Beckmann in this picture. The culprit with the billed cap is a variation of a beggar in the fresco, *Triumph of Death*, dating from the first half of the fourteenth century, in Pisa's Campo Santo. According to information furnished by Günther Franke, the only wall decoration in Beckmann's Frankfurt studio, as late as 1923, was a photograph of this fresco.

C. Sch.-H.

20 Women's Bath 1919

Oil on canvas; 97.5 x 66 cm.
S.U.R.: Beckmann F.19
Berlin, Staatliche Museen Preußischer
Kulturbesitz, Nationalgalerie
Göpel 202

The tightly packed arrangement of figures bears little resemblance to what the title suggests. There is nothing of the relaxed atmosphere of a family bath. The figures are crammed into a narrow closet that looks like an air raid shelter or a dungeon, and there is no room for anyone to move about. In their hectic, senseless play and their sickly color, the women and children alike appear as cretins who persist in roles incomprehensible even to themselves, as if they were mad. Their skin is either an unhealthy green-gray or is too pink, as if scalded. The water looks uninviting, bloody, and dirty. All in all, this is not a place where one would linger, but a place that encloses the persons represented as if in a prison.

The composition tersely underscores the sense of being locked in from the outside as well as the isolation of the individuals within. The hermetic quality of the bath chamber is so strikingly apparent in that too many people are crowded into a narrow space and they are bound together as if they were dancing in a circle. They are clearly cut off from the viewer by the children in the foreground and the figure with her back turned. Yet this formal connection among figures is not taken up by

the lines of sight; even between the girl and the child in front, no eye contact is made. Thus on the one hand the group is isolated from the outside, but on the other hand, it gives the individual no support. The isolation within the group is especially evident in such an overcrowded space.

We should seek thematic prototypes for this mode of presentation first in the graphic art of the late Middle Ages. Dürer's pen-and-ink drawing, *Women's Bath* (cf. fig. below), dated 1496, for example, exhibits certain parallels in the manner of arrangement and also contains an inclination toward caricature. However, it is in the differences between the two works that Beckmann's peculiar interpretation of the theme becomes more intelligible. Dürer's figures represent an altogether vital corporeality; in the fat old woman on the right and the lovely young woman in the middle we see the two sides of a medallion, Youth and Age. The natural as well as the comic qualities of the scenario result from an undistorted, open depiction of small everyday pleasures in the easy atmosphere of the bath house.

How different is Beckmann's oppressive scenario! Most of his figures are, quite inappropriately, clothed, and those that are naked would be easier to bear if they were dressed. The small children appear as sickly little monsters, and the boy on the right is a whiner. The emaciated old woman in the middle, a negative retort to the pretty young one in Dürer, defines the composition with her caved-in back and angular shoulder blades. The viewer is drawn again and again over this figure into the picture's inner center, which remains as empty and undetermined as the object which the woman on the swing gazes at.

No doubt the painting is closely related to Beckmann's psychic condition after the First World War. As was the case with *The Night* (cat. 19), here, too, we can only be dealing with a metaphor. Beckmann is hardly likely to have been in a women's bath and, had he really wanted to depict a bath, the figures would not have been clothed.

The world is conceived here as a spatially closed prison. Lack of freedom as such is clearly tied to restriction of movement and to the impossibility of letting oneself enjoy free time. Nevertheless it is difficult to develop any sympathy for these people. In light of their sullen and surly dispositions they are more likely to elicit aversion. Hence this picture is determined by a bipolarity: The imprisonment of the individual is not merely ordained from without; it belongs to him. He is mutilated, incapable of emancipating himself from his cretinous existence, and therefore apathetically stuck in it. And in this Beckmann does not even stop short of including himself (cf. cat. 22).

C. Sch.-H.

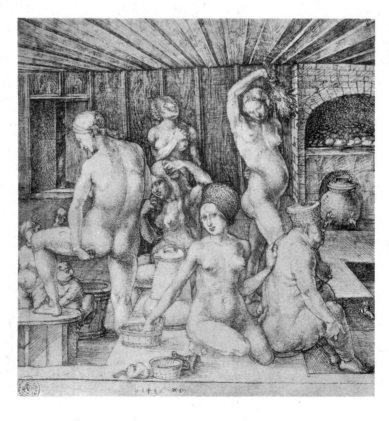

Albrecht Dürer:
Women's Bath, 1496
Pen and ink, Bremen,
Kunsthalle

21 Portrait of Fridel Battenberg 1920

Oil on canvas; 97 x 48.5 cm.
S.U.L.: Beckmann F.20
Hannover, Kunstmuseum Hannover mit
Sammlung Sprengel
Göpel 205
References: Reifenberg, 1921, p. 107; Weisner, 1975,
vol. 2, p. 16.

In the fall of 1915, after being stationed for
three weeks in Strasbourg, Beckmann was sent
on furlough to Frankfurt am Main because of
his nervous breakdown. For four years he
found a cordial reception at Schweizer Strasse
3, the home of Ugi Battenberg, a painter and
friend from his Weimar student days, and his
wife, Fridel. From 1919 to 1933 he took over
his friend's studio at this address. The close
association with the two most important people
in his Frankfurt period was to continue to the
end of the artist's life. One gathers from the
testimony of a close circle of friends that Fridel
Battenberg, *née* Carl (1880-1965), was a per-
son who with her musicality, cheerfulness
decided power of judgment, and selflessness,
was "a woman who was able to give again and
again" (Lili von Braunbehrens, 1969, p. 13).
The mutual esteem in which Fridel Battenberg
and Max Beckmann held each other is evident
both in their later correspondence and by the
numerous etchings, sketches, and paintings in
which she figures prominently.

Locked in a narrow pictorial format and
closely encircled by drapery, mirror and potted
plant, the woman portrayed is an inhabitant of
a small, secure, and shielded world. Even the
window visible in the mirror affords no view of
the outside. The viewer sees a woman whose
entire appearance expresses trust as well as
warmth and closeness. Leaning forward with
open hand, smiling mouth, and thoughtful gaze
she opens herself graciously to someone who
enters, though she herself remains somewhat
melancholy. The cat, constant house pet of
Fridel Battenberg (Max Beckmann frequently
called his friend by the pet name, The Cat),
may further symbolize the woman's nature,
specifically her loving disposition, her ten-
dency toward self-will, and her cleverness.

Beckmann conceives his friend as a mysteri-
ous creature, and at the same time as one who
has welcomed not only him. The gaze directed
past the viewer upon an imaginary arrival, the
mirror which reinforces the forward-tilted pos-
ture, the reflected window which reverses this
posture, and the singular ambivalence of the
hand serve to establish a tension between
closeness and distance. The woman appears to
be there for others and yet be there entirely for
herself. On another level of meaning, Weisner
has drawn a comparison with the *Self-Portrait
as Clown*, 1921 (cat. 31). The same distinctive
features, including the stabilizing mirror, con-
front us in the woman's portrait. The extended
hand with crooked finger, reminiscent of the
Man of Sorrows and *Pièta*, had already been
used by Beckmann in the *Deposition* of 1917
(cat. 17), and in the hanging victim of *The Night*
of 1918/19. The image appears in his work
again and again from 1920 on as symbol of vul-
nerability and suffering (cat. 25, 23). This
expression of pathos, as well as the painful

cramping of the other hand (like the tethered woman in *The Night*), transforms the figure into a doll, and the carnival clothing of a Pierrette hinted at in the sleeves implies that human life here, too, is played on an ephemeral stage. Roles are played blindly and in vain. The mirror and curtain are symbols of vanity. The dignity of the person portrayed comes, as in the *Family Portrait* (cat. 25) from the undistorted, knowing gaze. The position of Schopenhauer, namely that life is both frightful suffering and a significant drama, was taken up by Beckmann in 1918 and is reflected in this portrait as well.

The disquieting expression of the crystalline pictorial structure is related to the lonely mood of the painting, *The Synagogue*, 1919 (cat. 24).
C. St.

22 Self-Portrait with Champagne Glass

Oil on canvas; 95 x 55.5 cm.
S.U.L.: Beckmann Frankfurt a/M Sept. 19
Private collection
Göpel 203
Reference: Zenser, p. 26ff.

The artist, who wants "to give people a portrayal of their destiny," as Beckmann wrote in 1918, presents himself here as a sketched offering. One year after the end of the war, he still searches for the situation in which life might once again be enjoyed to the full. However, the intimate space with the bar-counter encloses the guest like a prison cell. The champagne bottle in the ice bucket remains pushed to the edge, confining rather than facilitating the man's elbow-room. The cigar and champagne glass would normally reflect a moment of cheerfulness and superfluity, but the man contradicts this in every respect. Beckmann is out of place in the bar where the satiated, infamously smirking *nouveau-riche* in his tuxedo indulges himself (cf. the print by George Grosz, p. 60). Whereas the raised champagne glass, projected into the narrow outward view, complements the other man perfectly, it heightens the grotesque appearance of this figure. Wrapped in an ill-fitting jacket, his cramped hands laboriously pulled into proper poses, his body pushes close to the edge of the counter in quest of support. Beckmann is the displaced one, who does not have his movements and his facial features under control. Upon his sunken face, turned toward an imaginary arrival, the smile freezes into a painful expression.

The war is still with him. He is under the pessimistic influence of Schopenhauer. He must make a new beginning for his life in the disquieting year of 1919. All this the painter of *The Night* (cat. 19) brings demonstratively and painfully into the pursuit of mortal vanity. The caricature becoming visible in the mirror embodies the malicious powers of fate to whom man is delivered up, no doubt in keeping with the Gnostic doctrine which had preoccupied Beckmann since 1918. During the early post-War years Beckmann on numerous occasions presented himself as witness to an absurd reality, filled with atrocities and self-anaesthetization (cf. the 1919 series of lithographs entitled *Hell*, cat. 247-257 and the etching *Königin Bar*, 1920, cat. 269). It is interesting that Beckmann gives himself the familiar cold gray-green tones of *The Night*, whereas he lets the surrounding space flare in yellow-red, suggestive of hell (cf. *The Liberated One*, 1937, cat. 80).
C. St.

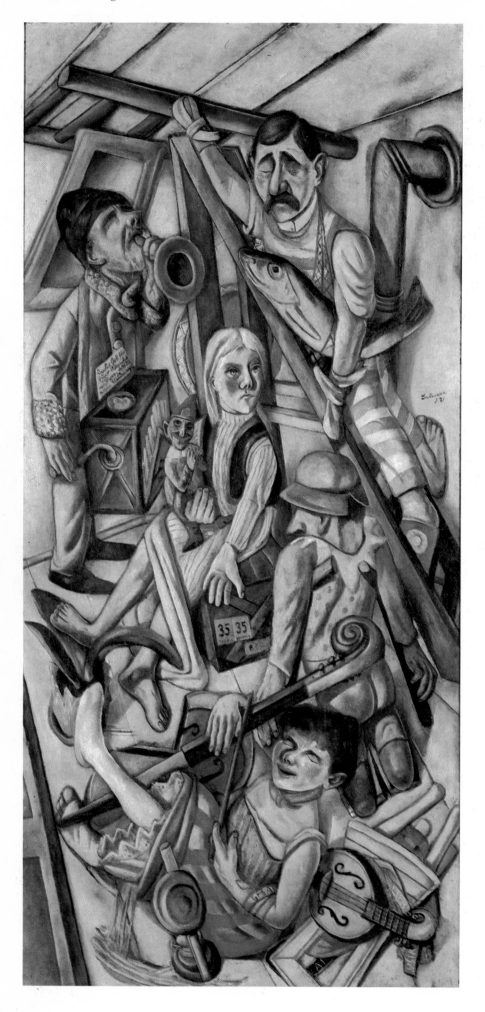

23 The Dream 1921

Oil on canvas; 184 x 87.5 cm.
S.R.M.: Beckmann F.21
St. Louis, The Saint Louis Art Museum,
Bequest of Morton D. May
Göpel 208

The oppressiveness of the nightmare depicted here lies in the impossibility of any beginning and the senselessness of all effort. It is grotesquely escalated by the fact that the simplest preconditions for attaining the intended goal are absent. The silly fools make the greatest exertions even though it is easy to see that they have no prospects of success. The center of the group of people squeezed into a narrow, box-like room is formed by a blond-haired girl sitting on a truck. She apparently is not drawn into the foolish carryings-on of the others. Blue-eyed and naive, she sits in wonder and without fear, unpretentious and open, her left arm extends its palm turned outward, her right hand holds an applauding Punch and Judy doll. Judging by the trunk, she seems to have come from elsewhere to this lunatic asylum of Berlin, in which cretins exhaust themselves in pointless activity.

It is not by accident that Beckmann titled the painting as he did: it enabled him to give the most preposterous combinations a measure of justification and verisimilitude. Even if one takes into account the imponderable and idiosyncratic logic of the dream, there nonetheless remain some very clear points of departure for interpretation, whose key no doubt lies in the girl, the doll, and the allusion to Berlin. Berlin must represent the depot for those uprooted and made desperate by the war, who now are assembled around this girl. She remains untouchable in her openness. They are all cripples, physical or psychic, and the doll congratulates them sardonically on their hopelessly insane antics which, in their senselessness, surpass his own tomfoolery by a wide margin. They themselves seem least conscious of the purpose for which they are grimly expending their energies. Their eyes are closed as if in sleep (to this extent we have dreams within a dream). The man in the sailor suit is trying to climb, by means of his arm stumps, a ladder which leads only to the ceiling where he is about to bump his head. If he means to fetch the ladder to escape from this chamber, there is quite plainly no opening at the top. The blind man blows his horn as if possessed, and grinds his organ even though there is no one who could reward his efforts. Perhaps he has failed to notice that he is in a room? The cripple with his harlequin costume and steel helmet, supported on crutches with his knees on the boards of his stage, slides senselessly along the floor. The woman singing clumsily and unselfconsciously strums a cello that is obviously not playable. And the kerosene lamp in the foreground is placed so we cannot see its light. It stands turned away from us and lights up, if anything, the woman's skirt. In any case, it does not illuminate the scene at all.

Doesn't all this make the painting a metaphor for Beckmann's ongoing theme of the big city, whose symbol is Berlin? Doesn't it

signify the senseless, fear-ridden and desperate doings of a lost generation which, because of the war, has been robbed of all life-affirming principles, but which continues tormenting itself without realizing how senseless its activity is? Doesn't Schopenhauer's idea of the world as theater already take shape here, in that these alien powers are capable of entertaining the people so much better than the much cleverer Punch and Judy doll ever could. If so, the painting takes on a meaning so ghastly that it was necessary to disguise it in a dream in order to temper so frightening a recognition.

Even more tragic in this connection is the self-disclosure of the young girl, who reaches out an open hand. Who among these idiots is capable of recognizing the gesture; who can accept it? In this insane environment, her naive candor and unfeigned wonder have no discernible prospect of survival. C. Sch.-H.

24 The Synagogue 1919

Oil on canvas; 89 x 140 cm.
s.u.l.: Beckmann 19
Frankfurt a. M., Städtische Galerie im Städelschen Kunstinstitut
Göpel 204

References: Reifenberg, 1921, p. 106; Selz, 1964, pp. 35, 39; Lenz, 1973, p. 299ff.; Erpel, No. 7.

The former Börneplatz in Frankfurt am Main which shows the Jewish synagogue is transformed in this painting into a puzzling and disquieting urban landscape. It is a partial view of the old Jewish quarter, the topography at the left edge also suggesting the Jewish cemetery. Narrow streets reach far into the distance; the corners of buildings, fences, and sidewalks thrust forward aggressively; and buildings present impenetrable yet animated facades. The pale morning light heightens this repulsive scenery, in which the three little passers-by appear singularly lost and insignificant. This is a lifeless and hermetically sealed city, in which things take on a physiognomic appearance. What is solidly constructed loses its equilibrium as if under external forces: the synagogue tilts backwards, the houses sway and slide into one another, the lamp posts stagger, and the globe lights are suspended in mid-air. Everything is held in a crystalline numbness, which likewise infects the faded sky with its artificial dawn, the pallid sickle moon, and the unwieldy captive balloon. In spite of objects which fill

the canvas, emptiness and a sense of choking are decisive—factors which Beckmann evokes by means of severe linearity, cold coloration, sprawling corner construction, and perspectival distortion, much as he did in *The Night* (cat. 19). The levels of meaning and references to reality are multi-layered in this painting.

Agonizing constraint and misanthropic closure are here not so much characteristics of a German metropolis of that time as reflections of the menacing presence of the early post-war years. The word NOT (danger) and the cropped face on the poster attached to the kiosk indicate profanation. As motifs, they are a kind of shorthand for terror, and peril becomes commonplace. In the portfolio *Hell* (cat. 247-257) and the painting *The Night* (cat. 19), Beckmann objectified the political and personal frame of mind of the years 1918/19. A hidden, only too foreboding violence is the governing impulse of *The Synagogue* as well. The tottering windows, some of them dark, some lit up malignantly, resemble the window bars on the title-sheet of the series of prints, *City Night* (1920), behind which, amid an "inaudible uproar," a murder is being enacted. The sickle-shaped moon, which reappears on the advertising pillar, may well be an allusion to disaster, in keeping with Expressionist thought (cf. the paintings *Resurrection*, 1916, and *The Night*). The captive balloon, suggestive of freedom, hangs tangled in the power lines. The stature of the buildings in relation to the dwarfed figures

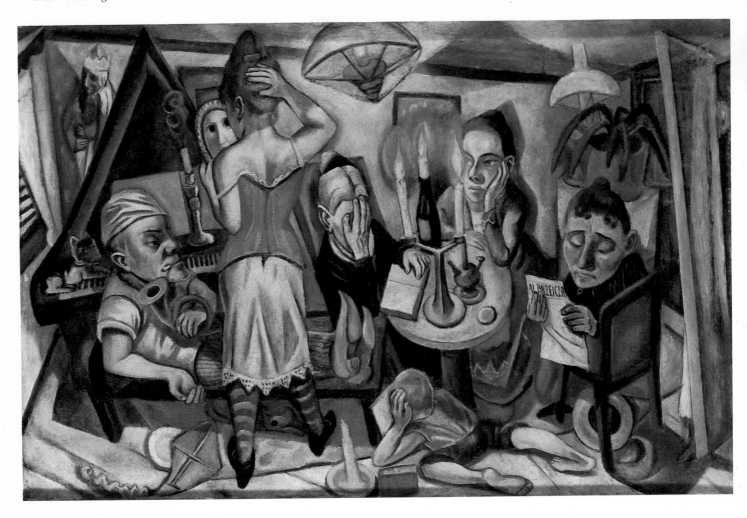

gives human existence a futile status—a theme Beckmann further expresses with the motif of a carnival party. According to an iconography that is both traditional and specific to Beckmann, the carnival or masked ball is a metaphor for life where man must live foolishly, i.e., unfreely and transiently (cat. 25, 26, 31). For the first time after the war, Beckmann employs here the coded symbolism in which he dressed himself and his Frankfurt friends, Ugi and Fridel Battenberg. What remains puzzling about the pictorial continuity, whose enigmatic character is reinforced by the idol-like cat, is the choice of the synagogue as motif. As in the overt allusion to the assassination of Rosa Luxemburg in the *Martyrdom* of 1919 (cat. 250), it may be a reference to the revival of anti-Semitism after 1916, from which the artist maintained a critical distance. Striking nonetheless is the formal correspondence between the synagogue and the "corner of danger." The edifice of worship, whose cupola is conceived like a heavenly body, in all probability represents the other world, a symbol of hope and faith. Between 1916 and 1919, Beckmann had repeatedly used religious, albeit Christian, themes to express the contemporary need for deliverance (cf. cat. 17).

In his essay, "Schöpferische Konfession" (1918), which was no doubt formulated before the end of the war, Beckmann writes about a new place of worship as a focal point of contemporary community: "This is my crazy hope, which I cannot abandon and which in spite of everything is stronger in me than ever. Just once to make an edifice along with my paintings. To build a power in which people could scream out all their rage and despair, all their paltry hope and pleasure, and their wild longing. A new church." It is interesting that this need for religiosity is expressed in the thinking of contemporary architects as well, for example that of the "Bauhaus." Nevertheless, it is in keeping with Beckmann's fundamentally pessimistic outlook that, in the context of this painting, even the monumental structure of the synagogue provides no haven of security.

The Synagogue, like *The Night,* is exemplary of Beckmann's distinctive contribution to the Neo-Objective or Magic Realism movement. A crayon sketch with an architectural study of the synagogue's cupola exists in a private collection in Munich. C. St.

25 Family Portrait 1920

Oil on canvas; 65 x 100 cm.
S.L.R.: Beckmann F.20
New York, The Museum of Modern Art,
Gift of Abby Aldrich Rockefeller, 1935
Göpel 207

References: Hoffmann, Vol. 2, p. 285 f.; G. Schmidt, p. 3; Selz, 1964, p. 35; Fischer, 1972, p. 36ff.

The painting shows the calm and distanced conception which replaces the theme of suffering in the works surrounding *The Night* (cat. 19, 20, 23) and which comes increasingly to determine Beckmann's thought during the 1920s. The narrow, box-like room with low ceilings is tightly filled with figures: Max Beckmann on the piano bench, Minna Beckmann-Tube seen from behind, and, gathered around the table, Beckmann's mother-in-law, his wife's sister Anni Tube, their son Peter, and, with the *Lokalanzeiger,* a distant relative who helped out with the household. Since 1915, Beckmann was already spending most of his time in Frankfurt and Minna was frequently on tour as an opera singer, while the family continued to live in Berlin. Peter Beckmann from time to time stayed at his grandmother's house. While the couple set apart from the domestic community may well refer to an autobiographical situation, the scenic organization and thematic pattern interpret what is represented above all as "significant drama" in the "theater of the world." Not only the two costumed figures at the left, but even those absorbed in

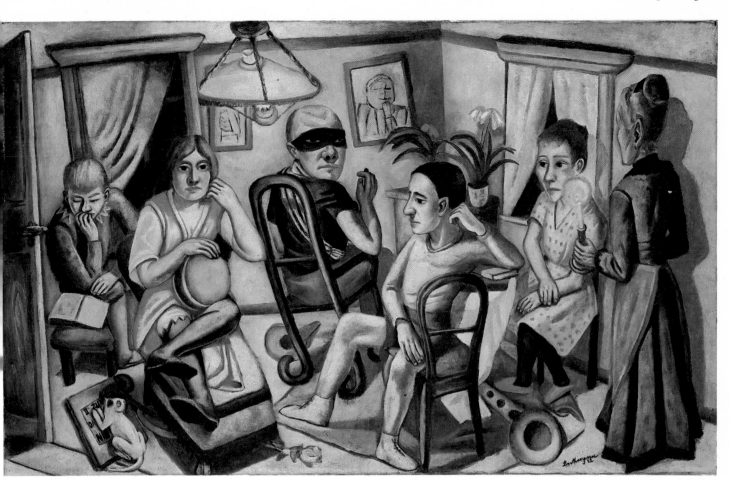

reading or daydreaming act on the stage of "Carnival."

The theme of Mardi Gras, masked ball, or carnival is pivotal in Beckmann's work as a simile for the absurdity, role-playing, and ephemerality to which the world is condemned. Beckmann expounded on that theme, for instance, in the drama *Das Hotel*, which he wrote ca. 1920. While in the first setting of the theme (*Carnival*, 1920) Beckmann protested desperately against this "slave life" and confinement, he now strains his gaze through the open door to the outside and into the "terrible abyss" of "infinite space," into the "dark black hole... of eternity," as he writes in his letter of May 24, 1915. He is the seer who from now on presents suffering only symbolically by means of a gesture of the hand and the binding around the head. His instrument is no longer the carnival horn of the clown but the trumpet, in all likelihood an allusion to the painter's claim that he is a prophet (cf. cat. 86). Significantly, for the first time, there appears in the upper left corner the curious figure of the king, with which Beckmann comes more and more to identify himself (cat. 78, and p. 40). As symbol of sovereignty it represents his claim to leadership. In Gnostic teaching, the king symbolized man's spiritual and free existence, and stands opposed to folly. Probably since 1906, and surely since 1916, Beckmann had come to terms with the esoteric by way of Schopenhauer. The ear behind the door may be an

allusion to an evil god or a Gnostic demiurge (cf. the etching, *Behind the Scenes*, 1921 cat. 272).

This new understanding of self, which is retracted later in the *The Dream*, 1921 (cat. 23), is expressed in various effects. The room expands and opens up; the figures attain stability; and traditionally characteristic motifs are assembled conspicuously. As *vanitas* symbols, the burning lights, the books, and the extinguished-but-still-smoking candle refer admonishingly to death (cat. 19, 23, 26, 81, 82, 84). The woman with the mirror personifies earthly vanity and delusion (cat. 54); moreover, she plays the pernicious role that Woman, "voluptuous lure," will play over and over again in Beckmann's "cycle of becoming." Old Frau Tube, whom the artist held in high esteem, probably represents, by gesture and contiguous placement, the contemplative path to knowledge of the world (cat. 113). C. St.

26 Before the Masquerade Ball 1922

Oil on canvas; 80 x 130.5 cm.
S.L.R.: Beckmann/F 22
Munich, Bayerische Staatsgemäldesammlungen,
Staatsgalerie moderner Kunst
Göpel 216

References: Hausenstein, p. (5); Linfert, 1935, p. 6of; Jedlicka, 1959, p. 122f; Martin, *Kunstwerke der Welt*, vol. 5 (1965), No. 171.

This painting, commissioned by the publisher Reinhard Piper, radicalizes the setting of *Family Portrait* (cat. 25), for now every figure, including the viewer, is drawn forcibly into the frightening folly. Of secondary importance is the external state of affairs which, according to Peter Beckmann, is centered in Graz, where his mother had been employed as an opera singer since 1918. The group pictured here include: Peter reading behind the opened door; next to him Minna Beckmann-Tube, dressed as Pierrette with a tambourine; in the middle the artist himself, with cigarette and black mask; two of Minna's friends in Graz, the physician Erich Stichel as Pierrot and Grete Skalla; and Beckmann's mother-in-law, who is entering the room with a burning candle. The actual situation is macabre, for the masked ball is awaited joylessly and in oppressive silence. With fixed, masklike faces these people remain unconnected in an "unstable" room, behind whose windows the black night "of eternity" (Beckmann 24.5.1915) hovers

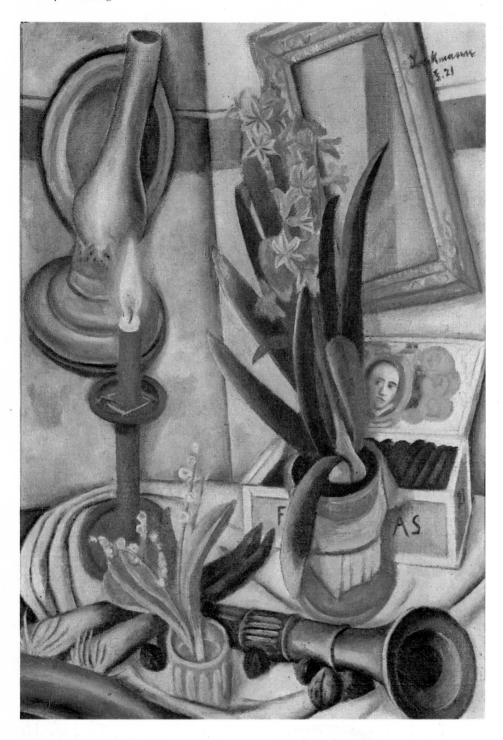

27 Still-Life with Burning Candle 1921

Oil on canvas; 50 x 35 cm.
s.u.r.: Beckmann F.21
Private collection
Göpel 209
References: Schmied, p. 34; Fischer, 1972, p. 73.

This painting is the first of a series of still-lifes in which the candle is an important motif. Associated with the tortured figures in *The Night*, 1918/19 (cat. 19), where the burning light of life was tipped over and extinguished, and the vain self-reflection of the masked woman in the *Family Portrait* of 1920 (cat. 25) which also shows a smoking wick, the candle functions here as a traditional symbol of epher-merality. Here too it alludes admonishingly to the finality of all earthly things, for the candle is burned down considerably. Surrounded by the folds of the tablecloth, the candlestick forms the displaced center of an arrangement in which flowers, leek stalks, nuts, wind instrument, cigarbox, mirror, and kerosene lamp are tightly woven. The line of the room's corner, the tilts of the lamp, mirror, lilies of the valley, and hyacinth as well as the a-perspectival conspectus, and the crowded, circular format enhance the austerity of this grouping. In spite of the number of *vanitas* symbols (flowers, musical instruments and mirrors, like the candle, have been motifs in *memento mori* paintings since the 17th century), this still-life seems nevertheless to be celebrating life (Fischer). Despite the minimal light, the luxuriant growth of the plants takes up a dominant position. Leek stalks and musical instruments introduce phallic forms. The cigarbox accentuates the secular and, in conjunction with the wind instrument, is a surrogate for the presence of the artist. Beckmann frequently represented himself by a musical instrument and as a smoker (cf. cat. 25, 31).

Disconcerting elements, which around 1919/20 had been bound up with candles and the dark openings of musical instruments, are de-emphasized here. By comparison with earlier works, the solidified pictorial structure and the new-won compactness reveal a measure of composure, equilibrium, and distance that are characteristic of *Self-Portrait as Clown* from the same year (cat. 31). In the years to follow, however, the still-lifes increasingly become arrangements emphasizing the magical. The motif of the cigarbox appears in a variant form in *Still-Life with Cigar Box*, 1926 (cat. 47).

C. St.

menacingly. Anticipated here is the feeling about life which the artist later articulated: "Imprisoned like children in a dark room, we sit there resignedly and wait for someone to open the door for us and lead us to our execution, our death" (Beckmann, 1927). As was already the case in the paintings surrounding *The Night* (cat. 19, 20, 23), life is construed as a sealed-off, marionette-like existence given over to negative forces. Only two figures amid the circle of role players assume different positions. In keeping with her earlier portrayal, the old woman with the candle alludes to transitoriness and insight. And Beckmann himself, turning his masked face toward us with a piercing glance, already embodies the "pride and defiance in the face of the invisible powers." It

is a posture he will maintain until the end of his life (4.5.1940). Free of despair and strain, the artist is the refractory witness who like a hawker or circus barker presents the "spectacle of life" on the stage (cat. 271). Lead actor in the Beckmann Circus is the figure costumed as Pierrot and acrobat, who appears to reflect Max Beckmann's melancholy and brooding alter ego. His glance through the open door (familiar from *Family Portrait*) and the skin-tight costume lend credence to this conjecture. At the beginning of the 1920s Beckmann presented himself in both these roles. The significance of the cat with the book or calendar is unclear. The composition is repeated, although with sides reversed, in an etching of 1923 of the same title.

C. St.

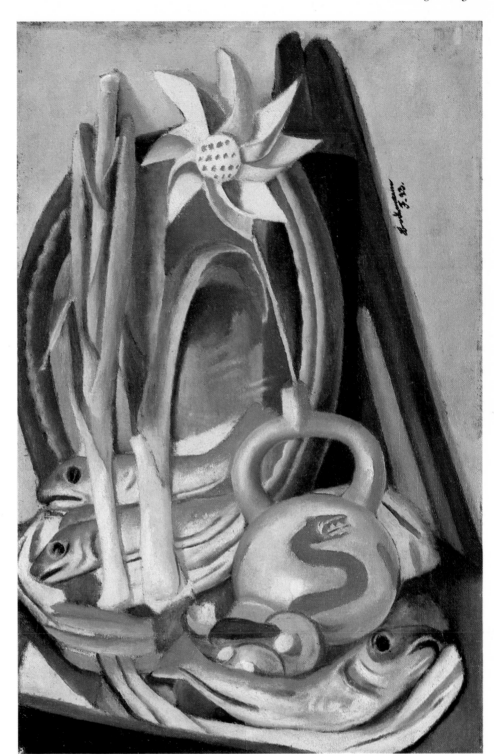

**28 Still-Life with Fish and Paper
Flower 1923**

Oil on canvas; 60.5 x 40cm.
S.U.R.: Beckmann F.23
Minneapolis, University of Minnesota Art Museum,
Gift of Ione and Hudson Walker
Göpel 220
Reference: Reifenberg, 1949, p.7.

These lifeless objects are interconnected in a
tighter and more concentrated fashion than in
the previous painting. A circular sweep now
determines the entire pictorial field; the oval
shape of the mirror is reiterated in the round-
ness of the vase, the compartmentalized paper
flower, and the rhythmic arrangement of the
fish. Together with the buttress on the right
side, the leek stalks standing upright stabilize
this group of objects. Aside from the mirror,
clearly identifiable symbols of *vanitas* are not
in evidence.

Nevertheless, this painting also is concerned
with a metaphor of life which Beckmann,
urged on by his pessimistic view of life, kept
reformulating. Both the themes and the princi-
ple of composition allude to the meaning. As
part of a negative symbolic pattern, the phallic-
shaped fish in Beckmann's work represent not
only fertility, but above all the soul which,
seduced by instinctual needs, is forced to float
in the inescapable spillway of life and death
(cat. 70, 87, 121).

The instigator of this process, as well as its
demonic power, is the snake from the story of
the Fall, which plays an important part here.
As decoration on the vase, it determines the
fishes' pattern of movement, which imitates
the line of the snake's curves in mirror-reflec-
tive fashion. In later still-lifes, where Beck-
mann again makes symbolic use of the vase (a
Mexican drinking vessel, now in the possession
of Mathilde Beckmann), the demonic takes on
an eerie incandescence.

Beyond this connection, which can be found
in many of Beckmann's mythological paint-
ings, there appears to be an allusion to the
Gnostic idea of an "eternal cycle" and rebirth.
A downward movement, starting at the center
of the paper flower, develops across the mir-
ror-frame, the phallic leek stalks, and the
fishes, only to recoil in tightly closed fashion
across the snake motif, the vase, and the arc of
the mirror (cf. the later symbol of the wind-
mill, cat. 114). Reifenberg notes that the vase
and pinwheel were things in Beckmann's apart-
ment. The mirror, which is so closely bound up
with this interlocked system, already antici-
pates the outer form of the cabbalistic 'En-
Soph,' which appears again in the paintings
after 1924. C. St.

solid trunks (Fischer). For the viewer, an unreal, suspended position is intended. The crossing-gate, which forms a diagonal from lower left to upper right, is bounded by two sets of parallel lines: the iron railing and the train tracks. One's eye is guided across a lower-lying plane toward a kind of stage. Thus the front view of the houses, composed as though it were stage scenery, is placed at eye level, even though one's gaze is actually sucked into the depths below. There is no overriding perspective for the things represented to obey. Instead, the many layers of the surface facades are exposed, and each object is seen for itself, experienced, and put back. The pictorial space builds itself up from these discrete bodies.

M.B.

30 The Iron Footbridge 1922 ▷

Oil on canvas; 120.5 x 84.5 cm.
S.L.R.: Beckmann F 22
Düsseldorf, Kunstsammlung Nordrhein-Westfalen
Göpel 215

References: Einstein, p. 567; Selz, 1964, p. 39; Schmied, p. 34.

Frankfurt's 'Iron Footbridge' whose neo-Gothic style made a great stir in 1868/69, connects the old city with the Sachsenhausen district, visible in the picture. The bridge and its erstwhile surroundings are reproduced with topographical precision: the landing place with crane and dredger, the Main River with its boat traffic and its fenced-in swimming facility, and the neo-Gothic Church of the Three Kings on the opposite bank of the river. Just as in the previous painting (cat. 29), a factually constituted vista of a city is recognizable here. And here again the quotation of an actuality is translated into a reality of another sort. A new concreteness with a novel definition of objects and their volumes results.

The bridge stretching into the distance is bounded by the ridge in the foreground and the opposite bank of the Main. This Z-shaped, clearly plotted pictorial composition appears to be as coolly thought out as the 'Iron Footbridge' seems architecturally drafted.

It is difficult to imagine that this city, with its huge buildings, impressive bridge, its dirt and noise, the cables traversing the sky, was conceived and built by the tiny people in evidence here. They more plausibly play the parts of bit-players. Here it appears that they are now prisoners of their own faith in progress, subordinated to their once highly praised technical innovations.

M.B.

29 The Nizza in Frankfurt am Main 1921

Oil on canvas; 100.5 x 65.5 cm.
S.U.R.: Beckmann F 21
Basel, Kunstmuseum
Göpel 210

References: Einstein, p. 567; Rave, p. 79; Reinfenberg, *Was da ist, Kunst und Literatur in Frankfurt* (1963); Reifenberg, FAZ, 2/10/1970; Fischer, 1972, p. 27ff., 73.

The "Nizza" (Nice) in Frankfurt, so named because garden designers from Frankfurt constructed park facilities along the Riviera in the 19th century, is a park on the right bank of the Main River between the tracks of the harbor railway and the lower Main quay. Even though a real and perfectly identifiable urban scenario is depicted here, it has much more the effect of an uninhabited dream landscape.

The rich green plants in particular are suggestive of the naive primeval forest paintings of Henri Rousseau, whom Beckmann called his "great old friend" and "Homer in the gatekeeper's lodge." The impression arises that the painter had taken a childish delight in displaying luscious foliage, sumptuous blossoms, and

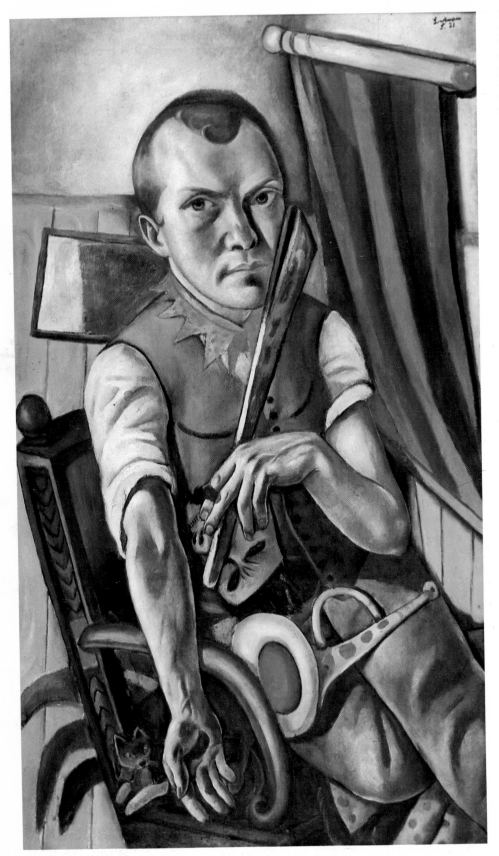

31 Self-Portrait as Clown 1921

Oil on canvas; 100 x 59 cm.
s.u.r.: Beckmann F.21
Wuppertal, Von der Heydt-Museum
Göpel 211

References: Jedlicka, 1959, p. 119f.; Fischer, 1972,
p. 38ff.; Evans, p. 15; Weisner, 1975, Vol. 2, p. 16;
Wachtmann, p. 16ff.; Zenser, p. 37ff.

This demonstratively symbolic self-portrait marks a turning-point in Beckmann's life, for a self-examination that strives for distance has now replaced the excessively active despair of the post-war years. The artist presents himself as fool, sufferer, and dignitary. The essentials of carnival night—trumpet, mask, wooden sword, and harlequin collar—are surrounded by a pattern of gestures that calls to mind the prototype of the ridiculed, suffering, and risen Christ. The fool's wooden sword resembles the mock sceptre, the shading of the protruded palm recalls the stigmata of Christ's Passion. Armchair and curtain play variations on motifs of the traditional royal portrait, thus framing a figure worthy of representation. For Fischer, who has established these iconographic connections, the portrait embodies a melancholy meditation on the dialectic between a sovereign claim to rule and an impotent foolishness.

Dignity is, however, the primary feature of the painting. All the slantings and distortions that previously destabilized the scenes here fortify the construction, and attributes no less than gestures produce a tensive equilibrium. The mirror, the *vanitas* symbol, again supports the figure. A remarkable unreal relation of light-colored wall, curtain, board covering, and lack of floor triggers the impression that the artist and his armchair are being raised aloft. That Beckmann can now separate himself from his roles gives him strength to observe and depict life itself in a more distanced way (cat. 26, 271-274). This turning point was already proclaimed in the *Family Portrait,* 1920 (cat. 25). These stand in sharp contrast with the vulnerable self-portraits from the period 1915-1919 (cat. 15, 22). C. St.

32 Varieté 1921

Oil on canvas; 100.5 x 75.5 cm.
s.u.l.: Beckmann F.21
Mr. and Mrs. Jerome L. Stern
Göpel 213

Noteworthy in this early variation on Beckmann's highly favored theme of stage/circus/vaudeville is the lace of relationships of the artists to one another. Although they are performing before an audience, it appears to be more of a rehearsal at which each practices his act without regard to the others and with no attempt at coordination. There is, of course, a unity in the formal sphere: the stability of the composition stems exclusively from the figures and the stage properties. It is from them, and not from any actual spatial preconditions, that the picture's inner space arises; it is in fact identical with them. The background, on the other hand, remains a foggy, undifferentiated foil for their activity. In this respect it differs markedly from the overstuffed, box-like rooms pictured in some of Beckmann's paintings just prior to this (cf. among others cat. 20, 23). The figures appear on stage as if they are in a closed form, inaccessible to the audience. This is reinforced by the narrow slice of space for the spectators which is situated so low that those sitting there must crane their necks to view what is happening. It is the formal composition alone that gives rise to an insuperable barrier between artists and audience, since in light of the actual distance between them they could actually touch one another with ease.

The vaudeville artists represent various branches of the trade. Thus on the one hand

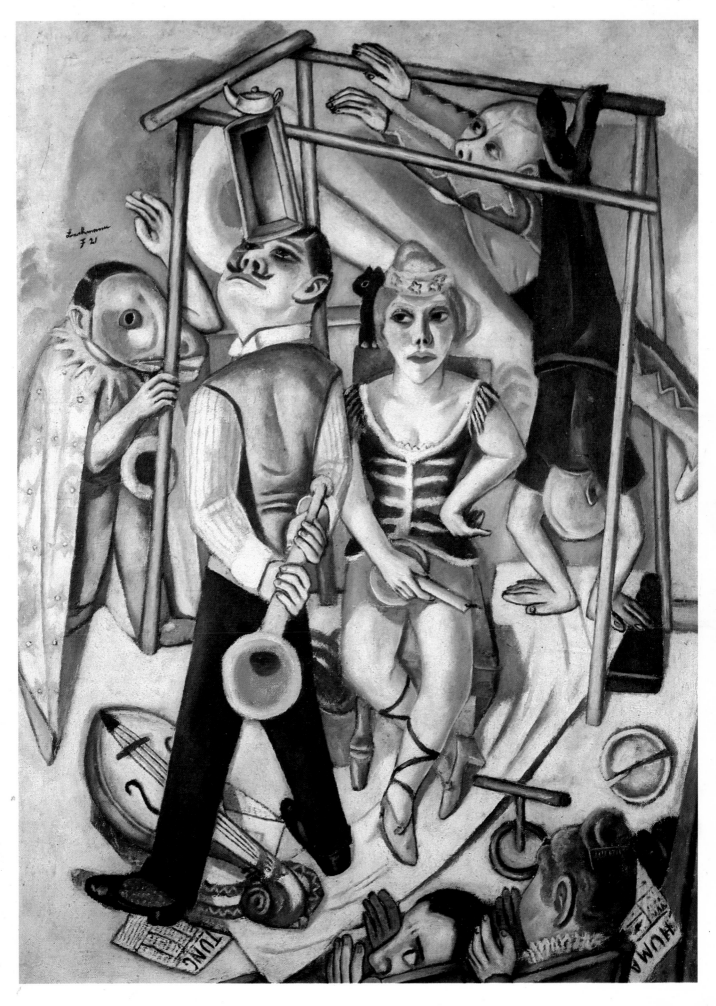

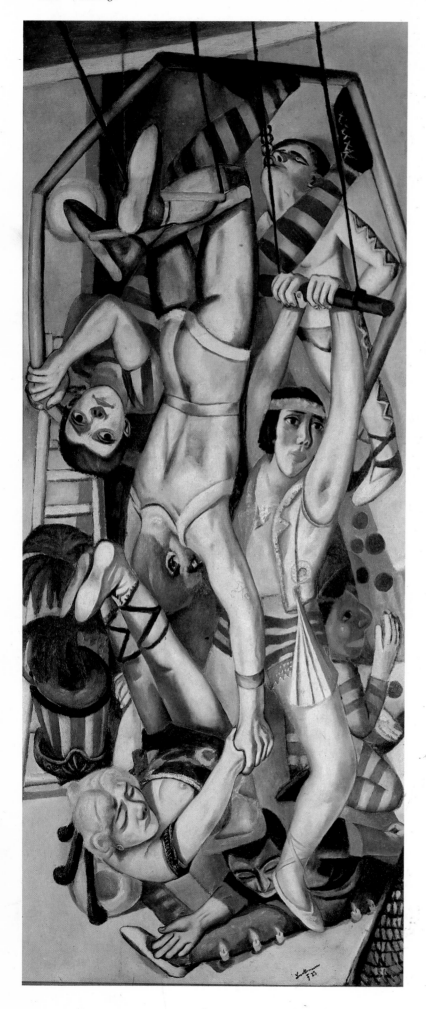

we have the traditional acrobats and juggler, but in addition there are two figures more likely associated with the magical arts. One is wearing a donkey mask and star-covered cloak. The other is a woman with a candle that has gone out and tipped over, a star-spangled headband, and a black cat—traditional symbols to introduce a magic act. At the same time, and in more hidden form, they play on transitoriness, a dark destiny, and the enigmatic character of life. C. Sch.-H.

33 The Trapeze 1923

Oil on canvas; 196.5 x 84.5 cm.
S.L.R.: Beckmann F23
Toledo, Ohio, The Toledo Museum of Art,
Gift of Edward Drummond Libbey
Göpel 219

References: Reifenberg, 1949, pp. 20, 30, 69;
Busch, 1960, p. 59f., 64; Fischer, 1972, p. 46f.

Beckmann again takes his motif here from the world of the circus and the annual fair which, like the carnival, were metaphors of human behavior for him. Crowded tightly together and lacking any freedom of movement, the acrobats drill on trapeze bars within a polygonal contraption. Although it appears to be behind the trapeze wires, in fact it tightly encloses the trapeze. The actions of the figures are senseless, since the contraption does not permit them to swing, as the man hanging upside down and the woman in Indian costume indicate. The distance between the level of the floor and the gymnastic apparatus is too small in relation to the size of the people, producing a crate-like space which is further constrained by the narrowly vertical format. Forcibly interlocked, men and women hinder each other's efforts. There is an air of heaviness and strain. Acrobatic activity comes to a standstill and seems to serve no other purpose than to compensate for the precariousness of the contraption and the trapeze. No less grotesque is the demeanor of these people, who carry on like wind-up dolls. They are isolated from one another in spite of their being so tightly intertwined.

The painting illustrates the futility and constraint of human existence which Beckmann again and again made the theme of his works from the First World War to the end of his life. The later paintings of acrobats and athletes, whose towerlike construction is anticipated in *The Trapeze*, formulate the phenomenon of inhibited movement and hazardous balance in a new concrete fashion (see p. 41). The cumbersome detail-laden pictorial structure, the peepshow perspective of the space, and the marionette character of the figures are hallmarks of the symbolically demonstrative works of the 1920s.

The vacuous or fearful facial expressions and the allusions to the tomfoolery of carnival time are familiar. Noteworthy is the position of the man pressed against the ground, who appears

to be displaying his hand in a gesture of suffering (cf. cat. 31). Perhaps this figure is an encoded self-portrait, especially inasmuch as his juxtaposition with the Negro at the right is surely a variation on the sixth sheet of the portfolio, *Annual Fair*. One might compare the individual suspended in *Galleria Umberto*, 1925 (Göpel 247) with the motif of the man at the left who, upside down, clings frantically to the bars.

Catalogues and critiques prior to 1930 designate this work as *Large Trapeze* to distinguish it from *Small Trapeze*, also known as *Varieté* (cat. 32). The trapeze motif appears again in two later paintings, in *Artiste*, 1936 and in *Acrobat on His Swing*, 1940.　　C. St.

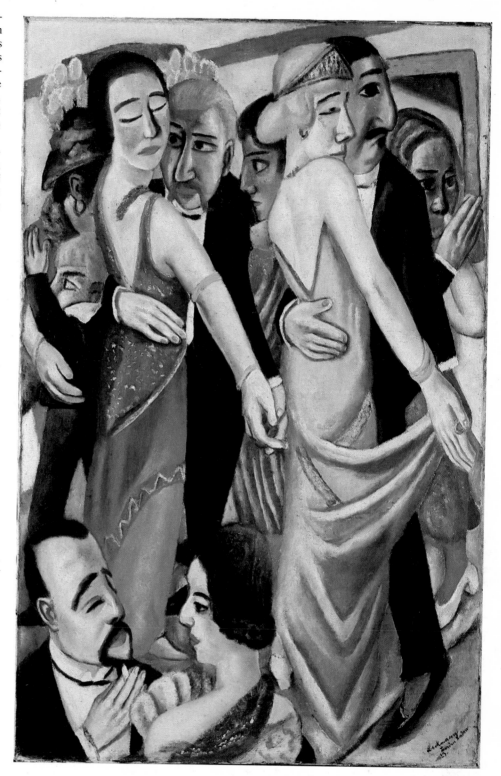

34　Dance in Baden-Baden 1923

Oil on canvas; 100.5 x 65.6 cm.
S.L.R.: Beckmann Baden-Baden 23
Munich, Bayerische Staatsgemäldesammlungen,
Staatsgalerie moderner Kunst
Göpel 223

References: Busch, 1960, pp. 56, 58; Wilckens, *Das Kunstwerk* 13 (1959/60) 15; Schmeisser, *Neue Deutsche Hefte* 84 (1961) 60f.; Lackner, 1978, p. 70.

Beckmann reworked his impressions of his stay in this fashionable health resort into the scenario of a maskless masked ball. The dance is represented as a party game, as a mirror of a grotesque contemporary world, and as the sheer dance of life. Crowded into the tightest of spaces, these modish couples move in the mechanically jerky rhythm of a tango. Without any real foothold these figures have grown to an extreme height, coolly pompous above their own shoulders, arms, and dance steps. They are like marionettes in roundelay, in which each gaze is apathetic or calculating, every contact alien and indifferent. The forceful beat, which organizes the arms and hands in rigid unison, is at the same time an expression of the inner life of this society. These figures stride forth unceasingly and unheedingly. Seen from the angle of vision provided from below, they stretch flirtatiously and arrogantly to the ceiling.

It is not sensuality that unites these couples, but a superficial game that toys with dignity, eros, and luxury. Sallow flesh, glossy fabrics, spangled accessories, and black-and-white tuxedos are stacked up against one another in fully objectified fashion, as if ready to be bought and sold. Sarcastically, but at the same time fascinated, Beckmann captures the behavior of the *nouveaux-riches*, these inflation-profiteers who clamp on to one another without making eye contact. The dance, originally an expression of joy, is perverted into a system of studied exploitation. The couple in the foreground is defined by role playing, faces that are masks, and glittering surfaces. In the course of idle conversation they meet only materially, by way of contact between hand and fan. Beckmann uses icy cold colors and the petrified design of a playing card to direct the viewer's gaze downward and upward. In a more concentrated fashion than George Grosz or Otto Dix (see p. 104), he portrays the *nouveaux-riches* of the post-war era.

At the beginning of the 20s, party scenes of this sort occur most extensively in Beckmann's graphic work. However, (as is likewise true of the second major theme of these years, carnival time), the way the dance is depicted is not just a commentary on an infamous contemporary world hiding the intimidation and poverty of the many by means of the dissipation and luxury of the few. (cf. the seventh sheet, *Malepartus*, of the 1919 portfolio *Hell*, cat. 254 in the context of the sequence, and the 1920 etching *Königin Bar*, cat. 269). The *Dance in Baden-Baden* is also a metaphor of a life in which compulsory role-playing and lack of mutuality are definitive in a world where man and woman are ineluctably bound together by unbridled greed. The woman centered in the background, with her horrified gaze and her Pierrette collar, is a profile variant of the witness in *The Night* (cat. 19). She introduces into this futile and ephemeral activity a dimension of direct interpretation: masked ball and horror.　　C. St.

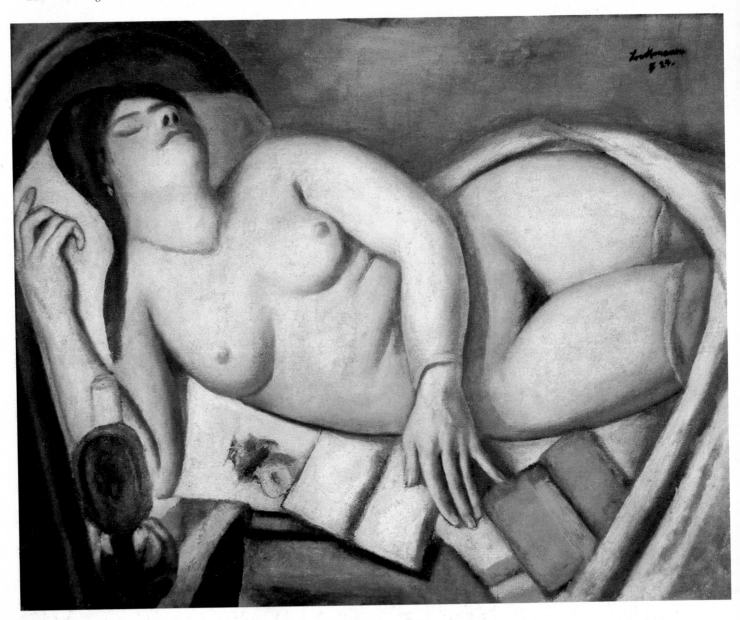

35 Sleeping Woman 1924

Oil on canvas; 48 x 61 cm.
S.U.R.: Beckmann F 24
Private collection
Göpel 227

Reference: London 1974 cat., No. 10.

The painter has depicted the sleeping woman naked, the legs surrounded by a sheet, the head by the upper end of the bed. Curved throughout and turned to the front, the body's plastic energy becomes increasingly more relaxed from the relatively incisive forms of the thighs, via the creases of the stomach and the outstretched hand to the head and the other hand beside it. The body, not the face, catches the full light of the lamp and reflects its shine. The combination of the two surrounding, and at the same time revealing, objects, with the turn towards the beholder and the lighting, results in an "exhibition" of the woman. This is emphasized by the distancing effect of the lampshade and chair back in the darkness at the front. Thus the beholder experiences his sight of the woman as an event. C.L.

36 Self-Portrait with Cigarette on a Yellow Background 1923

Oil on canvas; 60 x 40 cm.
S.U.L.: Beckmann F.23
New York, The Museum of Modern Art,
Gift of Dr. and Mrs. F.H. Hirschland, 1956
Göpel 221

References: Selz, 1964, p.39; Evans, p.15; Zenser, p.74f.

More severely and unsparingly than in the other self-portrait from this year, Beckmann confronts himself here with his own person. He shows himself in a lordly pose before a yellow wall. Without any distracting surroundings, he draws our gaze to his face, chest, and hands. Everything about this figure is powerful and hard: the compact, square-chested body; the grimace reminiscent of the character studies of the sculptor F.X.Messerschmidt (1736-83); the penetrating glance; the tightly bound collar; and the strong, demonstratively presented hands. The line that extends from the left shoulder across the folds of the jacket and then disappears into the relaxed hand brings about,

in combination with the extreme contrast of light and shade, the impression that Beckmann is out of control, pulling his jacket together. The red-dotted cloth draped around him, relic of a carnival masquerade (cf.cat.19, 31), underscores this rhythm, which seems to recoil against the dark interior frame. A menacingly self-reclusive Beckmann embodies here, in contrast to his melancholy side, defiance in the face of the world and destiny familiar to us since 1920 (cf.cat.26). In spite of the harlequin cloth, the painting captures not the clown but the stubborn rebel, who may also appear as a sceptered autocrat. Since 1918 Beckmann had combined his posture of protest against suffering with the notion that existence is predetermined by negative forces. The neo-objective realism of the portrait is closely related to the conception of an Otto Dix. C.St.

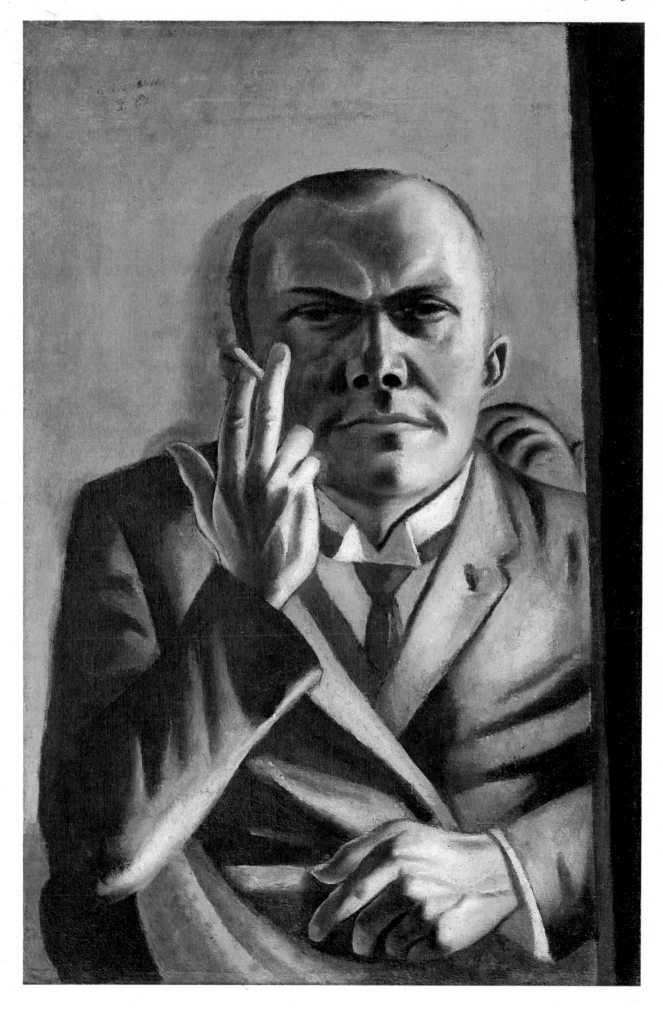

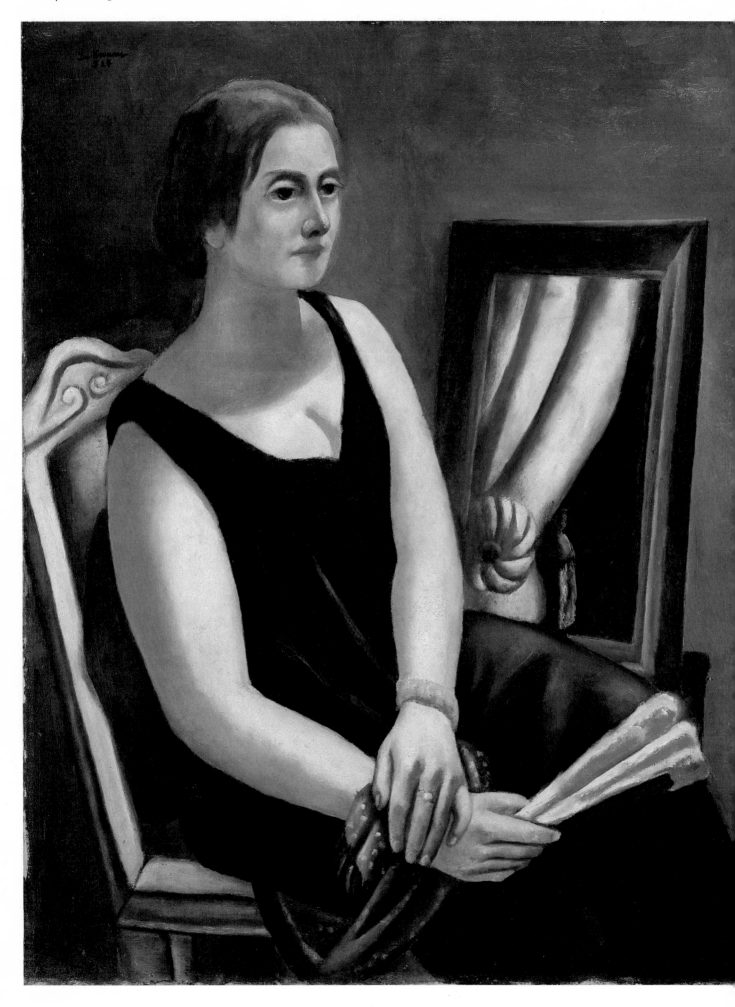

37 Portrait of Minna Beckmann-Tube 1924

Oil on canvas; 92.5 x 73 cm.
S.U.R.: Beckmann F24
Munich, Bayerische Staatsgemäldesammlungen,
Staatsgalerie moderner Kunst
Göpel 233

References: Fischer, 1972, p. 38.

This portrait of Minna, which is one of the loveliest and most monumental of Beckmann's paintings, was produced just a few months before the couple's final separation. Sitting calmly and quietly, inclined slightly forward and sensually rounded out, the subject of the portrait nonetheless remains at a cool distance. The expression is one of solemn determination. The locked position of her gaze, the crossed arms, the head held emphatically erect in contrast with the sensual inclination of the body, the austere and motionless face, and rigid position of the fan all endow the figure with a firmness which is intensified by the form of the chair. The curtain appearing in the mirror takes on the distinctiveness of the portrait: with its pink and swelling folds it corresponds to the woman's sensuous arms; together with the chair, cloth, and fan it forms a stable frame. The way the curtain is gathered up repeats the manner in which the woman clasps her hands. It functions not only as symbol of sovereignty (cat. 31), but is also a reference to the domain of the theater. On the one hand it may be alluding to the stage career of Minna Beckmann-Tube, while on the other hand it may invoke the metaphor of the stage, which construes human life as the playing of roles.

In keeping with the paintings around 1920, there stands behind the curtain the dark Unknown (cf. cat. 25, 26). The dotted cloth, familiar as an accessory of carnival, in turn ties the woman to the strange reality of the mirror.

<div align="right">C. St.</div>

38 Still-Life with Gramophone and Irises 1924

Oil on canvas; 114.5 x 55 cm.
S.L.L.: Beckmann F24
Private collection
Göpel 231

References: Fischer, 1972, pp. 66, 85;
Bielefeld 1975 cat., vol. 2, p. 19.

More accurately characterized as a domestic scene, this still-life is a kind of summary of Beckmann's earlier Frankfurt period. The vase with the flowers and the inscription, which in complete form would read '(An)denk(en) (Frank)furt' (souvenir of Frankfurt), provides the motto for the arrangement both in form and in content. The roundness of the base of the vase is repeated, a-perspectively, in the table top, the mandolin, the gramophone horn, and the smaller mirror, and serves as focal point for the circular structure of the entire assemblage. At the same time the flowers and the musical instrument are traditional motifs to

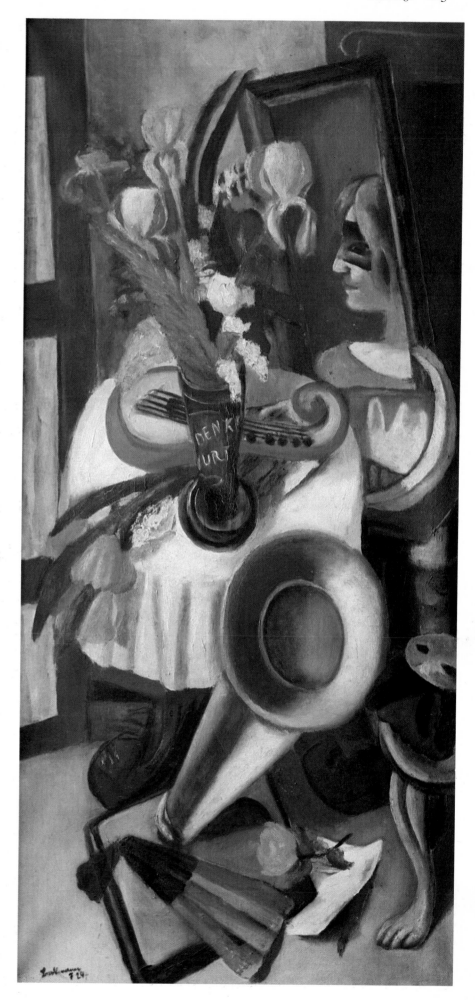

sound the theme of transitoriness. A suggestion of the demonic appears in the voracious horn of the gramophone and the curious animal-like footstool on which a melancholy mask has been left, and is consolidated in the disquieting darkness that breaks into the corner of the room. Instead of material objects, it is appearances that gather here. The rectangular mirror captures the profile of a masked woman. The woman and the gullet of the gramophone horn probably point to the pernicious meaning taken on by the libido in the cycle of life and death. The gramophone is a phallic-vaginal symbol of vitality: the footstool with the mask hints at the presence of sinister powers.

The painting is the first in a series of still-lifes which may be regarded as magical incantations of arcane mysteries (*Large Still-Life with Telescope*, 1927; *Still-Life with Helmet and Red Horse's Tail*, 1943). The mirror-image of the woman may be a disguised portrait of Naila, with whom Beckmann was probably on intimate terms as early as 1923 and for a long time thereafter (cf. *Portrait of Naila*, 1934). C.St.

39　Landscape with Lake and Poplars 1924
Landscape with Anglers

Oil on canvas; 60 x 60.5 cm.
S.L.R.: Beckmann F.24
Bielefeld, Kunsthalle
Göpel 232

References: Lackner,1978, p.72; Weisner, "Max Beckmann: Seelandschaft mit Pappeln, 1924," *Erläuterungen zu Gemälden und Plastiken,* Kunsthalle Bielefeld, 1978; Weisner, 1982, p.161.

Peace and quiet lie over the entire landscape. This scene of well-groomed nature sets its trees and reeds in rows, and everything appears carefully arranged. The surface of the lake is calm, as is the delicate blue sky. Even the two men, the only humans present, are shown in the serene and leisurely activity of fishing. While the one holds his rod upright, the other extends his, screened by the reeds, out over the water. A cart with tools and three small haystacks intimate that, on other occasions, work is done here as well. But not now. With its two anglers, pleasant light, pastoral serenity, and clean orderliness, this landscape has the character of a Sunday afternoon. Accordingly, the painting can hardly be "a symbolic depiction of the futility of human existence within a closed system" that "grants no prospect of a transcendent horizon" (Weisner, 1982). It is rather a picture about peaceful existence within a peaceful nature which humans have refashioned.

It has been pointed out that this work shows affinities with paintings of Henri Rousseau (Göpel). But these references are really more "a kind of token of respect for his predecessor" (Lackner 1978), and in the end they are beside the point, since Beckmann's painting differs strongly from the works of Rousseau in its artful composition, its successful depiction of each area of the landscape, and in the meaningful insertion of people into it. This is true of the *Landscape with Balloon*, 1917, (Göpel 195), which begins this series of paintings. The painting of 1917, with its sad, rainy mood and the eerie balloon, is also indicative of the direction which the artist's development had taken up to the painting of 1924. As Lackner says, "In the Seascape with Poplars one can breathe freely again." C.L.

40　Lido 1924

Oil on canvas; 72.5 x 90.5 cm.
S.L.L.: Beckmann 24 "Lido"
St. Louis, The Saint Louis Art Museum,
Bequest of Morton D. May
Göpel 234

References: Fischer, 1972, p.50f; Letter 8/9/24 to I.B. Neumann, Auction cat., Klipstein and Kornfeld, Bern, 1962; Lenz, 1976, p.21.

After Beckmann, his wife Minna, and their son Peter had spent a vacation at a health resort in Pirano, south of Trieste, in July of 1924, he declared that he now wanted to paint "Life as it simply exists," and nothing more. "Without thoughts or ideas. Filled with colors and forms taken directly from nature and from myself. —As lovely as possible." One would be hard-pressed to find that intention realized here. To be sure, what we have is an apparently exhilarating beach scene; and the differentiated mode of painting here, which transmutes concreteness in a plastic manner, is markedly

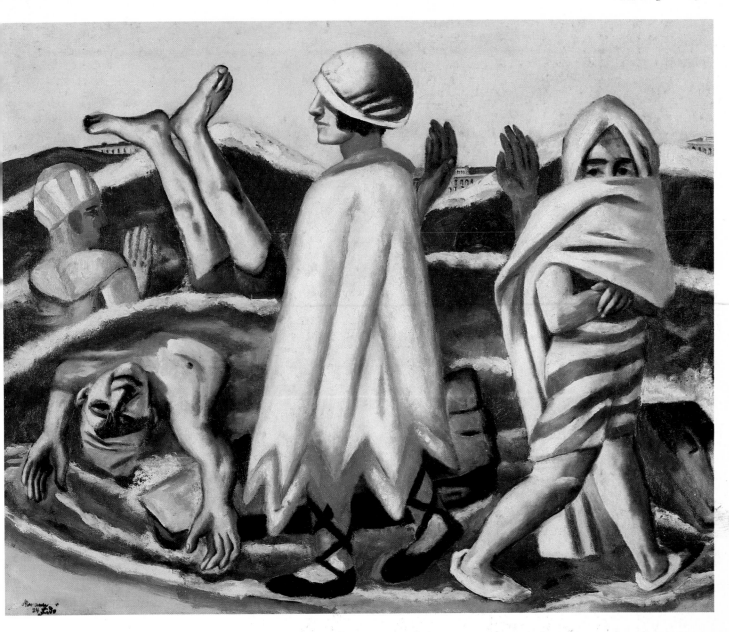

different from the austere style characteristic of earlier compositions (cf. cat. 34). Nevertheless, the impression of relaxed summer cheer is not forthcoming. Something unfathomable and mysterious deprives the scene of easy comprehensibility and thereby closes it off from the viewer in a singular way.

Two figures walk along the beach who, because of their remarkable clothing, expose and withdraw themselves at the same time. Because of their odd appearance they give the immediate impression of being foreign bodies on the beach. All visual contact is prohibited: the figure in a tent-like cloak reminiscent of Beckmann's Pierrettes has a bathing cap pulled low over her face, and the one walking out of the picture on the right is covered by a large shawl which leaves only the eyes exposed. Even the figures cavorting in the water do not generate a relaxed atmosphere. To the left we have a man lying on his back with legs stretched high and arms tossed behind his head being washed onto the beach by a wave. In

itself it would be an amusing bit of play, but here, because of the pointed wooden plank in his path and the surf about to wash over him, in addition to the rigid motion of the swimmer himself, we almost anticipate a broken neck. Next to him a woman who is evidently afraid of the water gives the impression of being anxious. To the right is a man struggling in the foaming waves; all that sticks out of the water is a portion of his head and the upthrust arms with their conspicuously clumsy hands. Two bulky wooden devices drift in the water; no doubt intended to be floating havens of rest, here they are impediments on which one might well injure oneself. Singular too is the compositional arrangement; the ocean towers between sandy beach and palatial houses in a wide band that defines the painting, and yet it seems that the figures could not find adequate room in it. A key to the interpretation of this curiously false-bottomed picture may lie in the contrast between the veiled figures on the one hand and those who expose themselves openly to the

water on the other. Both, however—those who withdraw from nature as well as those who surrender to it—do so unwillingly. The former are locked into the roles they have taken on, causing them to appear ridiculous and out of place. The latter act woodenly and awkwardly in their exacting play. They are far removed from the unrestrained, self-assured cheerfulness of Arnold Böcklin's *Play of the Waves*, 1883, which one feels unintentionally reminded of here. C. Sch.-H.

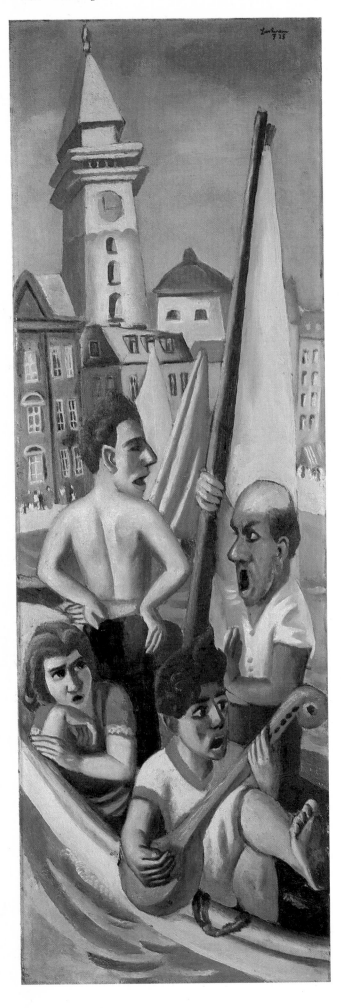

41 Italian Fantasy 1925

Oil on canvas; 127 x 43 cm.
s.u.r.: Beckmann F 25
Bielefeld, Kunsthalle
Göpel 238
Reference: Lenz, 1976, p. 22f.

This picture also derives from the trip Beckmann took to Pirano with his wife and son (cf. cat. 40). However, according to Mathilde Beckmann, the woman in the boat has to do with herself (compare the facial appearance with the portraits of Quappi, cat. 43, 45). Because the painting was begun in August of 1924 and completed in June 1925, it documents a significant biographical change. In early 1925 Beckmann was divorced from Minna Beckmann-Tube; on September 1 he married Mathilde von Kaulbach. The figure with his back turned is discernible as the physician Dr. Erich Stichel (cf. cat. 26), a friend of Minna's in Graz, and dates from an earlier phase.

Beckmann does choose a cheerful Mediterranean boat ride with mandolin music and expressive singing as his motif. But the figures seem to have no reference to one another. They are caught up in themselves as they sing sentimentally and threateningly, while keeping a melancholy watch. The expression of the two travellers is pensive. The gaze of the man in the bow is turned to the rear; the woman looks out aimlessly. It is precisely in the contrast between the Italian escort and the travellers that one senses that this trip is overshadowed by something in the past. The city goes unnoticed. With respect to the motif of the boat, free sailing does not take place: the sail hangs heavy, and the boat is lopped off and held captive by the edges of the picture. The tall, compact visual plane, together with the sealed horizon and enormously obstructive sails, suggest an inhibited movement, indeed a standstill which is further reinforced by the mandolin player who seems to be pushing away from the edge of the painting and yet unable to move. The *Italian Fantasy* affords no access to a "life of simply existing," but instead actualizes a situation of restraint, a problematic condition between departure and arrival, neither of which takes place.

Recent events had triggered a faint revival of the theme of a helplessly abandoned, crazy existence, which Beckmann was already fashioning in the paintings, *Carnival* (Göpel 206) and *The Dream* (cat. 23), among others, and now reappears. This no doubt is a reminder as well of the traditional motif of the ship of fools. The picture mutedly expresses the uneasiness communicated in the hooded figures and the neck-breaking waves of *Lido* (cat. 40). In *Galleria Umberto*, 1925 (Göpel 247) it intensifies into a vision of utter disaster. Two undated pencil sketches connected with this painting are in the collection of Wolfgang Swarzenski in Winterthur: the harbor with buildings and the tower depicted here; and sailboats in the harbor (von Wiese 110, 111). C. St.

42 The Bark 1926
(Play of the Waves)

Oil on canvas; 180.5 x 90 cm.
S.U.L.: Beckmann F 26
New York, Richard L. Feigen
Göpel 253

Reference: Fischer, 1972, p. 46 ff.

In the artist's catalogue this painting appears under the title *Play of the Waves,* an allusion to Arnold Böcklin's 1893 work of the same name.

A stout, twin-keeled rowboat and a tiny dinghy with a sail have come upon one another while cavorting about merrily on the water. A half-hidden figure sits alone in the sailboat, wearing a dark bathing cap, while seven persons occupy the rowboat. Beckmann displayed himself so often in a dark cap that it became one of his identifying signs. The couple in front is enjoying a playful game, which would most readily invite association with the above-mentioned Böcklin painting. However, the figure of the oarsman with the Italian flag and child, his back turned to us, conveys an attitude of serious concentration. He forms something of a barrier in front of the two women who, like icons, look as though they had been unselfconsciously captured in a photograph. The one on the right, possibly a veiled portrait of Quappi, appears to be drying herself off. Her bathing suit has slipped below her breasts. Frozen in time, her breasts framed by the diagonals of the white towel and the blue bathing suit, she takes on an almost ceremonial aura. The woman on the left, whose raised hands applaud as though to musical accompaniment, support that illusion.

The impression of an innocent summer frolic is aborted by the coloration. Boat and water alike are suspended in a chilly green, and the dual appearance of similar color coordination is noteworthy; white/green/red in the flags, yellow/red striping in the bathing suit and the wrap. A cool reserve dominates an almost symbolically powerful distribution of colors: the green has a crystalline effect, the red and yellow are too luminous to radiate a pleasant warmth.

The arrangement of figures and coloration, together with what, for Beckmann, is a novel spatial expansiveness extending toward the edges of the painting, introduces an enigmatic presence into what would otherwise be an innocuous situation. One gets the impression of a secularized ritual being performed, conducted with the iconic immobility characteristic of a tapestry. Banal everyday movements are transformed into meaningful symbols. The painting illustrates a more stable phase in the artist's work. Though always grounded in skepticism and enigma, he becomes master, for a time, over what is immediate and menacing, and is able to address problems concerning the art of painting with renewed energy.

C. Sch.-H.

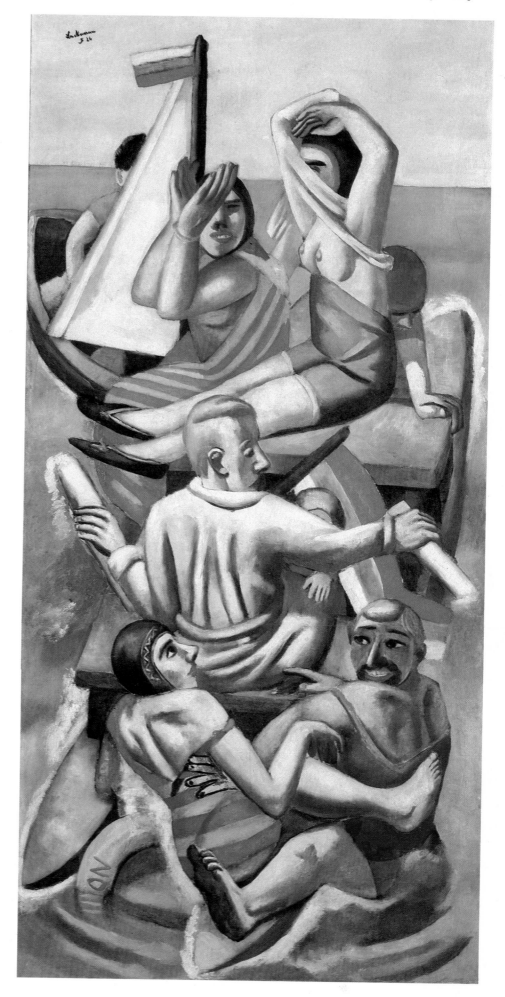

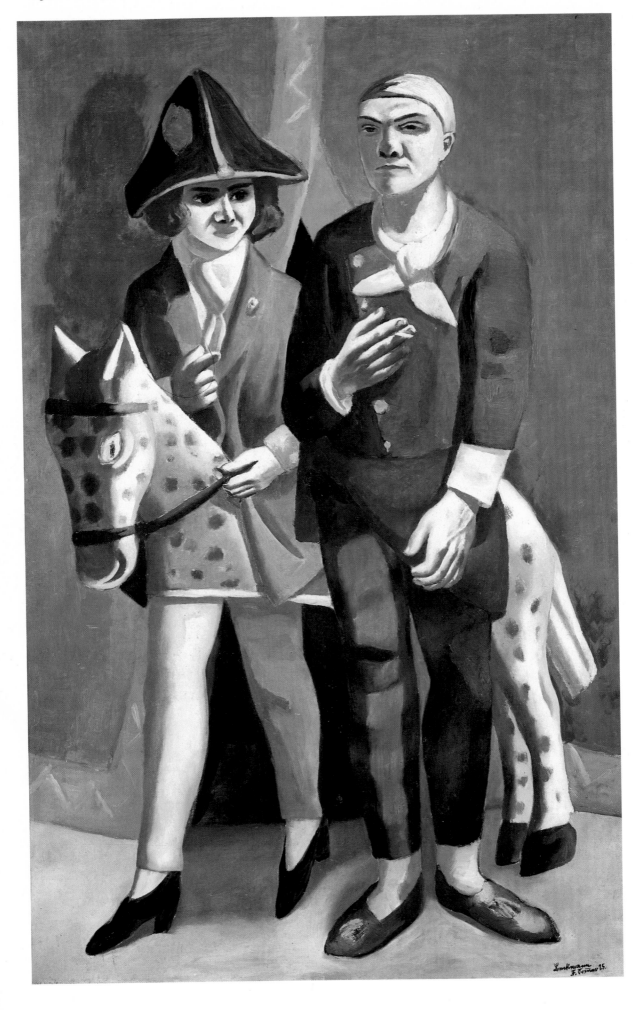

43 Double-Portrait Carnival 1925

Oil on canvas; 160 x 105.5 cm.
S.L.R.: Beckmann F. Sommer 25
Düsseldorf, Kunstmuseum
Göpel 240

References: Jedlicka, 1959, p. 126; Fischer, 1972,
p. 40ff.; Evans, p. 15f.; Lackner, 1978, p. 74;
Zenser, p. 78.

Two decisive events in Beckmann's life oc-
curred in 1925: his marriage to Mathilde von
Kaulbach in September and his appointment to
the Städelsche Kunstinstitut in Frankfurt.
Beckmann had gained artistic recognition and
had found in his second wife a partner for life.
It is surprising then, that this painting con-
ceives the new situation so joylessly. Both
figures stand as actors of preordained roles on
a carnival stage, or in a circus arena. He is the
white-faced clown who in his puppetlike, pas-
sive melancholy exposes himself unprotected
to what confronts him. She is a story-book
creature, part woman/part horse, who actively
paces around on the stage. The color
tonality—gradations of violet for him, warmer
gradations for the woman—supports the allo-
cation of roles. Reifenberg had already seen
the helpless and dejected attitude of the Pierrot
figure in connection with the painting, *Gilles*,
1717-19 by Antoine Watteau (see fig. p. 36). In
contrast, Quappi plays the lead role. She
guides not only the 'horse,' symbol of chthonic
powers, instinct, death, and life: but by stride
and costume she guides Pierrot and protects
him from the dark fissure between the tent
sheets. Under her gaze he is able to raise the
hand with the cigarette hesitantly and aim his
eyes outward. In this double portrait two
things are reflected. One is the fundamental
relationship between the artist and his wife: "It
is an angel that has been given to me..." The
undisguised double-portrait of 1941 (cat. 95) is
a variation on this relationship in a new con-
text. The other aspect is the important phase of
self-discovery which had already begun in 1920
(cat. 25, 31, 25) and is capsulized here.

C. St.

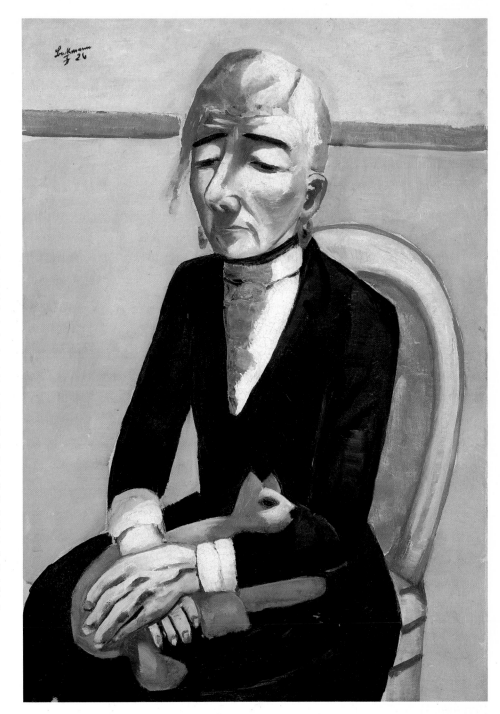

44 Portrait of an Old Actress 1926

Oil on canvas; 100.5 x 70.5 cm.
S.U.L.: Beckmann F. 26
New York, William Kelly Simpson
Göpel 255

Reference: Erpel, No. 10.

Max Beckmann has portrayed the actress
sitting quietly, but also with the tension
demanded by the upright posture of this old
lady. A first indication of this person's bearing
is given by her clothing in the dense blue-black
coloring and hard outline of her dress against
the light background. From the tranquil
expanse below, where the large dark oval form
of the cat and the hands laid on top of one
another create a cohesive serenity, it climbs
upward tautly, closes high around the neck,
and frames the shoulders angularly. The
austere form of the large white breast piece
also depicts indirectly the figure's bearing. At
the same time this breast piece supports the
head, leading up to it and accentuating its
importance. The head has a far more differen-
tiated effect than anything else in this portrait
due to the broad brushwork and is thus able to
communicate the most subtly variegated expres-
sion. Because of the age and fragility of the
woman, the head has a tendency to sink; yet it,
like the upper body, is held up by tense effort.
This can be seen as well in the lowered eyes
and raised eyebrows. The natural impulse to
relax amid all this tension is shown in the hands
folded on top of one another; thus the lowered
eyes lead one back to the region of the lap,
even if the gaze is actually turned inward.

In this portrait Beckmann has represented
the conflict between the frailty of old age and
the exertion of the will in the form of a genteel,
self-possessed bearing which moves the
beholder to respect. We do not know the iden-
tity of the woman. In type, she is reminiscent
of the artist's mother-in-law, Frau Tube, par-
ticularly as he painted her in 1919. Frau Tube
and similar elderly women often appear in
Beckmann's multi-charactered paintings as
well, not infrequently with young, erotic
women. There they represent the sibyl, whose
physical appearance reveals the transitory,
beyond which her deeply knowledgable soul
has risen.

C. L.

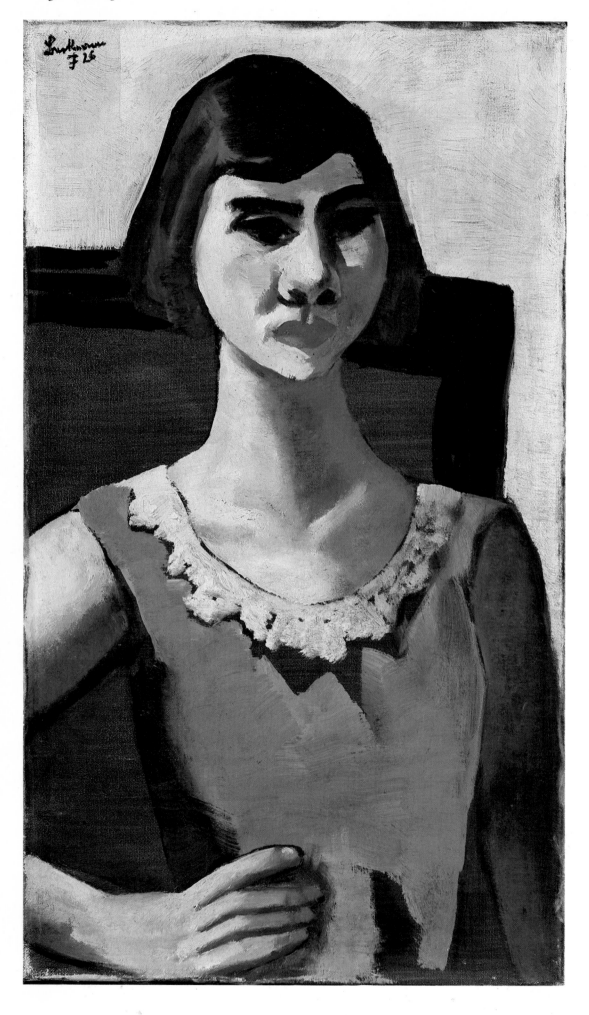

45 Quappi in Blue 1926

Oil on canvas; 60.5 x 35.5 cm.
s.u.l.: Beckmann F26
Munich, Bayerische Staatsgemäldesammlungen,
Staatsgalerie moderner Kunst
Göpel 256

References: Göpel, 1956, p. 133; Selz, 1964, p. 41;
Göpel, *Universitas,* 1965, p. 611.

In a lucky run of a mere three days, Beckmann produced this portrait in which the luminous coloration signals a new phase in his development. The setting too is radical: situated in the closest possible foreground, lopped off severely by the edges of the painting, and tightly fixed in its plane by the blue-black frame placed behind it, the figure is constructed with the utmost objectivity. Strong contour, cubist forms, and a faceted surface combine with tonal contrasts which in the most extreme sense pit white against black. The blue of the dress splits open to dark spots; and portions of the neck and face come into relief as if tilted away from the shaded regions. Particularly striking is the antithesis between the dazzling brightness of the cheek and the deep-etched black of the eyes. The powerful construction presents a figure of someone who is at once awkward and recalcitrant. Her character is further accentuated by the falling corner of the inner frame and the open angle of the projected arm. This forceful structure is balanced, however, by the blue, which retracts the compact volumes, opens the painting, and pulls the figure, in spite of its nearness, back into the distance. The triad formed by the luminous, coldly broken blue of the dress, the gray-blue of the color mass behind, and the light background already mystifies the figure in the direction of Beckmann's impending mythological conception. Even the undercoating is in blue. C. St.

46 Portrait of the Duchess of Malvedi 1926

Oil on canvas; 66.5 x 27cm.
s.u.r.: Beckmann Spotorno 26 La Duccessa
di Malvedi
Munich, Bayerische Staatsgemäldesammlungen,
Staatsgalerie moderner Kunst
Göpel 259

References: Reifenberg, 1949, p. 23;
Göpel, 1956, p. 133; Selz, 1964, p. 41.

According to information furnished by Mathilde Beckmann, the woman portrayed is a lady of high Italian nobility whom the Beckmanns came to know during their stay in Spotorno on the Riviera. Mrs. Beckmann reports that the woman's name was changed in the signature, since beyond the acquaintance made during the vacation no further contact took place. In all likelihood we have here a member of the family of the Counts of Malvinni-Malvezzi, who to this day bear the title Ducca de Santa Candida. The pictorial conception resembles that of *Quappi in Blue,* dating

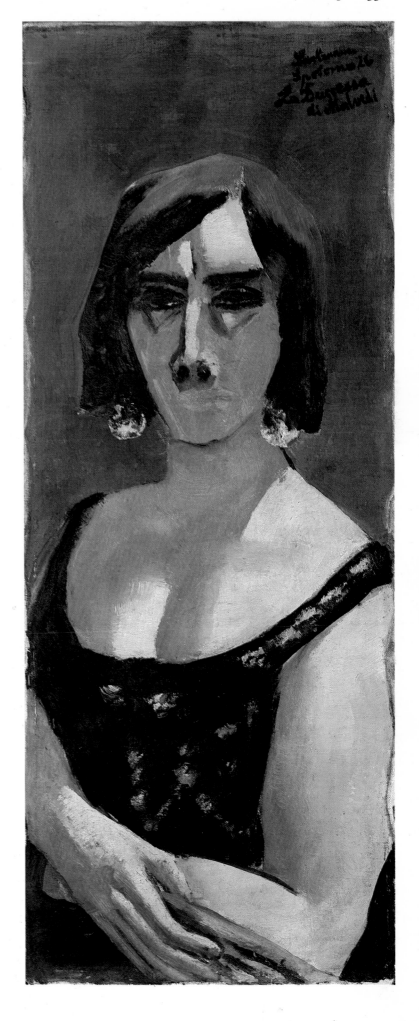

from the same year (cat. 45). Squeezed into the narrow format, the half-figure develops forcefully with its compact masses and the tensive relation of arms and shoulder line. The extreme accentuation of white (a new pictorial device since 1925) generates, in conjunction with the shadow regions of the flesh color, a plasticity which seems to press against the narrow, encroaching boundaries of the painting. Man is no longer passively confined, but has become a compact, contradicting existence. This consolidated force is a characteristic of Beckmann himself (cf. fig. p. 62). The sensuous posture of the Minna of 1924 (cat. 37)—one might compare the motifs of arms and fans —has been transformed into a new dynamism. Singular, yet familiar from his other work, is the demonic aspect of this woman who, by virtue of her exotic visage, the extreme patterns of light, and the austere gray-black and green-ochre color tonality becomes a sinister, sphinx-like apparition.

Unusual as well is the quality of the painting which, as in the 1929 *Portrait of an Argentinian* (cat. 55), leads to free expression in the face and at the parting of the hair. Beckmann inserts brown folds into the greenish flesh color under the eyes and a diffused red in the mouth. The hair in red-violet is set strangely against a surrounding field of gray. It is possible that with this portrait Beckmann was able to come to terms critically with Gauguin, of whom he did not think highly. The hard detail of the V-shaped forms under the eyes probably refer back to improvisations by Picasso during his so-called Negro period. The person depicted can be found once more in the painting of *The Beach,* 1927 (Göpel 267). C. St.

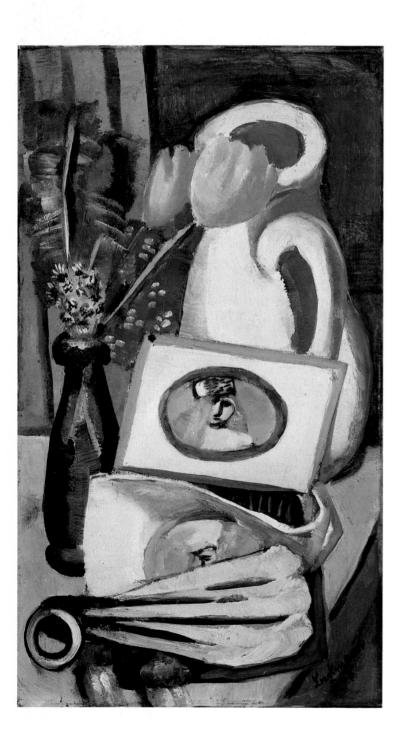

47 Still-Life with Cigar Box 1926

Oil on canvas; 60.5 x 35.5 cm.
S.L.R.: Beckmann F 26
Munich, Bayerische Staatsgemäldesammlungen, Staatsgalerie moderner Kunst
Göpel 264
Reference: Fischer, p. 74.

This painting takes up once more the motif of the cigar box which we first encountered in *Still-Life with Burning Candle,* 1921 (cat. 27). A comparison of these works makes clear how much freedom as an artist Beckmann had achieved in those few years since 1921 and how much he had replaced traditional iconography with objective studies. Where the earlier still-life had linked its several objects within a cool, symbolically demonstrative context of meaning, this work develops meaning merely from the compactness of the objects depicted and from the unifying composition. In tight sequence the fan, bowl, cigar box, and pitcher rise stepwise one after the other, accompanied by the vase from which the two red tulips press toward the opening of the pitcher. While the vase with the curtain placed behind it is reminiscent of still-lifes by Henri Rousseau, the arrangement as a whole anticipates the principle that was to remain definitive even in Beckmann's late still-lifes (cf. among others cat. 83). The skewed view of the table produces a steeply ascending order which closes the space to the viewer. The world of things becomes inaccessible. Just as the fan, with its enigmatic symbolism, had appeared in the large still-lifes (cat. 38; fig., p. 29), so does the dark, violet-colored view represent the counter-world of the mysterious unknown (cat. 25, 26). Transitoriness is visually depicted by the flowers. The differentiated reverberation of yellow, gray, and white tones is in keeping with the use of lighter colors from the mid-1920s on.

 C. St.

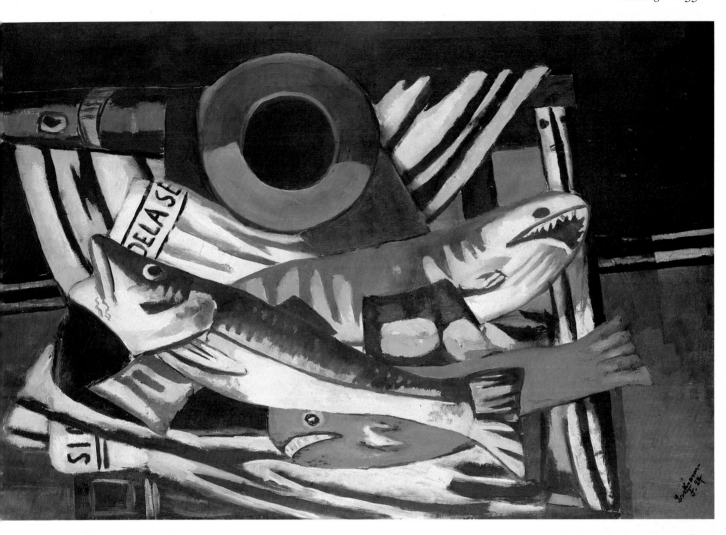

48 Large Still-Life with Fish 1927

Oil on canvas; 96 x 140.5 cm.
S.L.R.: Beckmann F. 27
Hamburg, Hamburger Kunsthalle
Göpel 276

References: Thwaites, *The Art Quarterly* 14 (1951)
277; Hentzen, *Jahrbuch der Hamburger
Kunstsammlungen* 3 (1958) 46, p. 15; *Katalog der
Meister des 20. Jahrhunderts in der Hamburger
Kunsthalle,* 1969, p. 12; Fischer, 1972, p. 76.

The impetus for this still-life presumably can
be traced to impressions Beckmann had of Ital-
ian harbors during his travels. In commenting
on this painting, Göpel observes that when
completed the letters no doubt add up to the
name of the Italian newspaper CORRIERE
DELLA SERRA, and the SI in the lower left refer
perhaps to SIMOLIN. Three fish lie on a table
partially covered with cloth and newspaper.
Above the fish the funnel of a wind instrument
faces the viewer. The colorful still-life is
encompassed by a dark background. A line
running horizontally divides the background
into two color zones of brown and black. In the
foreground the objects displayed are situated
within the rectangle projected by the table; a
triangle is formed when the opening of the
wind instrument is included. Above these
severely geometric forms, the composition

builds in rhythmic waves, which are manifested
in the cloth and the fish carcasses, ranging up
to the blue opening of the saxophone. The
table appears to be standing folded up in the
painting's forward plane.

According to Fischer, the saxophone's horn
symbolizes power in the sense of mastery of the
Life-force, or vitality. Busch compares the
instrument to a coiling snake, thus bringing a
feminine element into the interpretation,
where fish represent phallic power, fertility,
and life. Together with the newspaper, which is
a symbol of the passage of time, there is a
reference to the *vanitas* theme common in
Dutch still-lifes of the 17th century. However,
because of the aggressive coloration of the
open-mouthed fish carcasses and the mouth of
the instrument, we feel we are being sucked
into the painting's depth. But if one takes into
account Beckmann's statements about his rela-
tion to space, a more ambitious interpretation
suggests itself. This painting is one of the first
in which Beckmann inserts black coloration in
order to open space infinitely; behind and sur-
rounding the objects whose colors form the
comprehensible foreground is space, which for
Beckmann is the "palace of the gods" and the
"infinite deity." In the face of unintelligible
space he is afraid; against it he must, according
to his own testimony, protect himself. The

objects represent life by virtue of their symbol-
ism and their arrangement. As geometric
forms they are confined within an artificial con-
struct to prevent them from becoming lost in
the infinity of space opened up by the dark-
ness. M.B.

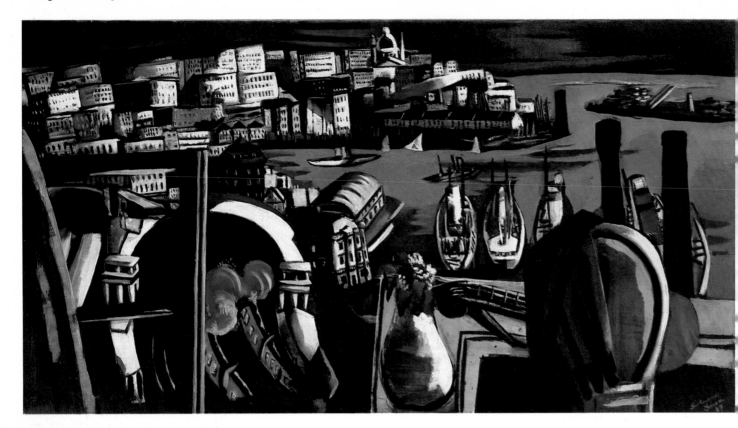

49 The Harbor of Genoa 1927

Oil on canvas; 90.5 x 169.5 cm.
S.L.R.: Beckmann Genua 27
St. Louis, The Saint Louis Art Museum,
Bequest of Morton D. May
Göpel 269
References: Selz, 1964, p. 43; Lenz, 1976, p. 29f.

From a high vantage point, one's view ranges
over the harbor of Genoa at night, bathed by
the moon in a cold light. The metallic tonality
of dark blue-green, black, white, and a faded
yellow in the foreground dispenses a surreal,
magical mood, reminiscent of visionary realist
paintings like those of Franz Radziwill. How-
ever, the formal pictorial organization is
plainly neo-objective which is characteristic of
Beckmann's chosen mode of abstraction.

There is at first the abstract detail of the
architecture. Only the panorama as a whole
communicates the impression of Genoa's har-
bor. Taken by themselves, the individual
edifices—except for a few orientational aids
such as the church and the tunnel—are flat and
faceless forms that only hint at some anony-
mous city or other. Secondly, the variety of
visual foci creates an abstractness in the discon-
tinuity of perspective. Things are seen now in
extreme horizontal perspective, now obliquely
from below, now collapsed into a plane sur-
face. Although one's gaze does indeed origi-
nate from a balcony objectively situated on a
higher level, this nevertheless does not necessi-
tate that the city as a whole would actually
come into view beneath the viewer. The effect
is much more of a frieze-like arrangement com-
posed of different perspectives. Because of the
way in which individual groupings of objects

(ships, railroad station, sea, houses, sky) are
piled on top of one another, all parts attain
equal importance. And although one's view
does move from a higher vantage down to the
harbor, it does not actually lead into the spatial
depth. Before it stand the green barrier of the
sea and the blackness of the night sky, neither
of which suggests an infinite expanse but rather
an impenetrable wall. Finally, there is abstract-
ness with respect to the coloration, i.e., its
extreme confinement to a few powerfully con-
trasting values. By being so closely linked with
emphatically surreal, enigmatic visualizations
of objects (to what, for instance, does the free-
swinging casement on the left, with its flutter-
ing green curtain belong?), visible actuality is
here radically reconstituted as a balance be-
tween Abstraction and Realism. In this respect
Beckmann is comparable only to Picasso.

C. Sch.-H.

50 Scheveningen, Five a.m. 1928

Oil on canvas; 56.5 x 63 cm.
S.L.R.: Beckmann F. 28
Munich, Bayerische Staatsgemäldesammlungen,
Staatsgalerie moderner Kunst
Göpel 293
Reference: Reifenberg, 1949, p. 23f.

This painting is closely related to a drawing
that presumably was done in Scheveningen
early in the summer of 1928 (Bielefeld 134).
The drawing, however, shows the beach and
boardwalk later in the day and therefore popu-
lated, whereas the effect of the painting has to
do with the deserted scene in early morning.
Beyond that, in the painting everything is rep-
resented as being seen through a window,
whereas in the drawing this indication of a
beholder is lacking. The gaze of the beholder
through the window whose curtain has been
thrust aside perceives the glowing red sunlight
as the *event* of daybreak. Beckmann, however,
does not allow this event to take place in pure
nature, but to a high degree brings workaday
things into the picture. Among these are the
hotel window ledge with a wine glass, the pavi-
lion with the cigarette advertisement ROCHT
MIS BLAN (correctly and in full: ROOKT MIS
BLANCHE), the boardwalk with the street
lamps, and the bath huts drawn close together.
Sea and sky too are flooded in sunlight; they
are lifted up into the light, and thereby lose
their familiar character.

The sun itself is not visible, only its reflection
is. But the latter is so intense that one can infer
an imposing view of the rising sun. By depriv-
ing both the viewer and himself of the actual
sight, Beckmann has made the sunrise an over-

whelming cosmic event that can be perceived and endured only indirectly. Not until fifteen years later will he illustrate the verse from Faust II for which this painting had already created a symbol: "For us, life is a matter of colorful reflection." C.L.

51 Evening on the Terrace 1928
Scheveningen at Sunset

Oil on canvas; 95.5 x 35.5 cm.
S.L.R.: Beckmann F 28
New York, Richard L. Feigen
Göpel 296
Reference: Lackner, 1978, No. 17.

Beckmann has confined this view of the sea within a very narrow vertical format, limited still further by a curtain. From a high terrace one looks out over the arched lamps and row of bath huts on the boardwalk, across the beach partially washed over by the water and thus reflecting the sky, and finally out over the shore with the breaking waves and the deep blue sea up to the horizon. There the setting sun breaks through evening clouds which rise up before the open sky. One's gaze is not expansive, but travels into the distance, straight towards the day's final event: the pinkish evening light which flares up one last time before being overwhelmed by the approaching night. The gathering clouds approach, leading the viewer, like the painter on the terrace, to expect the total darkness which will refer him back to himself. In this sense the terrace and the curtain have a restrained symbolic character. C.L.

51

50

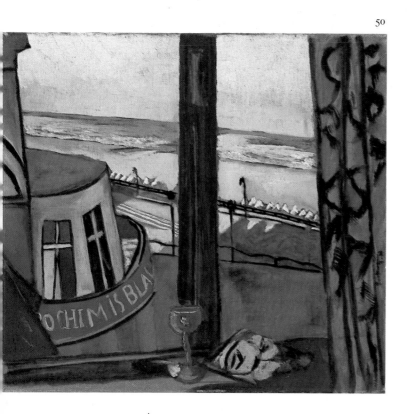

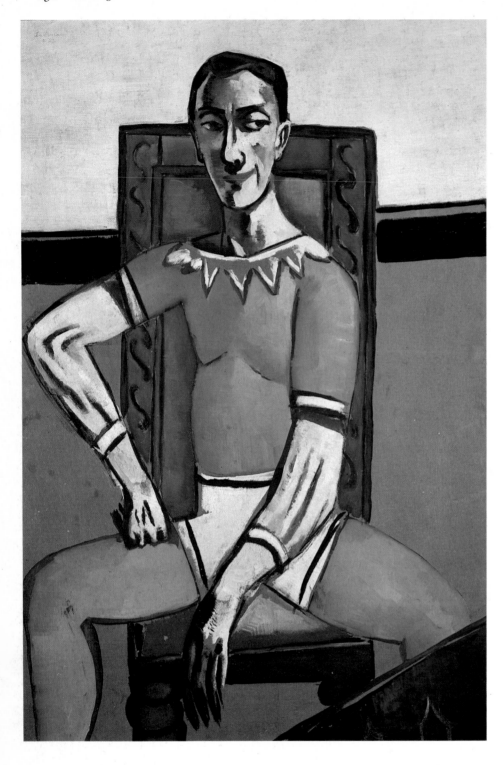

compact, sculptural substance out of which volume is formed.

The individual represented is the Russian actor, Nicolai Michailovich Zeretelli, a member of the avant-garde Moscow Chamber Theater, which gave guest appearances in Europe during the 20s with sensational success. His demeanor here may reflect the choreographic and theatrical representations, which were also formulated by Zeretelli. According to Göpel, he particularly denounced illusionistic stage depiction which is replaced here by geometric constructions, the dominance of verticals and horizontals, and the severity of the harlequin costume. Zeretelli also appears in several of Beckmann's other works. C. Sch.-H.

52 Portrait of N.M. Zeretelli 1927

Oil on canvas; 140 x 96 cm.
S.U.L.: Beckmann F 27
Cambridge, Mass., Fogg Art Museum,
Harvard University,
Gift of Mr. and Mrs. Joseph Pulitzer, Jr.
Göpel 277
Reference: Göpel, 1976, I, p. 202.

In spite of differing treatments of volumes, space, and color, Beckmann approaches in striking fashion the pictorial language of Pablo Picasso in the early 1920s in this painting. The seductively sensuous effect of a color gradation inclined to generally reserved blue-gray, gray-beige, and red-violet tones; the pictorial effect of having been powdered over with gray; and the insistence on austere basic forms which presuppose developments in Cubism demonstrate the classicist tendencies of the 20s. Also represented by Picasso from time to time, it is a conception which unquestionably presupposes a self-confident, successful artistic personality, as set forth in the self-portrait of 1927 (cat. 53). A further parallel can be made to Picasso's Blue Period, in which a similarly forlorn gaze of silent endurance is articulated. But the painting differs markedly from the comparable examples mentioned: color is conceived as a

53 Self-Portrait in Tuxedo 1927

Oil on canvas; 141 x 96 cm.
S.L.R.: Beckmann F. 27
Cambridge, Mass., Busch-Reisinger Museum,
Harvard University, Museum Purchase
Göpel 274

References: Lackner, 1969, p. 58 (originally 1938);
Reifenberg, 1949, p. 22, No. 247; Göpel, 1957 (2),
p. 11, 59; G. Schmidt, 1960, p. 14; Busch, 1969, p. 28,
30, 32; Jedlicka, 1959, p. 123f.; Selz, 1964, p. 42f.,
53; Fischer, 1972, p. 65ff.; Evans, p. 16; Lackner,
1978, p. 82; Erpel, No. 12; Zenser, p. 79ff.

For the only time in his work, Beckmann presents himself as a person who confronts reality self-confidently, powerfully, and openly. The figure is constructed from the central axis of the pictorial field, sternly facing forward. Not merely the pose, but the resilient posture, the sovereign hand propped on the hip (a motif since 1926—see cat. 45), and the negligent hold of the cigarette help establish his clear, self-assured place. The block-like black of the tux-

...edo steps expansively and concentratedly in front of the open background. A comprehensive equilibrium defines the composition: both horizontal and vertical lines correspond in the figure, the curtain, and the wainscoting, generating a quiet calm which is confirmed by the massive black, white, golden brown, and gray color tonality. The soft contour of the silhouette reaffirms the succession of V-forms which travel across the root of the nose, the corners of the mouth, the collar, and the shirt front, across the splayed thumbs and down to the narrow parting between the legs. The contrast of black and white, of shadow and light, is staged in such a way that things attain an unexpected life of their own and yet are able at the same time to remain part of the pervasive calm. Thus the white carves out sharp, well-defined incisions; the hands hover luminously and animatedly in front of the black; and the face flickers as a cool shadow might spread over an expanse of water. In place of a suffering, remonstrating, and provocative Beckmann (cat. 26, 36) we find an individual who knows himself to be at the height of his powers and in the center of his world. Beckmann calmly takes over the space that was still restricting him in 1926 (cf. fig. p. 62). He has now obviously come to terms with both: the menacing darkness which begins in the fold of the curtain and comprises the entire zone of the left edge, and the luminous area which opens out limitlessly upward and to the right. In this light and dark one can see, as one could in earlier works, metaphors of the unknown. The infinite, however, no longer appears demonic.

"It's all there..." The person thus depicted is "an individual who is at home in the world." This interpretation by Lackner of the socially successful Beckmann must be expanded by reference to another important dimension. The indeterminable locale, the monumental size, the distance, the striking contrasts, the powerful black, and the mysterious self-illumination all express, in conjunction with the role of elegant and prominent citizen, an authoritarian pretension to leadership. Fischer sees in this Beckmann the Magus and despot; Jedlicka sees the embodiment of a "self-assertiveness driven to such a limit that it turns into self-mockery, the painter as a man of the world being transformed into lecturer about himself." "The Artist in the State," a piece Beckmann published only a few months before completing the painting, corroborates this perspective. Beckmann here speaks out against man's metaphysical dependence (a topic of earlier years), and designates as the goal of a free humanity the individual who must accept absolute self-responsibility and must himself become God. The cultural and religious focal point of this self-deification is alleged to be art. The complete equilibrium in a work of art reflects "autonomy in relation to infinity," the idea of "power and influence on the basis of self-responsibility." "New edifices are needed for the practice of this new faith and the new cult of attained equilibrium... What is at issue is an elegant mastery of the metaphysical. To live an austere, clear-headed, disciplined romanticism enabling us to live our own existence, one that shall be as "unreal" as possible.

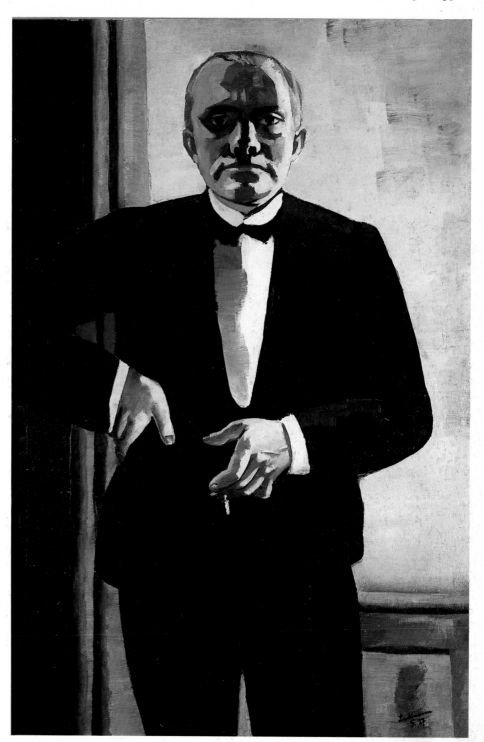

The new priests of this new Center of Culture must appear in black suits or, at festive ceremonies, in tails... Indeed, and this is essential, the worker should appear in tuxedo or tails as well. This should mean: we want a kind of aristocratic Bolshevism." Beckmann as aristocratic worker and modern priest, which is a complete turnabout from his early Frankfurt years, defines the portrait, and characterizes a person who still feels threatened (contrast the harmonious self-portrait of 1907, cat. 8). The variable estimation of this self-portrait is significant. Purchased in 1928 by the Nationalgalerie in Berlin and sent with the Carnegie Exhibition to the U.S.A. for a year-long tour, it was judged by the majority to be Beckmann's greatest masterpiece since *The Night* (cat. 19); it was also criticized as being an expression of a Superman ideology. C. St.

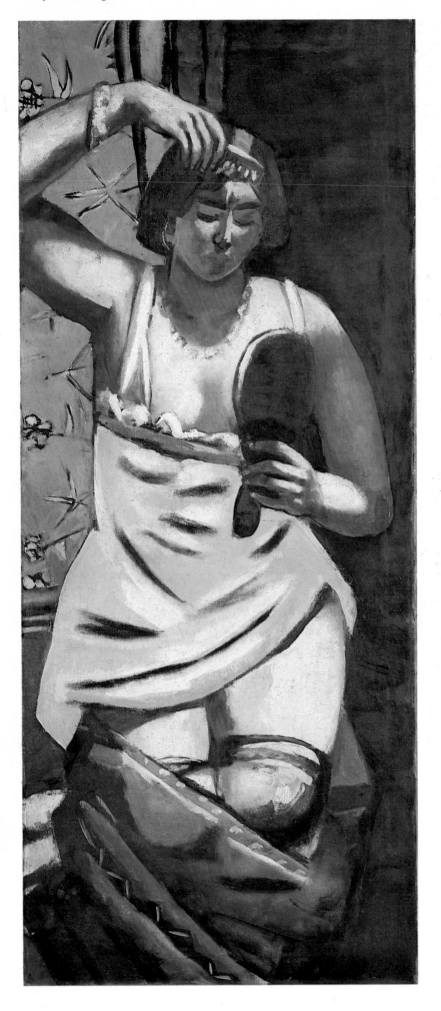

54 Gypsy Woman 1928

Oil on canvas; 136 x 58 cm.
Unsigned
Hamburg, Hamburger Kunsthalle
Göpel 289

References: Roh, 1946, p. 3; Platte, *Die Kunst des
20. Jahrhunderts,* Munich, 1957, p. 228, 230;
Hentzen, *Jahrbuch der Hamburger
Kunstsammlungen,* 3 (1958) 178; Fischer, 1972, p. 76.

The Gypsy woman, whom the viewer observes grooming herself in an intimate atmosphere, radiates a powerful vitality and sensuality. Compositionally this is expressed by means of the dominant verticals and accentuated by the narrow vertical format. The rigid middle verticals are enlivened by means of diagonals whose directions are patterned after the upraised arm, moving gently downward from the verticals.

The hefty physique of the figure is displayed by means of a harsh beam of light from the upper right. Flashes of chalky white and pale violet shadows bring the curves of the figure and the draping effect of the fabrics into prominence. Even though the face and hands are fine-featured, the body's massiveness and its cold coloration are underlined by the ochre-colored surface in the background as well as by the black on the right side. These elements cause the contour of the body's left side to attract particularly strong attention. The contrast between tangible nearness and the black void displays Beckmann's preoccupation with the relationship of bodies to space.

The woman is scantily dressed in a raised light green slip and blue stockings. The red embroidery on the slip and stockings provides delicate color accents. Between skirt and stockings her tightly closed naked thighs are visible. The Gypsy woman seems to be sitting on a bench, suggested only by means of the tapered thighs. She is placed directly before the viewer, as if she were being offered to him. She does not offer herself, for eye contact with the viewer is missing, thus the impression aroused by her frontal presentation is retracted. The Gypsy woman is busy with herself, self-absorbed in her mirror image. It almost seems as if by means of the position of her arms she means to protect herself from something or someone. The shawl at the woman's feet provides an additional protective device. It is thrust into the foremost plane of the picture and creates a barrier that holds the viewer at a distance.

The mysterious tension in this painting no doubt stems from the antitheses that are united in it: tranquility and vitality, tangible nearness and imponderable space, sexual invitation and aloof distance.　　　　　　　　　　M.B.

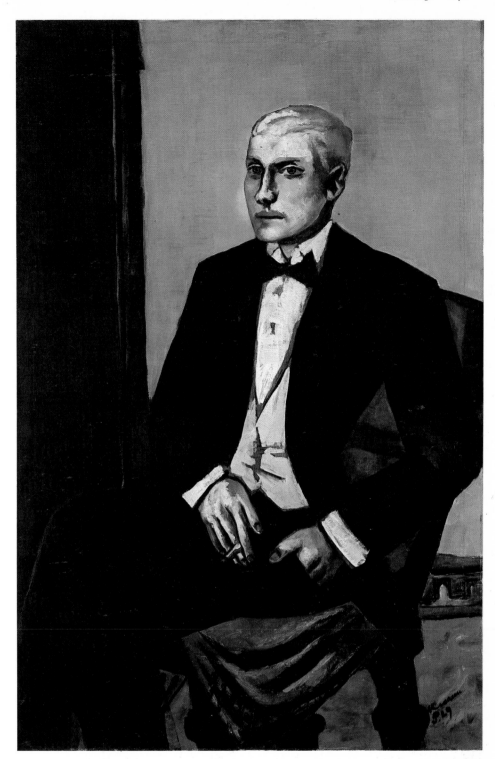

55 Portrait of an Argentinian 1929

Oil on canvas; 125 x 83.5 cm.
s.l.r.: Beckmann P.29
Munich, Bayerische Staatsgemäldesammlungen,
Staatsgalerie moderner Kunst
Göpel 305.

According to his wife's report, Max Beckmann made the acquaintance of the young Argentinian depicted here at the Grand Hotel in St. Moritz, where the Beckmanns were spending Christmas. The young man drew Beckmann's attention because he, unlike the rest of his lively and temperamental family, seemed to be introverted and enigmatic. Beckmann began painting the portrait immediately after his return to Frankfurt.

The young man is turned toward the viewer in half-profile. He is sitting cross-legged, with one hand in his trouser pocket and the other holding a cigarette, on a chair whose back and legs are cropped by the picture frame. The compositional structure sustains a rigid posture. The man's head and upper body shift away from the central axis to the right. It is noteworthy that angular, tilted forms were employed almost exclusively. The irregular lozenge shape, outlined by the left half of the body and the left arm angling away from it, describes the form of the composition. The entire upper body is harnessed within this rhombus and its variations of different sizes.

The visual focus of the painting is held by the face, with its singular color gradations of white, yellow, and red. The person behind this mask-like visage is not in touch with his outer appearance or the space surrounding him. In the festive black tuxedo lurks a man whose fixed gaze bypasses the viewer, revealing that his thoughts are far away from what is happening around him. Evoked by the theatrical face are images of the actor and the clown after a performance. The room, indicated by the unadorned wall in the background, suggests an oppressive void. Out of keeping with most of Beckmann's portraits, it contains not a single personal attribute nor any object having symbolic reference. Through the luminous black on the left, space opens ambiguously onto unfathomable depths. The Argentinian seems not actually to sit on the chair, but rather he appears to be hovering, for he nowhere touches the floor. His legs, like those of the chair, are cut off by the picture's edge as if he were no longer sitting with both feet on the ground. As Günther Franke discovered, the young man committed suicide shortly after his stay in Switzerland. M.B.

56 Soccer Players 1929

Oil on canvas; 213 x 100 cm.
S.U.L.: Beckmann F. 29
Duisburg, Wilhelm-Lehmbruck-Museum
Göpel 307
References: Linfert, 1935, p. 66, 76; Buchheim,
p. 72; G. Schmidt, 1960, p. 14; Lackner, 1978, p. 90.

The theme of sports is especially inviting for a contemporary consciousness that experiences modern times euphorically in movement, mechanics, and vitality. Thus games like soccer or rugby, which became popular in the second half of the 19th century, can serve as symbols of mass culture and mechanical thinking, but also as emblems of human existence. Beckmann's pictorial style is a continuation of the dynamic compositional series of Robert Delauney (such as *L'Equipe de Cardiff,* 1912/ 13) and Fernand Léger (among others, *La noce,* 1910/11, *Les acrobates,* 1918) Cubistic compartmentalization and the rhythmically staggered sequence of gestures characteristic of Futurism are transformed into an "objective Expressionism."

Crowded into a narrow space and closely interlocked, five players are piled high along a measuring rod. Brawny, thickset bodies, angular and bulging biceps, and checkerboard alterations of white, gray, black, and violet generate a rhythm which precipitously and mechanically runs through the group all the way to the top. The wrestling along the ground and the victor's unimpeded throw of the ball across slanting positions and angular forms create a composite in which strength, the battle, and victory are glorified. Because of its violent and drastic structure, the painting has been criticized as being a peerless ode to the mindless use of muscles, and the expression of society's power complex.

Surely this staging of the theme on a large scale can also be traced back to the exaggerated standpoint Beckmann had adopted in 1927. But just as in *Self-Portrait in Tuxedo* (cat. 53), man's absolute self-responsibility is viewed rather grimly here as well. Fixed by black outlines and rigid construction, the players are caught in their individual actions, their sequence of movements frozen into a static monument. There is an automatized mode of behavior in which each individual is a cog in a gear-work. Man as machine, a criticism of the times often found in Expressionist literature (Wolfgang Rothe, *Tänzer und Täter,* Frankfurt am Main, 1979, p. 112 f.), would appear to be this painting's pessimistic theme. Drastic exaggeration, the labyrinthine intertwining of bodies, sport that is more violent than playful, and the grotesque presence of the measuring rod drives this interpretation home. By associating the sport with manmade constructions in the background, Beckmann portrays human life as a battlefield and an assault on the heavens. Thanks to the player who points toward the megaphone and the program sheet, the ball game may be regarded as a metaphor.

A comparison of this painting with the composition of *The Trapeze* (cat. 33) makes Beckmann's evolution particularly evident. In place of a group of people all coiled up in one

another, unstably balancing each other and helplessly exposed, we now have the individual who is independent, but no less unrelated and trapped within himself. The equilibrium functions as deception, for "the labyrinth becomes narrower—even out of doors." C. St.

57 Artists by the Sea 1930

Oil on canvas; 36.5 x 24 cm.
S.U.L.: Beckmann F. 30
New York, Richard L. Feigen
Göpel 332

The clumsy figures, pressed into a tiny format, have a brutish presence about them which contradicts the actual size of the painting. The massive bodies of these young men are so crowded within the dimensions of the frame that they seem altogether too short, as if they were deformed. This flies in the face of the situation itself, in which the expanse and dissipation of beach and sea appear to be nature in its very freedom. Whereas during the 1920s Beckmann had expressed the constriction of space by amassing objects within a defined area, now the figures themselves have become giants who find no room in the space made available to them. This reversal no doubt coincides with a change in meaning as well. These young men are not efficacious in the world, but instead are locked up within their ungainly bodies. They are completely given over to a conventional existence which causes their lofty, artistic endeavors to be ludicrously inappropriate.

The similarity to Picasso's figural types in the early 20s is obvious here: one is reminded, for example, of the *Pan Flute*, 1923 or the *Woman Sitting*, 1920. While Picasso accentuates the archaic and original, in this construction Beckmann emphasizes a crude awkwardness, an earthbound heaviness which unmistakably binds the artists to what is material.

C. Sch.-H.

58 Large Still-Life with Candles and Mirror 1930

Oil on canvas; 72.5 x 140.5 cm.
Unsigned
Karlsruhe, Staatliche Kunsthalle
Göpel 315

References: Reifenberg, 1949, p.9, 24f.; Busch, 1960, p.50; Göpel, 1962, p.91; S. Kaiser, 1962, P.45ff., 56; Fischer, 1972, p.69ff.; Fischer, 1973, p.23f.; Lackner, 1978, p.92; Bielefeld 1975 cat., vol.2, p.19f.

Among Beckmann's many still-lifes, this work has a special role, for the extreme horizontal arrangement uses the motif of the mirror to capture a picture within a picture. Two burning candles and one candle that has fallen over and been extinquished remind us of the transitoriness of life. Ever since his painting, *The Night* of 1918/19 (cat.19), Beckmann utilized the symbolism of the light of life again and again. The mirror which transforms reality into fleeting appearance and the heavy curtain are *vanitas* symbols from traditional painting. An unequivocal allusion to the vanity of earthly activity is provided by the upside down book, with the star symbols and the inscription EWIGKEI(T) (Eternity). Yet over and above this traditional allegorical meaning, the entire still-life bears an unmistakable imprint of Beckmann. Space and objects are not as they immediately appear. The mirror frame rests with its left edge on the black staging, whereas on its right, covered over by the folds of the spread, it stands suspended. The spread, together with the tilted book, moves into the plane of the mirror. The vase, by means of its convexity, water-level, and opening, shows two irreconcilable views, one flat and the other perspectival. The manner of reflection is entirely odd. While in place of the reflected vase a black rectangle protrudes massively into our field of vision, the pair of candles is repeated, although not in mirror-image but as a reality in its own right. The candles in the mirror do not drip; the spatial perspective on the candlesticks is carried through without interruption; and the distances to the surface of the mirror are inconsistent, for the candle placed closer to the viewer on the left is repeated closer up, yet the one pushed right up to the frame is seen as farther away. The candles in the mirror exist in a space of their own, in which black agglomerations rise up from below. Their green color field, like the blue in the portrait of Quappi from 1926 (cat.45), affords an unintelligible view out. Beckmann will write in his journal much later (31.12.1940): "The metaphysics of the substantive. The distinctive feeling suggested to us when we sense—this is skin... that is bone—within a vision that is entirely unearthly. The illusory character of our existence at the same time as the unspeakable sweet appearance of reality." This "metaphysics of the substantive" already occurs here, for the world behind the mirror begins to encroach on what is in the foreground. The black, Beckmann's "ominous black hole" of an infinite space, has already swallowed a portion of the left candlestick and is penetrating into the receptacle.

Together with the sweep of the folds in the spread, the black and white contrasts, and the light green rear wall, the candles seem to wander into the mirror's space which, with its curtain, opens like the stage of a theater. Locked within the green frame, the red-brown of the candles and drape, and the shadow lines of the gathered-up materials, the cycle of life takes place, designated by the word "eternity." One might compare the similar theme of *Still-Life with Gramophone and Irises* (cat.38) and the self-portrait of 1933 (cat.68).

Beyond the theme of transience, however, the painting is also a metaphor of the work of the artist, who encounters the mysteries of life as he portrays the world of appearances. (Compare the drawing, *Mirror on an Easel*, 1926, cat.164; the same ornamental mirror functions there as picture within a picture, accompanied by painting utensils and a tragic mask.) C.St.

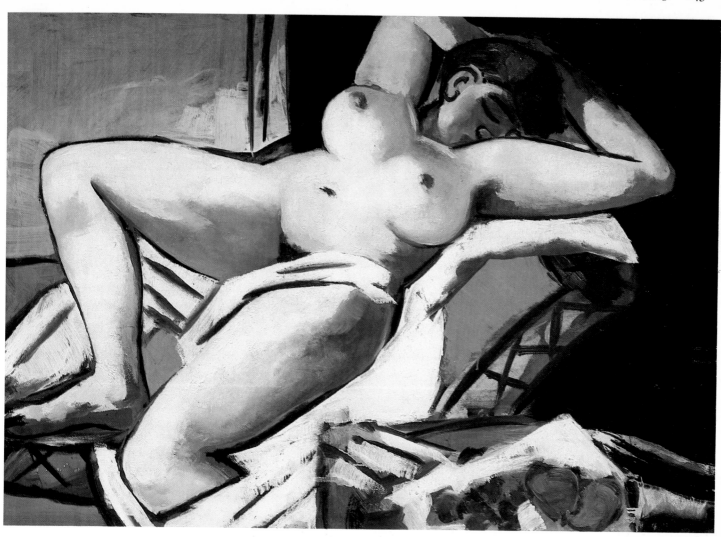

59 Reclining Nude 1929

Oil on canvas; 83.5 x 119 cm.
Unsigned
The Regis Collection
Göpel 308

Reference: London, 1974 cat., No. 13.

The body of this sleeping woman is composed of powerful parts. The angular forms of the arms and legs enclose a foreshortened trunk on which rest the two large breasts. The figure's active impulse finds expression above all in the position of the drawn-up leg and is carried out in the white sheet, which at several points surrounds the figure and in other places covers or crosses it. A correspondingly severe effect is produced by the lounge with its edges and grated design, as well as by the table and the angular forms of the cloth on which lies some fruit. The background has its own severity in the sharp division and abrupt change from black to light gray. Thus not only is the white female body with its rounded plastic forms itself encompassed within a large angular configuration, but it is further embedded within a relatively severe frame. In this confrontation between soft and hard, the sensually exuberant body proves superior. The artist has displayed a woman of extraordinary eroticism,

which even in sleep is disquieting for the viewer.

This nude is closely related to a drawing and an etching. The etching, *Sleeping Woman*, of 1929 (VG 320) reproduces the painting in reverse but with minimal changes otherwise. In contrast, the drawing (Bielefeld 132) shows notable deviations in the format of the presentation, in the proportions of the body, and in the things depicted. The position of the body, however, corresponds most closely to the one in the painting.

Göpel has proposed that the date "1929" on the drawing should be considered as part of its dedication (to Quappi) and not as its date of completion. He suggests that the drawing might well have been made in 1927, as a basis for the painting begun in that year, even though it is not a preliminary sketch but an independent work. There are no drawings from 1927 and 1929 which may be suitably compared to determine precisely the date of the present one, yet the relatively soft forms would suggest that 1929 is the likelier date. Accordingly, the painting would predate the drawing. Its figure is found in a preliminary form in an etching from 1922, *Reclining Woman* (VG 231). C.L.

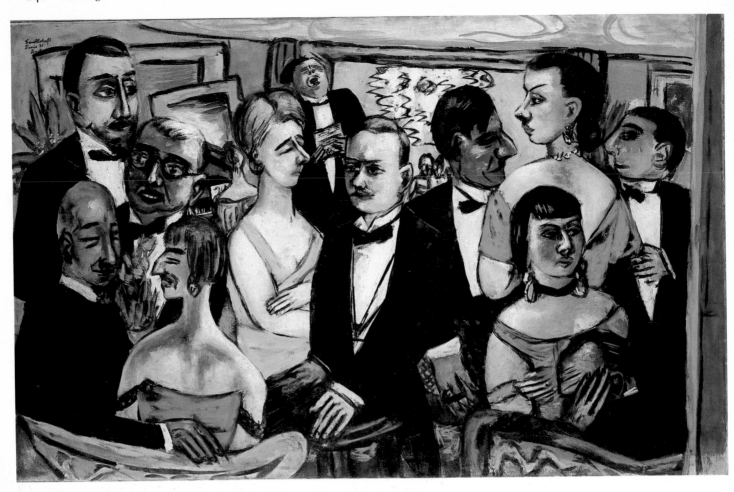

60 Parisian Society 1925/1931/1947

Oil on canvas; 110 x 176cm.
s.u.l.: Gesellschaft Paris 31 Beckmann
New York, The Solomon R. Guggenheim Museum
Göpel 346

References: Fischer, 1972, p.9off.; Göpel 1976,
I., p.244; Lackner, 1978, p.94.

This scene is a variation of a theme Beckmann
had already taken up in 1923 in the painting,
Dance in Baden-Baden (cat.34). However,
there is less emphasis here on social commen-
tary than on the theme that the individual
remains isolated even in the company of his
peers. Arranged next to one another as in a
frieze, these figures are so rigorously cut off
from each other by variations in size, striking
disproportions, stereotypical turns of the head,
dress, and coloration that no figure, however
close, can share the sphere of any other. Thus
the couples placed in the lower corners of the
painting shrink before the towering, large-
headed persons behind them. Profiles stand
locked in oblivious confrontation and all
glances remain unfocused into a void. The
figures are reduced to busts pushed edgewise
against one another.

The contrast of cold and warm tones, the
sharply incised black-white of the tuxedos, and
the specklings of a gloomy blue underscore the
pervasive mood of unconcerned estrangement.
The figures are individualized to the point of
being grotesque; obviously they don't belong

together. The area for singers and pianists
merely creates a foil for the solitary individual
who persists in a narcissistic display.

Beckmann painted the picture in 1931, fol-
lowing an invitation to the German embassy in
Paris. He touched it up in 1947, a few days
before his departure from Amsterdam, al-
though he left the signature intact. An early
version of the theme, dating from 1925, was
discussed by Beckmann only in writing. Traces
of the later retouching can be seen in the brittle
drawing of the lines, the added black, and the
morbidly altered flesh-tones. The concentrated
areas of black and white herald the eerie trans-
formation which the evening dress undergoes
in paintings like *Death,* 1938 (cat.82), or the
triptych *Blindman's Bluff,* 1945 (fig. p. 38-39).

Although the figures are not intended as
portraits, Mathilde Beckmann identifies them:
in the middle, Karl Anton Prinz Rohan; front
right with his head in his hand, the German
ambassador in Paris, Leopold von Hoesch; at
the right edge of the painting, the Frankfurt
banker, Albert Hahn; standing on the left,
perhaps the Parisian fashion designer, Paul
Poiret; sitting left, the Frankfurt music histor-
ian, Paul Hirsch. C. St.

61 Parisian Carnival 1930

Oil on canvas; 214.5 x 100.5 cm.
Unsigned
Munich, Bayerische Staatsgemäldesammlungen,
Staatsgalerie moderner Kunst
Göpel 322

References: Göpel, 1956, p. 135; Selz, 1964, p. 52;
Fischer, 1972, p. 89 ff.

This painting was purchased in 1932 by the Nationalgalerie in Berlin in connection with the installation of a Beckmann Room in the former palace of the crown prince. It takes up the oft-treated carnival theme, familiar since 1920, in a new manner. In the narrowest possible quarters, diagonally intersected, we find a masked couple, a musician, a chair, a houseplant in bloom, and the striped back of an easy chair, all crowded together into a tightly knit arrangement. On the trumpeter's upbeat a curious dance begins, but it is not so much a dance as an intermeshing of seduction, threat, and violence. The roles are reversed. Provocative and belligerent, the woman strides forth, appropriating space by virtue of her powerful build, forceful turn, and open stance. Her erotic figure unifies the action, for here the body is objectified through sharply glaring light and shadows, and a certain coldness is intensified through the interplay of a poisonous green, phosphorescent blue, and bright flesh toner. The ludicrous figure of a Hussar exists without space of his own. Shoved into the corner and blocked by the rear wall, the window lattice, and the black of the view outward, this soldier is reduced to the guise of an unwieldy, woodenly straddled puppet, without firm footing, elongated to an extreme height, and fragmented, for the gray-green background surface cuts away his right arm. From his weak position he drives into her green garment a dagger or the mouthpiece of a horn, at once a symbol of sexuality and an instrument of aggression.

Here the carnival does not represent human existence abandoned to blindness and lunacy as it did in 1920 or 1922. Rather, it characterizes life as convoluted instinct and guilt, and the inescapable state of an "eternal abominable vegetative corporeality" (4.7.1946). The theme of temptation is one to which Beckmann had already given shape around 1920 in the drama, *Das Hotel* and holds the key to the artist's view of the world. Rather than having to do with the vanity found in the annual fair of *Dance in Baden-Baden,* 1923 (cat. 34), this scene is played on the mythological stage of the GRAN(D) BA(R), or the GRAN(D) BA(L). There Man will always be unalterably guilty.

The negative forces of destiny appear to take a direct part in the action. This Columbine, the archetype of the *femme fatale* (cf. cat. 130), acts like a heroine of antiquity glorified and invulnerable. She is accompanied by the trumpeter who, lacking a place of his own, grows out of the pleated vestment at her hip. He resembles the demiurge seen in later paintings (cat. 73; cf. also cat. 161). The rich, energetic coloration, the accentuated sketching, and the intense black demonstrate the painterly freedom Beckmann had attained since his yearlong stay in Paris in 1926. C. St.

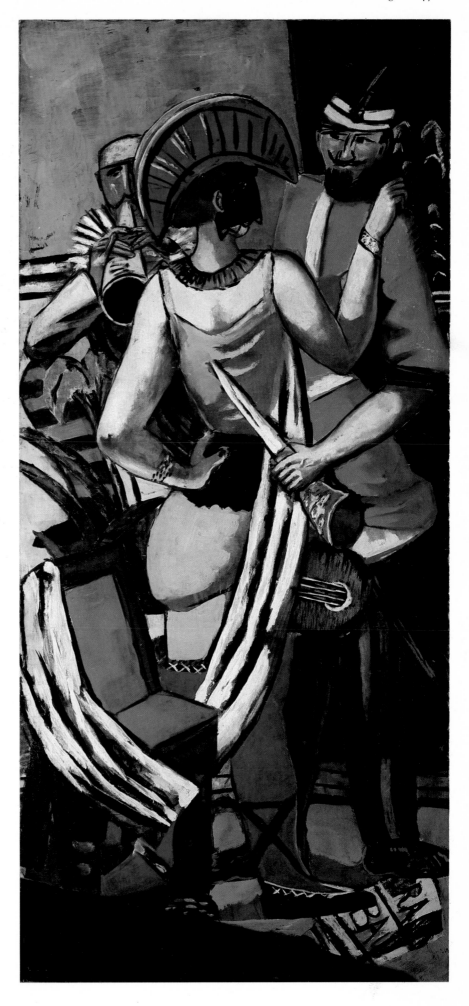

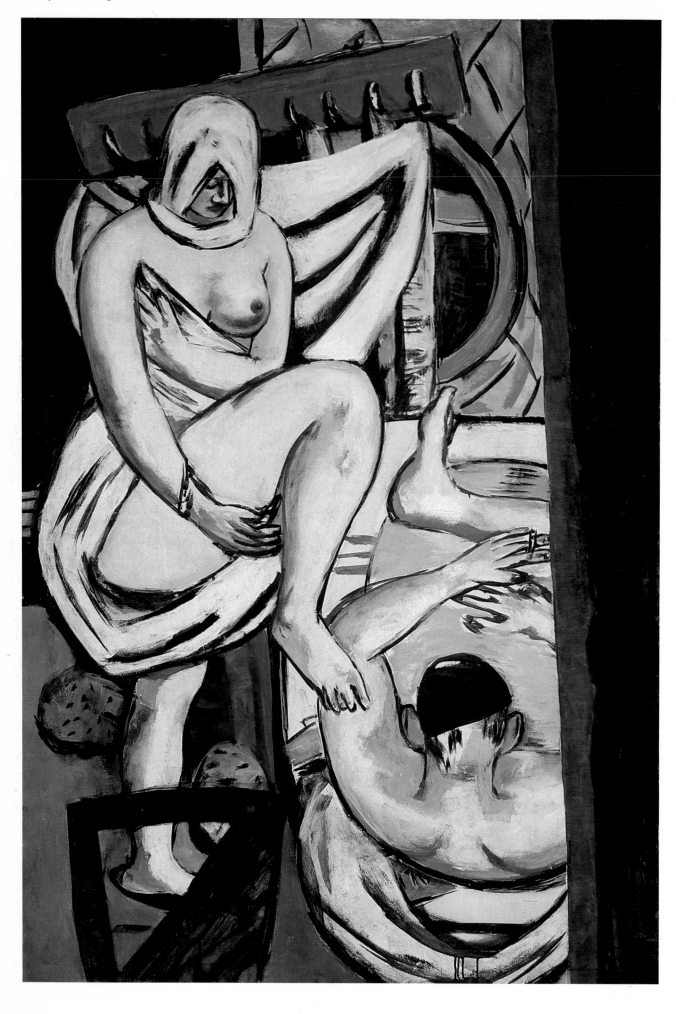

62 The Bath 1930

Oil on canvas; 174 x 120cm.
Unsigned
St. Louis, The Saint Louis Art Museum,
Bequest of Morton D. May
Göpel 334

This painting was completed, according to
Beckmann, in Paris in 1930. It shows two
figures in a bathroom: at the right, lying
relaxed in the bathtub with his massive, muscu-
lar back turned to the viewer, is a man smoking
a cigarette and wearing a tilted black bath cap;
to the left, an unclothed woman is wrapping
herself in a white towel, her right leg pulled
up angularly in front of her body. The woman
is presumably Minna Beckmann-Tube, the
artist's first wife.

At first glance this is a commonplace domes-
tic scene; however, it attains a mysterious and
closed-off impression thanks to the use of black
as a non-color and certain compositional ele-
ments. The immediate sensuous presence of
both figures seems to recede from every view-
point; it is quite plain with respect to the man,
who seems to be altogether enclosed within the
oval of the bathtub. The effect is more compli-
cated with regard to the woman, who simul-
taneously exposes and conceals herself. The
bath towel wound around her head, the down-
ward direction of her gaze, and the position of
her arms and legs withdraw her from any outer
grasp. This impression is reinforced by the
black coloration, which defines the painting
more than all the colors.

If one bears in mind the biographical facts,
the juxtaposition of sensual presence and dis-
tance may allude to the relationship of the
artist and his former wife. This may be a late
creative confrontation with the problems of his
first marriage. C. Sch.-H.

63 Portrait of Minna Beckmann-Tube
1930

Oil on canvas; 160.5 x 83.5cm.
S.L.L.: Beckmann für Minna Tube P. 30
(painted over and difficult to read)
Kaiserslautern, Pfalzgalerie
Göpel 337

References: Göpel, 1957 (2), p.60; Kaiserslautern
Pfalzgalerie, *Neuerwerbungen ab 1965,* 1967, No.7.

Five years after their divorce Beckmann
painted another portrait of his first wife, with
whom he would remain in contact until the end
of his life.

Determination and cool distance, character
traits familiar from the portrait of 1924
(cat. 37), are subordinated here to the intimacy
of the situation. This meditative pose, which is
encountered in many of Beckmann's females,
serves as counterbalance for the demonization
of womankind in his mythological paintings.
Evident here are the techniques of modern
French painting, with which Beckmann had
become familiar while in Paris in 1926. The
distortion of the armchair and the flat presen-
tation into which the figure is consistently inte-
grated produce a structure that presupposes
synthetic Cubism. The ornamentation of the
background and linear execution in the figure
are reminiscent of Matisse. C. St.

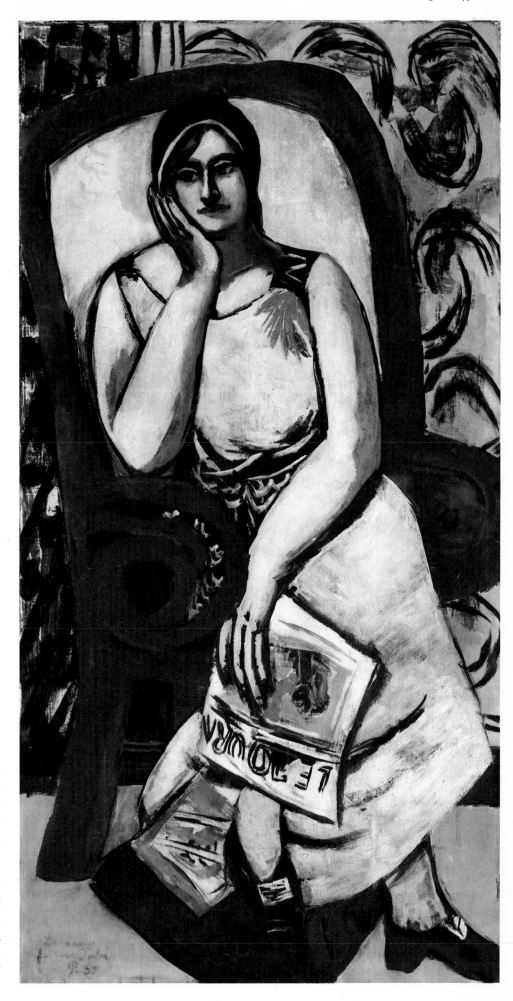

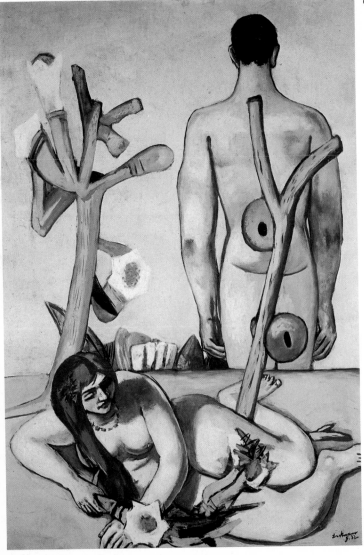

64

64 Man and Woman 1932

Oil on canvas; 175 x 120 cm.
S.L.R.: Beckmann F. 32
U.S.A., Private collection
Göpel 363
References: Lackner, 1969, p. 63; Selz, 1964, p. 51,
53; Kessler, p. 95; Fischer, 1972, p. 91 ff.; Lackner,
1978, p. 98.

This painting belongs to the great series of
mythological, and therefore ambiguous, rep-
resentations which Beckmann began in the
middle of the 1920s. It is also frequently re-
ferred to as "Adam and Eve." In 1917 Beck-
mann had approached the theme of the Fall in
what was still a traditional iconographic fash-
ion (cf. cat. 16). Now, however, he transcribes
the archetypal situation into the relationship
between male and female roles which, with
variations, he will again and again make the
subject of his paintings. The pictorial arrange-
ment, articulated in monumental fashion by
the sequence of horizontal and vertical strokes,
counterposes the two figures who are sharply
cut off from one another and yet at the same
time closely interconnected. The man with his
back turned rises up motionless in the expan-
sive blue plane behind the stage in the fore-

ground. The soft, voluptuous, and animated
woman spreads herself out in her sovereign
domain and curls herself around the horn of
plenty, the symbol of fertility. She is the
inhabitant of the earth and the mistress of the
immediate; he is the wanderer who, uncon-
fined by any horizon, is oriented toward the
unlimited. What remains unclear is whether
Beckmann is depicting this contrast as before
(Göpel) or after (Fischer, Lackner) the Fall.
For the alluringly exposed trees, with all their
phallic-vaginal symbolism, hold the man tightly
on the line between temptation and the distant,
promising terrain. On the other hand, the
austere rear view of his large figure may
already express the man's decisive renuncia-
tion of sensuality, that disdain of the present in
which Beckmann envisioned the possibility of
redemption from the pernicious "cycle of
becoming" (3.7.1946). For Beckmann how-
ever, the theme of Adam and Eve always illus-
trates the principle of an ineluctable Fall.

C. St.

65 The Small Fish 1933

Oil on canvas; 135 x 115.5 cm.
S.L.R.: Beckmann B. 33 für Quappi
Paris, Musée National d'Art Moderne—Centre
Georges Pompidou
Göpel 373
References: Lackner, 1969, p. 59; Fischer, 1972,
p. 83 ff.

Seduction is clearly the motif here. Wooing
and enticing her, the man offers the modishly
dressed woman in the yellow beach dress a
lively fish whose tail is thrashing about. Her
response hovers between recoil and approach,
a condition reinforced by the crosshatches of
the folds of the fabric. The characters in this
erotic situation are further related by their yel-
low accents. As in earlier versions of this
theme, the fish is introduced as the phallic
creature that brings man and woman together.
In contrast with *Journey on the Fish* (cat. 70),
however, here there is only a hint of the perni-
cious role of the libido in Beckmann's
theosophical model of a world condemned to
rebirth (cf. cat. 23, 70, 82, and the still-lifes
with fish). Only the woman dressed like a Pier-
rette, who admonishes the man with her
pointed finger, assimilates the scene within the
larger framework, i.e., the "theater of the
world" ruled by hostile powers of fate. In con-
trast to the earlier painting, *The Catfish* (1929),
the "evil demiurge" does not appear here. The
man with cap and collar is not unlike the cap-
tive fool in other depictions of Shrovetide and
Carnival (cat. 26, 61). This activity on the part
of "wretched slaves"—as Beckmann called
them—is set against the ocean and horizon as
an "arena of infinity." It also appears, as it did
in the painting *The Bark* (cat. 42), that Beck-
mann is giving us an encoded biographical
reference to his encounter with his second
wife. The woman's physiognomy is similar to
previous depictions of Quappi (cat. 45), and
the artist frequently represented himself in a
black cap (cat. 62). C. St.

66 The Skaters 1932
Oil on canvas; 128 x 98 cm.
s.l.l.: Beckmann F 32
Minneapolis, The Minneapolis Institute of Arts,
Bequest of Putnam Dana McMillan
Göpel 358
Reference: Scheffler, p. 146.

This picture encloses four figures in a tight,
utterly absurd configuration defined by a pic-
ture frame and a door frame. Two men dressed
as harlequins raise a daringly balanced woman
muffled up in winter attire. A waiter in tails
with a tray full of champagne glasses slides bet-
ween the figures. In the background is a broad
sky, low-lying snow covered mountains, and
two figures in a horse costume. Beckmann
spent New Year's vacation in Garmisch in
1931/32, and Shrovetide, winter, and iceskat-
ing all play a part here.

Quite aside from any possible external
impression, what is happening here is set in a
symbolic reality. The door hanging uselessly in
the pictorial field, as in compositions toward
the end of the 1920s, is significant. Ice-skating
is conceived not as an elegant motion, but as a
hopelessly static balancing act. The group stag-
gers forward to the left, kept upright only by
the painstaking effort of two skaters' legs. The
repeated one-leggedness, the diagonal per-
spective carved by the slanting door, the

66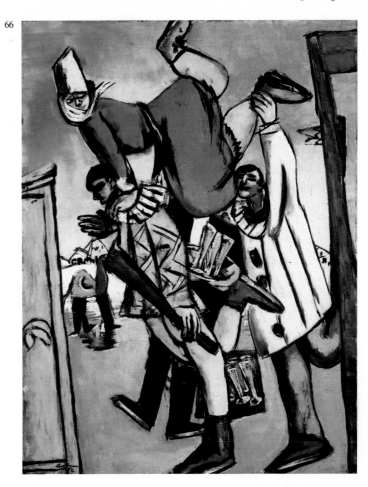

65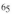

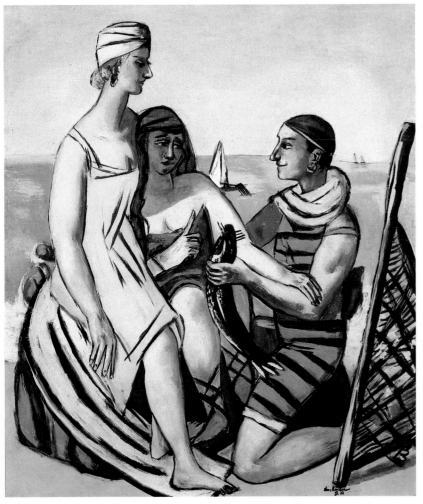

wooden sword and the striped jacket, the
shrinking of the bodies at the top, and the
unsteady footing causes the entire construction
to totter. The woman, with her massive limbs,
free-flying leg movements, and arms planted
powerfully on the shoulders of her supporters,
poses a major threat to the precarious equilib-
rium. Only the flat surface of the water and the
two trays provide the visually falling mass with
any sort of buttress. Like the numerous rope-
dancers and acrobats in Beckmann's work, the
ice skaters embody man's insecure existence
(cf. cat. 33). In comparison with compositions
like *Aerial Acrobats*, 1928 (Göpel 299), insta-
bility now permeates the artificial order to a
greater degree. The carnival theme is inter-
preted on this stage of ice where the male plays
the role of strong supporter and ridiculous
clown, while the female seems to direct the
scenario like a witch. (Compare the drawings
Skater in Davos, 1928, and *Ice Artistry*, 1928;
Bielefeld 125, 126).

The compositional connection between car-
nival sword and horse costume in the back-
ground underscores the earthy and sexual
aspects of the painting. Those images appeared
earlier in *Double-Portrait Carnival* (cat. 43).

C. St.

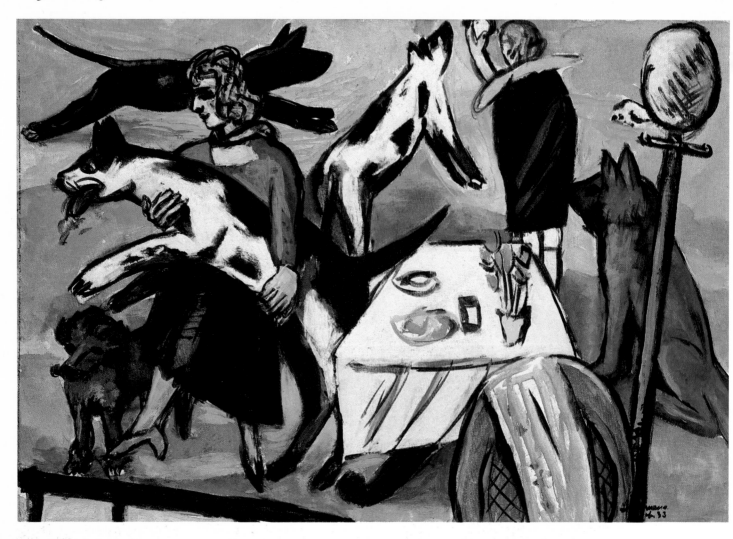

67 Girl Playing with Dogs 1933

Oil on canvas; 65 x 95.5 cm.
S.L.R.: Beckmann B.33
London, Marlborough Fine Art Ltd.
Göpel 382
Reference: Göpel, 1976, I, p.261.

Beckmann found the stimulus for this painting
in the Bois de Boulogne in Paris, where he
observed a similar scene and sketched it on a
postcard. The thin, almost watercolor mode of
work gives the painting a lightness which, while
appropriate to the playfulness of the subject, is
not in keeping with the artist's interpretation.
The disproportionately large dogs, dashed off
with angular, awkward outlines, have the
effect of being hyperactive. Their play takes
them almost to the threshold of uncontrolled
aggression. The situation thus resembles a
childlike dream, in which the high-spirited pur-
suit of frolicsome play can unexpectedly turn
into a fightening nightmare. The simple config-
uration and almost childishly crude rendering
are in keeping with what for Beckmann is an
unusual artistic immediacy. Although his
paintings often suggest a visual directness, his
style of painting does not allow for its fulfill-
ment. C. Sch.-H.

**68 Self-Portrait in a Large Mirror with
Candle 1934**

Oil on canvas; 100 x 65 cm.
S.U.L.: Beckmann B.34
London, Marlborough Fine Art Ltd.
Göpel 380
References: Fischer, 1972, p.117ff.; Zenser, p.126ff.

Beckmann hides himself here, making himself
into a shadow within a still-life. Wine bottle
and water jug, burning candle and agave plant
are present, yet are not visible in the mirror.
Only the eye-glasses and the curiously marked
book refer to the presence of the artist, who
remains inscrutable. This is no less disquieting
if one takes the mirror to be not a mirror but a
perspective on another reality. Like an ances-
tral figure, the dark bust is enthroned stiffly in
the corner of the frame, surrounded by a
gloomy red and the outlines of a curtain. Fre-
quently in his work Beckmann had used the
mirror for a perspective on some hidden real-
ity, whether it had been to present the grimace
of a gnome (cf.cat.22), or to provide his first
wife Minna with a curtain and an indetermi-
nate darkness (cf.cat.37). Be it opaque or
revealing, the mirror, just like the candle, was
traditionally understood as symbolic of the
transitoriness of things (cf.cat.25, 31).

The meaning of this self-portrait can be
deciphered with the aid of similar works. A

direct antecedent is *Still-Life with Gramopho-
ne and Irises* (cat.38), where a woman wearing
a mask and likewise enclosed within the four
corners of a mirror is confronted by the wider
connection between life and death, the
demonic and the infinite. In this black and
sculptured profile, however, Beckmann is not
a fleeting appearance but an existence which,
like the menacing black rectangle in the *Large
Still-Life with Candles and Mirror* (cat.58), is
very much at home in this mysterious other
world. The candle as symbol of life, the glasses
as instrument of recognition, and the book of
wisdom surround the shadow which is crowned
like a Caesar by the agave frond, heightening
the claim to sovereignty in this gloomy still-life.
The book with the ciphers and celestial body
refers to the domain of magic and eternal laws.
 C. St.

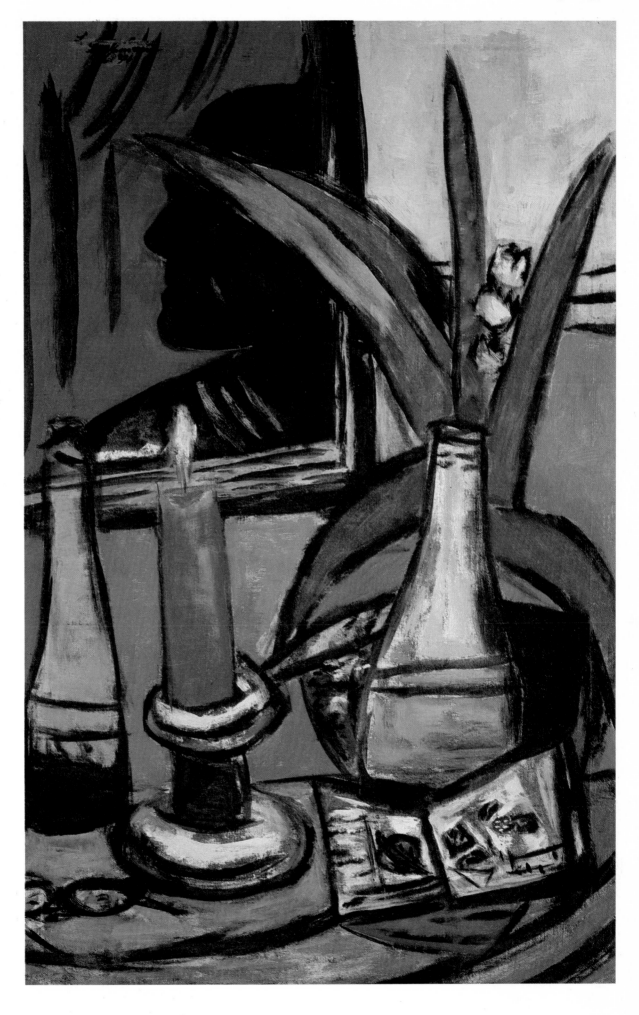

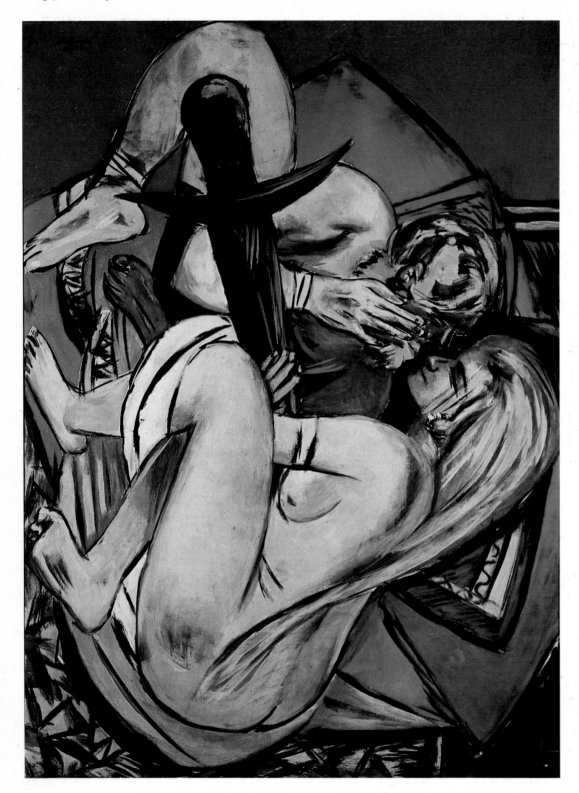

69 Brother and Sister 1933

Oil on canvas; 135 x 100.5 cm.
S.U.L.: Beckmann B.33
U.S.A., Private collection
Göpel 381

References: Selz, 1964, p.55; Lackner, 1968, p.4, 8;
Lackner, 1969, p.16; Fischer, 1972, p.93; Lackner,
1978, p.104.

For this painting Beckmann borrowed a motif
which Richard Wagner had adapted from an
old Norse legend for his *Ring of the Nibelun-
gen.* The story of incestuous love between the

twins Siegmund and Sieglinde, parents of Sieg-
fried, provides the material for Beckmann's
further investigation of the theme of tempta-
tion (compare, among others, cat.73). Because
of the political situation in 1933, he altered the
original Germanic title, "Siegmund and Sieg-
linde," to something more general. The paint-
ing is a dramatic interpretation of the conflict
between libido and moral law: that "entire
nonsensical covetousness and tragedy"
stamped upon the "theater of the world" by the
negative powers of fate.

The figures come together as a couple
around the sword that separates them even
while it functions as a phallic symbol. In
Wagner the sword is a symbol of recognition, a
bridal gift, and a token of love. Bound together
as if on a playing card by means of the red
background of the bed, the view from above,
and the turning motion of the bodies, the cou-
ple is at the same time separated with respect
to their profiles, their hands, and their circling
legs. Passionate advances by the man, and the
coolly seductive behavior of the woman are

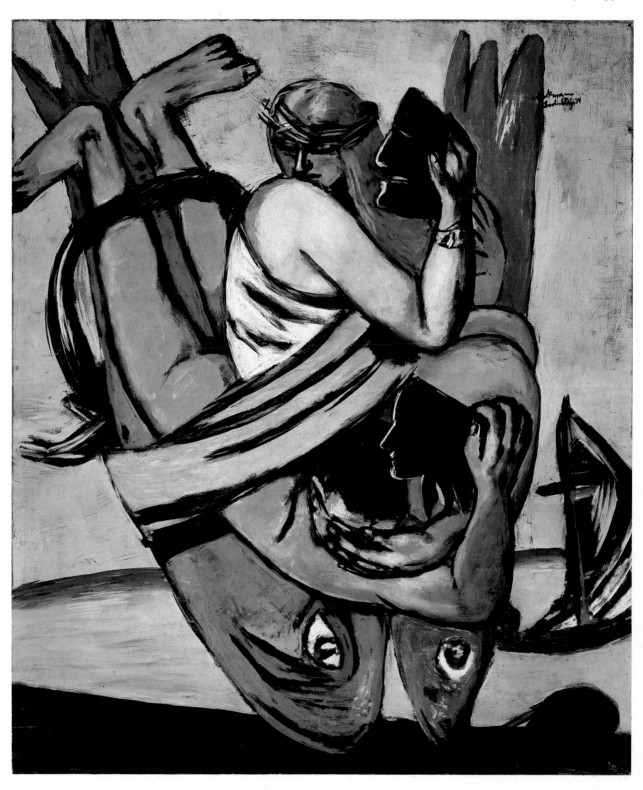

thematic here. The woman as *femme fatale* is the central figure. That the situation is inevitable is communicated by the compact grouping and the appearance of fettering, which is seen in the sword and the folds of the sheet. The radical foreshortening, surface-like projection, and distortion are devices which Beckmann would have seen in the works of Picasso. Beckmann also treated material from the Nibelung legend in the drawing, *Brunhilda and Krimhilda,* which he completed in August 1949 (cat. 203). C. St.

70 Journey on the Fish 1934

Oil on canvas; 134.5 x 115.5 cm.
s.u.r.: Beckmann Berlin Aug. 34
U.S.A., Private collection
Göpel 403

References: Busch, 1960, p. 64; Lackner, 1962, p. 8, 20; Lackner, 1969, p. 59; Lenz, 1971, p. 217 ff.; Fischer, 1972, p. 121 ff.; Lackner, 1978, p. 106.

Beckmann himself designated the title of this painting as *Journey on the Fish* in his Journal (7.1.1948) even though it is frequently entitled "Man and Woman." Unlike more positive vi-

sions (cf. cat. 64), it deals with the inescapable connection between sexual passion, constraint, and destruction. For the situation of erotic union, indicated both by the fishes and the trappings of bondage, is depicted as a mutual plunge into a black and bottomless region. The man experiences alarm at the self-deception and role-playing, for the masks have been taken off (cf. *Icarus,* Beckmann's illustrations of Goethe's *Faust* II, Act 3). Less constrained and sitting on top, the sphinx-like woman seems to be navigating the precipitous plunge.

Since along with its phallic significance (cf. cat. 65, 82, 121) the fish can embody the soul, this voyage also represents the inevitability of rebirth, which woman as *femme-fatale* serves as instrument and enticement. The ocean scenario with the sailboat remains ambiguous: it has been interpreted on the one hand as sphere of a promising continuation of the voyage, and on the other hand as Charon's boat charting the way to death. The oppressive horizon, the leaden lights, the ghostlike billowing of the sail, the pervasive black undercoating, and the hermetically sealed pictorial structure argue for the latter conjecture.

The figurative motif belongs in the tradition of paintings of the Last Judgment. According to Lackner, Max Beckmann owned a reproduction of the *Triumph of Death* in Pisa's Camposanto, dating from c. 1350; Lenz makes reference to similarities with Michelangelo's *Judgment Day*. As for the erotic ride on the fish, it can be compared with Max Klinger's 'Seduction' in the series, *A Life,* 1880/84.

<div align="right">C. St.</div>

71 View on the Chiemsee 1934

Oil on canvas; 65 x 95.5 cm.
S.L.R. in 1950: Beckmann B. 32
Originally signed correctly L.R.: Beckmann 34
U.S.A., Private collection
Göpel 398
Reference: Reifenberg, *Die Piper-Drucke,* Munich: 1956, p. 128.

The painting shows the view from the von Schnitzlers' house on the Aischinger Höhe near Gstadt, where Beckmann had spent two weeks in the summer of 1934. From the shadows of the terrace with lounge chairs and umbrella, one gazes on the hay harvest, and farther, through the trees, to the lake and over to its far shore. In travelling from the powerful dark forms in the foreground to the delicate blue sky in the background the mind of the viewer relaxes to become more and more taken in by the bright atmosphere of a hot summer day. The smell of freshly-cut hay seems to permeate the air.

<div align="right">C.L.</div>

72 Mountain Lake with Swans 1936

Oil on canvas; 65 x 75.5 cm.
S.L.L.: Beckmann B 36
U.S.A., Private collection
Göpel 444

In 1935 and 1936 Beckmann was in Baden-Baden, where he painted several pictures on themes from the city, as well as some scenes from the Black Forest nearby. In all likelihood *Mountain Lake with Swans,* which has not yet been identified topographically, belongs among those works.

Beckmann confines himself, as he did in other landscapes of the 1930s, to a few forms which guide the gaze, and thereby the mind of the viewer, allowing him to experience the landscape as an actively changing one. Like huge beings, the two pines guard the lake, at the same time providing a gateway to it. The mind of the beholder is perceptibly arrested by the taut oval of the lake and its impenetrable emerald green water, before ascending the far shore and regaining freedom in the sky above.

The wild, disheveled crowns of the trees, which screen the far shore, project their tops beyond the shorelines into the sky, demonstrating the high degree to which Beckmann was able to bind contrasts together in tension. In the end, all the elements of this painting work energetically against one another and with one another, in the full distinctiveness of their nature. The cold green lake surrounded by the shore in warm, ochre-colored tones, the delicate light blue of the sky above, and finally the mighty black-green pines are all united in an autumnal landscape suffused with a feeling of melancholy, a mood augmented by the two swans who are retreating toward their shelter.

C.L.

73 Temptation 1936/1937
(Temptation of St. Anthony)

Oil on canvas
Left panel: 215 x 100 cm; s.l.r.: Beckmann/B 36
Middle panel: 200 x 170 cm; s.l.r.: Beckmann/B 37
Right panel: 215 x 100 cm; s.l.r.: Beckmann/B 36
Munich, Bayerische Staatsgemäldesammlungen,
Staatsgalerie moderner Kunst
Göpel 439

References: Lackner, 1965, p. 9; Schiff, 1968,
p. 269 ff.; Schade, p. 237 ff.; Kessler, 1970, p. 25 ff.;
Lenz, 1971, p. 219 ff.; Fischer, 1972, p. 136 ff.;
London 1974 cat., No. 21; P. Beckmann, 1977;
Clark, 1978; Lackner, 1978, No. 28; Dube, 1980;
Schiff, 1980, p. 14 ff.; Dube, 1981.

Beckmann referred to this triptych in conversation as both "Temptation" and "Temptation of Saint Anthony." Both titles are therefore legitimate, the longer one not necessarily being the more precise. "Temptation" is also the "Temptation of St. Anthony," but not exclusively so. Beckmann obviously did not want the subject to be understood so narrowly. It is related to the book of the same title by Gustave Flaubert, with which Beckmann was acquainted since at least 1923 and which during the following decade he read over and over again. In 1935, shortly before beginning the triptych, his interest in it was so strong that he requested that it be given to him as a present. He expressed a desire to illustrate it in 1946, after *Apocalypse* (cat. 294) and *Faust.* Nevertheless he was not satisfied with the book, and, aside from sundry critical annotations in the text, he wrote on the flyleaf of his copy: "From Simolin in June, 1935, Beckmann —ordered at my request. The book's failing: scant articulation of Anthony, a lot of erudition and yet not enough. No standpoint taken, hence only a defective reference book."

On the left Beckmann has depicted a young woman, bound to a lance on a raft. She is evidently a captive taken by the sailor who, with his gigantic black head, creates an eerie, demonic impression. In the woman one can see Helen, the great seductress; Lucretia, the patrician woman raped by kings; Delilah; and the Daughter of Israel, who gave herself to the rams. She is the woman who has prostituted herself for the people. Helen is also Sigeh, Barbelo, Prunikos, and Ennoia, characters from Gnostic literature. Among these, Ennoia is especially important. As Helen she lived in a brothel in Tyre, until the Father of All descended to earth as Simon Magus and liberated her. In Beckmann's depiction of the woman at the left, powerful eroticism and sympathy-arousing captivity coincide with the Gnostic conception of Helen-Ennoia.

The demonic sailor, lord of the captive woman, may well refer to Flaubert's Hilarian. The latter has a sinister face and white hair, keeps growing larger, and finally turns out to be the devil and knowledge simultaneously. In this he corresponds to the Gnostic angels of the demiurge, who hold Ennoia captive.

Lust in a much baser and more depraved form is represented by the fleshy monster being slain by the person in armor. This armored woman, markedly differentiated from the exposed and bound woman, is made asex-

ual by her dress, bearing and action, and thus, according to Schiff, becomes the personification of militant, punitive chastity. According to Schade, the antique clothing is suggestive of Athena. The lance of Athena to which the woman is tethered is then symbolic of punishment above and beyond its phallic associations. Beckmann was familiar with the goddess as fighter against depravity not only from the written tradition, but also from a painting by Andrea Mantegna.

The woman in the right panel is no less of a seductress than the one on the left. According to Schiff, the large bird suggests that Beckmann was thinking of the Queen of Sheba whose large magical bird, Simorganka, flies around the world in one day and then reports on everything he has seen. Beckmann has made this servant and scout into a huge malevolent creature who holds the woman in the cage captive.

In this panel, too, Beckmann has portrayed a base form of lust in the woman who crawls along the ground. In Flaubert, she is represented as the goddess of Ariccia, "on all fours like an animal." The crawling woman is led on a leash by a bellhop from the Hotel Kempinski in Berlin, who, in his other hand, carries a tray with a crown. This boy, too, like the Athena-figure in the left panel, has a basically asexual appearance. However, in contrast to her, he is not aggressively warlike, but merely a messenger.

The background of sea and sky in the two side panels has been rightly designated by Lackner as the world. This sphere does not represent expansiveness or freedom, as it did in *Departure* (fig. p. 40), but quite the opposite: it represents freedom used up, or unused. This can be seen in detail in the main figures as well. Neither the raft nor the boat can be used by the women for purposes of escape; rather the captives can only drift on the water.

The side panels are related to the central panel in numerous ways. The bellhop is leading the crawling woman toward the center, and the armed woman on the left faces toward the center. Unlike the side paintings, the central panel presents an interior room. The figure of a dark, many-breasted goddess, Diana of Ephesus in Flaubert, and the magnificent pillars distinguish the place as belonging to divinity, a shrine. The woman next to the godlike image is in keeping with the special character of her surroundings. There are no two of her as there are of the women in the side pictures: unique in her beauty and no less erotic than the others, she is at the same time free. With such perfection, she must be termed divine. The image of Venus automatically suggests itself, even without invoking Flaubert's text.

The young painter in the foreground, in light of his position on the ground before the goddess and his being twice fettered, is clearly lower in status than the circle of divinities. Laboriously he holds himself upright at his easel and gazes resolutely up at the godlike woman. She, however, takes no notice of him. As the hero of the triptych, everything turns around him. Although he cannot be simply identified with St. Anthony, he is nonetheless an Anthony-figure, exposed to manifold temp-

tations. In the side panels there are enticements of ordinary sorts: varieties of sexual craving and power as indicated by the crown. We hear the three voices in Flaubert whisper seductively; "Do you want women? Rather a large pile of gold? A shining sword?" In the centerpiece, however, a temptation of a higher order appears to be at issue. The texts on the floor express the meaning more precisely. There one can read on the one hand SATURN and on the other IN THE BEGINNING WAS THE WORD. The name of the planet often refers to the artist, for Saturn is the god of melancholy in the form of creative depression. However, Kessler notes that according to tradition, it is not only the artist who is ruled by Saturn; the Christian hermit, Anthony, also represents the type affected by a saturnine temperament. On the basis of this tradition too, the young man here can be understood to be St. Anthony and artist in one. The second text in the picture, the beginning of the Johannine Gospel, points to the Other, that which exists over against the artist: "In the beginning was the Word, and the Word was with God, and the Word was God." By way of this fragment, Beckmann gives us an

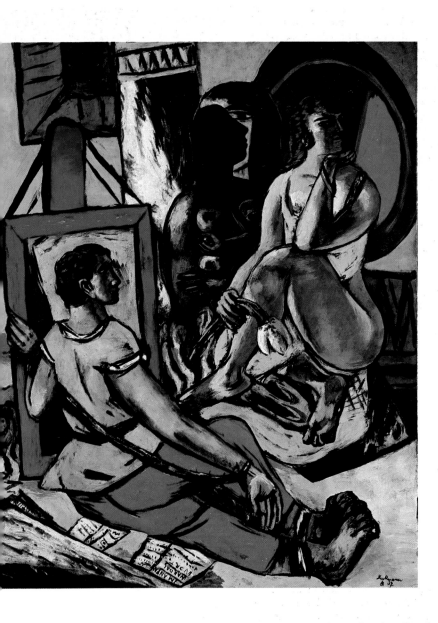

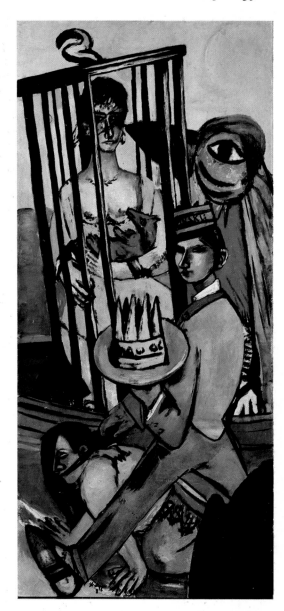

explicit reference to the Divine which the painter has before him and above him.

The artist is thus beset by various temptations which seek to divert his attention from his artistry. But the greatest temptation for him obviously consists in his wanting to approach the divine directly. He has to realize that he is bound, and that direct access to the realm of the divine will always be denied to him. He can only glimpse the divine and attest to it in his own creative activity. His works are images of what he has seen, hence the mirror on the easel. By virtue of seeing, the artist becomes a figure like St. John, of whom it is said in the Gospel, that he is to attest to the Light in the darkness. But John, who was important to the Gnostic tradition as well, was not only the author of a Gospel, but also wrote the Apocalypse. As one whom God permitted to have special visions of the end of the world, John must have been of interest to Beckmann. In this sense the artist identified with him, and depicted himself again and again as seer and witness. In 1941/1942 he finally illustrated the *Apocalypse,* again citing the beginning of the Johannine Gospel (cat. 294).

The seeing and attesting, just like the temptations, occur in a limited time, for one column in the centerpiece's shrine has already collapsed and fire is beginning to spread. Perhaps the water in the two side panels is symbolic of the Flood, in which case these depictions would likewise have signified a termination. Beckmann did not think, however, that such a demise heralded an absolute end. For him the end of earthly existence was at the same time the beginning of a transformation to a new, higher mode of being that would be defined above all by freedom. There would then be neither bondage nor any kind of oppression by evil powers. To that extent the face of the fettered young artist is full of yearning, the godlike woman is a promise of freedom, a freedom in which the union of man and woman is at last possible. C.L.

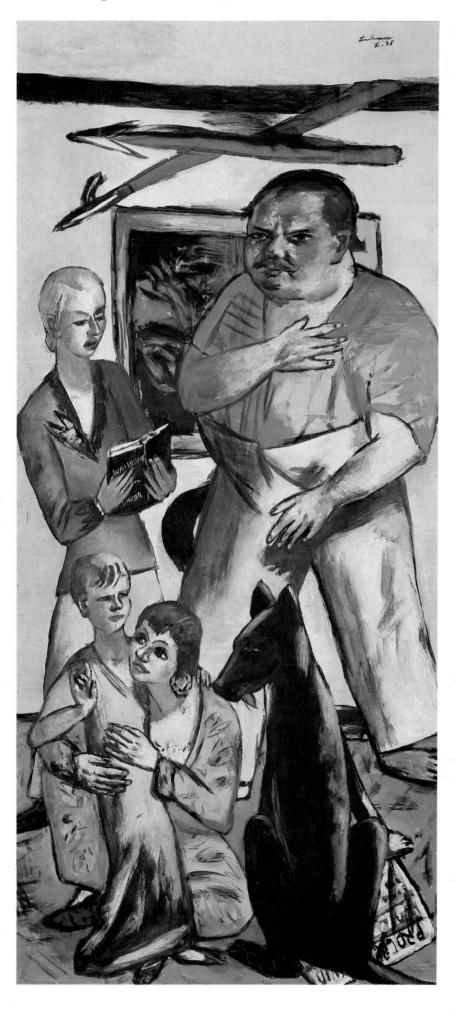

74　Family Portrait of Heinrich
George 1935

Oil on canvas; 215 x 100cm.
S.U.R.: Beckmann B.35
Berlin, Staatliche Museen Preußischer Kulturbesitz,
Nationalgalerie
Göpel 416
Reference: Göpel, 1976, I, p. 279.

The actor Heinrich George (1893-1946) contri-
buted decisively to the international renown of
the Berlin Theater during the 1920s and 30s.
He was a dedicated interpreter of expressionis-
tic as well as classical roles, a producer and,
from 1936 on, director of the *Schillertheater*.
Shortly after the War Beckmann and George
became acquainted in Frankfurt when the
actor visited the studio in the Schweizerstrasse.
They met again in Berlin during the Thirties.
Beckmann received the stimulus for this paint-
ing, according to the actor's wife, from
George's interpretation of Wallenstein, when
during his initial entrance he came rapidly and
agitatedly from the farthest recesses of the
stage onto the apron, dressed in a dazzling ver-
milion uniform. A reflection of this scene in
this studio-produced painting allegedly can be
seen in George's dynamic movement forward
and in his luminous red shirt. One can make
out "WALLENSTEIN (V) ON SCHILLER" on the
book in the standing woman's hands. Beck-
mann took the motif of the crossed spears from
the apartment of the family, who owned a siz-
able collection of weapons. The woman next to
George is the actress, Lolle Habecker, who
frequently rehearsed George's roles with him
and accompanied him as prompter on tour.
Frau Berta Drews-George with son, Jan, and
their mastiff, Fellow II, are in the foreground.

George is characterized as an almost brutal
figure who dominates the world around him.
Striding forth more like a crude butcher than
an actor, he determines the entire composition
by dint of his size, his furious forward move-
ment, his clothing, and his bull-like head. The
spears which point aggressively from the ceil-
ing and the threatening black dog enhance his
frightening stature. His wife and son shrink
away from this space-grabbing, lordly figure.
Both women, although themselves actresses,
seem to retreat completely into roles that are
merely ancillary: mother and prompter.

C. Sch.-H.

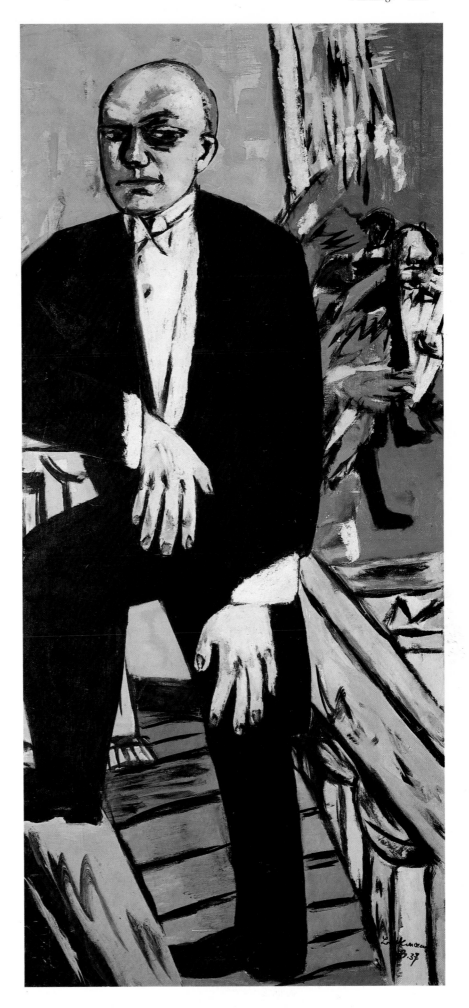

75 Self-Portrait in Tails 1937

Oil on canvas; 192.5 x 89 cm.
S.L.R.: Beckmann B. 37
Chicago, The Art Institute of Chicago, Gift of
Mrs. Sheldon Ackermann and Mr. Philip Ringer
Göpel 459
Reference: Zenser, p. 152 ff.

Parallels between biographical and artistic situations could not misfire more grossly than they do in this portrait and the one completed ten years before (cf. cat. 53). In both instances the artist is dressed in that cultivated, austere raiment of the tuxedo; in both instances he thrusts himself into the pictorial field in a large scale and with harsh outlines, positioned so that he must inevitably confront himself. This Beckmann, however, has almost nothing in common with the earlier one. Solidity, the posture of self-assurance and balance, and self-stylization have all disappeared. The figure occupies no space. The head, and particularly the hands, broaden out in a surreal fashion. They are integrated into the continuity of the black-and-white surface. The body is reduced to an angularly sprawling silhouette. From the sketchy definition of the head across the hands that hang like pieces of paper, and down to the outlines of the feet, the figure becomes increasingly attenuated. Numerous factors produce additional weakening effects: the dark, deep-seated areas of the eyes, nose, and mouth; the predominance of diagonals; the compressed vertical format; and the singular position of the figure itself. Curtain, flowers, staircase, and banisters are dissolved into ephemera. The entire field slides, augmented by the succession of hands and legs, into the lower right corner of the painting. The baluster offers no support for the arm resting on it; the banisters do not enclose the man but remain in curious proximity to the floor. Most importantly, Beckmann steps to the left and overlaps the edge of the painting, suggesting the relativity of a fleeting moment by means of this Impressionist technique. An endangered existence, melancholy, and indecisiveness are evident in this portrait of the artist, who had been the target of Nazi campaigns since 1932 and who in this year, 1937, would be numbered among those officially designated as "Degenerate Artists."

C. St.

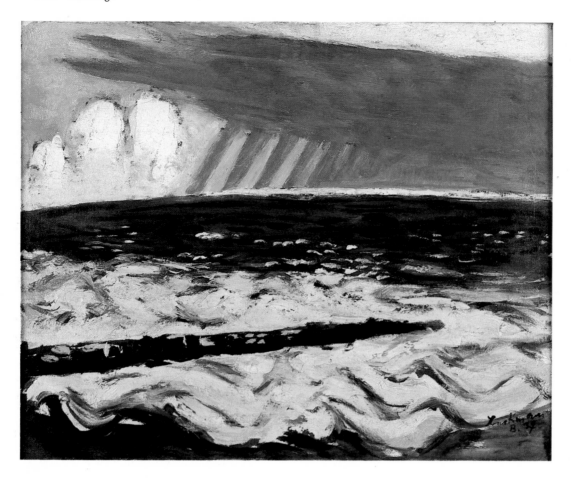

76 North Sea Landscape I (Storm) 1937

Oil on canvas; 56.5 x 71.5 cm.
s.l.r.: Beckmann B. 37
U.S.A., Private collection
Göpel 464
Reference: Lackner, 1978, No. 29.

In the early summer of 1937 before his emigra-
tion to Amsterdam, Beckmann was on the
island of Wangerooge in the North Sea. He
painted this picture along with *North Sea
Landscape II (Clouds Retreating)* (fig. p. 34)
and *Stormy North Sea (Wangerooge)*, (Göpel
466), shortly afterwards in Amsterdam. All
three have virtually the same format.
Moreover, inasmuch as the paintings depict
three phases of a particular natural event—the
onset of the storm, its peak, and the clouds in
retreat—they work together almost like a trip-
tych to form a meaningful triad. This is espe-
cially true in comparison with three further
seascapes executed a little later: these neither
relate to each other so closely, nor do they
exhibit a similar grandeur of conception.

In this painting Beckmann depicts a blackish
green sea with a powerful surf, into which a
breakwater projects divisively and obstruc-
tively. From the opposite direction a wall of
clouds approaches, darkening the sea as it
empties itself of rain. Its luminous blue, its
diagonal thrust skyward with pointed spikes,
and the golden intervals of sunlight give this
cloud a triumphant, beacon-like character. A

contrapuntal effect is produced by the towers
of the white cumulus clouds: there is a mode-
rate calm as opposed to energetic movement, a
round shape as opposed to a sharp form, and a
neutral coloration as opposed to the emphatic
luminosity of the blue cloud. With only a few
forms, the artist has presented a spectacular
natural occurrence. C.L.

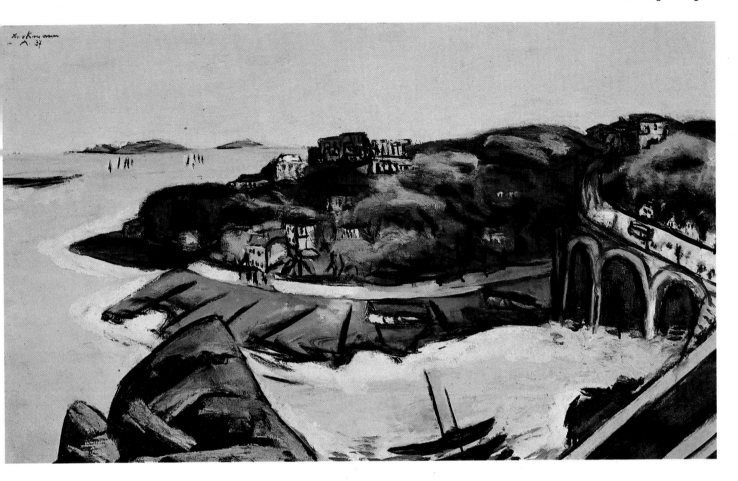

77 Outskirts Overlooking the Sea at Marseille 1937

Oil on canvas; 65 x 110.5 cm.
S.U.L.: Beckmann A37
U.S.A., Private collection
Göpel 477
Reference: Lackner, 1978, No. 32.

Since one year before this painting two landscapes of southern France, *Monte Carlo* and *Château d'If,* (Göpel 437, 438) were also produced, one must assume that Beckmann extended his sojourn in Paris that year to include a trip to the Mediterranean. Perhaps sketches made there provided the basis for the paintings of 1936 and 1937, since he did not visit France in 1937.

Primordial and mighty, a boulder projects upward against the tongue of land which pushes out into the sea from the right. The dense groves of dark pines above, the taut arc of the shore's ledge, and the energetic girdling formed by the road combine for a tensile strength in this slip of land. The houses serve to relax that impression only slightly. To the right, another curved street advances over the bridge and cuts its way between the pines. Additional houses mark the point at which the road arrives at the summit.

In the lower right corner, Beckmann has cropped the view into the bay diagonally and abruptly by means of an ambiguous form, perhaps the edge of a balcony. Thus, forces and energy dominate this geomorphic structure. But the silvery green shimmer of the pines, the colorful detail of the houses, the rugged gray-violet boulder in front, the bright blue sea with the surf, and the pale light green sky indicate how much Beckmann has brought out the sensual richness and beauty in everything. This depiction of a Mediterranean landscape unites gravity and gaiety, darkness and brightness, and rigor and ease in a grand view of nature. C.L.

78 The King 1937

Oil on canvas; 135.5 x 100.5 cm.
s.u.l.: Beckmann A 37
St. Louis, The Saint Louis Art Museum,
Bequest of Morton D. May
Göpel 470

Reference: Fischer, 1972, p. 132 ff.

A comparison of this painting with the first version of 1933 (see below) makes clear that Beckmann thoroughly reinterpreted its composition. In the earlier version which was simply constructed and slightly out of balance, the figures are hemmed in by the pillar at the right edge of the picture and the young lady gazing out of the picture over her shoulder on the left. The king in harlequin shirt sits straddle-legged and propped on the sword as symbol of his strength. He gazes straight ahead, with a trace of vexation. The dark woman with a shawl stands behind him, eyeing him mistrustfully. She seems ready to push him to the side with her bent-back left hand.

The composition of the 1937 painting has a more encoded effect. The pictorial foreground is not curtained, and the group of figures is no longer protected in a middle distance but is drawn entirely into the forward plane of the painting. Beckmann achieved this by painting out much of the pillar (whose presence can now be found only in the shadow in the background) and the body of the young woman, who now sits behind the king's right thigh. His legs open out defenselessly; the way the lower edge of the painting cuts off the calves adds to the impression that he no longer finds protection within the security of the pictorial composition but is at the mercy of whatever exists outside. There is now only a fragile system of protection that would be easy to break through: the arm and hand of the woman on the right are clearly positioned in a gesture of defense against outside forces, and the arm of the young woman evokes an intimacy between the man and herself which excludes whatever confronts them. An even more impressive change in expression was effected by changing the color and strengthening the black contours of all the figures. Beckmann painted them over and accentuated them with nervous and variably graceful black brush strokes, inserted some unidentifiable forms in the background, and shaded in the faces. In the king this has been carried to the point where his eyes are now no more than colorless hollows whose line of sight is not discernible. The head of the woman on the right is turned in profile. Now she appears only as a mysterious dark form, more closely resembling an idol or a mask than a living creature.

If one considers the increased vulnerability and defenselessness of the figure on the one hand, and the black overshading which psychically closes the self to the outside on the other hand, there is a clear displacement of content in comparison with the first version. The shift may well have been motivated by the aggravated political situation in Germany. That here, as so often before, the features of the king suggest a self-portrait, and that the woman on the left bears a resemblance to Mathilde Beckmann support the conjecture.

The dangers encountered by the artist, a king in fool's clothing, have been escalated by National Socialism in a way that threatens his very existence. He must withdraw, cover himself and his surroundings with 'black,' so that at least he will not be so easily recognized. A hostile exterior will begin to disguise his extreme vulnerability. Melancholy and sorrow are now pervasive and are supplemented by the nervous structural surface of the entire pictorial plane, which seems to suppress sensibility and nervous tension. At the same time the blind eyes of the king suggest a reference to the blind seer of Greek antiquity, to whom the secrets of the future were revealed.

An interpretation of the man as the good king of all the worlds in Indian mythology is also plausible considering the remarkable manner in which the king is sitting (familiar from pictures of Indian divinities), his dark skin color, and the earrings. The painting becomes a metaphor for the existentially threatened artist, who can find shelter only by turning away from the outside world, yet who at the same time is its true seer. C. Sch.-H.

Max Beckmann: *The King,* 1933, First version

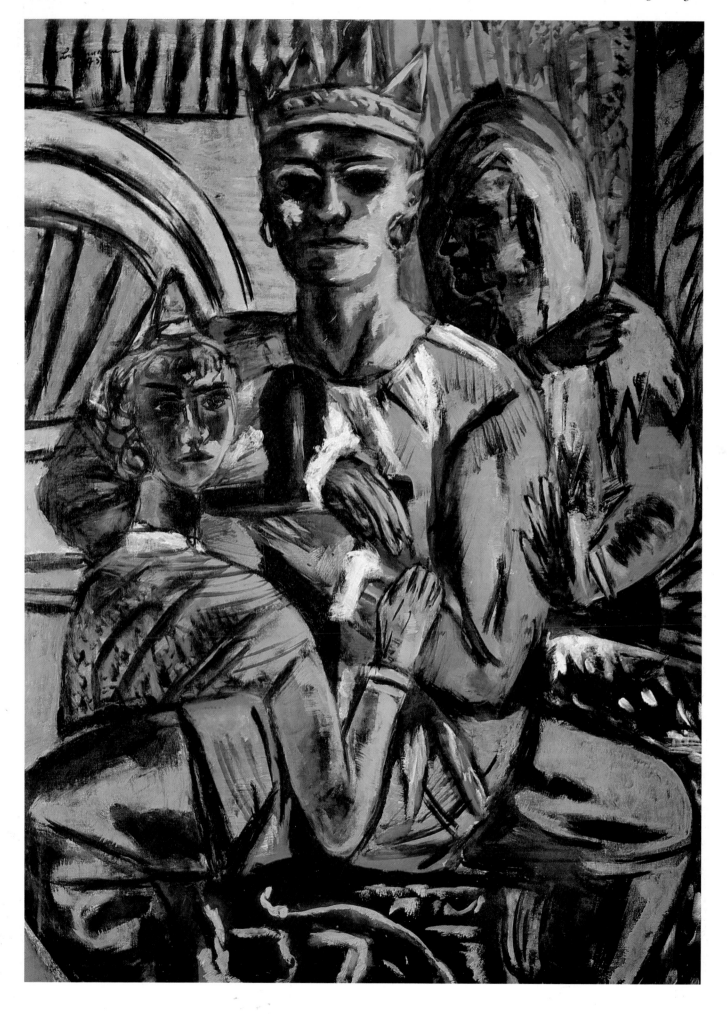

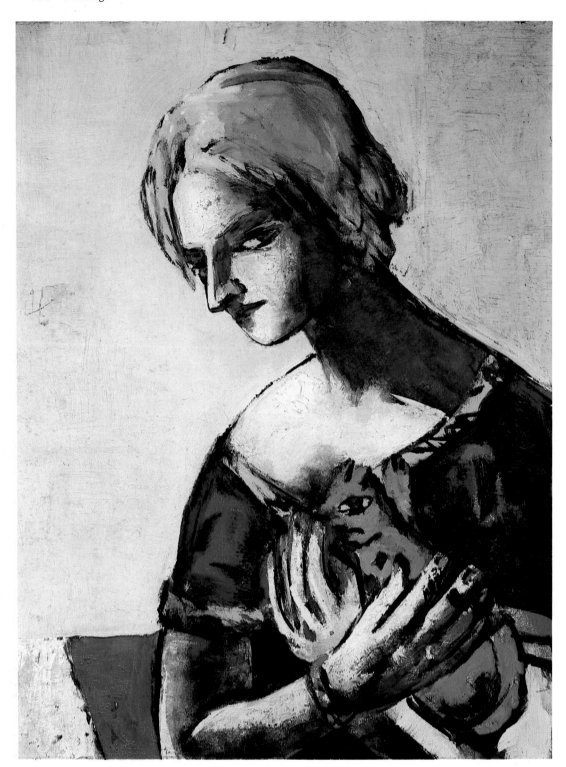

79 Girl with Yellow Cat (on Gray) 1937
Oil on canvas; 76 x 58 cm.
Unsigned
Private collection
Göpel 472

With its mixture of reserve, skepticism, and anxiety, this depiction is one of the artist's coyest portraits of women. Although the girl is neither remarkably beautiful nor does she radiate extraordinary intelligence, she still exerts a fascination which seems to stem from her curious sphinx-like glance. We have here one of the artist's rare portraits in which the person depicted stares at the viewer so much out of the corners of her eyes that one is made to feel uncomfortable.

The peculiarity of the painting is underscored by means of the almost aggressive yellow in her hair and in the embroidery of her dress, as well as the orange-yellow of the animal which nestles against her. Among Beckmann's portraits, this coloration is only comparable to the earlier *Portrait of an Old Actress*, 1926 (cat. 44), in which a similar pet is included. Identified in the artist's list of paintings as a cat, it could just as well be a small fox, similar to the one in the *Temptation* triptych (cat. 73). Whereas the fox usually symbolizes sly cunning, the cat is more often given a magical and erotic role. There is no way to know whether Beckmann had all these aspects in mind, but the girl's facial expression and the coloration make this interpretation possible.
C. Sch.-H.

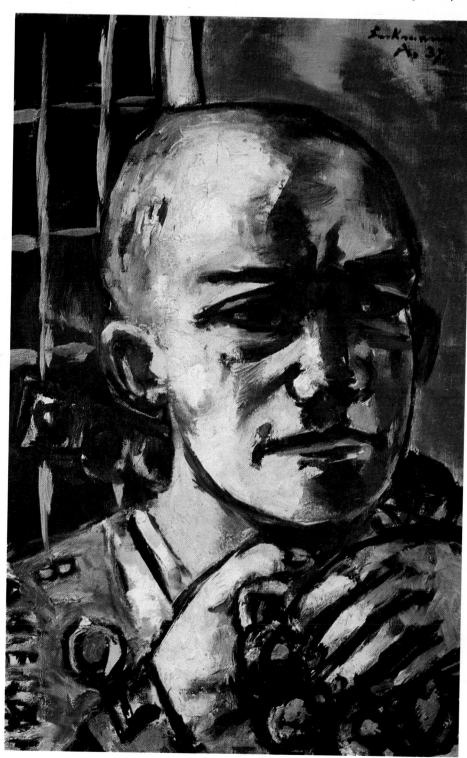

80 The Liberated One 1937

Oil on canvas; 60 x 40 cm.
s.u.r.: Beckmann A. 37
Private collection
Göpel 476

References: Jedlicka, 1959, p. 124f.; Lackner, 1969,
p. 42; Evans, p. 17f.; Zenser, p. 155ff.

Beckmann painted this self-portrait in Amsterdam shortly after his emigration. He is the prisoner who has burst his chains, but who is nonetheless still confined, perplexed, and without hope. Even more than the historical situation, this picture documents the man who was never to return to Germany and who, until the end of his life, suffered the fate of an emigrant. Here is a Beckmann who allows his pessimistic world-view, heretofore dramatically exaggerated or theatrically veiled, to present itself undisguised. Trapped within his own existence, hedged in by the edges of the painting and backed by the barred window, the figure remains constrained within itself.

Not a single element of freedom is discernible here. The steel blue chain links the man and bars together, and although it has been disconnected from the metal cuff around the hand it still functions as a fetter. Chain links and fingers are inextricably meshed together in the dense dark corner on the right. The hand-wringing corresponds to the pained facial features, produced by broad areas of black. Coloration establishes the depressive tonality, for the metallic blue-green in the face makes the coldness of the fetters palpable, even as the flickering reddish-brown in the background, and the warm yellow and green of the shirt and the back of the hand suggest heat. Beckmann employed this disconcerting contrast in a much more intensified fashion in his large compositions of 1937/38 (cat. 78, 84). The black behind the window bars is a later variant of the darkness which in earlier paintings symbolized the unknown reality which Fate holds in store for human existence (cat. 26, 37). This self-portrait has been convincingly interpreted as a modern Ecce Homo painting. It can be compared with Rouault's clown paintings, since the relentlessly dull and form-consuming black plays the dominant role there also. C. St.

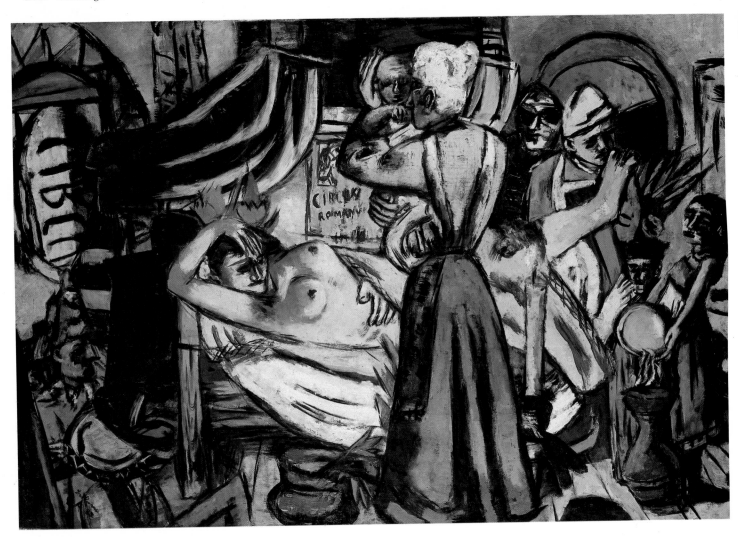

81 Birth 1937

Oil on canvas; 121 x 176.5 cm.
S.L.L.: Beckmann A 37
Berlin, Staatliche Museen Preußischer Kulturbesitz,
Nationalgalerie
Göpel 478

In a manner characteristic of Beckmann, this birth takes place in a circus wagon, as is evident from the overall surroundings: the placard visible between the woman lying on the bed and the midwife reads CIRCUS ROMANY, and the sign-board with the inscription reversed in the mirror says CIRCUS. The theatricality of the scene is underscored by a yellow curtain draped to the left over the woman and by the Punch and Judy doll observing from outside. In an obliviously provocative position, the woman lies half-covered by a yellow blanket in a bed much too small for her. Beckmann apparently made use of a scale, already in vogue in the Middle Ages, which proportions people within a given pictorial event according to their significance. In this instance, accordingly, he allows the woman, and after her the midwife, to appear overly large.

The burning candle and the blossoming flowers grouped around the bed allude to the eternal cycle of life, and link the painting directly to its 1938 counterpart, *Death* (cat. 82). There the flowers are bound into a funeral wreath which associates the burning candle with the one that has been extinguished. A further parallel between the two paintings can be seen in the figure of the attendant with the white apron and cap, who in both pictures stands turned away from what is happening and moreover bears a certain resemblance to the artist himself. A dark figure added in the background of *Birth* could be intended as an allusion to an unknown, mysterious future. Behind both is a mirror diagonally divided into red and black, which reflects nothing recognizable in the room. The antithetical colors here seem to suggest a juxtaposition of living and non-living; the faint suggestion of that may also be seen in the dark figure and the doctor.

A singular effect is produced by the newborn in the arms of the midwife. It is the only figure in the picture facing the viewer directly and, in spite of the traces of blood on its arm, it looks remarkably old. This child has an obvious parallel in the artist's work, *In the Circus Wagon* of 1940 (cat. 94), which shows the circus director, reading a newspaper, in comparable head-on perspective and physiognomy. There is a clear resemblance to Beckmann in both cases. The newborn, like the adult, is characterized as existing somehow outside his surroundings, as an attentive and yet at the same time coldly objective witness to some event taking place beyond the commonplace (the child is gazing out of the picture, the adult reads the paper). In both paintings there may be an allusion to the artist's comprehension of himself as an alien who observes reality without taking part in it. But no doubt this is only one of many possible interpretations.

That all this takes place in a circus wagon reflects Beckmann's well-known enthusiasm for circus and vaudeville, and his use of those motifs as metaphors of human ways of being. The child has been born into a world on whose stage it must play its assigned role, performing its tricks well or poorly in keeping with its talents. The blue-costumed clown observes the event—as he did already in *The Dream* of 1921 (cat. 23)—with the indifference of the self-assured outsider. C. Sch.-H.

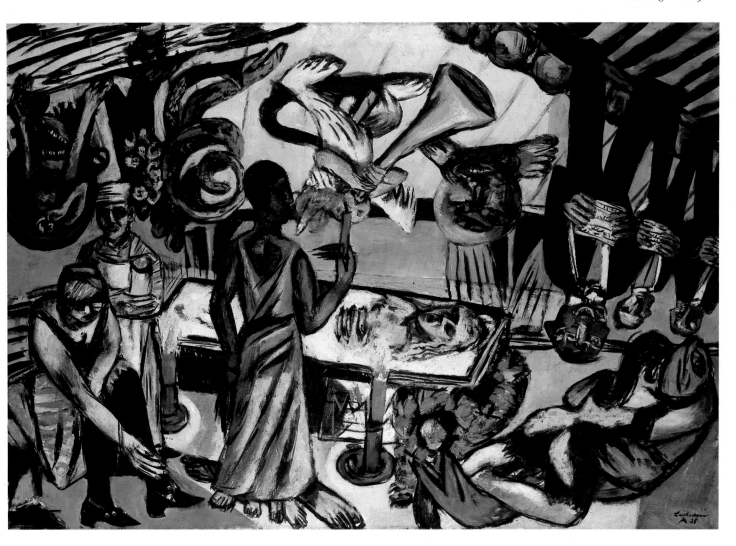

82 Death 1938

Oil on canvas; 121 x 176.5 cm.
S.L.R.: Beckmann A 38
Berlin, Staatliche Museen Preußischer Kulturbesitz,
Nationalgalerie
Göpel 497

Reference: Fischer, 1972, p. 130ff.

This painting is the counterpart of *Birth* (cat. 81) which dates from the previous year and has the same dimensions. Its scenario, however, is a great deal more complicated. The central image is an open casket in which lies the deceased, who is surrounded by both comprehensible and mysterious figures. The medical chart and hospital attendant who stands averted from the deceased imply that death in the hospital has just occurred, whereas the memorial candles and the wreath move us quickly into the phase of mourning. A kind of guardian of the dead, a dark-skinned figure with six feet and an extinguished candle, stands erect before the casket; at the left sits a woman, perhaps a nurse, preoccupied with her shoes; and to the right is a woman tightly entwined with a gigantic fish. The figures in the upper half of the painting are all upside down and disfigured: a repulsive male choir whose members have tripled heads; a monstrously deformed angel with a large trumpet and an obscene penis; and a singular breed of 'head-feet' which occupy a sort of stage that seems to be sliding away toward the rear. This arrangement intimates the first movement in the direction of death, the passage from this world to the next, in which the laws of gravity and the forms familiar to us become null and void. The black stripe that appears along the stage might be a piece of that infinite black of nothing, into which the deceased passes.

Fischer suspects, no doubt correctly, that Beckmann borrowed directly from the sources of Anglo-Indian theosophy familiar to him. According to Fischer's interpretation, death is a long process in which various stages succeed one another. Kama-Loka, the first phase and the one probably represented here, is characterized by recollections of the life just ended as well as the independence of subordinate and impure parts of the soul, which at this stage separate themselves from their human existence to live a life of their own. Hidden desires and passions, represented here in the woman with the fish, are set free through the disintegration of the body and finally bring about reincarnation. To some degree they fashion a "life-craving residue," which clings to the material world in the eternal cycle and are the cause of life's continuity. To what extent Beckmann consciously made use of these trains of thought is uncertain. That this interpretation is correct, however, appears to be confirmed by the fact that Beckmann chose the leading character in this drama of death to be a woman, traditionally regarded not only as giver of life but also as object of passion.

C. Sch.-H.

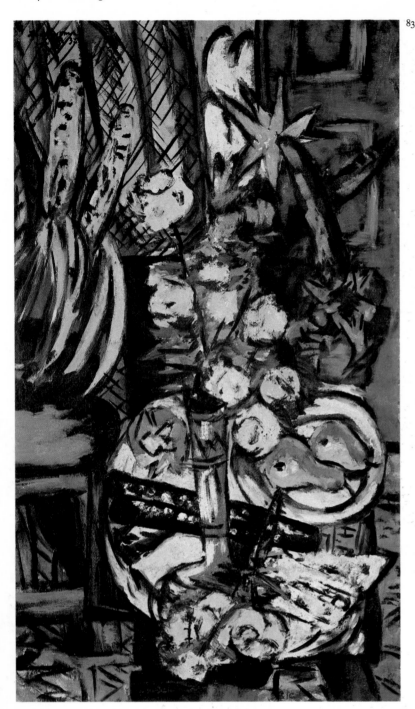

83

83 Still-Life with Yellow Roses 1937

Oil on canvas; 110 x 66 cm.
s.u.l.: Beckmann A37
Lugano, Switzerland, Thyssen-Bornemisza
Collection
Göpel 483
Reference: R.N. Ketterer, Campione,
Lagerkatalog III, No. 21.

This painting belongs to a series of floral still-
lifes which seem to ignore the iconography of
the enigmatic for the sake of unrestrained
painting. The brush strokes generalize the
forms to such an extent that it remains unclear
what all the objects are; it appears that a double
flute and sheet music are included on the
table. The composition is built up around the
central nexus of yellow in the roses and the
corn cobs. They are answered by the green,
reddish-brown, and gray of the surrounding
area, interspersed with luminous accents of
blue. Striking nonetheless is the sinister mood
produced, as in *The King* of the same year
(cat. 78), by the burgeoning presence of black
and the closed arrangement within the orbit of
the table. *Still-Life with Gramophone and
Irises* of 1924 (cat. 38) may provide an antece-
dent for this work. C.St.

84 Birds' Hell 1938

Oil on canvas; 120 x 160.5 cm.
s.u.r.: (painted over)
New York, Richard L. Feigen
Göpel 506
Reference: Lackner, 1978, p. 114.

This nightmarish scene is sustained by an
unusually aggressive coloration and a ferocious
manner of painting. With equal plausibility, it
may be said to concern a concretely political,
religious, or philosophical pattern of thought,
or a combination of all three.

Gigantic, colorful, monstrous birds (cf.,
cat. 73), direct the torture proceedings in an
underground vault. A fettered young man is
having his back sliced open with a knife; other
naked people stand in the fiery red archway to
the left, making some sort of salute with their
raised right arms while an avian monstrosity
armed with a knife awaits them. Next to him a
black and yellow eagle guards pieces of gold,
and a Fury-like goddess of fertility arises from
an egg. Behind her, naked white female figures
huddle together in terror. The circular black
and yellow forms, which occur more frequently
in Beckmann now, may signify gramophone
speakers or wind instruments. Or in light of the
flaming red background, they may be seen as
entrances into an oven. The still-life arrange-
ment in front contains a small seascape with
setting sun, in addition to a burning candle and
grapes.

A political connection with National Social-
ism seems evident: none of the artist's other
paintings take so undisguised and direct a
stand. Stephan Lackner, who interprets the
painting along these lines, refers among other
things to the Hitler salute, the screaming mass,
the Prussian eagle which the Nazis adopted as
their insignia, and the saluting multi-breasted
Earth Mother personifying the ideology of
'Blood-and-Soil.'

In the mode of painting employed here,
orgiastic in form as well as in color, the
unspeakable cruelties of the regime become an
oppressive nightmare, at once real and unreal.
From a less concrete perspective, one might
interpret this painting as a metaphor of terror-
ism, inhuman violence unchained, and perhaps
even an allegory of hell. Surely Beckmann did
not intend to depict the Christian version of
hell as the counterpart of heaven. He is more
likely to have been thinking of a hell which lies
within each individual and looms before him
when he surrenders himself completely to
human cravings. This interpretation is more
plausible when one remembers the triptych,
Temptation (cat. 73). The man who is being tor-
tured here is similar to the young artist there;
the monstrous birds are counterparts of the
bird of paradise in the triptych's right panel;
and the goddess in the center panel is here the
goddess of fertility turned Fury.

This interpretation facilitates another link
with National Socialism which, for Beckmann,
had its foundation in the perversion of human
desire. It became, independently of its political
currency, Beckmann's metaphor of an
omnipresent hell—a world in which there is no
daylight and in which even the painted sun of
the picture within the picture subsides into the
sea. C. Sch.-H.

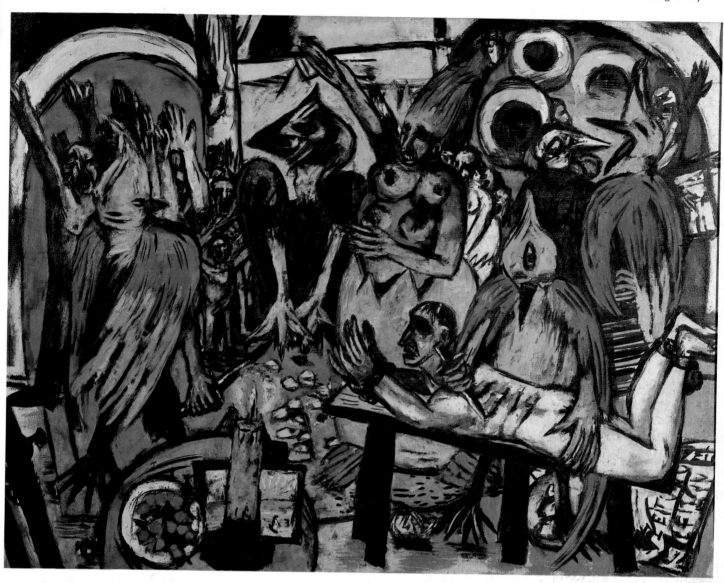

85 Studio (Night). Still-Life with Telescope and Covered Figure 1938

Oil on canvas; 110 x 70 cm.
S.L.L.: Beckmann A 38
London, Marlborough Fine Art Ltd.
Göpel 510
Reference: Fischer, 1972, p. 62ff.

This nocturnal still-life, whose first version dates from 1931 and was reworked in 1938, unites a variety of the artist's characteristic symbols both substantively and formally into a tightly crowded, sinister kaleidoscope. A precise objective description is rendered precarious by the dovetailing of inner and outer space. This seems to be an interior, presumably one of those large turn-of-the-century studios with a Romanesque window reaching from the floor almost to the ceiling. Through this, one looks out onto a dark window; its shutter to the left is situated in front of the window frame, and the drapes are behind it. Nevertheless, these areas are not clearly separated from one another. The nocturnal darkness transforms these planes, obviously separate during the day, into an interweaving of interior and exterior space, rather like the way real and unreal combine in a dream. Even the inherently intelligible objects in the studio seem to be mysterious and unreal stage props.

On the one hand the dark veiled figure, whose shadow is reflected in the studio window, can readily be identified as a clay model of a sculpture which is covered overnight to keep it from drying out. It is set on a work table that can probably be adjusted to various heights. On the other hand the figure, veiled by the cloth which leaves visible only a clumsy leg, stirs up a variety of associations beyond the descriptive content. This motif, which turns up in numerous variations in the artist's work (cf. cat. 103), might suggest a psychic condition of sorrow or pain, the personification of some hidden destiny, or the custodian of a secret. The same is true of the snake-decorated vase with its magnificent blooming orchids. One can almost smell the intoxicatingly sweet scent. The sensuous effect of these flowers, supported by the motif of the snake and the round, softly flowering forms, has something so mor-

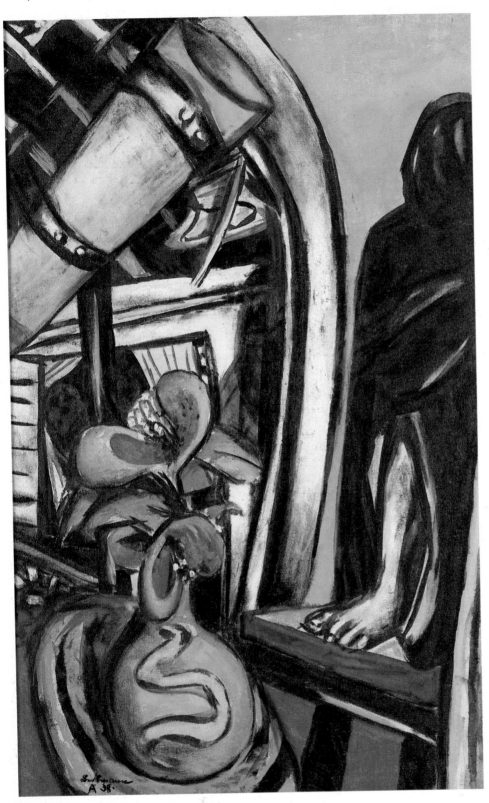

86 Self-Portrait with Horn 1938

Oil on canvas; 110 x 101 cm.
S.L.M.: Beckmann A. 38
U.S.A., Private collection
Göpel 489
References: Göpel, *Die Weltkunst* 33 (1963) No. 21,
p. 14; Selz, 1964, p. 72; Lackner, 1969, p. 31, 35f.,
118; Fischer, 1972, p. 119ff.; Evans, p. 18; Göpel,
1976, I; Lackner, 1978, p. 122; Zenser, p. 162ff.

This self-portrait was produced in exile in Amsterdam, about one year after Beckmann's proscription at the hands of National Socialism. It is the most melancholy, but also the most mystifying, of his self-portraits. The darkness which begins to infiltrate the pictorial field in 1927 (cf. cat. 53), now advances across the entire person with shadows and black stripes, and swallows up the narrow surrounding space. Although tightly confined within the square and pushed between the strip of curtain and the golden frames, the powerful figure seems to stand in infinity. Beckmann now exists in the realm of the unknown and the mysterious. Most remarkable are the striped, glowing red gown; the empty picture frame in the background; and the horn, which is held up high in relation to mouth, eyes, and ear.

Wind instruments often function in his work as symbols of the artist. But here the painter appears not to have established an outward signal, but rather to have intended the horn as a means to penetrate and plumb the darkness. He suspends the curved instrument as though it were a telescope or stethoscope. Its dark-throated funnel, sharply overlapped by the hang of the curtain, seems to make physical contact with its immediate surroundings. Introversion and an intense anticipation for a sound in the silence describe the mood of the situation, which Beckmann, the individual, does not want to share with any viewer, not even with his second, customarily self-observing self. The man remains isolated, with no outward glance, his suspended right hand in midair, his shaded face heavy, gloomy, and tense.

This self-portrait can be interpreted on three levels: as a glimpse of someone blindly trapped within the circumstances of his personal life; as an image of the unknown fate of mankind; and finally as a representation of the artist, who remains existentially committed to mystery and inspiration. The three circular forms of the funnel opening, the clutching hand, and the powerful face are linked forcefully together in close sequence, while the glowing gold frame encloses the face from above. Free of the extroverted role-playing of earlier self-depictions, Beckmann becomes a stranger to himself and a medium. The concentration on the mysterious and abyss-like is especially pronounced in comparison with the earlier version of this self-portrait. There the artist, in a fashion reminiscent of the self-portrait of 1930 (cf. fig. p. 66), appears as a clown or entertainer, ensconced within a recognizable and harmonious environment. He was able, in spite of his early detachment, to react in a smiling and positive manner. In the reworking, the picture attains not only a visionary expression and great artistic freedom (one need only contemplate the sheer artistry of the striped robe), but

bid about it that one is reminded of a flesh-eating plant. The celestial telescope is turned into the room's interior and thereby becomes a useless asset.

The concentration of these peculiar symbolic objects into so tight a space, the dominant yellow-and-black color contrast, and the fusion of various spatial layers suggests that Beckmann is concerned to an unusual extent with an enigmatic pattern of what is "in and of itself." The theme of the painting becomes the Mysterious itself, something the artist appears to know since he is the one who has consciously veiled things. Thus, he inherits the role of magician, who combines mysterious properties at his own discretion and introduces us to an inextricable puzzle as though it were a fact of everyday reality. One can only suppose that this mystery is enticingly beautiful and fearful at once, as is symbolized by the orchid, which has a counterpart in the window opposite: a dark specterlike form resembling a skull. C. Sch.-H.

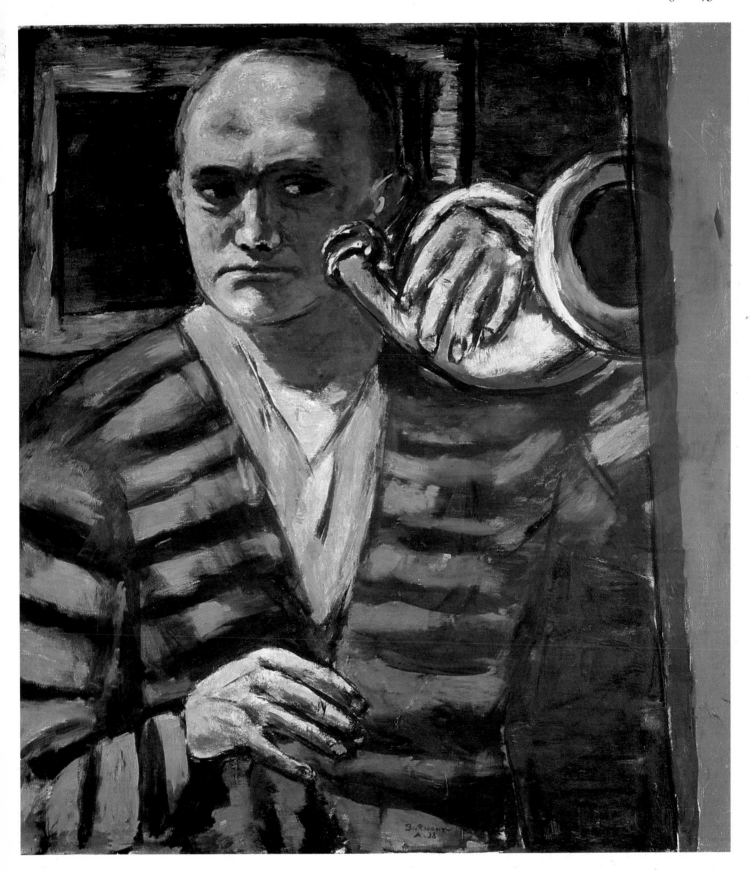

for the first time we see the dimension of the "inner migration" that made possible Beckmann's great mythological creations from 1932 on (cf. cat. 68). The views which Beckmann had formulated in his lecture in London in 1938 are discernible here, specifically the myth of space as the myth of the infinite godhead, the blackness as one aspect of an all-encompassing God, the longing to become a Self, an "I in eternal, imperishable form." First approximations of this are found in the two self-portraits, *The Liberated One* (cat. 80) and *Self-Portrait with Crystal Ball* (fig. p. 65), in which it is noteworthy that the unequivocal pose of the one who sees and despairs has now been taken over by the concentrated person. The contrast of warmth and cold seen in *The Liberated One* have been softened here, achieving a newly mystical character. C. St.

1940-45 (cat. 188) depicts those fishing as a king, naked women, and a skeleton. The soul chooses earthly power, erotic passion, and thereby death. This opting to live is connected here with the fish symbolism and the Gnostic conception of the demiurge. The 'Children of Twilight' are the creatures who, with their femininity and attributes of power and wealth, lure the soul into their nets. The signpost SORTIE, also connected by Beckmann with the Métro, accordingly stands for the exit leading to an upper world or to the earthly world.

C. St.

88 Warrior and Birdwoman 1939

Oil on canvas; 81 x 61 cm.
S.L.R.: Beckmann P. 37
Private collection
Göpel 522
Reference: Göpel, 1976 I, p. 328.

The unusually expressive, spontaneous flow of this painting all but explodes its relatively small pictorial format. This impression is produced not only by the forceful and gestural brushwork, but also by the compositional arrangement. The armed and ferocious warrior dominates the entire pictorial surface: feet, head, and spear reach to the outermost edges of the painting. Larger than his surroundings and thereby able to look beyond them, he strides with erect posture toward the right, taking notice neither of the remarkable bird woman nor of the dark apparitions in the background.

Beckmann no doubt found inspiration for this painting in Greek mythology, which became increasingly important to him in the early 1930s (cf. cat. 73, 92). Actually, Beckmann may have subordinated a variety of influences to his own context of meaning. The bird woman suggests images of the Sirens, although not the charmers of Odysseus, but rather widespread images of Sirens as creatures of the underworld assigned to console the dead. This would to some extent explain the dark apparition decorated with feathers who resembles Charon, the ferryman of Hades (cf. in this connection the left panel of the triptych, *Temptation,* cat. 73). Furthermore, some of the warrior's features suggest self-portraiture; that in turn would invite comparison with the figure of Odysseus, with whom Beckmann frequently identified himself in his journal. As is always the case with Beckmann, however, this can serve only as an interpretative hint, not as an unqualified explanation. In light of the composition as well as the forceful manner of painting, one can entertain the possibility that Beckmann was concerned in this painting to depict unbroken manly strength, self-assertion in the face of dark and mysterious powers. What finds expression here, especially in the martial bearing of the warrior, is a fundamentally positive attitude that is both defiant and confident of victory.

The painting was erroneously dated 1937 by the artist; since he did not have access to a studio that year, it was no doubt produced in 1939.

C. Sch.-H.

87 Children of Twilight—Orcus 1939

Oil on canvas; 81 x 60 cm.
S.L.R.: Beckmann P. 39
U.S.A., Private collection
Göpel 526

References: Lackner, 1969; Fischer, 1972, p. 127 ff.
Completed one year after *Death* and *Birds' Hell* (cat. 82, 84), this painting stages a view of a terrifying world beyond. No human is in evidence; only blue-skinned, grotesquely formed monsters and a group of white figures inhabit this region. With no view to the outside, with dark water, and with a signpost SORTIE (exit) reminiscent of Parisian subway stations, it is recognizable as the underworld.

The eerie nature of this place stems not, as it did in *Birds' Hell,* from tumultuous activity, but from the stiffness that is expressed by the immaterial colors blue and violet, the noncolor

white, the tight-sealing ochre, and the rigidly fixed forms. The phantoms sketched in the background (the sketchiness identifies the painting as an uncompleted work) and the mask-like, inert creatures in the boat embody an existence of inexorable waiting. Fishing is the central motif. The two ball-shaped shrunken monsters pull a small fish out of the water with their long fishing lines, while the woman has caught a large fish in her net.

The symbolism of the fish, the animal lured into the cycle of life, desire, and death, is frequently seen in Beckmann (cf. cat. 65, 70, 121). As Fischer has shown, two late variations of the composition unlock the meaning. The charcoal sketch, *Women Fishing,* 1949, endows the biting fish with human heads and shows the fishing women as erotically seductive creatures, while the pen drawing, *The Fishermen,*

89 Acrobats 1939

Oil on canvas
Left panel: 200.5 x 90.5 cm; S.L.M. Beckmann A 39
Middle panel: 200.5 x 170.5 cm; S.L.R. Beckmann A 39
Right panel: 200.5 x 90.5 cm; S.L.M. Beckmann A 39
St. Louis, The Saint Louis Art Museum,
Bequest of Morton D. May
Göpel 536
References: Lackner, 1965, p. 10; Lackner, 1969, p. 90; Fischer, 1972, p. 159 ff.; Schiff, 1980, p. 16 ff.

In contrast to the two preceding triptychs (fig. p. 40 and cat. 73), Beckmann relocates the action to interior quarters, and devotes himself to a theme that is at once limited, identifiable, and relatively easy to comprehend. All three panels have to do with the world of acrobats. While the scenes on the two wings are public views, the central panel depicts a room reserved for performers such as a dressing room or perhaps a room for props.

An overtly erotic tension exists between the snake-handler costumed in blue and the blond, half-naked woman who size each other up warily. It is unclear whether the man holds in his hand a crystal ball; whether the snake has him tied up or he is its master; or how the woman, her body provocatively turned away from him, intends to pursue the game. There seems to be an ironic allusion to Genesis here: whether Eve is seducing Adam or vice versa turns out to be irrelevant. Both are caught up—inescapably and in isolation from the rest of the world—in a cold and calculating passion. A small child, resembling an African idol, is about to beat his drum to an ancient ritual which, independently of time and space, is repeated endlessly. A clock with blood-red numerals and a Parisian daily newspaper, PET(IT) PARI(SIEN), are being heedlessly trampled underfoot. A crowned figure holding a large glove looks away from the scene with an unpleasant sphinx-like smile. Do crown and globe as traditional symbols of rule rightfully belong to this hybrid character? The screens or mirrors strewn chaotically around the room scarcely conceal the impenetrable blackness of an unknown outer world.

The circus performers in the left panel devote themselves to their respective roles obliviously, attentively, or overzealously. One tightly intertwined couple is making love in singular fashion, balanced on a high wire from which they will presumably fall and tumble into the safety net. Standing next to them is a tuxedo-clad waiter with the drinks that have been ordered. Below them a woman holding a large fish in one arm and some small ones in a net cowers on the safety net, grimacing sightlessly into nowhere. She is perhaps intended to be a woman angling for men, thereby unmasking at least the female figure involved in this self-conscious love play. An overly zealous trapeze artist makes a neck-breaking turn near the wooden ceiling; he likewise is preoccupied exclusively with his own activity.

While the actors in this panel all play their roles without costumes, the characters in the right panel are presented in outfits appropriate to their occupation. Here we see small trumpeting clowns with a bottle of champagne, and a blond vendor who is waiting uncertainly on a fierce-looking performer decked out as Mars, the god of war. While this may be merely a playful allusion to the business of war in the most harmless of contexts, it is more probably a depiction of the barbarity of the Second World War that, unnoticed by most, is already invading the little world of the circus, Beckmann's symbol for the chaos of human life.

"The new triptych climbs out of dark waters, over champagne, cadavers, and the little madness of the world, and up to the height of clarity. Oh my God, life is worthwhile," he wrote to Stephan Lackner while working on the triptych. In the left panel he placed the words CIRCUS and ME. Although the latter when completed is undoubtedly MEDRANO, a famous circus in Paris until the Second World War, the abbreviation is so strategically situated that an allusion to the artist's inner condition and his comprehension of the world is probably intended (cf. in this connection cat. 33).

Beckmann's talent for accentuating and balancing a composition which is apparently chaotic in form by means of color weights is significant here. The colors introduced on a large scale in the center panel are repeated and confined to smaller portions in the side panels. This method gives rise to an inner pictorial rhythm: in the center panel the yellow/ochre provides a background for the figures in inverted U-shaped fashion, whereas in the side panels it appears only in small surfaces such as the tights and tray on the left and the woman's hair, costume embroidery, and skirt on the right. The blue of the snake-handler is repeated in the trapeze artist and in the armor of the god of war. The red in his costume is matched in turn in the center panel's mirror and by the big fish on the left. A seemingly arbitrary arrangement thus becomes structured. One's eye follows the wavy lines of the color rhythm and thus experiences the composition as self-contained and somehow inevitable. That "little madness of the world," the "Circus Beckmann," is presented as an ordered chaos.

C. Sch.-H.

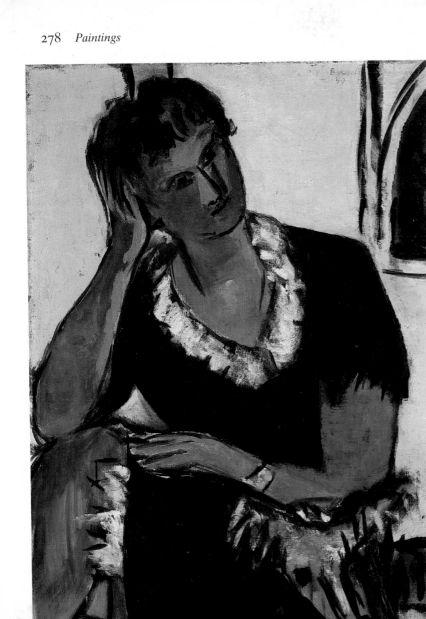

91 Ladies' Band 1940

Oil on canvas; 151.5 x 110.5 cm.
S.L.L.: Beckmann Januar 1940 A.
Munich, Bayerische Staatsgemäldesammlungen,
Staatsgalerie moderner Kunst
Göpel 541
References: Göpel, 1957, p. 5, 23; Wichmann, p. 18;
Netzer, *Kunstwerke der Welt,* vol. 4, 1964, No. 157.

From the Twenties on, Beckmann again and again depicted scenes of entertainment in the city: the café, the dance hall, the bar, and the salon of fashionable society. But if early works, such as the fourth sheet of *The Berlin Trip* of 1922 (cat. 276) or the painting *Dance in Baden-Baden* of 1923 (cat. 34), still bring into play an eye critical of society, the thematic material since 1930 increasingly acquires a mysterious or mythical meaning. There is much that is peculiar about this painting which was completed shortly before the German occupation of Amsterdam: the impression of a throng of people, even though only six figures occupy the room; the dominance of the three female musicians; the unreal expression of the two black-and-white men; the isolation of the figures in spite of close coexistence; and the overheated atmosphere conveyed by the red and yellow tones.

Prior to this picture, one spoke of the "chthonic underworld" (Frommel to Beckmann), of "veiled *vanitas*-depiction," and of the "ecstasy of Walpurgis Night" (Wichmann). The domains of the annual fair, circus, vaudeville, and theater, which Beckmann exploited over and over again as metaphors for a life of foolish and blindly compulsive roleplaying, are evident here as well. This lowbrow music-hall is the site of stupefaction and seduction. In their white dresses and aggressive red boots, the three women resemble the prostitutes in *The Prodigal Son* of 1949 (cat. 120). They rule over this oppressive scene in which men appear only as shadows, strangers, or dwarfs. Whereas the guest, the black waiter, and the little man are present in merely subordinate roles, the women with their instruments turn out to be erotically bewitching enchantresses. Thus the gypsy in the center embodies the *femme fatale,* while the crowned one seems to set the pace of this game with her demonstrative drumbeat (cf. the town-crier who heralds Life as a stage appearance in the right panel of the triptych, *Departure,* fig. p. 40). The relationship of the powerful female and the ridiculously weak male is, after all, one that Beckmann depicted over and over. The scenario recalls, among others, the *Large Painting of Women* (Göpel 415) and *Fisherwomen* of 1948 (cat. 121), which shows the women as snarers of men's very souls. This central motif of women reappears in modified form in the right panel of the triptych, *Argonauts* of 1949/50 (fig. p. 37). C. St.

90 Young Girl 1940

Oil on canvas; 81 x 50.5 cm.
S.U.R.: Beckmann 40
Munich, Bayerische Staatsgemäldesammlungen,
Staatsgalerie moderner Kunst
Göpel 548

This girl props her head pensively on her arm. Her dreamy gaze does not establish contact with the viewer. The upper part of the body is visible head-on; the frill around the collar of her black dress accentuates the décolletage and, together with the white lace of the petticoat visible beneath the hem of her dress, suggests an allusion to sexual provocation. This impression is reinforced by the woman's obviously expectant pose as though she anticipated a specific event or the arrival of a particular person. The latent sexual insinuation is, on the other hand, immediately withdrawn by means of the closed presentation of her body. She rests her head on her right arm, propped on her knee, while her left arm rests on her thigh.

A trapezoid is inserted here as a compositional element. Below the waist her crossed legs are turned sharply toward the left edge of the painting, which cuts them off. An impression is created, reinforced by the extremely flat manner in which she is depicted in front of the gray background, of the girl forming a barrier, folded into the foreground of the painting, that blocks access to her. M. B.

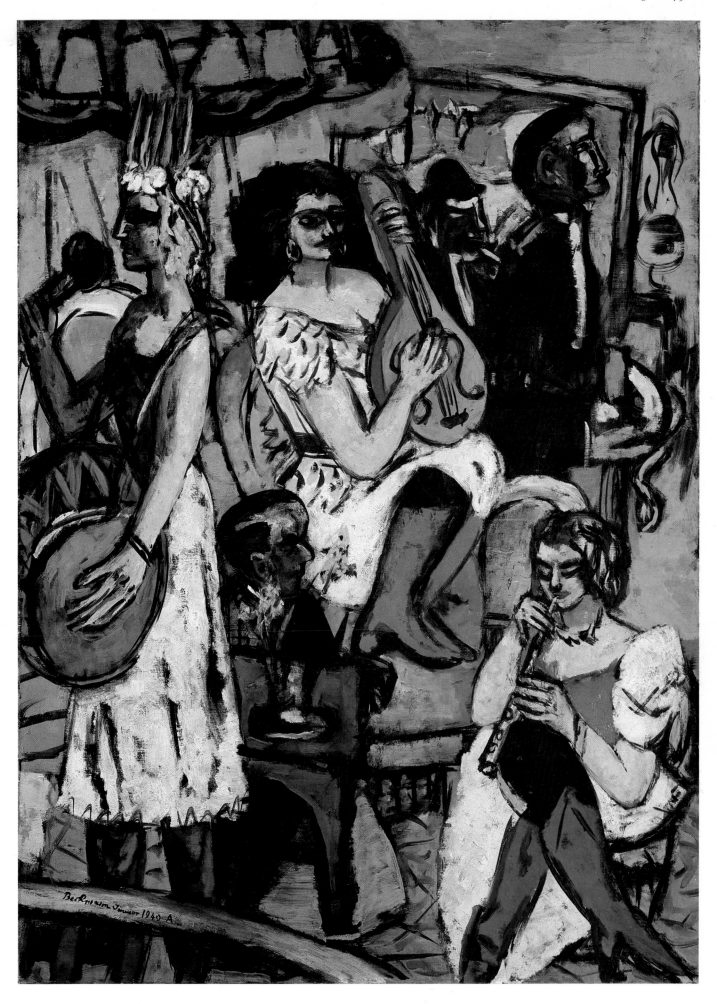

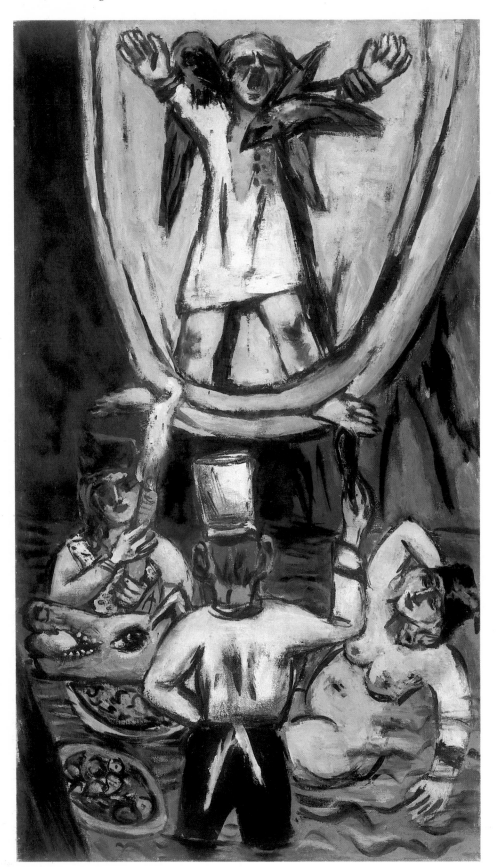

92 Prometheus 1942
The One Left Hanging
Oil on canvas; 95 x 55.5 cm.
S.L.R.: für Peter Beckmann aus (?) Russland A.42
Private collection
Göpel 596
References: Göpel, 1957, p.6ff.; Frankfurt am Main
1981 cat., p.69f.; Lackner, 1983, p.77.

Peter Beckmann, stationed for a time in Russia
as a military doctor during World War II, vis-
ited his father in Amsterdam and asked him to
paint for him a small picture in the manner of
the triptych which had just been completed,
(fig.p.42). He wanted one that he would be
able to carry around as part of his luggage. The
result a few months later, in March of 1942,
was *Prometheus,* a painting in which the
mythological content of the legend was clearly
related to the current historical situation. The
idea of referring back to the figure of Prome-
theus in order to illustrate a contemporary as
well as a timeless theme offered itself readily in
this very personal painting. Zeus, the father of
the gods, deprived mankind of the fire needed
for survival after the Titan Prometheus had
cheated him out of a sacrificial bull. Thereupon
Prometheus stole the fire from Mount Olym-
pus and brought it back to men. As punish-
ment for his transgression he was chained to a
rock in the Caucasus. There an eagle would
come daily to peck away at his liver, which
would regenerate itself overnight.

 Because of the position of his arms as well as
the pink-colored mandorla which both sur-
rounds him and at the same time serves as a
platform, the Prometheus who cries out in pain
here reminds one of the crucified Christ. The
eagle of legend has been replaced by two par-
rot-like birds who are gruesomely attacking the
man. In contrast with this scene of endless suf-
fering, the lower half of the painting shows a
voluptuous debauch: a remarkable banquet
takes place in the water in which a naked
woman lolling about lustfully and a woman in
costume nonchalantly burning the sole of
Prometheus's foot are being served a grotesque
meal by a cook. The dinner plates them-
selves—one of which holds a boar's head that
looks very much alive—are floating on the
lightly ruffled surface of the water, which
seems to be imperceptibly rising up around the
figures.

 The perversity of this scene and the lascivi-
ous sensuality of the naked woman intensifies
the gruesome desperation of the torture scene
above. This intolerable juxtaposition of vio-
lence and sacrifice on the one side and mind-
less debauchery on the other side prompts the
question whether Beckmann is inclined to
moralize here. Schiff denies this because of the
equivalence of the two halves of the painting.
Beckmann seems to have been much more
concerned to verify the juxtaposition of the two
realms, rather than to judge. Beyond such a
general interpretation, the concrete historical
situation alluded to here seems obvious. The
idea of the coexistence of human sacrifice—be
it made by those persecuted by National
Socialism or those endorsing the war's efforts—
and the dissipation of a society "up to its neck
in water" is one which the mythological theme
presented here surely articulates. C.Sch.-H.

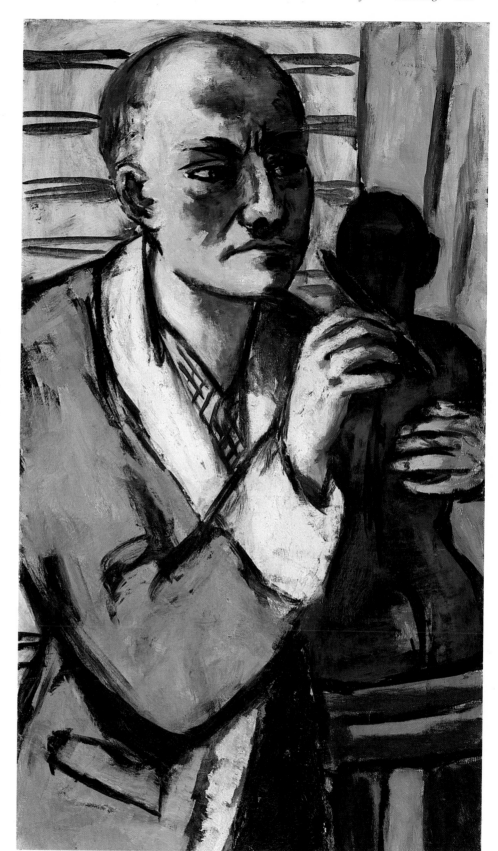

93 Self-Portrait in Gray Robe 1941

Oil on canvas; 95.5 x 55.5 cm.
s.u.r.: Beckmann A. 41
Munich, Bayerische Staatsgemäldesammlungen,
Staatsgalerie moderner Kunst
Göpel 578

References: Kesser, 1958, p. 31; Weisner, 1976,
p. 18; Arndt, p. 719 ff.

Beckmann displays himself here much as he
did in *Self-Portrait with Horn* of 1938 (cat. 86).
Although not shrouded in darkness but nestled
instead in the familiar security of home, he is
nonetheless sealed off from the outside world
by Venetian blinds and a curtain. He is dressed
in the intimacy of his robe, pensively given
over to something not visible to us. As a sculp-
tor he seems to be putting the finishing touches
to the brown sculpture on the modeling stool,
yet his gaze travels past the small figure with its
back to us. Between 1934 and 1950 Max Beck-
mann made eight bronze sculptures (see fig.
p. 137 ff.). This painting alludes not only to that
aspect of his art, but also carries the matter
into the symbolic. The pained expression of the
artist's face, the extreme closeness and tender-
ness *vis à vis* the sculpture, and the concentra-
tion of the animated colors brown, ochre, and
green on the right side are noteworthy. Beck-
mann himself exists, like his background, in
the non-color gray; only his face is garnished
with a trace of yellow.

 Thus we have here a symbol of the creative
act as such, for which the activity of sculpting
has often been used. As God created man, so
does the sculptor fashion his creature. In a
narrower sense, however, what is at issue for
Beckmann is the specific problem of self-know-
ledge. Weisner has offered this interpretation:
"The artist must constantly exert the most
extreme effort to become a self. It is to achieve
this that he begets his works. Through these
works and in these works he fashions himself,
his own self. This self is what is manifested in
his works. Thus in *Self-Portrait with Sculpture*
the artist here is not really busy fashioning
some piece of sculpture, but is instead, with
painful exertion, absorbed in the process of
creating what is even to him his own dark,
alien, averted, mysterious self." The ghostly
brown of the figure as an expression of the
unknown invites comparison with *Self-Portrait
in a Large Mirror with Candle* (cat. 68), and the
symbolism of sculpture with *The Man in Dark-
ness,* 1934 (fig. 2, p. 138). With regard to the
modeling of Beckmann's face, see the *Self-Por-
trait* in bronze from 1936 (fig. 7, p. 140).

 C. St.

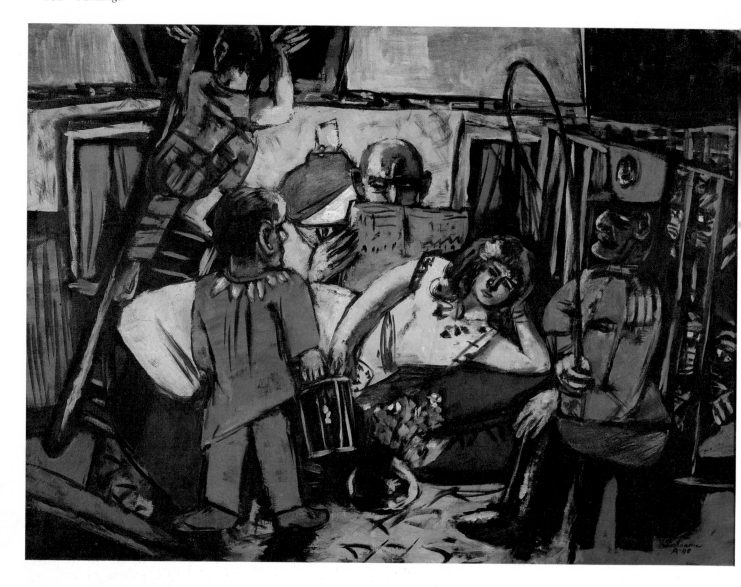

94 In the Circus Wagon 1940

Oil on canvas; 86.5 x 118.5 cm.
s.l.r.: Beckmann A 40
Frankfurt a.M.,
Städtische Galerie im Städelschen Kunstinstitut
Göpel 552
References: Haftmann, vol. 2, p. 302; Lenz, 1971,
p. 225 f.; Fischer, 1972, p. 42 ff.; Frankfurt am Main
1981 cat., p. xviif.

As in the painting *Birth* (cat. 81), this picture is
located in a circus wagon, and the head of only
one figure faces front. The circus director,
reading the paper in the background, has obvi-
ous parallels with the newborn in *Birth*: both
form the contentual center, both have their
heads brought into prominence by their isola-
tion, and both display features of self-portrai-
ture. Without question, however, the focus on
this one figure is carried further here than in
the earlier painting; compositionally, the sub-
ordinate figures, with the exception of the
youngster climbing a ladder, are entirely
oriented toward the director. Without looking
up, he has everything under control: the beasts
of prey in the cage, the tamer, and the dwarf
gaze in his direction. The young beauty (not
without resemblance to Quappi) stretched
indolently on a couch seals him off willingly

from the outside, protecting the background
which is his alone. The kerosene lamp which
illuminates only his area furthers the impres-
sion of privilege and authority.

Once again, life becomes a circus. Already
in 1921, namely in the title-page of the Annual
Fair series (cat. 271), one reads the inscription
CIRCUS BECKMANN, placed in close proximity to
a barker who represents him. In this decisive
respect, however, his self-understanding has
changed during the intervening years: he has
become the personification of cynicism and dis-
dain, indifferent to his surroundings, concen-
trated only on himself and his newspaper. He
thinks he has his performers so well in hand
that he need no longer take notice of them.
One is trying to escape into the darkness of the
night. Unlike the comparable figure in *The
Dream* (cat. 23), he will not bang his head
against a massive ceiling; but even if he
escapes through the dormer window, what
awaits him outside is nothing but the darkness
of an impenetrable night. The artist knows the
futility of this effort, since he alone sits in the
light and is supported by it from behind. His
reaction is not sympathy, however, but bitter-
ness and contempt. "One thing is certain, pride
and defiance in the face of the unseen forces

must not cease, even if the very worst should
happen." (4.5.1940). He has separated himself
from the everyday course of events, and has
"trained" the world around him so that he can
devote his time to himself and the impersonal
facts a newspaper might contain. It is a bitter
knowledge, which does not leave even him
unscathed, for certainly the sympathies of the
viewer are not spontaneously on his side.

C. Sch.-H.

95 Double-Portrait, Max Beckmann and Quappi 1941

Oil on canvas; 194 x 89 cm.
s.u.r.: Beckmann Amsterdam 1941
Amsterdam, Stedelijk Museum
Göpel 564

References: Busch, 1960, p. 32; Jedlicka, 1959,
p. 127 f.; Selz, 1964, p. 75; Anderson, p. 223;
Lackner, 1969, p. 106; Evans, p. 18; Zenser, p. 171 ff.

This painting is a variation of the early double portrait of 1925 (cat. 43). No longer in the ambiguous disguise of carnival costume and circus gadabout, the artist and his wife make their appearance in the inconspicuous roles of members of the elegant upper middle class. Affected role-playing and demonstrative gestures have been abandoned; what remains is the couple's relationship.

Protected in front by the physical strength, shoulder, and arm of her husband, the dainty Quappi remains in the background. And yet it is she who guides the man at her side. Charming in her blue hat and with her little nosegay, expansive in her stride, and attached to him with her gaze and her hand, she motivates and calms Beckmann who, in spite of his bulk, his massive skull, his lordly facial expression, and his recalcitrant bearing, stands awkward and helpless in the pictorial field. He lacks firm footing on the chaotically patterned red floor. With his other arm clenched against his hip and with the introverted gaze of *Self-Portrait with Horn* (cat. 86), he remains mistrustful and alone with himself. No less passive than his earlier Pierrot reflection, he now carries the accessories of a man of the world: the walking stick and the top hat showing the label LON-DON. Beckmann as citizen of the world appears without the glossiness of the situation back in 1927 (cat. 53). The existence of the emigrant can be felt in the way the two seem to be wandering out into the world and at the same time to be trapped in the corner of some anonymous room. This double portrait is made all the more touching by the fact that the original solitude of the artist, compounded by the enforced isolation, reinforces the silent partnership of the two people. Next to Quappi, who is braced by the door behind her, Beckmann shows himself in front of the open yellow background to be someone who is unprotected and endangered. In spite of their separate individuality, the two are most intimately connected by the circle that begins at his hat and continues around to their hands. C. St.

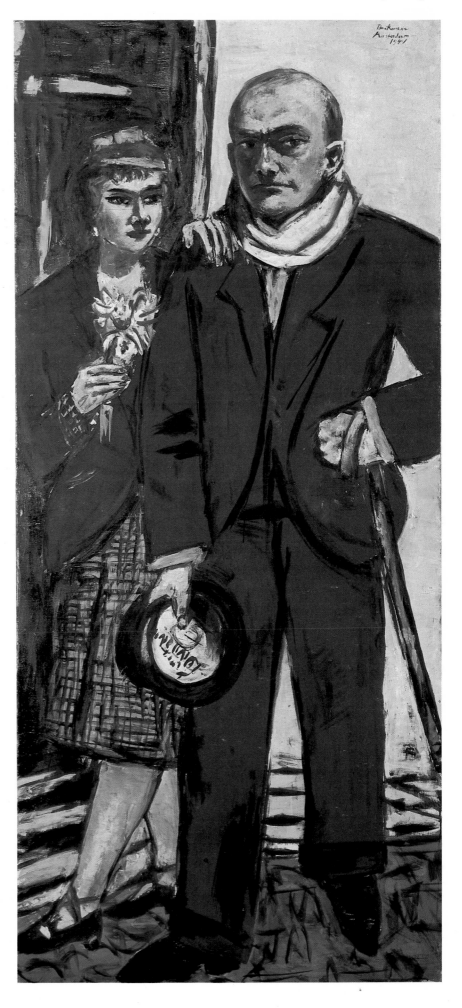

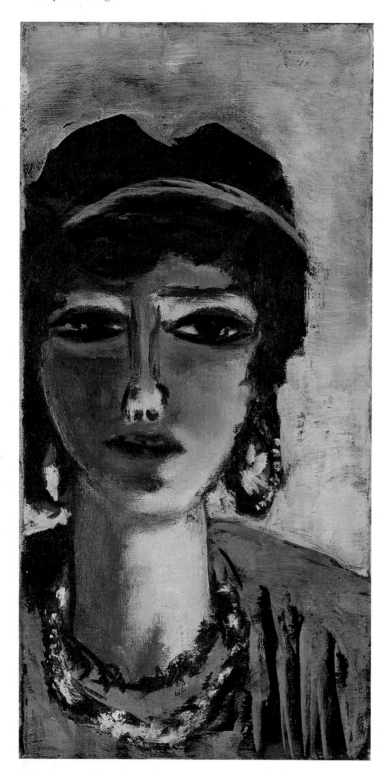

As Busch correctly observes, the province of portraiture has been left far behind here. This exotic woman, not unlike the mythological figures of the triptychs, is the personification of the enigmatic. The sphinx motif was frequently identified by Beckmann, a latter-day Symbolist, with the motif of the *femme fatale*, as is surely evident here.

The lighting from below, which is actually more like an inner light emanating from the figure itself, together with the sinister color tonality of blue, black, gray, white, and brown, produces an effect of enchantment. Beckmann's fundamental estrangement from womanhood and his inclination to mystical literature are particularly evident in this painting. The magical depiction of light is present in two other works, the crayon drawing *Quappi with Candle*, 1928 (cat. 168), and the oil painting *Quappi and Indians*, 1941 (Göpel 587).

C. St.

97 Resting Woman with Carnations 1940/42

Oil on canvas; 90 x 70.5 cm.
s.l.r.: Beckmann A 42
Hannover, Kunstmuseum Hannover
mit Sammlung Sprengel
Göpel 611
References: Seiler, p. 253; Bielefeld 1975 cat., vol. 2, p. 32.

Ever since the exhibition in Philadelphia in 1947, the literature has generally referred to this painting as *Portrait of Quappi*. Indeed, a resemblance with the Quappi of the *Double Portrait* of 1941 (cat. 95), among others, can be established. However, the woman's rejuvenated expression and the fact that the title was kept general indicate that what Beckmann was striving for here was less a portrait than the presentation of a situation. The sensuously seductive and the aloof unattainability are linked together in this depiction of womanhood. Built up across her tightly crossed legs, the curving forms of her body, and her sharply angled arms, the figure braces the pictorial quadrangle. Beckmann consciously distorts the hips and legs, and integrates the figure within the non-spatial color fields of the spread, pillow, and wall, surrounding it. Erotic objects and sphinx-like existence express the tension that Beckmann usually used to develop his type of the dangerous *femme fatale*. Here, however, he sees the woman as an alien being, to be sure, but one enveloped in warmth. Fear of the feminine, the central theme of Symbolist art which Beckmann continued, is absent here. In its brittle, sketchy brushwork, its colors, and its simple composition, this work is exemplary for Beckmann's pictorial technique during the last decade of his creativity. The painting was locked away in 1940, reworked, and signed in 1942.

C. St.

96 Female Head in Blue and Gray 1942

Oil on canvas; 60 x 30 cm.
s.u.r.: Beckmann A 42
Private collection
Göpel 606
References: Busch, 1960, p. 40, 43, 62; Göpel, 1962, p. 256 f.

Recorded in Max Beckmann's catalogues as "Female Head on Gray," this picture was placed in trust with the Circle of Friends in Amsterdam under the designation "The Eygptian Woman." This painting is not a portrait but an expression of mystery. Built up in strong axial fashion across the bridge of the nose, vertically along the neck and horizonatally across the hair band, eyes and shoulders, the figure has been moved sideways so far off center that the left edge of the painting crops parts of her hair and her shoulder. This technique of cutting off the figure, utilized by the Impressionists to depict a casual situation, suggests something momentary here as well, although the hieratic form contradicts this. The woman is pushed up close and yet remains distant. Frontal perspective and simple composition reinforce this impression, a common feature of the self-likenesses and portraits.

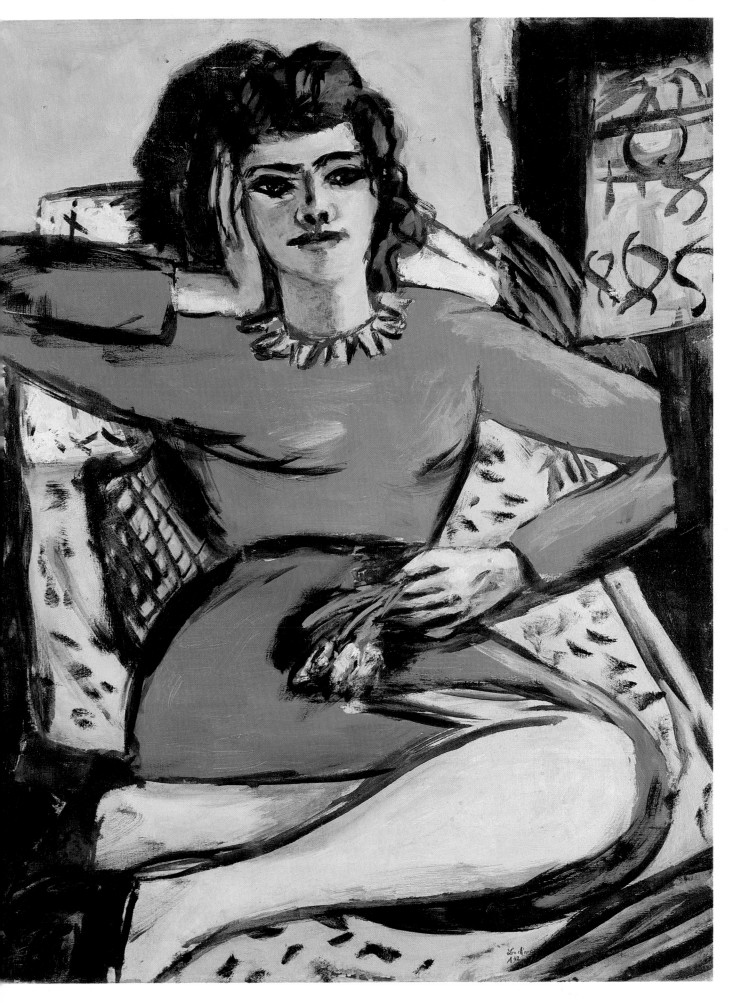

98 The Soldier's Dream 1942

Oil on canvas; 90 x 145 cm.
S.L.R.: Beckmann A 43
Elise V. H. Ferber
Göpel 616
Reference: H. Swarzenski, p. 8.

The soldier's dream is a dream of temptation, transience and finite catastrophe. Surrounded by the bars of the cage and the paradisiac-demonic flowers, the soldier lies enchanted beneath the gaze of the sphinx. The cycle of destruction, a central theme in Beckmann's work, begins with a bugle call played by the grotesque character on the left edge of the picture much as it did in the painting *Parisian Carnival* of 1930 (cat. 61). The negative powers of fate, the Gnostic demiurges including "the lure that is woman," dissect the proceedings, which take place amidst what is already the world's impending demise. The large-eyed, apocalyptic creature surfacing on the horizon of the water is comparable to the lamb of the Seventh Seal in Beckmann's illustration for the *Apocalypse* (cat. 294, No. 7). The passage of time and the end of life are suggested by the large odalisque in the foreground who displays the face of a clock. The hour-hand is approaching 12 o'clock (cf. the triptych; *Blindman's Bluff*, 1944/45, fig. p. 38 f.). The divided circle above the woman contains the cabalistic symbol, "En-Soph," which Beckmann had already introduced during the 1920s into his magical still-lifes (cf. cat. 38). The infinity of a 'higher Godhead' stands in opposition to the prison of

earthly life as well as the destructive powers of fate. Similar content may be found in the painting *Air Balloon with Windmill* of 1947 (cat. 114), which also connects the motifs of cage, demiurge, and catastrophe. This painting was presumably signed later and dated (19)43.

Another picture, which Beckmann refers to in his journal entry of July 22, 1947 as *Soldier's Dream No. 2*, reduces the allegory presented here to the portrayal of the soldier caught between a cat and a woman. C. St.

99 Les Artistes with Vegetables 1943

Oil on canvas; 150 x 115.5 cm.
S.L.L.: Beckmann A. 43
St. Louis, Washington University Gallery of Art
Göpel 626

The men grouped around a table with Max Beckmann were close associates and friends who played an important role in the artist's life, especially during his war years in Amsterdam. According to Mrs. Beckmann, the persons depicted are the Constructivist-abstract painter Friedrich Vordemberge-Gildewart (1899-1962) front left, the painter Otto Herbert Fiedler (1891-1962) in the rear, and next to him the poet Wolfgang Frommel.

The rather formal and not quite convincing composition is interesting and informative with respect to the underlying biographical situation. Beckmann's manner of work as well as his

preference for speaking with his friends individually rather than collectively suggests that Beckmann conceived this scene in his mind's eye rather than having painted it from an actual event. This is borne out by the more or less disjointed togetherness of the four, which produces a deliberate and stilted effect. There does not seem to be easy conversation among the circle of friends. But there is surely a contentual element in this as well. Although they are on friendly terms with one another, no real intimacy takes place; the political situation, existentially threatening for each of them, serves to isolate them rather than bind them together. The only unifying factor is the leanness determined by the war, which is discernible not only in the figures but also in the application of color itself. The everyday problems of getting heat and light are alluded to by the cap, muffler, and coat worn by Fiedler and by the burning candle. All four men depicted are given accessories: a mirror in which a face appears, a loaf of bread, a fish, and a heart-shaped turnip. To connect the edible objects with the hunger of those years is an obvious though superficial interpretation. The gravity and ceremony of this friendly get-together, along with the ostentatious display of these accessories, point rather to some kind of ritual meal. The mirror in Beckmann's hand, in which an indefinable face appears, might refer to the role of the artist who sees the world as though in a mirror and who at the same time, through continuous self-reflection, makes himself the center of that enterprise. C. Sch.-H.

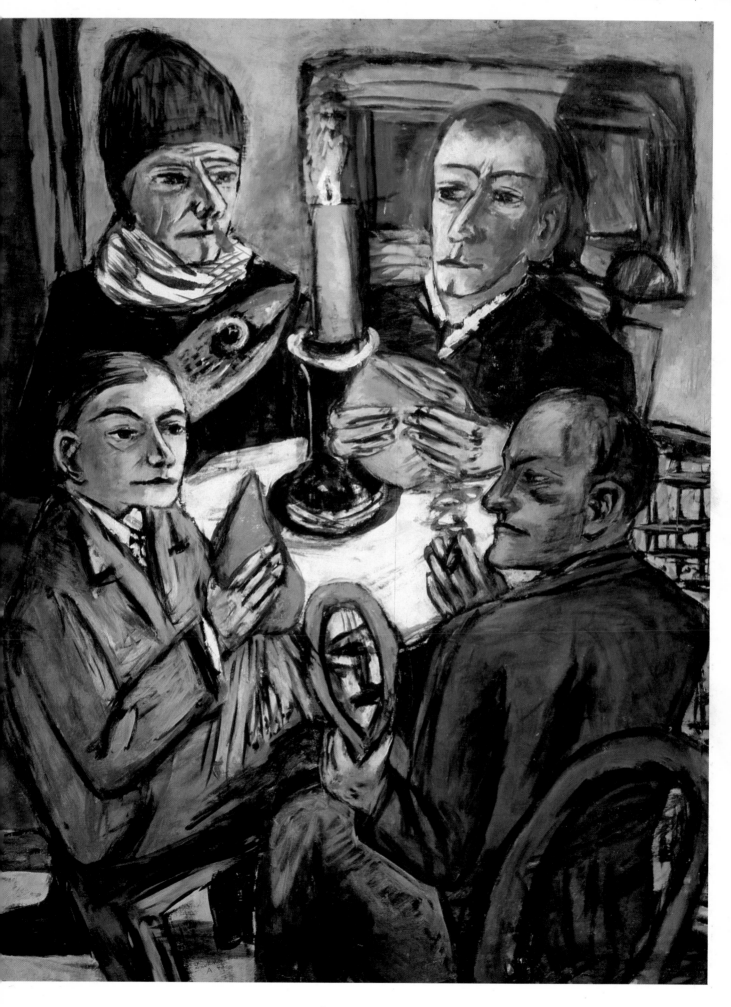

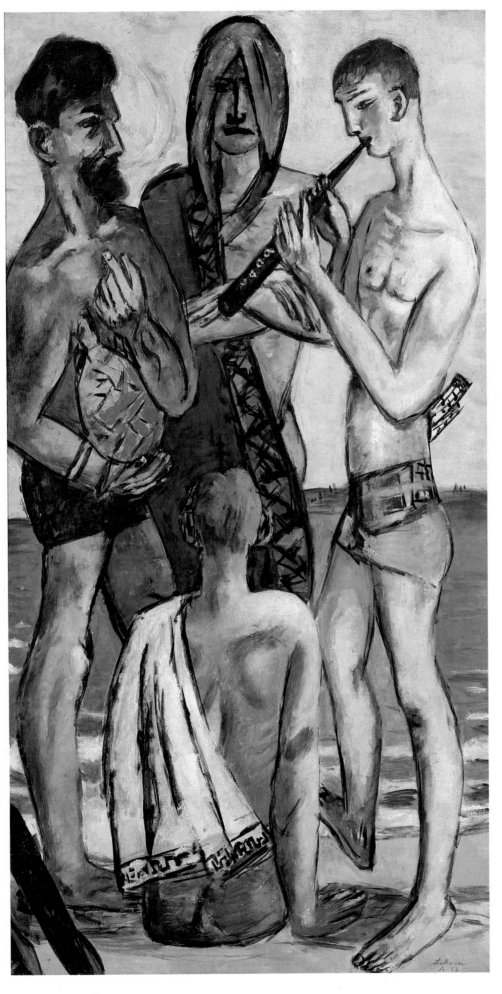

100 Young Men by the Sea 1943

Oil on canvas; 189.5 x 100.5 cm.
S.L.R.: Beckmann A 43
St. Louis, The Saint Louis Art Museum
Göpel 629
Reference: Kessler, p. 65, 89 ff.

A deep horizon which subdivides the planes of
sea and sky emphasizes the extremely narrow
strip in the foreground of the painting. The
four men barely have room to stand on the
shore. Drawn in overemphatic close-up, they
fill the pictorial surface to the edges, without
extending into the spatial depth at all.

The statuesque and symmetrical composi-
tion, approximating the form of a cross, places
the figure of the blond youth sitting with his
back to us and a sad-looking, half-veiled young
man on the vertical axis. He is flanked by the
bearded man on the left and the flute-player on
the right. The embroidery on the towels, the
classical compactness of the composition, and
the posture of the figures reflect Beckmann's
dialogue with classical antiquity (cat. 73, 88).
This painting is related to Beckmann's *Young
Men by the Sea* of 1905 (fig., p. 113), which
brought the artist early recognition. The influ-
ence of Luca Signorelli and Hans von Marées,
which is evident there, has been altered in the
1943 version into a form appropriate to it
alone, though indeed it also incorporates a var-
iation on the classical and classicist prototypes.

With respect to an interpretation, Beck-
mann's journal entry of December 18, 1942 is
informative: "Started painting Young Men by
the Sea. Stubborn will to live mixed with anger
and resignation rage in confusion." One can
surely relate this comment directly to the paint-
ing, which elevates the ambivalence between
defiant self-assertion and a feeling of useless-
ness to its actual theme. The figures are on the
one hand completely dominant, and they
define the pictorial surface almost like a block-
ade warding off intruders from outside. The
two central figures in particular, the darkly
veiled one and the one with his back turned to
us, seem to be guarding some secret known
only to them. Closed in by their bearing, yet in
fact defenseless, they are characterized by a
measure of melancholy and grief. In their clas-
sically beautiful arrangement and formal inte-
gration into the symmetrical composition they
are removed from the commonplace. In fact,
they seem to be located in mythological re-
gions, not in factual reality.

C. Sch.-H.

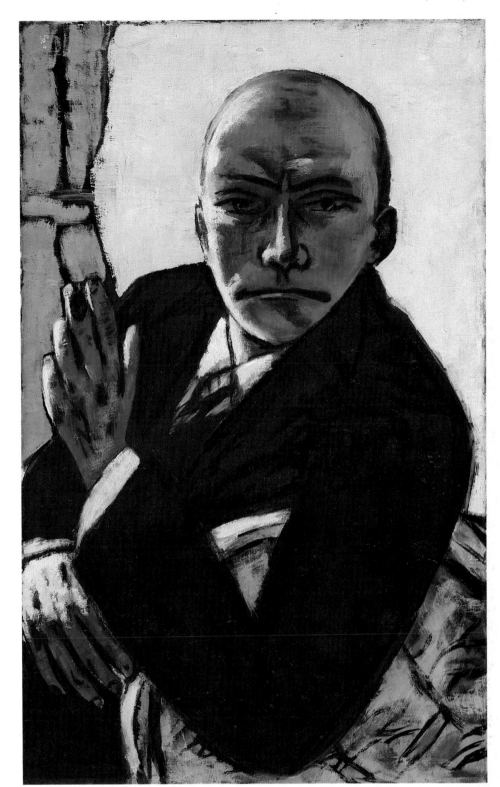

101 Self-Portrait in Black 1944

Oil on canvas; 95 x 60 cm.
S.L.R.: Beckmann A 44
Munich, Bayerische Staatsgemäldesammlungen,
Staatsgalerie moderner Kunst
Göpel 655

References: Busch, 1960, p. 34; Göpel, *Kunstwerke der Welt*, I (1961) 21; Wichmann, p. 28; Göpel, 1956, p. 136; S. Kaiser, 1962, p. 126; Evans, p. 19; Zenser, p. 177f.

The uncompromising Beckmann who shows the world a bold front yet remains inexorably hidden behind his mask-like face is the subject of the painting. Something lordly, something unfathomable, and a sense of "being on the verge of something" comprise the expression of this late self-portrait. The black evening suit evokes neither the exultation of a public appearance as in the *Self-Portrait in Tuxedo* of 1927 (cat. 53), nor does it reduce the man to a melancholy figure as in the *Self-Portrait in Tails* of 1937 (cat. 75). The black of the suit, integrated into the hard form of the shoulders and the angle of the arm, thrusts the figure aggressively and solidly toward the front, yet at the same time pulls him back. This tension determines the entire picture, for Beckmann pushes his face, the turn of his body, and his arm forward; yet at the same time cuts himself off by means of the large triangular form of the arm and the shielding circle of the back of the easy chair. The inaccessibility of this individual is compromised only in the hands, and even these, despite their mild gesture and rose tone, are introvertedly withheld. One might compare the softly closing bend of the relaxed hand here with the grip on the horn in the more intimate self-portrait (cf. cat. 86).

Beckmann remains for himself an attorney for the enigmatic. He is bound, as in 1927, to an unlimited background surface, which in the 1938 portrait was the sheer darkness and is here a frosty brightness. Whereas in earlier self-portraits he had to play through the defense mechanisms of defiance and threat (cf. cat. 36), he has now become the valiant alien. The green tinge of the flesh color frees him from every mutual tie and escalates the earlier claim to rule into a ruthless cynicism.

Much is expressed in this self-portrait, rigorously established on black-white contrast and solidified in spite of the unstable angular form: anonymity, refusal, mystification, and an impenetrable hardening of the personality. The situation of the emigrant and the pressure to make a new beginning (Göpel) are not enough to explain this sight. Beckmann, the painter of myths, has become a sinister and haughty figure, a frightening unknown person in his own eyes.

Noteworthy here are the variably colored underpainting, which Beckmann first employed in the 1920s, and the monumentalization of the form. C. St.

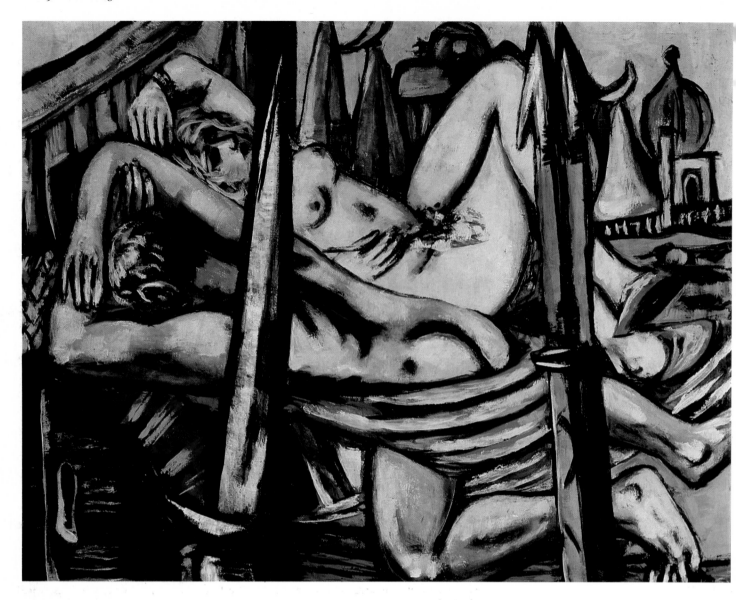

102 City of Brass 1944

Oil on canvas; 115 x 150 cm.
S.L.M.: Beckmann A 44
Saarbrücken, Moderne Galerie des Saarland-
Museums in der Stiftung Saarländischer Kulturbesitz
Göpel 668

References: Busch, 1960, p. 69 f.; Selz, 1964, p. 77 f.

Cut off from the outside world by the menacing sword and pair of sharp-pointed lances, this man and woman are indissolubly bound together on the bed. The crowded pictorial space, the arrangement of their limbs and hands, the enveloping bands of fabric, and the densely textured silhouetting of the heavy contours create a sense of captivity. The posture of the man, who is hiding his face, should be compared with that of the plunging man in *Journey on the Fish,* 1934 (cat. 70).

It is clear in comparing this theme with the ambivalence expressed in the picture *Man and Woman,* 1932 (cat. 64), that the Fall has already taken place here; the inescapable entanglement of guilt is recognized. If Beckmann was familiar with the story "City of Brass" in *A Thousand and One Nights,* (according to Göpel, Nights 572 through 578),

he changed the story into one of ambiguity. While the virgins there defend the city of buried treasures from conquest by luring the invaders to their death, the city in this painting can be identified readily as a closed arena of lust and seduction. Evidence for the former allusion is the location of the pair outside the city and the inserted gate; evidence for the latter view is the uniformly sexual symbolism of the towers, cupolas, crescents, spikes, and swords as well as the pervasive yellowish bronze color tonality. This suggests an association with gold as one of those negative means of enticement "by which we are again and again lured back into the bridle of life," as Beckmann says in his journal on July 4, 1946.

Beckmann also referred to this painting as "Golden Mine Shaft," "Golden Horn," "Golden Gate," and "Dream," using words which allude to erotic enclosure, confinement, and death. Forms of bondage (cf. cat. 69, 70) and imprisonment, stamped by Beckmann's religious philosophy, frequently are symbols of man's blindness, the transience of life, and materialistic subjection (cf. the cage motif, cat. 73, 114).

The woman is not his usual corrupting *femme fatale*; like the man, she is victim of an occurrence which augurs doom. The archway that surprisingly evolves out of the bed in the lower left corner of the picture may offer some clarification; in the painting, *Children of Twilight,* 1939 (cat. 87), it demarcates the realm of the underworld which seeks to entice souls into a meaningless cycle of rebirth. The keyhole in the archway may carry forth the riddle, but it may also be an invitation to the viewer for a solution to the problem. (Regarding the motif of keyhole and key, see p. 29 and cat. 111.) According to Mathilde Beckmann, *City of Brass* represents the situation of love and farewell; the sword symbolizes man as warrior; the city is a free fantasy about Istanbul; and the entire painting a variation on the theme of man and woman. C. St.

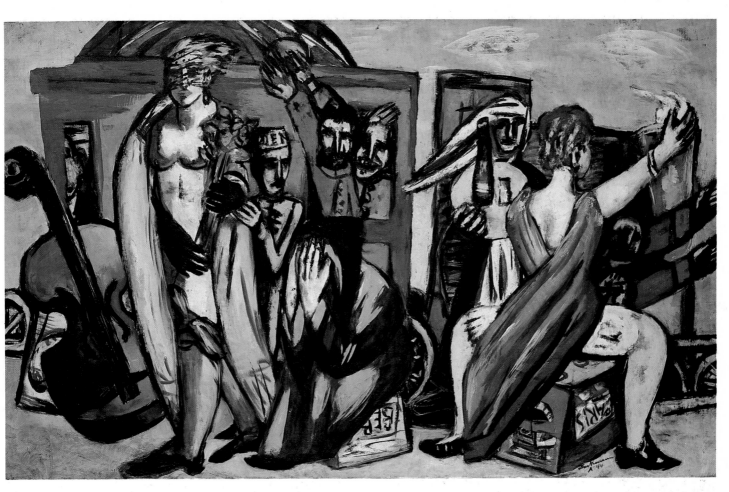

103 The Journey 1944

Oil on canvas; 90 x 145 cm.
s.l.r.: Beckmann A. 44
Private collection
Göpel 659

This painting depicts a singular departure scene: a toy railroad is running out of the picture to the right; the train crew and a passenger are waving; and in the last window one can make out a dark head. On the platform are those who have remained behind. A scantily dressed woman waves a handkerchief as she straddles a trunk with the label PARIS on it. Next to her is a nurse with a fluttering cowl and a tray. On a second trunk labelled BER(LIN) sits a woman in a green hooded gown, her hands clasped to her face—a motif which Beckmann ever since the *Resurrection* of 1916 took up and varied again and again (p.47). The little bell-hop with (E)DEN inscribed on his cap, who looks at the hooded figure disapprovingly, is associated with the woman on the left by the position of his hand and body. She is turned away from the scene and strides forward with such determination that her hair and open wrap, which hardly covers her naked body, blow in the opposite direction of the train's tail wind. Her virtual nakedness, together with the stockings that have slipped halfway down, her black gloves, her bouquet of flowers and her black half-veil, give her a peculiarly frivolous look, which contrasts with her proud, upright bearing. A double bass carelessly propped

against the train completes this remarkable scene.

Beckmann has used the arrangement of the figures and the directional forces to divide the painting into different areas. On the one hand it is divided horizontally: there is the train in the background occupied exclusively by men, in front of which are the women and the bell-hop on the platform. On the other hand the composition is divided vertically between the locomotive and the coach: these two resulting pictorial regions are defined by diagonals which lead in opposite directions toward the upper right and toward the upper left. What results is the absence of the harmonious continuity of movement that would be in keeping with the departure of the train. Instead we have dynamic impulses pulling away from one another. A splitting of the composition into two unconnected parts is avoided by the horizontals constituted by the train and the platform. The result of all this gives the impression of a diptych, i.e., a two-paneled picture with interrelated content.

Possible avenues of interpretation are provided on different levels as well. Superficially one begins with a departure as a factual event. But a merely descriptive interpretation is unsatisfactory because the many details in the painting don't fit with this commonplace occurrence. If one considers the idea of a journey in the conventional sense and bears in mind the artist's existential situation at that time, a fuller interpretation reveals itself. A

journey understood as break-up or leave-taking, as the conclusion of an old and the beginning of a new stage of one's life, would explain the centrifugal character of the composition. Beckmann was in exile in Amsterdam; the cities that were important to him, Berlin and Paris, were far away; National Socialism and the Second World War had left him bereft of his existential roots; and he had just turned sixty. All these factors are strong evidence that this is a journey to another, still undetermined way of life and that Beckmann regards himself as the one who is departing and leaving behind what is near and dear to him. The women who are left behind on the platform along with the cities, the double bass—always a vital element in Beckmann's iconography—as well as the tonic, i.e. the bottle of alcohol on the nurse's tray: these were all component parts of his life up to then. What the men in the train, noticeably flat and bodiless compared with the figures in the foreground, can rescue of the past and carry over into the life ahead remains in doubt. Thus the painting, in spite of its bright coloration, is rather a resigned metaphor of departure into a problematic new segment of life.

C. Sch.-H.

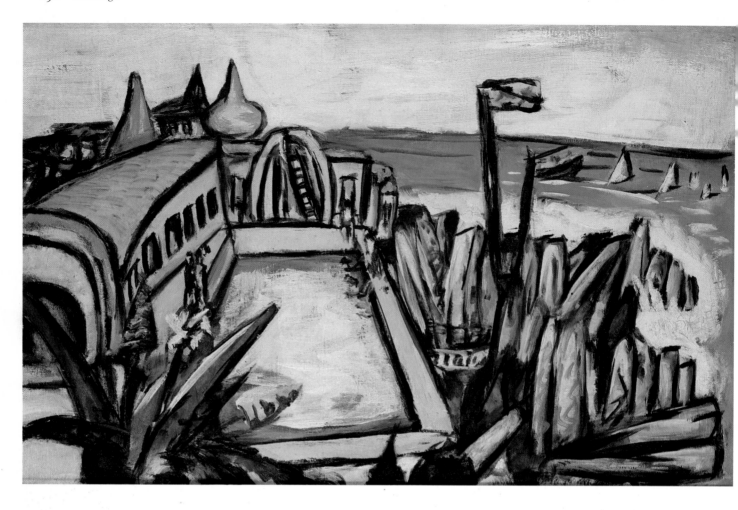

104 Swimming Pool at Cap Martin 1944

Oil on canvas; 60 x 95 cm.
S.L.R.: Beckmann A.44
Private collection
Göpel 671
Reference: Lackner, 1969, p. 101.

Beckmann spent the spring of 1939 in Cap
Martin, a spa situated between Monte Carlo
and Menton along the French Riviera. He
wrote about it to Stephan Lackner: "Cap Mar-
tin has done wonders for me and has given all
my nerve-endings and ideas a fresh tinge.
Entirely new things have opened up for me,
and it will take me the next twenty years to
bring all this to fruition." This painting relates
to his impressions of that trip, and an inher-
ently banal subject has become the metaphor
for an idea central to the artist's work. In the
juxtaposition of the expansiveness of the open
sea and the narrow rectangle of the pool, the
antithesis of freedom and restraint finds a pal-
pable transcription. The consistently colorful
structure of the painting gives it an impression
of uniformity which is not, however, borne out
in the formal composition. We have on the one
hand the large surfaces of sky and sea with a
group of sailboats, and on the other hand the
area of the artificially constructed swimming
pool with its accompanying architecture,
almost brutally blocked off by the oversized
wooden breakwater. The aggressive forms of
the piling, the spiky flowers in the foreground
and towers in the background, along with the
angular geometry of the pool and the buildings

ensure that this enclosed, double screened area
is uninviting. Significantly, this bathing area is
devoid of people; it is animated only, and
needlessly, by buoys which one would usually
associate with the ocean. In contrast to the
small pool is the open sea: mirrored here is a
reflection of the expanse of infinite space
which for Beckmann was a continual source of
inspiration. C. Sch.-H.

105 Quappi in Blue and Gray 1944

Oil on canvas; 98.5 x 76.5 cm.
S.L.R.: Beckmann A.44
Düsseldorf, Kunstmuseum
Göpel 673
References: Kalnein, p. 28; Jappe, *Weltkunst* 40
(1970) No. 1, p. 13; Mitschke, p. 60.

Beckmann made 16 portraits of his second
wife, used her frequently as inspiration for
depictions of women, and on innumerable
occasions disguised her amid pictorial situa-
tions and mythological scenes. Even in the five
portraits of her illustrated in this catalogue, the
special relationship between the artist and his
wife, 20 years younger than he, is apparent.
Whether held gently in yellow and blue
(cat. 45), in green (*Quappi with Parrot,* 1936,
Göpel 431), or in gray (cat. 119), whether pre-
sented simply or stylishly, she is always the crea-
ture onto whom he could project in idealized

fashion his notions regarding the mysteries of
womanhood. The characterization of woman
as omnipresent sin, familiar enough in the rest
of his work, will not be found here. In this
portrait too, Quappi, like a flower, is complete
within herself. She embodies beauty and
youth, and remains unaffected by the circum-
stances of outer life, thus belying the transfor-
mation which Beckmann exhibited in 1944 in
his own person (cat. 101) and, albeit in milder
form, even in the Quappi of the double-por-
trait of 1941 (cat. 95). Directly confronting the
viewer, brought close to the lower edge of the
painting, and softly exposed around the arms
and hands, she remains nonetheless untouch-
ably within herself. The luminous blue of the
dress, a color in which Beckmann painted his
wife frequently, moves her into the distance
and reinforces the even-tempered tranquillity
of the figure, which is concentrated within the
oval formed by the arms. The cool color tonal-
ity emanating from the blue dress, the violet
irises, the green leaves and the gray back-
ground creates a sphere of intimacy, which is
preserved in spite of the warm accents of
brown. Beckmann had already developed this
harmonious representation of his wife in the
portraits around 1936. Here the woman
coalesces with the bouquet of flowers.

The quality of unconstrained brushwork is
especially noticeable in the way Beckmann can
split the composition with an animated white
light falling on the scarf, letter, and sleeves and
how he even manages to retain black as a
color. C. St.

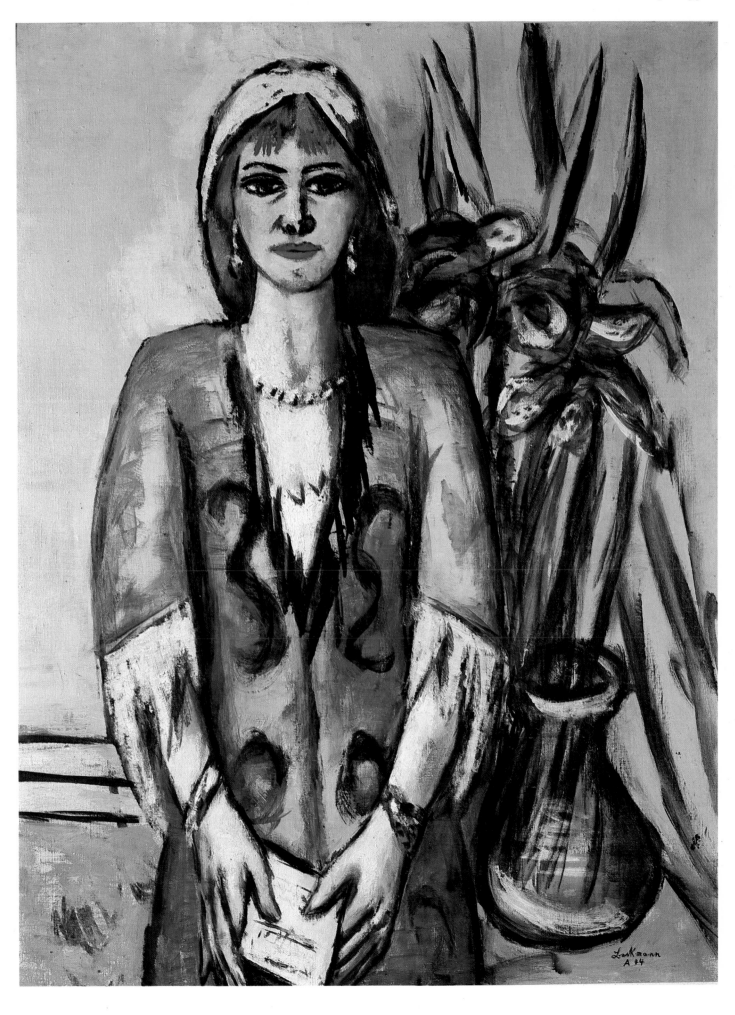

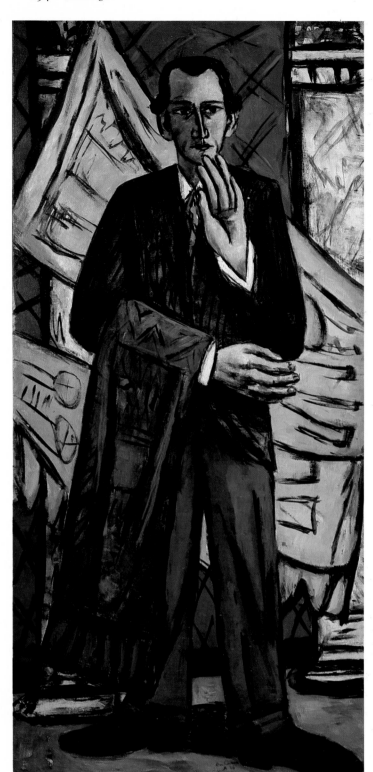

for this well-dressed man with the fine-featured, narrow face, and the hands which in spite of their size do not create the effect of being clumsy, the carpets seem to be more than a mere living. He has a genuine affection for them, and they represent for him a connecting link with the past. The blue carpet is laid carefully, almost circumspectly, over his right arm, and it is hardly by accident that the antique columns stand in the background. This reclusive individual creates the effect of being an alien who lives in a world which he wants to keep at a distance. Perhaps this portrait also expresses Beckmann's feeling of alienation after his flight from Germany into exile in Amsterdam. M.B.

107 Dancer with Tambourine 1946

Oil on canvas; 146 x 89 cm.
S.L.L.: Beckmann A 46
Dr. and Mr. Henry R. Hope
Göpel 717

This large and muscular woman presents herself to the viewer self-assuredly and without a trace of coquetry. She is conscious of her body in a quiet, matter-of-fact way. This is evident especially in her pose, which in another woman might have the effect of being vulgar and provocative. With her left leg placed easily on the table and her arms propped casually on her tambourine and thigh respectively, she takes a posture more natural for a man. Although strong physical and psychic presence is often characteristic of women in Beckmann's work, this is generally experienced as a direct or indirect threat. Here, on the contrary, we have one of the few examples where this tension is not present, where painter and model relate to each other in a manner that is harmonious. In this instance the other is unambiguously accepted and allowed to go his own way—an impression also confirmed by means of the restrained, emphatically unaggressive coloration. This becomes all the more evident when one compares this dancer with the *Columbine* of 1950 (cat. 130), who closely resembles this woman in physiognomy, body structure, and mode of dress, but in whom a matter-of-fact corporeality has been transformed into a menacing sexuality.

The distribution of color values is characteristic of Beckmann. The blue-gray of the curtain passes behind the woman's clothing, in which dark gray dominates over blue from left rear towards right front. Compensating for this is the yellow of the background discernible on the right, the tambourine, and the back of the chair. C. Sch.-H.

106 Portrait of a Carpet Salesman 1946

Oil on canvas; 194.5 x 94.5 cm.
S.L.M.: Beckmann A 46
New York, Private collection
Göpel 714

The carpet dealer stands in front of two white pillars that are backed by a dark brown wall. Conspicuous are the man's oversized hands and the carpet draped ostentatiously between the two pillars. This corn-yellow carpet seems to crowd the salesman into the foreground; at the same time the brown of the wall and the trousers establishes a close connection between foreground and background. The distance from the viewer, effected by the portrayal of the figure in its entirety, is emphasized by the man's alienating gesture.

At first glance, the painting looks like Beckmann's play on the occupational designation 'carpet salesman', similar to the *Portrait of Herbert Tannenbaum,* 1947 (Göpel 738). But

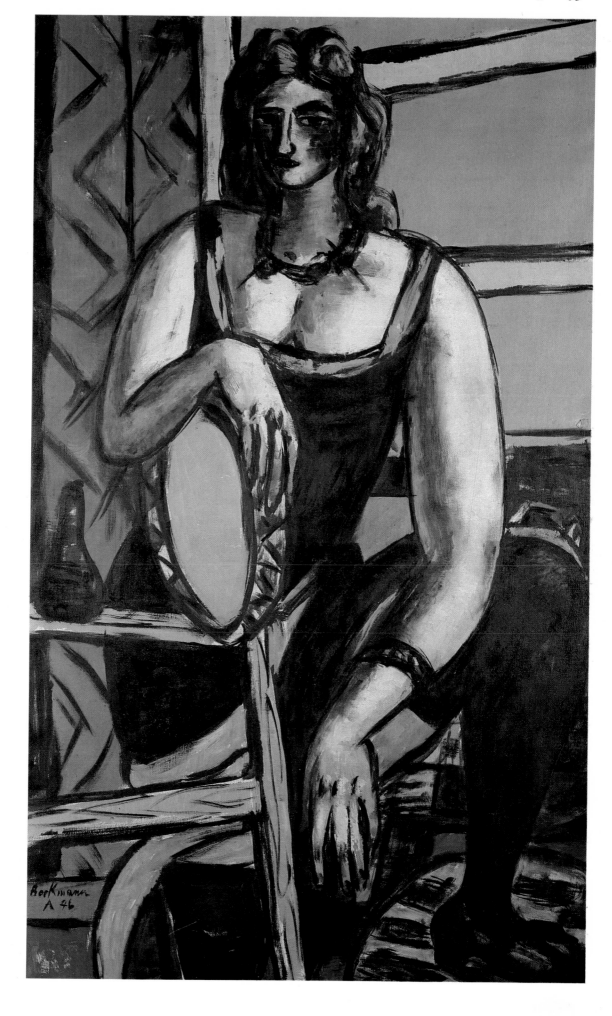

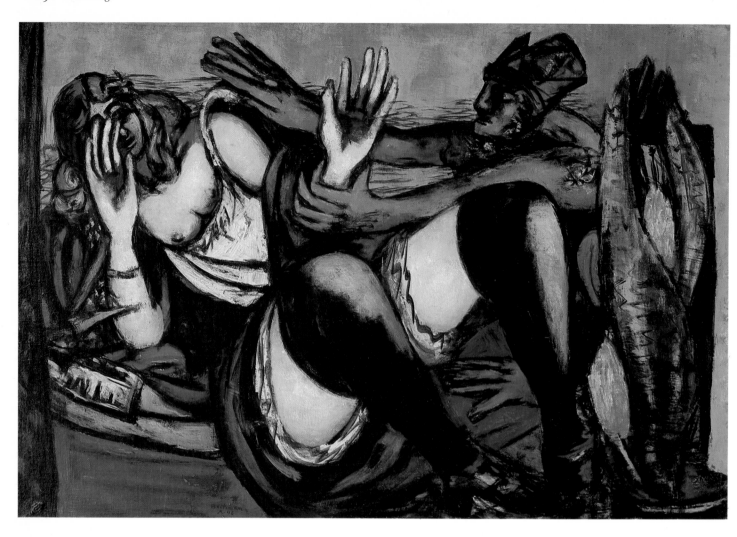

108 Afternoon 1946

Oil on canvas; 89.5 x 133.5 cm.
S.L.L.: Beckmann A.46
Dortmund, Museum am Ostwall
Göpel 724

Fifteen journal entries document how much difficulty Beckmann had with the actualization of this picture. He began the painting December 26, 1945; not until August 22 of the following year could the finished work be viewed in the studio in Amsterdam. A decisive step in the progress of the work turned out to be, as one learns from Beckmann's remarks, "the inspiration regarding the leafy plant" (April 13). No doubt he referred to the large plant at the right edge of the picture which sharply curtails this scenario of extremes.

Beyond the distinctive theme of the painting is the drastic form of the figures. A half-human, half-creature harasses a powerfully supine, provocatively dressed woman. Sultriness and unbridled lust define the erotic situation, which is ambiguously somewhere between seduction and violation. The demonic man's direct clutch is answered by the provocative open position of the woman, whose gestures of fright and resistance seem curiously meager and false. In his journals, interestingly enough, Beckmann called the painting not only "Afternoon" and "Visit," but also "Girl's Dream," thus selecting a title in keeping with the psychic dimension of the theme. The woman is certainly the primary figure who determines what is happening; like a prostitute she gives herself to the voyeuristic viewer extravagantly and alluringly, yet at the same time apprehensively. The hybrid creature resembles the grotesque figures which embody the diverse possibilities for gratifying desire in the mythological compositions (cf. cat. 82).

Extreme feelings of repressed sexuality in terms of violence and fear of the female are expressed in this 'male fantasy,' for which Beckmann chose a cast of the *femme fatale* and the brutish man. This projection, which threads its way through Beckmann's entire oeuvre, is formulated in particularly striking fashion in several late works. The radically, at times, grossly distorted proportions, especially of the hands, are symptomatic of the artist's last creative years. As a stylistic device, it allows Beckmann's obsessive interest to become immediately clear. C. St.

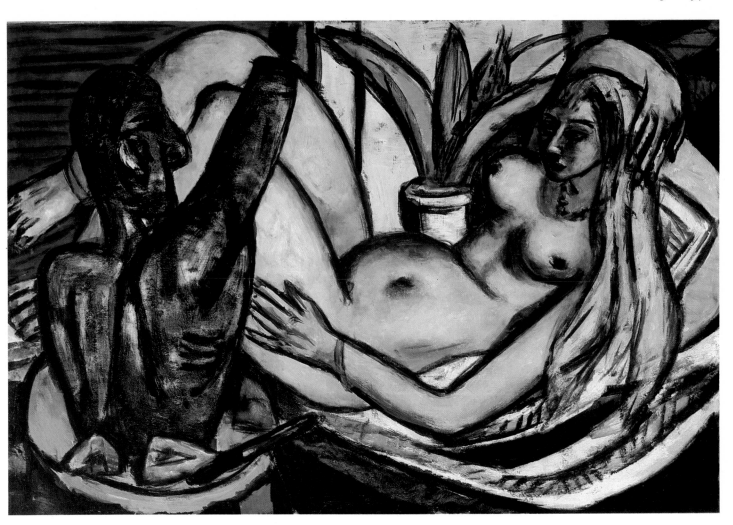

109 Studio 1946

Oil on canvas; 90 x 135 cm.
S.L.R.: Beckmann A 46
St. Louis, The Saint Louis Art Museum,
Bequest of Morton D. May
Göpel 719
Reference: Göpel, 1976, I, p. 431.

In the literature this painting also carries the title "Olympia," which originated with Morton D. May and was allegedly accepted by Beckmann. This links it with Manet's painting of the same name (fig., p. 51), with which Beckmann undoubtedly was familiar and to which he is consciously or unconsciously referring here. In both paintings the reclining nude female is joined by a dark figure which accentuates her splendor by way of contrast. Whereas in the Manet the black female attendant in the background is a foil to underscore the courtesan's beauty, in Beckmann's version we have a dark, half-figure male sculpture which establishes eye contact with the woman in a manner that makes it seem almost alive.

The original title, *Studio,* indicates that the painting addresses something material as well as spiritual: the former is represented by the familiar, everyday life of the studio; the latter by Beckmann's conception of his 'spiritual studio.' That the emphasis is on the latter is confirmed by the fact that the studio situation represented is not, after all, entirely matter-of-

fact. For the female nude is not at all a casual and optional stage prop, but is brought into a carefully considered relationship with the sculpture. The contrast of female and male, white and black, which Beckmann made his theme again and again, lies at the basis of this composition as well. Here, however, a balance, as conceived in the symbolic Chinese couple Yin and Yang, is put forth as a possibility. Light and dark are juxtaposed alternately: the woman is outlined in black, the sculpture shows areas of light. Yet on what preconditions the harmonious coexistence of man and woman might even be possible is made unmistakably clear in the juxtaposition of a living, vital nude on the one hand and petrified masculinity on the other. C. Sch.-H.

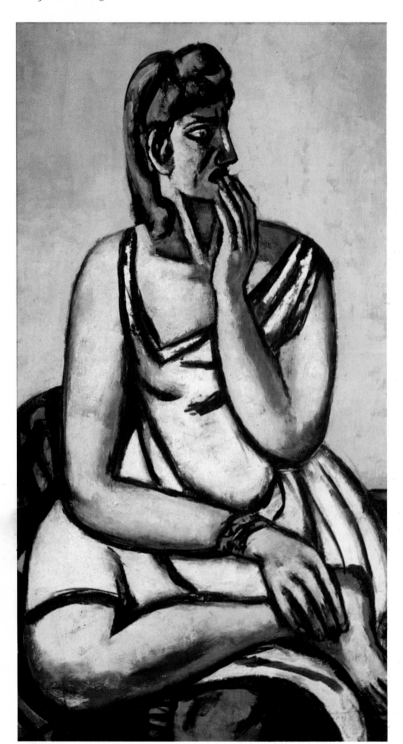

Paintings from the last three years of his life show a conspicuous brutalization of the corporeal. The distortion of the figure has a dual effect: for one, its abstract integration into the surface pattern: for another, the imprisonment of the figure. The folds of the garment and the three large, prominent limbs give it the appearance of being tethered. This binding structure, in connection with the fearful expression, probably alludes to the interrelationship of libido, lack of freedom, and punishment that are depicted in the triptychs, *Departure* and *Temptation* (fig. p. 40, and cat. 73). C. St.

111 Begin the Beguine 1946

Oil on canvas; 178 x 121 cm.
s.l.r.: Beckmann A 46
Ann Arbor, The University of Michigan
Museum of Art
Göpel 727
References: Fischer, 1972, p. 172 ff.; Fischer, 1973, p. 75 ff.

None of the figures in this painting is shown in a form that corresponds to any visible reality we know; and the superficial theme of a fashionable dance to the music of Cole Porter's popular song from the early post-war years defies a straightforward interpretation. The impression of a state of affairs suspended between the determinate and the indeterminate is supported by an assessment of what is happening in the painting. This seemingly conventional middle-class interior consisting partly of patterned wallpaper and partly of wood paneling is not even tentatively recognizable in terms of its spatial proportions. The individual wall segments seem more like pictorial surfaces propped against one another, into which the figures appear to be woven as though into a carpet.

The couple in formal dress, apparently dancing the Beguine, is sheerly incapable of doing so. Besides the fact that he is not making contact with the floor, the man has a crude wooden stump in place of his left leg. His partner seems to be floating upward; her left leg disappears behind her dress, and in place of her right leg a wing-like piece of cloth extends far into the lower right corner. Her upward motion is accentuated by her upstretched right arm. She directs her dreamy, enchanted gaze toward a young man peculiarly outfitted in tight blue pants, a sleeveless green smock, a net thrown over his shoulder, and a plumed hat. He returns her gaze as if equally entranced and holds toward her a gigantic key. His right foot is propped on a sign bearing the title of the hit song, and he is braced on a wooden crutch which he does not actually seem to need. Behind the woman are several large pelican-like birds, while in front of her on the left is a half-naked, squatting woman with upstretched,

110 The Frightened Woman 1947

Oil on canvas; 135 x 75 cm.
s.l.r.: Beckmann A 47
Private collection
Göpel 736
References: Busch; 1960, p. 65.

In this painting both the theme and the strangely deformed aspect of the figure are distinctive. The subject's fright is communicated only by her drastic facial expression and remains a purely episodic pretext, for the emotion is not carried through in the body. The woman's scanty dress, her exaggerated limbs, the forceful way she sits, and the contorted leg are meant to communicate the menacing eroticism that Beckmann perceived in womankind again and again, almost to the point of obsession.

Originally conceived as a nude, this picture is part of the series of powerful nudes (cf. cat. 35, 59), and threatening dancers, actresses, and Columbines (cat. 107, 130). Were one to argue in depth on a psychological level, one would have to take the powerful vise-like leg as a symbol of the male's fear of the Great Castrating Mother and *femme fatale*—a theme at the very center of what Beckmann the Symbolist fashioned.

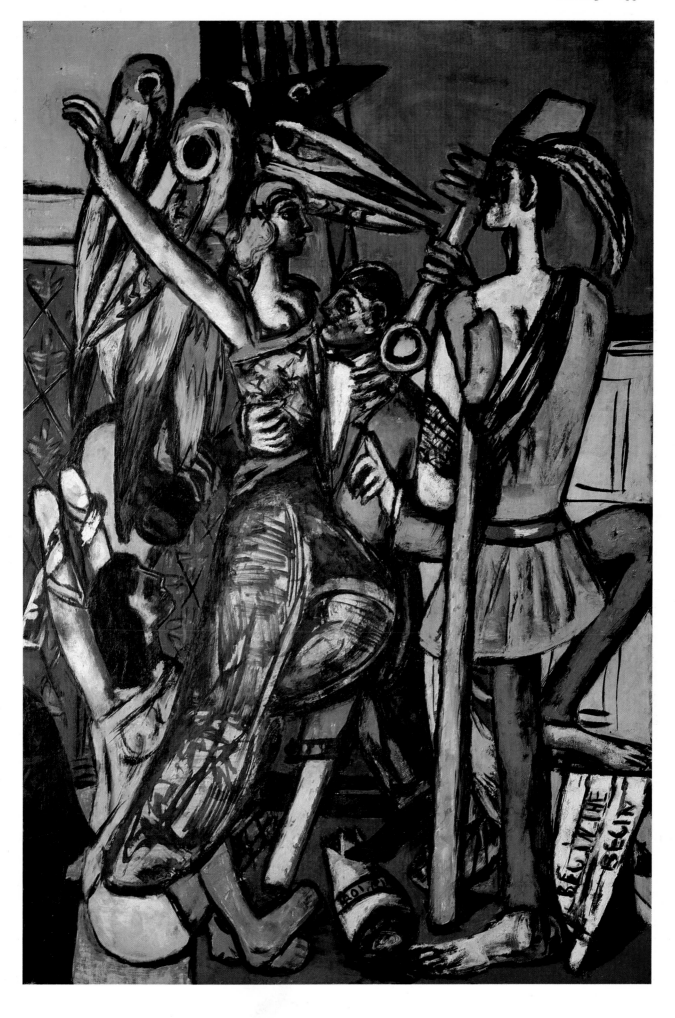

tethered arm stumps. Her gaze is directed longingly at the woman floating upward.

Certain parallels with the painting, *The Dream* (cat. 23), completed 25 years earlier, are obvious. Like the earlier work in which a man with stumped arms climbs toward a closed ceiling in a senseless expenditure of energy, this too is an allegory of vain human effort. Here, as there, we find crippling injuries and a peculiarly unconscious, dreamy mode of activity. In *Begin the Beguine,* however, this has a decidely more positive impression, at least with respect to the two main figures, who are bound together by means of eye contact and disproportionate size.

The title of the popular song is being used for its double meaning: it refers not just to the dance but quite generally to a hopeful new beginning, as was expressed during the postwar period. The two youthful main figures in the painting support that suggestion. The key may signify access to a secret which the young man knows in which he means to initiate the woman. That the young man might be intended as an allusion to the messenger of the gods, Hermes, and perhaps the Hermes Trismegistes of Gnosticism, i.e., the magician who knows the secret of the world, is an interesting but unconfirmed conjecture. C. Sch.-H.

112 Promenade des Anglais in Nice 1947

Oil on canvas; 80.5 x 90.5 cm.
S.L.M.: Beckmann N 47
Essen, Museum Folkwang
Göpel 741

References: Göpel, 1955, p. 40; S. Kaiser, 1962, p. 78; Schmoll, p. 60.

This painting was first conceived when Beckmann was back in Amsterdam, two days after his return from Nice. It shows a view from a window in the Hotel Westminster onto the bay, the promenade lined with palms, the tight row of houses belonging to the city, and the distant chain of hills. It is curious that in spite of the elevated viewpoint and the far-ranging perspective, one experiences the feeling of an almost oppressive constriction. This sense of confinement is expressed by the dark hilly region that seals off the sky; the heavy curtain, fashioned like a piece of sculpture, that draws the broad sweep of the bay visually closer; and the perspective which is so distorted that the street with palms and the globe lamps looks as if it had been folded up into one plane. Foreground and street panorama penetrate each other, for between the guard rail of the balcony and the curtain several of the lamps and crowns of trees have been pushed in unexpectedly close. Shades of violet, pale yellow, and concentrated black reinforce the constriction into which the observer, along with the woman seen from the rear, is locked. Nice is not only the nocturnal, sultry city to the south; it is represented here as a place of enigma and a metaphor of confinement. This most unusual cityscape no doubt belongs among Beckmann's "dream" representations. C. St.

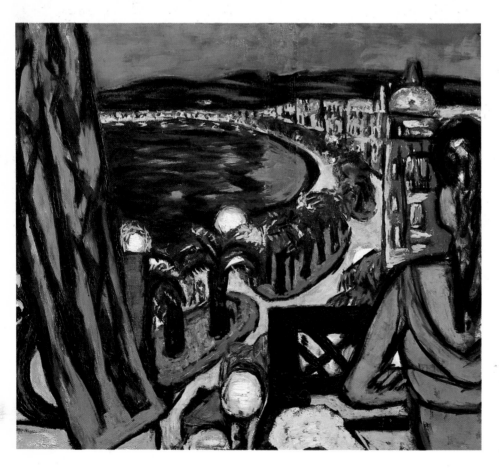

113 Girls' Room (Siesta) 1947

Oil on canvas; 140.5 x 130.5 cm.
S.L.R.: Beckmann A 47; S.L.M.: Beckmann A 47
Berlin, Staatliche Museen Preußischer Kulturbesitz, Nationalgalerie
Göpel 739

This painting surely depicts a bordello scene with three half-dressed women who rest languidly in lascivious sensuality, an old woman reading, and sultry red veils scattered throughout the picture. Once again, feminine pulchritude in full flower (emphasized by tulips in full bloom) is confronted by the withered, dark-veiled old hag. The picture is complete with the familiar symbols of ephemerality and vanity, the clock and mirror.

But it would be wrong to infer a hidden tendency to moralize here. In their sensual beauty the three women are spontaneous and quite self-possessed; their portrayal here is objective and non-judgmental. There is, however, a pervasive gloominess, an atmosphere which, like the sultriness of a hothouse, seems to make breathing difficult. This scene is cut off from nature in that the window is closed tight and light comes not from the sun but from a kerosene lamp.

The females represented here are ones we encounter frequently in Beckmann's work. Particularly striking, however, is the resemblance of the woman in the upper right with the one in the center panel of the triptych, *Temptation* (cat. 73), who is likewise surrounded by a tulip-like flower and a mirror. Although there are several possible meanings for her presence here, she is reduced entirely to her sensuous existence. C. Sch.-H.

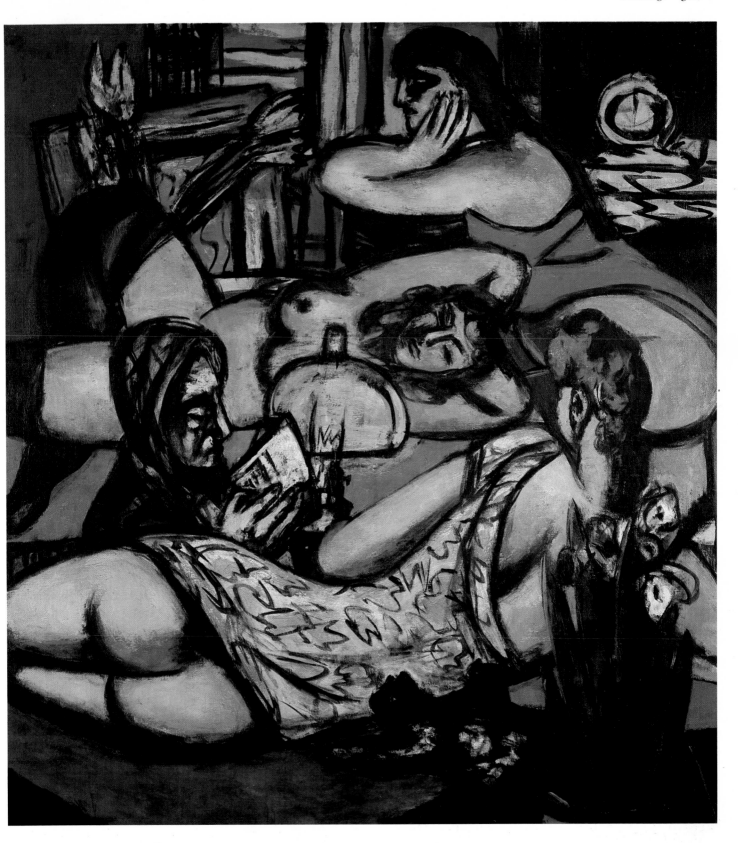

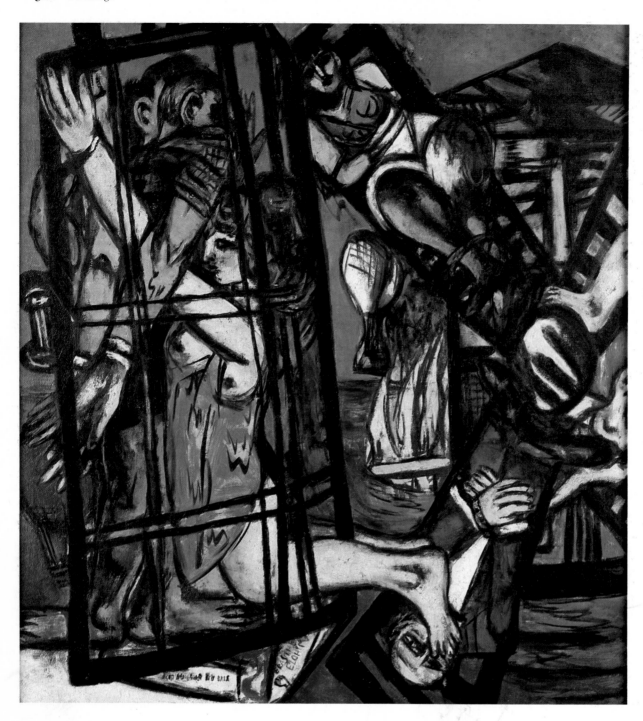

114 Air Balloon with Windmill 1947

Oil on canvas; 138 x 128cm.
s.l.r.: Beckmann A.47
Portland, Oregon, Portland Art Museum,
Helen Thurston Ayer Fund
Göpel 749
References: Göpel, 1955, p.34; Fischer, 1972,
p.180ff.; Lackner, 1978, p.136.

Men and women who are locked in a cage or
tied to the arms of a windmill, a raging sea, a
flaming dock, and two captive balloons in
sluggish ascent are the simultaneous scenes
involving physical torment and lack of freedom
in this painting. Everything seems to move
under the aegis of alien forces, and there is no
place that promises stability. Man is powerless
against the swaying and circling of his unstable

situations as well as the natural violence of fire
and water. The black, which is combined with
phosphorescent colors as in stained glass win-
dows, effects a sinister, closed surface structure
in keeping with the motifs of bondage. On the
face of it, the apocalyptic elements specify the
scene as a depiction of the end of the world.
The Great Flood, a cosmic conflagration, and
the Last Judgment join forces. The depressive
atmosphere no doubt has less to do, as Lackner
supposes, with biographical matters than with
Beckmann's psychic condition, as one finds it
described in a late journal entry: "I am still
unable to find my way in the world, the same
measureless discontent that I felt 40 years ago
still fills my heart even now... Oh no, life is
bad, art is bad.—But what is better?—the far-

distant land—save me oh great Unknown—"
(17.9.1946).

This atmosphere so characteristic of the
entire body of work is the point of departure
for Beckmann's early confrontation with a pes-
simistic world in the spirit of Schopenhauer
and according to the Gnostic, theosophical,
and Indian traditions. Even more than it is a
depiction of the end of the world, this painting
is a metaphor for a principle of life in which
Beckmann believed. The man caught in the
cage is symbolic of the soul imprisoned in the
body (cat.73), the bound man and woman are
indicative of physical compulsions and desires
(cat.70, 73, and fig. p.40), and the windmill is
symbol of pointless rebirth. All these analogies
are to be found in the religio-philosophical

sources which Beckmann had studied and which Friedhelm W. Fischer has subsequently elucidated. The inscriptions beneath the cage are particularly noteworthy. Fischer traces the BRASITH ELOHIM back to the cabbalistic esoteric doctrine of Helene Blavatsky and interprets the text in conjunction with the little fist as protest against the God of a negative creation. He interprets the windmill as the face of the demiurge himself. The windmill's demonic violet color has its precedent in the eerie figures of the *Children of Twilight* (cat. 87). Most peculiar is that the violet apparition whose ear, arm, and hands are visible behind the cage must no doubt embody an active demon. The sinister, oppressive structure of the painting suggests no element of deliverance (Fischer), but rather reinforces the tortuous scenario, which plays out the "patent insanity of the cosmos." Even the captive balloons do not signify hope, for they hang awkwardly among things (fig., p. 41).

Beckmann started this painting in August of 1946, only a few days after the completion of *Large Landscape with Windmill,* which very closely anticipates, in spite of its being a pure landscape, the motifs, composition, and aura of confinement here. C. St.

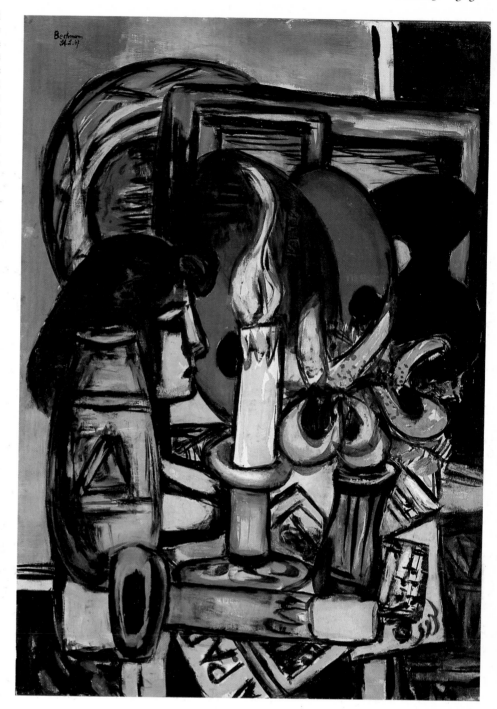

115 Still-Life with Two Large Candles 1947

Oil on canvas; 108.5 x 78cm.
S.U.L.: Beckmann St. L. 47
St. Louis, The Saint Louis Art Museum,
Bequest of Morton D. May
Göpel 755
References: Reifenberg, 1949, No. 619; Fischer, 1972, p. 118; Fischer, 1973, p. 78f.; Göpel, 1976, I, p. 453.

This was one of the first paintings which Beckmann completed after his arrival in St. Louis in 1947. It is distinguished by its unusual colorfulness and closely confined mode of composition. At the same time it documents how little Beckmann's basic attitude was affected by his emigration to America. The mysterious, darkly luminous colors, the tightly crowded space, which should be considered in light of Beckmann's anxiety about space, the severely geometric pictorial construction, and the unusual

assemblage of objects do not differ significantly from previous interpretations of the theme.

The picture is plotted around the centrality of the burning candle. The flame throws a peculiar, unreal light onto the classical profile of the wooden female bust and the oval blue vase, which screens the sculpture and to some extent is bound up with it. The same light is reflected in the series of round and rectangular framed mirrors, and it illuminates the three variably shaped palettes in the background as well as the sensual, exotic orchids. The flower's petals form a tensive contrast with the cool, static lines of the bust and the vase on the other side of the composition. A second, recently extinguished candle lies perpendicular to the burning one, forming a parallel with the edges

of the table and the painting. Thus a rigid central scaffolding is created, accentuated by a piece of pale green paper on which the printed letters, when completed, spell PARIS.

By means of their conspicuous arrangement, the candles not only dominate the composition of the painting but identify it thematically as a *vanitas* still-life. This signification, originating with classical still-life painting, is one which Beckmann used over and over again in altered form. The two candles in this picture—one standing and lit, the other tipped over and extinguished—could thus signify life, eternity and creativity on the one hand; death, destruction, and impotence on the other. They function not only as symbols, but also as pure painterly form. L. E.

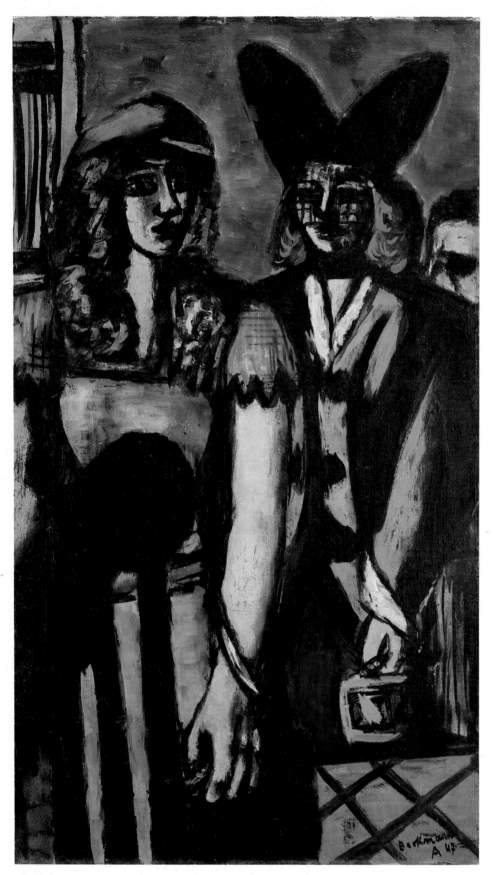

**116 Two Women by the Stairs
(Hotel Hallway),** 1942, 1945, 1947, 1948
Oil on canvas; 96 x 56 cm.
S.L.R.: Beckmann A 47
London, Marlborough Fine Art Ltd.
Göpel 771

Phosphorescent colors of sooty green and vio-
let and an irritating black imitate the melange
of darkness and transparency one finds in
stained glass windows in this late picture. In its
dark austerity and inner glow it has an affinity
with the painting of Rouault. The theme is
once again Woman as an alluring, mysteriously
veiled, and dangerous creature. These two
women display themselves as birds of paradise.
Because of the offputting effect of the blue
tonalities and the figures' location in some
unreal place between the deep blue floor and
the black railing of the staircase, they are com-
pletely unapproachable. As in the painting
Ladies' Band (cat. 91), the man is reduced to a
partial view of his face and plays a subordi-
nated role. Woman as the great seductress
wears the veil of a cocotte, a curiously horned
coiffure, and the symbol of sin, a yellow-green
snake, is coiled around the arm of the woman
in violet (cf. *Large Painting of Women,* 1935
Göpel 415).

In *Fisherwomen,* 1948 (cat. 121), the woman
who catches fishes and souls in the lower right
corner of the picture has her hair styled in a
fashion that resembles the black hat here. The
image of the modern urban Amazon, a motif
found in Kirchner and Rouault among other
early Expressionists is expressed in a variety of
analogous forms in several of Beckmann's
paintings. His subtitle for the picture is sig-
nificant in that since approximately 1919 (*Mar-
tyrdom,* cat. 250, and the drama, *Das Hotel*)
'hotel' has been his metaphor for an unfathom-
able world.

The painting was reworked again and again
over a period of years; the first version dates
from 1942, but it was not completed until 1948.
A comparison of the first version (a photo of it
still exists in The Museum of Modern Art, New
York) reveals a process of simplification and
consolidation recognizable in the genesis of
other works as well (cf. cat. 78, 86). Flower
decorations, a detailed description of locale,
and the psychological interplay between the
two women have been eliminated here. Instead
the figures have grown to monumental propor-
tions and are bound to the surface. The woman
in the foreground's hanging arm binds the
figures into a close-knit couple (cf. cat. 95).
The present signature was affixed in 1949,
probably when the painting was sold. C. St.

117 Masquerade 1948

Oil on canvas; 164.5 x 88 cm.
S.L.R.: Beckmann StL 48
St. Louis, The Saint Louis Art Museum,
Gift of Mr. and Mrs. Joseph Pulitzer, Jr.
Göpel 765

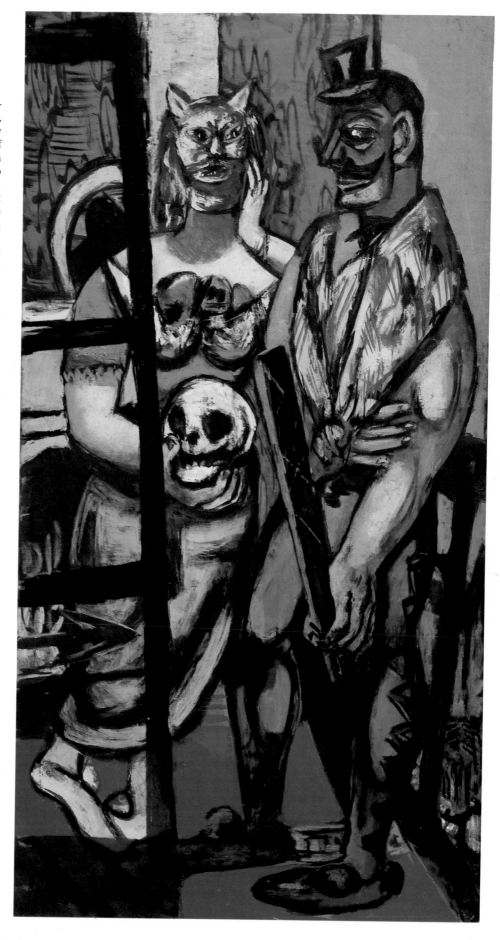

As is well known, the themes of carnival, masquerade and the characters of entertainers, clowns, and vaudeville artists occupy a key position in Beckmann's work. The motif of role-playing and disguise became for him a simile for human limitation and the inability to show oneself freely and straightforwardly. Masking not only signifies protection against some hostile external condition, but can also be an expression of defiant self-assertion in the refusal to allow oneself to be known; on occasion it also seems to be the means to hide some fearsome inner condition, something repulsive which one does not want disclosed. For Beckmann, disguise is never innocent playfulness, despite his enthusiasm for masked balls, vaudeville, and circus. Instead, it is a constant symbol of human compulsions and desires.

This is one of the last in the series of such paintings which concludes shortly before his death with *Carnival Mask, Green, Violet and Pink* (cat. 130), in which a comparable female is portrayed. In *Masquerade* the artist has captured a pause in the dance; a couple is leaning against a balustrade more or less by chance. They are not looking at one another. The woman stands behind a glass door with a directional arrow; its wooden struts are associated with a ladder (cf. among others, cat. 122, 125). Although apparently innocuous, the situation carries a menacing effect, which is contrary to the merry evening's entertainment one might ordinarily associate with such a theme.

The muscular man stands firmly on the floor with both feet, while the woman is propped on her elbow so far to the right behind the man that her feet barely touch the floor. And yet she makes a more menacing impression than does he, for the grip of the skull in her right hand looks entirely too casual. Her face is completely covered by the cat's mask; in fact, it has become her actual face as it merges with her hair of the same color. The blue kerchief in her bosom does not serve to veil it provocatively, but crudely "stuffs" it shut. The man masked or painted in blue, whose ridiculously small hat is in curious contrast with his unpleasantly angular features, seems to be looking out hesitantly or skeptically. His right arm lies across his body as though it were protecting him from whatever approaches. Both figures are unrecognizable as individuals and, in spite of their strong physicality which should actually suggest vitality, they both have a lifeless effect. Even in their coloration they are no livelier than the background, which manifests comparable flesh colors (fireplace flue and strip of wall) and shades of green. An aggressively sensuous red appears in the laboriously glimmering fire, the braid at her sleeve, the man's hat, and the slip of paper on the floor. Costume and mask are no longer designed to facilitate even superficial and fleeting communication between man and woman; they stand next to each other as strangers, each locked com-

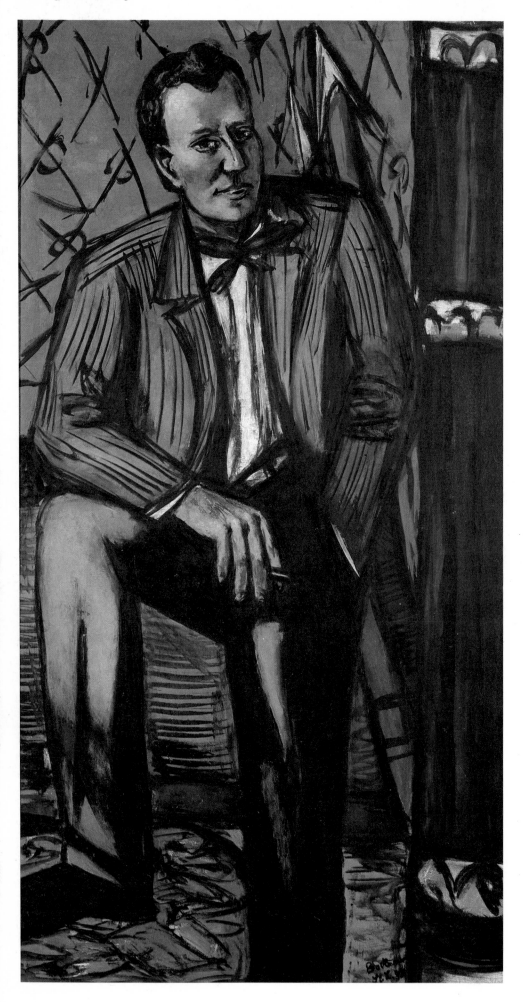

pletely into his role, fixated in it to the point of immobility.

The symbolic content is as ambiguous as it is indeterminate. The cat, symbol of sin in both Buddhism and the cabbala and popularly believed to have magical foreboding powers, might express the fear of impending death and, at the same time, the ability to conjure it away like a fetish. The skull, of course, is a traditional *vanitas* symbol. If one adds the man's tights, with their curious snakish ornamentation reminiscent of Indian ritual paintings, one might consider this a reference to the veneration, presumably known to Beckmann, of North American Indians for the cat and the snake which are important in ritual exorcisms. In the manner in which they are masked, the two figures also recall the stolid, awe-inspiring majesty of pagan priests. C. Sch.-H.

118 Portrait of Perry T. Rathbone 1948

Oil on canvas; 165 x 90 cm.
S.L.R.: Beckmann St. L. 48
Perry T. Rathbone
Göpel 773
Reference: Göpel, 1976, I, p. 465 f.

The art historian Perry T. Rathbone, b. 1911, and his wife Euretta were good friends of the Beckmanns during their American years. Rathbone, who was director of The City Art Museum of St. Louis while this portrait was painted, had much to do with Beckmann's appointment at Washington University, and in 1946 acquired *Young Men by the Sea,* 1943 (cat. 100) for the Museum. Rathbone also organized the arrangements and the catalogue for the 1948 retrospective which contributed appreciably to the artist's recognition in the United States. On December 29, 1950 Rathbone gave the eulogy at Beckmann's funeral.

The individual portrayed in near-full figure is represented in an emphatically unconventional and unrestrained position. With his right leg placed on a chair, propping himself loosely on his right thigh with his elbow, and holding a cigarette carelessly in his right hand while his left is casually stuck in his trouser pocket, he communicates the impression of a self-assured personality who has no need of an outer pose. By means of the agitated surface of the clothing and the background, which is unusual in the work of the artist in this genre (cf. cat. 113), a nervous, restless element is added. Together with the alert gaze which does not avoid eye contact, the presentation succeeds in the depiction of a personality at once sensitive and spontaneously responsive to its surroundings. Here is a man who is receptive and open to everything new. That Beckmann could here relinquish the distance between artist and model that is so often in evidence in his portraits results in a remarkably accessible depiction of this man's individuality. It is possible that Beckmann was attempting to express here what may have struck him as a typically American openness. C. Sch.-H.

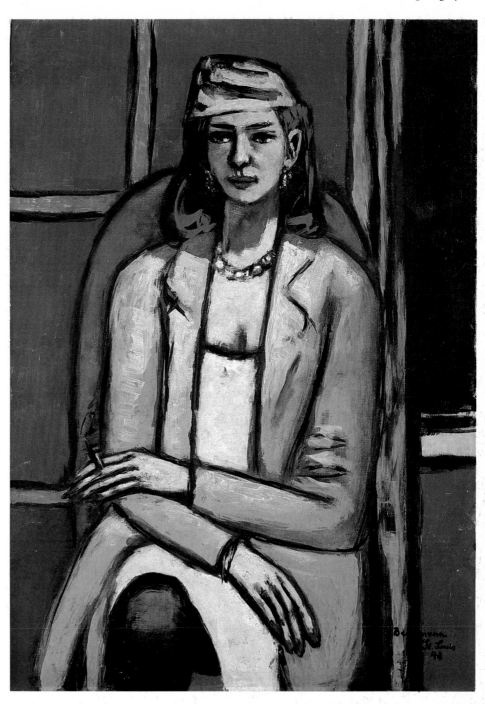

119 Quappi in Gray 1948
Oil on canvas; 108.5 x 79 cm.
S.L.R.: Beckmann St. Louis 48
Private collection
Göpel 761

By means of its austere construction, its almost geometrical articulation, and its elegant coloration, this likeness of the artist's wife attains an unapproachable dignity. In the long series of portraits painted of Mathilde Beckmann, this is the concluding one, if we except the one done in 1926 and significantly reworked in 1950 (cat. 129). The journal entries having to do with this work extend over four months, rather a long stretch of time for a painting so com-

paratively uncomplicated thematically and so relatively small.

Characteristic of almost all of Max Beckmann's portraits is the deliberate renunciation of distracting paraphernalia, ornamental accessories, furniture, etc. One's view is concentrated entirely on the figure, consciously attentive, to be sure, to that person's individuality but at the same time kept at a distance. No matter how sharply observed, the subject of the portrait retains an aura, a kind of protective circle against every importunity. This fundamental attitude, decisive already in the 1920s, distinguishes the portrait from the self-portrait, in which Beckmann makes use of a sharpness and severity to observe his own person.

This portrait of his wife exhibits these principles with particular clarity, indeed almost over-emphatically. Placed in front of a largely planar background, the figure is reinforced by the wood frames of a glass door or the backside of a canvas which subdivides the painting into parallel fields. The total absence of anecdotal elements neither supports the spatial layout nor describes the foreground. And the slight turn of gaze on the part of the figure past the viewer, given in three-quarter perspective, focuses on nothing concrete but instead reflects something visible only to herself. Her distance is further reinforced by the position of her arms, which closes the figure off in front and yet maintains a matter-of-fact respect for the individuality of the other. C. Sch.-H.

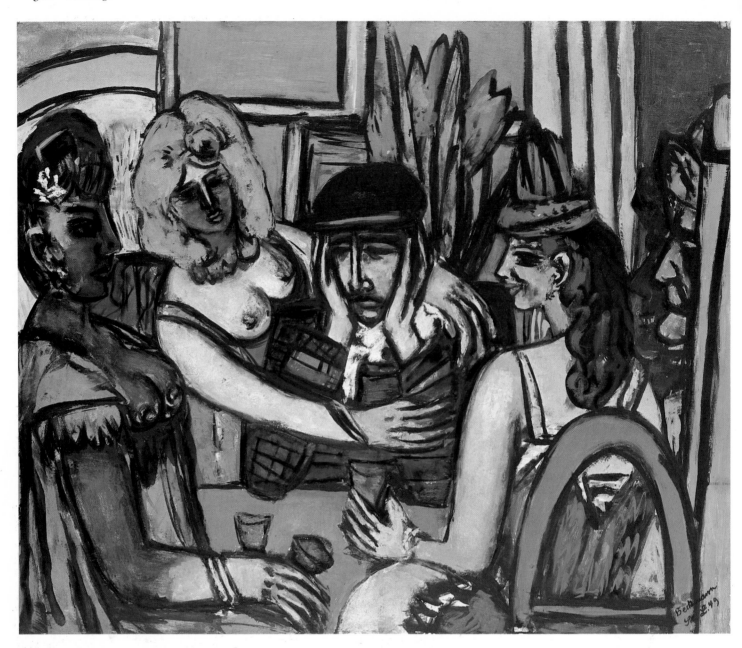

120 The Prodigal Son 1949

Oil on canvas; 100 x 120cm.
s.l.r.: Beckmann St. L. 49
Hannover, Kunstmuseum Hannover mit
Sammlung Sprengel
Göpel 780

References: Göpel, 1955, p. 30; Seiler, p. 148, 253;
Lackner, 1978, p. 140.

In keeping with his pessimistic picture of the
world, Beckmann selects not the return of the
prodigal son (Luke 15:11-32) but the moment
of despondent recognition of a futile and hope-
less situation. Caught in the arms of the brassy
blonde woman and tightly surrounded by the
exotic, luminous prostitutes with whom he has
spent his fortune and his youth, the young man
is trapped in a hopelessly dissipated existence.
The vitality of the flaming tulips heightens his
forlorn demeanor. Again, idol-like women
play the role of soul-snarers (cf. cat. 121, 132).
The sharply etched head projecting a demonic
shadow at the right edge of the painting

remains ambiguous. Though Lackner sees it as
the brothel madam and Seiler supposes it is an
allusion to the expectant father and the envious
brother, this double profile is more likely
intended to represent knowledge of a preor-
dained fate, much like the motif of the old
woman (cf. cat. 25, 113) or the apparitions of
the Gnostic negative gods (cf. cat. 73) would
suggest. Autobiographical testimony is pro-
vided by the much earlier elaboration of this
theme (6 gouaches pertaining to the *Prodigal
Son,* 1918) in which Beckmann fashions the
main figure as a self-portrait and forms a real-
life connection with his fated status as emig-
rant, which is, by now, a *fait accompli.* "Beck-
mann finally moved to a large and distant land
—and gradually we saw his image becoming
less and less clear. At last it disappeared
altogether in the indeterminable vastness."
(9.2.1949). C.St.

121 Fisherwomen 1948

Oil on canvas; 191 x 140cm.
Unsigned
St. Louis, The Saint Louis Art Museum,
Bequest of Morton D. May
Göpel 777

References: Valentiner, 1955, p. 85; Selz, 1964, p. 92;
Fischer, 1972, p. 189ff.

Three provocatively dressed young women,
each with a fish she has caught for herself,
define the composition not so much as a
unified phenomenon but rather by means of
their ostentatious display of individual naked
body parts. The one on the left—nude except
for her corset—sits so far to the rear on a chair
that her buttocks are provocatively framed by
the back of the chair. The neck of a transpar-
ent, bulgy vase in which some exotic growth
paraphrases the erotic form of the buttocks
overlaps this part, thus bringing it into promi-
nence once more. The white, short-sleeved

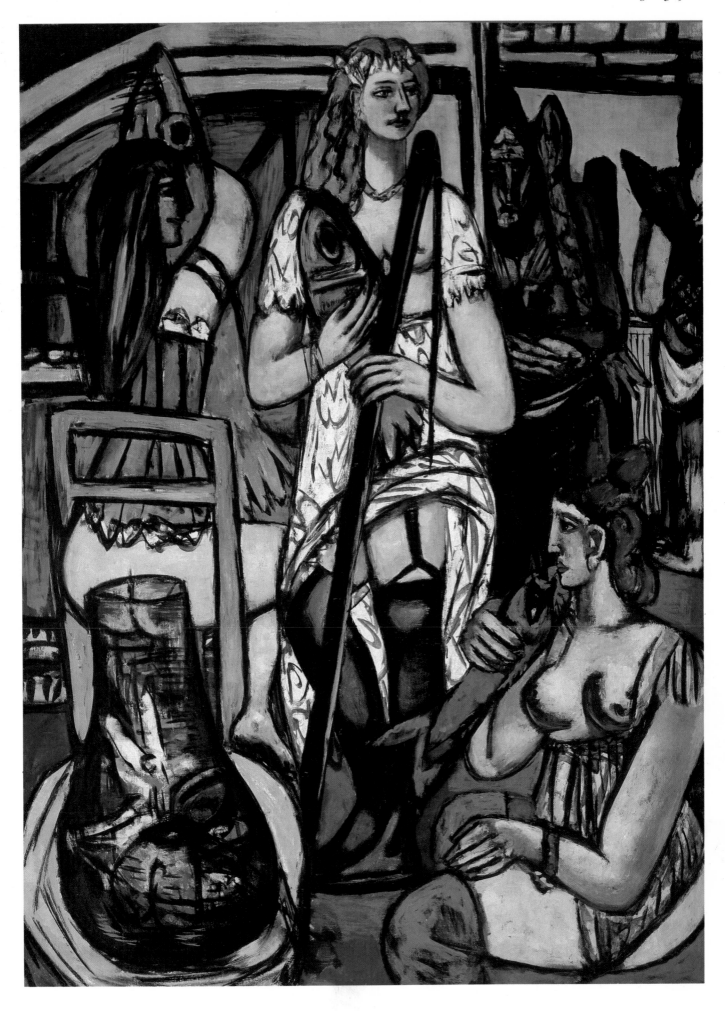

dress of the woman in the middle exposes her upper body to the waist and is deliberately pulled up in front so that one's view is forcibly concentrated on the portion of her thigh visible between the black stocking and the dress. The well-developed bosom of the woman on the right is framed by the cut of a yellow dress which also leaves her thigh and bottom exposed. From the point of view of its material, the clothing gives the impression of mere color surface, thus underscoring the sexuality of the naked body parts, framing and displaying them like fetishes. The reserved and mysterious faces of the women form a striking contrast. Here there is nothing obscene, or even frivolous. For them at least, their activity seems rather to be endowed with the seriousness of a ritual performance, in which the caught fish—male sexual symbols—are trophies and sacrificial animals in one. Painted in a glazed technique, these fish do not approach the sensuality of the female bodies; as almost transparent, incorporeal beings, they evoke the connection between fish and soul.

That this idea is hardly remote from Beckmann's iconography is shown by a comparison with the drawing, *Women Fishing,* produced in 1949, in which the women are catching fish that have men's heads, and the drawing, *The Fishermen,* 1940-45 (cat. 188), which refers back to the painting *Children of Twilight* of 1939 (cat. 87). "They catch husbands, not lovers...," Beckmann allegedly said to his wife in reference to this painting. The old woman lurking expectantly in the background, who is holding an eel or a green asparagus in her arm, appears to take the role of sage and overseer. She watches over the situation alertly and, by virtue of her age, brings an element of transience into the picture, as in the *Girls' Room* of 1947 (cat. 113).

The non-color black plays a decisive role in the articulation of the painting so that the plasticity or planar aspect of individual segments of the picture are brought into prominence. The composition thereby attains a distinctive relief-like character, as though the colored portions enclosed by the lead lines in a stained glass window were sometimes arched forward and sometimes flat. An impression of individual semi-sculptural pictorial components standing between completely flat portions results. The confinement of this plasticity to the unclothed body parts reinforces their symbolic and erotic character. At the same time a juxtaposition of the materially sensuous and the immaterially spiritual is effected, the latter manifesting itself absolutely in the black areas. C. Sch.-H.

122 The Beginning 1946-49

Oil on canvas;
Left panel: 165 x 85 cm.
Middle panel: 175 x 150 cm.
Right panel: 165 x 85 cm.
S.L.R.: Beckmann StL. 49
New York, The Metropolitan Museum of Art,
Bequest of Miss Adelaide Milton de Groot
(1876-1967), 1967
Göpel 789

References: Lackner, 1965, p. 26; Schiff, 1968, p. 281 f.; Kessler, p. 77 ff.; Fischer, 1972, p. 202 ff.

This painting is the eighth of Max Beckmann's nine completed triptychs. After the seventh, *Blindman's Bluff* (fig. p. 38), had already been finished in September of 1945, we find this journal entry dated August 5, 1946: "This evening Johannes was here, stretching canvas frames for two new triptychs." Then, on October 3: "Already today a draft for 'Puss in Boots,' becoming quite interesting." Beckmann is referring to the tomcat hanging upside down from the ceiling in the center panel which was so important a figure to him that it provided the tentative title for the entire triptych.

The idea for a painting with the tomcat can perhaps be traced back to a dream on April 13, 1946, for one reads the following about it in the journal: "I just had an absurd and unpleasant dream in which somehow a Puss in Boots played a role that made me mighty ridiculous..." Beckmann was surely familiar with the fairy tale about Puss in Boots, in which it is actually mentioned that the tomcat catches mice and rats while hanging upside down. Rodents are in fact depicted along the floor. Beckmann began painting the center panel in October of 1946, and the side panels in January of 1947. During the course of his work he called the triptych "L'Enfant" or "L'Enfance," and later on "Jeunesse." Then he must have abandoned the project, for in America in December of 1948 he wrote: "Interesting, that old new little triptych 'l'Enfance'." It appears that the triptych was only finished on April 5, 1949: "!! Turned out beautifully!!" Nonetheless, Beckmann took up the painting once more. On May 16 the work was finally concluded.

The triptych consists of a large rectangular central painting flanked by narrower, somewhat lower side panels, which do not so much frame the center panel as attach to it. Beckmann must have wanted the three paintings to match not on the lower edge but rather with reference to central horizontals of the main painting (cf. letter to Valentin on 2/25/47 about *Blindman's Bluff*).

The triptych's main figure is a boy who is shown in different contexts in each of the three panels. On the right he is in a classroom, on the left he is experiencing a heavenly vision, and in the center he makes a conquering leap "into the world."

In the right panel he is integrated into the order of a classroom, where mean-spiritedness is embodied in the wretched figure of the schoolmaster. His strictness is apparent in the youth who is punished by being made to stand up front with his arms raised high. However, there is a hope of liberation in this oppressive place. Not only has the barred door already

swung open, but a bright painting with mountains and blue sky as well as a globe suggest the freedom of nature and the wideness of the world, just as the harp in the foreground suggests free artistic development. The youthful head of a classical statue, which contrasts with the figure of the teacher in front of it in size, bearing, and noble form, embodies the world beyond the classroom, toward which all hope is directed. The arc of the harp encompasses the head and arm of the boy, who frees himself from this confinement by indulging in artistic activity and erotic fantasies: turned away from the class and the teacher, he displays a sketch of a naked woman.

With this depiction Beckmann is remembering his own childhood experiences: "In Braunschweig I distinguished myself in school most of all by setting up a small picture factory during lessons. The products wandered from hand to hand and mesmerized away many a poor fellow slave's dreary fate for a few minutes" (*Almanac* of R. Piper and Co., 1904-1924, Munich, 1923, p. 82).

In the left panel the boy already has a little female companion. He is not turned toward this creature garlanded with blossoms, however; he is looking out of the window and

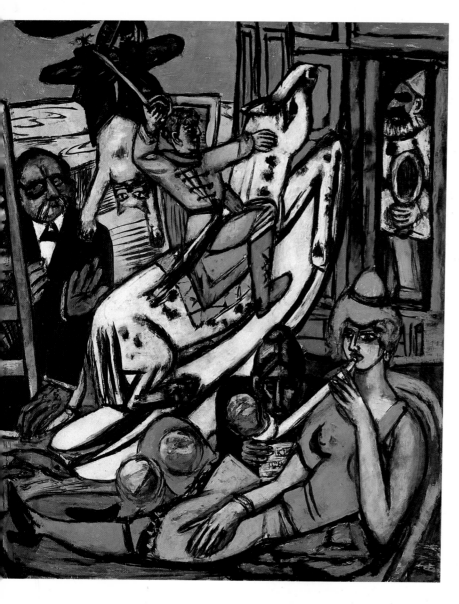

beholding a heavenly vision. With a crown on his head and a spear in his hand, he has been transformed into a little prince who is capable and worthy of such a visionary perspective. The mind of the girl, however, seems to be limited to the mundane, so that a reflection of her own beauty satisfies her. To be sure, the room confines the youth even here, but through the window he sees descending from the bright blue sky a host of angels who accompany an old organ-grinder and bow down before him. The boy seems to be gazing in particular at the angel left front, whose large eyes are in turn directed at him. In the unearthly beauty of this angel with the face of a girl, the lad finds his fulfillment.

In conspicuous contrast with the angels, the organ-grinder is fragile, blind, old, and, not least of all, a man. Lackner has made reference to an analogous figure in *The Dream* of 1921 (cat. 23); the organ-grinder in *Beggars* (VG 218) in *The Berlin Trip* of 1922 is also comparable. In the older works they are figures of Fate, who bring the old song of life symbolically into focus. The organ-grinder of the triptych must be understood thus, though Fischer, too, is correct in seeing the sinister old man as the evil demiurge who has created the world

and oppresses humankind. He does indeed inhibit the boy's view of the open vault of heaven and produces a menacing effect. Yet for Beckmann he is after all blind, old, fragile, and in the end, powerless. In the transcendant sphere he is the equivalent of the schoolmaster who is a similarly impotent figure.

Beckmann has depicted the boy's actual world in the middle painting. It is a garret in which the boy's parents, who have climbed up a ladder, appear almost as intrusive onlookers. The rocking-horse, the Puss in Boots figure, and the figure of a clown are the child's toys. That these are not playthings in the usual sense is made clear by the woman lying in front.

Heralded in the boy's drawing in the right panel, this woman now embodies a full-blown eros, with an entirely different kind of femininity than what is manifested by the young girl and the angels in the left panel. The soap bubbles falling from her pipe symbolize not only the colorful dreams associated with this woman, but also her ephemerality. There is an additional allusion to this in the person of the old woman directly behind her, who embodies the sibylline aspect of feminine existence. In numerous works Beckmann depicted these two prototypes of women together. The clown with

the mirror in the closet—half doll, half human—recalls Beckmann's costumed figures from the circus, cabaret, and theater, who expose life as a game of masks and role-playing. The boy himself is clad in the circus uniform of an animal trainer. In the high swing of the powerful white horse he leaps with his saber upraised "into the world" as conqueror. His parents, who correspond to the schoolmaster and the organ-grinder, can only watch his wild ride anxiously and try to restrain him. The boy apparently has vanquished the dangerous tomcat already and hung it by its legs like a trophy.

While the side panels depict the boy living in restricted circumstances, he is able in the central panel to develop his capabilities fully. Here he is sovereign in his own domain and executes his own 'heroic actions' situated between eros and the wisdom of fools. His play, indeed the colorful surge of life itself, is reflected by the old woman, who is not only the antipode of the younger one but as embodiment of consciousness is a central focus in the middle panel, in fact of the entire triptych.

The Beginning as a representation of youth, recollection, and instruction all in one is not unique in Beckmann's work. With the *Argonauts* triptych (fig. p. 37), dedicated to

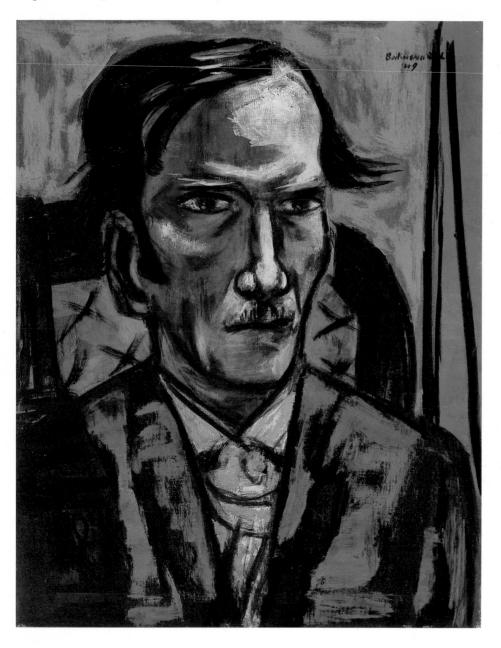

123 Portrait of Fred Conway 1949

Oil on canvas; 64 x 51 cm.
s.u.r.: Beckmann StL 49
St. Louis, The Saint Louis Art Museum,
Bequest of Morton D. May
Göpel 792

Fred Conway (1900-1973) was a painter and professor of fine arts at Washington University in St. Louis. Known for his convivial personality, Conway was a favorite teacher at the University from 1929 until 1970. He was a close friend of Beckmann, although their paintings were very different in style and subject. In one of the few English phrases in his diary, Beckmann notes, "I like Fred Conway." The two painters would criticize each other's paintings on studio visits, each in his own language.

Here, in contrast with Beckmann's diary comments and Conway's legendary personality, Conway is depicted as serious and composed. The cold light on his face is another indicator of Göpel's comment that Beckmann often painted under fluorescent lighting at night. The painting is a wonder of off-beat color harmonies, with strikingly different colors atop one another. The rich surface is so quick and self-assured in its brush marks that it participates in American "action painting" almost before its time.

The fluorescent palette is itself surprising and new. The execution is so much more experimental and free that we are reminded that it is not a commissioned portrait. Beckmann painted this out of admiration for an artist and friend, in a free style to suit Conway, himself a free spirit.

The preparatory drawing for this painting (cat. 200) is close to the painting's full size. It is important to note that Beckmann eliminated the hand and arm here to concentrate on face, color, and brushwork. J.B.

youth in a double sense, Beckmann culminated his entire creative effort, indeed his life. The painter began work on the left panel of the *Argonauts*—whose center panel depicts an Old Man of the Sea positioned not unlike that of the parents, but this time showing the youths a path to heroic action—even before *The Beginning* was finished. There are also connections with the etching, *Children at Play*, 1918 (VG 134), where childlike existence and activity correspond to that of the adults, thus depicting life as Beckmann experienced it. C.L.

124 Large Still-Life with Black Sculpture 1949

Oil on canvas; 89 x 142 cm.
S.L.R.: Beckmann/NY. 49
Berlin, Private collection
Göpel 797

References: Tagebücher 1940-1950;
Sotheby, London Auction cat., 28 June 1978, No. 47.

This large painting shows a view of a room which is richly furnished. Behind a partially opened glass door there is an oval table on which a goldfish bowl, a seashell, and pears are festively arranged between two large candles. Flowers emphasize the festive mood. The impression all this creates is as though a ritual offering had been prepared for the dark sculpture at the back. By painting a woman as a sculpture here, Beckmann has removed her from life, and delineated her distance from the things that constitute a richly sensuous existence. A quite similar relationship can already be found in the painting, *Studio,* 1946 (cat. 109). Though separated from the lively immediacy of life, this woman's removal also takes her to a higher plane, so that this becomes like the traditional depictions of gods to whom fruit, flowers, and candles are brought as sacrifices. It is not certain whether in this sculpture the artist represented, in altered form, a woman close to him and accordingly veiled his relationship with her.

Beckmann developed this genre of large still-lifes which fill the entire available space during the 1920s. The *Large Still-Life with Telescope* of 1927 (fig., p. 29) also shows a festive arrangement, a woman, an evening setting, and an open door. The *Large Still-Life with Candles and Mirror,* 1930 (cat. 58) is related to the painting of 1949 in that it too depicts a solemn grouping of candles, whose symbolic meaning in connection with the mirror is clarified by means of the inscription EWIGKEI(T) indicating the transition, threshold, or the window from this world to the unknown. Corresponding to that inscription is the word TIME(S) on a newspaper to the right in the later painting. As a sculpture, the woman is removed from life into the existence beyond time, around which Beckmann's notions kept gravitating. The *Still-Life with Sculpture* of 1936 (Göpel 448), in which the sculpture resembles the head of the artist himself and which invites association with one of his actual sculptures, must also be understood in this sense.

Beckmann described the work on this painting in his journal between September 6 and October 11, 1949. The entry for November 17, 1949 informs us that on this day Beckmann received a telegram from the Director of The Museum of Modern in New York, who in January 1950 purchased the painting for the Museum's collection: "Just saw your candle still-life. Marvelous. Congratulations. Alfred Barr." On August 26, 1950 Beckmann saw the painting there, hanging "in lonely splendor."

C.L.

125 Large Still-Life / Interior
(Blue) 1949
Oil on canvas; 142.5 x 89 cm.
S.L.M.: Beckmann NY 49
St. Louis, The Saint Louis Art Museum,
Bequest of Morton D. May
Göpel 801
Reference: Lackner, 1962, p. 22.

Beckmann completed this still-life in October,
1949 in New York, after he had spent the sum-
mer in Boulder, Colorado. The forms and col-
ors of everyday life in America were beginning
to leave their imprint on his work. The palette
is unusually lively here, almost strident. The
blue of the doors and the chair has a cold,
harsh, almost mordant effect. A bright yellow
sun glares harshly and icily through the window
in the background.

The aggressive bright red tablecloth on the
table dominates the composition and acts as a
dynamic color surface. The vase in the middle
and the fruit on the table, however, are kept in
cold green as a complementary color. In con-
trast to the vibrant red of the tablecloth, the
fruit and the artificially arranged flowers and
plants appear static, almost lifeless. The table
with its leg in the form of a lion's paw has the
aura of something animate.

Although the palette is uncommon for Beck-
mann, the composition itself is characteristic of
his late work: the flat space gives the effect of
having been compressed into the foreground
plane. The pictorial surface looks like a
geometrical design, projected by means of
walls, windows, and furnishings. Beckmann's
connection with abstract art becomes visible in
the overlapping of the various spatial planes
and in the complicated relationship between
the rooms. Examples of this are the luminous
light yellow inserted into the plane farthest in
the background, the absence of shadows, and
the inaccurately depicted forms. In comparison
with interior scenes by Matisse, the pictorial
effect here remains clearly three-dimensional
(see fig., p. 30). Matisse's harmonious juxtapo-
sition of gentle colors and color surfaces and
his open, flowing space are not to be found in
Beckmann's work. It was in powerful and con-
structed forms, rather than in decorative
forms, that Beckmann found the distinctive
and essential element of his painting.

L.E.

126 Self-Portrait in Blue Jacket 1950

Oil on canvas; 139.5 x 91.5 cm.
S.L.R.: Beckmann NY 50
St. Louis, The Saint Louis Art Museum,
Bequest of Morton D. May
Göpel 816

Reference: Göpel, 1956, p. 137f.; Selz, 1964, p. 97;
Lackner, 1978, p. 148.

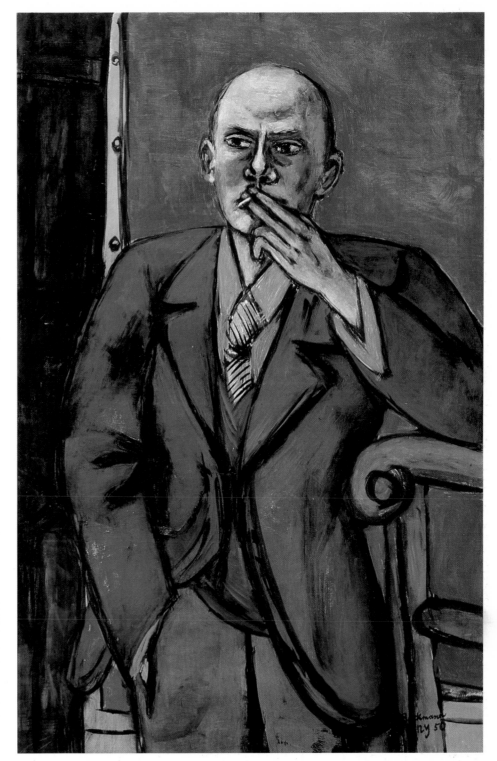

This is the last self-portrait in Beckmann's oeuvre, the final example in a series that spanned 49 years. It is very much the picture of the artist in his studio, relaxed, thoughtful, even contemplative.

The years in St. Louis and New York had been good to Beckmann. Treated as a renowned guest and showered with honor and praise, he had escaped the gloom of exile and left the old world behind him. His diary shows that he was sought after by a variety of art schools, travelled widely in the United States, and was obviously stimulated by a new generation of demanding and eager students.

Lackner is most correct in his comments about this self-portrait, calling it a "reflective stock-taking of self," in the context of Beckmann's renewed self-assurance. Here in the brightly colored sports clothes that American artists favored then, leaning against a chair-back, he stands in a setting defined by the stretched canvas behind him. Relaxed and smoking, he looks thoughtfully not at himself as the viewer might, but in a rare and briefly-seen moment of deep visual study. Here is an artist carefully and thoughtfully contemplating an unseen painting.

The success of the American years brings not the dandy in tuxedo, with its connotations of wealth and society, but a new persona for Beckmann. The artist as self is regained; the strong, directed view and serious attention is screened by the casual pose, sports clothes, and the cigarette at his mouth.

In formal terms, this is an excellent example of Beckmann's late style. Color areas are large and flat, yet painterly in execution. A contrasting underpainted color is often allowed to come through from behind, lending an eerie impression to fields of painted action. Black outlines set off forms and value areas as strongly as in Mondrian's work. Everywhere is the act of painting evident in direct brushwork. Paint shows as paint in these late works; they are a new world of art for Beckmann. Thus it is that Beckmann's self-images end on such a powerful and clear note of self-renewal. Here is the painter who has found himself and his chosen profession again after difficult years. There is a revived confidence in a new and even more vigorous style of painting. The strength of personality and stylistic verve reminds us that Beckmann was at the height of these new powers when he so unexpectedly died in New York. J.B.

127 Landscape in Boulder 1949

Oil on canvas; 139.5 x 91.5 cm.
s.l.r.: Beckmann 49 B
St. Louis, The Saint Louis Art Museum,
Bequest of Morton D. May
Göpel 802

Reference: Thwaites, *The Art Quarterly* 14 (1951) 281.

Whether we are dealing here with a real or an artificially composed segment of landscape is not relevant since the form, color, and overall mood of the composition capture with startling clarity a scenic ensemble that is to be found only in the American West. Beckmann succeeds at this in spite of, or precisely because of, a rather forceful abstraction from a natural prototype. Thanks to a non-objective overemphasis of specific features, a landscape is created whose fascination lies in its unreality and its inaccessible grandeur. By virtue of their black contours the rocks climb out of the ground with an exaggerated severity and immediacy. An idyllic, inviting landscape that provides the individual with shelter and respite is not what is intended. Instead he portrays an alien nature which keeps any human in the role of admiring onlooker at an impassable distance. Beckmann reinforces this impression by means of the composition, which presents the landscape in the form of a stacked, yet relatively flat, stage set, rather than as a spatial depth into which one might actually enter.

C. Sch.-H.

128 Woman with Mandolin in Yellow
and Red 1950

Oil on canvas; 92 x 140 cm.
S.L.R.: Beckmann NY 50
Munich, Otto Stangl
Göpel 818

Reference: Lackner, 1978, p. 144.

The painter places the viewer in the immediate
presence of the woman's private sphere: she is
stretched idly on a red sofa with a yellow cover,
and has a mandolin lying in her lap. Her
averted expression and closed eyes are con-
trasted with the provocatively rendered thighs
and breasts. The woman has her head turned
away from the mandolin, as though she finds it
oppressive. The distorted form of the instru-
ment invites one to surmise a sexual allusion;
its birdlike shape may stem from Beckmann's
original idea of representing "Leda with the
Swan," which is mentioned in several journal
entries.

The motif is sexual enticement on the part of
a woman who at the same time holds herself
aloof. These antithetical attitudes are reiter-
ated in the red and green colors. The geometric
pattern of the cover on the sofa and the angular
form of the instrument's neck are set in oppo-
sition to the soft contours of the body. The play
of contrasts is pursued in the woman's skirt.
What at an earlier point in time had been a red

dress was painted over from the waist down in
a green color that does not altogether cover it.
The density of the skirt contrasts with the
transparent blouse in the same way the wo-
man's body-language does not agree with her
facial expression. M.B.

Catfish. The mature perspective of 1950 is expressed by the monumental presentation of the figure. With her powerful limbs and the broadly exposed thigh she becomes the kind of intimidating heroine who confronts us again and again in Beckmann's paintings (cf. cat. 110, 130). As in the middle of the 1920s, the curtain on the left side of the painting opens onto the scene theatrically and permits the mythological prototype to appear in the guise of an unapproachable actress (compare the door, fig. p. 29). C. St.

130 Carnival Mask, Green, Violet and Pink. Columbine 1950

Oil on canvas; 135.5 x 100.5 cm.
S.U.L.: Beckmann NY 50
St. Louis, The Saint Louis Art Museum,
Bequest of Morton D. May
Göpel 821

Once more in this late work Beckmann takes up his central theme of the relationship between man and woman. Sex as enticement and threat, the juxtaposition of a sexuality being proffered with self-assurance on the one hand and a cold, unconquerable distance on the other, is palpably clear in this Columbine. She faces the viewer head-on, sitting on a table with her legs spread wide, and appears to offer herself directly. This impression is reinforced by the peculiar blond mane, the luminous red lips, the voluminous naked arms, and the fleshy thighs above her stockings. The impression is simultaneously retracted by means of the black mask, the position of the arms, and the blue-black outfit that looks more like impenetrable armor. The threatening aura of this woman emanates from her vital femininity which uses up one man after another, then casts him carelessly aside (as the Jack on the table makes abundantly clear).

Also worthy of mention in this painting is the construction of offsetting colors, typical of Beckmann, within the composition. The pyramid of black moving from the stockings, outfit and mask, and the fleshy tones of the thighs, arms, shoulders, and head are matched by corresponding portions of pink and green (hat and cloth along with the green in the left front, the bow and curtain). They in turn are backed by the blue of the table and the violet of the wall. C. Sch.-H.

129 Quappi in Blue in a Boat 1926/1950

Gouache and oil on paper, stretched over cardboard;
89.5 x 59 cm.
S.L.R.: Beckmann
New York, Private collection
Göpel 819

Reworked with oils and decisively altered in 1950, this early portrait of Quappi makes distinct the developmental phases of Beckmann's working procedure. In 1926 Beckmann depicted his second wife, her dress, and the vista in varying degrees of blue (cat. 45). She was not the energetic, dominant woman of *Double Portrait* of 1925 (cat. 43), however, but an aloof, ethereal being oriented toward the distance, the water, and the sky depicted here. Even then, the clear blue did not serve so much as to characterize the person but, in mythological scenes like *The Bark* of 1926 (cat. 42) and *The Catfish* of 1929 (Göpel 312) it played the more decisive role of confronting human events with infinity.

In spite of a 24-year interval, Beckmann retained the earlier thematic pattern in this portrait, as well as the clear brightness which links the figure with the sea. The woman very closely resembles the terrified woman in *The*

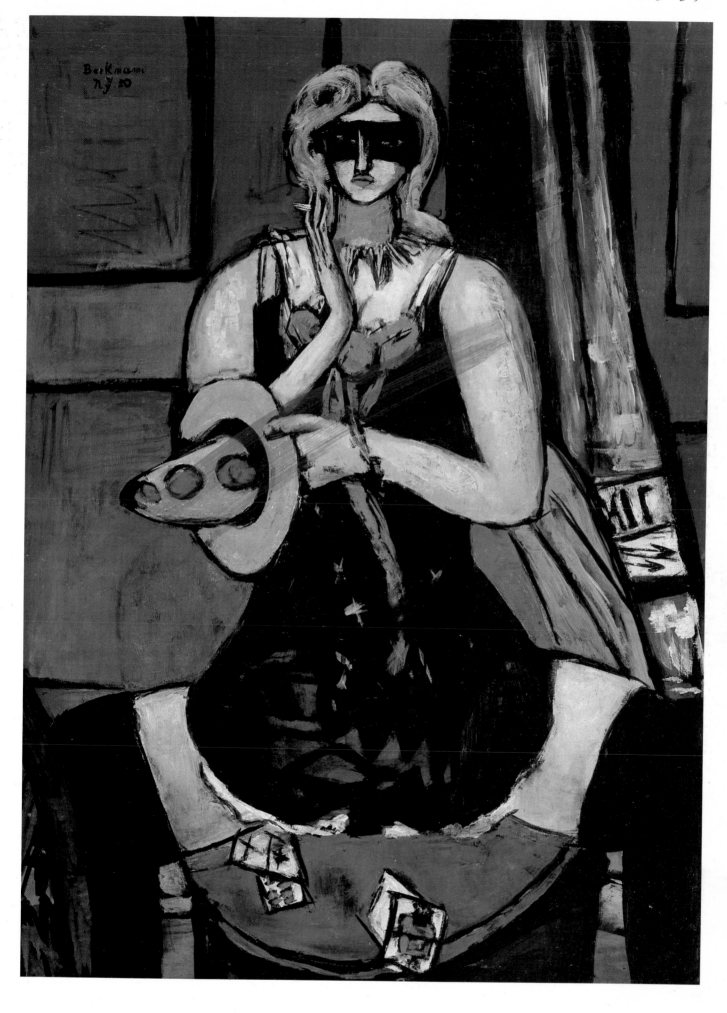

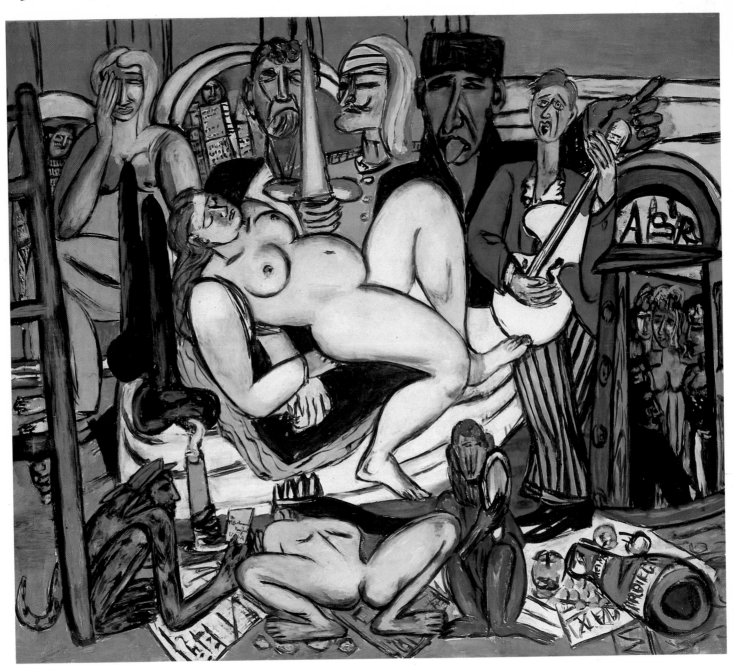

131 The Town (City Night) 1950

Oil on canvas; 165 x 191 cm.
s. as in an address, L.R.: Mr. M. Beckmann
New York USA
St. Louis, The Saint Louis Art Museum,
Bequest of Morton D. May
Göpel 817

References: Janson, *Magazine of Art* 44 (1951) 92;
Göpel, 1955, p. 51, 55; Langsner, *Art International* 5
(1961), No. 2, p. 29; Fischer, p. 21; Göpel, 1976, I,
p. 497; Schiff, *Images of Horror and Fantasy,*
New York, 1978, p. 85, 87; M.Q. Beckmann, 1983,
p. 163 ff., 227.

The Town shows the continuing fascination
which the modern city held for Beckmann. The
painting was completed in March of 1950,
while he was teaching at the Brooklyn Museum
School. Although he took several motifs from
his new surroundings, such as the skyscrapers
discernible in the round window, the subject is
the city in general.

The composition is dominated by a full-
bodied, voluptuous, naked woman, whose
hands are tied behind her back; with her eyes
closed, she is lying in an exposed, provocative
position on a bed with overemphatically phal-
lus-like bed posts. According to Mathilde
Beckmann, the prone woman is a symbol of
beauty; the bare-breasted blonde behind her,
covering one of her closed eyes with her hand
in a gesture of shame or isolation, represents a
prostitute. By means of his scrunched-up eyes
and mouth, the ugly man next to her likewise
removes himself from the scene. The police-
man or sentry in the middle holds the upraised
sword, a traditional symbol of masculinity,
menacingly over the body of the naked
woman. A dark-skinned man dressed in black
sticks out his red tongue disgustingly and
points portentously upwards. And the flashy
sidewalk entertainer with a melancholy expres-
sion is absorbed in singing and playing his
guitar, a musical instrument which Beckmann
frequently uses as a symbol of female sexuality.

On one level, the figures are allusions to the
human senses (feeling, seeing, tasting, hear-
ing). On a second, they are part of the long
tradition of *vanitas* allegories which Beckmann
confronts consistently throughout his life. In
this context the naked woman represents the
short-lived pleasures of this world and the
fleetingness of beauty. The empty champagne
bottle, the apples, the grapes, and the mirror
all carry forward this theme. The froglike
naked man with the crown, who is greedily
snatching up pieces of gold, may allude to the
fairy tale, "The Emperor's New Clothes,"
which is a story of vanity and its price. The
strange green creature with a mailman's cap is
holding a burning candle, symbol of life, and a
mysterious letter which in ironic fashion is
addressed to MR. M. BECKMANN, NEW YORK,
USA. The ladder, a common motif in Beck-
mann, refers to a higher sphere yet to be
attained.

Despite the woman's beauty and the numer-
ous allusions to sensual pleasures, the figures
in the painting appear bored and joyless, ill-
humored and cynical. The city becomes a place
of trite feelings and unending boredom.

L.E.

Arnold Böcklin:
Triton and Nereid, 1873
Oil on canvas, Munich,
Bayerische Staatsgemäldesammlungen,
Schack-Galerie

132 Ballet Rehearsal 1950
Amazons

Oil colors, charcoal, tusche and colored chalk on
canvas; each panel 208.5 x 124.5 cm.
Unsigned
Beverly Hills, The Robert Gore Rifkind Collection
Göpel 834

References: M.Q. Beckmann, 1964; Lackner, 1981,
p. 82 ff.

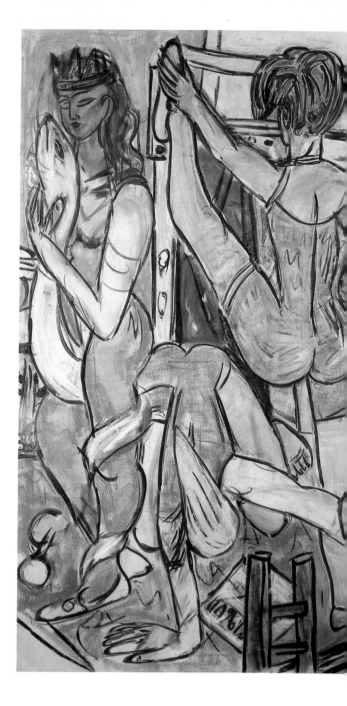

In its unfinished state this painting enables us
to observe the manner in which Beckmann
worked: from the priming state to the prelimi-
nary sketch in charcoal, the retracing and cor-
recting in thinned black paint, and then the
experimental application of color with crayon
and thin oil paint (the greenish-yellow back-
ground segments in the middle picture). The
triptych, therefore, has a light, transparent
character and its drawing a sketchy effect, even
though the figures and objects appear with
relative distinctness.

Lackner has noted that it is the only one
among Beckmann's triptychs in which all three
panels have the same format and in which only
women are depicted. Half naked, dressed only
in tights and transparent garments, these
women have a decidedly erotic appearance and
little of the reserve that characterizes the group
in the right panel of the *Argonauts* (fig., p. 37).
But Beckmann alludes to their sexuality in
other ways as well.

In the left panel is a figure whose eroticism is
already suggested by her red tights. She is ten-
derly and unambiguously fondling a thick
snake, by means of which she is partially fet-
tered. With this figure Beckmann refers to his
own related depictions (*The Catfish,* 1929,
Göpel 312; *Perseus,* 1940/41, fig. p. 42; *Fisher-
women,* 1948, cat. 121). The viewer is also
reminded of Böcklin's paintings (among
others, *Triton and Nereid,* fig. p. 321). The
woman as the special figure in this picture, and
therefore distinguished by a crown, is entirely
absorbed in her loveplay. The other two
women content themselves with meaningless
gymnastic contortions.

The figures in the right panel correspond to
those in the left. The woman tethered to the
lance, with her erect posture and gesture of
bondage, is similar to the crowned woman.
However, no loveplay such as that on the
opposite panel occurs; instead, the lance sym-
bolizes the woman's radical confinement
within her own erotic nature, comparable with
the young woman in *Temptation* (cat. 73). The
second woman in the right panel (a sketchy
draft of this painting shows the figure reversed
and alone) forcefully manifests her freedom by
means of the extended position of her upraised
leg. A regal red cloak distinguishes her like the
crown does the woman on the left. But in spite
of her strong physicality, Beckmann has not
characterized her in purely animal fashion like
the others. He has located her distinct indi-
viduality in her gaze. i.e., in her thoughts and
aspirations, her consciousness. While she looks
into a mirror held in her left hand, she catches
straight on, in another mirror on the wall, a
glimpse of the head of a man whose gaze is
focused on her. By virtue of this clear, yet
reserved relationship to the man, this woman
differs from the others, each of whom is limited
in her own fashion, in the side panels.

In earlier works (among others, *Large Paint-
ing of Women,* 1935, Göpel 415 and *Actors,*
1941/42, fig. p. 43) Beckmann had depicted
such reciprocal glances between a man and
woman, in which both mutual attraction and
irreconcilable distance are present. The etch-
ing, *Woman in the Night,* 1920 (cat. 263), also
shows the exclusion of a man from the room of
a largely self-sufficient woman.

Whereas in the side panels Beckmann has
stressed the lack of mutuality among the
women and has depicted varying degrees and
kinds of erotic fulfillment, in the center panel
he has united three women over a meal. On the
right, a woman sits in a transparent negligee,
with one leg tucked under herself, holding a
plate full of fish. The one in the middle, promi-
nent by virtue of her orange-colored dress and
the helmet at the nape of her neck, is holding a
glass in her hand and is eating one of the fish.
The third one is drinking. She is tightly
enclosed in a black bodice as though it were a
piece of armor, under which appear a spotted
lap cloth and a red-violet skirt. As a proud
warlike figure with a helmet on her head and
lances behind her, she illustrates the former
title, 'Amazons,' most clearly.

The fish that are being devoured at this meal
are, as always in Beckmann's work, significant.
We need mention only the *Fisherwomen,*
(cat. 121) completed two years before, which
represents three emphatically erotic women
with relatively large fish: one of them is fish-
ing, while another is in the process of eating a
fish. The drawing, *Fisherwomen,* 1949, shows
women who are "catching" fish with men's
heads.

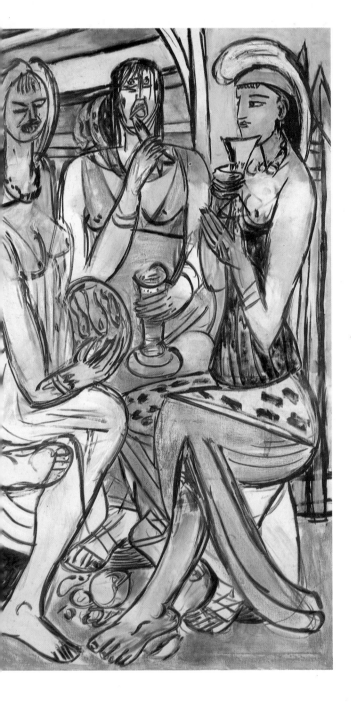

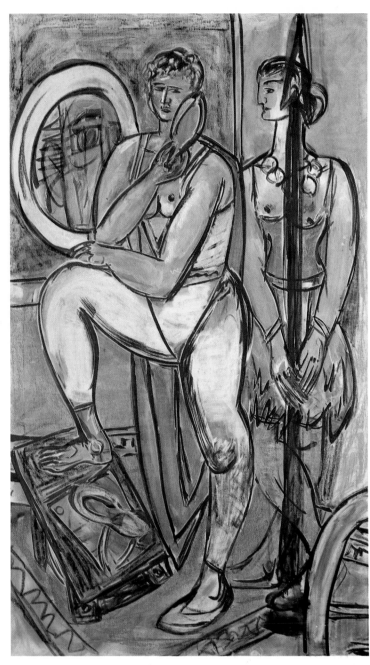

Ballet Rehearsal depicts women in various circumstances of free or forced self-sufficiency, or in a more or less marked relationship to the opposite sex. In contrast to the single figures in the side panels, the center panel depicts a group of free, sovereign women. The works cited for comparison suggest that the meal of these three Amazons is of particular significance. Their eating of fish is a veiled allusion to the way in which the relation of these women to men might be regarded.

Max Beckmann had already painted a *Battle of the Amazons* in 1911 (cat. 11). In that painting Beckmann represented the aggressive, erotic confrontation between man and woman which culminates in death. The confrontation between man and woman is found throughout Beckmann's entire work in many variations. Those paintings which are particularly interesting in relation to *Ballet Rehearsal* are those devoted almost entirely to women by themselves. The series begins with a family portrait from 1908 (cat. 7), in which the theme is not yet so evident, and is pursued in *Women's Bath*, 1919 (cat. 20). Closely linked with the latter is the *Large Painting of Women*, 1935, a group portrait of five women who were especially close to the artist. Beckmann himself appears there in the mirror which his first wife is holding. The series continues with *Ladies' Band*, 1940 (cat. 91), *Girls' Room*, 1947 (cat. 113), and *Fisherwomen*, 1948, to name only the most important examples, and closes with the *Ballet Rehearsal*, just after the right panel of *Argonauts* had been devoted exclusively to women. That the examples accumulate in the last decade, indeed in the last three years, of the artist's life is conspicuous. *Argonauts* depicts, besides the festive community of the music-making women on the right, the isolated artist wrestling with his work, and a community of youths about to embark on some great deed.

In these paintings and in the triptych, *Ballet Rehearsal,* which is a kind of adjunct to the *Argonauts,* one can see how Beckmann toward the end of his life and creative work, so often experienced as solitude and bondage, fashioned the optimistic picture of a society of free human beings. C.L.

Drawings and Watercolors

As there is no complete catalogue raisonné of Beckmann's drawings and water-colors, the following books have been cited as references:

Stephan von Wiese: *Max Beckmanns zeichnerisches Werk 1903–1925*, Düsseldorf, 1978. Some works from this period which are included in the present exhibition do not appear in von Wiese.

Bielefeld, Kunsthalle Bielefeld: *Max Beckmann Aquarelle und Zeichnungen 1903–1950*, 16 October – 11 December 1977.

133 Self-Portrait with Straw Hat 1903
Graphite; 17.4 x 11.1 cm.
von Wiese 5; Bielefeld 3
S.U.R.: 15 Mai 03; S. on verso: 5. Selbstporträt
Private collection

This drawing of the young Beckmann, seen in profile and wearing a straw hat and starched white collar, is one of his earliest known drawn self-portraits, which clearly is still indebted to the impressionist style of Liebermann.

134 Portrait of Friedrich Beckmann,
the Artist's Uncle 1903
Black chalk ; 38 x 33 cm.
von Wiese 5a
s.u.r. : MB 1903
Dr. Lore Leuschner-Beckmann

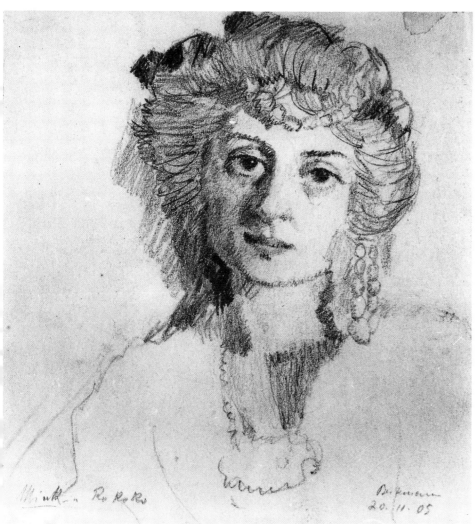

135 Mink in Rococo 1905
Graphite ; 16 x 15 cm.
von Wiese 12 ; Bielefeld 9
s.l.l. : Mink in Rokoko
s.l.r. Beckmann/20.11.05
Private collection

The very controlled, yet soft line with dense
shading and careful attention to anatomical
accuracy is characteristic of Beckmann's early
'impressionistic' style.

136 Portrait of Minna Sewing 1908

Graphite; 21.5 x 14 cm.
not in von Wiese
S.L.R.: 20 Juni; Verso: S.L.L.: 20. Juni 1908/MB
St. Louis, The Saint Louis Art Museum,
Gift of Morton D. May

Beckmann carefully observes his wife deep in
thought as she sits sewing. According to the
date, the drawing was done two months before
the birth of their son, Peter, in August 1908.

137 **Walking Youth** ca. 1910
Graphite; 30.7 x 22 cm.
not in von Wiese
Kassel, Staatliche Kunstsammlungen,
Graphische Sammlung

Evidence of Beckmann's voracious need to
draw is this charming drawing of a young boy
walking. Beckmann's pencil has flown across
the sheet to capture the gesture in a fleeting
moment.

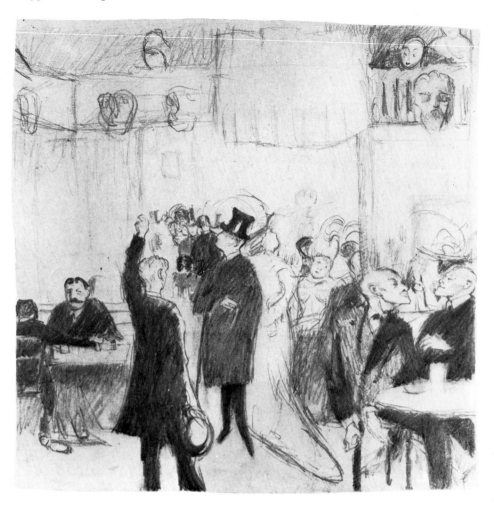

138 Café Scene ca. 1905

Graphite; 29.5 x 29.8 cm.
von Wiese 11; Bielefeld 8
Private collection

On the basis of the stylistic affinity to Toulouse-Lautrec and the contours reminiscent of the art nouveau style, von Wiese dates the drawing ca. 1905. He also mentions that it could possibly date somewhat later when compared with the lithograph of *Reading Man (Self-Portrait)*, 1912 (VG 47). In addition, it bears a close relationship in feeling and execution with other prints such as *Tavern*, 1911 (VG 31); *Admiralscafé*, 1911 (cat. 217); and *Tauentzienstrasse*, 1912 (VG 49).

140 Nude Studies for Battle of the Amazons 1911

Graphite; 32.7 x 26.5 cm.
von Wiese 80; Bielefeld 25
s.l.r.: Beckmann 11/Studie zur Amazonenschlacht
Private collection

There are a total of nine preparatory studies for the painting, *Battle of the Amazons*, 1911 (cat. 11). This energetic drawing explores the movements of the fighting woman in the lower right portion of the picture.

139 Study for The Flood 1908

Charcoal; 20 x 23 cm. (image)
von Wiese 26; Bielefeld 13
Private collection

In this preparatory study for Beckmann's painting, *The Flood*, 1908 (fig. p. 72), six figures form a closed composition, in a distinctive figural arrangement. Although changes occurred between the drawing and painting, Beckmann captures the anguished and distorted gestures in a few, broadly executed strokes, evoking the chaos of the deluge which surrounds them.

141 Seated Woman,
Holding a Child 1912

Graphite; 32 x 23 cm.
von Wiese 108; Bielefeld 31
S.L.L.: Beckmann 12... (illegible) liebe Ugi
Klaus Hegewisch

While the identity of the sitters is unknown,
this drawing appears to be a study for two
figures which appear in the painting, *The Sink-
ing of the Titanic*, 1912 (cat. 12). The figures
resemble those of the mother and child in the
center of the lifeboat in the lower right hand
corner.

142 Seated Young Woman with a Coffee
Cup ca. 1912
Black chalk; 19.5 x 24.5 cm.
von Wiese 136; Bielefeld 35
S.L.R.: Beckmann
Frankfurt a. M., Karin and Rüdiger Volhard

This charming drawing is probably of Minna. It
recalls an earlier drawing of the wife of the
artist with its sensitive depiction of this intro-
spective moment.

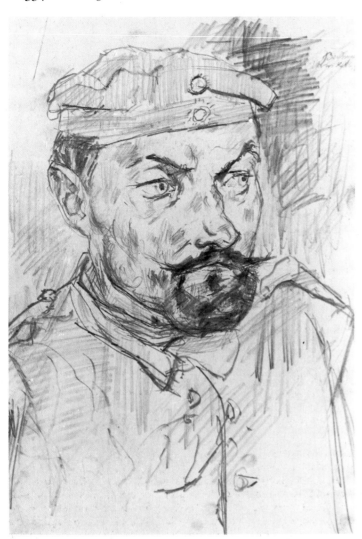

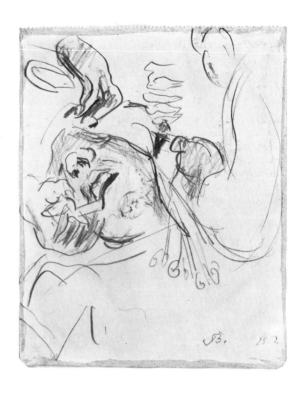

143 Soldier Ernst Pflanz 1915

Graphite ; 36.1 x 25.5 cm.
von Wiese 261 ; Bielefeld 49
s.u.r. : Beckmann/Verwik 16.4.15 ; Verso :
Landsturmmann Ernst Pflanz, Berlin N.
Feldstraße 12
Frankfurt a. M.,
Städtische Galerie im Städelschen Kunstinstitut

Reference : Bielefeld, 1977, p. 35.

It is possible that this drawing served as a
detailed study for the destroyed fresco which
Beckmann was commissioned to do in the field
hospital in Wervik. Beckmann has taken great
care in delineation of the bust portrait of Ernst
Pflanz. Special attention is given to the shading
of his face, where Beckmann employs a series
of short parallel lines at various angles to one
another. He also varies the pressure applied to
the pencil, enlivening the drawing with a rich
tonal value. A second drawing of this soldier
(von Wiese 262) depicts only his head, with
cursory attention given to the definition of his
cap and collar.

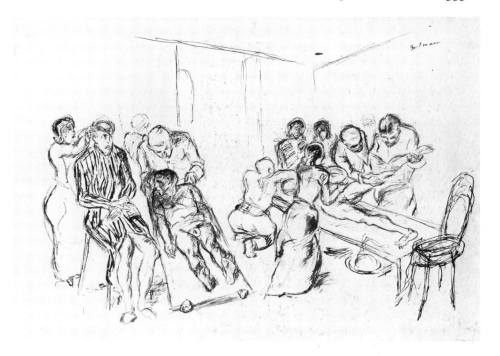

**144 Head Operation on a
Wounded Soldier ca. 1915**

Graphite; 14.9 x 12 cm.
von Wiese 227
s.l.r.: B.25.2
Hamburger Kunsthalle

Beckmann focuses attention on the face of a
wounded soldier as he undergoes surgery. The
tilted, skewed positioning of the soldier's head
and the closed eyes heighten the fear, pain,
and anguish of the soldier. In less defined
strokes, he sketches in the surgeon and assis-
tant.

146 The Large Operating Room 1914

Pen and ink, wash, over graphite; 30.3 x 46.8 cm.
von Wiese 186; Bielefeld 38
s.u.r.: Beckmann
Private collection

During the war, Beckmann's production of
paintings and prints understandably declined
significantly; however, there is a marked
increase in the number of drawings he pro-
duced. Over 100 drawings remain to record the
tragedy and destruction Beckmann witnessed
while serving as a volunteer medical corpsman.
This drawing relates to the following prints:
The Large Operation, ca. 1914 (VG 79), *The
Small Operation,* 1915 (VG 80), as well as to
the two depictions of *Morgue* (cat. 227, 286).

**147 The Ruins of Lille:
Soldiers, Civilians and a Cripple ca. 1915**

Graphite; 25.3 x 35 cm.
von Wiese 259; Bielefeld 48
s.u.r.: B 15; annotated l.r.c.: Lille
Hamburg, Hauswedell & Nolte
Reference: Briefe im Kriege, p. 32.

On a two-day visit to Lille, Beckmann com-
pleted a group of drawings (von Wiese 256-
260). There, according to his war letters, Beck-
mann saw the "streets yawned apart as at the
Last Judgment," and there was an "unbearable
pestilential smell." Any romantic notions or
idealized views Beckmann held of war were
shattered by this point, as the stark reality of
the war's effects became all too clear.

**145 A Man with a Crutch in a
Wheel Chair 1914**

Pen and black ink; 15.7 x 12.8 cm.
von Wiese 211
s.u. Margin: Theatre Du Monde—Grand Spectakel
de la Vie
s.l.l.: 21.12.14/B
Stuttgart, Staatsgalerie, Graphische Sammlung

Beckmann was stationed in a hospital in Cour-
tray, Belgium, when this drawing was exe-
cuted. Precise attention to anatomical detail
was not of importance to Beckmann as one
sees in the exaggerated and cursory attention
given to the delineation of the figure, espe-
cially in the hands and feet. Instead, suffering
is made visible as a destructive element of the
innermost part of an individual.

148 Standing Male Nude,
Front and Rear View 1915
Graphite ; 31.4 x 18.9 cm.
von Wiese 294
S.L.R. : B
Basel, Kunstmuseum, Kupferstichkabinett
Reference: Wiese, 1978, p. 71.

A group of eight drawings of nudes date from
June 1915 (von Wiese 293-300), which von
Wiese suggests were preparatory studies for a
second, never-executed mural, or for the
unfinished painting, *Resurrection*, 1916-18
(fig. p. 83).

These drawings depart from the academic
nude drawings of the pre-war years in their
broken contours and exaggerated, distorted
proportions.

149 Portrait of Fridel Battenberg 1916

Graphite; 30.8 x 23.5 cm.
von Wiese 339; Bielefeld 62
S.U.R.: Meiner lieben Titti/Beckmann/19.8.16
Frankfurt a. M.,
Städtische Galerie im Städelschen Kunstinstitut

Many portraits exist of Beckmann's close friends in Frankfurt, Ugi und Fridel Battenberg. This portrait of Fridel distinguishes itself by its unusual sensitivity. Beckmann represents the multi-faceted personality of his friend with a piercing, introspective gaze.

150 Female Portrait ca. 1915

Graphite; 32.2 x 23.8 cm.
von Wiese 327
S.U.R.: B
Chicago, The Art Institute of Chicago

Executed while Beckmann was still serving as a volunteer in the medical corps, this portrait makes use of the barest details to characterize a woman filled with sadness and emptiness. Beckmann concentrates his attention on delineating the sitter's facial features, especially the eyes.

This drawing is related to another of the same sitter (von Wiese 328), which is signed and dated 1915/Straßburg. In that drawing the sitter holds her left hand up to her face and is seen from a closer vantage point.

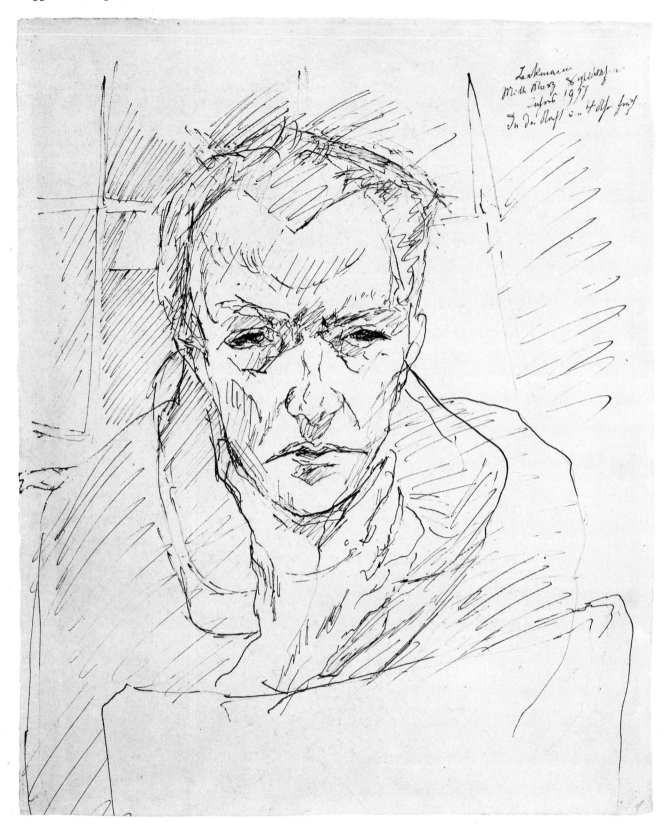

151 Self-Portrait 1917

Pen and black ink; 38.7 x 31.6 cm.
von Wiese 368; Bielefeld 71
S.U.R.: Beckmann/Mitte März des glorreichen [?]/
Jahres 1917/In der Nacht um 4 Uhr früh
Chicago, The Art Institute of Chicago,
Gift of Mr. and Mrs. Allan Frumkin

Beckmann's intense concentration in capturing
on paper this self-portrait is seen in his piercing
gaze and the quick, almost frenzied quality of
the pen lines. The drawing has great immedi-
acy, even urgency, yet the features are care-
fully observed. One knows from the inscription
that the artist completed this work in the early
morning hours, and the effects of the late
sleepless hours are evident.

Compositionally this drawing is related to
the *Self-Portrait While Drawing,* 1919 (von
Wiese 280). Both drawings utilize short, bro-
ken, angular lines, reminiscent of Beckmann's
drypoint technique and are stylistically related
to several printed self-portraits (cat. 222, 233,
238).

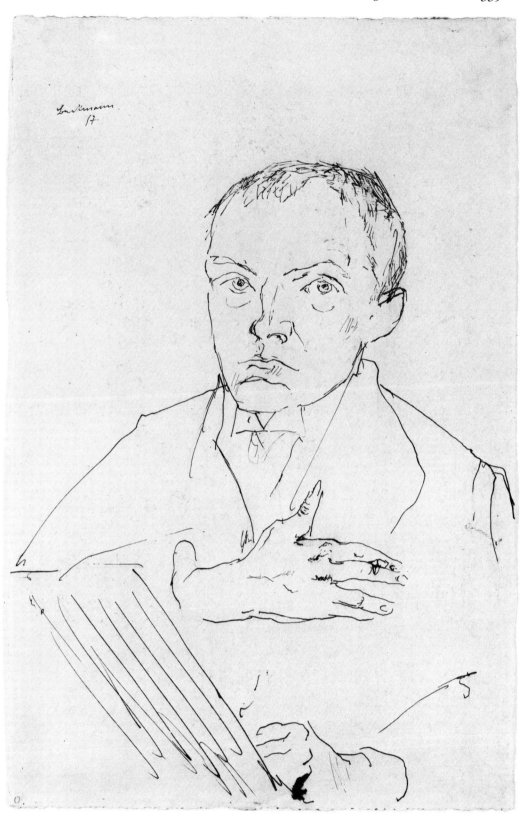

152 Self-Portrait While Drawing 1917

Pen and black ink; 51 x 33 cm.
von Wiese 369; Bielefeld 72
s.u.l.: Beckmann/17
Private collection

Compared with the previous self-portrait (cat. 151), this work displays a more economic use of line, with fewer strokes in broader outline, not unlike Beckmann's drypoint self-portrait of the same year (VG 118). In the other drawing, the nervous, rapid stroke increases the expressive quality of the penetrating, yet curiously remote gaze of the artist and the gesture of the right hand. Here the lightly rendered line places the person in a state of calm anticipation.

153 Main River Landscape I 1918
Graphite ; 24.3 x 31.4 cm.
von Wiese 408 ; Bielefeld 80
S.L.L. : Beckmann/18
St. Louis, Fielding Lewis Holmes

This drawing and *Main River Landscape* II
(von Wiese 409) were done as preparatory
sketches for Beckmann's print, *Main River
Landscape*, (cf. cat. 242).

154 Seated Youth ca. 1918
Graphite ; 50.1 x 32.2 cm.
von Wiese 403
S.L.R. : Beckmann
Chicago, The Art Institute of Chicago

Due to the high vantage point, the figure of
this young boy is distorted, enlarging the size
of his head in comparison to his lower
extremities. Presumably Beckmann chose this
extreme view to display the exaggerated dis-
position of the hands and face : the boy is not
childlike, he appears almost senile and is simi-
lar to fools in Beckmann's dream pictures
(cf. cat. 23). There are four other drawings of
this boy (von Wiese 399-402).

155 Garden View from the
Window 1916

Graphite; 24 x 31.8cm.
von Wiese 363; Bielefeld 65
s.l.r.: dem armen Kranken/Wäulemätzchen/von/
Beckmann/5.3.16
Frankfurt a.M.,
Städtische Galerie im Städelschen Kunstinstitut

Very few landscape drawings exist from the
early Frankfurt years. According to von Wiese,
only three additional drawings remain which
date before 1920: (cf. cat. 153; von Wiese 409,
410). The view in this drawing is from a win-
dow overlooking a garden of winding paths.
The twisted leafless trees and streaked window
convey a gloomy mood on a rainy day.

156 The Café (Dance Hall) ca. 1920
Graphite; 26 x 21 cm.
Bielefeld 93
S.L.R.: Beckmann
New York, Catherine Viviano Gallery

Beckmann's love of café life is apparent in this drawing. Even though it is a quick sketch, probably done on the spot, his rapid but accurate strokes energize the lively scene. Several drawings and prints of dancing figures date from this period.

158 Martyrdom 1919

Black crayon on transfer paper; 61.5 x 85 cm.
von Wiese 412
S.L.C.: Originalzeichnung zum Martyrium
S.L.R.: Beckmann 19
Boston, Museum of Fine Arts,
Sophie M. Friedman Fund

This drawing belongs to a group of eight which were used for the lithographic portfolio, *Hell* (cf. cat. 247-257).

Transfer drawings are rare, because they are usually lost in the process of transferring the image to the stone or plate. Here Beckmann made corrections by collaging pieces of paper over certain areas that he wanted to change and redrawing those specific parts. The man at lower left and the lower torso of the man at the right have been altered.

157 Study for Family Portrait 1920

Colored pencil; 14.4 x 21.6 cm.
von Wiese 441
Unsigned; drawing is annotated with an inscription by an unknown hand
Stuttgart, Staatsgalerie, Graphische Sammlung

Beckmann utilized the back of a piece of paper from the Commerz- und Privatbank Berlin for this drawing which was a study for his painting, *Family Portrait* (cat. 25). In this rapidly executed sketch, Beckmann indicated the position of the various figures within a narrowly defined space. The figures from left to right are the artist, his wife, his mother-in-law, Anni Tube (Minna's sister), an unidentified distant relative, and Peter, who lies on the floor. When compared with the painting, it is remarkable how much Beckmann was able to achieve in so incomplete a drawing.

159 Portrait of Quappi in Half-Figure 1925

Graphite; 48.5 x 32.5 cm.
von Wiese 561
s.l.r.: Beckmann/Wien 25
Private collection

This work, one of the earliest portraits of Quappi, distinguishes itself from Beckmann's previous drawn portraits. He now utilizes a more continuous, clear line to describe the form, and the shading heightens this new, almost sculptural quality of his drawing style.

161 Carnival in Naples 1925/1944

India ink and brush, graphite and white chalk; 110 x 69.5 cm.
von Wiese 562; Bielefeld 113
s.l.r.: Beckmann/A 44
Chicago, The Art Institute of Chicago,
The Margaret Day Blake Collection

In this monumental drawing, Quappi stands in what appears to be a narrow boat, surrounded by four flute-playing figures to the left and a mandolin player behind her. The flutes, which the figures hold up like weapons, have a menacing and, most probably, a sexual connotation. The woman attempts to protect herself with the explicit gesture of covering her ears. The impression of resistance is reinforced by the veil and her partially opened mouth.

This highly finished painterly drawing relates to Beckmann's painting, *Italian Fantasy*, 1925 (cat. 41), in the vertical format with distorted space as well as in the subject matter. The changes which Beckmann undertook in 1944 are apparent from a photograph of an earlier state. Particularly unusual is the addition of the veil over the eyes.

160 Reclining Female Nude 1924

Graphite; 25 x 35.7 cm.
von Wiese 542; Bielefeld 108
s.l.r.: Beckmann
Frankfurt a. M., Karin and Rüdiger Volhard

This drawing served as a preparatory sketch for the painting, *Sleeping Woman* (cat. 35). In the painting Beckmann added a few details such as the lamp and books, and he closed the figure's eyes. This change is essential, since the musing woman with open eyes does not offer herself to the voyeur. Compositionally, as well as in the use of line, this drawing compares to the etchings, *Reclining Figure* and *Siesta* (VG 231, 279).

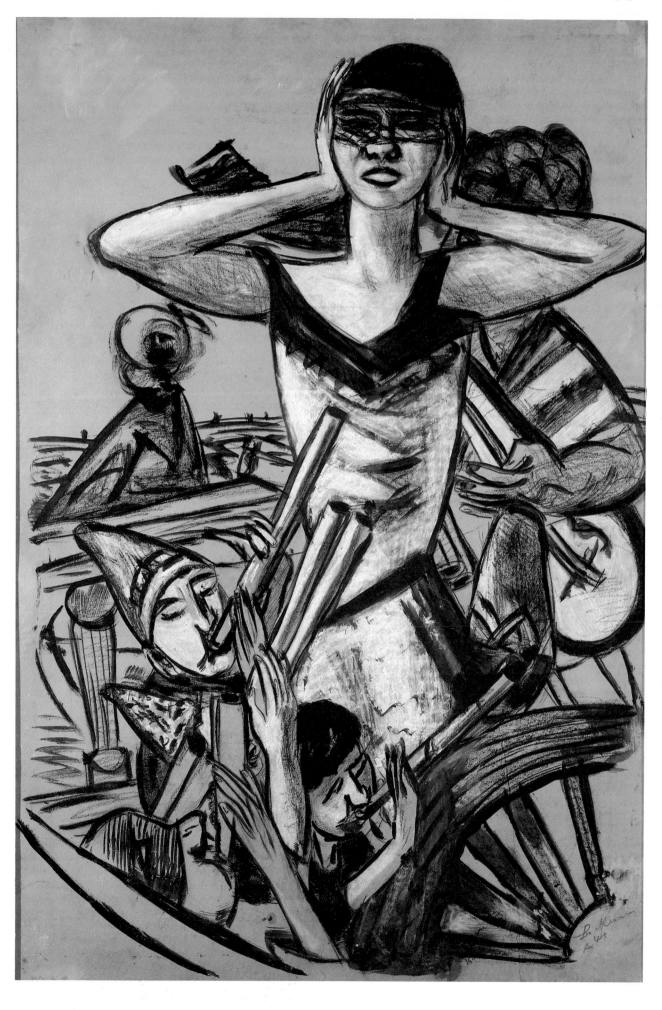

Charcoal heightened with white; 60.5 x 45 cm.
von Wiese 568
S.L.R.: Beckmann/26
Frankfurt a.M., Karin and Rüdiger Volhard

In the mid-1920s, Beckmann's printmaking output diminished as his attention was focused on paintings and drawings. The drawings of this period are often independent of his paintings and very highly finished compositions.

The figure of the boy is clearly defined against the white background, and gains a monumentality by the placement of the figure in the entire picture plane. The articulation is restricted to the upper part of the picture, particularly the arm and lobster, which form a unity. In this gesture the boy resembles the mythological motifs of this period (cf. cat. 65) and probably incorporates their phallic significance.

163 Double Portrait of Wolfgang and Wilfried Swarzenski 1925

Black crayon; 43.1 x 30.5 cm.
von Wiese 563; Bielefeld 114
S.L.R.: Beckmann/F. 23.12.25
Dr. and Mrs. W. V. Swarzenski

Georg and Marie Swarzenski were close friends of Beckmann (cf. cat. 170, 208). This portrait is of two of their children. They are placed in close proximity, seated in separate chairs, with their bodies turned toward one another, and their faces staring towards the viewer. The sensitive and impressive portrait documents the personal closeness of the artist to the two children.

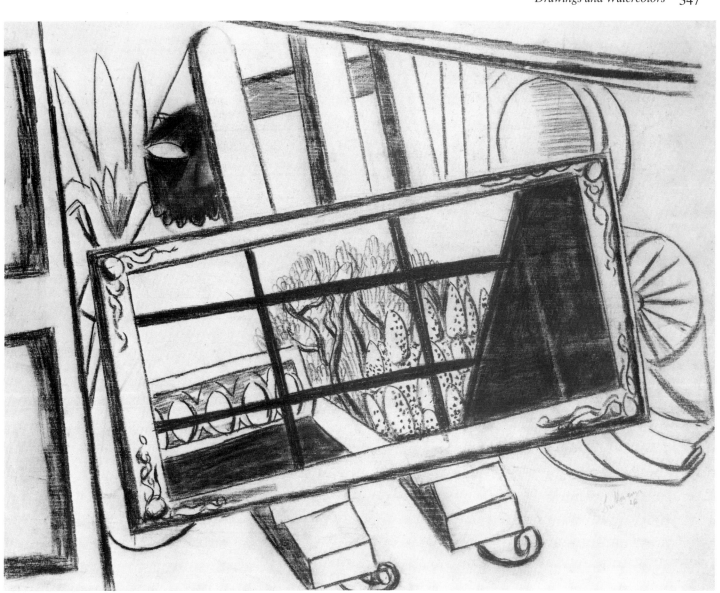

164 Mirror on an Easel 1926

Charcoal and black crayon; 50.2 x 64.1 cm.
not in von Wiese
S.L.R.: Beckmann/26
New York, The Museum of Modern Art, Gift of
Sanford Schwartz in memory of Irving Drutman

For this still-life Beckmann has pulled together items from his Frankfurt studio. The central portion is occupied by a mirror resting on an easel; the mirror reflects the view from the window. It is unusual that the mirror, framed like a picture, exists as a picture. The view being barred, the outside world is partially obscured by a dark plane, perhaps a roof overhang.

A mask hanging on the easel—no doubt a reference to transience, perhaps also to Beckmann—heightens the enigmatic combination of reality and illusion in a narrow space. The spatial relationships remain nevertheless unclear, since a perspectival view was not utilized and the object on the right side can only be distinguished as a piece of furniture, a sofa, on the basis of another related, earlier drawing (cf. figure at right).

Max Beckmann:
Mirror on an Easel, 1926
Black chalk, Munich,
Staatliche Graphische Sammlung

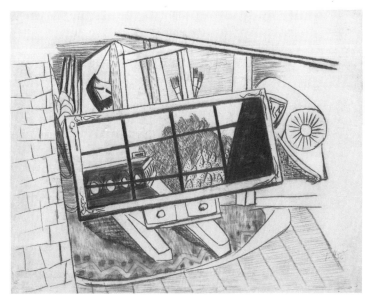

165 Partially Nude Woman at the Window 1926

Pen and black ink and wash: 51 x 22.5 cm.
von Wiese 569
S.L.R.: Beckmann/26
Berkeley, University Art Museum, University of California, Gift of Mathilde Q. Beckmann

The silhouette-like depiction, as well as the surface articulation, reminds one formally of the decorative, flat style of Matisse. The content is reminiscent of the motifs of the new realist painters, particularly Schrimpf. Pen and ink drawings became increasingly important for Beckmann in the mid-1920s.

166 Quappi, Playing Solitaire 1926

Black chalk; 63.5 x 48 cm.
not in von Wiese
S.L.R.: Beckmann/F. 26
Frankfurt a.M., Karin and Rüdiger Volhard

Beckmann has captured an elegant view of Quappi as she quietly sits playing cards. The perspective of the drawing is disquieting, but not unusual for Beckmann. At first glance we see Quappi straight on as she sits with legs crossed to her side, her arms and hands placed in front, adjusting the cards on the table before her. But Beckmann tilts the table forward, permitting us a view of the tabletop. This dual point of view heightens the exaggerated length of her arms and hands, and offers a reference to a cubist sense of space.

167 Quappi in Headdress 1927

Pen, brush, watercolor and tempera; 62 x 48 cm.
Bielefeld 119
s.l.r.: Beckmann
Private collection

Reference: Weisner, Bielefeld 1977, cat. 119.

Beginning in the late 1920s and continuing throughout his career, Beckmann executed a number of watercolors (cf. cat. 176-187). At times he utilized the watercolor in collabora-tion with an underdrawing in other media, but in others he used watercolor alone. He also hand-colored several prints (cf. cat. 286, 294).

This drawing anticipates much of what Beck-mann formulates only years later in his paint-ings of the 1930s, both in reference to the pic-torial center as well as the subject: the broad spontaneous brush strokes, the severe arrange-ment, the monumental forms, as well as the intensity of the dark tones and the mythologi-cal meanings. Framed and heightened by the large square, perhaps a mirror, Quappi with feather and headdress presents herself like a priestess. The illumination from below and the shadows of the eyes (cf. cat. 78) increase the sphinx-like character of her appearence.

The painterly quality of the drawing is unusual. The sketchy drawing is tensely com-bined with condensed color area, such as the white highlights of the arm and face. Accord-ing to Weisner, a signed and dated sketch of the same figure appears on the verso.

168 Quappi with Candle 1928

Black chalk heightened with white; 61.5 x 48cm.
Bielefeld 120
S.L.R.: Beckmann/F. 28
Basel, Kunstmuseum, Kupferstichkabinett

As in *Quappi in Headdress* (cat. 167), Beck-mann is fascinated with the play of light. In fact here the phenomenon is visibly explained in that Quappi holds a candlestick with a large burning candle in her hand. But the shining brilliance on her chest, neck, cheeks, and eyelids appears to come less from the concrete light source as from the woman's inner source of light. Quappi becomes a mysterious being in an unidentified place. The unmodelled, strongly delineated body shows the flat sculptural form, which is also characteristic of Beckmann's paintings from the mid-1920s.

169 Rimini 1927

Pastel; 48.5 x 64cm.
Bielefeld 117
S.L.R.: Beckmann/Rimini/27
Private collection

As an apparently casual sketch, this work attempts to brace a hasty impression of nature with firm surface lines. The gentle, but deliberate play of diagonally crossing lines organizes the expansive landscape and leads the eye into the distance, where sailboats are barely visible along the horizon.

170 Portrait of Marie Swarzenski
ca. 1927

Pastel; 33 x 50 cm.
Unsigned
Dr. and Mrs. W. V. Swarzenski

Marie (also known as Maria) and her husband
Georg Swarzenski, director of the Städelschen
Kunstinstitut, were close friends and support-
ers of Beckmann. However, in this portrait a
sense of intimacy and immediacy is missing and
replaced with mystery and reserve. Beckmann
places her against a severe background, gives
her an indeterminate expression and makes her
seem distant by means of extreme light and
shadow effects. Beckmann portrayed Marie
Swarzenski several times in other drawings, as
well as prints (VG 280, 309), and a painting,
*Double-Portrait of Frau Swarzenski and Carola
Netter*, 1923 (Göpel 222).

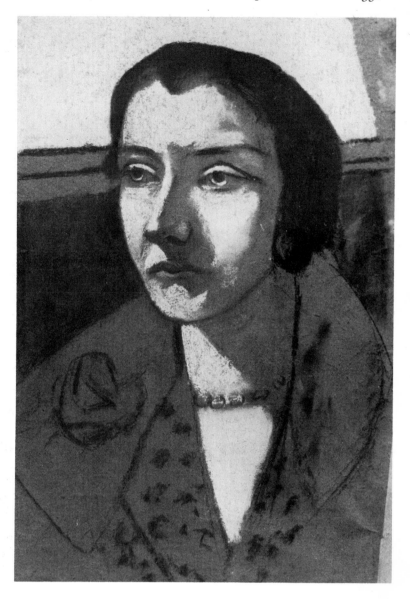

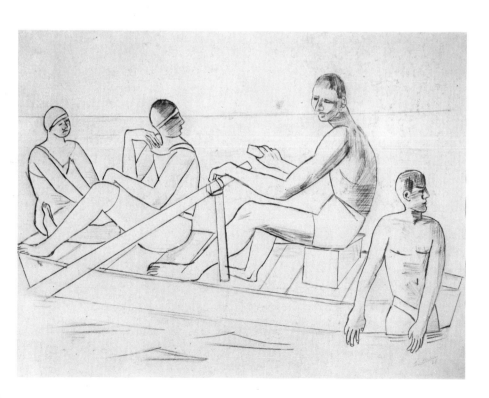

171 Rowers 1928

Black chalk; 54 x 72 cm.
Bielefeld 122
S.L.R.: Beckmann/28
Private collection

This drawing, as well as several paintings,
drawings, and prints were completed during or
after a vacation which Beckmann took in
Scheveningen on the coast of Holland in 1928
(cf. cat. 50). The emptiness of the drawing, the
contrast of the distant horizon against the large
figures in the foreground and the boldly deline-
ated form of the rowers accented with minimal
shading all give the impression that these peo-
ple are a mysterious group, not unlike the
mythological pictures such as *The Bark*,
1926 or *The Small Fish*, 1933 (cat. 42, 65). The
man seen in profile on the right bears a physi-
cal resemblance to Beckmann.

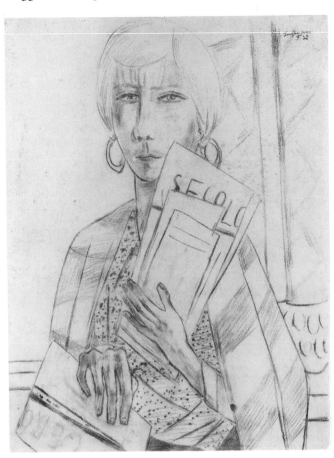

172 Newspaper Seller 1928
Black chalk ; 63.5 x 48.5 cm.
Bielefeld 121
S.U.R. : Beckmann/F. 28
Private collection

As in many of Beckmann's portraits, he pays particular attention to the delineation of the figure's hands and individualization of the face. Here the woman stares intently at the viewer, while she clutches her newspapers close to her body ; her long-fingered hands have a nervous life of their own. While the elongated mass of the figure and almond-shaped eyes recall the work of Modigliani, the patterned surfaces of the shawl, printed blouse, and background exhibit the pictorial structures of synthetic cubism.

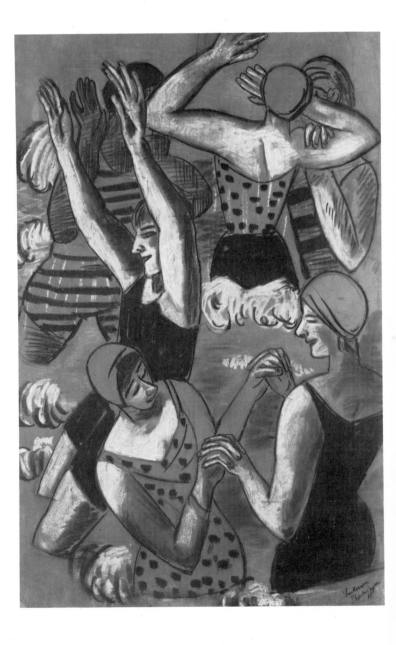

173 Bathers 1928
Black and white chalk on blue paper; 87 x 58 cm.
S.L.R.: Beckmann/Scheveningen/28
Chicago, The Art Institute of Chicago,
Gift of Mr. and Mrs. Stanley M. Freehling

The painterly quality and boldly conceived
composition of this work relate directly to the
pictorial intentions of Beckmann's paintings
during this period. The bathers, a motif from
his vacation in Scheveningen, are all placed
one on top of the other in a tight space with
little regard to proper perspective (cf. cat. 42).
It is precisely this condensed flatness which
lends a monumentality to the figural group, in
which each gesture and movement has a pene-
trating presence. The rhythm of the arms, the
playful quality of the bathers, and the patterns
of the bathing suits make for a lively scene.

Beckmann completed a preparatory drawing
(Bielefeld 127), much smaller in scale, in which
there are several more figures. This earlier
drawing probably was executed on the spot.
Evidence of this is in the way the figures have
been hastily blocked-in, thus demonstrating
Beckmann's concern for capturing the essence
of their individual fleeting gestures rather than
attempting to create a coherent composition.
The later drawing employs many of the same
gestures (i.e., the two women with joined
hands and the man on the left with upraised
arms), but clearly exhibits a more thoughtful
and deliberate composition.

174 The Night 1928
Black chalk; 65.5 x 187 cm.
Bielefeld 123
S.L.R.: Beckmann/28
Private collection

Lying one against the other, almost as two
figures separated on a playing card, the couple
sleeps with bodies intertwined. Whereas the
man's figure is almost totally obscured—even
his head is hidden within the crook of his left
arm—the woman lies relaxed in a deep sleep
like an odalisque. The position of the man is
strained and expresses a sense of burden and
moodiness.

Weisner suggests that the gesture of the male
figure connotes a sense of painful renunciation
of the sensuous fascination of woman, not
unlike Beckmann's later depiction in the
watercolor, *Odysseus and the Sirens* (cat. 178).
As is often the case in Beckmann's work, there
is an allusion to the Fall of Man and his over-
riding guilt.

175 Portrait of Lilly von Schnitzler-Mallinckrodt 1931

Graphite; 40 x 31 cm.
s.l.r.: Beckmann/F. 31
Frankfurt a.M., Karin and Rüdiger Volhard

Lilly von Schnitzler-Mallinckrodt was a friend and patron of Beckmann, from the 1920s when both lived in Frankfurt. Her home was a gathering place for artists, writers, and politicians.

In spontaneous, yet precise strokes, the drawing captures the social status and the serious character of this woman. Beckmann completed a portrait of her in 1929 (Göpel 313), for which two drawings exist. A second painting, begun in 1938 while Beckmann was in Amsterdam, was completed in New York in 1949 (Göpel 803), for which there is a related watercolor. She also appears in a group portrait entitled *Large Painting of Women,* 1935 (Göpel 415).

This drawing does not appear to be a study for a particular painting and is more highly finished than the two which served as preparatory works for the earlier painting (Bielefeld 129, 130).

◁ **176 Peter, Resting 1931**
Watercolor; 41 x 65 cm.
Bielefeld 136
S.L.L.: Beckmann/31
Private collection

Beckmann captures his 23-year-old son Peter in the broad strokes and the ornamentalized structure characteristic of his pictures of the 1930s. The extreme foreshortening of the figure, the disproportionate treatment of feet and arms in relation to the head, and the motif of the blanket draped over him create not only

the appearance of Peter as a young boy, but represent the true theme of sleeping and solitude. The use of distortion will take on a more decisive role in Beckmann's later works.

177 Two Women in a Café 1933
Watercolor: 71 x 62 cm.
Bielefeld 143
S.L.R.: Beckmann/33
U.S.A., Private collection

Beckmann's interest in café scenes is evident in this watercolor of two fashionably dressed women who are seated in a restaurant. Compared to a similar theme of an earlier drawing, *Café Scene,* ca. 1905 (cat. 138), this later drawing displays a more highly developed, painterly technique, especially in the deft handling of the washes and the more complex composition.

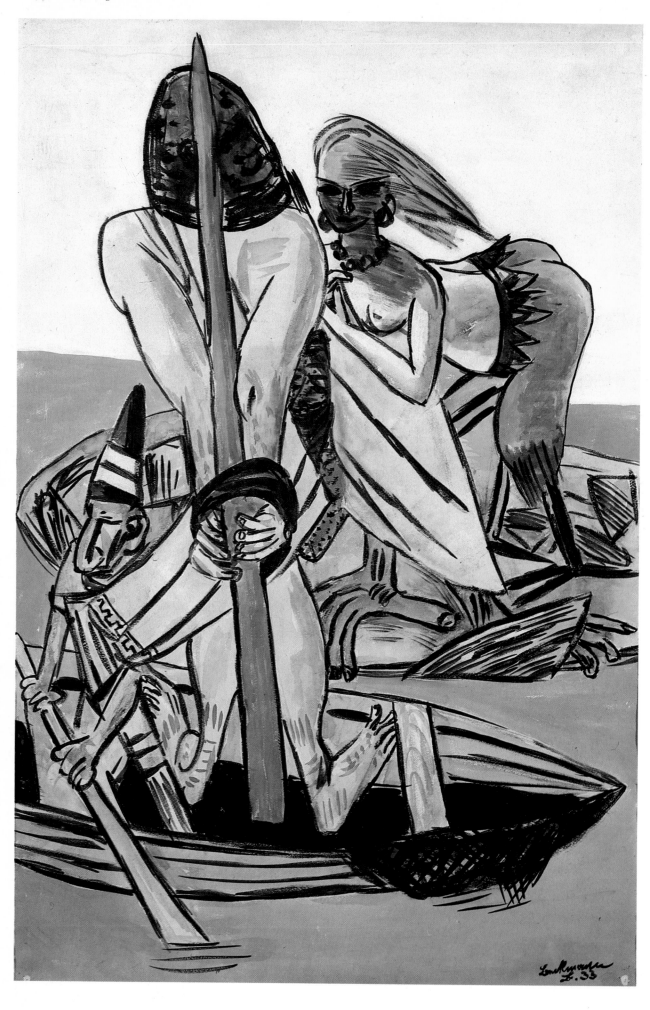

178 Odysseus and the Sirens 1933
Watercolor; 101 x 68 cm.
Bielefeld 141
S.L.R.: Beckmann/B.33
New York, Private collection

Beckmann's repeated portrayal of seduction
appears again in this depiction of Homer's
mythological tale of Odysseus and the Sirens.
On the return to his kingdom of Ithaca, Odys-
seus encounters the Sirens, bird-like women
living on the island of Scylla, who seduce ships
into the dangerous, rocky shores with their
bewitching songs. In order to avoid capture,
Odysseus plugs the ears of his crew; however,
he wants to listen and has himself tied to the
mast so as not to succumb to their magic.
Throughout history, the images of Sirens and
the Bull, as seen in *The Rape of Europa*
(cat.179), have been used as universal images
of seduction.

In *Odysseus and the Sirens,* the hero wears a
veil and is seen in profile from behind. That
Odysseus' face bears a resemblance to the
artist is not surprising since Beckmann had
referred to himself as Odysseus in his diaries
(27.9.48). With Beckmann's 1933 dismissal
from his teaching position in Frankfurt, it is no
wonder that he associated so fully with the clas-
sical man without a country.

179 The Rape of Europa 1933
Watercolor over graphite; 51.1 x 69.9 cm.
Bielefeld 140
S.L.R.: Beckmann/33
Private collection

Beckmann again uses a motif from Greek
mythology, depicting the tale of Europa's vio-
lation by Zeus. As Europa played along the
beach, Zeus, disguised as a bull, charmed her
onto his back and carried her off to Crete,
where she bore him three sons. The strong
composition illustrates not only the literary
theme, but also mirrors Beckmann's attitude
towards the erotic.

Throughout his entire work Beckmann con-
tinually chose mythological themes which
treated the problematic relationship of man to
woman. Just as in the two earlier paintings,
The Battle, 1907 (fig.p.17) and *Battle of the
Amazons,* 1911 (cat.11), the latter also depict-
ing scenes of rape, in this watercolor violence is
given expression. The grip of the masculine is
dominant; the woman is the suffering one,
though she offers herself seductively. The com-
position is conceived monumentally, in that the
gentle and strong curve of the woman's back
corresponds with the menacingly raised head
of the bull and both figures encompass the en-
tire surface of the paper.

180 The Snake King and the Stagbeetle Queen 1933
Watercolor; 61.5 x 48.2 cm.
Bielefeld 142
S.L.R.: Beckmann/33
Bernhard and Cola Heiden

The motif of this work is unpleasant and extreme, even within the framework of Beckmann's personal mythology. The snake king, with his huge arms and hands, reaches for the stagbeetle queen. The problem of the erotic, which prevades all of Beckmann's work, is expressed most urgently here. In this fantasy, the male sexual urge and the frightening possibility that he might devour the woman are predominant. He appears as a small-headed phallic being, characterized by snaky arms, fingers, and a rigid position, whereas the armored woman, equipped with pincers and claws, becomes an enigmatic and threatening insect. As in the paintings of the 1920s, the close gray ocean and the distant horizon reinforce the archetypal character of this situation.

181 Dunes in Zandvoort 1934
Watercolor; 48 x 62 cm.
Bielefeld 149
S.L.R.: Beckmann/Zandvorde/Juli 34
U.S.A., Private collection

Beckmann traveled often to the coastal town of Zandvoort in Holland where he visited with Eduard von der Heydt, a collector and one of his patrons. The view is from a window, overlooking an "ocean" of dunes, in which rooftops unexpectedly become visible in the distance. Two paintings date from this trip as well: *View of Zandvoort at Dusk* and *Bathers with Green Cabana and Sailors in Red Trousers* (Göpel 399 and 400).

182 Studio 1934
Watercolor; 58.4 x 46.4 cm.
Bielefeld 146
S.U.L.: Beckmann/B.34
U.S.A., Private collection

A view of the artist's new Berlin studio is depicted, showing a chair with a board laid over the arms, upon which rest brushes, paints, paper, and other supplies. A cloth is draped over the back of the chair and behind this are what appear to be several framed canvases. On the right, an open door leads to a darkened room.

Beckmann often depicted views of his various studios, such as in *Mirror on an Easel* (cat. 164). He does not imbue this work, however, with any apparent additional symbolic or mysterious meanings.

184 Landscape in Upper Bavaria 1936

Watercolor; 46 x 59 cm.
Bielefeld 154
s.l.r.: Beckmann/36
Bernhard and Cola Heiden

This watercolor displays another view of the area near Ohlstadt and the von Kaulbach house. It seems that 1935 was the last year that the Beckmanns were able to spend time in their familiar landscape.

183 Bavaria ca. 1934

Watercolor with pastel; 64.5 x 49.8 cm.
Unsigned
Minneapolis, The Minneapolis Institute of Arts,
The Katherine Kittredge McMillan Memorial Fund

Quappi Beckmann's family, the von Kaulbachs, owned a country house in Ohlstadt, Upper Bavaria, where the Beckmanns would often visit between 1930-1935. Several landscape paintings of this area date from that period. This spontaneously executed watercolor portrays a similar view of the garden which is depicted in the painting, *Garden Landscape in Spring with Mountains* (Göpel 395).

Graphite; 30.6 x 22.9 cm.
Bielefeld 158
S.L.R.: Beckmann/Paris 37
New York, Catherine Viviano Gallery

This drawing is a portrait of Marie Paule Pomaret, a Parisian art dealer and director of the Galerie de la Renaissance, where in 1931 Beckmann had his first Paris exhibition. It is one of six studies for a now lost painting of Mme. Pomaret, dated 1939 (Göpel 515). The sketches show her from various views and poses. Four of them, including the one exhibited, are different from the painting; however, they apparently served as visual notes for the artist.

Only two of the drawings are dated, one 1937 and the other 1938. It has been suggested that Beckmann executed these drawings at one sitting and mistakenly dated them when he signed them later.

185 Portrait of Quappi in a Beach Café 1935

Watercolor; 65 x 50 cm.
Bielefeld 150
S.L.R.: Quappi/für Herr Gast/Berlin 1.4.35/
Max Beckmann
U.S.A., Private collection

This watercolor is reminiscent of Beckmann's watercolor, *Two Women in a Café,* 1933 (cat. 177), where both reveal a certain stylistic similarity to Matisse. While the subject matter is not particularly French, it recalls many similar works by Matisse of women seated within interiors, emphasizing surface decorations and architectural elements. Beckmann was surely familiar with the works of contemporary French painters for, beginning in the mid-1920s, he often traveled in France. From 1929 to 1932 he rented a studio apartment in Paris where he lived from September through May, returning to Frankfurt for a week every month to fulfill his teaching obligations.

186 Beach Scene with Umbrellas 1936

Watercolor; 65 x 50 cm.
Bielefeld 153
S.L.L.: Beckmann/36
U.S.A., Private collection

Beckmann has taken obvious delight in utilizing the watercolor technique to depict this brightly colored beach scene. Vivid and precise washes describe the three women as they sit on the beach under large umbrellas. A strong order is achieved despite the apparent ease of execution. The location of the beach is most likely Zandvoort (cf. cat. 181).

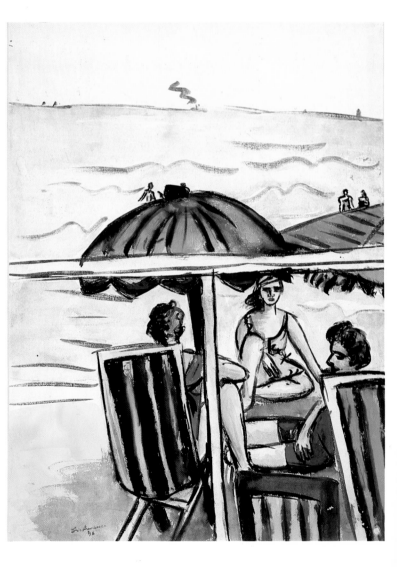

188 The Fishermen 1940-45

Pen and black ink; 31.5 x 24cm.
S.L.R.: Beckmann
St. Louis, The Saint Louis Art Museum, Purchase,
Funds given by S. Arlent Edwards, by exchange
References: Fischer, 1972, p. 128; Göpel, 1976,
I, p. 300.

Themes of fish and people fishing appear often
in Beckmann's work. This drawing is related
to his painting, *Children of Twilight-Orcus*
(cat. 87), which Beckmann began in 1939 and
continued to work on until he signed and dated
it in 1950, although it was unfinished even
then. According to Stephan Lackner, Beck-
mann told him that the idea partially stemmed
from an infernal vision the artist had of the
Parisian subway.

The drawing has been variously dated ca.
1939 by Clark; 1940-45 by Göpel; and 1948 or
1949 by Friedhelm Fischer. Fischer's date is
too late, as the drawing entered The Saint
Louis Art Museum's collection in 1946. Stylis-
tically the drawing relates to Beckmann's other

drawings of the early 1940s. There is another
related drawing in charcoal; its present loca-
tion is unknown.

189 The Iceman ca. 1944

Pen and black ink; 36.1 x 13.6cm.
Bielefeld 167
S.L.R.: Beckmann
New York, The Museum of Modern Art,
Gift of John S. Newberry

Beckmann combines paradoxical elements in
this work—ice and sun, cold and heat are
united, and the iceman is presented almost
mythologically to resemble a magician. These
images coincide with Beckmann's thoughts as
expressed in "Letters to a Woman Painter,"
Part II: "Under the cold ice the passion still
gnaws, that longing to be loved by another,
even if it should be on a different plane than
the hell of animal desire. The cold ice burns
exactly like hot fire. And uneasy you walk
alone through your palace of ice..."

In 1947 Beckmann traveled to Paris and
Nice. The Mediterranean flavor of this drawing
may originate from that trip.

190 The Chained Man 1944

Pen and black ink; 40.6 x 25.1 cm.
Bielefeld 166
s.l.r.: Beckmann
New York, The Museum of Modern Art,
Gift of Curt Valentin

Reference: Göpel, 1954, No. 32.

Whether the imagery of this drawing alludes to a specific theme or whether it comes solely from Beckmann's imagination is unclear. In his diary he wrote only "Drew the chained man." (17.5.1944.) Göpel suggests that Beckmann felt chained during his years of exile in Amsterdam, and the artists's frustrations are connoted by the screaming figure in the foreground, protesting his enslavement. Perhaps the reclining, classically draped female figure in the background suggests a sleeping muse, providing little inspiration for the imprisoned artist.

The image of a chained figure appears in Beckmann's *Temptation* triptych, 1936-37 (cat. 73), and a self-portrait with sprung chains is pictured in *The Liberated One,* 1937 (Göpel 476).

Stylistically, Beckmann's pen and ink drawing is similar to his last lithographic portfolio, *Day and Dream,* 1946 (cf. cat. 295-297).

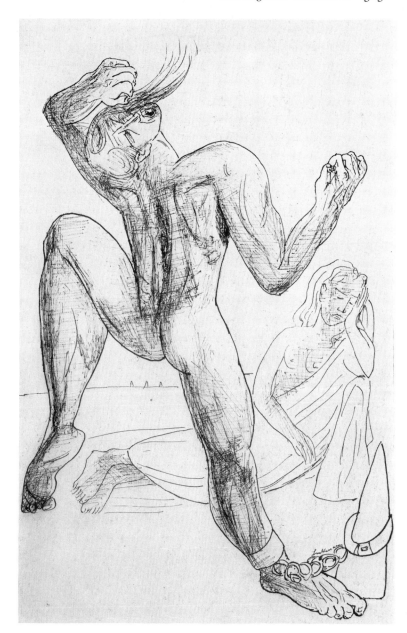

191 The Letter 1945

Pen and black ink; 22.9 x 33.1 cm.
Bielefeld 173
s.l.r.: 13. Okt. 45/A. Beckmann
New York, The Museum of Modern Art,
The Joan and Lester Avnet Collection

Reclining female figures appear in Beckmann's work throughout his career. This particular drawing is related to another, dated 15 months later (Bielefeld 196). In each case, the woman is in a similar reclining position holding a paper up to her face, revealing only her eyes. The later composition is more complete, with greater attention given to the delineation of the figure and the creation of the interior space. Both demonstrate Beckmann's later drawing style, utilizing his characteristic nervous, scratchy pen and ink line.

192 Tram Stop 1945

Pen and black ink over graphite ; 32.5 x 35.5 cm.
Bielefeld 181
S. on verso: Haltestelle/31. Dez. 1945
Private collection

Reference: Göpel, 1954, p. 14.

Beckmann translates his own feelings of
impatience and hopelessness throughout the
war into the anxiety of these gaunt, immobile,
and muffled figures, waiting in line for the
streetcar on a cold wintery day. Göpel suggests
that the symbolism of the ladder in the
Argonauts triptych, 1949-50 (fig. p.37), where
the old man directs the Argonauts to other
spheres, is here suggested by the figure on the
far right.

Beckmann refers to this work in his diaries
twice ; "In the morning I bicycled in the freez-
ing temperature and drew *The Tram Stop...*"

(31.12.1945) and "Lots of snow, storms,
rheumatism and Lutjens... He bought two
more drawings, *Tram Stop* and *Self-Por-
trait...*" (1.3.1946).

**193 Double-Portrait of Max and
Quappi Beckmann ca. 1945**

Pen and black ink ; 20 x 12.5 cm.
Bielefeld 182
S.L.R. : Beckmann
Perry T. Rathbone

The years of exile in Amsterdam were not easy
ones. Beckmann's freedom to travel and visit
with friends was greatly curtailed. His feelings
of isolation are depicted graphically in this
double portrait of himself and his wife. He
stands, almost full-length, facing the viewer;
Quappi is positioned in profile to the right in
the background, holding their dog, Butchy.
They seem to be in close proximity, yet each
stands in silent, distant thought. The darkening
of the faces and the box-like room emphasize
the partnership as well as the sense of separa-
tion.

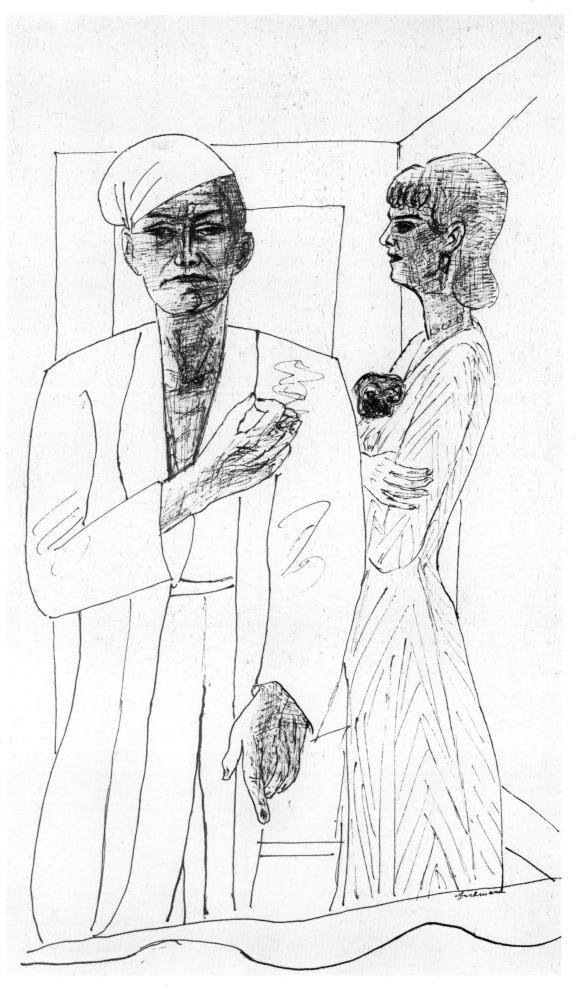

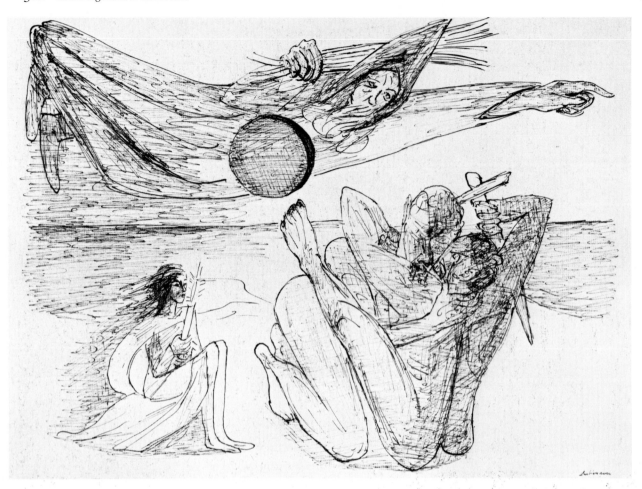

194 Father Christmas ca. 1944

Pen and black ink ; 26.7 x 36.8 cm.
s.l.r.: Beckmann
St. Louis, The Saint Louis Art Museum, Purchase,
Funds given by J.T. Milliken, by exchange
Reference: Göpel, 1954, No. 34.

As Göpel suggests, Beckmann's image of two
nude men battling on the shore alludes to his
vision of the Allied invasion. The woman on
the left holding a candle and the bearded Fa-
ther Christmas soaring over the scene are
strange and enigmatic motifs.

195 A Walk (The Dream) 1946

Pen and black ink and wash : 32 x 26.5 cm.
Bielefeld 186
s.l.r.: Beckmann/A. 46; Verso:
Spaziergang 7. Februar 46
Private collection

The mysterious, dream-like quality of this
drawing depicts a partially destroyed bridge
and a man walking over it. With the man's very
next step he will drop through the missing sec-
tion of the bridge and fall into the unknown
depths below, which enigmatically reflect the
image of a voluptuous nude reclining on her
back. Beckmann's use of washes creates a feel-
ing of stormy agitation, heightening the fantas-
tical quality of this work and mirroring the fear
felt by the man.

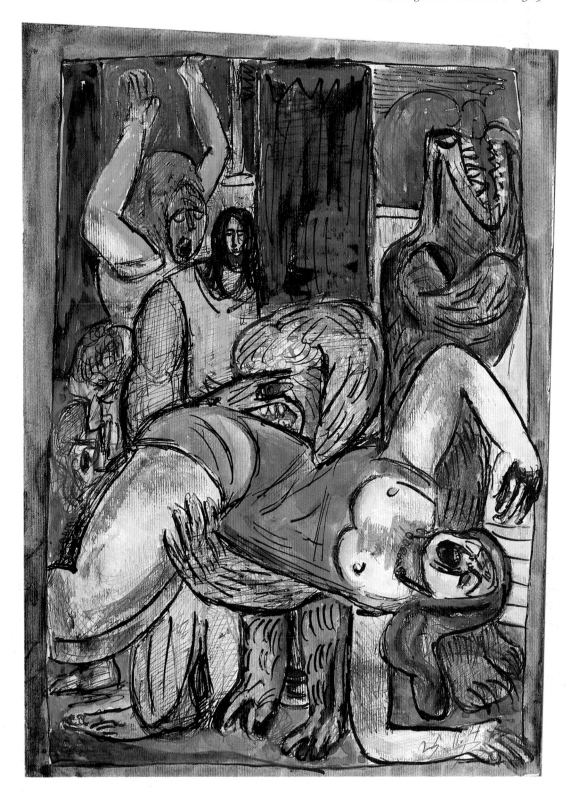

196 The Dogs Grow Larger 1947

Pen and ink and watercolor; 33.7 x 25 cm.
Bielefeld 204
S.L.R.: 25.11.47/B
Private collection

This nightmarish work depicts a screaming woman who is being viciously attacked by an over-sized dog. A second dog appears on the right with raised head, eyes closed, and mouth slightly open to reveal his sharp teeth, accentuating the aggressive nature of the scene. On the left two women and a bearded old man observe the scene, which can be interpreted as a male sexual fantasy (cf. cat. 180).

The watercolor washes are bright and garish, adding substantially to the ghoulish mood of this work. According to the date on the drawing and Beckmann's mention of it in his diary, he continued to work on it for over a month. His entry reads "...I finally corrected the new and old watercolors. The Dogs Grow Larger is finished." (27.12.1947).

197 Nightclub in New York 1947

Pen and ink and watercolor; 25.4 x 35.6cm.
Bielefeld 206
S.L.R.: For Wally/from Beckmann/4 Nov. 47/
St. Louis
Collection of Fred Ebb

Beckmann's enjoyment of haunting cabarets
and nightclubs continued with his journey to
the new country. Depicted here is a nightclub
act in which a woman performs a split and is
raised in mid-air, with each leg held by a man
dressed in a clown costume. The audience sits
on either side, while the band in the back-
ground accompanies the performance.

This drawing is alive with a carefree vitality,
but sinister as well as sexual overtones are evi-
dent in the almost larger-than-life mysterious
male figures who forcefully hold the woman in
this erotic, stradled position.

198 Portrait of Louise V. Pulitzer
ca. 1949

Graphite; 21.6 x 14cm.
Unsigned
Private collection

*Reference: Modern Painting, Drawing and Sculpture
Collected by Louise and Joseph Pulitzer, Jr.,*
Volume III, Cambridge, Mass.: 1971, p.352.

Louise Vauclain Pulitzer and her husband,
Joseph Pulitzer, Jr., were members of the close
circle of friends, admirers, and patrons who
clustered around Beckmann during his stay in
St. Louis. According to Walter Barker, Louise
Pulitzer was one among several who assisted
the Beckmanns in their struggle to obtain the
necessary immigration papers.

Beckmann's painted portrait of Louise
Pulitzer (Göpel 781) was uncommissioned and
is a testament to the artist's great affection for
and admiration of the woman he referred to as
"The Egyptian Princess." From numerous
diary entries it is clear that Beckmann began
the painting before the three extant drawings
were executed (2./3.2.1949).

Beckmann executed three drawings in prep-
aration for the portrait. The one exhibited
here is the most detailed of the three; how-
ever, in the painting the woman faces the other
direction. He has managed to instill this rather
small drawing with an air of dignity and grace,

emphasizing the delicately formed features and
elegant neck line.

Joseph Pulitzer has said Beckmann asked his
wife to wear certain jewelry during the sketch-
ing sessions. In the painting, she is wearing
earrings, which do not appear in this drawing.
They do appear in another drawing that the
artist destroyed upon completing, but which
the Pulitzers saved and had restored.

199 Yellow Lilies and Green Sea 1949
Watercolor; 50.1 x 31.1 cm.
S.L.R.: Beckmann/St.L.49
Mrs. William J. Green

Although completed in St. Louis, this water-
color is reminiscent of scenes from the Riviera
or the beaches of Holland which Beckmann
knew so well and had drawn so many times
(cf. cat. 181, 186). A woman sits wearing a
large hat, with her back toward the viewer.
Beside her is a vase of yellow lilies. She is
positioned on a porch or balcony, overlooking
the expansive sea and sky.

 Beckmann makes a reference to this work in
his diary, "...In the afternoon I did another
watercolor with yellow lilies and green sea..."
(13.3.1949).

200 Portrait of Fred Conway 1949
Charcoal; 60 x 45 cm.
S.L.R.: Beckmann/Mai 1949/St. L.
Joan Conway Crancer
Reference: Göpel, 1976, I, p. 481.

Fred Conway was on the faculty of the Wash-
ington University Art School and became a
good friend of Beckmann during his brief stay
in St. Louis. After the "Beaux Arts" Ball of the
Art School, Beckmann notes in his diary, in
English, "... I like Conway..." (22.5.1948).

This drawing is a study for an uncommissioned
portrait (cat. 123). Beckmann makes several
references to this work in his diary. In the
finished painting, the position of Conway's arm
has been altered, and Beckmann has added a
bottle on the left and indicated the back of a
chair. This drawing is not unlike the following
work in its bold and painterly handling of the
drawing medium.

201 Woman with Shaded Face 1949
Black chalk; 57 x 39 cm.
Bielefeld 211
S.L.R.: for Perry Rathbone / Beckmann /
April 18/1949
Perry T. Rathbone
Reference: Göpel, 1954, No. 42.

This powerful, energetic, and mysterious drawing shows a woman in half-length with her left hand obscuring the left side of her face. Her right hand is brought in front of her body with her palm held outward in a seemingly defensive gesture. As Göpel points out, the loose, broad, and painterly handling of the chalk is reminiscent of Beckmann's late painting style. As in earlier drawings, Beckmann's attention continues to focus on the expressive rendering of face and hands.

202 Park in Boulder 1949

Black chalk, pen and black ink, 58.5 x 44.4 cm.
Bielefeld 216
S.L.R.: Beckmann 49
New York, Catherine Viviano Gallery

Park in Boulder recalls Beckmann's earlier
Bavarian landscapes, especially his watercolor,
Timber Track near Ohlstadt, 1934 (Biele-
feld 148). Beckmann was impressed with the
new surroundings and makes specific refer-
ences to the Colorado landscape in his diaries.
This entry may refer specifically to this draw-
ing: "This afternoon I made another drawing
of the Park in the Mountains, then, rather
tired, I sat in the park..." (23.8.1949).

According to Göpel, Beckmann did not
work on any paintings that summer and busied
himself with drawings instead. His painting,
Landscape in Boulder, 1949 (cat. 127), was
executed in his New York studio and recalls the
awe-inspiring scenery of the American West
that Beckmann found so fascinating.

203 Brunhilda and Krimhilda
(War of the Queens) 1949

Pen and black ink over black chalk; 58 x 44 cm.
S.L.R.: Beckmann./Boulder 9.8.49
Private collection
Bielefeld 214

This scene transpires within a stage-like set-
ting, as Beckmann depicts the conflict between
the two queens, Brunhilda and Krimhilda,
characters from German Nibelung poetry.
Beckmann makes specific references to this
work in his diaries. On August 9, 1949 he
writes "... This afternoon drawings for the
'War of the Queens'." On August 11 he says
"... I have finished reading Simrok's *Nibe-
lungenlied.* A great work, but now I must also
read the Nordic versions. Much of the sense-
less greed and tragedy, but also the heroic is
prophetically foreseen there;" and on August
13 "... very stormy today and I did some work
on 'Krimhilda' (drawing)."

204 Self-Portrait with Fish 1949

Brush and black ink over chalk; 59.7 x 45 cm.
Bielefeld 213
S.L.R.: Beckmann/Boulder/8. August 49
Hamburger Kunsthalle
References: Fischer, 1972; Weisner, Bielefeld, 1977
cat. 213.

In 1949, Beckmann accepted a summer teaching position at the University of Colorado in Boulder. This self-portrait shows the artist in half-length from the back as he turns his head towards the viewer over his left shoulder. The wide-brimmed hat comes over his eyes, heightening his intense gaze. With a firm grasp, he holds a fish up to his face, thus the single eye of the fish lies in the same plane as the eyes of the artist. The fish is a symbol Beckmann utilized frequently throughout his career and its meanings for the artist vary. It may allude to fertility in general, or have a phallic connotation. Fischer suggests additional parallels: the fish may be a sign of supernatural power, or it may hold the secret potential for the regeneration of life, as well as signify existence and the principle of the soul.

Stylistically, Beckmann's bold use of the brush adds vitality to this late work. The contrast between the black ink and the white of the paper creates a sense of energy and monumentality, especially in the way he sets off his face and hat against a background of black wash.

205 Early Men 1946, 1948/49

Watercolor or gouache and ink; 50.2 x 64.8 cm.
dated 1946, 1948/49 (reworked)
Private collection
Bielefeld 197

An egg-shaped form refers back to Hieronymus Bosch. Multi-breasted female figures, two fish swimming past, dark mask-like faces, and a huge pair of many-toed feet: all these curious creatures embody various religious and philosophical views in a world of primoridal Unity—a world which prior to the Fall of Man had not separated mind and matter. Like a view into the future, a detail from Beckmann's present appears in the middle of the scene, turned at a 90-degree angle.

206 Self-Portrait, 1950

Ballpoint pen; 25 x 20.4 cm.
Bielefeld 219
s.l.r.: Beckmann/Carmel Juni 50
Private collection

This is one of Beckmann's last drawn self-portraits, executed while he was on vacation in Carmel, California. Beckmann did not often portray himself in strict profile, and this very intense characterization reveals the artist's great facility for capturing the essence of a sitter, albeit himself, with the most economic of means.

207 Quappi with Cat 1949

Charcoal; 61 x 40.8 cm.
s.l.r.: Beckmann/Bou 49
Joan Conway Crancer

Throughout their marriage, Beckmann's wife was his favorite model. Here Quappi is pictured in half-length, her head facing slightly to the left, averting direct eye contact. In her right hand she holds a cat up to her breast. Quappi's pose may be reminiscent of the figure appearing on the left in Beckmann's painting entitled *Before the Ball (Two Women with Cat)*, 1949 (Göpel 796).

209 Self-Portrait with Fishing Pole 1949

Pen and black ink with graphite; 60.2 x 45.5 cm.
S.L.R.: Beckmann/Boulder 49
Ann Arbor, The University of Michigan Museum of
Art

In the same summer that Beckmann drew *Self-Portrait with Fish* (cat. 204), he completed this work as well. The two drawings make a striking comparison, especially in the choice of medium; the former with its broad, painterly brush strokes versus the spare, concentrated and simplified lines of the pen in the latter. Now the gaze makes direct contact with the viewer.

On Beckmann's last day in Boulder, he made the following entry in his diary, "...Tomorrow I will do the latest self-portrait with rope..." (27.4.1949). Perhaps this refers to the present work, and what previously has been identified as a fishing pole is really some sort of rope or cable.

208 Portrait of Georg Swarzenski 1950

Black chalk on blue paper; 60 x 45 cm.
Bielefeld 220
S.L.R.: Beckmann/N.Y. 50
Private collection

This drawing of Georg Swarzenski, the former director of the Städel Museum in Frankfurt and one of Beckmann's close friends, was done for the Festschrift "Beiträge für Georg Swarzenski zum 11.Januar 1951" (Verlag Gebr. Mann, Berlin). At the time of the portrait, Swarzenski was a Fellow of Decorative Arts of Europe and America at the Museum of Fine Arts, Boston.

In a letter published in the Bielefeld exhibition catalogue, Swarzenski's son, Hanns, recalls the circumstances surrounding the portrait. The idea for the drawing was that of Oswald Goetz, a former assistant during Swarzenski's directorship in Frankfurt, who then was working at The Art Institute of Chicago. The portrait was done in Beckmann's New York studio. Hanns Swarzenski recalls meeting his father after the session, when he complained of how exhausting it had been and spoke of the great intensity and concentration with which the artist had worked. This atmosphere of extreme tension and anxiety appears to have been unavoidably transferred to the sitter (Letter from Hanns Swarzenski, May 6, 1977).

Prints

The catalogue of prints is arranged chronologically according to a new catalogue raisonné of Beckmann's graphic work being prepared by James Hofmaier to be published by Verlag Kornfeld und Cie, Bern. The work has been commissioned by the Max Beckmann Society with Klaus Gallwitz as editor. It will be referred to here as VG (Verzeichnis der Graphik/catalogue of graphic works). Throughout the project, James Hofmaier has been most generous with the information he has compiled and has shared his findings freely. This author owes a sincere thank you to Hofmaier for all his invaluable assistance in preparing the catalogue portion on Beckmann's prints.

Gallwitz refers to Klaus Gallwitz: *Max Beckmann – Die Druckgraphik – Radierungen, Lithographien, Holzschnitte,* Karlsruhe, 1962.

Glaser refers to Curt Glaser, Julius Meier-Graefe, Wilhelm Fraenger, Wilhelm Hausenstein: *Max Beckmann,* Munich, 1924.

Dates and dimensions are according to Hofmaier. Dimensions are given in centimeters, height preceding width. The dimensions for etchings and drypoints are of the plate; the dimensions for lithographs and woodcuts are of the image. Inscriptions include the artist's signature and notations in the artist's hand, unless indicated differently. *Judith C. Weiss*

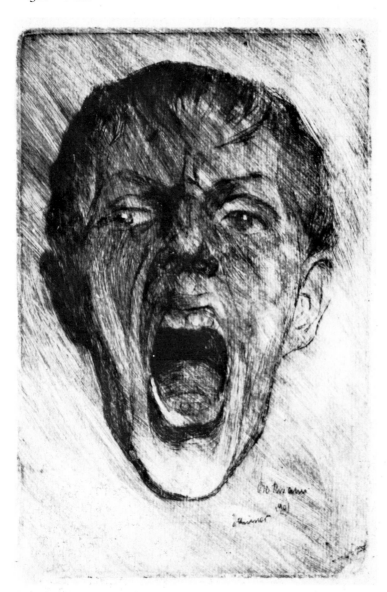

210 Self-Portrait 1901
Drypoint; 21.8 x 14.3cm.
VG 2 proof; Gallwitz 1; not in Glaser
S.L.R.: Beckmann/Januar 1901
Private collection

As with many artists, Beckmann was fascinated with the self-portrait; the attraction was to continue throughout his career. The earliest painted self-portrait was done at age 15 (cat. 2). This earliest printed self-portrait was executed at age 17 while Beckmann was a student at the Weimar Academy. According to Hofmaier, this is the only known impression, and it was never published. Here we see a studied and careful examination of the young artist in a scream or perhaps a hearty yawn.

Technically this print is very straightforward, the image having been drawn directly onto the plate in a draftsmanlike manner, in a series of very fine parallel lines.

211 Self-Portrait with Beard ca. 1903
Lithograph; 17.4 x 11.2cm.
VG 3 proof; not in Gallwitz or Glaser
Private collection

This is Beckmann's first attempt at lithography. It is known in only three impressions, and is directly related to a graphite drawing, *Self-Portrait with Beard* (von Wiese 4), which is signed in monogram and dated 1903. That Beckmann used the drawing as a model is evident by the fact that the part in the artist's hair appears in reverse from the print. However, Beckmann changed the print by omitting the collar and tie, obscuring the left side of his face in shadow, and cropping the image at the top and bottom.

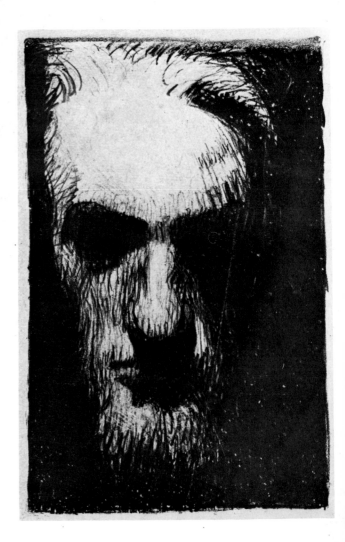

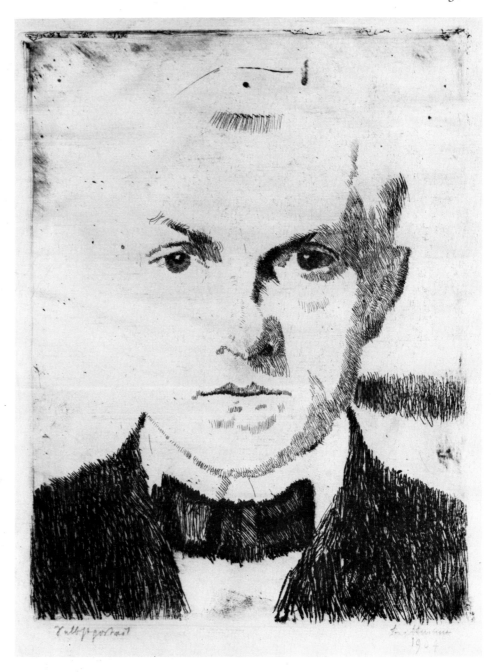

212 Self-Portrait 1904

Etching and drypoint; 23.7 x 18.1 cm.
VG 4 II/II proof; Gallwitz 2; not in Glaser
S.L.L.: Selbstportrait
S.L.R.: Beckmann/1904
Private collection

As with the two previous self-portraits, this print is quite rare and known in only two impressions. The proof of the first state has pencil additions along the contour of the head at the top and left and in the shading of the bow tie. In this second state, drypoint lines have been added to complete the head's contour and etched lines have been added to the right bow of the tie.

In contrast to Beckmann's *Self-Portrait with Beard* (cat. 211), which was a study in shadow, this print displays Beckmann's interest in light. The artist's features are completely revealed with minimal use of line. The facial characteristics are delineated primarily by a series of lightly-etched, short parallel lines; in fact, the contour of the left half of the face is not indicated.

Although executed in the same year as the previous self-portrait, a more sophisticated, self-assured young man appears to engage the viewer directly. Technically, the print shows more advanced experimentation with the medium. There is more contrast in tone and sketchier, freer handling of the line.

While there is no painting of 1904 that directly relates to this print, Beckmann's *Self-Portrait in Florence,* 1907 (cat. 8) conveys a similar mood and feeling.

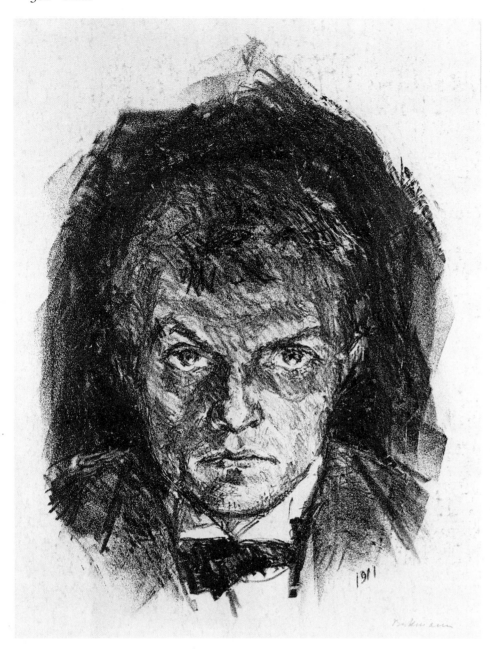

213 Self-Portrait 1911

Lithograph; 25 x 18.8cm.
VG 23 trial proof; Gallwitz 12; Glaser 18
S.L.L.: Beckmann
S.L.R. on the stone: 1911
New York, The Museum of Modern Art

According to Hofmaier, there were two editions of this print; the first in 1911 by E.W. Tieffenbach, Berlin, and the second around 1920 by I.B. Neumann, Berlin. This is a trial proof for the first edition.

Compared to *Self-Portrait with Beard* (cat. 211), this print reveals Beckmann's increased technical abilitiy in the lithographic medium. He takes advantage of the medium's wide tonal range, setting his figure against a richly printed dark background to use a light source from below, thus creating a haunting portrait.

214 The Merry Ones 1912

Drypoint; 12.1 x 18.1cm.
VG 51 trial proof; Gallwitz 34; Glaser 46
S.L.L.: Probedruck; S.L.R.: Beckmann 12
Frankfurt a.M.,
Städtische Galerie im Städelschen Kunstinstitut

With the two early *Self-Portraits* of 1901 and 1904, this print, and *Brothel in Hamburg* (VG 50), are the earliest examples of Beckmann drypoints. By rigorously attacking the plate, Beckmann achieves a sense of the hustle and bustle of a crowded city street.

The repetition of the curved lines in the figures accentuates the forward movement across the sheet from left to right. While Beckmann's later drypoints may demonstrate a greater control over the medium, he achieves a wonderful sense of immediacy in this early print.

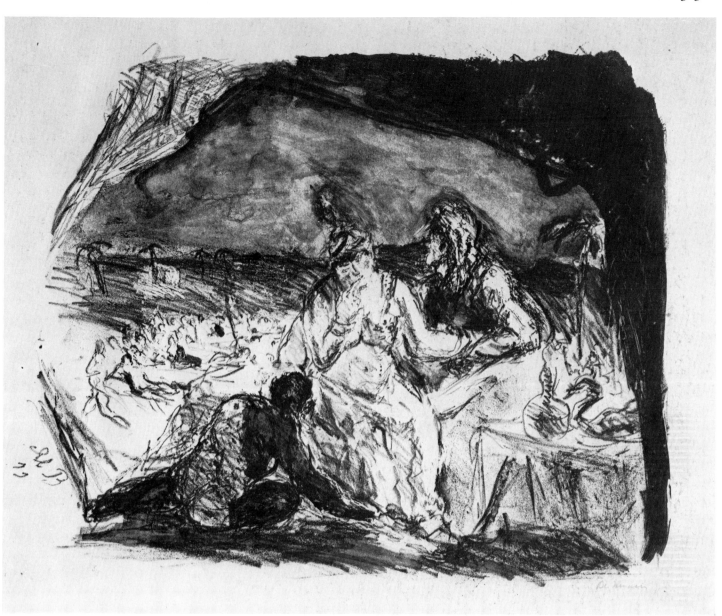

215 Samson and Delilah 1911
Lithograph; 22.5 x 30cm.
VG 26 II/II; Gallwitz 15; Glaser 21
s.l.r.: Beckmann
s.l.l.: 5/5; s.l.l. on the stone: MB/11
New York, The Museum of Modern Art, Purchase
Fund

Stylistically this print relates to Beckmann's
series of New Testament prints (VG 16-21),
executed in the same year. During this period,
Beckmann did several paintings and prints on
Biblical themes (Göpel 104, 119, 124, 128, 139,
152); (VG 15, 22, 25). *Samson and Delilah* is
very similar to a painting of the same subject
done a year later (Göpel 155). The composi-
tions indicate only minor changes. In addition,
there are two related drawings which are
studies for the figure of Delilah, both dated
1912 (von Wiese 112, 113).

216 Ulrikusstrasse in Hamburg 1912

Lithograph; 26.3 x 30.7 cm.
VG 37; Gallwitz 27; Glaser 31
s.l.l.: Ulrikusstr. in Hamburg;
s.l.r.: Beckmann 12
New York, Private collection

Beckmann's life-long interest in city life ranged
from that of the ambiance of high society cafés
to that of brothels and bars. (VG 50, 75, 83 and
cat. 225).

This lithograph bears a stylistic similarity to
the *Admiralscafé* (cat. 217), in which Beck-
mann achieves a comparably rich tonal quality.
In both instances he varies his strokes by using
the sides of the lithographic crayon.

According to Hofmaier, this print was prob-
ably published in a small edition since he
knows of only six unnumbered impressions.

217 Admiralscafé 1911/1912

Lithograph; 26.3 x 30.7 cm.
VG 32 II/II trial proof; Gallwitz 23; Glaser 26
s.l.r. in stone printed in reverse: Beckmann 12;
s.l.l.: Admiralscafé; s.l.r. Beckmann 12
Stuttgart, Staatsgalerie, Graphische Sammlung

Scenes depicting café life, dance halls, and night-
clubs appear in Beckmann's work throughout
his career. This print bears a certain resem-
blance in both mood and execution to certain
lithographs of Toulouse-Lautrec and Steinlen.

Among several differences from the first
state, the seated woman in the foreground
leaning forward has changed from a male
figure, and the scene was originally placed out-
of-doors.

Hofmaier dates this print 1911 following a
signed and dated proof of the first state in the
Frumkin collection. He suggests the print was
begun in 1911 and completed the following
year.

218 Evening Party 1912

Etching and drypoint; 14.6 x 19.7 cm.
VG 52 III/III trial proof; Gallwitz 43; Glaser 52
s.l.l.: 3 Zustand
s.l.r.: Beckmann 14
New York, Private collection

Five people have gathered in the *Evening Party*
to talk and read in a lamplit interior. This print
has gone through three states. The first,
executed in pure etching, establishes the initial
composition. In the next two states, Beckmann
re-etches, burnishes, and adds drypoint lines,
thereby creating more shadows, defining the
figures, and further enhancing the room's
interior. By the third state Beckmann's con-
centration has focused on the effects of lamp-
light as it both illuminates and casts shadows
on the figures and the room.

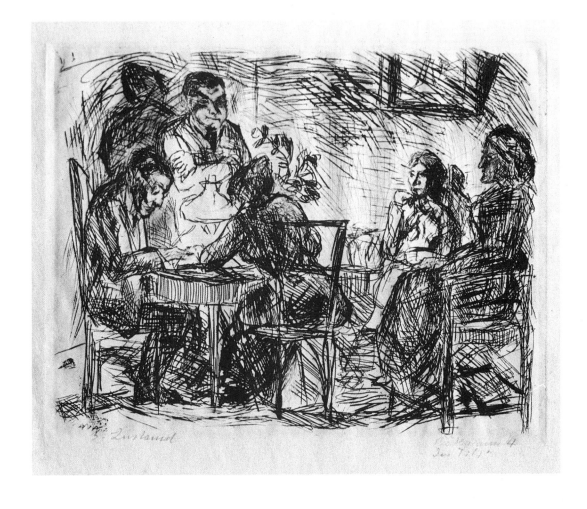

219 Small Self-Portrait 1913

Drypoint; 15.4 x 12.2 cm.
VG 60 II/II; Gallwitz 35; Glaser 54
s.l.r.: Beckmann 12
New York, Private collection

This small and intimate self-portrait demon-
strates Beckmann's ability to work directly onto
the plate as if he were sketching on a sheet of
paper. He creates dramatic shadows in the eyes
and to the right of the face by utilizing the burr
of the drypoint. The plate was cut down in the
second state (originally 25 x 20 cm.), intensify-
ing its impact.

220 The "Millions" Bridge 1914

Drypoint; 16 x 21.8 cm.
VG 68 proof; Gallwitz 47; Glaser 63
s.l.r.: Beckmann; s.l.l.: Millionenbrücke
(Handprobedruck)
Munich, Staatliche Graphische Sammlung

Beckmann's earliest cityscape print depicts the
Swinemünder Bridge in Berlin. Berliners came
to refer to it as *The "Millions" Bridge* because
of the extremely high construction costs.

This print relates closely to the painting,
View of the Gesundbrunnen Station, 1914 (fig.
p. 95), however, the view is reversed here and
the foreground figures have been eliminated.
The Himmelfahrtskirche seen in the back-
ground of both print and painting was des-
troyed in World War II.

Beckmann did ten additional cityscape prints
during the seven-year period from 1917-1923

millionenbrücke (Swinemünderbrücke) Beckmann

222 Self-Portrait 1914

Drypoint; 24 x 17.8cm.
VG 72 II/II trial proof; Gallwitz 51; Glaser 67
S.L.R.: Beckmann
New York, The Museum of Modern Art,
Gift of Paul J. Sachs

In contrast to *Small Self-Portrait* of the previous year, Beckmann has brought his face closer to the picture plane in this self-portrait. More attention has been given to the delineation of his features, particularly the eyes. He no longer portrays himself as a sophisticated, young artist directly engaging the viewer as in the self-portrait of 1904 (cat. 212). Rather we now see the artist's head turned slightly to the left in three-quarter profile, which strikes a very intense and imposing presence.

when he lived in Frankfurt. In most cases, he depicted those views he could see from his studio window or on his daily walks. Beckmann surely must have passed by this scene often, since the Gesundbrunnen Station was on the route he travelled to and from his home in the Berlin suburb of Hermsdorf.

Although this print was never published and is known in only several proofs, Hofmaier notes an impression inscribed "Modelldruck 2—Zustand," (Private collection) which he feels indicates that Beckmann had contemplated an edition.

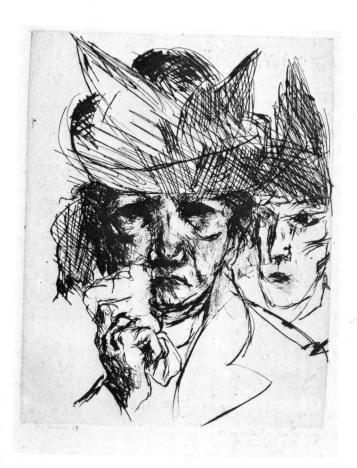

221 Weeping Woman 1914

Drypoint; 24.8 x 19.7cm.
VG 70 III/IV trial proof; Gallwitz 49; Glaser 65
S.L.L.: Beckmann 14; inscribed
L.R. a dedication: Weihnachten 1915
Frankfurt a.M.,
Städtische Galerie im Städelschen Kunstinstitut

In the later states of this print Beckmann has burnished away heavy drypoint lines in the face and hat of the foreground figure, the hat of the background figure, and in the background to the left. Major emphasis has been given to the changed facial features of the foreground figure, where he drastically altered the eyes, cheekbones, and chin. Here the woman's features are more delicately defined, her face is more oval, and it recedes slightly into the background.

Perhaps the woman's tears are a reaction to Germany's declaration of war, a theme Beckmann depicted in another print of that year (cat. 224). The woman is sometimes identified as Frau Tube, Beckmann's first mother-in-law, whose son Martin was killed in battle in October 1914 (cf. cat. 223).

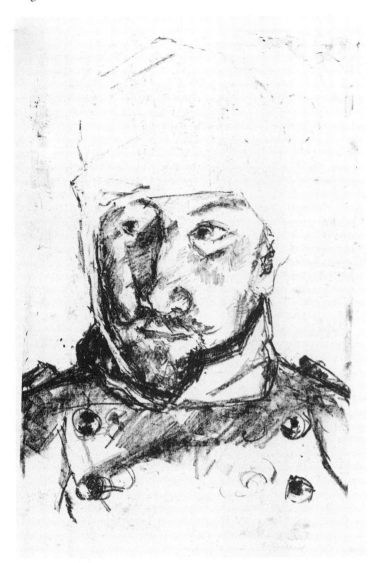

223 Portrait of his Wounded Brother-in-Law, Martin Tube 1914

Lithograph; 30.3 x 25.1 cm.
VG 74 I/VII proof; Gallwitz 53; Glaser 69
S.L.L.: I Zustand
New York, Private collection

This lithographic portrait of Martin Tube conveys Beckmann's warm feelings toward his brother-in-law not only in the compassionate rendering of his fallen friend but in the inscription on the final state. It appeared in *Kriegszeit,* "Künstlerflugblätter," (*War Time,* "Artists' Handbills," No. 11, November 4, 1914, p. 4), a patriotic publication supportive of the war. The publication appeared between August 31, 1914 and late March 1916, and was edited and published by Paul Cassirer, Berlin. The magazine included brief texts, poems, and illustrations by artists such as Ernst Barlach, Käthe Kollwitz, and Max Liebermann.

The composition remains basically unchanged except for a few slight additions, until the sixth state when the composition was reduced and the inscription was lithographed on the stone. (A small edition was pulled from this state.) In the seventh and final state, the composition was further reduced and the abridged inscription type-printed along the bottom. The inscription reads: "In memory of a fallen Friend/Martin Tube, Captain and Company Head in Infantry Regiment 59/ Wounded at Tennenberg in August. Fallen at Ivangorod on October 11."

224 Declaration of War 1914

Drypoint; 20 x 24.9 cm.
VG 76 III/III trial proof; Gallwitz 57; Glaser 73
S.L.L.: Die Kriegserklärung (Probedruck)
S.L.R.: Beckmann
Private collection
Reference: Wiese, 1978, p. 169 ff.

The tight composition of this print focuses on the people's response as they huddle around the newspaper which announces Germany's declaration of war. Their reactions range from indifference through curiosity to perplexity.

Declaration of War is probably related to a group of sketches Beckmann did of the crowds gathered outside the Kronprinzenpalais in Berlin in early August 1914 as they awaited the government's decision of war.

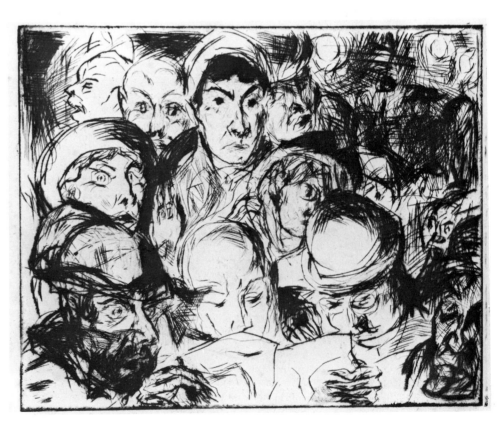

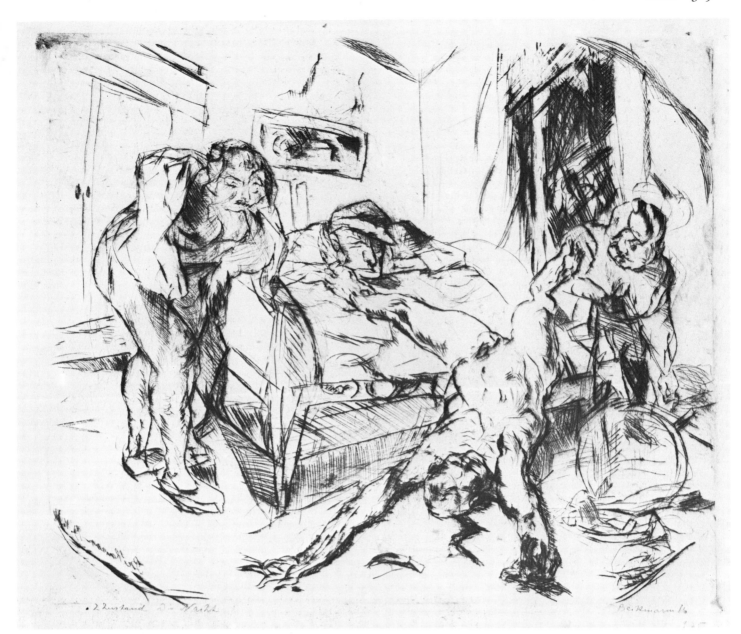

225 The Night 1914

Drypoint; 22.5 x 27.5 cm.
VG 75 III/V trial proof; Gallwitz 54; Glaser 70
S.L.R.: Beckmann 16
S.L.L.: 2. Zustand (sic) Die Nacht
In plate L.L. in reverse: Beckmann 19.4.16
New York, The Museum of Modern Art, Purchase Fund

References: Braunbehrens, p. 26; Wiese, 1978, p. 154 ff.

While scenes of death are apparent in Beckmann's previous work, they have been within a Biblical or mythological context. However, the events of *The Night* appear to have occurred within the realm of everyday life, in this instance, a brothel. There is evidence of a struggle, and the body of a dead man lies half on the bed and half on the floor. Blood is streaming from his skull and a knife lies near the body. Two nude women and one man, who appears to be clothed, huddle around the corpse.

The figures may have been witness to a murder, although it is more likely that they are active participants. Beckmann has titled the print as both *The Night* and *Death*, thus providing the only clues. In the final states, this print appeared in the 1918 Marées Gesellschaft publication of *Shakespeare-Visionen: Eine Huldigung deutscher Künstler* (Shakespearean Visions: A Tribute by German Artists), a portfolio containing the prints of 28 artists.

Unlike most of these prints, Beckmann's contribution does not refer to a specific Shakespearean incident. Rather, Julius Meier-Graefe, editor of the portfolio, felt that Beckmann's print evoked a Shakespearean mood. He wrote in an unpublished letter to Beckmann, dated March 11, 1918, "This is the Shakespeare of which I dreamed for this portfolio."

Beckmann made significant changes while reworking the composition. In the second state (the earliest known state) (cf. repr. Gallwitz 54a), traces of two figures are noticeable: the head of one at upper left and the upper body of another directly behind the crouching center figure. In the third state, he redefines some of the figures and interior details and adds a second female figure on the right.

It has been suggested that *The Night* is connected to an event Beckmann encountered while in Hamburg in 1912, where he would frequent the harbor taverns. Although the print dates two years after Beckmann's visit, there are two drawings from this period which indicate Beckmann's initial thoughts for the composition (von Wiese 101, 102). In addition, two prints of Hamburg prostitution scenes were completed in 1912 (VG 37, 50).

Von Wiese suggests two prints which may have served as models for Beckmann's composition. The first is Honoré Daumier's famous lithograph, *Rue Transnonain*, 1834, which illustrates an interior scene of dead bodies murdered in the night. The second is William Hogarth's print, *The Idle 'Prentice betray'd by his Whore and taken in a Night Cellar with his Accomplice,* 1747. Hogarth's print not only furnished Beckmann with figural types from brothel scenes, but also provided compositional elements, especially the figure of the body being lowered into the cellar.

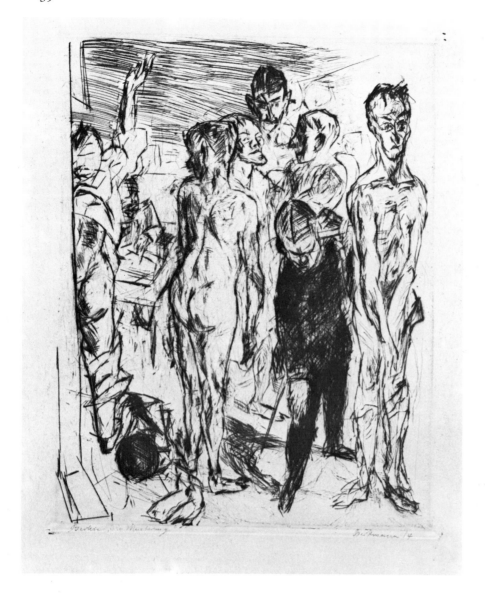

226 Inspection 1914
Drypoint; 29.6 x 23.7 cm.
VG 77 III/III, trial proof; Gallwitz 58; Glaser 74
S.L.L.: Berlin "Die Musterung"
S.L.R.: Beckmann 14
New York. Private collection

In this print Beckmann depicts newly recruited soldiers receiving their medical examinations, a theme he repeated in a drawing entitled *Inspection* II, 1944 (Bielefeld 165). While the 1914 print presents the scene with compassion and dignity, the drawing satirizes the event, in which the old and infirm are subjected to the humiliation of conscription. Surprising in the earlier variant of the theme is the critical attitude, which contradicts the always-cited war enthusiasm of the artist.

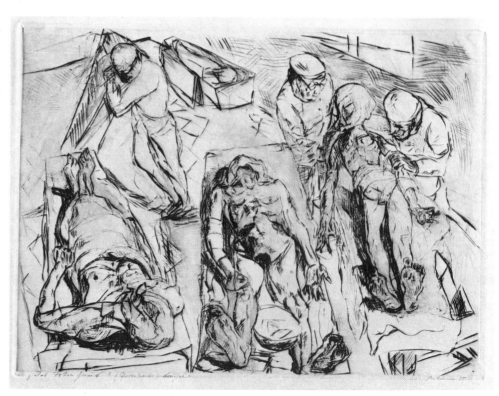

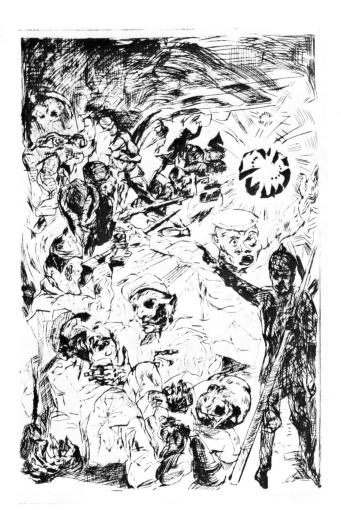

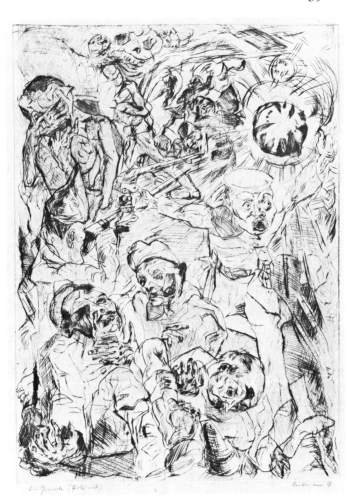

Max Beckmann:
The Grenade, 1915
Drypoint (VG 78 III/IV)
Frankfurt a. M., Städtische Galerie
im Städelschen Kunstinstitut

227 Morgue 1915

Drypoint; 25.9 x 35.9cm.
VG 81 III/IV proof; Gallwitz 59; Glaser 75
S.L.L.: Das Totenhaus (Probedruck) Brüssel
S.L.R.: Beckmann 15
New York, Private collection

Beckmann's experience as a medical corpsman
is reflected in this sobering depiction of a
morgue in which bodies are laid out on tables
and in coffins. The death of the individual
becomes an anonymous miserable experience,
far from the heroic view.

Beckmann repeated this composition in a
woodcut *Morgue,* 1922 (cat. 286). There are
also two related drawings which appear to be
studies for the figures on the left and in the
center (von Wiese 285, 296).

228 The Grenade 1915

Drypoint; 38.6 x 28.9cm.
VG 78 IV/IV trial proof; Gallwitz 62; Glaser 78
S.L.L.: Die Granate (Probedruck)
S.L.R.: Beckmann 15
Perry T. Rathbone,
Reference: Vogler, 1973, p. 16.

Beckmann's depiction of an exploding grenade
conveys the destructive effect of this event by
utilizing powerful pictorial means. The radiant
light of the exploding globe bursts forth from
the dense composition, propelling the fleeing
soldier forward. The agitated, scratchy strokes
heighten the sense of confusion and chaos. The
figural arrangement is complex and ambigu-
ous, allowing us to view simultaneously the sol-
dier's actions and reactions to the devastation
surrounding them.

Beckmann worked this print through four
states over a period of time. In the first three
states he included the figure of a crusading sol-
dier in the lower right corner (cf. illustration).
The final version, however, shows no such
figure, perhaps indicating Beckmann's
changed attitude towards war: that "war pro-
duces no crusaders, German or otherwise..."

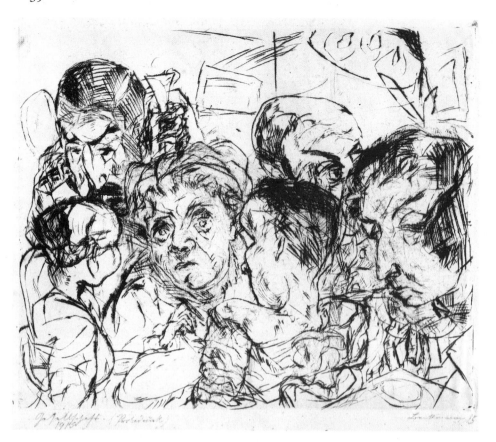

229 Party 1915

Drypoint; 26 x 32 cm.
VG 84 III/IV trial proof; Gallwitz 63; Glaser 79
s.l.l.: Gesellschaft (Probedruck)/1915
s.l.r.: Beckmann 15
Private collection
Reference: Göpel, 1976, I, p. 134.

In this print Beckmann depicts an evening party at the Battenbergs. From left to right we see Klara, the Battenberg's servant; Major von Braunbehrens, Lili's father; Fridel Battenberg; Lili von Braunbehrens, whose back is turned; Ugi Battenberg; and Wanda von Braunbehrens, Lili's mother.

The Battenbergs appear often in Beckmann's work. Lili von Braunbehrens, a poet, collaborated with Beckmann on the *City Night* portfolio, 1920 (cat. 258, 259). Her father presided on the induction board and was influential in obtaining for Beckmann a release from his duties as volunteer to the medical corps. Klara also appears again in Beckmann's work (Göpel 192, VG 84, 116). Beckmann painted *Company* III. *Family Battenberg* in the same year (fig. p. 58).

230 Lovers I 1916, plate 4 of *Faces*

Drypoint; 23.8 x 30 cm.
VG 86 III/III trial proof; Gallwitz 65; Glaser 81
s.l.l.: Im Bordell; s.l.r.: Beckmann 17
New York, Private collection
Reference: Vogler, 1973, p. 18 ff.

The *Faces* portfolio, published in 1919, included 19 drypoints which were done from about 1915 to 1918. The prints were not organized chronologically, but, as Richard A. Vogler suggests, the selected sequence may form a visual narrative.

Lovers I, sometimes called "The Brothel," reveals a nude couple in bed. Beside the bed lies a tiger skin rug, the head of which appears slightly raised to engage the viewer. The animal's head is the only sign of life, for the lovers are both lost in sleep. Perhaps Beckmann is using the tiger rug as a symbol for animal lust and the dissatisfaction of bought love. Beckmann repeated this theme several times in prints *Lovers,* 1916 (VG 99), and *Lovers* II, 1918 (VG 124).

Technically this print demonstrates a similarity in execution with *The Night* (cat. 225), *Inspection* (cat. 226), and *Party* (cat. 229). In each case the plate has a very scratchy surface, revealing indications of earlier compositions. Beckmann utilizes the same agitated, quick, sketch-like strokes to lay in his composition. In *Lovers* I we see how Beckmann has repositioned the woman's left leg and moved the male figure further to the right.

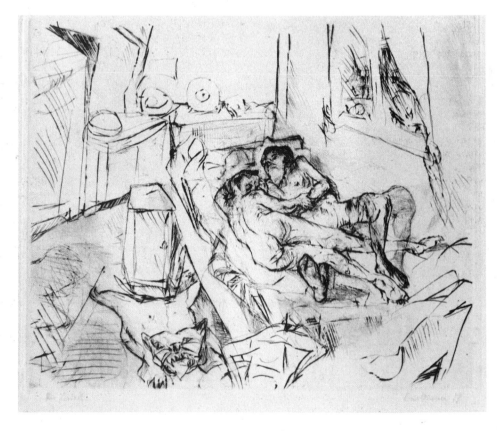

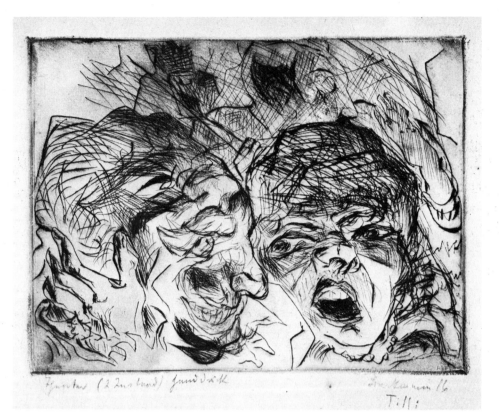

231 Theater 1916, plate 8 of *Faces*
Drypoint; 13.1 x 18.1 cm.
VG 87 II/III proof; Gallwitz 66; Glaser 83
S.L.L.: Theater (2. Zustand) Handdruck
S.L.R.: Beckmann 16
Frankfurt a.M.,
Städtische Galerie im Städelschen Kunstinstitut

Beckmann has depicted a scene from Giuseppe Verdi's opera, *Rigoletto,* in this print. We see Rigoletto, the court fool of the Duke of Mantua, and his daughter Gilda, who has fallen in love with the Duke against her father's wishes.

The scene is presented as though we are sitting in the audience just below the stage. The faces are dramatically lit from below, accentuating and distorting their expressions. In the background is the partially obscured figure of the conductor, who bears a strong resemblance to Beckmann's friend, Ugi Battenberg.

232 Evening (Self-Portrait with Battenbergs) 1916, plate 10 of *Faces*
Drypoint; 24 x 17.9 cm.
VG 88 II/IV proof; Gallwitz 67; Glaser 84
S.L.L.: Der Abend (Probedruck)
S.L.R.: Beckmann 16
Zürich, Kunsthaus

Many of Beckmann's evenings with the Battenbergs were probably spent with friends in informal gatherings like the one shown here. The compressed space of this print, as seen from above, accommodates the figures of Fridel and Ugi Battenberg, Beckmann and, at the far right, a figure who looks like Walter Carl, Fridel Battenberg's brother (cf. Göpel 199).

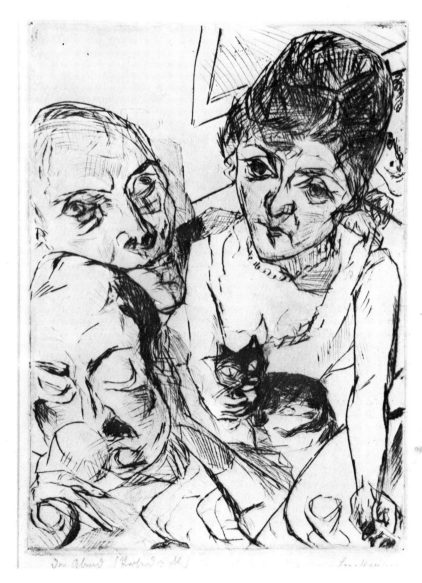

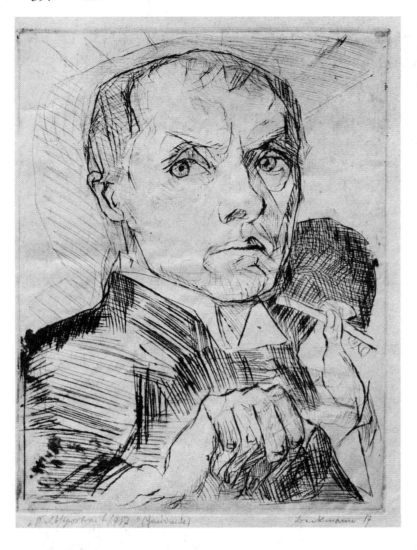

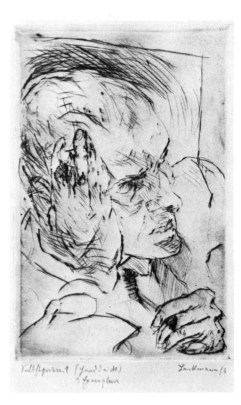

233 Self-Portrait with Stylus 1917, plate 19 of *Faces*

Drypoint; 29.6 x 23.6cm.
VG 103 II/III proof; Gallwitz 82; Glaser 82
S.L.L.: Selbstportrait 1917 (Handdruck)
S.L.R.: Beckmann 17
New York, Private collection

Beckmann created this striking self-portrait by combining long parallel strokes with areas of crosshatching, thus breaking up the surface of the print and creating a vibrant sense of energy and movement. The artist is seen holding a drypoint stylus as he prepares to work on a plate. The cast shadows indicated in the background suggest a lamplit evening. This print is plate 19 of the *Faces* portfolio, and not the first plate as Gallwitz indicated.

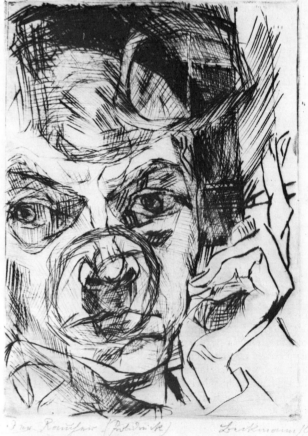

234 Self-Portrait, Hand to Cheek 1916

Drypoint with graphite additions; 17.8 x 12.1 cm.
VG 98 II/II proof; Gallwitz 77; Glaser 105a
s.l.l.: Selbstportrait (Handdruck)/3 Exemplare
s.l.r.: Beckmann 16
New York, Private collection

This is an unpublished self-portrait, known in only four impressions. Pencil additions are found in the right eye and along the right cheek and printed with a thin layer of plate tone.

Unlike most of Beckmann's self-portraits, this print does not show him engaging the viewer directly. Rather, we see him in three-quarter profile with his head resting on his right hand, recalling an air of relaxed sophistication seen in prints by Lovis Corinth and Max Liebermann rather than those by Ernst Ludwig Kirchner or Erich Heckel.

Compared with the 1914 self-portrait (cat. 222), the lines are more fluid and there is less cross-hatching. The print recalls the self-portrait of 1913 (cat. 219), in the way that Beckmann effectively integrates the barbs of the drypoint lines into the composition.

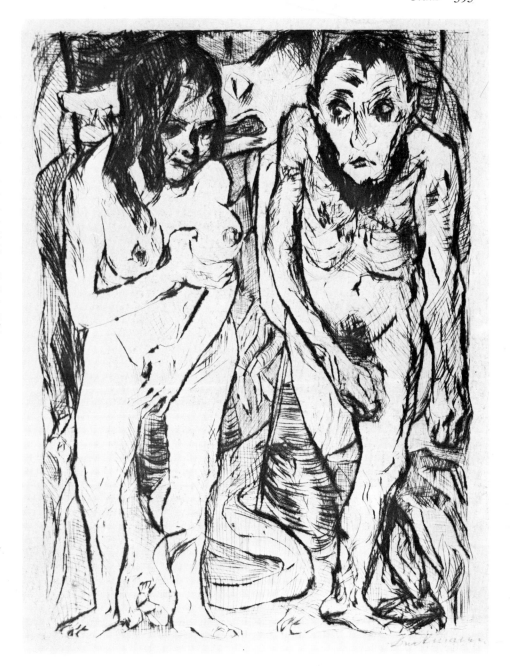

235 The Smoker (Self-Portrait) 1916

Drypoint; 17.5 x 12.5 cm.
VG 96 II/III proof; Gallwitz 81; Glaser 92
s.l.l.: Der Raucher (Probedruck)
s.l.r.: Beckmann 16
Frankfurt a.M., Heinz Friederichs

Executed in the same year as *Self-Portrait, Hand to Cheek* (cat. 234) this print, despite a close-up view, turns its subject face front with a downward gaze, still self-absorbed. Careful scrutinization is given the elegant gesture of his left hand. The smoke rings as they pass before his face mediate the situation of inner detachment in which the elegant hand gesture displays a definite life of its own.

This impression is the only known example of this state. The significant change in the final state is the addition of a smoke ring in front of Beckmann's bent fingers.

236 Adam and Eve 1917

Drypoint; 23.7 x 17.5 cm.
VG 108 III/III; Gallwitz 88; Glaser 100
s.l.r.: Beckmann
New York, Private collection

In addition to this print and one other (VG 369), Beckmann chose the theme of Adam and Eve for three paintings during his career (cat. 16, 64 and Göpel 67). In the later print, as well as in the paintings of 1907 and 1932, Beckmann portrays the earlier moment before the two have become aware of their own nakedness. However, it is with the 1917 painting (cat. 16) that the print bears its closest association: the figures are reversed and the gesture of Eve offering her breast to Adam in a sexual interpretation of the apple is repeated.

The background is obscured in the print so that the only discernible reference to the Garden of Eden is the menacing serpent that encircles the tree between them. Beckmann has pulled the figures into the immediate foreground, creating a powerful and evocative image by means of tightly controlled, shallow space.

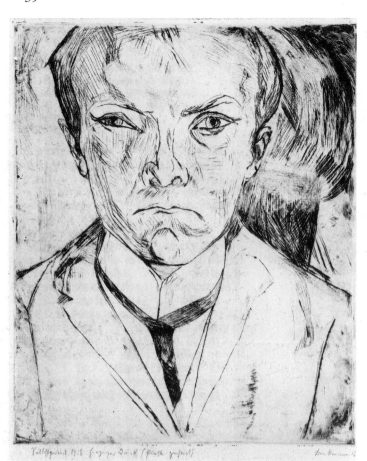

238 Frontal Self-Portrait, House Gable in Background 1918

Drypoint; 30.5 x 25.6 cm.
VG 123 II/IV proof; Gallwitz 96; Glaser 106
S.L.L.: Selbstportrait 1918 Einziger Druck (Platte zerstört) [sic]
S.L.R.: Beckmann 18
Philadelphia, Philadelphia Museum of Art,
Print Club Permanent Collection

Beckmann completed two printed self-portraits in 1918, one of which is included in the exhibition, the other an etched self-portrait. In both prints, he confronts the viewer as a depressive person with an intense gaze and down-turned facial expression. Gallwitz incorrectly listed this print and another (VG 135) as plate 19 of the *Faces* portfolio; actually it is *Self-Portrait with Stylus* (cat. 233).

237 Portrait of Mink 1917

Lithograph; 24.5 x 24.1 cm.
VG 119 II/II proof; Gallwitz 20; not in Glaser
S.L.R.: Beckmann; Annotated lower margin:
Existieren nur 3 Exemplare
Private collection

Minna Beckmann-Tube, Beckmann's first wife, appears countless times in her husband's work. This print had previously been dated ca. 1911 by Gallwitz, but Hofmaier has given it a more appropriate date of 1917, based on its stylistic similarity to another print, entitled *Portrait of Peter* (cat. 240). Both are personal and moving portraits of people very dear to him and, as only a few proofs exist, they were probably never intended for publication.

As Beckmann's first lithographs since 1914, they signal the use of a medium he would turn to more frequently during his career. The painterly quality displayed in the broadly-executed strokes of this print remains unique in Beckmann's oeuvre.

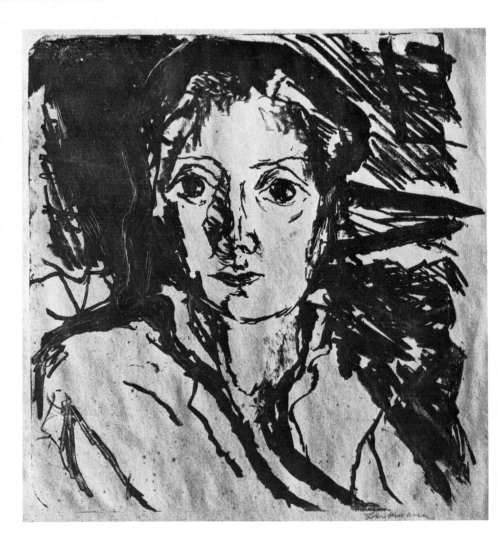

239 Family Scene (Beckmann Family) 1918, plate 2 of *Faces*
Drypoint; 30.6 x 25.9cm.
VG 125 II/II trial proof; Gallwitz 98; Glaser 108
S.L.L.: Familienszene (Probedruck)
S.L.R.: Beckmann 18
Frankfurt a.M.,
Städtische Galerie im Städelschen Kunstinstitut

The family portrait includes Beckmann, his wife, his son, and his mother-in-law. It is strange, yet characteristic of the artist, that a portrait of those to whom Beckmann was closest has none of the figures making eye contact with one another. Frau Tube and Peter look off into space, Minna Beckmann glances down to the book in her lap, and Beckmann himself appears in the background, leaning out of a window with closed eyes.

The composition is placed within a compressed space overlooking a city street from a balcony, which, in an earlier state, might have been an interior scene. The composition is not unlike that seen in *The Yawners*, 1918 (cat. 244), also from *Faces*.

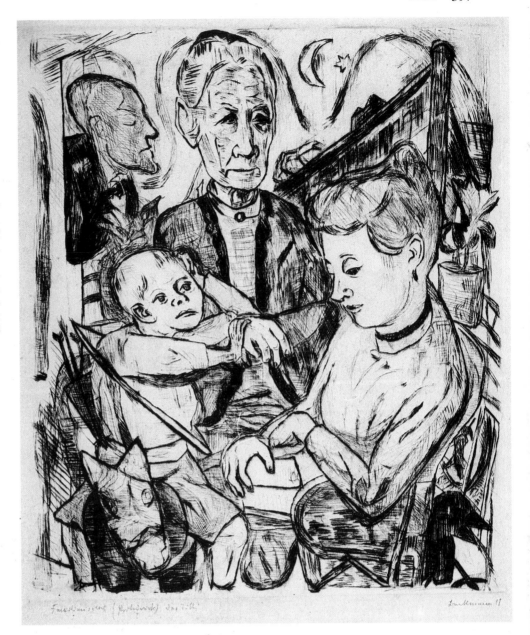

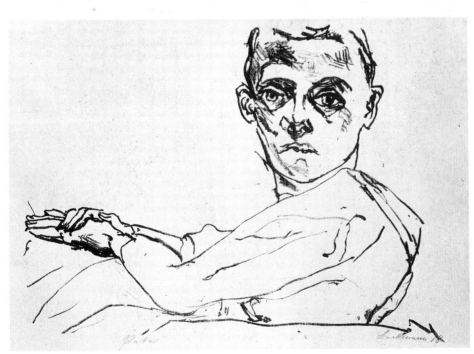

240 Portrait of Peter 1917
Lithograph; 24.3 x 33.2cm.
VG 120 II/II proof; Gallwitz 110; not in Glaser
S.L.L.: Peter
S.L.R.: Beckmann 18
Private collection

Beckmann's only child, Peter, was born in Berlin in 1907. This portrait and the previous one of his wife, Minna (cat. 237), show a similar execution. Stylistically they remain unlike most of his other prints.

This print is reminiscent of artists such as Munch, Klimt, and Schiele, especially in the attentive delineation of the face and hands, while the rest of the body is sketched in outline.

241 Small City View 1917

Drypoint; 15.7 x 20.2 cm.
VG 117 proof; Gallwitz 92; Glaser 104
S.L.L.: Stadtansicht (Handdruck)
S.L.R.: Beckmann 17
R.E.Lewis, Inc.

This is Beckmann's first printed cityscape since *The "Millions" Bridge* (cat. 220). He would do nine additional views, all of Frankfurt, from 1918 to 1923. Here he depicts the Cathedral and the Main River with the Eiserne Steg (Iron Footbridge), which was also represented in a painting (cat. 30) and a related print (VG 242). The vantage point from the lower Main Bridge is very similar to that of a later painting, *Drifting Ice,* 1923 (Göpel 224) and its related drypoint, *City View with Iron Footbridge,* 1923 (VG 286). Beckmann must have drawn the composition directly onto the plate, because it appears in reverse of the actual view.

This is a very rare print that was probably never published and known only in two other impressions. Beckmann pulled a macalature of this print on the lower part of the sheet, which has been trimmed in half.

242 Main River Landscape 1918, plate 6 of *Faces*

Drypoint with pencil additions; 25.1 x 30 cm.
VG 126 II/IV proof; Gallwitz 99; Glaser 109
S.L.L.: Mainlandschaft (Handprobedruck zweiter Zustand)
S.L.R.: Beckmann 18
St. Louis, Fielding Lewis Holmes

As a view from the Lower Main Bridge (Untermainbrücke) towards Sachsenhausen, the print shows the area of Frankfurt in which Beckmann lived. In the upper right is the dome of the Städel Museum, while the Peace Bridge (Friedensbrücke) is in the background. The Lower Main Bridge leads to the Schweizer Strasse where, at number 3, Beckmann had his studio.

Beckmann drew directly onto the plate, so the scene appears in reverse. His quick, sketch-like lines indicate the flowing, swirling motion of the waters, which is repeated in the delineation of the clouds above. While not filled with a great number of figures and ships, this panoramic view of the Main and its busy shores is instilled with energy and vitality.

Beckmann did two preparatory drawings for this print entitled *Main River Landscape* I, (cat. 153) and *Main River Landscape* II, 1918 (von Wiese 409). The first drawing, executed in greater detail, displays a broader view than both the second drawing and the print, and perhaps was done on the site. The second drawing reveals a tighter, compressed space, and the indications of the trees and buildings along the embankment are less detailed. In the second drawing Beckmann includes additional boats and figures on the river, which then appear in the print.

243 Landscape with Balloon 1918, plate 14 of *Faces*

Drypoint; 23.3 x 29.5 cm.
VG 132 II/II; Gallwitz 105; Glaser 115
S.L.R.: Beckmann
Private collection

Göpel suggests that the street depicted is the Darmstädter Landstrasse in the Sachsenhausen section of Frankfurt, which had an airport for airplanes and balloons by the end of World War I. In the print Beckmann has added the sun/moon element as well as the flagpoles extending from the building facades. The print repeats in reverse the painting, *Landscape with Balloon,* 1917 (Göpel 195). The general mood of the painting is one of a quiet, peaceful neighborhood, while the print, with its sharp, crisp lines, conveys great motion.

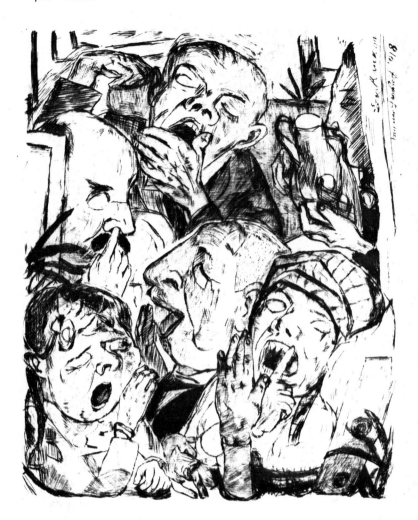

244 The Yawners 1918, plate 7 of *Faces*

Drypoint; 30.8 x 25.5 cm.
VG 127 V/v trial proof; Gallwitz 100; Glaser 110
S.L.L.: Die Gähnenden (Probedruck) gehört mir
S.L.R.: Beckmann 18
Zürich, Kunsthaus

In *The Yawners,* the artist portrays himself and his friends yawning in boredom with the world, society, and life in general. Beckmann appears in the upper center, along with Ugi Battenberg, shown with his eyes closed and gesturing to his nose, and probably Fridel Battenberg, below him. Even Fridel's cat, at the bottom, reflects the overall ennui of the group. The only figure who does not share in this ennui is the servant, busily carrying in a tray with pitcher and glasses.

The composition is similar to that seen in Beckmann's prints of *Evening,* 1916 (cat. 232) and *Family Scene,* 1918 (cat. 239), in which he creates a very tightly compressed space with no indication of perspective and with limited indication of interior setting. As all the prominent figures' eyes are closed, Beckmann focuses his attention on the patterning of their hands, which acts as a unifying element in the composition.

245 Theater Box 1918

Drypoint; 29.8 x 24 cm.
VG 136 II/II trial proof; Gallwitz 109; Glaser 118
S.L.L.: Theater (Probehanddruck)
S.L.R.: Beckmann 18
inscribed on the plate in reverse L.C.: An Frau Tube
Mr. and Mrs. Paul L. McCormick

As Minna Beckmann-Tube sits in a theater box, an unidentified male figure, similar to a figure in *Christ and the Woman Taken in Adultery* (cat. 18), leans over her shoulder at left. The choice of location for Minna points indirectly to her connections with opera and the stage.

Beckmann has focused all his attention on Minna in this print and has cropped the composition to include only her box. He relieves the very tightly constructed space by having her left elbow descend out of the composition to rest on the balustrade.

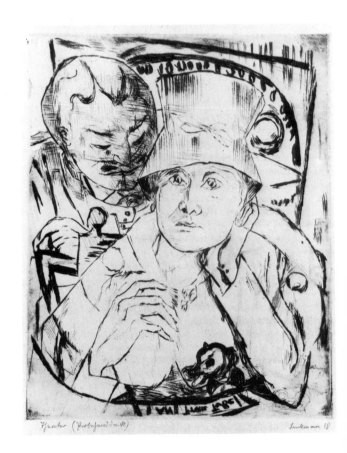

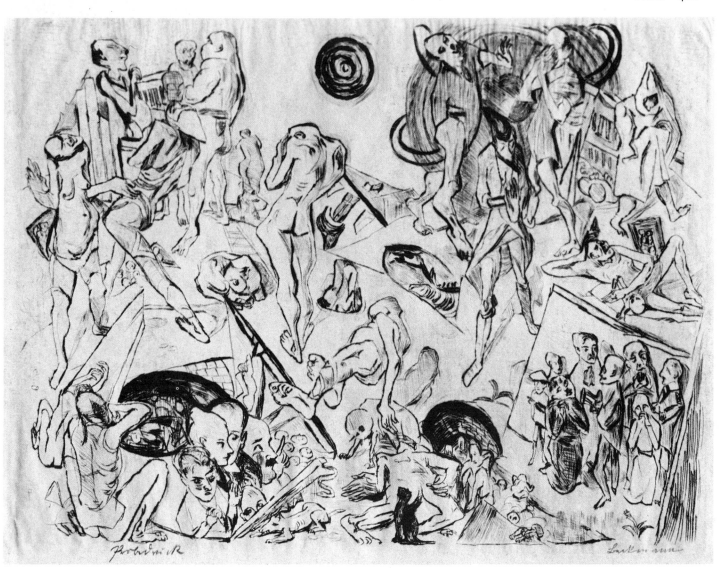

246 Resurrection 1918,
plate 12 of *Faces*

Drypoint; 24 x 33.2 cm.
VG 130 III/III trial proof; Gallwitz 103; Glaser 113
S.L.L.: Probedruck
S.L.R.: Beckmann
New York, Private collection

This print is directly related to Beckmann's
painting of *Resurrection* (fig., p. 83), which was
begun in 1916 and was never completed. The
image, when printed, appears in reverse of the
painting and includes additions not incorpo-
rated into the original composition.

Three related drawings exist for this compo-
sition. Two studies date from 1914 (von
Wiese 204, 205) and probably reflect Beck-
mann's initial ideas for the painting. The third
drawing, dated 1918 (von Wiese 390), bears a
much closer resemblance to the present state of
the painting, but includes details not seen
either in the painting or the print.

Two prints from *The Princess* (VG 110, 113)
repeat details from the *Resurrection*. The first
one shows the floating, horizontal resurrected
soul in reverse as it appears in the 1918 drawing
and the painting. The second print shows
Beckmann, his wife Minna, and two additional
unidentified figures.

247

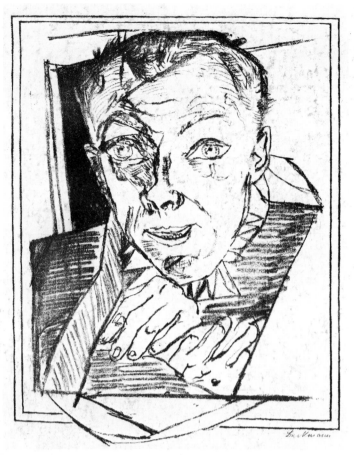

247-257 Hell 1919

Transfer lithographs; title page 37.1 x 27 cm.
VG 137-147; Gallwitz 113-123; Glaser 121-131
Each sheet is signed, numbered (11/75) and titled by
the artist along the lower margin.
Private collection

247	Title page – Self-Portrait	37.1 x 27.0 cm.
248	Plate 1 The Way Home	73.3 x 48.8 cm.
249	Plate 2 The Street	67.3 x 53.5 cm.
250	Plate 3 Martyrdom	54.5 x 75.0 cm.
251	Plate 4 Hunger	62.0 x 49.8 cm.
252	Plate 5 The Ideologists	71.3 x 50.6 cm.
253	Plate 6 The Night	55.6 x 70.3 cm.
254	Plate 7 Malepartus	69.0 x 42.2 cm.
255	Plate 8 The Patriotic Song	77.5 x 54.5 cm.
256	Plate 9 The Last Ones	75.8 x 46.0 cm.
257	Plate 10 The Family	76.0 x 46.5 cm.

Only Plates 1, 2, 3, and 7 will be seen in the United
States. They are from a private collection in New
York.

The portfolio *Hell,* like the painting *The Night*
(cat. 19), considers the social, economic, and
political situation in postwar Germany and pre-
sents them as a metaphor for the paradox of
life.

The underlying tone of this portfolio is one
of perplexity, introduced in the title print by
the artist's terrified and visionary glance. Hell
is found on the streets and in the houses.
Wounded veterans reinforce the horrifying
reality of war in the nocturnal city, as Beck-
mann stops to ask directions from a disabled
soldier. *The Street* and *Martyrdom* are directly
related to the November Revolution and the

248

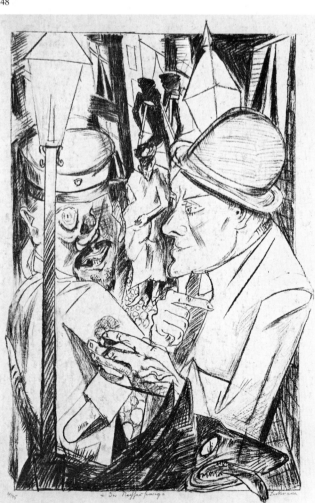

249

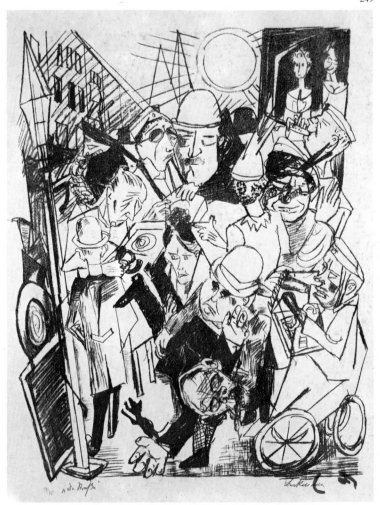

250

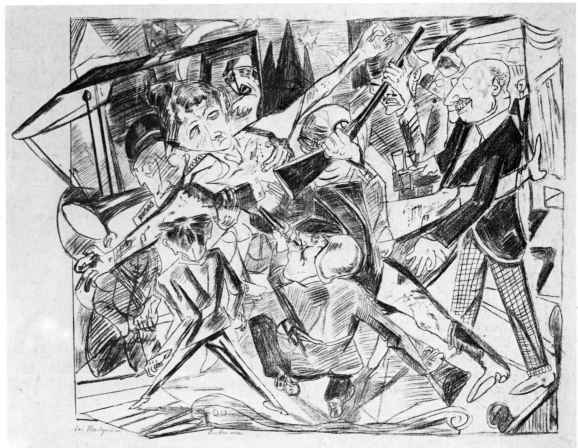

251

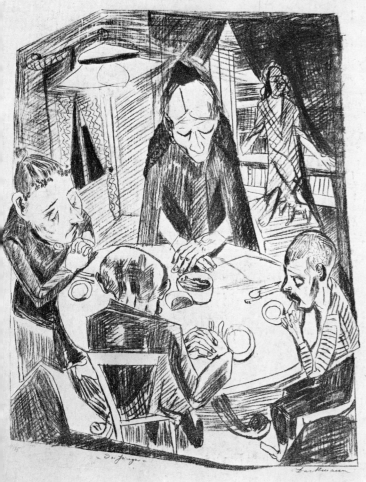

252

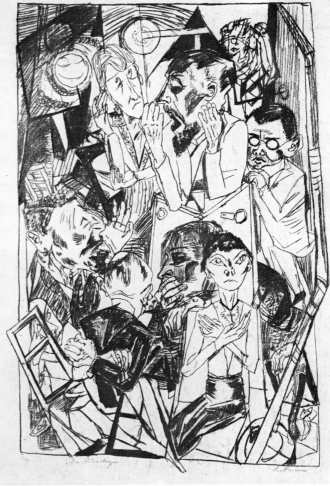

253

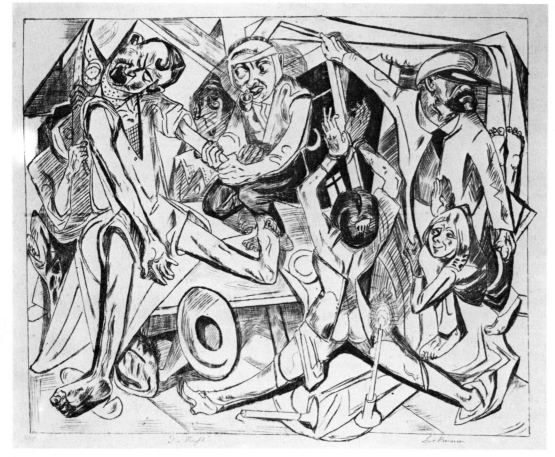

254

255

murders of Karl Liebknecht and Rosa Luxemburg. Beckmann has given religious significance to these political deaths. The woman's figure (cat. 250) portrays the traditional posture of one crucified.

Misery and cruelty are to be found in the private sphere as well. *Hunger* establishes itself not only at the family's table through the meagerness of the dinner in their humble surroundings, but also through the looseness of the picture's structure and the avoidance of any clean, strong lines. *The Night*, which repeats the essential characteristics of the 1918/19 painting, (cat. 19) represents the victim and the perpetrator, both of them equally representative of senselessness and brutality.

The prints *The Ideologists, Malepartus, The Patriotic Song,* and *The Last Ones* portray differing forms of self-bewilderment and delusion, whether in fantasy, ecstasy, or mindless patriotism. The series ends with *The Family,* in which a childish game of war juxtaposed to the shock of experienced adults results in a soothing, protected equilibrium. (For the biographical background of the scene, see Peter Beckmann's essay in this catalogue.)

Original transfer drawings exist for the following seven prints: *The Street* (von Wiese 411); *Martyrdom* (cat. 158); *The Ideologists* (von Wiese 413); *Malepartus* (von Wiese 414); *Patriotic Song* (von Wiese 415); *The Last Ones*

(von Wiese 416); and *The Family* (von Wiese 417). In addition, there exists an alternative drawing for *The Last Ones* (von Wiese 418).

Except for a few changes, *The Night* reproduces the painting of the same name which was completed in 1919 (cat. 19). The figure of Frau Tube in plate 10 is very similar to a painting entitled *Portrait of Frau Tube,* 1919 (Göpel 201). The portrait of Peter Beckmann in the same print, closely resembles *Peter with Hand Grenades,* 1919, a drawing which originally was catalogued as a print. (Gallwitz 128, fig. p. 13).

256

257

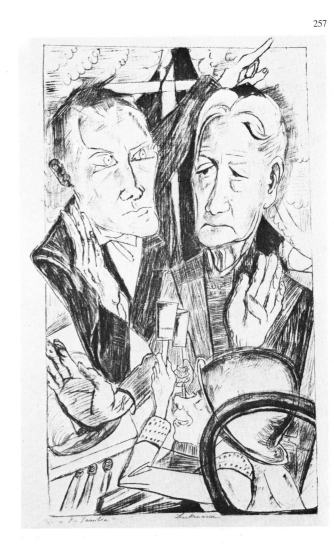

258 Drinking Song 1920,
plate 1 from *City Night*

Transfer lithograph; 19 x 16.7 cm.
VG 163 II/III proof; Gallwitz 136; Glaser 142
S.L.L.: Probedruck zur Stadtnacht
S.L.R.: Beckmann 20
New York, Private collection

259 City Night 1920,
plate 2 from *City Night*

Transfer lithograph; 19 x 15.3 cm.
VG 164 I/II proof; Gallwitz 137; Glaser 143
S.L.L.: Probedruck zur Stadtnacht
S.L.R.: Beckmann
New York, Private collection

These two prints are part of a portfolio of six lithographs plus a title page which were done as illustrations for the poems of Lili von Braunbehrens (cf. cat. 229). The poems deal with contemporary life in Frankfurt, particularly the lives of the lower classes. Beckmann's prints follow von Braunbehrens's poems quite closely.

In *Drinking Song* four men, not unlike George Grosz's burgher-types, are seated around a table enjoying an evening of food and drink. A fifth must already have succumbed, since only his feet raised high in the air are visible. Beckmann has drawn a border around the composition, visually reinforcing the sense of confinement.

City Night, the title poem, illustrates a brothel scene. One man is seated at a table with two women. In the background, the second man, with his back to us, turns to reveal a disturbing face with an eyepatch. A third man has consumed his fill and lies on the floor. In both sheets the compositional arrangement results in a sense of claustrophobia and restriction, thereby strengthening the enigmatic and ominous atmosphere of the grotesque scenario.

260 Christmas 1919

Drypoint; 17.7 x 23.7 cm.
VG 153 II/II trial proof; Gallwitz 126; Glaser 134
S.L.L.: Probedruck (Weihnachten 19)
S.L.R.: Beckmann
S.L.C. in the plate in reverse: Weihnachten 1919
New York, Private collection

This print and the *Large Self-Portrait* (cat. 261) were probably done in Berlin when Beckmann might have gone to visit his family over the holidays. *Christmas* carries on Beckmann's thematic interest in cafés and is reminiscent of his earlier lithograph, *Admiralscafé,* 1911 (cat. 217). But in the intervening years, Beckmann's technique as well as means of expression have changed significantly. Where the earlier work has a clearly defined space and figures modeled in a more traditional manner, the space in *Christmas* is foreshortened and compressed, and the figures are angular and distorted.

The central figure is a blind cripple holding a cane who stands before a seated couple at the left. The man, probably a war veteran, gropes and begs his way through a restaurant in which only the nouveau-riche are in evidence. Beckmann's reworking of the plate is still visible, especially in the alteration of the blind man's right and left hands, creating a sense of movement, which may or may not be intended to accentuate the helplessness of the invalid.

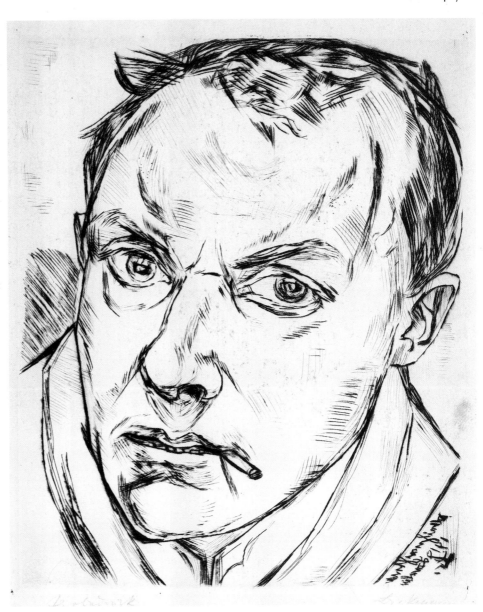

261 Large Self-Portrait 1919

Drypoint; 23.7 x 19.7 cm.
VG 151 trial proof; Gallwitz 124; Glaser 132
S.L.L.: Probedruck
S.L.R.: Beckmann; S.L.R. in the plate in reverse: Weihnachten/1919 Berlin/B.
Brooklyn, The Brooklyn Museum

Beckmann confronts the viewer directly here, not only with his intensely piercing gaze, but also by the extreme foreshortening. His head takes up almost the entire plate. Heavy and broad drypoint lines outline the figure and delineate the features in this dramatic and brooding portrait.

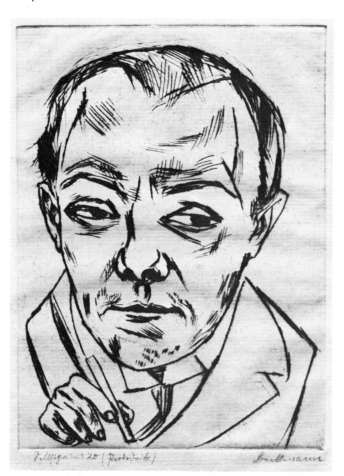

262 Self-Portrait 1920

Drypoint; 19.6 x 14.6cm.
VG 170 II/II trial proof; Gallwitz 144; Glaser 150
S.L.L.: Selbstportrait 20 (Probedruck)
S.L.R.: Beckmann
New York, Private collection

Compared to Beckmann's larger self-portrait of 1919 (cat. 261), this work does not convey the same intensity. His glance is downward here, and there is no confrontation with the viewer. However, Beckmann's compressed space and the scrutinization of his facial features are still evident. In his right hand he holds what appears to be a drypoint stylus as in *Self-Portrait with Stylus,* 1917 (cat. 233).

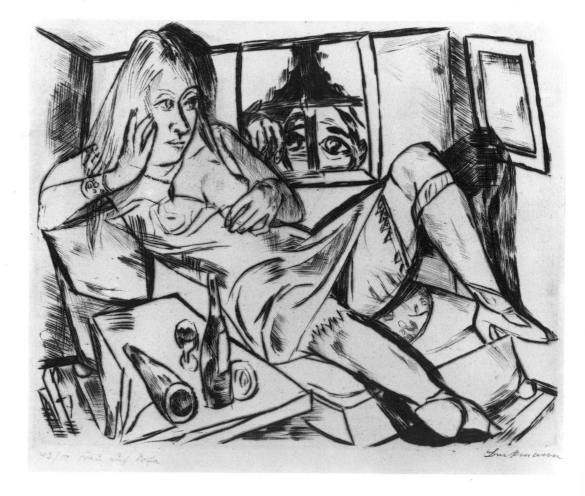

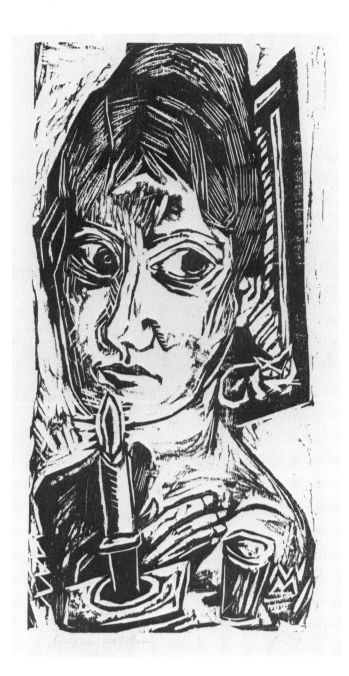

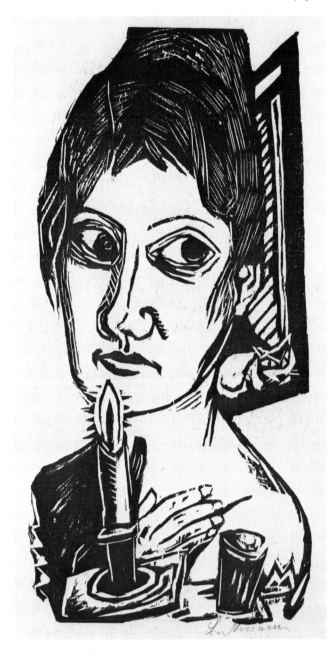

263 Woman in the Night 1920
Drypoint; 24.7 x 31.9 cm.
VG 173 II/II; Gallwitz 147; Glaser 153
S.L.L.: 42/50 Frau auf Sofa
S.L.R.: Beckmann
Portland, Portland Art Museum, The Vivian and
Gordon Gilkey Graphic Arts Collection

Given the oppresive view of *Woman in the Night*, the scene could be one of a bordello or a haunting dream. A woman suggestively posed in an open dress reclines on a sofa. On a table to the left are two bottles of wine, one empty, and two glasses. In the background a man is seen tapping on the window to attract her attention. The shadows create a dense and simultaneously uncomfortable atmosphere.

In this relatively small print, the woman takes on monumental proportions. Her reclining figure fills the entire space from the upper left corner to lower right. Beckmann repeats a similar image in two later prints: *Seduction*, 1923 (cat. 289) and *Siesta*, 1923 (VG 279).

264 Woman with Candle 1920
Woodcut; 30.3 x 15.3 cm.
VG 169 I/III proof; Gallwitz 143; Glaser 149
S.L.L.: Handprobedruck 1. Zustand
S.L.R.: Beckmann
St. Louis, The Saint Louis Art Museum

265 Woman with Candle 1920
Woodcut; 30.3 x 15.3 cm.
VG 169 III/III; Gallwitz 143; Glaser 149
S.L.L.: II/XXX
S.L.R.: Beckmann
Private collection

Woman with Candle is one of Beckmann's earliest woodcuts. Unlike the artists associated with Die Brücke and Der Blaue Reiter, Beckmann did only 18 woodcuts out of a printed oeuvre of over 300 prints.

Beckmann pulled three known proofs of the first state and two of the second before the woodcut was printed in an edition. The comparison between the first and third states demonstrates how carefully Beckmann worked away at the composition, clarifying details and strengthening the image.

The woman is probably his wife, Minna. Even though Göpel compares the print to a painting of Fridel Battenberg (cat. 21), the fact that there is a signed proof of the second state inscribed "Mink (Probedruck)" is sufficient evidence of the sitter's identity. The inscription is located in a place where Beckmann usually wrote the titles of his prints and appears, therefore, not to be a dedication of the work to his wife.

266

267

268

266 Self-Portrait in Bowler Hat 1921
Drypoint; 31.3 x 24.7 cm.
VG 179 II/IV proof; Gallwitz 153; Glaser 157
S.L.L.: Selbstportrait 1921
(Handprobedruck 1. Zustand)
S.L.R.: Beckmann
New York, Private collection

267 Self-Portrait in Bowler Hat 1921
Drypoint; 31.3 x 24.7 cm.
VG 179 III/IV; Gallwitz 153; Glaser 157
S.L.L.: 2 Zustand
S.L.R.: Beckmann
Chicago, The Art Institute of Chicago

268 Self-Portrait in Bowler Hat 1921
Drypoint; 31.5 x 25.6 cm.
VG 179 IV/IV trial proof; Gallwitz 153; Glaser 157
S.L.L.: Selbstportrait 1921
(Probedruck 2. Zustand) [sic]
S.L.R.: Meiner lieben Minette/von ihrem Maken/
Berlin 23. Feb 23
Private collection

Four states exist of this etching, one of Beck-
mann's best-known. The most important chan-
ges were undertaken between the second and
third states. In the first two states Beckmann
shows himself in an interior setting, presum-
ably an atelier brightly lit by a lamp from
behind. He presents himself in bust length, not
as an artist, but as a well-to-do burgher with
bowler hat, suit, tie, and cigarette. He holds a
cat in his left arm. In the third state Beckmann
removes the previous background, and only
the shadow cast by Beckmann's hat remains.

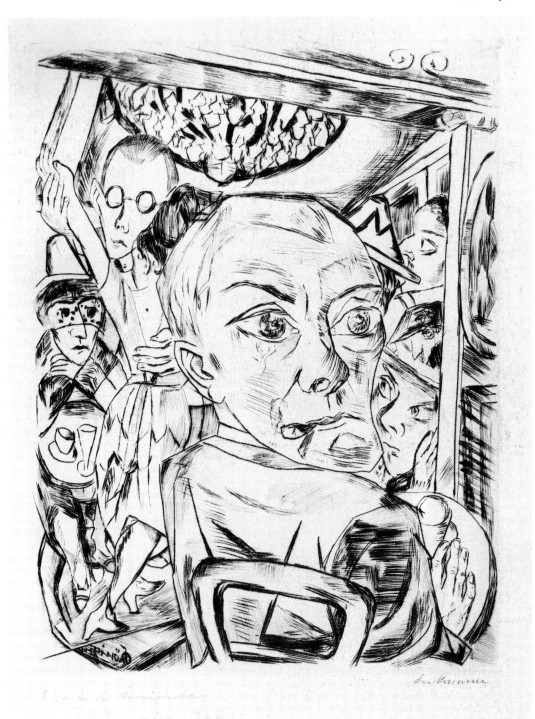

The cat now sits on a shelf to the left just behind the artist, and in its place Beckmann adds an open-lidded container and a kerosene lamp. In addition, he has strengthened and reworked the drypoint lines throughout the composition. In the final state, Beckmann continues to burnish the background lines, making the final composition more focused on this powerful and striking self-portrait.

269 Königin Bar (Self-Portrait) 1920

Drypoint; 32 x 25 cm.
VG 174 II/II; Gallwitz 148; Glaser 154
S.L.L. in an unknown hand: 5/10 In der Königinbar/
Druck von der unverstählten Platte
S.L.L. in plate in reverse: Königin
S.L.R.: Beckmann
New York, Private collection

The Königin Bar was a Berlin night club which appears again in Beckmann's drypoint *Königin Bar* II, 1923 (VG 269) and in the painting *Königin Bar,* 1935 (Göpel 417). However, the print is more closely related in composition to Beckmann's painting of the previous year, *Self-Portrait with Champagne Glass* (cat. 22). In both,

Beckmann is seated within an interior of the night club, his shoulder turned to the viewer, his head is unnaturally turned against the position of his body, and his glance directed toward an unidentified person or event outside the picture space. Formally, he closes off entry to the event taking place behind him; thematically, however, he shows it to the viewer by means of his emphatic body position. His enjoyment is merely an obligatory pose; beyond that it becomes a means to self-absorption and thereby corresponds to Beckmann's pessimistic view of this post-war period.

**270 Schöne Aussicht
(Winter Landscape) 1920**

Drypoint; 24.8 x 31.5cm.
VG 175 trial proof; Gallwitz 149; Glaser 155
S.L.L.: Schöne Aussicht (Handprobedruck)
Herrn Reinhard Piper mit freundlichem Gruß
S.L.R.: Beckmann 20
St. Louis, The Saint Louis Art Museum,
Friends Fund

In this print Beckmann depicts the Schöne
Aussicht, a street along the Main River, where
his friends, the Battenbergs, moved to No. 9 in
1919. The view is probably from Beckmann's
Schweizer Strasse studio, which was across the
river from the Schöne Aussicht.

 The scene shows building facades, barges on
the Main, and a single figure, possibly Beck-
mann, walking along the river. Compared with
his *Main River Landscape*, 1918 (cat. 242),
Beckmann's view of the river here is more con-
centrated. He has taken great care to depict a
scene that he liked very much.

 Beckmann's editioned prints were usually
cleanly wiped and uniformly printed. This spe-
cial proof, dedicated to his publisher, was
pulled by Beckmann himself. He left a thin
layer of plate tone, thus creating an overcast
and cloudy view, very different from the edi-
tion.

**271 The Barker (Self-Portrait) 1921,
plate 1 of *The Annual Fair***

Drypoint; 33.5 x 25.6cm.
VG 190 III/III trial proof; Gallwitz 163; Glaser 166
S.L.L.: Der Ausrufer (Handprobedruck)
S.L.R.: Beckmann
New York, Private collection

This well-known self-portrait is the first plate
for Beckmann's portfolio, *The Annual Fair*.
The portfolio contains ten prints which focus
on carnival life, a theme often depicted in
Beckmann paintings at that time (cat. 31-33).

 Here we see Beckmann not as the renowned
and respected artist, but rather as the barker
who rings his bell to attract people to the Beck-
mann circus. He thereby portrays himself as
the stage manager who opens the curtain to the
annual market of life before an astonished
public.

**273 Carousel 1921, plate 7 of
*The Annual Fair*** ▷

Drypoint; 29.3 x 25.9cm.
VG 196 III/III trial proof; Gallwitz 169; Glaser 172
S.L.L.: Karusell II (Handprobedruck)
S.L.R.: Beckmann 21
Portland, Portland Art Museum, The Vivian and
Gordon Gilkey Graphic Arts Collection

The *Carousel* scarcely fits into the tightly com-
pressed space which Beckmann has delineated.
The exaggerated and contorted configuration
and upward tilt of the carousel heighten the

272 Behind the Scenes 1921, plate 3 of
The Annual Fair

Drypoint; 21.7 x 31.8cm.
VG 192 trial proof; Gallwitz 165; Glaser 168
s.l.r.: Beckmann 21
s.l.l.: Garderobe I (Handprobedruck)
Philadelphia, Philadelphia Museum of Art,
Gift of J.B. Neumann

Before the curtain rises, the performers in
Beckmann's circus ready themselves behind
the scenes in a cramped and crowded dressing
room. The standing figure to the left, wearing a
wig and an obviously fake moustache and
beard, appears to be Beckmann. The seated
woman at the far right is probably Minna.

The composition is very similar to two paint-
ings by Beckmann, *Family Portrait*, 1920
(cat. 25) and *Before the Masquerade Ball* 1922
(cat. 26).

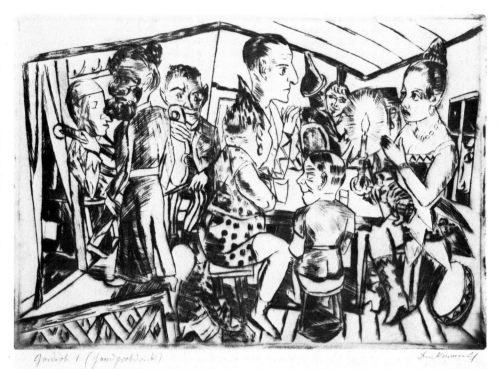

frantic sense of movement. Whether Beck-
mann is alluding to the idea of the wheel of life
is not certain, but in any case the presentation
seems to play on an existential assumption.
Bored and indifferent adults ride this carousel,
instead of happy children. Beckmann sits
among a group of four, grimacing over his
shoulder. Mask motifs and seemingly alive
carousel animals bring to the picture a demonic
accent. Two young onlookers, one of whom
may be Beckmann's son Peter, are not drawn
into the frenzy.

274 The Tightrope Walkers 1921,
plate 8 of *The Annual Fair*

Drypoint; 25.8 x 25.8cm.
VG 197 II/II trial proof; Gallwitz 170; Glaser 173
s.l.r.: Beckmann 21
s.l.l.: Seiltänzer (Handprobedruck)
Philadelphia, Philadelphia Museum of Art,
Gift of J.B. Neumann

In this print, two tightrope walkers perform
their act high above the crowd. On the left, a
woman raises her left leg and balances herself

with closed eyes. Approaching her on the right
is her partner, draped in a hood. One is not
sure whether this was actually part of the high
wire act or whether Beckmann is seizing the
opportunity to comment on society, which he
felt was walking on the edge of disaster.

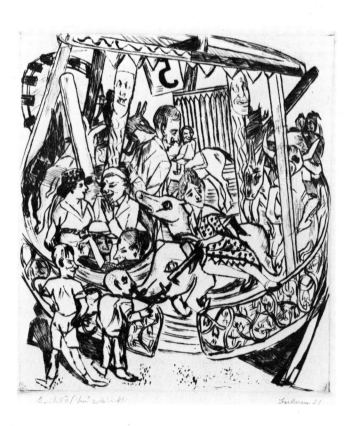

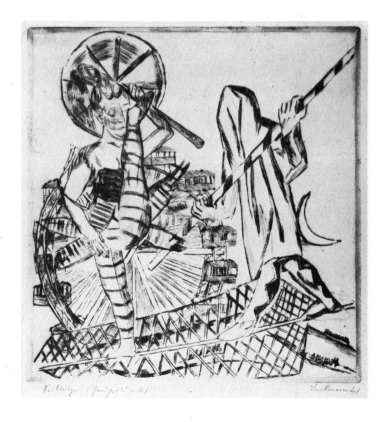

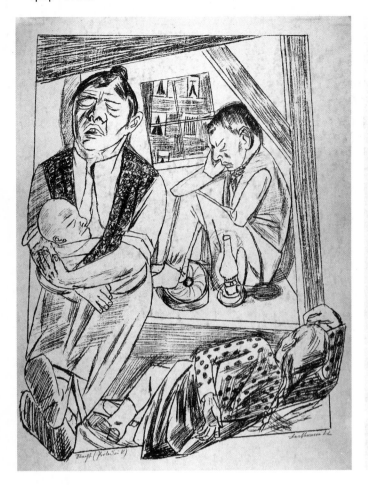

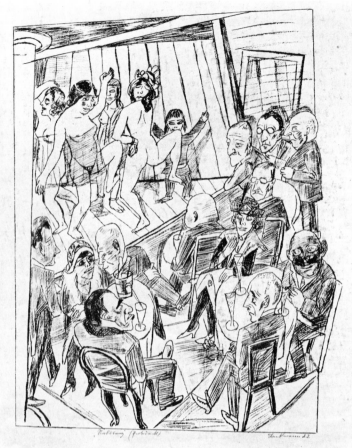

275 The Night 1922,
plate 3 of *The Berlin Trip*

Transfer lithograph; 45.5 x 36cm.
VG 214 trial proof; Gallwitz 184; Glaser 194
S.L.L.: Nacht (Probedruck)
S.L.R.: Beckmann 22
Philadelphia, Philadelphia Museum of Art,
Purchase, Thomas Skelton Harrison Fund

276 Striptease 1922,
plate 4 of *The Berlin Trip*

Transfer lithograph; 47.2 x 37.5cm.
VG 215 trial proof; Gallwitz 185; Glaser 190
S.L.L.: Nackttanz (Probedruck)
S.L.R.: Beckmann 22
New York, Private collection

277 The Theater Lobby 1922,
plate 8 of *The Berlin Trip*

Transfer lithograph; 49 x 40cm.
VG 219 trial proof; Gallwitz 189; Glaser 188
S.L.L.: Berlin-Theater Foyer (Probedruck)
S.L.R.: Beckmann
Munich, Staatliche Graphische Sammlung

278 The Chimney-Sweep 1922,
plate 10 of *The Berlin Trip*

Transfer lithograph; 45 x 33.5cm.
VG 221 trial proof; Gallwitz 191; Glaser 196
S.L.L.: Berlin Der Schornsteinfeger Beckmann 22/
(Probedruck)
New York, Private collection

Berlin offered Beckmann material for a panorama of social relations in post-war Germany. The depictions encompass scenes from the lives of the rich and poor, the disillusioned, the apathetic, and the bored. The portfolio contains ten lithographs, plus a cover and title page.

The Night portrays a family huddled together in their cramped, sparsely-furnished dwelling. Beckmann's use of slanted beams, ceiling, and floor heightens the sense of despair. A drawing entitled *The Mother,* 1922 (von Wiese 485) appears to be an alternative compositional idea for this print.

The image of a family crowded in a humble interior is reminiscent of two of Beckmann's earlier compositions: *Hunger,* 1919 from the portfolio, *Hell* (cat. 251) and *Furnished Room,* 1920 from *City Night* (VG 167).

Striptease offers us a glimpse of one of Berlin's nightclubs where nude dancers perform on stage while the well-dressed audience sips champagne in relative indifference. Some of these figures are reminiscent of characters seen in the work of George Grosz. There are three drawings from one of Beckmann's sketchbooks which served as initial studies for some of the figures in the composition (von Wiese 498-500).

Berlin's upper classes are gathered in *The Theater Lobby.* Isolated and self-satisfied, they make their own "entrance."

The portfolio plots Beckmann's journey through Berlin, depicting the ills and evils that befall the city. In the last plate of the series, *The Chimney-Sweep,* he offers a view from high above the city where, released from the contradictions of life, he directs his glance freely into the distance.

279 Self-Portrait 1922

Woodcut; 22.2 x 15.5 cm.
VG 225 II/III proof; Gallwitz 195; Glaser 200
S.L.L.: Probedruck 2. Zustand
S.L.R.: Beckmann
St. Louis, The Saint Louis Art Museum,
Friends Fund

This striking woodcut is the only single figure
self-portrait done in this technique and is one
of only two known impressions of the second
state. Although Beckmann did very few wood-
cuts, he achieves a boldness and directness
comparable to his work in drypoint. Both
techniques require working directly on either a
plate or block of wood. With drypoint, correc-
tions can be made by burnishing; however,
with woodcuts, mistakes are difficult to hide.
The sense of confidence in this self-portrait is
displayed not only in the figure's presence, but
also in the deft handling of its execution.

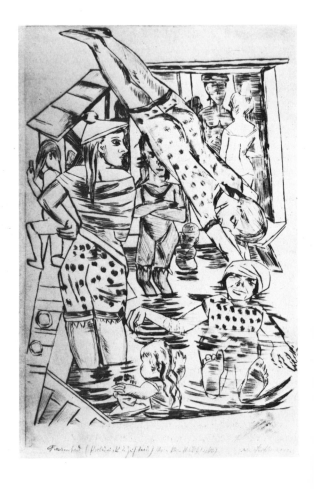

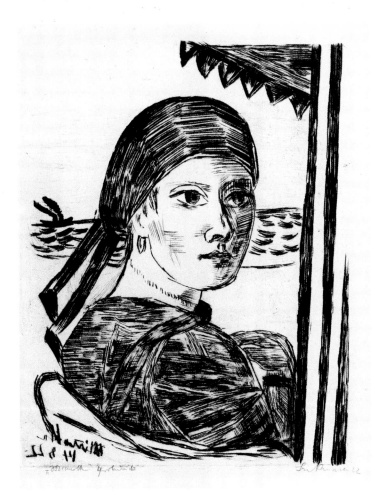

282 Minette 1922

Drypoint; 25.3 x 20.5 cm.
VG 237 VI/VI trial proof; Gallwitz 208; Glaser 212
S.L.L.: Minette Probedruck
S.L.R.: Beckmann 22
S.L.L. in the plate in reverse: Minette/14.8.22
New York, Private collection

This print of Minna went through six states in which Beckmann drastically reworked the plate. In the earliest known state there was a reclining male figure in the middle ground, Minna wore a polka dot dress, there was a moon, and the ocean was drawn closer to the top of the sheet. Through the subsequent states Beckmann alters the composition in an attempt to frame and enhance the figure. He achieves this by lowering the horizon line, adding a fragment of a cabana awning, redrawing Minna's dress, and adding two ends of a scarf.

283 In the Tram 1922

Drypoint; 29 x 43.4 cm.
VG 234 III/III; Gallwitz 205; Glaser 209
S.L.R.: Beckmann
Middletown, Conn., Davison Art Center, Wesleyan University

In contrast to *Women's Bath* (cat. 280), the spatial composition of *In the Tram* is less complicated and more direct. The three main figures occupy the same plane and are lined up across the sheet. The figure in the center, wearing a hat and a blindfold which conceals his nose and part of his mouth, bears a resemblance to Beckmann. This mysterious figure stares out at the viewer while the woman and man on either side have their eyes closed. The man on the right is seen in profile with his thumb in his mouth. While this appears to be an everyday scene, Beckmann's added touches give it new and unexplained connotations. The relationship, if any, among the figures is unclear.

280 Women's Bath 1922

Drypoint; 43.7 x 28.6 cm.
VG 233 I/II hand-corrected trial proof;
Gallwitz 204; Glaser 208
S.L.L.: Frauenbad (Probedruck mit Correktur)
S.L.R.: Beckmann
Munich, Staatliche Graphische Sammlung

281 Women's Bath 1922

Drypoint; 43.7 x 28.6 cm.
VG 233 II/II trial proof; Gallwitz 204; Glaser 208
S.L.L.: Frauenbad (Probedruck 2. Zustand) Meiner kleinen Mink (links); S.L.R.: Max Beckmann
Private collection

The *Women's Bath* depicts a subject which Beckmann treated in an earlier painting (cat. 20). The print does not repeat the composition of the painting. Rather, each is an independent composition, sharing Beckmann's cramped and distorted sense of space. The dotted pattern of the three women's bathing suits draws the surface composition together, adding a decorative and expressive element to the severity of the composition.

The Munich impression contains pencil additions throughout the composition which were not incorporated into the second state.

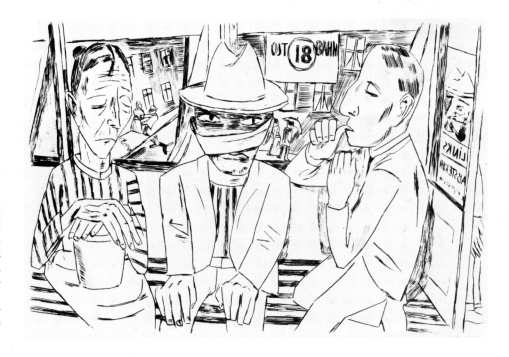

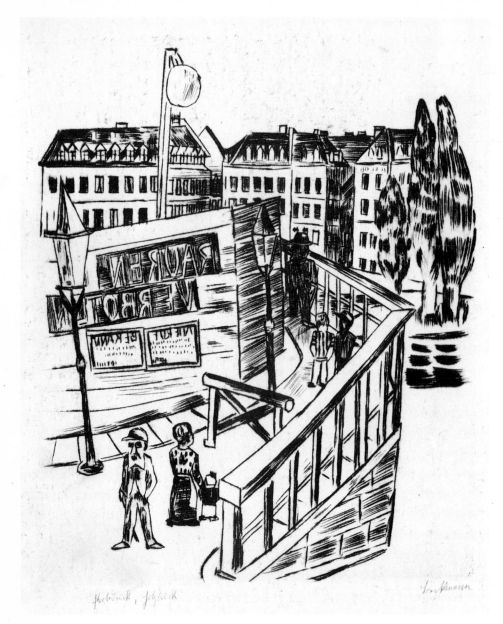

284 Wooden Bridge 1922

Drypoint; 28.6 x 23.8cm.
VG 241 trial proof; Gallwitz 212; Glaser 216
s.l.l.: Probedruck Holzbrücke
s.l.r.: Beckmann
New York, Private collection

The editioned print appeared in the portfolio, *Die zweite Jahresgabe des Kreises graphischer Künstler und Sammler* (Verlag Arndt Beyer, Leipzig, 1924). Beckmann was one of nine artists whose works were included; the others were Lyonel Feininger, Carl Hofer, Willy Jäckel, Alfred Kubin, Graf Luckner, Adolf Schinnerer, Otto Schubert, Richard Seewald, and Walter Teutsch.

The Wooden Bridge was a temporary bridge that was constructed while the Alte Mainbrücke was being repaired.

285 Shore 1922

Drypoint; 21.4 x 32.7cm.
VG 238 trial proof; Gallwitz 209; Glaser 213
s.l.l.: Strand (Probedruck)
s.l.r.: Beckmann 22
Ann Arbor, The University of Michigan Museum of Art. Gift of Jean Paul Slusser

According to an annotation found on an impression of this print in Bremen, the scene is in Wangerooge, an island in the North Sea off the coast of Germany. Most likely, the print, *Minette,* (cat. 282) was executed at the same time. As early as 1902, Beckmann began doing paintings of the ocean and beach scenes (cat. 1, 3, 4) which he continued throughout his career.

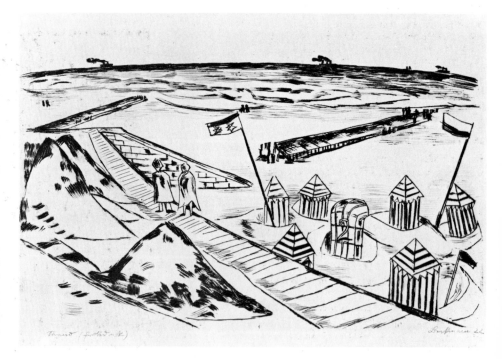

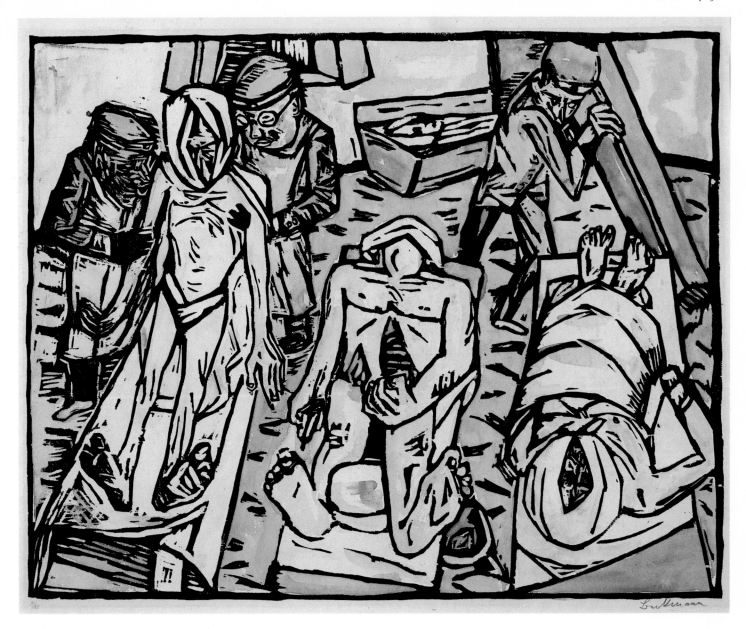

286 Morgue 1922
Woodcut; 37.2 x 47.7cm.
VG 251 II/II hand colored; Gallwitz 221; Glaser 227
S.L.L.: 3/35
S.L.R.: Beckmann
Private collection

287 Morgue 1922
Woodcut; 37.2 x 47.7cm.
VG 251 II/II; Gallwitz 221; Glaser 227
S.L.R.: Beckmann
Private collection

This woodcut repeats, in reverse, *Morgue* (cat. 227), a drypoint executed by Beckmann in 1915. Beckmann incorporated several changes into the later version: he enlarged the woodcut, shifted the position of the three corpses, and changed several details in the background.

In both works, the bodies are placed close to the picture plane creating a strong feeling of tension. The figures in the woodcut have been placed in a shallower space, further heightening this mood. The hand-colored impression strengthens the suggestive power of the picture. Beckmann never printed in color, but on rare occasions he would handcolor impressions afterwards.

288 Tamerlan, 1923

Drypoint; 39.6 x 20 cm.
VG 283; Gallwitz 235; not in Glaser
S.L.L.: 19/60
S.L.R.: Beckmann; S. in the plate in reverse
L.L.C.: TAMERLAN/10.4.23
Private collection

Beckmann and his female companion, seated in the lower left corner, are being serenaded by a strolling violinist. To the right, a moustachioed performer sits astride an animal riding atop a large ball. The real activity, however, appears to be beyond our view as we see the waiters climbing the stairs with trays bearing drinks for the private rooms.

The strong vertical format of the composition is reminiscent of that seen in many of Beckmann's paintings of the 20s, such as *The Dream*, 1921 (cat. 23). This wonderful sense of motion and activity zig-zagging from top to bottom heightens the sense of frenzied activity.

289 Seduction 1923

Woodcut; 15.8 x 24.2 cm.
VG 256 II/II proof; Gallwitz 222; Glaser 228
S.L.L.: Verführung (Probedruck)
S.L.R.: Beckmann
Private collection

Although executed on a rather small scale, this seduction scene creates a powerful image. A reclining woman stretches across the foreground, while a male figure looks on from the left. In the same year, Beckmann depicted a similar scene in a drypoint, *Siesta* (VG 279). However, the mood is quite different there: the scale is larger and the ambiguity gone.

Beckmann did not publish the print in an edition. According to Hofmaier, only one proof of the first state is known, and there are only four known impressions of the second.

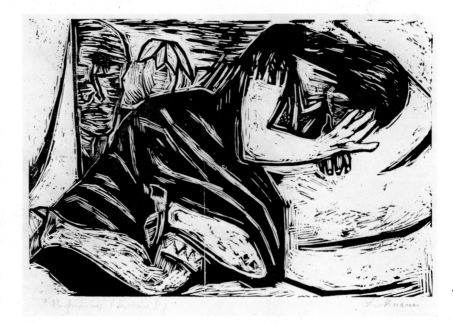

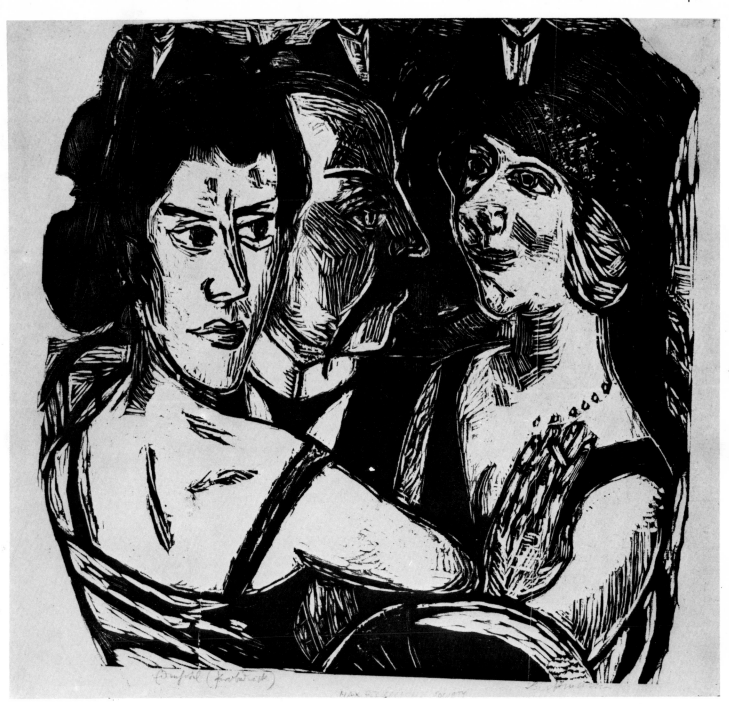

290 Group Portrait, Eden Bar 1923
Woodcut; 49.4 x 49.8cm.
VG 276 II/II trial proof on green paper;
Gallwitz 261; not in Glaser
S.L.L.: Edenhotel (Probedruck)
S.L.R.: Beckmann
Chicago, The Art Institute of Chicago

Beckmann again and again portrayed fashionable society with all its elegant but empty conventions. Here it becomes the setting for one of his largest and most ambitious woodcuts. Three well-dressed and sophisticated people are seated in the bar of the Eden Hotel in Berlin. The woman on the left is Johanna Loeb, who also appeared in a painting (Göpel 176), as well as another print (VG 209). Next to her, most likely, is her husband Karl. On the right is Elisa Lutz, who along with Johanna Loeb appeared in the earlier lithograph, *Two Women* (VG 244). Behind the group three musicians are seen from the neck down.

Even though Beckmann utilizes the woodcut technique so closely associated with artists such as Kirchner, Heckel, and Nolde, his manner of execution is very different. He does not strive for contorted or overly exaggerated forms, but rather he carves out his composition in a more linear fashion. The very nature of the technique lends itself to exaggeration; however, this was not Beckmann's sole intention. He was above all a keen observer of surroundings who sought to translate these observations of the world into his work. He achieves his goal by combining the expressive nature of the woodcut with his tightly controlled composition. The three main figures are grouped closely together, yet none of them is engaged in conversation. The truncated bodies of the musicians define the shallow space by providing an impenetrable backdrop.

291 Cabana 1924

Drypoint; 34.8 x 21.8cm.
VG 304 II/II proof; Gallwitz 272; not in Glaser
S.L.L.: Nach dem Bade (Probedruck)
S.L.R.: Beckmann 24
S. in plate U.R.C.: 15.7.24 Pirano
New York, Private collection
Reference: Göpel, 1976, Vol. 2, p. 173.

Here Beckmann observes his wife, Minna, as she changes in a cabana by the sea. From the inscription on the plate and from a letter to I.B. Neumann, we know that in the summer of 1924 Beckmann and his family vacationed in Pirano, a resort on the Adriatic Sea. During this trip Beckmann did a number of drawings (von Wiese 552-558); the painting entitled *Lido* (cat. 40) also dates from this period.

293 The Curtain Rises 1923

Drypoint; 29.9 x 21.7cm.
VG 284 II/II trial proof; Gallwitz 240; not in Glaser
S.L.L.: Der Vorhang hebt sich (Probedruck)
S.L.R.: Beckmann/Das Mysterium aller/
Mysteriums von/Max
Private collection

The curtain rises to reveal a scene from Beckmann's "World Theater," in which various pictorial signs and symbols reappear. Familiar figures and attributes—for example, the woman seen from behind, riding a reptile, is similar to the figure in *The Journey* (cat. 103)—are arranged as in a kaleidoscope.

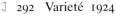

292 Varieté 1924

Drypoint; 40.3 x 20.4cm.
VG 303; Gallwitz 273; not in Glaser
S.L.L.: 10/30
S.L.R.: Beckmann
s. in the plate in reverse at top:
O NO WE HAVE NOT/BANANES
New York, Private collection

In *Varieté,* the high-stepping cabaret dancers perform a popular American song of the day, which Beckmann delightfully misquoted as "O no we have not bananes." The composition demonstrates the familiarity with similar depictions by Degas, Seurat, and Toulouse-Lautrec. One is especially reminded of Seurat's *Le Chahut* from 1889/90.

By this time Beckmann's drypoint line is more controlled, and forms are defined in bold outline. There is very little cross-hatching or shading. The delineation of a tightly compressed space is carried through, yet it now appears more controlled and refined. A marvelous counterplay of diagonal lines is formed by the angle of stage, the floor slats, and the raised legs of the dancers.

1 Title Page: Gospel According to St. John, 1:1: *In The Beginning Was The Word;*
and Revelation of St. John The Divine, 14:13: *Blessed are the dead...*

294 Apocalypse 1941/1942

82 pages with 27 hand-colored lithographs.
Format: 40 x 30 cm; type area: 25 x 20 cm.
Colophon: "This book was printed in the fourth year of the Second World War, as the visions of the apocalyptic seer became dreadful reality. The pictures in this book are hand-colored lithographs by Max Beckmann. The type-face used is double pica "Legend," designed by F.H.E. Schneidler. Privately printed at Bauerschen Giesserei, Frankfurt am Main, 1943. Twenty-four numbered copies were printed, of which this is no. one. Hand-colored by the artist himself for Georg Hartmann."
Private collection
VG 329-355. Gallwitz 287. Not in Glaser.

References: Tagebücher 1940-1950; Georgen, 1955; Buchheim, 1959; Göpel, 1956, p. 257f.; Jannasch, 1969, p. 10f.; Fischer, cat. Zürich Kunsthaus, 1976, p. 24f.; P. Beckmann, 1982, p. 69ff.; Lenz, 1982, note 14; (E. H.) Weltkriegsapokalypse in Thesaurus Librorum, Wiesbaden, 1983, No. 124.

Questions remain as to which copies of the *Apocalypse* were hand-colored by Beckmann. The edition reproduced here is the one the artist hand-colored for the publisher Georg Hartmann. The coloring of no. 1 differs significantly from that of no. 9 (Private collection); however no. 9 is very similar to that of nos. 13 (Munich, Private collection) and 23 (Hannover, Kunstmuseum, Hannover mit Sammlung Sprengel), which are very similar to that of the unnumbered copy from the estate of the Bauersche Giesserei (Munich, Staatsbibliothek). All of these, and probably no. 9 as well, were not colored by Beckmann. A few slight variations indicate that copies nos. 9, 23, and the one in the Staatsbibliothek form an independent group, from which no. 13 differs. Perhaps the as yet unidentified copy which the artist colored as a model for the others gave rise to the differing copies, which in turn, served as models for further copies.

Peter Beckmann has kindly informed me that he possesses a "Hartmann list," which names nos. 1, 8, and 9 as having been colored by the artist himself. As a result, both the list and the works themselves will have to be examined more closely.

Göpel, who knew Beckmann well and was acquainted with the origins of *Apocalypse,* writes:

"Max Beckmann drew the lithographs in Amsterdam during 1941 on lithographic paper and they were transferred to the stone in Frankfurt... The edition was limited, since according to a regulation then current, private printings with a press run of 25 copies or less did not have to be submitted to the Propaganda Ministry. The actual press run may have amounted to 30 or 35 copies. The surplus copies were not numbered. It is certain that Max Beckmann, using watercolors, hand-colored a copy for Georg Hartmann, a copy for Mathilde Q. Beckmann, a copy for Dr. Erhard Göpel (lost), and a copy for Frau L. von Schnitzler. It is possible that Beckmann hand-colored one or two copies more. The larger part of the edition was turned over to watercolorists in Frankfurt for illumination. These illuminations are difficult to distinguish from those done by Beckmann himself though they are, oddly enough, more expressionistic than those of Beckmann, who was guided by his own very precise, personal conception. In 1946 Heinrich Jost, artistic director of the Bauersche Giesserei, was in possession of proofsheets, especially of the partial-page illustrations.

At the second meeting of the Max Beckmann Society on October 22, 1955, in Munich, an informative lecture on 'The Origins of Beckmann's Apocalypse Illustrations' was delivered by Professor Ernst Holzinger [director of the Städel in Frankfurt]. Professor Holzinger delivered Georg Hartmann's commission to Beckmann, and participated decisively in each stage of the work."

Unfortunately the lecture was not printed and, according to Frau Dr. Holzinger, the manuscript has not survived.

Georg Hartmann (1870-1954) came from an old Frankfurt family and was a highly successful businessman. At the age of 28 he purchased the Bauersche Giesserei in Frankfurt; later he bought the de Neufville Type Foundry in Barcelona; and he finally established a branch in New York. He also operated an important factory for dental equipment, employing the sculptor Petraschke as product designer. At the Bauersche Giesserei Georg Hartmann retained the services of such outstanding type-face designers as Emil Rudolf Weiss, F.H. Ernst Schneidler, Rudolf Koch, Imre Reiner and others, and through their efforts succeeded in bringing about a gradual renaissance of the printer's art, the effects of which were felt worldwide. This addition to, and extension of, his business talents was augmented by a strong affection for music and the visual arts. He assembled a sizeable collection of medieval sculptures and purchased works of modern art by Rodin, Despiau and Beckmann, among others. In 1943 he commissioned Beckmann to produce illustrations for Goethe's *Faust II*. With his talents, his proclivities, and his success, Georg Hartmann was predestined for the active, supportive role of a patron and, accordingly, was associated with the important cultural institutions of his native city. He was thus head of the trustees of the Freie Deutsche Hochstift, and served as a member of the governing board of the Städel from 1935 until his death. He was also on the board of the municipal library and active in promoting the reconstruction of the Goethe House and the old Opera House after World War II. In 1950 he was made an Honorary Citizen of Frankfurt.

Not least among Georg Hartmann's merits is the active support which he gave during the dark period of National Socialism to the "degenerate" artist, Max Beckmann, whose creative work he encouraged. The artist's diary records in detail his work on the illustrations to the *Apocalypse*. It is not known whether Beckmann first made sketches, using a working copy with the text for this purpose, as he did in the case of the *Faust* illustrations. However, Peter Beckmann remembers having seen in his father's library a small edition of the Apocalypse with preliminary sketches. A diary entry for August 27, 1941 notes "Began Apo." By December 23 the work was obviously well advanced, since the *Apocalypse* is now already being looked at. Four days later Beckmann notes his "final effort" and on the 28th he writes "Apo finalized." In March of the next year he receives the first proofsheets of the lithographs from Frankfurt, and in the following month he begins the coloring. On December 29, 1942 he notes: "2 colored Apos finished."

The text of the colophon refers expressly to the connection between the *Apocalypse* and current history. We therefore summarize briefly the most important events. After losing his position in Frankfurt in 1933, Max Beckmann emigrated to Amsterdam on July 19, 1937, having become one of the most prominent of the so-called "degenerate" artists. His hopes of settling in Paris had been dashed by the outbreak of war on September 1, 1939.

After the capitulation of Poland in Sep-

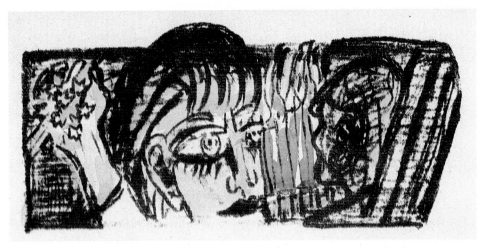

2 Revelation 1:16: *His countenance was as the sun shineth in his strength.*

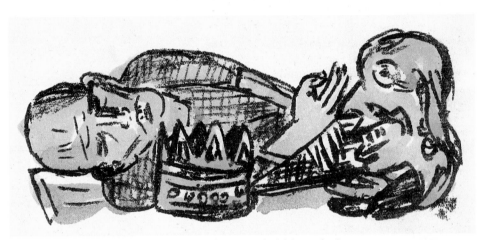

3 Revelation 2:10: *Be thou faithful unto death...*

4 Revelation 2:29: *He that hath an ear...*

5 Revelation 3:17-18: *And anoint thine eyes*

6 Revelation 4:2-8: *The vision of the throne of God*

metrical placement and significant symbolism of the candles enhance the tableau's ceremonial character, so that one is reminded of an altar. This ceremonial character is derived not least from the words, which resemble the inscription upon the tablets of the Ten Commandments.

The first sentence is not from the Apocalypse, but is rather the beginning of the Gospel according to St. John: "In the beginning was the Word." The second sentence is a contraction of two sentences of the Apocalypse. The complete text reads: "Blessed are the dead which die in the Lord from henceforth: Yea, saith the Spirit, that they may rest from their labors; and their works do follow them." (Revelation 14:13). In Beckmann's use of the quotation, "works" must be understood as applying to his own works of art. Beckmann had already used the beginning of the Gospel according to St. John in the central picture of the triptych, *Temptation* (cat. 73). Here the words refer on the one hand to the correlation between the tableau and the totality of the world, while on the other, they allude to the figure of John the Evangelist who, for Beckmann, served as a prototype of the artist. In the present lithograph, too, Beckmann identified himself with St. John.

The snake is an ancient symbol of knowledge. Beckmann had portrayed it in a similar way in 1939 in the triptych *Acrobats* (cat. 89). The fish also has a long tradition as a symbol, and in Christian culture often is associated with Christ himself in a variety of meanings.

With the title picture, therefore, Beckmann did not illustrate merely a single passage of the Apocalypse, but rather created a programmatic interpretation for the whole. The inscribed tablets open like a gate or a book. They offer a glimpse of the artist himself who stands in the center, like John.

2

Partial Page. 80 x 200 mm. VG 330.

This illustration of Revelation 1:16 shows John the Evangelist facing the Messiah, who holds seven stars in his right hand. "His countenance was as the sun shineth in his strength." Beckmann concentrated upon the face of the figure with its radiantly penetrating eyes, and placed it in direct confrontation with John, who recedes into the shadows. The raised hand, in a gesture of power, is related to the overwhelming aspect of the face. The hand, the face, and the candles' flames are joined through the use of a bright yellow which emphasizes the radiance of the vision as a whole.

3

Partial Page. 80 x 200 mm. VG 331.

The illustration of Revelation 2:9-10 shows the epistle to the church of Smyrna. The head on the right represents the blasphemers, while the reclining figure of the suffering, perhaps even dead, man (a self-portrait of Beckmann), and the golden crown, refer to the exhortation to endure the tribulations which are to come. "Be thou faithful unto death, and I will give thee a crown of life."

tember and the occupation of Denmark and Norway in April 1940, the German armies attacked Belgium and the Netherlands in May 1940 and advanced into France. The Netherlands capitulated on May 5 and was under German control until the end of the war. Beckmann was now exposed to new dangers. Rotterdam had suffered a devastating air attack, and from August 1940 until May 1941 the "Battle of Britain" raged, in which the cities of Coventry and Birmingham were destroyed. The war spread further and further afield, and on June 22, 1941 the Soviet Union was attacked. At the time that Beckmann received the commission to illustrate the Apocalypse, apparently during July/August 1941, the conflagration of war had been unleashed throughout the world.

1

Full Page. VG 329
Inscribed on the stone

IM ANFA[NG] WAR DAS WORT
SELIG SIND DIE IN DEM HERREN
DIE TOTEN S[T]ERB[EN,] VON N[UN] AN
DENN IHRE WERKE
 FOLGEN IHNEN NACH

Against a purple background two white tablets are represented, having the appearance of an upright, open book. There is, however, a gap between the two tablets in which one glimpses the artist, dressed in a green suit, entangled in the coils of a large yellow snake. In front of the rectangular tablets are two triangular ones, each bearing a large fish; a third fish is placed above the two rectangular tablets. Large candles burn on each side of the tablets. The sym-

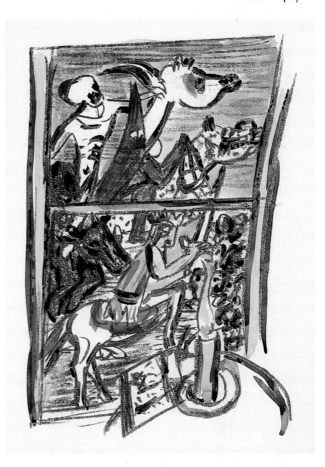

7 Revelation 5:6-7:... *a Lamb as it had been slain*...

8 Revelation 6: 1-8: *The horsemen of the Apocalypse* ▷

4

Partial Page. 40 x 160mm. VG 332.

The three heads with the large ears are a laconic visualization of the words "He that hath an ear, let him hear what the Spirit saith unto the churches" (Revelation 2:29).

5

Partial Page. 40 x 180mm. VG 333.

This illustration of Revelation 3:17-18 shows the fools who deceive themselves about themselves. As the spiritually blind, their eyes should be anointed with eye salve, so that they may see. Beckmann depicts the restored sight in the second figure from the left.

9 Revelation 7:2-3: *The servants of our God...sealed in their foreheads*...

10 Revelation 7:17:... *and God shall wipe away all tears from their eyes.*

6

Full Page. VG 334.

The first large illustration within the text, its coloring governed by light blue, illustrates Revelation 4:2-8. It is a vision of Heaven with the throne of God and the 24 elders in light yellow robes as well as the four beasts, of which one is like a lion, another like a calf, a third like a man, and the fourth like an eagle. Beckmann departs from the text, especially in his depicting the face of God, where John writes only: "And he that sat was to look upon like a jasper and a sardius stone...".

However, the open, mobile, and energetic forms of the countenance are quite close to the

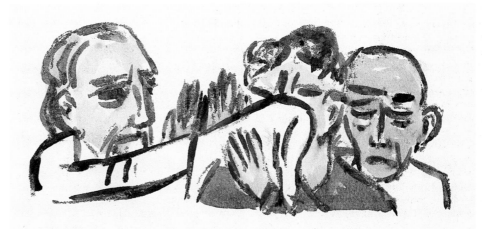

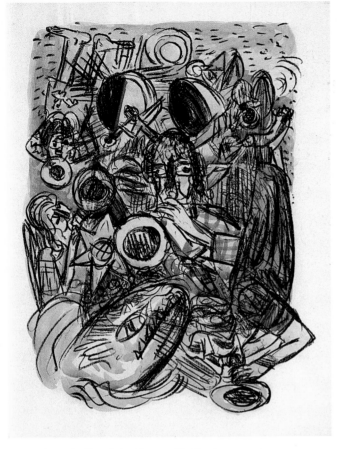

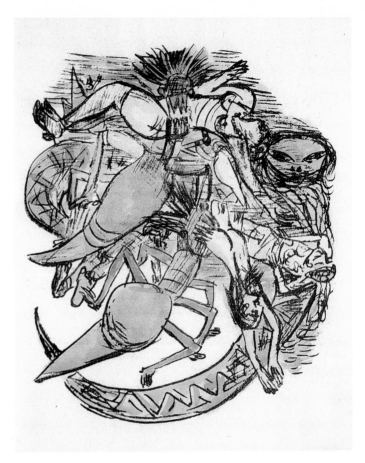

11 Revelation 8:1-13: *The first four trumpets*

12 Revelation 9:1-12: *The fifth trumpet*

text, insofar as they depict the words: "And out of the throne proceeded lightning, thundering and voices..." Beckmann has used the rainbow which John saw "round about the throne, its sight like unto an emerald" as the basic form for the irregular trefoil which surrounds the figures.

7
Three-quarter Page. 200 x 200 mm. VG 335.

The picture derives from Revelation 5:6-7 where the lamb is described "as it had been slain, having seven horns and seven eyes." The lamb alone is worthy to open the book with seven seals from the hand of God. Beckmann has pictured the pink animal in front of the gray book, while the yellow cord used to strangle the lamb provides a contrast.

8
Full Page. VG 336.

The lithograph shows the four apocalyptic riders of Revelation 6:1-8. One of them appears in response to the call of one of the beasts as the first four seals of the book are opened in succession: "And power was given unto them over the fourth part of the earth, to kill with sword, and with hunger, and with death, and with the beasts of the earth." Beckmann shows the riders passing by his window against a burning, reddish-violet sky. This is the first example in his work of a super-terrestrial phenomenon being revealed through a win-

dow. In this context it is preceded by the etching, *Boys at a Window,* 1922 (VG 236), and followed by the *Mater gloriosa* of the Faust illustrations and the triptych, *The Beginning,* 1946-1949 (cat. 122).

9
Partial Page. 80 x 180 mm. VG 337.

On the right stands the angel "having the seal of the living God" and on the left "the servants of our God" with seals on their foreheads (Revelation 7:2-3). These are the elect, who will be spared by the judgment of God.

10
Partial Page. 80 x 180 mm. VG 338.

This scene refers to the passage concerning the martyrs and their sufferings, which says "and God shall wipe away all tears from their eyes" (Revelation 7:17). In one sense the artist has interpreted the text quite literally; the figure on the left, however, does not represent God, but perhaps the artist himself as one of the comforters.

11
Full Page. VG 339.

This large illustration is devoted to the opening of the seventh seal. Then the sound of the first four trumpets brings down ruin upon Heaven and Earth, so that a part is destroyed as each

trumpet is blown (Revelation 8:1-13). Beckmann depicts the event as the unleashing of chaos in purple light. The dark mouths of the trumpets suggest the savagery of the sound; the star at the lower left ("And the name of the star is called Wormwood..."), the gray-green fish emerging from the water, and the sun and the moon, each one-third darkened, are based upon other details of the text.

12
Full Page, VG 340.

The fifth trumpet (Revelation 9:1-12) lets a star fall to the earth, opening "the bottomless pit," from which a mighty smoke arises, "and there came out of the smoke locusts upon the earth." "And the shapes of the locusts were like unto horses prepared unto battle; and on their heads were crowns like gold, and their faces were as the faces of men. And they had hair as the hair of women, and their teeth were as the teeth of lions." They attack only those persons not bearing the seal of God upon their foreheads, torturing them for five months without killing them.

Around the two huge green creatures holding people between their teeth, and around the other figures, Beckmann has drawn the curved, shining body of a great, greenish-yellow serpent, whose head peers out at the right. He thus refers to the words: "And they had a king over them, which is the angel of the bottomless pit..."

13 Revelation 10:6-7: *... that there should be time no longer...*

14 Revelation 11:3-13: *... the tenth part of the city fell...*

13
Full Page. VG 341.

Illustrated here is the solemn oath of one of the mighty angels, "that there should be time no longer. But in the days of the voice of the seventh angel, when he shall begin to sound, the mystery of God should be finished, as he hath declared to his servants the prophets" (Revelation 9:10).

Beckmann depicts the esoteric significance of the worlds in quite a lapidary fashion by having the two angels stop the hands of the big clock at 12. The arrow pointing downwards from the clock, like a hand which has fallen off, not only transects the reclining figure, but more radically, it actually destroys its temporal existence.

"*Time* is Man's invention; *space* the palace of the gods," Beckmann said later. All his conceptions concern space. That passage of the Apocalypse which speaks of the end of time was thus particularly important to him.

14
Full Page. VG 342.

On this page, illustrating Revelation 11:3-13, the two mighty "witnesses" of God are depicted. In the text their symbols are olive trees and torches, but Beckmann pictures them with a kind of palm tree and with stars. Conquered by the beast of the abyss, they are nevertheless resurrected by God. "And they ascended up to heaven in a great cloud; and their enemies beheld them. And the same hour was there a great earthquake, and the tenth part of the city fell, and in the earthquake were slain of men seven thousand..." With their ash-gray hair, the two heads do indeed hover like clouds above the red earth, while the trees with their dark brown trunks and green tops represent the solid, earthly realm.

15
Full Page. VG 343.

Revelation 12:1-17 recounts the vision of the pregnant woman who, in great suffering, bears a male child. The dragon as an incarnation of the Devil pursues both her and the child. Beckmann's depiction of the woman is much simpler and coarser than the description in the text. According to the text, the dragon is conquered by the Archangel Michael and then hurled to earth with its retinue. Beckmann shows them being driven out in the upper part of the picture, while on the left the victorious angels sing hymns of praise. In the center of the picture the woman, who has been given wings to enable her to flee the dragon, is shown once again. "And the serpent cast out of his mouth water as a flood after the woman, that he might cause her to be carried away with the flood." Since the woman in Beckmann's picture does not flee, but rather advances aggressively upon the fiery dragon, the idea of the victorious angel, Michael, is also associated with this figure.

16
Full Page. VG 344.

In this picture Beckmann has sharply abridged and noticeably altered the long and pictorially detailed text concerning the beast and the false prophets (Revelation 13:1-18). The panther-like beast, with seven heads and ten horns, is represented as a woman, thus transforming its significance from that of the power which blasphemes and denies God to that of the power of vice. Next to the woman is "another beast" with two horns, no less powerful, which comes bearing everything needed for the worship of the first beast. This second, violet beast is the false prophet. On the right, a teacher is clearly represented as one who follows the false prophet and forces the youth to worship the beast. The head beneath his raised arm accordingly belongs to one of the people who does not worship the beast and is therefore killed. The theme of temptation to evil is thus present both in the text and in the illustration. Under the National Socialists this idea had regained a special relevance, and not least for a "degenerate" artist like Beckmann.

17
Full Page. VG 345.

This lithograph illustrates the words quoted on the title page: "Blessed are the dead..." (Revelation 14:3), as well as the following text:

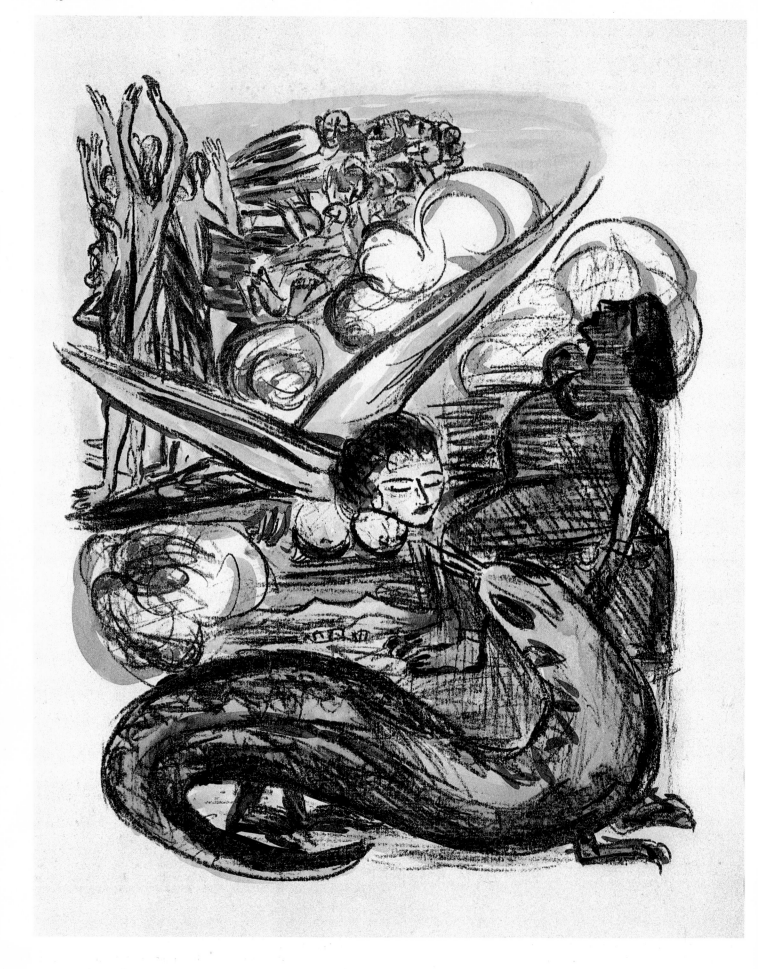

15 Revelation 12:1-17: *The woman and the dragon*

"and I looked and beheld a white cloud, and upon the cloud one sat like unto the Son of Man, having on his head a golden crown, and in his hand a sharp sickle." (Revelation 14:14) A figure in a shroud lies upon a wooden bench; beneath and above the figure float light blue clouds in which the two angels and the figure with the sickle appear in gold.

18
Full Page. VG 346.

Here are depicted the seven angels with the seven last plagues, "for in them is filled up the wrath of God." The beast, now conquered, can be seen half-covered by their light robes (Revelation 15:1 and 16:1).

19
Partial Page. 80 x 190 mm. VG 347.

"...the men which had the mark of the beast, and... which worshipped his image" (Revelation 16:2) are shown committing murder and other vices. The ochre and flesh-colored tones, surrounded below by a poisonous green, reinforce the evil impression made by the figures.

20
Partial Page. 110 x 190 mm. VG 348.

One of the angels with the seven plagues speaks to John: "Come hither, I will show unto thee the judgment of the great whore [Rome, symbolized by the name Babylon] "with whom the kings of the earth have committed fornication, and the inhabitants of the earth have been made drunk with the wine of her fornication" (Revelation 17:1-2). The woman's nude body gleams against the sultry dark-red background, while her blond hair corresponds to the gold of the kings' crowns.

21
Full Page. VG 349.

The text for this picture follows directly on the previous one. The picture shows the great whore against a nocturnal blue background: "...and I saw a woman sit upon a scarlet-colored beast... having a gold cup in her hand full of abominations and filthiness of her fornication. ...And I saw the woman drunken with the blood of the saints, and with the blood of the martyrs of Jesus..." (Revelation 17:3-6). On the right, surrounded by an arc of fiery red, stands the angel whose two swords will destroy the whore.

22
Partial Page. 105 x 215 mm. VG 350.

Revelation 18:9-13 describes the lament of the kings and merchants at the fall of the city of Rome, the great whore. Revelation 18:14 continues: "And the fruits that thy soul lusted after are departed from thee, and all things which were dainty and goodly are departed from thee, and thou shalt find them no more at all."

Beckmann has depicted fruit and bread, colorful and desirable, behind a grating whose dark blue tone, together with the cold blue of

16 Revelation 13:1-18: *The beast and the false prophet*

the background, makes vivid the unattainability of the things mentioned. This both illustrates the text and at the same time refers to the deprivations of the war which in 1941 had not yet reached their worst extreme.

23
Full Page. VG 351.

The illustration is based on Revelation 19:11-21, describing the first eschatological battle to destroy the heathen. The crowned judge charges forward dressed in a bloody robe and with flaming eyes. He conquers the beast and the kings of the earth with their hosts, all of whom will be devoured by "... all the fowls that fly in the midst of heaven...," and "... all the fowls were filled with their flesh." The artist has not used the colors indicated by the text, but has shown the rider in a blue robe upon a bright yellow horse, while the slain are

rendered in toxic green and the birds with bloody beaks. The brutality of the events is thus made vivid.

24
Full Page. VG 352.

This lithograph depicts the Last Judgment (Revelation 20:11-13). Beckmann has portrayed the judge of the world "from whose face the earth and the heaven fled away" as a radiantly yellow head, surmounted with a crown of thorns not mentioned in the text. Before him the dead appear to be judged, "every man according to their works." Their flesh is mostly grayish pink in color; they wear shrouds.

25
Full Page. VG 353.

Here Max Beckmann illustrates for the second time a passage from the text which speaks of

17 Revelation 14:13-16: *Blessed are the dead...*

18 Revelation 15:1 and 16:1: *The last seven plagues*

19 Revelation 16:2:...
the men which had the mark of the beast...

divine consolation (compare VG 338). Concerning the vision of the Heavenly Jerusalem, John writes that God will then be with the people, "And God shall wipe away all tears from their eyes; and there shall be no more death, neither sorrow nor crying, neither shall there be any more pain..." (Revelation 21:4). The artist has taken these words quite personally, by portraying himself as one of those whose tears are being wiped away by the angel of God. This is probably the reference for the diary entry of December 31, 1941: "visit of the angel of death." The angel is pictured in a golden robe, with blue wings. Behind him, in a vision of light encircled by a rainbow, there appears the light blue sea, the light green sky, and unusual stars. They refer to the opening

20 Revelation 17:1-2:
The kings fornicate and drink with the great whore Babylon

words of the chapter: "For I saw a new heaven and a new earth; for the first heaven and the first earth were passed away; and there was no more sea."

26
Full Page. VG 354.

On the last large page, "one of the seven angels which had the seven vials full of the seven last plagues" (Revelation 21:9) shows John a vision of the messianic Jerusalem. Again Beckmann has pictured himself as John, whose closed eyes are filled with an inner vision. A superter-restrial phenomenon, the angel is contrasted to John not only by his radiant gaze, but also through his very light, tender coloration in pink and white, setting off John's figure in brown. The sea looms large in the background, obviously intending a reference to the words: "And he showed me a pure river of water of life" (Revelation 21:1). This is the promise of a redeemed human existence soon to come: "And there shall be no night there, and they need no candle (which John/Beckmann still needs here), for the Lord God giveth them light: and they shall reign for ever and ever" (Revelation 22:5).

27
Partial Page. 110 x 205 mm. VG 355.

After the previous picture proclaiming a new life, Beckmann creates this vignette-like clos-ing scene. The great blossoms against the light blue water in the background refer once again to the "water of life" (Revelation 21:17). The symmetrical trinity of the unusual stars against the purple sky contrasts with the living plants and appears like a seal of inevitability placed on the spoken word. And yet it is also like a cosmic cell which will bring forth a new world.

Beckmann conceived the lithographs as a varied series of full-page and small illustrations woven into the text. Special pictures occur at the beginning and end; in between, there are climaxes, but also many illustrations of less sig-nificance. Thus, the illustrated *Apocalypse* as a whole has its own form, whereby it enlivens both the reading of the text and the viewing of the pictures.

Beckmann's imagination is revealed in the way he dealt with the text. In some of the illus-

21 Revelation 17:3-6:
The great whore upon the beast

22 Revelation 18:14: . . .
the fruits that thy soul lusted after . . .

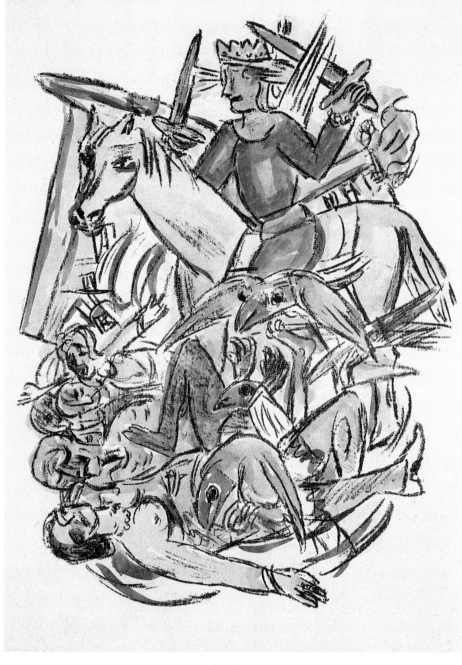

23 Revelation 19:11-21:...

and all the fowls were filled with their flesh

24 Revelation 20:11-13: *The Last Judgment* ▷

trations he keeps strictly to the written word. In others, he combines disparate textual excerpts, or uses the text as the basis for the development of his own ideas. Whenever he begins with an image taken from one of John's visions of picturesque narratives, he changes it in a more or less drastic way. He always creates his own images, based on the meaning of the text. This is a particularly difficult task in the case of the most powerful of the visions, where the image created by the words themselves is so detailed and so rich, that the artist is hard pressed to achieve an adequate representation. The appropriateness of showing only an essential part, rather than the whole, of such a vision, is demonstrated by the image of the Messiah (VG 330), in which supernatural radiance and divine power have found an extremely succinct and meaningful form.

However, Beckmann not only made use of the various images of the visions, he also took literally the verbal imagery of the text —"crown of life", "water of life", "great whore"—and the abstract concept: "no time." By transforming the pictorial element of these allusions and descriptions into the basic data of images, he created for them a reality of such intensity that their allegorical meaning actually recedes. Dürer's illustrations are no different in this respect.

The commission to illustrate the Apocalypse provided Beckmann with a fresh opportunity for graphic work after a lapse of many years. The artist began his prinkmaking career in ca. 1900, and between 1914 and the mid-1920s numerous prints appeared, becoming a vital means of representation for Beckmann. He had, however, produced little graphic work since then. As a result of his ostracism and exile, Beckmann's opportunities to sell his work were greatly reduced. In 1937 Stephan Lackner commissioned illustrations for his book, *Man Is Not A Domestic Animal* (VG 322-328) with the intention of helping Beckmann financially, just as later Georg Hartmann would commission his illustrations for the Apocalypse. In both works Beckmann harks back to the series of his earlier illustrations; only the lithographs for Johannes Guthmann's *Eurydice's Return,* 1909 (VG 5-14); Dostoevski's *Prisoners' Bath,* 1913 (VG 38-46); and the etchings for Brentano's *Fanferlieschen,* 1924 (VG 290-297) will be mentioned here. Beckmann, extraordinarily well-versed in literature, was thus well acquainted with the art of illustration when he began the lithographs for the Apocalypse. Still, the commission was something new for him because it required colored prints. Aside from a few prints on colored papers, Beckmann had not executed colored prints before. There are, of course, a few hand-colored etchings and at least one hand-colored woodcut from the 1920s (cat. 286), but these were individual sheets for private purposes; the public editions remained uncolored.

It is obvious that from the beginning the *Apocalypse* was conceived in color. A comparison of the black and white lithographs with the colored ones shows that unlike the corresponding graphics of the 1920s, color is an essential, necessary component of these pictures. The *Apocalypse* illustrations thus have a doubly

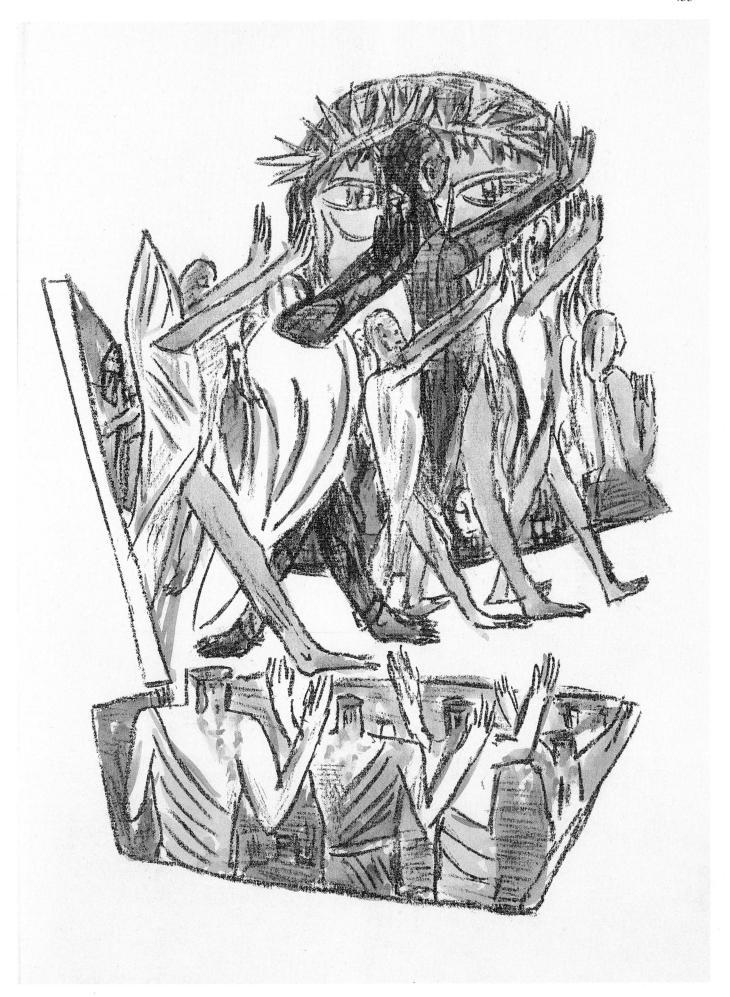

close relationship to Beckmann's paintings of the same period. On the other hand, the far more graphically conceived illustrations for *Faust* of 1943/44, despite certain affinities to *Apocalypse,* are clearly a return to the graphic work of the 1920s.

As with all his works, Max Beckmann related the images of the Apocalypse to himself. He is John, to whom the visions of the destruction of this world and the rise of a new world appear. But he also stands for those who suffer affliction, poverty, and abuse, those to whom the crown of life is promised, and those whose tears shall be wiped away. The artist's thoughts had always been directed towards immortality and redemption, towards the apocalyptic dawning of a new world. The *Apocalypse* illustrations offered him a unique opportunity to create pictures in which his plight and his hope could stand for the plight and hope of humanity at large. He was only able to do so because he was distinguished from his fellow human beings by his ability as an artist to see and to testify to what he saw —like John. C.L.

26 Revelation 21:1 : *And he showed me a pure river of water of life…*

27 Partial page, the end of the text

25 Revelation 21:4 :
◁ *And God shall wipe away all tears*
from their eyes

295 Self-Portrait 1946,
plate 1 from *Day and Dream*

Transfer lithograph; 32 x 26.5 cm.
VG 356; Gallwitz 289; not in Glaser
S.L.L.: 57/90
S.L.R.: Beckmann
St. Louis, The Saint Louis Art Museum,
Gift of the Buchholz Gallery

The *Day and Dream* portfolio, Beckmann's
last major printmaking endeavor, contains 15
lithographs. It was commissioned by his New
York dealer, Curt Valentin, and intended for
an American audience since discussions were
already underway to bring Beckmann to
America. While the primary force behind the
venture was to promote Beckmann's reputa-
tion in America, the content was solely Beck-
mann's creation. The original drawings for the
lithographs are in the collection of the Library
of Congress, Washington, D.C.

No one central theme is apparent in this
series: rather, one sees a combination of
figures and symbols which Beckmann utilized
throughout his career. In a letter to Curt Val-
entin (Museum of Modern Art Library files),
Beckmann suggests that the motifs might be
Biblical, mythological, theatrical, or relating to
circus or café life. Indeed, he says, it could be
an "all-in-one thing," for which he could easily
find a title. (Karen F. Beall, "Max Beckmann
Day and Dream," *The Quarterly Journal of the
Library of Congress,* January, 1970, p. 8). The
first title for the series was Time-Motion, but it
was later changed.

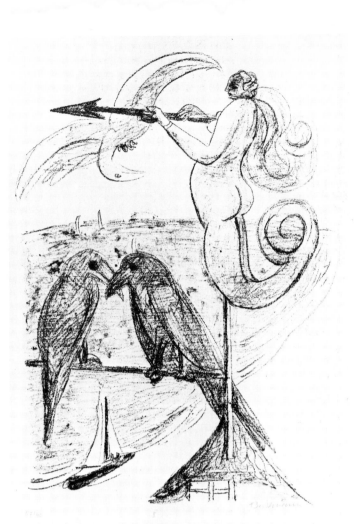

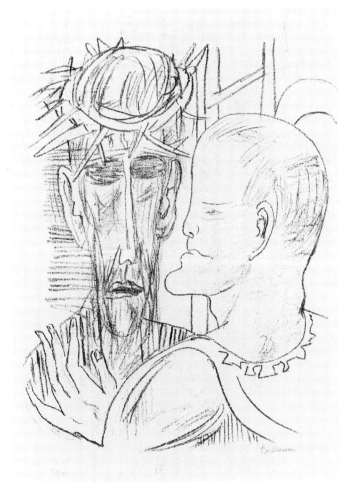

296 Weathervane 1946,
plate 2 from *Day and Dream*

Transfer lithograph; 37 x 27.5 cm.
VG 357; Gallwitz 290; not in Glaser
S.L.L.: 57/90
S.L.R.: Beckmann
St. Louis, The Saint Louis Art Museum,
Gift of the Buchholz Gallery

297 Christ and Pilate 1946,
plate 15 from *Day and Dream*

Transfer lithograph; 35 x 27.5 cm.
VG 370; Gallwitz 303; not in Glaser
S.L.L.: 57/90
S.L.R.: Beckmann
St. Louis, The Saint Louis Art Museum,
Gift of the Buchholz Gallery

Appendix

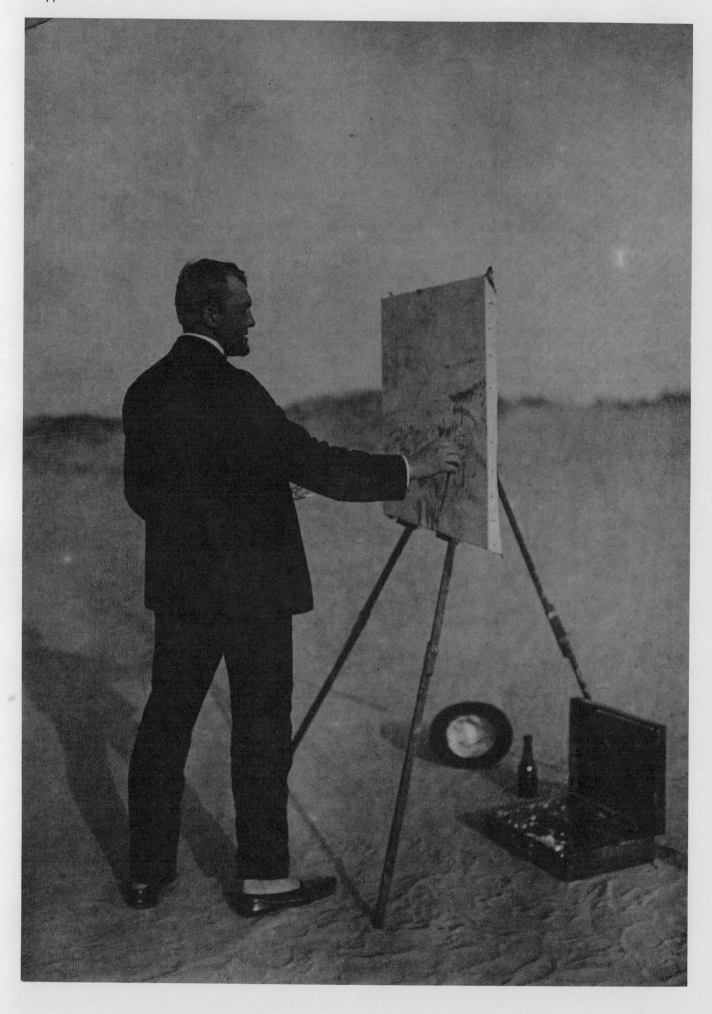

Doris Schmidt

Biography

Fig. 1 The Beckmann family's house in Leipzig (1891-1894), Rosenthalgasse 12/III

◁ Max Beckmann, painting on the Baltic Sea, 1907

Fig. 2 Max Beckmann: *Portrait of Beckmann's Mother*, 1906, Private collection

Fig. 3 Max Beckmann at confirmation

1884

Max Beckmann is born in Leipzig on February 12th. Both his parents, Carl Heinrich Christian Beckmann (1839-1894) and Antonie Henriette Bertha Düber (1846-1906), came from farming families in the region of Braunschweig. The Beckmanns lived in Braunschweig until 1880, where Carl Beckmann worked as a real estate agent and flour merchant. When the family moved to Leipzig, Carl Beckmann worked in a laboratory, experimenting with artificial meerschaum. The Beckmanns had two older children, Grethe and Richard.

1892

Max Beckmann attends school in Falkenburg in Pommern while living with his married sister, Grethe Lüdecke.

1894

Carl Beckmann dies. Beckmann's mother moves back to Braunschweig with both sons. Max attends several schools in Braunschweig and Königslutter. During class, he prefers to draw, rather than study his lessons. At a strict private boarding school in Gandersheim, Max Beckmann arranges that his comrades pose for him. In exchange he gives them the food sent to him by his mother to alleviate the terrible boarding school fare. Finally, Beckmann runs away and returns to his mother. He does not pass the middle examination, so-called the "Einjährige;" later he prepares for it at the academy in Weimar, but finally passes it in Braunschweig.[1] The triptych, *The Beginning,* 1946-49, reflects some of his memories of his childhood and school days.

1895

Beckmann paints a watercolor of the fairy tale in which a king asks a little shepherd how many seconds eternity has. The little shepherd replies "In lower Pommern is a diamond mountain . . . every hundred years a tiny bird comes to it and sharpens his tiny beak on it,

1. Recollections of Minna Beckmann-Tube, unpublished.

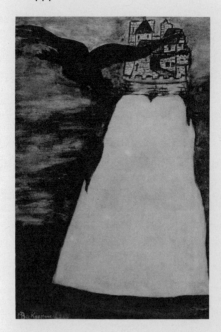

Fig. 4 Max Beckmann: *Diamantberg,*
watercolor, ca. 1896, Private collection

Fig. 5 "Nature" class of Frithjof Smith at the
Kunstakademie in Weimar, 1902. Beckmann is
sitting to the left of Smith.

and when the entire mountain is completely sharpened, then the first second of eternity
is passed." The watercolor is dominated by a violet sky and dark brown landscape rather
than the white diamond mountain. As a child in Leipzig, Beckmann trades his box of tin
soldiers for his friend's watercolor set, because the colors fascinated him. His mother
makes him return the set.[2]

1897

Beckmann paints his first self-portrait (dated 1899 by Göpel). Around this time, he
reads about the Amazon river and applies for a position as a cabin steward with a
shipping firm, but is rejected because of his young age. The important themes of his life's
work are already formulated in his childhood: eternity, an interest in mankind, ques-
tioning individual self in his self-portraits, and the desire to explore the foreign cultures
of the world.

1899

Beckmann applies for admission to the Dresden Academy, but is rejected because he
added extra details on his examination drawing after a plaster cast of a Greek statue.[3]

1900

Beckmann is admitted to the art school in Weimar; he is placed on probation in late
June in Otto Rasch's antique class. On October 10th, he is conclusively admitted.

1901

He completes his first etched *Self-Portrait* (cat. 210). In April Beckmann enters the
'nature' class of the Norwegian Frithjof Smith (1859-1917) who teaches him the method
of sketching directly on the canvas with charcoal. Beckmann meets fellow classmate Ugi
Battenberg (1879-1957), with whom he continues a lifelong friendship.

1902

Beckmann receives a diploma with commendations from the Weimar Academy in draw-
ing. At a school carnival party he meets his future wife, Minna Tube (1881-1964) who
was the daughter of a head military clergymen, Dr. Paul Friedrich Abraham Tube, and
Ida Concordia Minna (nee Römpler) Tube. Ida Tube, "Buschchen" as Beckmann often
called her, was portrayed several times by the artist. Minna Tube had studied with
Heinrich Knirr and later studied under Christian Landenberger at the Munich
Academy. In Weimar, she studies with Hans Olde; in Berlin she studies with Lovis
Corinth from 1903-04.

2. Mathilde Q. Beckmann, *Mein Leben mit Max
Beckmann,* Munich, 1983, p. 111 ff.

3. *ibid.,* p. 116.

Fig. 6 Max Beckmann: *Minna Tube*, mid-December 1903, pen and ink drawing in Beckmann's diary, Private collection

Fig. 7 Max Beckmann on the balcony of the apartment of Mrs. Minna Tube in Berlin, Pariserstrasse 2, 1904/05

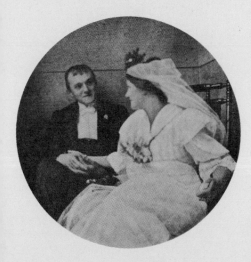

Fig. 8 Max Beckmann and Minna Beckmann-Tube on their wedding day on September 21, 1906 in Berlin

4. Max Beckmann, *Sichtbares und Unsichtbares,* edited by Peter Beckmann, Stuttgart, 1965, p. 46.

1903

Beckmann and Minna Tube leave the academy on October 19th. He moves to Paris, setting up a studio on the rue Notre Dame des Champs 117. There he paints his largest painting to date—a horseman, in pointillist manner. It is never completed, and Beckmann finally cuts it into pieces. He is deeply impressed by the work of Cézanne. In December, he visits Minna Tube in Amsterdam where she is copying paintings by Rembrandt and van der Helst. Throughout the year, Beckmann records what he has read in his journal: works by Keller, Maupassant, Prévost, Goethe, Maeterlinck, Kant and Nietzsche. One journal entry for August 29, 1903, in Weimar, clearly delineates the skepticism and irony typical in his later conception of the World-Theater: "A logical, dull sober going-away party is imminent. A grotesque swearing of friendships with so many exaggerated good wishes on all sides for later years. Oh my, we are so magnanimous. Oh, I must laugh, it's all so stupid, these rigid politenesses. With so much lamentable self-observation and not a moment of craziness... I will even, after I have delivered a parting speech with full dignity and almost developed maturity, depart again with a broken heart, there I see myself already sitting on the train with two heavy creases of worry on my brow, the view quickly running by, a melancholy gray landscape, mild sentiment of the pain and self-irony in my breast, in short, all of the scenes which are necessary for this sequence of little dramas. Moreover, we play the usual roles well, so that in the end, some sort of style will result. It is, after all, the style that counts."[4]

1904

Beckmann remains in Paris until the end of March, travelling through France, Geneva, and Frankfurt and arriving in Berlin on April 28, where he again meets Minna Tube. He spends the summer at the seaside, painting many seascapes and landscapes. In the fall, he moves to Berlin-Schöneberg, 103 Eisenacher Strasse.

1905

Beckmann paints *Young Men by the Sea* (fig. p. 113), recorded as the first notation in his painting register, which he keeps from now on. Beckmann uses the signature "HBSL" (Herr Beckmann seiner Liebsten—to his beloved) for the first time on this work. He also uses "MBSL" (Max Beckmann seiner Liebsten—to his beloved). His beloved is Minna Tube. The signature "HBSL" is used for the last time in 1913 on the painting, *Nativity*. This year, Beckmann also paints twelve landscapes and seascapes, amongst them *Sunny Green Sea* and *Large Gray Waves* (cat. 3 & 4).

1906

Beckmann receives the prize of honor from the German Künstlerbund in June for *Young Men by the Sea*. The prize includes a scholarship at the Villa Romana in Florence. The Grossherzogliches Museum für Kunst und Kunstgewerbe in Weimar acquires the painting.

Beckmann exhibits for the first time at the Berlin Secession and continues to do so until his withdrawal in 1913. He also receives portrait commissions in Niebusch in Schlesien by Kurt von Mutzenbecher and Hedwig von Schmeling.

He paints *Large Death Scene* (cat. 5), *Small Death Scene* (cat. 6), and *Drama,* a crucifixtion scene, which is later destroyed by fire in a 1943 air attack on Cologne.

Beckmann's mother dies of cancer in the summer. In late September, Beckmann marries Minna Tube. As of November 1, the Beckmanns are in Florence at the Villa Romana.

In this year, Beckmann reads *Parerga und Paralipomena* which initiates his life-long fascination with Arthur Schopenhauer, who greatly influenced Beckmann's own philosophy.

1907

One of the paintings produced in Florence is the *Self-Portrait in Florence* (cat. 8). After his return to Berlin, he paints *The Battle* (fig. p. 17).

The Beckmanns build a house in Berlin-Hermsdorf, at Ringstrasse 8. They vacation

that summer on Vietzker beach on the Baltic Sea at the home of the Pagels. He paints portraits of Herr and Frau Pagel.

In March, there is an exhibition at the Grossherzogliches Museum für Kunst und Kunstgewerbe in Weimar, entitled "Georg Minne—Max Beckmann," which includes 18 paintings by Beckmann. He also exhibits at the "First German National Art Exhibition" in Düsseldorf, the Berliner Sezession in Berlin, and Paul Cassirer's gallery in Berlin.

Fig. 9 Max Beckmann: "*Le Début*—To My Dear Minkchen," Portrait of Minna Tube, graphite, April 22, 1906, Private collection

1908

Beckmann's son, Peter, is born on August 31.

The major works of this year are: *Conversation (Company* I) (cat. 7), *Lamentation, Mars and Venus, The Flood* (fig. p. 72), *Three Women in the Studio, Portrait of Countess Augusta vom Hagen.* Beckmann exhibits at the Berlin Sezession and Paul Cassirer's gallery in Berlin, the Kunstpalast ("Grosse Kunstausstellung") in Dresden, and the Kunsthalle ("Deutsche Kunstausstellung") in Bremen.

Max Liebermann (and not Edvard Munch, as is often assumed) encourages Beckmann to continue with the artistic style he began in *Large Death Scene*, 1906.

Beckmann converses with painters Waldemar Roesler and Wilhelm Schocken, forming a "Neue Sezession" and breaking away for the Berlin Secession. On December 27th, Beckmann reports in his journal a conversation about the work of Hans van Marées. "Relative to Hans von Marées, who was for the moment so very much acclaimed, I endorsed a strong individualization of figures and for this reason, placed Böcklin higher as an artistic principal since he would have understood how to make his figures more naively and powerfully lifelike, whereas the figures of Marées would be for me far too much the intentional carriers of lines, light and shadows, and would be therefore too abstract for me; a certain aesthetic quality but not necessarily so directly an individualized feeling for life as many of the intentions of Böcklin. To say nothing, of course, of Rubens and Rembrandt. I compared Marées with Stefan George. Both not vulgar enough. Schocken and Roesler shared to a certain degree my opinion. Only Schocken demurred. Naturally I acknowledge the justification of the Marées artistic concept, yet it still seems to me to belong to a special artistic world which at the moment doesn't correspond with my own painterly intentions and my sensibility for the particularized individual life."[5]

Fig. 10 Max Beckmann and Hans Purrmann in Florence, 1906

1909

Major works: *Resurrection* (fig. p. 85); *Feast; Scene from the Destruction of Messina; Double Portrait, Max Beckmann and Minna Beckmann-Tube;* and *The Crucifixion.* The first series of lithographs, illustrations for *Eurydice's Return* by Johannes Guthmann, are published by Paul Cassirer in Berlin.

The Flood, Shipwreck, Resurrection, and *Scene from the Destruction of Messina* are shown in an exhibition at the Berlin Secession where they are negatively criticized. Beckmann is represented at the International Art Exhibition in the Glaspalast in Munich. He also exhibits for the first time at the Salon d'Automne in the Grand Palais, Paris.

On January 9, 1909, after a visit to an exhibition of Chinese art, Beckmann writes in his journal "My heart beats more for a raw average, vulgar art, which doesn't live between sleepy fairytale moods and poetry but rather concedes a direct entrance to the fearful, commonplace, splendid and the average grotesque banality in life. An art which can always be present in the reality of our lives."[6] This attitude is still evident in a 1912 statement by Beckmann about his primary concerns in art during a controversial exchange with Franz Marc; the statement was published in *Pan:* "It is written in all of Cézanne's work, that his genius was largely coloristic, and the agony of his life was that he was not able to give a strong enough impression to the artistic essentials—a spacious working of depth and with it a feeling of plasticity. I myself revere Cézanne as a genius. He was able in his paintings to give expression in a new manner of the mysterious sensation of the world which before him animated Signorelli, Tintoretto, Greco, Goya, Géricault, and Delacroix. When things went well for him, he had only to thank his own efforts, his coloristic vision of artistic objectivity and his feeling for space, and his ability to establish them as principles of painting. Only in this way did he escape from the dangers of professional superficiality."[7] Beckmann holds artistic objectivity and space as

5. Max Beckmann, *Leben in Berlin,* edited by Hans Kinkel, 2nd edition, Munich, 1983, p. 6.

6. *ibid.,* p. 22.

7. Max Beckmann, "Gedanken über zeitgemässe und unzeitgemässe Kunst," A response from Max Beckmann in *Pan,* II, 1912, p. 499-502.

8. Max Beckmann, "Das neue Programm," *Kunst und Künstler,* XII, 1914, p. 301.

the fundamental laws of painting. He differentiates two directions in art: the easy and stylized decorative qualities, and the penetration of space. "For my part, I follow with my whole soul the art of inner space and seek to achieve my own style. In contrast to the overly decorative art, I want to penetrate nature and the soul of everything as deeply as possible. That so many of my sensibilities are already in existence, I know full well. I also know and I am fully aware of a new feeling and a new spirit in my own time. This I do not want and cannot define. It is in my paintings."[8]

1910

Beckmann finishes *The Descent of the Holy Spirit* begun in 1909. Other large figure compositions that are painted this year are *The Prisoners,* and *Christ Announces His Last Departure for Jerusalem.*

Beckmann is the youngest member nominated to the board of the Berlin Secession. His work is exhibited in Berlin, Bremen, Darmstadt, Dresden, Leipzig, and Munich.

In June Beckmann vacations at Wangerooge, where he meets Wilhelm Giese, whom he knows from Weimar Academy days. He stays in Bad Nenndorf, near Hannover, to paint.

The Beckmanns live during the winter in a studio in Berlin, Haus Nollendorfplatz 6, from 1910-1914.

1911

Major works: *The Carrying of the Cross, Company 11, Battle of the Amazons* (cat. 11), and *Portrait of Hanns Rabe.* Rabe was a doctor in Berlin, and an early collector of Beckmann's work.

Beckmann exhibits work in Berlin, Dresden, Leipzig, Düsseldorf, and Magdeburg.

Beckmann begins his associations with Israel Ber Neumann in Berlin who publishes his graphic works. Neumann also takes over the publication of the *Six Lithographs for the New Testament,* which were first published on Japanese paper by E. W. Tieffenbach in Berlin, in 1911.

1912

In this year, Beckmann paints *The Sinking of the Titanic* (cat. 12) based on newspaper accounts of the catastrophe. Nine lithographs based on Dostoevski's "House of the Dead" were produced with the title *The Bath of the Convicts.* Until 1912, Beckmann has used primarily lithography for his graphic works, with the exceptions of the two etched self-portraits of 1901 and 1914.

In 1912, Beckmann had his first one-man shows: in Magdeburg at the Artists Association (32 paintings), and in Weimar at the Grossherzogliches Museum für Kunst und Kunstgewerbe (28 paintings: an overview of his work from 1905-1912). He also participated in exhibitions in Amsterdam and Vienna. *Battle of the Amazons* (cat. 11), *The Lovers,* 1912, and *Portrait of Hanns Rabe,* 1911 are exhibited at the Berlin Secession.

Beckmann has his first encounter with the Munich publisher, Reinhard Piper, who visits him in Berlin. He meets Ludwig Meidner and is also visited by the Hamburg collector Henry B. Simms. In May he goes to Helgoland. In November he goes to Davos to paint a portrait commissioned by Karl Simms. His controversy with Franz Marc is published in *Pan* (see 1909).

In 1912, an advertisement "School for modern painting—Steglitzer Strasse Nr. 27—artistic instruction by Max Beckmann" appears in the catalogue of the Berliner Sezession, Nr. 26 and is repeated in 1913. It is not known whether Beckmann had done any teaching before Frankfurt.

1913

Beckmann produces such forceful and expressive paintings as *Falling Bicycle Rider* (fig. p. 75), *Couple on the Beach, Nativity,* and various scenes of Berlin street life. He often travels to Hamburg, where he paints *Portrait of the Simms Family,* and a portrait of Jeanne Kaumann, daughter of the collector Albert Kaumann.

In January and February, he has a large one-man retrospective with 47 paintings at Paul Cassirer's gallery in Berlin. Hans Kaiser writes the first monograph on Beckmann, published by Paul Cassirer. Beckmann participates in an exhibition at The Art Institute

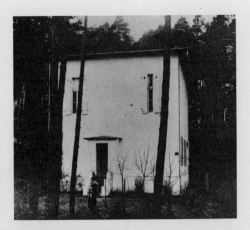

Fig. 11 Beckmann's house in Berlin-Hermsdorf, Ringstrasse 8

Fig. 12 Max Beckmann in front of *Resurrection I,* 1909 in the Berlin-Hermsdorf studio

Fig. 13 Max Beckmann: *Double-Portrait of Max Beckmann and Minna Beckmann-Tube,* 1909, Halle/Saale, Staatliche Galerie Moritzburg

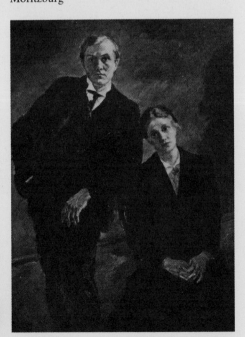

of Chicago on "Contemporary German Art," (exhibiting the lithographic series *Eury-dice's Return,* 1909, and *Six Lithographs for the New Testament,* 1911). He also exhibits 20 paintings at the Kunstsalon Wolfsberg in Zürich. At the Berlin Secession, *Sinking of the Titanic,* 1912 and *Portrait of the Simms Family* are exhibited. He takes a summer trip to Italy via south Tyrol and briefly stays in the house of Simms in Klobenstein. At the end of August he is in Venice.

Beckmann, along with many other artists under the leadership of Max Liebermann, leaves the Berlin Secession. In the fall, those who withdrew exhibit at the Kurfürsten-damm. Beckmann is a member of the exhibition committee and the jury. Eleven of his paintings are shown.

1914

Main Works: *The Street* (cat. 14) and *In the Automobile* (fig. p. 95), both of which portray the Beckmanns with their son Peter: *View of the Gesundbrunnen Station,* (fig. p. 95), *Still-Life with Lilacs, Still-Life with Red Roses.*

Beckmann is nominated to the Board of the new Berliner Freie Sezession. He is also a corresponding member of the Munich Neue Sezession. He participates in the annual exhibitions of both organizations and continues to do so in subsequent years.

After the outbreak of World War I, he accompanies one of Countess Hagen's organized "comfort transports" to the Baltic sea. In late fall he was a volunteer nurse in East Prussia, then returns to Hermsdorf.

Beckmann's brother-in-law, Martin Tube, dies (cf. cat. 223).

Several of Beckmann's etchings in 1914 displays impressions of the War: soldiers, war deeds, operating rooms, life behind the lines, and brothels. There are also portraits of friends and self-portraits which depict a changed self and men put to the test of time. The theme of "The Night" appears for the first time as an etching of a death scene (cat. 225) which seems to be a preview of the painting *The Night,* 1918-19 (cat. 19).

Fig. 14 Max Beckmann on horseback, Hamburg, Harvestehuder Weg, 1913

1915

Beckmann is a volunteer medical orderly in Belgium. He works in a hospital, then later in an operating room in Courtrai. At the end of March, on a commission from the chief doctor, Professor Kuhn, he paints the mural in Wervicq (Riders with Lances) in the bathhouse of Field Hospital 9, which is later destroyed in the war. He then travels to Lille, Brussels, Ghent, and Ostende, where he meets Erich Heckel who is a medical orderly there.

Beckmann receives a commission to illustrate the book of war songs of the XV Army Corps. The 13 pen drawings from the book are displayed at Paul Cassirer's publishing house in Berlin.

Beckmann suffers a collapse in July and is sent back to Strassburg. In October, after he is given a leave of absence from medical service, he goes to Frankfurt where he lives with his friends, Ugi and Fridel Battenberg, at Schweizerstrasse 3. During this time, *Self-Portrait as Medical Orderly* (cat. 15) is painted in Strassburg, and *Company* 111, *Family Battenberg* (fig. p. 58) is painted in Frankfurt. His etchings mirror increasing disabilities and insecurities developed during the war.

Minna Beckmann-Tube, who had already begun singing lessons in 1906, resumed them in 1912, is engaged by the opera in Elberfeld. Beckmann writes to her in mid-December from Belgium, "I am so happy that you have the opportunity to let your lovely voice be heard and be able to feel even more yourself, since after all, that is what art amounts to. Self-gratification. Naturally in its highest form. Sensations of exist-ence..."[9]

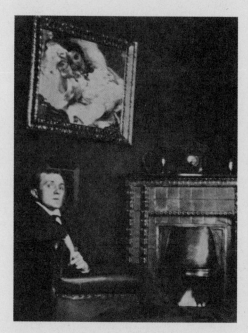

Fig. 15 Max Beckmann in the Kaumann home, Hamburg, 122 Harvestehuder Weg, 1913

1916

Still on leave in Frankfurt, Beckmann paints *The Defendants* and *Resurrection* (fig. p. 83) which is never completed. On *Resurrection* he wrote the word "Zur Sache" (to the matter at hand). This painting reflects a full transformation in his work in which reality is fused with vision. He coins the phrases "transcendental objectivity" and "objectivity to inner vision"—notions which seem to be two sides of the same coin.

In the World Theater henceforth, the spectator's role is no longer of interest to him. Beckmann is concerned now entirely with his own existence, although this does not rule out a critical and ironic distance.

9. Max Beckmann, *Briefe im Kriege,* Munich, 1955, p. 34-35.

Fig. 16 Max Beckmann: *Ypern*, 1915, tusche drawing, Private collection

Fig. 17 Max Beckmann in the home of Dr. Hermann Feith, Wolfgangstrasse 51 in Frankfurt, with Ugi and Fridel Battenberg and the Feith daughters, Eva and Beate, 1916 or 1917

Fig. 18 Max Beckmann: *Portrait of Walter Carl*, etching, 1917

His etchings show the psychic damages of those years more clearly; the self-portraits serve to reassure and claim the self.

In Frankfurt, Beckmann makes several new friends: the antique dealer, Walter Carl (Fridel Battenberg's brother) and his wife Käthe, his first collectors here; Major Fritz von Braunbehrens, who later arranged for Beckmann's dismissal from the medical corps, and his daughter Lili von Braunbehrens; and Kasimir Edschmid.

Beckmann's *Briefe im Kriege*, collected and somewhat abbreviated by Minna Beckmann-Tube, are published in a book by Bruno Cassirer. The letters mirror the hardships Beckmann was exposed to: "I have just been to the Feste B, something which for a civilian is otherwise very difficult. It's a wild and curious life that I'm leading, nowhere have the unspeakable contradictions of life been clearer." (24.9.1914)

"...my will to live is for the moment stronger than ever, even though I have already experienced dreadful things and died myself with them several times. Yet the more one dies, the more intensely one lives. I have been drawing, that protects one from death and danger." (3.10.1914)

"I myself vacillate continuously between great joy at every new thing which I see and depression over the loss of my individuality and feelings of profound irony about myself and occasionally the world. In the long run, it exhorts me to further admiration. Its capacity for variation is indescribable and its capacity for invention is without boundaries." (2.3.1915)

"I went across the fields (to avoid the straight highway) along the firing lines where people were shooting at a small wooded hill, which now is covered with wooden crosses and lines of graves instead of spring flowers. On my left the shooting had the sharp explosion of the infantry artillery, on my right could be heard the sporadic cannon shots thundering from the front, and up above the sky was clear and the sun bright, sharp above the whole space. It was so wonderful outside that even the wild senselessness of this enormous death, whose music I hear again and again, could not disturb me from my deep enjoyment." (28.3.1915)

"The circular trembling aperture of the French and Belgium floodlights, as if a transcendental airplane, and the nervous uninterrupted infantry firing and the amazing apocalyptic sound of the giant cannon accompanied me always in the sky. A rider at full gallop in the dark, large rats going back and forth out of the muddy graves along the road, creatures like young cats who accomplished the useful work of burying the corpses laying before the trenches. How curious it is, how the often cursed and lamented life of peace is now with iron logic promoted to paradise." (5.4.1915)

"I amuse myself often with my own idiotic tenacious will to live and for art. I worry about myself like a loving mother, I vomit, retch, push, force, I must live and I want to live. I've never kneeled before God or anyone else in order to have success, but I would make my way through all the sewers of the world, through all the degradations and desecrations in order to paint. I must do that. This I must do until the last drop of imagination to create form that lives in me is gone; then it will be a pleasure to get rid of this damned torment." (26.4.1915)

"I'm always working on form. In drawing, in my mind, and in my sleep. Sometimes I think I will go mad, from all this tiring and tormenting lust. Everything else is swallowed up, time and space, and I always wonder how you paint the head of the resurrected

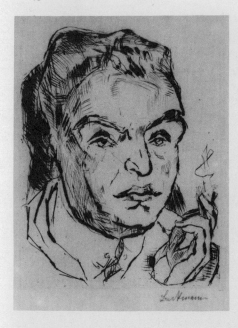 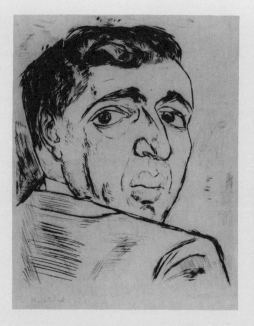

against the red constellations of heaven on Judgment Day? Or how do you manage to blend together the mustache of the petty officer with his red nose as a life-like ornament, or how will you now paint Minkchen (Minna), her knees drawn up and head resting on her hand against the yellow wall with its pink reflection, or the glittering light which reveals itself in the blinding white of the air grenades against the sky, leaden white from the sun, and the wet sharp, pointed shadows of houses, or, or... What I've done up to now, was merely an apprenticeship, I'm still learning and expanding myself... In my own life, painting devours me. Poor pig that I am, I can only live in dreams." (11.5.1915)

"Since I have been under fire I live through every shot again and have the wildest visions. The sketches for plates which I want to etch accumulate like victories in Galicia." (14.5.1915)

1917

Major Works: *Portrait of Max Reger* (fig. p. 24), commissioned by Simms, probably painted from a photo; *Deposition* (cat. 17) already in the Städelsches Kunstinstitut by 1918 and purchased by the Städtische Galerie in Frankfurt by Georg Swarzenski in 1919; *Christ and the Woman Taken in Adultery* (cat. 18) acquired by Fritz Wichert for the Städtische Kunsthalle in Mannheim; *Self-Portrait with Red Scarf* (fig. p. 54, 102); *Adam and Eve;* six etchings; and the title page to Kasimir Edschmid's "The Princess." Two etchings refer to parts of the large *Resurrection* of 1916.

Beckmann had a one-man show in Berlin at the I.B. Neumann Gallery of 110 prints and 100 drawings. He also participates in group exhibitions at the Munich Neue Sezession, the Ludwig Schames Gallery in Frankfurt, the Kunstverein in Frankfurt, and at the Kunsthaus in Zürich in a show entitled "German Painters of the 19th and 20th Centuries."

In Frankfurt in July Beckmann is visited by I.B. Neumann and Reinhard Piper. Later he writes to Piper, "I will paint four large paintings (similar to *Resurrection*) and build for them a modern *devotion hall.* Wilhelm II will surely not think much of my art. So I hope for a new German republic. In short, as you see, I am once again excessively ambitious. I'll not exhibit anything for three years. So much must be done before. Above all else, I'll have Frau Battenberg play Bach to me, the large Toccata for organ. The St. Matthew Passion is the most colossal piece in the world."[10]

1918

Major works: *Portrait of Käthe and Walter Carl, The Night* (cat. 19), and twelve etchings for the series *Faces* (cf. cat. 230-233, 239, 242-244, 246). Gustav Kiepenheuer, Weimar, publishes "The Princess" by Kasimir Edschmid that includes the etchings by Beckmann from 1917. In the *Tribüne der Kunst und Zeit* edited by Kasimir Edschmid, *Bekenntnis*

Fig. 19 Max Beckmann: *Portrait of Kasimir Edschmid,* etching, 1917

Fig. 20 Max Beckmann: *Portrait of I.B. Neumann,* etching, 1919

Fig. 21 The author Benno Reifenberg, late 1940s in Frankfurt am Main

10. Reinhard Piper, *Mein Leben als Verleger—Vormittag, Nachmittag,* Munich, 1964, p. 320.

11. Max Beckmann, "Schöpferische Konfession," *Tribüne der Kunst und Zeit,* Berlin, 1918.

Fig. 22 Max Beckmann in the Schweizerstrasse studio in Frankfurt, early 1920s

1918 appears under the title "Schöpferische Konfession: " "My form is my painting and therewith I am content, since I am in reality tongue-tied before nature, and at the very most an interest in something can force me to torment something out of myself. Today, where I with astonishment so often observe verbally astute painters, I often become lightheaded because my poor mouth cannot possibly formulate beautiful and vibrant words for my inner enthusiasm and my burning passion to things in the visible world. But in the end I am able to calm myself by saying you are a painter, do your handwork and let talk he who can talk." [11]

Minna Beckmann-Tube is engaged by the Opera in Graz. In the next few years Max Beckmann travels frequently to Graz.

1919

Beckmann completes *The Night* (cat. 19). He also paints *Women's Bath* (cat. 20), *Portrait of Frau Tube, Self-Portrait with Champagne Glass* (cat. 22) and *The Synagoge* (cat. 24). *Hell,* ten lithographs with one title page, is published by I. B. Neumann in Berlin (cat. 247-257). In June, an exhibition of Beckmann's recent works at the Frankfurter Vereinigung für Neue Kunst is organized by the book dealers, Tiedemann & Uzielli. Beckmann declines the offer of the position of professor of the Weimar Art School to teach a class on nudes.

Beckmann becomes a founding member of the Darmstädter Sezession, formed under the leadership of Kasimir Edschmid.

He spends the early summer in Berlin.

Beckmann lives temporarily in Frankfurt in the Westendstrasse 27 (at the Hänsel's) and from May to June in the home of Heinrich Simon *(Frankfurter Zeitung)* at Untermainkai 3, where Benno and Maryla Reifenberg also live. In July he sublets the 4th floor of Schweizerstrasse 3. The Battenbergs move to Schöne Aussicht Nr. 9.

1920

Major works: *Portrait of Fridel Battenberg* (cat. 21), who was a musician and composer (1880-1965); *Carnival,* which includes portraits of I. B. Neumann and Fridel Battenberg (who never met) and himself in the mask on the floor; *Family Portrait* (cat. 25). Beckmann also did a series of six lithographs with a title page entitled *City Night* which illustrate the poems of Lili von Braunbehrens (cat. 258, 259).

He begins to write the tragic drama, *Das Hotel* (published in 1984) and writes the comedy, *Ebbi*. Work on *Ebbi* continues into the next year.

"Max Beckmann—Graphic Works" is exhibited at the Zingler's Kabinett für Bücherfreunde in Frankfurt. Zingler publishes several etchings, and becomes Beckmann's representative in Frankfurt.

Beckmann's work is exhibited in group shows at the Darmstädter Sezession, Darmstadt, Mathildenhöhe; Lübeck, Overbeck-Gesellschaft.

Beckmann makes a firm contract with I. B. Neumann in Berlin, beginning a joint venture of several years.

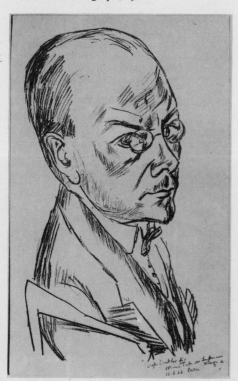

Fig. 23 Max Beckmann: *Portrait of Georg Swarzenski,* lithograph, 1921

1921

Major works: *The Dream* (cat. 23), *The "Nizza" in Frankfurt am Main* (cat. 29), *Self-Portrait as Clown* (cat. 31) and *Varieté* (cat. 32). Graphics: *Self-Portrait with Bowler Hat* (cat. 266-268), Portraits of *Reinhard Piper, Georg Swarzenski* and *Fridel Battenberg*, ten drypoints for the series *Annual Fair* (cat. 271-274).

City Night with poems by Lili von Braunbehrens is published by Piper in Munich in a special edition (cat. 258, 259).

One-man exhibitions: Berlin, I. B. Neumann (paintings). Frankfurt Kunstverein (17 paintings, 6 watercolors, 24 drawings and 157 prints). Beckmann participates in an exhibition of the Neue Sezession held in the west wing of the Glaspalast in Munich (14 paintings).

In Munich Beckmann becomes acquainted with the writer, Wilhelm Hausenstein and in Berlin with the art dealer, Günther Franke. Peter Zingler introduces him to the actor, Heinrich George, who is directing Kokoschka's "Orpheus and Eurydice" in Frankfurt.

Beckmann makes a short visit to Dresden for the lithograph, *Portrait of Dr. Weidner.*

Benno Reifenberg gives an apt description of the traumatic rupture which the First World War caused in Beckmann's psyche and in his work:

"The European war came as a monstrous liquidation of the great nothingness. There came the events of the last few years, in them one could see a kind of purification, a clarification. One tried to console oneself, saying it was good that eyes were being opened, facades torn away. But then, the great, burning revolution should have followed. And it did not. One could almost question whether there was even an attempt at revolution... Events lack the force of penetration, the great liquidation is in danger of being exposed as a fraudulent bankruptcy: one begins to forget the war... And then the agony of the war begins to seem meaningless, the collapse of the European world appears to be completely sealed. If this gigantic expenditure of energy was meaningless then it is hard to see that anything meaningful can ever grow again upon the same soil. The last opportunity for self-integration passed away unused. The intellectuals, those who felt responsibility, were scattered in every passing wind. And they are still fleeing. To Communism, to country life, to the suburbs; to Asia, to the exotic."

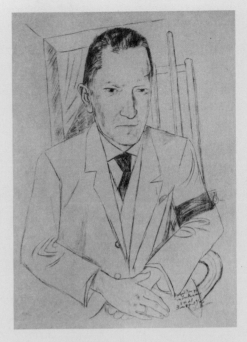

Fig. 24 Max Beckmann: *Portrait of Reinhard Piper,* lithograph, 1921

"Max Beckmann did not flee... War brought reality to the painter. It gave him a new object. When one carries wounded men on stretchers, blood seeping through their white bandages; when one watches the nurses bending over them, sees the surgeon cutting with rolled-up sleeves, then little doubt is left as to the existence of this suffering world. Certainly this world is terrible and full of suffering. But it is no longer empty, no longer yawning with boredom and the uselessness of idle conversations in cafés. For the painter immersed in the night of war, a new sun dawned. A dark, barren sphere glowed on the horizon, complacent and threatening. And, while others crept into the hiding place of their despair or their ideology and fell, their hopes pinned on an undefined "after-wards," into a stuporous slumber, Beckmann stayed awake. And, just as the light of the noonday sun may sometimes produce an effect of blackness, so to him, in turn, was granted the power to inject light into darkness. This light was the savage joy of giving form..."[12]

1922

Major works: *The Iron Footbridge* (cat. 29), *Landscape near Frankfurt with Factory, Before the Masquerade Ball* (cat. 26), painted according to the wishes of Reinhard Piper in the style of the *Family Portrait* (cat. 25) of 1920; and *Portrait of Frau Dr. Heidel. Trip to Berlin* (cat. 276-278), ten lithographs with cover and title picture, published by I.B. Neumann in Berlin, is the most important graphic series of the years 1922-1923, in which Beckmann creates more than a third of his prints: more than 90 sheets. Among them is the famous woodcut *Self-Portrait* (cat. 279) of the artist gazing into the distance, strangely reminiscent of portraits of Martin Luther.

Beckmann has a one-man exhibition in Peter Zingler's "Kabinett," and is a participant in the exhibition at Stockholm, Liljevalch's Konsthall; Exhibition of German Art organized by Gustav Pauli in Hamburg. A few of his prints are shown in Venice, at the XIIIth Biennale.

Kasimir Edschmid publishes two articles about Beckmann in "Deutsche Graphik des Westens," Weimar, and in "Die Zukunft," Berlin.

Beckmann makes a trip to Munich in December and visits Piper. At the Alte Pinakothek he is especially impressed by a work which at that time was still ascribed to Gabriel Mälesskircher: a Calvary Scene with Sts. Koloman, Quirin, Kastor, and Chrysogonus (the work has since been identified as that of the "Master of the Tabula Magna of Tegernsee," 1438)[13]. The Pinakothek does not, nor did it then, possess a work by Jerg Ratgeb, who is often mentioned in the literature in connection with the esteem in which Beckmann held Gabriel Mälesskircher. But the Städel in Frankfurt has two portraits of Claus and Margaretha Stalburg on the wings of the altar of the Stalburg's domestic chapel. They were listed in the 1924 catalogue of paintings in the Städel as the work of Jerg Ratgeb (they have since been ascribed to an anonymous "Master of the Stalburg Portraits"). Beckmann must have known the Ratgeb frescoes in the Carmelite convent in Frankfurt and the Herrenberg Altar by Ratgeb in the Württembergisches Staatsgalerie in Stuttgart. Reinhard Piper recounts that he and Beckmann took special interest in the great winged altar of Hans Holbein the Elder, a work whose significance was at that time not widely recognized.[14] The Städel had acquired the work in 1922 through an exchange of pictures with the Frankfurter Historisches Museum.

12. Benno Reifenberg, "Max Beckmann," *Ganymed* III, 1921, edited by Julius Meier-Graefe.

13. The Tabula Magna is in the Bayerischen Nationalmuseum in Munich. Works of this anonymous master are also in the Germanischen Nationalmuseum, Nuremberg and in the Bode-Museum, East Berlin.

14. Reinhard Piper, op. cit., p. 330.

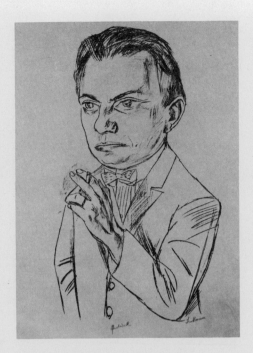

Fig. 25 Max Beckmann: *Portrait of Dr. Heinrich Simon*, lithograph, 1922

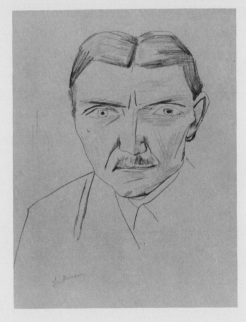

Fig. 26 Max Beckmann: *Portrait of Fritz Wichert*, graphite, 1923 (?), The Hague, Gemeente Museum

15. Letter to I.B. Neumann, in Göpel, *Max Beckmann-Katalog der Gemälde*, Bern 1976, Vol. 1, No. 234.

1923

Major works: *Self-Portrait in Front of a Red Curtain* (fig. 11, p. 61) in which Beckmann portrays himself as a kind of circus manager. *The Trapeze* (cat. 33), which also touches on the world of Vaudeville, *Self-Portrait with Cigarette on a Yellow Background* (cat. 36), *Double Portrait of Frau Swarzenski and Carola Netter, Dance in Baden-Baden* (cat. 34), *Drifting Ice*. Outstanding among the etchings are: *Fanferlieschen*—eight illustrations to the story by Clemens von Brentano, as well as *Still-Life with Globe,* his first still-life etching.

At the end of the year, the Moderne Galerie Thannhauser in Munich shows an exhibition of Beckmann's drawings and prints from the Reinhard Piper collection.

I.B. Neumann moves to New York and transfers to Günther Franke the management of his Graphisches Kabinett on Barer Strasse in Munich.

Beckmann travels to Baden-Baden, where he meets the painter and graphic artist, Rudolf Grossman (1882-1941).

He receives a letter from G.F. Hartlaub, director of the Kunsthalle at Mannheim, concerning the exhibition "Neue Sachlichkeit" (New Objectivity) planned there for 1925.

1924

Major works: *Käthe von Porada, Elsbeth Goetz, Portrait of Minna Beckmann-Tube* (cat. 37), *Sleeping Woman* (cat. 35) and *Irma Simon*. Among the three suburban landscapes completed this year, *Landscape with Lake and Poplars* (cat. 39) contains clear reminiscences of pictures by Henri Rousseau. The *Still-Life with Gramophone and Irises* (cat. 38) introduces an uninterrupted series of still-lifes in which objects, especially flowers, are exaggerated beyond their natural character and take on symbolic significance. "I paint portraits, still-lifes, landscapes, visions of cities rising from the sea, beautiful women and grotesque monsters, people bathing and female nudes. Life, in short. A simple life of sheer existence. Without thoughts or ideas. Filled with Nature's forms and colors and with my own. As beautiful as possible..."[15]

One-man exhibitions: Berlin, with Paul Cassirer, January; Frankfurt, Kunstverein in collaboration with Zingler's Kabinett, October/November. Group exhibitions: Stuttgart, "Neue deutsche Kunst" Kunstgebäude am Schlossplatz, May through August (9 paintings); Vienna, the Secession, Internationale Kunstausstellung der Gesellschaft zur Förderung moderner Kunst, September/October (3 paintings).

The six etchings of *Fanferlieschen*, 1923, are published by F. Gurlitt in Berlin, The comedy, "Ebbi," with six etchings is published by the Johannespresse in Vienna.

Contracts are completed with Peter Zingler in Frankfurt and Paul Cassirer in Berlin.

In the spring, at the home of Henriette von Motesiczky in Vienna, Brahmstrasse 7, Beckmann becomes acquainted with Mathilde von Kaulbach, youngest daughter of the painter August Friedrich von Kaulbach. She studies voice in Vienna with Mrs. Schlemmer-Ambros, lives with the Motesiczkys, and is nicknamed "Quappi." Marie-Louise von Motesiczky is called "Piz" or "Pizzi," and Beckmann is dubbed "Becki." During 1927/1928, Marie-Louise is Beckmann's student in Frankfurt.

In July, Beckmann travels with his family to Pirano south of Trieste for two weeks on the Adriatic. They stop at the Motesiczky's country house in Hinterbrühl on the return trip.

The first monograph on Beckmann is written by Curt Glaser, Julius Meier-Graefe, Wilhelm Fraenger, and Wilhelm Hausenstein in Munich. Hausenstein recalls:

"I see him before me as he was during friendly get-togethers back in 1924, when the four of us, Julius Meier-Graefe, Curt Glaser, Wilhelm Fraenger and myself were laboring over the monograph on Beckmann, which was later published by Piper in Munich. It was close to midnight. I knew where to find him: in that empty dining room in the restaurant of the main train station in Frankfurt, beneath the pitiless white of the electric lighting, all alone with a bottle of champagne and a Brazilian cigar. There he sat, broad-shouldered, heavy, absent, thoughtful, observing the imaginary scene, no, the virtual reality, as keenly as if it had edges. There he leaned, pale, fixated in a cold fever, on his forehead beads of sweat like an exhausted porter who has thrown down his load, with thunderstorms of nervous reflexes playing across a face both sensitive and athletic. Such was the man who spent the days hidden in his studio up above the Schweizerstrasse, on the corner facing the Main River, not far from the Städel, which kept the altar of

Holbein the Elder, so beloved of his eye and spirit, from the Dominican church of Frankfurt. That was the way he looked: the man who was more interested in painting the technical structure of the Iron Footbridge above the mildly flowing river and beneath the gold-silver atmosphere of the West, than a vision of the Frankfurt Cathedral or the Römerberg. He felt no commitment to this atmosphere, no longer saw this sweet air. It had belonged to earlier generations. He felt other obligations. He felt excluded from this atmosphere. Never have I known such a lonely man. One could not seriously want to imitate him."[16]

Among Beckmann's friends in Frankfurt were, in addition to the Battenbergs and the Carls, the co-owner and editor of the famous newspaper *Frankfurter Zeitung,* Dr. Heinrich Simon and his wife Irma (in 1920 in Vienna she had introduced Beckmann to her friends the Motesiczkys); Benno Reifenberg, who in 1924 had taken over the editorship of the "Feuilleton" (cultural features) department of the *Frankfurter Zeitung*; the director of the Städelsches Kunstinstitut, Professor Georg Swarzenski, and his second wife Marie, neé Mössinger (cat. 170), and Dr. Hanns Swarzenski, his son by a first marriage; finally Lilly von Schnitzler (cat. 175), an industrialist's wife who began collecting works by Beckmann in 1924. In 1927 Marie-Louise von Motesiczky came to Frankfurt. Fritz Wichert, formerly director of the Städtische Kunsthalle in Mannheim, had in 1923 taken over the management of the Städel art school, which had been merged with the Arts and Crafts School in Frankfurt. Other familiar guests in the Simon home were the writers Rudolf G. Binding and Fritz von Unruh, and the Swiss scholar Christoph Bernoulli.[17] For a private commemoration of the 20th anniversary of the Piper publishing house on May 19, 1924 Beckmann wrote the following autobiography:

"1. Beckmann is not a terribly nice person.

2. Beckmann's hard luck is that he was born with a talent for painting, not banking.

3. Beckmann works hard.

4. Beckmann – in Weimar, Florence, Paris and Berlin – trained himself to be a European citizen.

5. Beckmann likes Bach, Pelikan (a brand of oil paints), Piper and 2 or 3 other Germans.

6. Beckmann is a Berliner and lives in Frankfurt on the Main.

7. Beckmann is married. They live in Graz.

8. Beckmann is mad about Mozart.

9. Beckmann has been made ill by his indestructible preference for the defective invention called "Life." He is depressed by the new theory that the earth's atmosphere is enclosed in a gigantic shell of frozen nitrogen.

10. Beckmann, nevertheless, has established that "southern lights" really exist. And he feels placated by the idea of meteors.

11. Beckmann still continues to sleep well."[18]

1925

Major works: *Carnival* (fig. 7, p. 22) and *Double-Portrait Carnival* (cat. 43), showing the couple before their marriage: *Portrait of Quappi Beckmann;* Frankfurt urban landscape with the Main and the Church of the Three Kings, entitled *Bank of the Main River and Church* and *Moon Landscape;* the Italian pictures, already painted in Frankfurt, *Beach at Viareggio* and *Small Landscape Viareggio; Self-Portrait with Champagne Glass on a Yellow Background* (destroyed by fire in Munich, 1944); *Galleria Umberto,* a picture which seems to anticipate later history.

One-man exhibitions: Düsseldorf, Alfred Flechtheim, March (paintings and graphics from 1910 to 1924). Group exhibitions at: Mannheim, Städtische Kunsthalle, "Neue Sachlichkeit" (New Objectivity), June through September (5 paintings); a revised version of this exhibition travels to Dresden, Erfurt, Halle and Jena; Zürich, Internationale Kunstausstellung im Kunsthaus (12 paintings); London, International Society of Sculptors, Painters and Engravers, Royal Academy of Arts.

He makes a contract with I.B. Neumann for three years in which Neumann receives sole sales rights to the paintings in return for an annual guarantee of DM 10,000.

At the beginning of the year, in Semmering Beckmann fractures his left hand and is admitted to a clinic in Vienna.

An uncontested divorce is granted from Minna Beckmann-Tube, who is enjoying great success as a singer. Beckmann is engaged to Mathilde von Kaulbach, who declines

Fig. 27 Max Beckmann at the home of Henriette von Motesiczky in Vienna with Marie-Louise von Motesiczky (left) and Mathilde von Kaulbach, called "Quappi" (right), 1924

16. Benno Reifenberg and Wilhelm Hausenstein, *Max Beckmann,* Munich 1949, pp. 39-40.

17. Christoph Bernoulli, *Ausgewählte Vorträge und Schriften,* edited by Peter Nathan, private printing, Zürich, 1967, p. 194 ff.

18. Finally printed in: Peter Beckmann, *Max Beckmann—Leben und Werk,* Stuttgart/Zürich, 1982, p. 52.

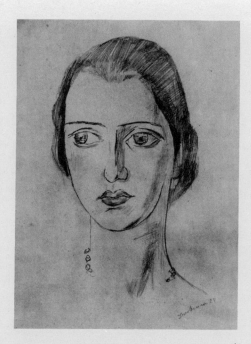

Fig. 28 Max Beckmann: *Marie-Louise von Motesiczky,* graphite, 1924, Private collection

an offer from the Dresden Staatsoper for his sake. Their wedding takes place on September 1 in Munich. They travel in Italy: Rome, Naples, Viareggio. In Frankfurt the Beckmanns live until May 26 in the Hotel Monopol-Metropol at the central train station. The studio at Schweizerstrasse 3 with its adjoining room is maintained until 1933.

In October Beckmann is called to teach a master class of the newly merged Städelschule/Kunstgewerbeschule where Fritz Wichert is now director. The master classes are held in the studio building next to the Städelsches Kunstinstitut, Dürerstrasse 10. After World War II the Staatliche Hochschule für bildende Künste is re-established there.

Beckmann's students in Frankfurt during 1925-1933 were Carla Brill (1927), Inge Dinand (1932), Theo Garve (1926-1930), Georg Heck (1928-1932) Walter Hergenhahn (1928-1931), Anna Krüger (1927-1928), Leo Maillet (Mayer) (1930-1933), Hella Mandt (1931), Friedrich Wilhelm Meyer (1928-1929), Marie-Louise von Motesiczky (1927-1928), Alfred Nungesser (1926), K. Th. Schmidt, Karl Tratt (1926-1932).[19]

1926

Major works: *Self-Portrait in a White Cap, Landscape with Vesuvius, Naples, The Bark* (cat. 42), *Large Still-Life with Musical Instruments* (fig. p. 28), *Quappi in Blue* (cat. 45), *Portrait of an Old Actress* (cat. 44), *Notre-Dame, Chinese Fireworks.*

One-man exhibitions: Leipzig, Kunstverein (retrospective with 40 paintings and with graphics); New York, New Art Circle Gallery, I. B. Neumann (no sales). Group exhibitions: Venice, XVth Biennale; Berlin, National Gallery in the Crown Prince's Palace, Young Artists from Germany, England, France and the U.S.A. (3 paintings); a revised version of the exhibition is later brought to Bern, Paris, and New York; Dresden, "Internationale Kunstausstellung–Jahresschau Deutscher Arbeit" (6 paintings).

The Beckmanns move to an apartment at Steinhausenstrasse 7/II on Sachsenhäuser Berg in July.

Beckmann travels to Berlin in January and Paris in the fall. August and September are spent in Spotorno on the Italian Riviera.

Beckmann is unable to buy back his graphic works (some 2000) from Piper; they are purchased by Günther Franke.

1927

Major works: *The Beach* (lost), *The Harbor of Genoa* (cat. 49), *Self-Portrait in Tuxedo* (cat. 53), *Forest Landscape with Woodcutter, Large Still-Life with Fish* (cat. 48), *Female Nude with Dog, Large Still-Life with Telescope* (fig. p. 29), *Portrait of N. M. Zeretelli.*

The Bark, 1926, donated by art patrons, becomes Beckmann's first work to hang in the Nationalgalerie, Berlin.

One-man exhibitions: Dresden, Galerie Neue Kunst Fides (graphics); Munich, Graphisches Kabinett (drawings of the postwar period and prints 1911-1924); New York, New Art Circle Gallery, I. B. Neumann (paintings). Group exhibitions: Berlin Spring Exhibition of the Preussische Akademie der Künste; Berlin, Alfred Flechtheim, "Das Problem der Generation" (5 paintings); Dresden, Deutscher Künstlerbund, Akademie der Künste (Staatliche Gemäldegalerie), "Werke deutscher Künstler: Malerei und Plastik"; Hamburg, "Europäische Kunst der Gegenwart" (Modern European Art) Kunsthalle/Kunstverein; Munich, Neue Sezession im Glaspalast; Paris, Grand Palais, Salon d'Automne (with the Berlin Secession).

During this year, in which *Self-Portrait in Tuxedo* is completed, Beckmann writes an article, "The Artist in the State:"[20]

"The artist, in the new sense of the times, is the conscious creator of the transcendental idea... the artist in the new sense is actually the creator of the world which, before him, did not exist. The new idea to which the artist, and simultaneously humanity, must give form, is that of self-reliance, autonomy in relation to infinity. The solution of the mystical enigma of equilibrium, *the final deification of Man*... that is the goal... We can expect nothing more from external sources. From ourselves alone, from now on. *For we are God.* By Jove... still a rather poor and inadequate God... but anyway a God... There we have our own image. *Art is the mirror of God who is humanity.* It cannot be denied that at certain times in the past these mirrors were more magnificent and awe—inspiring than they are today...

Humanity, having reached man's essence, now stares soberly and without faith into barren wastelands and is still unaware of its power.

19. *Max Beckmanns Frankfurter Schüler 1925-1933.* Exhibition catalogue of the Kommunale Galerie in the Carmelite Cloister at Frankfurt am Main, 1980/81; *Städelschule Frankfurt am Main. Aus der Geschichte einer deutschen Kunsthochschule,* Frankfurt am Main, 1982.

20. Max Beckmann, "Der Künstler im Staat", *Europäische Revue 3,* (1927) pp. 288-291.

What we lack is a new center of culture, a new center of faith. New buildings are needed, in which this new faith, this new cult of achieved equilibrium, will be ritually enacted, wherein everything in which equiblibrium has become complete would be collected. The problem is to achieve an elegant mastery of metaphysics. To live in a strict, clear, disciplined romanticism of our own existence, which is unreal in the highest degree. The new priests of this new cultural center will appear in black suits, or, on ceremonial occasions, in evening dress, unless we are able in the meantime to invent a more precise and elegant masculine garment. The essential thing, to be sure, is that the workers also wear tuxedos or evening clothes. In other words: we want a kind of aristocratic Bolshevism. A social levelling, but one whose basic idea is not the satisfaction of materialism, but rather the conscious and organized impetus to become God ourselves. External success, in this system, would no longer or only accidentally consist of money, but would be awarded to those who had reached the higher stages of equilibrium and who are therefore deserving of a greater degree of power and influence. Power and influence, therefore, would be granted on the basis of self-reliance. I am fully aware that I am hereby proclaiming a Utopia. But a start has to be made. Even if only in the form of ideas...

We are also the next generation and all those to come. And thus we shall encounter our will in the next life, where it will help us escape this chaotic enslaved existence which we now call life. Like children locked in a dark room, we sit in pious devotion and wait for the door to open so we can be led off to execution, to death. Once the faith in our own power to decide has been implanted in us, our sense of self-reliance will become stronger. We shall only find the power to become God by suppressing weakness, egoism, and so-called evil in favor of the shared love which will enable us to carry out *our great decisive work as humanity*. That means to become free and to decide ourselves whether to live or die. Conscious possessors of infinity free from time and space...”

Fig. 29 Max Beckmann, 1927

1928

Major works: *The Loge* (fig. p. 159), *Two Ladies by the Window, Gypsy Woman* (cat. 54), *Aerial Acrobats, Scheveningen, Five a.m.* (cat. 50), *Street at Night, Building under Construction, The Wendelsweg;* among the etchings *Portrait of Swarzenski* and *Portrait of Rudolf Baron Simolin.*

The Nationalgalerie in Berlin purchases *Self-Portrait in Tuxedo,* 1927.

Beckmann receives the Honorary Prize of the Reich for German Art (DM 1,000) which is also awarded to Max Liebermann, Erich Heckel, Ernst Ludwig Kirchner, and Max Slevogt, among others. He is awarded the Gold Medal of the City of Düsseldorf (not a money prize) for *Large Still-Life with Telescope,* 1927.

One-man exhibitions: Mannheim, Städtische Kunsthalle, February-April, “Max Beckmann—Das gesammelte Werk 1905-1927” (106 paintings, 6 watercolors for the *Prodigal Son,* 56 drawings, 110 prints, catalogue text by G. F. Hartlaub and Max Beckmann: ‘Six Sentences on the Making of Pictures’). Parts of the exhibition are then shown in Berlin, Alfred Flechtheim (55 paintings 1925-1928): Munich, the 50th exhibition of Günther Franke’s Graphisches Kabinett: “Max Beckmann—Gemälde aus den Jahren 1920-1928” (23 paintings, 6 drawings). Stuttgart, Kunsthaus Schaller. Group exhibitions: Berlin, Nationalgalerie, “Zweite Ausstellung der nachimpressionistischen Kunst aus Berliner Privatbesitz” (5 paintings); Düsseldorf, Kunstpalast, “Deutsche Kunst” (German Art); Venice, XVI Biennale (1 painting), also in Berlin, Frankfurt, and Munich.

In the early summer Beckmann spends several weeks in Scheveningen. He travels to Berlin and Paris and spends New Year’s at St. Moritz.

Rudolf Baron Simolin buys *Large Still-Life with Fish,* 1927, and *Gypsy Woman,* 1928, as the beginning of his significant Beckmann collection.

1929

Major works: *Soccer Players* (cat. 56), *The Catfish, Portrait of Curt Glaser, Portrait of an Argentinian* (cat. 55), *Portrait of Gottlieb Friedrich Reber, Reclining Nude* (cat. 59), *Still-Life with Overturned Candles.*

Beckmann receives the title of “Professor.” The Honorary Prize of the City of Frankfurt is awarded to him, together with Richard Scheibe, Jakob Nussbaum, and Reinhold Ewald. *The Loge,* 1928, is awarded a fourth honorable mention, in the 28th Interna-

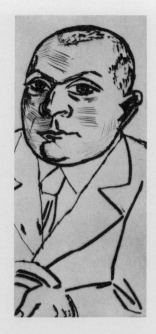
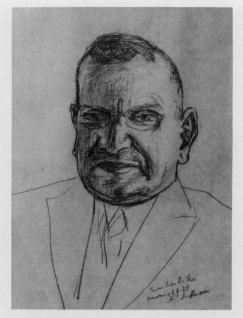
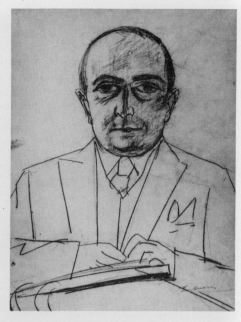

Fig. 30 Max Beckmann: *Portrait of Baron Simolin I,* small version, etching, 1928

Fig. 31 Max Beckmann: *Portrait of Dr. Ernst Levi,* September 11, 1929, graphite, Private collection

Fig. 32 Max Beckmann: *Portrait of Curt Glaser,* graphite, 1929, Private collection

tional Exhibition of Paintings, Pittsburgh, Museum of Art Carnegie Institute, October through December.

One-man exhibitions: Frankfurt, Kunstverein, October-November (46 paintings, 9 pastels, 6 drawings from the years 1923-1929); Frankfurt, Kunstsalon Schames (graphics); Braunschweig, Freunde Junger Kunst im Braunschweiger Schloss (paintings and graphics). Group exhibitions in New York, Paris, Stockholm, Warsaw, and Zürich (graphics).

Between 1929 and 1932 Beckmann lives in Paris from September through May of each year and travels for one week out of each month to Frankfurt to make corrections at the Städelschule. He has a studio at 23bis Boulevard Brune, Paris XIVe, and during 1929-1930 a furnished apartment at 24 rue d'Artois, Paris VIIIe.

April and May are spent in Berlin. There he paints *Portrait of Curt Glaser.* In the fall he visits the collector Gottlieb Friedrich Reber in Lugano. Summer vacation is spent in Viareggio, New Year's at St. Moritz.

Fig. 33 Max and Mathilde Q. Beckmann in front of the Hotel Esplanade in Berlin, 1929

1930

Major works: *Portrait of Valentine Tessier, Large Still-Life with Candles and Mirror* (cat. 58), *Self-Portrait with Saxophone, Parisian Carnival* (cat. 61), *Winter Landscape, Landscape Saint-Germain, The Bath* (cat. 62), *Hotel Claridge* (I), *Portrait of Minna Beckmann-Tube* (cat. 63), *Still-Life with Musical Instruments, (Supraporte),* (designed to hang over the doorway at the Friedrich-Ebert-Schule in Frankfurt, now lost, fig. p. 28).

In the Städtische Galerie im Städelschen Kunstinstitut in Frankfurt Beckmann now has 13 paintings hanging, for a while in a room of their own (among them *Self-Portrait,* 1905, *Company III. Family Battenberg,* 1915, *Deposition,* 1917, *The "Nizza" in Frankfurt am Main,* 1921, *Double-Portrait of Frau Swarzenski and Carola Netter,* 1923, *Double-Portrait Carnival,* 1925, *Large Still-Life with Musical Instruments,* 1926, *The Beach,* 1927, lost, and *Two Ladies by the Window,* 1928).

One-man exhibitions: Basel, Kunsthalle, August (100 paintings, 21 pastels, gouaches, drawings); Zürich, Kunsthaus, September-October (85 paintings, 23 pastels, gouaches and drawings, 113 prints); Dresden, Galerie Neue Kunst Fides, October-November (paintings and drawings from the years 1906-1930); Munich, Graphisches Kabinett of Günther Franke, February-March, "Arbeitsstadien in Max Beckmanns graphischem Schaffen" (Stages in Max Beckmann's Graphic Work), (Piper collection). Group exhibitions: St. Louis, Pittsburgh Exhibition of the Museum of Art of the Carnegie Institute of 1929; Venice, XVIIth Biennale (6 paintings), Berlin, Dresden, Düsseldorf, Munich, Saarbrücken, New York, Cambridge (Mass.).

Beckmann's teaching contract at the Frankfurt Kunstgewerbeschule/Städelschule is extended to the end of 1935.

In Paris the Beckmanns move to an apartment in Passy, 26 rue des Marroniers. Beckmann now works mainly in Paris, and travels to Cap Martin and Nice, Bavaria and Bad Gastein (in the fall). He meets Baron Simolin in Switzerland.

The monograph by Heinrich Simon, *Max Beckmann,* appears in Berlin and Leipzig. His contract with I.B. Neumann and Alfred Flechtheim is extended for seven years. In Frankfurt an exhibit by Beckmann's students is held at the Galerie F.A.C. Prestel.

Fig. 34 Max Beckmann: Lost, presumably destroyed painting with musical instruments above the entrance to the auditorium of the Friedrich-Ebert-Schule in Frankfurt, 1930

Fig. 35 Max Beckmann exhibition at the Kunstmuseum, Basel, 1930. From left: *Self-Portrait with Red Scarf,* 1917; *Self-Portrait with Champagne Glass,* 1919; *Self-Portrait as Clown,* 1921; *Women's Bath* 1919; *The Synagogue,* 1919; *Family Portrait,* 1920

1931

Major works: *Portrait of Quappi on Pink and Violet, Portrait of Rudolf Baron von Simolin, Parisian Society* (cat. 60), *Woodcutters in the Forest, Landscape near Saint Cyr-sur-Mer, Church in Marseille.*

One-man exhibitions: Paris, Galerie de la Renaissance, March-April (36 paintings); Brussels, Galerie Le Centaure, May; Hannover, Kestnergesellschaft, February, "Max Beckmann, Gemälde und Graphik 1906-1930" (29 paintings, 4 watercolors, drawings and prints 1911-1929). Group exhibitions: Frankfurt, Städelsches Kunstinstitut June-July, "Vom Abbild zum Sinnbild" (From Representation to Symbol) (6 paintings, 1 pastel, 16 prints); New York, Museum of Modern Art, "German Painting and Sculpture" (6 paintings); also in Bad Homburg, Belgrade, Berlin, Cambridge (Mass.), Munich, New York, Pittsburgh, Toronto.

The painting, *Woodcutters in a Forest,* 1927, is purchased for the Musée du Jeu de Paume in Paris.

Differences arise between Beckmann and Wichert due to the former's infrequent presence at the Städelschule; Beckmann gives notice on October 26, but is persuaded to remain by the Lord Mayor Landmann, Municipal Cultural Advisor Michel, and Professor Swarzenski.

Attacks on Beckmann's painting in the National Socialist and Fascist press, especially against the exhibition in Paris and the selection for the Biennale in Venice in 1930.

He travels to Marseille and Saint Cyr-sur-Mer in spring, to Ohlstadt in summer, to Bad Gastein and Vienna in the fall. New Year's is spent in Garmisch, return trip is made by way of Munich.

1932

Major works: *The Skaters* (cat. 66), *Self-Portrait in Hotel, Gypsy (II), Large Landscape during Storm, Man and Woman* (cat. 64), *Portrait of a Frenchman,* begins work on the triptych *Departure* (fig. p. 40).

One-man exhibitions: Berlin, Alfred Flechtheim, March (23 paintings); Berlin, Nationalgalerie: Ludwig Justi establishes a permanent Beckmann room in the Kronprinzenpalais (10 paintings, 4 of which are owned by the Nationalgalerie); Paris, Galerie Bing (17 paintings). Group exhibitions in Chicago, Danzig, Frankfurt, Munich, New York, and elsewhere.

The *Self-Portrait in Hotel* reflects the political pressure to which Beckmann was increasingly subjected. More frequent attacks by the National Socialists, who also attack

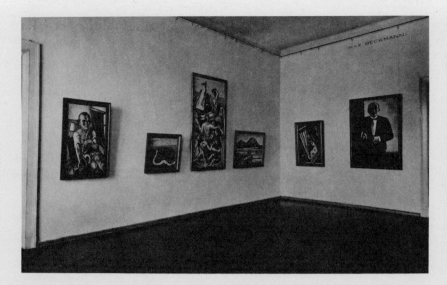

Fig. 36 The Max Beckmann Room at the
Kronprinzenpalais/Nationalgalerie in Berlin,
1932/33: *Self-Portrait as Clown,* 1921;
St. Germain Landscape, 1930; *The Bark,* 1926;
Landscape at Saint-Cyr-sur-Mer, 1931; *Golden
Arrow,* 1930; *Self-Portrait in Tuxedo,* 1927

Fig. 37 Ludwig Mies van der Rohe, 1932

Georg Swarzenski and his circle. The economic crisis causes Beckmann to give up his apartment and studio in Paris.

After the spring exhibition, Flechtheim dissolves his contract with Beckmann and I. B. Neumann.

Beckmann meets with Erhard Göpel in Paris in spring.

1933

Major works: *Self-Portrait in a Large Mirror with Candle* (cat. 68), *Brother and Sister* (cat. 69), *The Small Fish* (cat. 65), *Lake Walcher, Evening Garden in Thunderstorm, Oxen Stall.*

One-man exhibitions: Hamburg, Kunstverein, February-March (paintings).

Group exhibitions in Kassel, League of German Artists (4 watercolors), then in Magdeburg, Kunstverein; Worcester (Mass.) College Art Association, "International 1933" (1 painting); Chicago, World Exposition, June through November, "A Century of Progress-Exhibition of Paintings and Sculpture Lent from American Collections" (2 paintings).

In January the Beckmanns move to Berlin, Hohenzollernstrasse 27, later named Graf-Spee-Strasse 3. Here he meets Mies van der Rohe.

Hitler seizes power on January 30. On March 29 Director Wichert is suspended from the Städelschule. Two days later Beckmann is given notice effective April 15, together with Willi Baumeister, Richard Scheibe, and Jakob Nussbaum.

After the discharge of Ludwig Justi, the Beckmann room at the Nationalgalerie in Berlin is closed. At the Museum in Erfurt the opening of an exhibition of Beckmann's work is prohibited. Stephan Lackner buys the painting *Man and Woman,* 1932, (cat. 64) which is stored in the cellar of the Museum in Erfurt. Exhibitions in several German cities are shown for the purpose of defaming modern art and casting political suspicion upon it: Dresden, Karlsruhe, Mannheim ("Cultural Bolshevism"), Munich, Nuremberg, Stuttgart, and elsewhere.

Beckmann spends the summer in Ohlstadt, working in the studio of Friedrich August von Kaulbach.

1934

Major works: *Self-Portrait in Black Beret* (fig. p. 64), *Quappi in Pink Sweater, Journey on the Fish* (cat. 70), *Bathing Scene (The Green Robe), Still-Life with Large Glass Ball and Ears of Grain, View of Zandvoort at Dust, Portrait of Naila.* First Sculpture: *The Man in Darkness.*

Group exhibitions: New York, The Museum of Modern Art, January, "Fifth Anniversary Exhibition"; New York, New Art Circle Gallery, I. B. Neumann, April and summer; Pittsburgh, Museum of Art of the Carnegie Institute, October-December, "The 1934 International Exhibition of Paintings."

On the occasion of Beckmann's fiftieth birthday a single article (by Erhard Göpel) appears in the *Leipziger Neueste Nachrichten.*

He visits Curt Glaser in Ascona and travels to Zandvoort and Ohlstadt, where several works are completed in the Kaulbach studio, then to Gstadt on the Chiemsee.

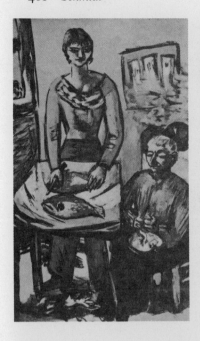

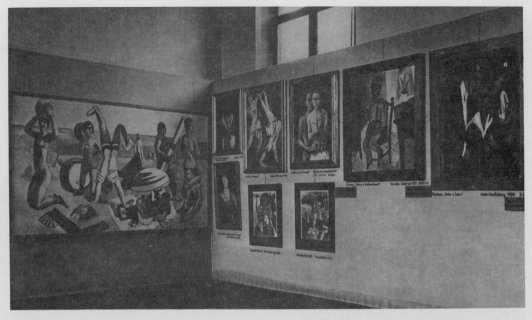

1935

Major works: *Departure* triptych completed (fig. p.40); *The Organ-Grinder* (fig. p.45), *Large Painting of Women, Family Portrait Heinrich George* (cat.74), *Portrait of Rudolf G. Binding, Stourdza Chapel (Rainy Day in Baden-Baden), Seashore.*

Group exhibitions: Berlin, Berliner Sezession, January-March, first exhibition after the 1934 reorganization (1 painting); Munich, Neue Pinakothek, March-May, "Berliner Kunst in München" (3 paintings).

Beckmann meets in Berlin with the book and art dealer, Karl Buchholz, and with Curt Valentin, who since 1933 has managed the gallery in the upper story of the Buchholz's bookstore. He becomes friends with Hanns Swarzenski.

Trips are made to Ohlstadt, Baden-Baden, and Zandvoort.

Beckmann writes to Reinhard Piper: "I am trying to use intensive work to get myself through the talentless insanity of the times. After a while this political gangsterism becomes ridiculously indifferent, and one feels best in the island of one's soul."[21]

Beckmann writes to Curt Valentin about the triptych, *Departure:* "The picture is, for me, a kind of rosary or a ring of colorless figures, which can take on a violent brilliance sometimes, when the contact is there, and tells me truths which I cannot express with words and did not even know before. I can speak only to people who, consciously or unconsciously, carry the same metaphysical code within themselves.

Departure, yes, departure from the deceptive surface appearances of life, to those things which are essential in themselves, which stand behind the appearances...

It should be made clear that "The Departure" is not a tendentious picture, and that it could be applied to any age."[22]

1936

Major works: *Self-Portrait with Crystal Ball* (fig. p.65), *Theater of Dreams, Quappi with Parrot, Pathway in the Black Forest, Landing Quay in Stormy Weather, View from the Window in Baden-Baden, Mother and Child, Sailor, Femina Bar, On the Trapeze (Woman Acrobat).* Sculpture: *Self-Portrait.*

He begins *Temptation.* The triptych, which has been subjected to many interpretations, makes clear as does none of Beckmann's previous work of his gift for mythic encoding. The inspiration taken from Flaubert's *Temptation of St. Anthony,* the visible reference to the beginning of the Gospel according to St. John, "In the beginning was the Word," are combined with ideas from Beckmann's long-lasting interest in Indian philosophy, the Cabbala, Gnosticism, and theosophy.[23]

One-man exhibitions: Hamburg, Kunstkabinett of Dr. Hildebrand Gurlitt (paintings and watercolors), Beckmann's last exhibition in Germany until 1946.

Group exhibitions: Hamburg, Kunstverein, April-May and July-September; Buffalo, The Buffalo Fine Arts Academy and the Albright-Knox Art Gallery, "The Art of Today;" New York, The Museum of Modern Art, January-February, "Modern Paintings and Drawings, Gift of Mr. and Mr. John D. Rockefeller, Jr.;" New York,

Fig. 38 Max Beckmann: *The Kitchen,* 1936, Private collection. Mathilde Q. Beckmann is represented with the concierge Mrs. Ruppelt, who in 1937 saw to the packing and transport of Beckmann's oeuvre from Berlin to Amsterdam, avoiding confiscation by the Gestapo

Fig. 39 "Degenerate Art" Exhibition, 1937 in Munich at the Hofgarten. On the left the large *Beach Scene* by Beckmann, 1927 (lost, probably destroyed). Official postcard of the exhibition

21. Reinhard Piper, *op. cit.,* p.340.

22. Max Beckmann, letter to Curt Valentin, February 11, 1938, quoted by Göpel, op.cit., Vol. I, p.276.

23. Compare Friedhelm W. Fischer, *Max Beckmann—Symbol und Weltbild,* Munich 1972, p.136ff; Peter Beckmann, *Die Versuchung. Zu dem Triptychon von Max Beckmann, Heroldsberg near Nuremberg* 1977; Stephan Lackner, *Max Beckmann,* New York 1978, p.126, Exhibition catalogue *Max Beckmann—Die Triptychen,* Städelsches Kunstinstitut, Frankfurt am Main, 1981.

24. Alfred Hentzen, "Das Ende der Abteilung der Nationalgalerie im ehemaligen Kronprinzenpalais," *Jahrbuch Preussischer Kunstbesitz,* VIII (1970) Berlin, 1971, pp.24-89.

25. Franz Roh, *Entartete Kunst—Kunstbarbarei im Dritten Reich,* Hannover, 1962. Paul Ortwin Rave, *Kunstdiktatur im Dritten Reich,* Berlin, 1949.

Fig. 40 The house at Rokin 85, Amsterdam, Beckmann's apartment and studio from 1937 to 1947

Fig. 41 The weathervane, Little Mermaid, at Rokin 85, Amsterdam

New Art Circle Gallery, I.B. Neumann; Pittsburgh, Museum of Art of Carnegie Institute, October-December, "The 1936 International Exhibition of Paintings."

"Temporary" closing to the public of the modern section in the former Kronprinzenpalais (Nationalgalerie) in Berlin on orders of Rust, the Minister of Culture, on October 30. In November art criticism is banned in Germany.[24]

Beckmann travels to Paris to explore the possibility of emigrating to the United States, together with Stephan Lackner and his father, Siegmund Morgenroth. Stephan Lackner commissions him to illustrate his drama, *Man Is Not a Domestic Animal*.

Beckmann travels to Hamburg, Baden-Baden, and Zandvoort.

1937

Major works: Completion of the triptych *Temptation* (cat. 73), *Self Portrait in Tails* (cat. 75), *Musing Women by the Sea, View of the Tiergarten with White Lamps, Stourdza Chapel in Baden-Baden, Bird of Paradise Portrait, The King* (cat. 78), *The Liberated One* (cat. 80), *Birth* (cat. 81), *Quappi with a White Fur, Tabarin, Still-Life with Yellow Roses* (cat. 83), *Outskirts Overlooking the Sea at Marseille* (cat. 77). Seven lithographs for Stephan Lackner's *Man Is Not a Domestic Animal*, Editions Cosmopolites, Paris, 1937 (fig. p. 148).

Group exhibitions: New York, New Art Circle Gallery, I.B. Newmann, February (paintings).

Beckmann remains in a sanatorium in Baden-Baden during March and April, and later travels to Wangerooge.

As part of the government campaign against "Degenerate Art," a total of 590 works by Beckmann are confiscated in German museums, including 28 paintings, as well as watercolors, drawings, and prints.

At the exhibition "Degenerate Art" in Munich in the Altes Galeriegebäude, Galeriestrasse 4 at the Hofgarten (the plaster casts of antique sculpture having been moved out), about eight or nine paintings by Beckmann (twelve according to Reinhard Piper) can be viewed, and about the same number of prints. No precise list exists, and the exhibition is enlarged after the first few days. It lasts from July 19 through October and attracts about two million viewers.[25]

On July 18 Beckmann listens to Hitler's speech at the opening of the Haus der Deutschen Kunst in Munich. The Beckmanns leave Germany the next day, accompanied by Quappi's sister, Mrs. Hedda Schoonderbeek, who is married to an organist in Amsterdam. The works which he has left in Berlin, together with his furniture, are packed by Mrs. Ruppelt, wife of the building superintendent, before the Gestapo can intervene. The art historian Dr. Hans Jaffé, who knows Beckmann from Berlin and has emigrated to Amsterdam before him, arranges for an apartment and studio in an old tobacco warehouse at Rokin 85 (it has two rooms on the first floor, cooking facilities in the stairwell).

Beckmann travels to Paris in September. He meets with Rudolf Baron Simolin and Stephan Lackner, who buys several paintings, among them the *Temptation* triptych. Winter is spent in Amsterdam.

1938

Major works: *Self-Portrait with Horn* (cat. 86), *Apache Dance, Birds' Hell* (cat. 84), *Studio (Night). Still-Life with Telescope and Covered Figure* (cat. 85), *Quappi with a Green Parasol, Self-Portrait on Green in a Green Shirt, Girl by the Sea, Woman at her Toilette with Red and White Lilies, Death* (cat. 82), *Blue Sea with Beach Chairs* (fig. p. 149), *Small Landscape at Bandol*.

One-man exhibitions: Bern, Kunsthalle, February-March (48 paintings, 19 prints); Winterthur, Kunstverein, April-May (45 paintings, 14 prints); Zürich, Galerie Aktuarius, June (16 paintings), travelling to Basel, Galerie Bettie Thommen (about 20 paintings), the Swiss exhibitions are initiated by Stephan Lackner, Käthe von Porada, and Max Gubler; New York, Buchholz Gallery, Curt Valentin, January-February, "Exhibition of Recent Paintings by Max Beckmann" (20 paintings 1930-1937, triptych *Departure,* (5 watercolors), travelling to Kansas City, Los Angeles, San Francisco, St. Louis, Portland, and Seattle.

The New Burlington Galleries in London open the "Exhibition of the 20th Century German Art" on July 7. Beckmann is represented with *Temptation; The Harbor of Genoa,* 1927, *The Skaters,* 1932; *Woodcutters in the Forest,* 1931/32; *The King,* 1937;

Quappi with White Fur, 1937; and the drypoint *Tamerlan*, 1923. All these works were lent by Stephan Lackner and Käthe von Porada. Sir Herbert Read is Chairman of the exhibition; patrons include Le Corbusier, Ensor, Maillol, Picasso, H. G. Wells, Sir Kenneth Clark, Axel Munthe, and the Lord Bishop of Birmingham. Oto Bihalji-Merin, whose book *Modern German Art* (under the pseudonym Peter Thoene) is published as a Penguin Book with an introduction by Herbert Read, is not named in the catalogue but is one of the initiators of the exhibition, and plays an essential role in the preparations. At the opening Beckmann delivers his famous speech "On My Painting," in German with a simultaneous English translation, which later is published.[26] Stephan Lackner's essay, especially written for the exhibition, "The World Theater of the Painter Max Beckmann," is issued in an English version.[27]

Group exhibitions: Columbus, Ohio, March, "Modern German Painting;" Hartford, Conn., January-February; Toledo, Ohio, The Toledo Museum of Art, November-December. "Contemporary Movements in European Painting" (2 paintings); Pittsburgh.

In June Beckmann travels to Zürich, where he meets Rudolf Baron Simolin. From July 20 to August 2 he is in London with Lackner; in the Tate Gallery he is especially impressed by William Blake. Later he stays with Lackner in Bandol.

In September a contract is made with Lackner for two paintings per month in return for a guaranteed monthly payment.

Starting in October the Beckmanns live in a furnished apartment in 17 rue Massenet, Paris XVI. They stay there until June 1939.

Some of the works of art confiscated in German museums are released to art dealers to be sold in return for payment in foreign exchange. Karl Buchholz and later Günther Franke buy several pictures, which may not be exhibited publicly. Some of the confiscated pictures by Beckmann go to Curt Valentin in New York.

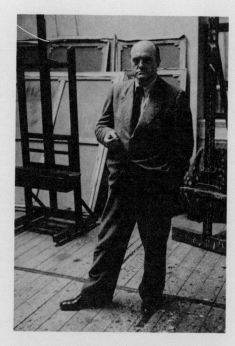

Fig. 42 Max Beckmann in his studio in the attic of Rokin 85, Amsterdam 1938

1939

Major works: *Acrobats*, triptych (cat. 89), *Mars and Venus, Children of Twilight-Orcus* (cat. 87), *Warrior and Birdwoman* (cat. 88), *Portrait of Stephan Lackner* (fig. p. 147). *Cap Martin, Harbor near Bandol (Gray) and Palm Trees, Seascape with Agave and Old Castle, North Sea Landscape with Tents, Girls in Black on Green.*

One-man exhibitions: New York, Buchholz Gallery, Curt Valentin, February-March, "Max Beckmann—Recent Paintings" (13 paintings 1932-1938). Group exhibitions: Boston, The Institute of Modern Art, November-December, "Contemporary German Art" (4 paintings); Cleveland, January-February, The Cleveland Museum of Art, "Expressionism and Related Movements" (2 paintings); New York, The Museum of Modern Art, May, "Art in Our Times;" Buchholz Gallery, Curt Valentin, May and September-October; San Francisco, "Golden Gate International Exhibition of Contemporary Art" (triptych *Temptation*); San Francisco, California Palace of the Legion of Honor and the M. H. de Young Memorial Museum, "Seven Centuries of Painting" (triptych *Departure);* Springfield, Mass., Museum of Fine Art, January, "Modern German Art;" Munich, Günther Franke's Graphisches Kabinett, September, "Schwarz-Weiss-Ausstellung" (Black-White Exhibition).

At the Golden Gate International Exhibition of Contemporary Art in San Francisco, Beckmann is awarded the first prize ($ 1,000) for the triptych, *Temptation*.

The Beckmanns continue in their apartment in Paris until June. Beckmann is issued a Carte d'Identité and considers settling permanently in Paris. He visits the health spa, Abano Terme, in Italy and travels to Geneva to view an exhibition of paintings from the Prado. In Amsterdam he views an exhibition of "Parisian Artists" with, among others, 28 paintings by Picasso, at the Stedelijk Museum.

Summer is spent in Amsterdam. The Beckmanns decide to remain there despite the threatening danger of war. Günther Franke visits after the outbreak of war. Efforts by friends in the United States (Neumann, Valentin, Georg and Hanns Swarzenski, Mies van der Rohe), are made to find a teaching position for Beckmann there.

In the spring, in the courtyard of the Berlin Fire Department, the overwhelmingly largest part of the "Degenerate Art" confiscated in 1939 is burned. 1004 paintings and sculptures, and 3,825 watercolors, drawings and prints are supposed to have been destroyed.

Fig. 43 Max Beckmann in his studio in Amsterdam, 1938

26. Original manuscript in Mathilde Q. Beckmann, op. cit., pp. 189-198 and p. 235 ff.

27. Compare Stephan Lackner: *Ich erinnere mich gut an Max Beckmann,* Mainz, 1967, p. 51-78.

28. On life in Amsterdam see: Max Beckmann, *Tagebücher 1940-50*, Munich, 1979; Mathilde Q. Beckmann, *op. cit.*; Erhard Göpel, *Max Beckmann in seinen späten Jahren*, Munich, 1955; Rudolf Heilbrunn, "Rokin 85," *Frankfurter Allgemeine Zeitung* No. 88, (April 29) 1978; Ludwig Berger, *Wir sind vom gleichen Stoff aus dem die Träume sind—Summe eines Lebens*, Tübingen, 1953, pp. 373-375.

On June 30 Theodor Fischer in Lucerne auctions paintings and sculptures by modern masters from German museums. Only 3 paintings by Beckmann are sold (2 after the auction).

Fig. 44 Max Beckmann: *Dismantling the Russian Pavillion after the World Exposition in Paris,* drawing, March 1938

1940

Major works: *Self-Portrait with Green Curtain, Ladies' Band* (cat. 91), *Large Riviera Landscape, Acrobat on the Swing, Large Reclining Woman with Parrot, Two Women (in a Glass Door), In the Circus Wagon* (cat. 94), *View of Menton with Pot of Lilies, Wood-Bearing Farmers (Returning Home), The Sea Gulls.*

One-man exhibitions: New York, Buchholz Gallery, Curt Valentin, January, "Max Beckmann Paintings 1936-1939" (14 paintings and the triptych, *Temptation*). Group exhibitions in Chicago, Minneapolis, New York, San Francisco.

Beckmann is offered a summer course at the Art School of The Art Institute of Chicago. The U.S. Consul General in The Hague refuses him a visa on the grounds that the United States is about to enter the war.

On May 10 German troops invade Holland. Beckmann and his wife burn the diaries they have kept since 1925, but they soon begin new ones. Marie-Louise von Motesiczky introduces Beckmann to her aunt in The Hague, Ilse Leenbruggen, who begins to collect Beckmann's work. Lilly von Schnitzler visits Beckmann in Amsterdam. His son, Dr. Peter Beckmann, visits as a military doctor and manages to take paintings to Germany. Erhard Göpel, now a German Army officer charged with the protection of art works in Holland, offers the couple some protection during the next few years.

In May Stephan Lackner's last monthly payment arrives. The Beckmanns' life in Amsterdam becomes increasingly difficult due to the German occupation.

Fig. 45 Günther Franke, 1942

1941

Major works: *Double-Portrait, Max Beckmann and Quappi* (cat. 95), *Perseus* triptych (fig. 29, p. 42), *Self-Portrait in Gray Robe* (cat. 93), *Apollo, Quappi with Indian, Quappi with Large Still-Life, Fish Still-Life with Net, Park at Night, Baden-Baden* (1935 and 1941). Begins work on the triptych, *Actors.* From August through December he works on the lithographs for the *Apocalypse* (cat. 294).

One-man exhibitions: New York, Buchholz Gallery, Curt Valentin, August-September, "Paintings by Max Beckmann" (16 paintings, the central panel of the triptych *Temptation,* and 13 prints). Group exhibitions: Cincinnati, Art Museum of the Cincinnati Modern Art Society, April-May. "Expressionism-An Exhibition of Modern Paintings... to Commemorate the 400th Anniversary of El Greco;" St. Louis, City Art Museum, August-September, "20th Century European Art."

In April a visit by Ernst Holzinger, director of the Städelsches Kunstinstitut in Frankfurt, who brings a commission from Georg Hartmann, owner of the Bauersche Giesserei in Frankfurt, to illustrate the Apocalypse. He is visited by Peter Beckmann and Günther Franke, who buys pictures. Peter Beckmann takes them with him rolled up and packed in an ambulance, and explains when crossing the German border that they are just decorations he has painted himself for a frontline theater.

Summer is spent in Zandvoort on the seacoast. He visits The Hague and takes a bicycle trip to Hilversum. In September he spends three weeks in Valkenburg, Limburg province.

Friends during the Amsterdam years are Dr. Helmuth Lütjens and his wife Nelly (Paul Cassirer, Amsterdam); the art historian Dr. Hans Jaffé; the lawyer Dr. and Mrs. Rudolf Heilbrunn, emigrés from Frankfurt; the physician Dr. Jo Kijzer and his wife Minna neé Lanz; Ilse Leembruggen; the author Wolfgang Frommel; Friedrich Vordemberge-Gildewart and Otto Herbert Fiedler, painters who had been expatriated from Germany; the Dutch glass painter Giselle Waterschoot-van der Gracht; and the theater director Ludwig Berger.[28]

1942

Major works: Completion of *Actors* triptych (fig. 30, p. 43), *Self-Portrait in the Bar, Large Variety Show with Magician and Dancer, The Soldier's Dream* (cat. 98), *Farewell* (fig. p. 46), *Prometheus* (cat. 92), *Landscape with Train and Rainbow, Female Head in*

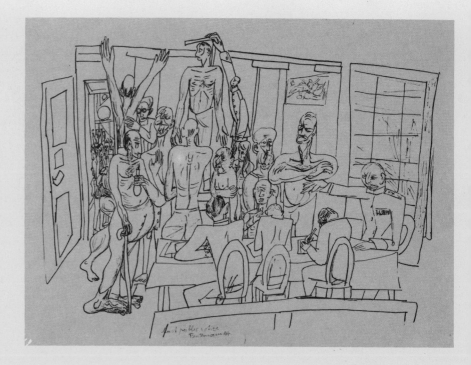

Blue and Gray (cat. 96), *Riviera Landscape with Rocks* (fig. p. 156), *Approaching Thunderstorm by the Sea, Still-Life with Red Roses and Butchy, Still-Life with Violin and Flute, Main Train Station in Frankfurt* (fig. p. 155). Beginning of the *Carnival* triptych.

One-man exhibitions: Chicago, The Arts Club of Chicago, January, "Max Beckmann Exhibition" (38 paintings 1917-1939, 4 watercolors, 4 gouaches, 10 prints). Group exhibitions: New York, The Museum of Modern Art, "Twentieth Century Portraits;" New York, Buchholz Gallery, Curt Valentin, "Aspects of Modern Drawing."

The Beckmanns spend May and June in Valkenburg.

He receives mobilization orders from the German Army in June and is examined on June 15, but found unfit for duty. He visits with Göpel in The Hague. Diary commentary on these days: "Tuesday, June 9. Spent the day in bed. G(öpel) busy the whole day, came back with good news. Thursday, June 11. examination in a tavern. Nervous the entire day. A slight relapse during the evening while walking (heart condition). June 15. Drove in car to examination, early morning. Cruelty to animals—because not yet entirely certain. A difficult evening. Tuesday, June 16. Once again to examination, early morning by car. At last a decision. Rejected. 'You can live out the evening of your life in peace,' spoke the voice of the 'archangel in breeches.' Thursday, June 18. My existence improves gradually. But? What will happen to Germany? Everything is dark, but after what I have been through in the last few days, one really should become fatalistic. Well, it was a crisis, a very serious one. Sketched 4 pictures..."

Beckmann is visited by Peter Beckmann, Klaus Piper, Karl Buchholz, and Lilly von Schnitzler, who buys two paintings. The Museum of Modern Art, New York, buys the triptych, *Departure.*

1943

Major works: *Carnival* triptych completed (fig. 26, p. 39), *Self-Portrait Yellow-Pink, Les Artistes with Vegetables* (cat. 99), *Odysseus and Calypso, Dream of Monte Carlo*, 1939, 1940-1943, (fig. p. 48), *Young Men by the Sea* (cat. 100), *Quappi on Blue with Butchy, Dancers in Black and Yellow, Eyckenstein Cypresses, Memory of Cap Martin, Still-Life with Helmet and Red Horse's Tail*. From April 1943 until February 1944 he works on the 143 pen drawings to Goethe's *Faust, Part II*, commissioned by Georg Hartmann, Frankfurt.

The *Apocalypse* with 27 lithographs by Max Beckmann is privately printed in 24 numbered copies at the Bauersche Giesserei, Frankfurt am Main (cat. 294).

Group exhibitions: Zürich, Kunsthaus, July-September, "Ausländische Kunst in Zürich" (Foreign art in Zürich) (1 painting, 4 prints); New York, Buchholz Gallery, Curt Valentin, "Early Works by Contemporary Artists."

In February Helmuth Lütjens, representing the Amsterdam branch of Paul Cassirer &

Fig. 46 Max Beckmann: Illustration for Goethe's Faust II.: "The Stars Contain both Light and Look," pen, 1943/44, Frankfurt am Main, Freies Deutsches Hochstift, Goethe-Museum

Fig. 47 Max Beckmann: *Last Public Notice,* Amsterdam, 1944, pen and ink, Private collection

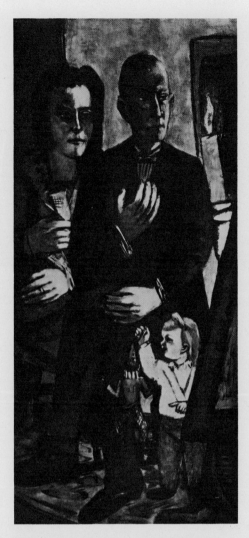

Fig. 48 Max Beckmann: *Family Portrait Lütjens*, Amsterdam, 1944, oil on canvas, Private collection

Fig. 49 Max Beckmann: *Portrait of Erhard Göpel*, May 31, 1944, graphite, Private collection

Fig. 50 Max Beckmann: *Portrait of Wolfgang Frommel*, 1945 and 1949, oil on canvas, New York, Private collection

Co., takes the larger part of Beckmann's paintings into his house at Keizersgracht 109, to save them from eventual confiscation by the German occupation forces; subsequent works are also deposited safely there. Close friendship with the Lütjens family, who help the Beckmanns in every way possible. He is visited by Peter Beckmann, Theo Garve, Beckmann's student in Frankfurt, and Günther Franke, who buys the *Perseus* triptych. He visits Laren several times. Air raids are intensified.

1944

Major works: *Self-Portrait in Black* (cat. 101), *Quappi in Blue and Gray* (cat. 105), *Lütjens Family Portrait, Portrait of Erhard Göpel* (fig. p. 153), *Academy I, Academy II, The Journey,* (cat. 103), *City of Brass* (cat. 102), *Still-Life with Two Flower Vases, Drawings for Faust, Part II* completed (fig. p. 154), the triptych *Blindman's Bluff* is begun.

One-man exhibitions: Seeshaupt, in the studio house of Günther Franke, "Max Beckmann, Pictures from the Günther Franke Collection and Works on Loan;" Santa Barbara, Museum of Art, June, "Third Anniversary Show" (paintings from the Lackner and Morgenroth collections). Group exhibitions: New York, The Museum of Modern Art, May-October, "Art in Progress, A Survey Prepared for the 15th Anniversary of The Museum of Modern Art" (triptych *Temptation*); Dayton, Ohio, The Dayton Art Institute, "Religious Art of Today;" Basel, Kunsthalle, August-September.

In February Beckmann is ill with inflammation of the lungs and a heart condition. Accompanied by Göpel on May 31 he is examined once again by military doctors, but again he is declared unfit for duty.

Life becomes more difficult due to the Allied landing on June 6 in Normandy. Fighting is expected in Amsterdam. The Beckmanns move in with the Lütjens. All contacts to Germany are broken.

Beckmann takes daily excursions to Overveen and Haarlem in July and August.

Diary, end of July: "To sail ad infinitum footloose—without goals—what a strange idea! What a gruesome fantasy to be always waiting to see whether or not one can unveil the mystery, always sitting with a stupid face in front of the gray curtain behind which the spirits stir, or perhaps nothing stirs... if you believe that all this uproar has a meaning, then you will be among the blessed,—oh so far away from here. But if you believe in chance, then that's your hard luck.—You will have to admit, won't you, that it is some kind of achievement to weave ideas together out of nothingness, which in any case keeps everything in a steadily intensified state of tension? But you can only do that if you play hide-and-seek with yourself. All that to entertain you."

December 31, 1944: "... Finish 1944/a hard year/Will 45 be harder?"

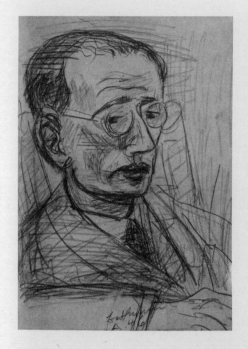 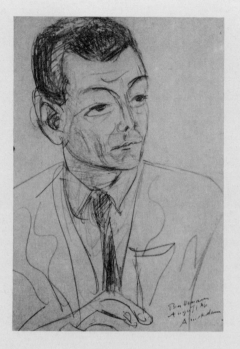 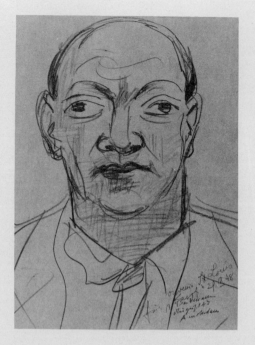

1945

Major works: *Blindman's Bluff,* triptych completed (fig. 24, p. 38 ff.). *Removal of the Sphinxes, Still-Life with Skulls, Self-Portrait in Olive and Brown, Portrait of Ludwig Berger, Before the Dress Ball, Schiphol, Ostende* (1931 and 1945).

One-man exhibitions: Amsterdam, Stedelijk Museum, September-October (about 14 paintings). Group exhibitions: New York, Karl Nierendorf Gallery, October, "Forbidden in the Third Reich," also in Paris and San Francisco.

The Stedelijk Museum, Amsterdam, buys *Double-Portrait, Max Beckmann and Quappi,* 1941.

Diary, September 15: "Heard of Beckmann's pictures, exhibited in the Stedelijk Museum... 15 September 45, historical, first exhibition in Europe since 1932—outlawed for 12 years—."

He travels in Holland to Hilversum, Laren, Zandfoort, Overveen.

Beckmann's isolation as a German citizen is renewed after the end of the German occupation. In June the first news from Germany is received. Minna Beckmann-Tube, fleeing Berlin for Gauting, has been forced to leave the Beckmann paintings in Hermsdorf; she gets them back again in 1950 with the exception of a few. Baron Simolin commits suicide at his estate Seeseiten, after the Americans appropriated it for their own use. Beckmann receives news of Günther Franke, whose collection has remained undamaged.

In July Beckmann's assets are threatened with confiscation, which however he is able to prevent. As a German he is under surveillance. Postal connections are restored to the United States and England, and friends send care packages with groceries and painting supplies. Beckmann starts English lessons.

Diary, August 27, 1945: "An accursed fate indeed, to be what I am. To live in the most extreme exaltation of sensibility and then to suffer humiliations like a little office employee.—The contrasts are enormous.—All around me the general confusion increases and my mood is bleak for other reasons as well."

1946

Major works: *Begin the Beguine* (cat. 111), *Soldiers' Bar, Portrait of Quappi in a Green Sweater, Portrait of Curt Valentin and Hanns Swarzenski, Dancer with Tambourine* (cat. 107), *Portrait of a Carpet Salesman* (cat. 106), *Large Laren Landscape with Windmill* (fig. p. 156), *Old Lady with Daughter, Day and Dream,* a lithographic portfolio (cf. cat. 295-297) is published by Curt Valentin in New York in 100 copies (4 of which Beckmann colors by hand in 1948 at Valentin's request).

One-man exhibitions: Bad Nauheim, Ausstellungssaal Bangers, April-May, prints owned by Ugi and Fridel Battenberg; New York, Buchholz Gallery, Curt Valentin, April-May, "Beckmann—His Recent Work from 1939 to 1945" (14 paintings, the *Acrobats,* triptych, and 15 drawings, almost all the pictures are sold); Boston, Museum

Fig. 51 Max Beckmann: *Portrait of Dr. Rudolf M. Heilbrunn,* 1946, Amsterdam, graphite, Private collection

Fig. 52 Max Beckmann: *Portrait of Dr. Hanns Swarzenski,* 1946, Amsterdam, graphite, Private collection

Fig. 53 Max Beckmann: *Portrait of Curt Valentin,* 1947, Amsterdam, graphite, location unknown

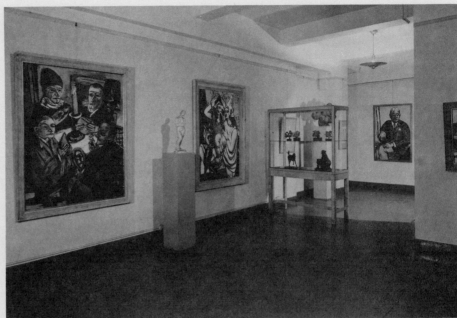

Fig. 54 Max and Mathilde Q. Beckmann with Butchy in their Amsterdam apartment, 1947

Fig. 55 Beckmann exhibition at the Buchholz Gallery (Curt Valentin), 32 East 57th Street, New York, April 1946. From left: *Les Artistes with Vegetables,* 1943; *Before the Costume Ball,* 1943; *Portrait of Ludwig Berger,* 1945

School, July-September; San Francisco, Museum of Art, June-July; Munich, Galerie Günther Franke, Part I June-July, Part II July-August in the Stuckvilla: "Max Beckmann" (74 paintings, 2 bronzes, 3 watercolors, 6 pastels and drawings, 26 prints and *Apocalypse*); Stuttgart, Württembergische Staatsgalerie, Graphische Sammlung, September, at the Holzhaus behind the Museum der Bildenden Künste (4 paintings, 3 drawings, 111 prints among them *Hell, City Night,* and *The Berlin Trip*). Group exhibitions: Baltimore; Boston; Braunschweig; Dresden; Iowa City; Cologne, Alte Universität, October-December, Sammlung Haubrich (which in 1947 travels to Stuttgart, Mannheim, Hamburg, and Oldenburg, and in 1948 to Wiesbaden and Constance, partly with its own catalogue); New York, The Museum of Modern Art, "Landscapes—Real and Imaginary," travelling to Chicago.

Beckmann has his first contacts with Germany through the art dealer Heinz Berggruen, who works for the U.S. Forces of occupation. He considers visiting Germany.

The University of Iowa Museum of Art, Iowa City, buys the *Carnival* triptych.

On March 1, 1947 Beckmann writes to Curt Valentin: "It's nice and enlivening for me to be in close contact with you, and I hope that this will be strengthened with time. . . . Everything here is unbelievably restricted and one can get nothing . . . Well, at least the bombs have stopped. . . . I am in urgent need of a terrible lot of canvas, if possible of the kind used for *Acrobats* (not too coarse and half or three-quarters oil). Also, I don't have any Cremser White or Prussian Blue. I'll take anything, I'm in the most fruitful working period!!! One can get almost nothing here. The last bed-sheets have been painted."[29]

He is offered teaching assignments in Munich (Akademie der Bildenden Künste) and Darmstadt (directorship of the Werkkunstschule) but declines.

In August Beckmann is classified as a "Non-Enemy" and is no longer in danger of deportation from Holland.

Curt Valentin and Hanns Swarzenski visit.

Beckmann visits Laren in May-June and September-October. The beginning of September is spent in Nordwijk. He continues his day trips to Zandvoort.

1947

Major works: *Self-Portrait with Cigarette, Air Balloon with Windmill* (cat. 114), *Festival of Flowers at Nice, Baccarat, Baou de Saint-Jeannet, Sacrificial Meal, Girls' Room (Siesta)* (cat. 113), *Still-Life with Two Large Candles* (cat. 115), *Portrait of Euretta Rathbone.*

One-man exhibitions: Buffalo, Albright Knox Art Gallery, The Buffalo Fine Arts Academy, April, "Max Beckmann Paintings from 1940 to 1946" (13 paintings); Frankfurt, Städelsches Kunstinstitut, June-July (65 paintings, also watercolors, drawings including illustrations to Goethe's *Faust, Part II,* and prints); Hamburg, Kunstverein, May (paintings); New York, The Museum of Modern Art, April-May (triptych

29. Göpel, *op. cit.,* Vol. I, p. 27.

Blindman's Bluff); New York, Buchholz Gallery, Curt Valentin, November-December, (18 paintings, 1944-1947); Philadelphia, The Philadelphia Art Alliance, January-February, "Max Beckmann Oils" (14 paintings, triptych *Carnival*); Princeton, University Art Museum, November-December, "Recent Watercolors by Max Beckmann." Group exhibitions: New York, The Museum of Modern Art, "Landscapes—Real and Imaginary" (travelling to Bloomfield Hills, Michigan; Bloomington, Indiana University; Grand Rapids, Mich.; Honolulu, Hawaii; West Palm Beach; San Francisco); New York, The Museum of Modern Art, "Symbolism in Painting", travelling to Austin, Texas, University of Texas; San Antonio; Minneapolis; and St. Louis.

In March he takes his first trip abroad since the war. The Beckmanns spend three weeks in Nice, visiting Paris and the Louvre, on the way there and back they spend ten days in Laren in May. Day trips to The Hague and Zandvoort continue.

Ernst Holzinger extends an invitation to the Beckmann exhibition in Frankfurt. Plans to visit Germany for two weeks are not realized. From Bloomington, Henry R. Hope offers a teaching position at the Indiana University Department of Fine Arts which is initiated by Cola and Bernhard Heiden, professor of music and Frankfurt emigré. From the Art School of Washington University of St. Louis comes an offer to take over the temporarily vacant professorship of Phillip Guston. The initiative behind this offer comes from Curt Valentin and Perry T. Rathbone, at that time director of the City Art Museum in St. Louis. Beckmann accepts.

July 1: Rathbone visits Amsterdam, looking for pictures for the Beckmann exhibition (1948) in St. Louis. He is visited by Curt Valentin, Hanns Swarzenski, Richard L. Davis, director of the Institute of Arts in Minneapolis, and Marie-Louise von Motesiczky from London.

On August 19 the Beckmanns depart from Rotterdam on the "Westerdam," on which Thomas Mann is also travelling. They stay in New York, at the Hotel Gladstone, September 7 through 17. They visit with old friends from Berlin and Frankfurt and with Beckmann's sister-in-law, Doris MacFerguson-Cooper. On their first evening in New York, Ludwig Mies van der Rohe shows the Beckmanns the town, and then takes them to the top of the Empire State Building.

Diary for September 18, 1947: "St. Louis. A park at last. Trees at last, ground under my feet at last. A magnificent dream in the park, this morning in St. Louis. . . . Possible, that here it will be possible to live again."

The Beckmanns live in the Chase Hotel, and from the beginning of October at 6916 Millbrook Boulevard.

Beckmann teaches his first class on September 23. His address to the students is read in English by Mrs. Beckmann, who also translates during instruction.[30] He makes good contact with the students, especially Walter Barker and Warren Brandt. Beckmann does not want to spend each day with the students, but wishes rather to let them work independently, and appears only twice a week to correct their work. This trial arrangement proves itself in practice.

Serving on the jury of the "Seventh Annual Museum Exhibition" in St. Louis, Beckmann speaks up for a selection made on the basis of modern criteria, and for the inclusion of abstract and surrealistic pictures. This causes excitement and criticism in the press.

Fig. 56 Jane Sabersky, art historian and close friend of the Beckmanns. Originally from Munich, she lived in New York.

Fig. 57 *Campus of Washington University in St. Louis.* The Beckmann's apartment was in the studio floor on the left from 1947 to 1949.

Fig. 58 Max Beckmann: *Campus Chapel at Washington University,* 1948 (?), black chalk, Private collection

30. Mathilde Q. Beckmann, *op. cit.*, pp. 198-200, 236/37.

31. Text in Mathilde Q. Beckmann, *op. cit.*, p. 200-206.

Fig. 59 Max Beckmann listening to lecture at the Art School of the Museum of Fine Arts in Boston, March 13, 1948. To the left behind Beckmann is Professor Georg Swarzenski

Fig. 60 Max Beckmann and Mathilde Q. Beckmann with students of the Museum Art School, Boston

From November 15 through 19 Beckmann visits New York for the opening of his exhibition with Curt Valentin.

At the end of December he is visited by the chairman of the art department of Stephens College in Columbia, Missouri, Mr. Montmini, who invites Beckmann to deliver a lecture in February 1948.

1948

Major works: *Christ in Limbo, Cabins* (fig. p. 163), *Fisherwomen* (cat. 121), *Self-Portrait with Gloves, Quappi in Gray* (cat. 119), *Portrait of Perry T. Rathbone* (cat. 118), *Rescue, Masquerade* (cat. 117), *Souvenir Chicago*.

One-man exhibitions: St. Louis, City Art Museum, May-June, "Max Beckmann-Retrospective Exhibition" (44 paintings, the triptychs *Departure, Actors, Blindman's Bluff,* 43 drawings and watercolors, 4 gouaches for the *Prodigal Son,* 41 prints, 5 illustrated books), with comprehensive catalogue and travelling to Detroit (July), Los Angeles (August-September), San Francisco (September-October) and in Cambridge, Mass. (December); Chicago, The Art Institute of Chicago, January-March (69 watercolors and drawings, 59 prints, a copy of the *Apocalypse* hand-colored by Beckmann; Columbia, Mo., February (5 paintings and graphics); Boston, Mass., March (about 12 paintings); Hamburg, Dr. Ernst Hauswedell, graphics. Group exhibitions: Oberlin, Baltimore, "Symbolism in Painting" travelling to Poughkeepsie, Wellesley, Baton Rouge, San Francisco, Portland, Evanston, Muskegon, Boston; Iowa City and Minneapolis, Minn., "Displaced Paintings, Refugees from Nazi Germany" (2 paintings, *Carnival* triptych); New York; Oklahoma City; San Francisco; St. Louis; Munich; Zürich.

Beckmann's "Letters to a Woman Painter" (English translation by Perry T. Rathbone and Mathilde Q. Beckmann)[31] are read by Mrs. Beckmann at Stephens College in Columbia, Missouri on February 3; in Boston by invitation of Professor Georg Swarzenski on March 13 in the Art School of the Museum of Fine Arts; in St. Louis during the Beckmann retrospective at the City Art Museum and on the radio.

Beckmann's teaching contract in St. Louis is extended until June 1949.

An offer comes from Hamburg to take over the direction of the Landeskunstschule there.

The Beckmanns travel by ship to Holland in June and remain in Amsterdam until the end of September. The apartment in the Rokin is now closed. They return to St. Louis by way of New York where Beckmann applies for American citizenship on October 5.

Beckmann becomes acquainted with the Mexican painter Rufino Tamayo, who teaches a workshop at the Brooklyn Museum Art School in New York. Negotiations concerning teaching at the Brooklyn Museum Art School begin after Tamayo's departure. Beckmann is visited by sculptor George Rickey and his wife.

Christmas and New Year's are spent in New York. A telegram is received, asking that Beckmann remain in St. Louis until the return of Philip Guston in 1950.

On December 29 a party in honor of Max Beckmann is held at The Plaza, by the artists' organization "Artist's Equity" and attended by 300 guests.

Fig. 61 Max Beckmann drawing, 1949

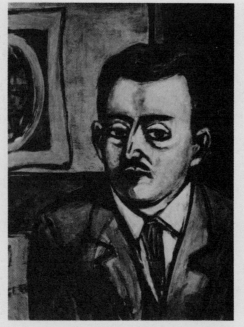

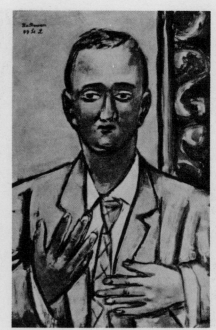

1949

Major works: triptych *The Beginning* completed (cat. 122), *Jupiter,* (1930, 1946, 1948, 1949), *The Prodigal Son* (cat. 120), *Morning on the Mississippi, Portrait of Morton D. May, Portrait of Edith Rickey, Hotel de l'Ambre, Portrait of Wolfgang Frommel* (1945 and 1949), *Portrait of Fred Conway* (cat. 123), *Portrait of Kenneth E. Hudson, Landscape in Boulder* (cat. 127), *Large Still-Life with Black Sculpture* (cat. 124), *Argonauts* triptych begun.

One-man exhibitions: Minneapolis, Minn., Institute of Fine Arts, 1948 retrospective from St. Louis, in January, opens with a lecture by Perry T. Rathbone, and is shown on a reduced scale Boulder, Colo., at the University of Colorado Museum June-July; Hannover, the Kestner-Gesellschaft, February-March (39 paintings, triptych *Perseus,* 1 bronze, 16 prints, among them *Day and Dream)*; Memphis, Tenn., Brooks Memorial Art Gallery, February (156 paintings); New York, Buchholz Gallery, Curt Valentin, October-November, "Max Beckmann—Recent Works" (21 paintings, triptych *The Beginning,* 1 bronze); New York, Brooklyn Museum, October-November, "Prints and Drawings by Max Beckmann, 1924-1948;" St. Louis, City Art Museum, beginning March, "Federation Exhibition" (14 paintings, 7 watercolors and drawings, 14 prints). Group exhibitions in Amsterdam; Cologne; Munich; Philadelphia; Pittsburgh; Zürich; New York, Whitney Museum of American Art, "Annual Exhibition of Contemporary American Painting" beginning December.

In January, Beckmann travels to Minneapolis with the Rathbones for the opening of his exhibition. Beckmann writes in his diary on January 17: "... Then again exposition, talk by Perry,—oh God, my own life marched past me in pictures—accompanied as in a dream by Perry's voice and slides. I had to take a bow—oh God, and was applauded—oh God, people clapped when Herr Beckmann stood up..." January 19 "... exposition again. ... Took leave of my pictures.—Nearly missed the train"

A trip to New Orleans is taken in April.

Portrait commissioned by the businessman, art patron and collector Morton D. May (1914-1983) whose collection of Beckmann's works was to become the most important in the world.

On June 15 Beckmann leaves St. Louis, where he has found friends and collectors: Perry and Euretta Rathbone; Morton D. May; the publisher and journalist Joseph Pulitzer, Jr. and his wife Louise; the painter and teacher Fred Conway; the painter and University Dean Kenneth E. Hudson, the painter Werner Drewes (formerly of the "Bauhaus"); the art historian Horst W. Janson; the anthropologist Jules Henry and his wife Zunia. Zunia Henry taught piano at the St. Louis Conservatory, and often played with Mathilde Q. Beckmann. During the winter they had both performed in two public concerts in St. Louis; Mathilde Q. Beckmann had received good reviews as the violinist.

During the summer Beckmann taught at the Art School of the University of Colorado

Fig. 62 Max Beckmann in his studio at 234 East 19th Street, New York, February 10, 1950

Fig. 63 Max Beckmann: *Portrait of Kenneth E. Hudson,* Dean of the Washington University Art School, St. Louis, 1949, Private collection

Fig. 64 Max Beckmann: *Portrait of Morton D. May,* St. Louis, 1949, The Saint Louis Art Museum, Bequest of Morton D. May

32. Quoted from: *In Memoriam Benno Reifenberg,* publication of the Max Beckmann Gesellschaft, Munich-Bremen 1970, p. 16.

Fig. 65 Max Beckmann teaching at the Brooklyn Museum Art School, 1950. Mathilde Q. Beckmann is in the middle

Fig. 66 Apartment house at 38 West 69th Street, New York

Fig. 67 Max Beckmann: *Portrait of William R. Valentiner,* drawn November 5, 1940, black chalk, Raleigh, North Carolina Museum of Art, Estate of W. R. Valentiner

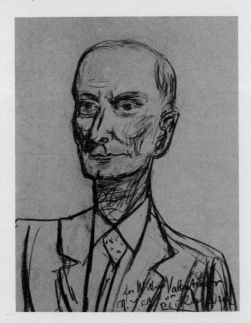

in Boulder and made excursions to the Rocky Mountains. The Beckmanns then travel to New York by way of Denver and Chicago. They keep an apartment near Gramercy Park, at 234 East 19th Street.

In early September Beckmann begins teaching at the Brooklyn Museum Art School.

For *Fisherwomen* Beckmann receives the first prize of $1,500 at the exhibition "Painting in the United States" held at the Carnegie Institute in Pittsburgh.

In Munich, Piper publishes the monograph *Max Beckmann* by Benno Reifenberg and Wilhelm Hausenstein. On March 9 Beckmann writes to Reifenberg: "The more one gets around the more one sees the same things repeated over and over, especially when the sheen of strangeness slowly rubs off the language. So I really don't have any reason for seeing great changes in myself. My world view hasn't changed since Frankfurt. Of course it's hard for me to tell whether I'm in the same condition in respect to my nerves and my general physical well-being. My work will have to demonstrate that. Anyway, I still have a lot to do ... I can't complain about America. I'm surrounded by a lot of noise and success and I'm still fighting—but that's my fate and probably will be right to the end..."[32]

1950

Major works: triptych *Argonauts* (fig. p. 37), *Self-Portrait in Blue Jacket* (cat. 126), *The Town (City Night)* (cat. 131), *Falling Man,* (fig. p. 165), *San Francisco* (fig. p. 169), *Family Portrait of Henry R. Hope, Still-Life with Cello and Bass Fiddle; Carnival Mask, Green, Violet and Pink. Columbine* (cat. 130), *Man with a Bird, Backstage*. Work begun on the triptych *Ballet Rehearsal* (cat. 132). Sculptures: *The Acrobat, Head of a Man, The Woman Snake Charmer* (fig. p. 139).

One-man exhibitions: Beverly Hills, Frank Perls, November-December (15 paintings); Düsseldorf, Kunsthalle, Kunstverein für die Rheinlande und Westfalen, February-April (25 paintings, 6 drawings, 59 prints); Munich, Galerie Günther Franke, Villa Stuck, January-February (25 paintings from 1906-1949); Oakland Calif., The Mills College Art Gallery, July-August (25 paintings from the collections of Lackner, Morgenroth and others, 25 drawings and prints); Stuttgart, Württembergische Staatsgalerie (about 30 paintings from the Günther Franke collection); St. Louis, Washington University, June, exhibition of nine paintings on the occasion of awarding Beckmann the honorary doctorate; Venice, xxvth Biennale (14 paintings).

Group exhibitions: Buffalo, N.Y., The Buffalo Fine Arts Academy, Albright Knox Gallery, April-May, "Bosch to Beckmann;" New York, Art School of the Brooklyn Museum, September, "Faculty Show" (3 paintings); Poughkeepsie, N.Y., Vassar College, February (6 paintings). Group exhibitions in the United States as well as in Germany, Italy and Switzerland.

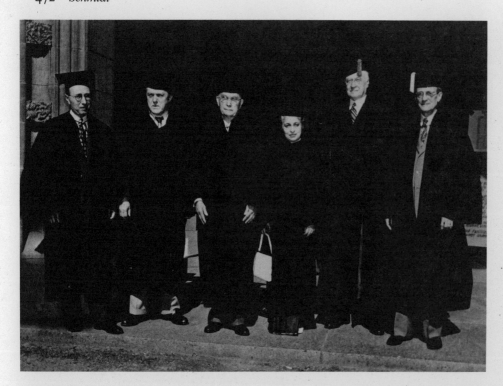

Fig. 68 Awarding of honorary doctorates at Washington University, St. Louis, June 6, 1950. From the left: Eugene P. Wigner, Max Beckmann, Luther E. Smith, Madame Vijaya L. Pandit, Bernard M. Baruch, and Alexander Langsdorf

Fig. 69 Max Beckmann's studio in New York, 38 West 69th St., after his death

At the Biennale in Venice Beckmann receives the Count Volpi Prize.

The contract with the Brooklyn Museum Art School is extended for six years.

At the beginning of April Beckmann spends three days in Bloomington making studies for the *Family Portrait of Henry R. Hope.* The Beckmanns move to their apartment at 38 West 69th Street near Central Park in early May.

Beckmann travels to St. Louis to receive an honorary doctorate from Washington University on June 6. At the ceremony Beckmann reads his address in English. His wife had read it in English for a gathering of friends of the university on June 5.[33]

Diary, June 2, 1950: "On the train to St. Louis... on the way to my honorary doctorate in St. Louis I wonder if I truly already like New York. I don't know—in any event I don't find the city unsympathetic. One has to work and forget everything, just in order to work, to be able to keep on working, now I'm travelling to dream..."

After St. Louis the Beckmanns travelled to Carmel near San Francisco until July 4. Plans for a trip to Europe are dropped because of the Korean crisis. In July and August Beckmann teaches a summer course at Mills College in Oakland, California, at the invitation of Alfred Neumeyer. In Oakland he becomes acquainted with Darius Milhaud. The Beckmanns visit San Francisco and take a trip through the desert to Reno.

Beginning August 22 Beckmann, now back in New York, teaches at the American Art School, a private school on 56th Street. The Beckmanns buy a car; Mrs. Beckmann drives.

Beckmann is visited by Ernst Holzinger of the Städelsches Kunstinstitut, who hopes to bring Beckmann back to Frankfurt to teach or as a guest artist.[34]

Around Christmas, Beckmann works feverishly on the central panel of *Argonauts,* and on *Backstage.* On December 27 he leaves the apartment shortly after 10 a.m. in order to walk through Central Park to go to The Metropolitan Museum for a look at his *Self-Portrait in Blue Jacket,* which is hanging in the exhibition "American Painting Today." At the corner of 61st Street and Central Park West he collapses and falls dead.[35]

In his last letter, written to his son Peter on December 17, 1950, Beckmann writes: "... after all, it may not be so important whether one undertakes the change of location a few years earlier or later... Dream that began with tears and ended with weeping of death (Klopstock) is probably our true lot at this level of consciousness. But please, don't interpret this as pessimism; I'm just now painting a triptych, the *Argonauts,* and we will see each other again in 'Dodona'... If I am able and Mr. Stalin permits, I am rather sure I will be coming in the summer and then we can discuss it further..."[36]

33. Mathilde Q. Beckmann, *op. cit.*, pp. 207-209.

34. Letter by Ernst Holzinger to Hans Mettel, director of the Städelschule, excerpts in: Mathilde Q. Beckmann, *op. cit.*, pp. 217-218: "I finally visited Max Beckmann yesterday... I saw great magnificent pictures at his studio, and found the man himself again very imposing, calmer, milder, and without 'force.' I assume that by nature he has a strong lyrical quality. ... I merely hinted at the possibility of a studio in the (Städel) School, and he rhapsodized about his old apartment, which he would prefer to have. He then said that Hamburg was trying to get him to come there, but that, if he were to go to Germany at all, he would like Frankfurt best. ... and that he had lived his decisive years in Frankfurt... If he were to teach at the School he would only want to come twice a week to correct pictures, something which I found entirely appropriate. He would anyhow only be asked to teach the most advanced students...."

35. A precise description of his last days of life is to be found in: Mathilde Q. Beckmann, *op. cit.*, p. 173 ff.

36. Quoted from: *In Memoriam Max Beckmann, 12.2.1884-27.12.1950,* Max Beckmann Gesellschaft, Frankfurt am Main 1953, p. 55.

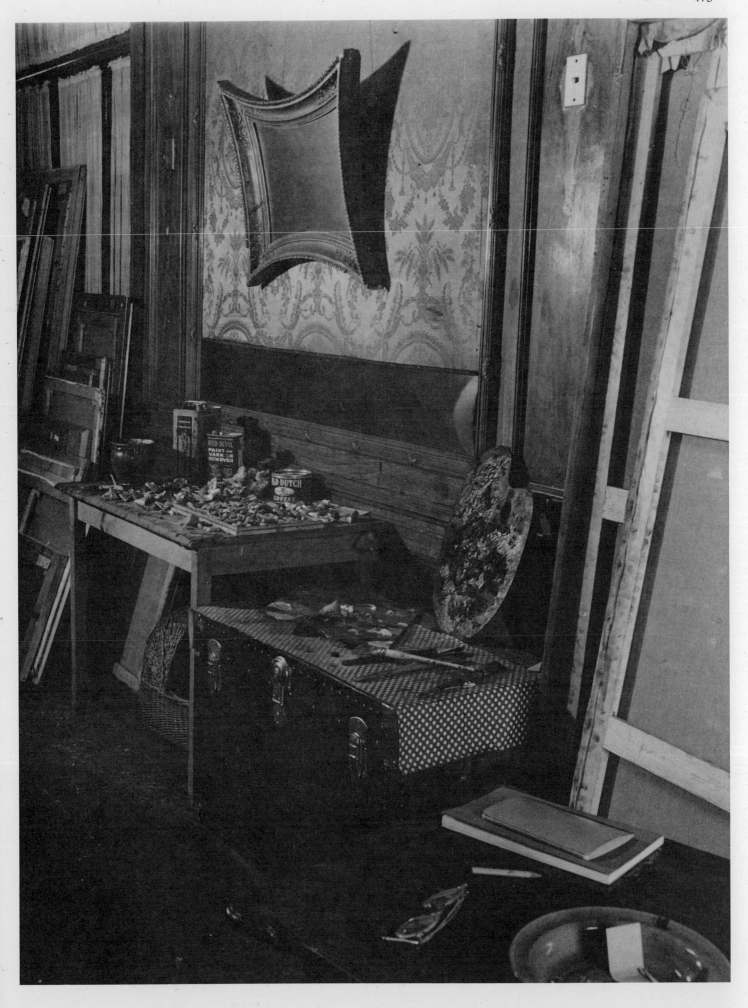

Bibliography

1. Writings of Max Beckmann

Leben in Berlin; Tagebücher 1908-1909, 1912-1913. ed. by Hans Kinkel. Munich: 1966; 1983.

[Untitled article] Im Kampf um die Kunst. Munich: 1911, p.37.

"Gedanken über zeitgemässe und unzeitgemässe Kunst." Pan 2 (March 1912) 499ff.

"Das neue Programm." Kunst und Künstler 12 (1914) 301. (English translation by Victor H. Meisel in Voices of German Expressionism, ed. by Meisel, Englewood Cliffs, NJ: 1970.)

Briefe im Kriege, collected by Minna Tube. Berlin: 1916; 2nd ed., Munich: 1955.

"Schöpferische Konfession." Tribüne der Kunst und Zeit vol. 13, 2nd ed., Berlin: 1920. (English translation by Victor H. Meisel in Voices of German Expressionism, ed. by Meisel, Englewood Cliffs, NJ: 1970.)

"Über den Wert der Kritik." Der Ararat 2 (1912) 132.

Das Hotel, play in four acts, 1912, typescript.

Ebbi: Komödie. Vienna: 1924.

"Autobiographie." Dem Verlag R. Piper & Co. zum 19. Mai 1924. n.p., n.d., p. 10f.

"Der Künstler im Staat." Europäische Revue 3 (1927) 288ff.

"Sechs Sentenzen zur Bildgestaltung." (in Mannheim 1928 catalogue).

[Answer to inquiry] "Nun sag', wie hast Du's mit der—Politik?" Frankfurter Zeitung Weihnachts-Ausgabe 1928.

On My Painting. New York: Buchholz Gallery, Curt Valentin, 1941. (English translation of Meine Theorie der Malerei or Über Meine Malerei a lecture given at the New Burlington Galleries, London 1938.)

Tagebücher 1940-1950, compiled by Mathilde Q. Beckmann, ed. by Erhard Göpel. Munich: 1955; 1979.

Speech given by Max Beckmann to his first class in the United States at Washington University, St. Louis, 23rd September, 1947 (in Mein Leben mit Max Beckmann, by Mathilde Q. Beckmann, p. 198ff.)

"Letters to a Woman Painter." College Art Journal 9 (Autumn 1949): 39ff. (English translation of Briefe an eine Malerin.

"Ansprache für die Freunde und die Philosophische Fakultät der Washington University, St. Louis 1950." In Memoriam: Max Beckmann 12.2.1884-27.12.1950. Frankfurt am Main: 1953. (Speech given upon conferral of Honorary Doctorate by Washington University, June 6, 1950. English typescript, Washington University Archives.)

"In der Arena der Unendlichkeit." Die Neue Zeitung, Munich, February 12, 1952.

[Twenty letters from 1926-1950]. Briefe an Günther Franke: Porträt eines deutschen Kunsthändlers. Cologne: 1970.

2. Exhibition catalogues

Mannheim 1928, Städtische Kunsthalle, Max Beckmann, Das gesammelte Werk, Gemälde, Graphik, Handzeichnungen aus den Jahren 1905 bis 1927.

Munich 1928, Galerie Günther Franke, Graphisches Kabinett, Fünfzigste Ausstellung Max Beckmann, Gemälde aus den Jahren 1920-1928.

London 1938, New Burlington Galleries, Exhibition of 20th Century German Art.

New York 1946, Buchholz Gallery, Curt Valentin, Beckmann: His Recent Work from 1939 to 1945.

St. Louis, 1948, City Art Museum, Max Beckmann 1948.

St. Louis, 1948, City Art Museum, St. Louis Collections: An Exhibition of 20th Century Art.

Munich 1951, Haus der Kunst, Max Beckmann zum Gedächtnis 1884-1950.

New York 1959, Catherine Viviano Gallery, The Eight Sculptures of Max Beckmann.

Karlsruhe 1962, Badischer Kunstverein, Max Beckmann, Die Druckgraphik – Radierungen, Lithographien, Holzschnitte.

Karlsruhe 1963, Badischer Kunstverein, Max Beckmann – Das Portrait, Gemälde, Aquarelle, Zeichnungen.

New York 1964, The Museum of Modern Art, Max Beckmann.

New York 1964, Catherine Viviano Gallery, Max Beckmann: An Exhibition of Paintings, Sculptures, Watercolors and Drawings.

Hamburg 1965, Kunstverein, Max Beckmann: Gemälde, Aquarelle, Zeichnungen.

Bremen 1966, Kunsthalle, Max Beckmann: Gemälde und Aquarelle der Sammlung Stephan Lackner, U.S.A.; Gemälde, Handzeichnungen und Druckgraphik aus dem Besitz der Kunsthalle Bremen.

Bielefeld 1968, Kunsthalle, Deutsche Expressionisten aus der Sammlung Morton D. May St. Louis, USA.

Munich 1968, Haus der Kunst, Max Beckmann.

London 1971, Sotheby & Co., auction, December 1, 1971, The Complete Series of Drawings by Max Beckmann for Goethe's "Faust II."

New York 1973, Catherine Viviano Gallery, A Catalogue of Paintings, Sculptures, Drawings & Water Colors by Max Beckmann.

Tucson 1973, Art Center, Max Beckmann Graphics; Selected from the Ernest and Lilly Jacobson Collection.

Hamburg 1973, Kunsthalle, Kunst in Deutschland 1808-1973.

Berlin 1974, Nationalgalerie, Realismus und Sachlichkeit: Aspekte deutscher Kunst 1919-1933.

Bremen 1974, Kunsthalle, Max Beckmann in der Sammlung Piper: Handzeichnungen, Druckgraphik, Dokumente, 1910-1923.

Bremen 1974, Kunsthalle, Druckgraphische Zyklen des 19. und 20. Jahrhunderts.

Hoechst 1974, Jahrhunderthalle, Max Beckmann: Druckgraphik.

London 1974, Marlborough Fine Art Ltd., Max Beckmann: A Small Loan Retrospective of Paintings Centred around His Visit to London in 1938.

Bielefeld 1975, Kunsthalle, Max Beckmann, 2 Vols.

Munich 1975, Galerie Günther Franke, Max Beckmann: 180 Zeichnungen und Aquarelle aus deutschem und amerikanischem Besitz.

New York 1975, Carus Gallery, Max Beckmann: Drawings, Sculpture.

Hamburg 1976, 25 Jahre Castrum Peregrini Amsterdam: Dokumentation einer Runde.

Innsbruck 1976, Galerie im Taxispalais, Max Beckmann, 1884-1950: Graphik.

Zürich 1976, Kunsthaus, Max Beckmann: Das druckgraphische Werk.

Berlin 1977, Große Orangerie im Schloss Charlottenburg, Tendenzen der Zwanziger Jahre.

Bielefeld 1977, Kunsthalle, Max Beckmann: Aquarelle und Zeichnungen 1903-1950.

Los Angeles 1977, UCLA, Frederick S. Wight Art Gallery, The Robert Gore Rifkind Collection.

Paris 1978, Centre Pompidou, Paris-Berlin, 1900-1933.

London 1978, Hayward Gallery, Neue Sachlichkeit and German Realism of the Twenties.

Hamburg 1979, Kunstverein, Stadtnächte: Der Zeichner und Grafiker Max Beckmann.

Frankfurt am Main 1980, Kommunale Galerie im Refektorium des Karmeliterklosters, Max Beckmanns Frankfurter Schüler 1925-1933.

London 1980, Whitechapel Art Gallery, Max Beckmann: The Triptychs.

New York 1980, Solomon R. Guggenheim Museum, Expressionism: A German Intuition 1905-1920.

Amsterdam 1981, Stedelijk Museum, *Triptieken.*

Frankfurt am Main 1981, Städtische Galerie, *Max Beckmann: Die Triptychen im Städel.*

Cologne 1981, *Westkunst: Zeitgenössische Kunst seit 1919.*

Munich 1981, Kunstgalerie Esslingen, *Max Beckmann: Radierungen, Lithographien, Holzschnitte.*

New York 1981, Grace Borgenicht Gallery, *Max Beckmann: Paintings & Sculpture.*

Bielefeld 1982, Kunsthalle, *Max Beckmann: Die frühen Bilder.*

Bonn-Bad Godesberg 1982, Wissenschaftszentrum, *Goethe in der Kunst des 20. Jahrhunderts. Weltliteratur und Bilderwelt.*

Berlin 1983, Kupferstichkabinett, *Max Beckmann: Die Hölle, 1919.*

Frankfurt 1983, Städtische Galerie, *Max Beckmann: Frankfurt 1915-1933.*

Esslingen 1984, Galerie der Stadt, *Max Beckmann Graphik zum 100. Geburtstag.*

Cologne 1984, Kunsthalle, *Max Beckmann.*

Bremen 1984, Kunsthalle, *Max Beckmann: Gemälde, Handzeichnungen, Druckgraphik.*

3. *Books and Articles*

Anderson, Eleanor. "Max Beckmann's 'Carnival' Triptych." *Art Journal* 24 (Spring 1965) 218ff.

Arndt, Karl. "Max Beckmann: Selbstbildnis mit Plastik; Stichworte zur Interpretation." *Ars Auro prior. Studia Ioanni Bialostocki sexagenario dedicata.* Warsaw: 1981. p. 719ff.

Beckmann, Mathilde Q. [Documentation] (in New York 1964, Museum of Modern Art catalogue)

— *Mein Leben mit Max Beckmann.* Translated from the English by Doris Schmidt. Munich: 1983.

Beckmann, Peter. *Max Beckmann.* Nürnberg: 1955.

— (ed.) *Max Beckmann: Sichtbares und Unsichtbares.* Stuttgart: 1965.

— *Die Versuchung; Eine Interpretation des Triptychons von Max Beckmann.* Heroldsberg: 1977.

— "Graphik als Selbstprüfung. Zum graphischen Werk Max Beckmanns." (in Munich 1981 catalogue)

— *Max Beckmann: Leben und Werk.* Stuttgart: 1982.

Blick auf Beckmann: Dokumente und Vorträge, ed. by Hans Martin Frhr. von Erffa and Erhard Göpel. Munich: 1962.

Braunbehrens, Lili von. *Gestalten und Gedichte um Max Beckmann.* Dortmund: 1969.

Buchheim, Lothar-Günther. *Max Beckmann.* Feldafing: 1959.

Buenger, Barbara C., *Max Beckmann's Artistic Sources; the Artist's Relation to Older and Modern Tradition,* Ph.D. Dissertation, New York: 1979.

— "Kreuztragung." (in Bielefeld 1982 catalogue)

Busch, Günter. *Max Beckmann: Eine Einführung.* Munich: 1960.

— *Entartete Kunst: Geschichte und Moral.* Frankfurt: 1969.

Clark, Margot O. *Max Beckmann: Sources of Imagery in the Hermetic Tradition,* Ph.D. Dissertation. St. Louis: 1975.

— "The Many-Layered Imagery of Max Beckmann's 'Temptation' Triptych." *The Art Quarterly* 1 (Summer 1978) 244ff.

— "Beckmann and Esoteric Philosophy." (in London 1980 catalogue)

— "Beckmanns Vorstellung vom metaphysischen Selbst." (in Frankfurt 1983 catalogue)

Dube, Wolf-Dieter. "Anmerkungen zum Triptychon Versuchung von Max Beckmann." *Pantheon* 38 (1980) 393ff.

— *Max Beckmann. Das Triptychon "Versuchung."* Munich: 1981.

— "Auferstehung im Werke Max Beckmanns." *Kunst und Kirche* 2 (1982) 65ff.

— *Der Expressionismus in Wort und Bild.* Geneva: 1983.

Dückers, Alexander. "Max Beckmann – Die Hölle 1919." (in Berlin 1983 catalogue)

Edschmid, Kasimir. *Lebendiger Expressionismus.* Munich: 1961.

Einstein, Carl. *Die Kunst des 20. Jahrhunderts.* Propyläen-Kunstgeschichte. Berlin: 1926, p. 154ff.

Erpel, Fritz. *Max Beckmann.* Berlin (DDR): 1981.

Evans, Arthur and Catherine. "Max Beckmann's Self-Portraits." *Art International* 18 (November 1974) 13ff.

Fischer, Friedhelm Wilhelm. *Max Beckmann: Symbol und Weltbild.* Munich: 1972.

— *Max Beckmann.* Translated by P.S. Falla. New York: 1973.

Fraenger, Wilhelm. "Max Beckmann: Der Traum, ein Beitrag zur Physiognomik des Grotesken," 1924. (see *Blick auf Beckmann*)

Gäßler, Ewald. *Studien zum Frühwerk Max Beckmanns, Eine motivkundliche und ikonographische Untersuchung zur Kunst der Jahrhundertwende,* Ph.D. Dissertation. Göttingen: 1974.

Gallwitz, Klaus, ed. (in Karlsruhe 1962 catalogue)

Gandelman, Claude. "Max Beckmann's Triptychs and the Simultaneous Stage of the 'Twenties'." (in London 1980 catalogue)

Glaser, Curt; Meier-Graefe, Julius; Fraenger, Wilhelm; Hausenstein, Wilhelm. *Max Beckmann.* Munich: 1924.

Göpel, Erhard. *Max Beckmann der Zeichner.* Munich: 1954, 1958.

— *Max Beckmann in seinen späten Jahren.* Munich: 1955.

— "Beckmanns Farbe," 1956. (see *Blick auf Beckmann*)

— *Max Beckmann: Die Argonauten, Ein Triptychon.* Stuttgart: 1957.

— *Max Beckmann der Maler.* Munich: 1957.

— "Max Beckmann und Wilhelm R. Valentiner," 1962. (see *Blick auf Beckmann*)

— and Barbara. *Max Beckmann: Katalog der Gemälde.* 2 vols. Bern: 1976.

Gosebruch, Martin. *Mythos ohne Götterwelt.* Esslingen: 1984.

Grosz, George. *Briefe 1913-1959,* ed. by Herbert Kunst. Hamburg: 1979, p. 436, 449f.

Güse, Ernst-Gerhard. *Das Frühwerk Max Beckmanns: Zur Thematik seiner Bilder aus den Jahren 1904-1914,* Dissertation. Hamburg: 1977. (*Kunstwissenschaftliche Studien,* vol. 6. Frankfurt: 1977.)

— "Das Kampf-Motiv im Frühwerk Max Beckmanns." (in Bielefeld 1982 catalogue)

Haftmann, Werner. *Painting in the Twentieth Century.* Translated by Ralph Manheim. 2 vols. New York: 1960.

Hartlaub, Gustav Friedrich. *Kunst und Religion.* Leipzig: 1919, p. 82ff.

— *Die Graphik des Expressionismus in Deutschland.* Stuttgart: 1947.

Hausenstein, Wilhelm. "Max Beckmann." (in Munich 1928 catalogue)

Heckmanns, Friedrich W. "Zu den Entwurfszeichnungen der Nacht." (in Frankfurt 1983 catalogue)

Jedlicka, Gotthard. "Max Beckmann in seinen Selbstbildnissen," 1959. (see *Blick auf Beckmann*)

Kaiser, Hans. *Max Beckmann.* Berlin: 1913.

Kaiser, Stephan. *Max Beckmann.* Stuttgart: 1962.

Kalnein, Wend von. "Max Beckmann: Quappi in Blau und Grau." *Düsseldorfer Museen Bulletin* 1 (1969) 28.

Kesser, Armin. "Das mythologische Element im Werk Max Beckmanns," 1958. (see *Blick auf Beckmann*)

Kessler, Charles S. *Max Beckmann's Triptychs.* Cambridge, MA: 1970.

Kinkel, Hans. "Die Sache des Lebens oder Der schlechte deutsche Sekt. Ein Brief Beckmanns an Baron Simolin vom 20.8.1930." (in Frankfurt 1983 catalogue)

Klötzer, Wolfgang. "Frankfurt am Main 1915-1933." (in Frankfurt 1983 catalogue)

Lackner, Stephan. *Max Beckmann 1884-1950.* Berlin: 1962.

— *Max Beckmann 1884-1950: Die neun Triptychen.* Berlin: 1965.

— *Max Beckmann.* Bergisch Gladbach: 1968.

— *Max Beckmann: Memories of a Friendship.* Coral Gables: 1969.

— *Max Beckmann.* The Library of Great Painters. New York: 1977.

— *Peter Beckmann im Bild seines Vaters.* Murnau: 1978.

— "Ballettprobe; Max Beckmanns unvollendetes Triptychon." (in Frankfurt 1981 catalogue)

— "Sehr schwarz, sehr weiss." (in Munich 1981 catalogue)

— *Max Beckmann.* Munich: 1983.

Lenz, Christian. "'Mann und Frau' im Werke von Max Beckmann." *Städel-Jahrbuch* N.F. 3 (1971) 213ff.

— "Max Beckmanns 'Synagoge'." *Städel-Jahrbuch* N.F. 4 (1973) 299ff.

— "Max Beckmann – 'Das Martyrium'." *Jahrbuch der Berliner Museen* 16 (1974) 185ff.

— *Max Beckmann und Italien.* Frankfurt am Main: 1976.

— "Max Beckmann in seinem Verhältnis zu Picasso." *Niederdeutsche Beiträge zur Kunstgeschichte* 16 (1977) 236ff.

— "Moderne Kunst: Ernst Ludwig Kirchner und Max Beckmann." *Universitas* 35 (1980) 1187ff.; *Universitas* 24 (1982) 123ff. (English)

— "Die Zeichnungen Max Beckmanns zum *Faust*." (in Bonn-Bad Godesberg 1982 catalogue)

— "Max Beckmanns Zeichnungen zum *Faust*." *Neue Zürcher Zeitung* (8-27-82) 31 f.

— *Max Beckmann: Ewig wechselndes Welttheater.* Esslingen: 1984.

Linfert, Carl. "Beckmann oder Das Schicksal der Malerei," 1935. (see *Blick auf Beckmann*)

Marc, Franz. "Anti-Beckmann." *Pan* 2 (1912) 555f.

Marwitz, Herbert. "Der Herr: Zur Genealogie des modernen Menschenbildes." *Wandlungen; Studien zur antiken und neueren Kunst.* Festschrift E. Homann-Wedeking. Waldsassen: 1975, p. 312ff.

Meier-Graefe, Julius. "Gesichter – Vorrede zu einer Mappe mit 19 Radierungen von Max Beckmann," 1919. (see *Blick auf Beckmann*)

— *Entwicklungsgeschichte der modernen Kunst.* 3 vols., Munich: 1924.

Metken, Günter. "Somnambulismus und Bewußtseinshelle, Beckmanns Umgang mit der Tradition." (in Frankfurt 1983 catalogue)

— "Max Beckmanns Schriften 1920-1928; eine Einleitung." (in Frankfurt 1983 catalogue)

Mitschke, Hans-Joachim. "Düsseldorf, Kunstsammlungen des Landes Nordrhein-Westfalen, Neuerwerbungen." *Pantheon* 28 (1970) 248f.

Myers, Bernard S. *The German Expressionists: A Generation in Revolt.* New York: 1957.

Neumann, I.B. *Sorrow and Champagne.* New York: 1958. (Typescript)

Paret, Peter. *The Berlin Secession: Modernism and its Enemies in Imperial Germany.* Cambridge: 1980.

Piper, Reinhard. *Nachmittag, Erinnerungen eines Verlegers.* Munich: 1950.

— *Mein Leben als Verleger, Vormittag, Nachmittag.* Munich: 1964.

— "Max Beckmann." *Briefwechsel mit Autoren und Künstlern 1903-1953.* Munich: 1979, p. 158ff.

Poeschke, Joachim. "Der frühe Max Beckmann." (in Bielefeld 1982 catalogue)

— "Der Neubeginn in Frankfurt: Beckmann in den Jahren 1915-1919." (in Frankfurt 1983 catalogue)

— *Max Beckmann in seinen Selbstbildnissen.* Esslingen: 1984.

Rave, Paul Ortwin. *Kunstdiktatur im Dritten Reich.* Hamburg: 1949.

Reifenberg, Benno. "Max Beckmann." 1921. (see *Blick auf Beckmann*)

— and Hausenstein, Wilhelm. *Max Beckmann.* Munich: 1949.

Roh, Franz. "Der Maler Max Beckmann." *Prisma* 1 (1946-1947) 1-11.

— *Entartete Kunst: Kunstbarbarei im Dritten Reich.* Hannover: 1962.

Schade, Herbert SJ. "Max Beckmann: Gestaltung ist Erlösung." *Stimmen der Zeit* 94 (1969) 231ff.

Scheffler, Karl. "Berliner Chronik: Max Beckmann." *Kunst und Künstler* 31 (April 1932) 146.

Schiff, Gert. "Max Beckmann: Die Ikonographie der Triptychen, Umrisse einer geplanten Arbeit." *Munuscula Discipulorum, Hans Kauffmann zum 70. Geburtstag 1966*, ed. by Tilmann Buddensieg and Matthias Winner. Berlin: 1968, p. 265ff.

— The Nine Finished Triptychs of Max Beckmann." (in London 1980 catalogue)

Schmidt, Diether, ed. "Manifeste, Manifeste 1905–1933." *Schriften deutscher Künstler des zwanzigsten Jahrhunderts,* vol. 1. Dresden: 1964, P. 26, 139ff.

Schmidt, Georg. *Die Malerei des 20. Jahrhunderts in Deutschland.* Königstein im Taunus: 1960.

Schmied, Wieland. *Neue Sachlichkeit und Magischer Realismus in Deutschland 1918-1933.* Hannover: 1969.

Schmoll, J.A. *Fensterbilder.* Munich: 1970.

Schneede, Uwe M., ed. *Die Zwanziger Jahre: Manifeste und Dokumente deutscher Künstler.* Cologne: 1977.

Schubert, Dietrich. "Nietzsche – Konkretionsformen in der bildenden Kunst 1890-1933." *Nietzsche-Studien; Internationales Jahrbuch für die Nietzsche-Forschung* 10/11 (1981/82) 278ff.

— "Die Beckmann-Marc-Kontroverse von 1912, Sachlichkeit versus innerer Klang." (in Bielefeld 1982 catalogue)

Schulz-Mons, Christoph. "Kirchner und Beckmann in Frankfurt." *Zeitschrift für Kunstgeschichte* 43 (1980) 203ff.

— "Zur Frage der Modernität des Frühwerks von Max Beckmann." (in Bielefeld 1982 catalogue)

Seiler, Harald. *Hannover – Niedersächsische Landesgalerie.* Cologne: 1969.

Sekler, Dorothy. "Can Painting be Taught? 1. Beckmann's Answer." *Art News* 50 (March 1951) 39.

Selz, Peter. *German Expressionist Painting.* Berkeley: 1957.

— "Max Beckmann." (in New York 1964, Museum of Modern Art catalogue)

— "Max Beckmann 1933-1950: Zur Deutung der Triptychen." (in Frankfurt 1981 catalogue)

Snyder, Margaret L. *A Bibliographical Study of Max Beckmann,* Masters Thesis. De Kalb, Il: 1975.

Swarzenski, Georg. "Foreword." (in New York 1946 catalogue)

Swarzenski, Hanns. "Prefatory Notes." (in St. Louis 1948, *Beckmann* catalogue)

Valentiner, W.R. "Max Beckmann," ca. 1955. (see *Blick auf Beckmann*)

Vogt, Paul. *Geschichte der deutschen Malerei im 20. Jahrhundert.* Cologne: 1972.

Wachtmann, Hans G. *Max Beckmann.* Von der Heydt-Museum Wuppertal, Kommentare zur Sammlung 2. Wuppertal: 1979.

Wankmüller, Rike and Zeise, Erika. "Zu einigen Faust-Illustrationen von Max Beckmann." *Münchner Jahrbuch der Bildenden Kunst.* 3. F. 33 (1982) 173ff.

Weisner, Ulrich. [Kommentare]. (in Bielefeld 1975 catalogue vol. 2)

— "Konstanten im Werk Max Beckmanns." (in Bielefeld 1982 catalogue)

Wichmann, Hans. *Max Beckmann.* Berlin: 1961.

Wiese, Stephan von. *Graphik des Expressionismus.* Stuttgart: 1976.

— "'Sachlichkeit den inneren Gesichten'; zum zeichnerischen Werk Max Beckmanns." (in Bielefeld 1977 catalogue)

— *Max Beckmanns zeichnerisches Werk 1903-1925.* Düsseldorf 1978.

— "Fessel-Entfesselung; Antinomien im zeichnerischen Frühwerk von Max Beckmann." (in Bielefeld 1982 catalogue)

— "Die Welt — ein Inferno: Bemerkungen zu Max Beckmanns lithographischem Zyklus 'Die Hölle'." (in Frankfurt 1983 catalogue)

Wolk, Joan M. "Das 'Vanitas' — Motiv bei Max Beckmann und Jean Paul: Symbole der Unsterblichkeit und der Liebe." (in Frankfurt 1983 catalogue)

Zenser, Hildegard. *Max Beckmanns Selbstbildnisse,* Dissertation. Munich: 1981.

Index of Names

Index of Paintings

Photo Credits

We thank the following individuals, studios, and galleries who have graciously allowed their photographs to be used as illustrations:

Al Monner-Photography, Portland, Oregon; Jörg P. Anders, Berlin; Artothek, Planegg bei München; Oliver Baker, New York; Barney Burstein, Boston; Christie's, London; Geoffrey Clements, New York; Prudence Cumming Ass.; Fred Ebb, New York; Ursula Edelmann, Frankfurt; Foto Goertz, Munich; Studio Grünke, Hamburg; Tom Haarsten, Oudenkerk a/d Amstel; Gerhard Heisler, Saarbrücken; Colorphoto Hinz, Allschwil-Basel; John Kennard; George Lantis, Middletown, Conn.; Mak-Photoline, Bielefeld; Marlborough, London; Colin McRae, Berkeley, Calif.; Rodemarie Nohr, Munich; Piaget-Studio, St. Louis, Mo.; Eric Pollitzer, New York; Repro-Studio Peter, Munich; Foto-Studio van Santvoort, Wuppertal; Savage; Walter Schmidt, Karlsruhe; Soichi Sunami, New York; Joseph Szaszfai, Branford, Conn.; Charles Uht, New York; Catherine Viviano Gallery, New York; A. J. Wyatt, Philadelphia, Pa.

Many of the photographs which appear in the Biography have been generously lent by Mrs. Mathilde Q. Beckmann, New York; the archives of Dr. Peter Beckmann, Murnau; the archives of the Bayerische Staatsgemäldesammlungen, Munich; and the archives of the Frankfurt Print Society, Frankfurt am Main. Additional photographs have been graciously supplied by: Geoffrey Clements, New York (58); Hugo Erfurth, Cologne (45); Felicia Feith (17); Helga Fietz (42, 43); Gordon Gilkey, Oregon (54); Barbara Göpel (57, 68); Photo Hess, Frankfurt (29); Jeanne Kaumann (14, 15); Mak-Photoline, Bielefeld (12); The New York Times GmbH Bilddienst, Berlin (33); Photo J. Raymond, New York (frontispiece of catalogue, 61); Saint-Gaudens, Carnegie Institute, Pittsburgh (62); Hanns Swarzenski, Wilzhofen (56); Adolf Studly (53); picture service of the Süddeutschen Verlag, Munich (37); Erika Wachsmann, Bad Hómburg v. d. Höhe (21); Paul Weller, New York (65).